# MIGRATIONS
## SEBASTIÃO SALGADO

# MIGRA

# TIONS

## HUMANITY IN TRANSITION

# SEBASTIÃO SALGADO

CONCEPT AND DESIGN BY LÉLIA WANICK SALGADO

APERTURE

The Staff at Amazonas Images is:
LÉLIA WANICK SALGADO, Director
FRANÇOISE PIFFARD, Picture Editor
MARCIA NAVARRO MARIANO, Production
DOMINIQUE GRANIER, Printer

In cooperation with:
ADRIEN BOUILLON, Retouching / Working Prints
ISABELLE MENU, Printer
MOUNA MEKOUAR, Assistant
SYLVIA MARTINS, Graphics Assistant
ISABEL D'ELIA DE ALMEIDA, Intern
RITA DELORENZO MORAIS, Intern

First English-language edition published by
Aperture Foundation, Inc., New York

Library of Congress Catalog Card Number: 99-67333
Hardcover ISBN: 0-89381-891-7
Paperback ISBN: 0-89381-892-5

The Staff at Aperture for *Migrations* is:
MICHAEL E. HOFFMAN, Executive Director
MICHAEL L. SAND, Project Editor
STEVAN A. BARON, Production Director
HELEN MARRA, Production Manager
WENDY BYRNE, Design Consultant
LESLEY A. MARTIN, Managing Editor
LAUREL PTAK, Assistant Editor

Aperture Foundation publishes a periodical, books, and port-
folios of fine photography and presents world-class exhibi-
tions to communicate with serious photographers and
creative people everywhere. A complete catalog is available
upon request. Phone: (518) 789-9003.
Fax: (518) 789-3394. Toll-free: (800) 929-2323.
E-mail: customerservice@aperture.org

Visit Aperture's website: http://www.aperture.org

Duotone reproduction and printing
Entreprise d'arts graphiques JEAN GENOUD S.A.,
Lausanne, Switzerland

The photographs were made using
LEICA R and M cameras.

THE TURNER FOUNDATION AND RHETT TURNER HAVE GENEROUSLY PROVIDED
SUPPORT TO APERTURE FOUNDATION FOR THE PUBLICATION OF *MIGRATIONS*.

Sebastião Salgado wishes
to express his special thanks for
the backing given to this project by
Kodak Professional, a division
of Eastman Kodak Company,
as part of its continuing support
of photography in journalism.

This book tells the story of humanity on the move. It is a disturbing story because few people uproot themselves by choice. Most are compelled to become migrants, refugees, or exiles by forces beyond their control, by poverty, repression, or war. They set off with the belongings they can carry, making their way as best they can, aboard rickety boats, strapped onto trains, squeezed into trucks, or on foot; they travel alone, with families, or in groups. Some know where they are going, confident that a better life awaits them. Others are just fleeing, relieved to be alive. Many never make it.

For six years in forty countries, I worked among these fugitives, on the road, or in the refugee camps and city slums where they often end up. Many were going through the worst periods of their lives. They were frightened, uncomfortable, and humiliated. Yet they allowed themselves to be photographed, I believe, because they wanted their plight to be made known. When I could, I explained to them that this was my purpose. Many just stood before my camera and addressed it as they might a microphone.

The experience changed me profoundly. When I began this project, I was fairly used to working in difficult situations. I felt my political beliefs offered answers to many problems. I truly believed that humanity was evolving in a positive direction. I was unprepared for what followed. What I learned about human nature and the world we live in made me deeply apprehensive about the future.

True, there were many heartening occasions. I encountered dignity, compassion, and hope in situations where one would have expected anger and bitterness.

I met people who had lost everything but were still willing to trust a stranger. I came to feel the greatest admiration for people who risked everything, including their lives, to improve their destiny. I found it astonishing how human beings can adapt to the direst circumstances.

Yet if survival is our strongest instinct, all too often I found it expressed as hate, violence, and greed. The massacres I saw in Africa and Latin America and the ethnic cleansing in Europe left me wondering whether humans will ever tame their darkest instincts.

I also came to understand, as never before, how everything that happens on earth is connected. We are all affected by the widening gap between rich and poor, by the availability of information, by population growth in the Third World, by the mechanization of agriculture, by rampant urbanization, by destruction of the environment, by nationalistic, ethnic, and religious bigotry. The people wrenched from their homes are simply the most visible victims of a global convulsion entirely of our own making.

In that sense, this book also tells a story of our times. Its photographs capture tragic, dramatic, and heroic moments in individual lives. Taken together, they form a troubling image of our world at the turn of the millennium.

People have always migrated, but something different is happening now. For me, this worldwide population upheaval represents a change of historic significance. We are undergoing a revolution in the way we live, produce, communicate, and travel. Most of the world's inhabitants are now urban. We have become one world: in distant corners of the globe, people are being displaced for essentially the same reasons.

In Latin America, Africa, and Asia, rural poverty has prompted hundreds of millions of peasants to abandon the countryside. And they crowd into gargantuan, barely inhabitable cities that also have much in common. Entire populations have moved for political reasons as well. Millions have fled communist regimes. The collapse of communism in Eastern Europe then freed many more to seek out new lives. Now, with the imposition of a new world political order, ethnic and religious conflicts are spawning armies of refugees and displaced persons. Many of these are becoming urbanized by the very experience of living in refugee camps.

In an effort to illustrate the main themes, we have organized the photographs in this book into four broad chapters: the flight of migrants, refugees, and displaced persons in different parts of the world; the unique tragedy of Africa; the rural exodus, land struggle and chaotic urbanization in Latin America; and images from Asia's new megacities. But it is also in the nature of this project that photographs in one chapter should have echoes in another. I was often reminded as I worked that human beings everywhere are alike.

I was probably drawn to this project by my own life on the move. I was born on a farm in the rural state of Minas Gerais in Brazil. When I was five, my family moved to the small town of Aimorés; in my teens, I went to Vitória, the capital of Espírito Santo state, to finish high school and attend university. After meeting my wife Lélia, we traveled to the metropolis of São Paulo where I continued studying to become an economist. Every step was a move into a denser urban world. Then in 1969, with Brazil under military rule, we left for Europe and found we had become part refugees, part immigrants, part students. Three decades later, we still live in a foreign land.

It is not surprising, then, that I should identify, even feel a certain complicity, with exiles, migrants, people shaping new lives for themselves far from their birthplaces. The Salvadoran waiter in a Los Angeles restaurant, the Pakistani shopkeeper in the north of England, the Senegalese hard hat on a Paris construction site, all deserve our respect: each has traveled an extraordinary physical and personal journey to reach where he is, each is contributing to the reorganization of humankind, each is implicitly part of our story.

But this book was also born of earlier projects—my travels in Latin America, Africa, and Asia, documenting the many forms of manual labor that were disappearing in the postindustrial age. Everywhere I went in the Third World, I saw that when poverty becomes intolerable, people seek to move on. Most head for large cities; the more adventurous set their sights on far-off prosperous nations. In the process, they transform the cities and countries where they settle: Third World cities become further pauperized; parts of the United States are now Hispanicized; migrants from the Indian subcontinent have created a new underclass in rich Arab countries; and poor Muslims from North Africa and Turkey have rooted Islam in Western Europe.

In Africa, as early as the 1970s, I had also come face-to-face with the refugee problem in the most horrifying of ways: wars aggravated by droughts were bringing starvation to hundreds of thousands of people in Ethiopia and Sudan. Only the luckiest ended up in refugee camps, with little hope of either returning home or moving on. Gradually, Africa became more and more trapped in cycles of wars, refugees, and hunger. I saw this happening in Angola, Mozambique, Chad, Ethiopia, and Eritrea, but it was no different in Liberia, Somalia, Sierra Leone—the list goes on. But I never imagined that this nightmare would repeat itself in Europe, in the Balkans, two decades later.

For this project, I visited many cities and countries for the first time. When I returned to places I had previously known, however, it was painful to discover that things were generally worse.

In my own country, I had not spent much time in São Paulo in thirty years. Now I barely recognized it: it had been transformed by migration—and social injustice—into a city of endemic street violence and mass poverty. At the other end of Brazil, deep in the Amazon, in the 1980s the Yanomami Indians were still relatively untouched by the outside world. When I returned in 1998, their habitat had been degenerated by the incursion of gold, diamond, and cassiterite miners who had poisoned their rivers with mercury and littered their land with industrial detritus. The Yanomami themselves were being driven toward assimilation, or extinction.

Everywhere I traveled, the impact of the information revolution could be felt. Barely a half-century ago, the world could say it "did not know" about the Holocaust. Today, information—or at least the illusion of information—is available to everyone. Yet the consequences of "knowing" are not always predictable. Television informed the world of the massacres in Rwanda or the mass expulsions of Bosnians, Serbs, and Kosovars almost as they were taking place, but these horrors nonetheless continued. On the other hand, North Africans can watch French television, Mexicans can watch American television, Albanians can watch Italian television, and Vietnamese can watch CNN or the BBC. The demonstration of conspicuous consumption is such that they can hardly be faulted for dreaming of migration.

But while information is the most obvious bridge between cause and effect, it is not the only one. I was often struck by the sequence of circumstances that led to specific crises. After Hurricane Mitch swept through Central America in 1998, I visited a Honduran village that had been destroyed by flooding and landslides. I asked locals if this was the worst storm they had known. Some old villagers recalled a similar hurricane in the 1930s. But it had caused far less damage, they said, because in those days surrounding hills were covered with trees that retained the water. In 1998, then, it was the hand of man that turned an act of nature into a tragedy.

Similarly, although freelance gold-miners are routinely blamed for the steady decimation of Brazil's Indian tribes, the reality is more complicated. Most miners are impoverished peasants who have no land to farm in a country with vast unproductive private estates. Thus, in Brazil, as in many other Latin American countries, it is concentration of land ownership and mechanized farming that drive the exodus from the countryside. The distorted land-tenure system is in turn sustained by economic and political structures that perpetuate the status quo. As one problem feeds on another, a chain reaction takes place. Everything becomes linked and no problem can be solved on its own.

It should not be surprising, for example, that São Paulo and Mexico City are so alike, because both have experienced "invasions" by peasant migrants and neither

has managed to cope. In São Paulo, the resulting slums are called "favelas" and in Mexico City they are called "ciudades perdidas" (lost cities), but they look alike: the shacks are built with wooden planks and metal sheets, precarious poles bring in electricity stolen from the mains, kids play soccer on muddy or dusty plots surrounded by garbage. Even the street children sniffing glue in doorways look alike. And in both cities, were it not for high crime rates, prosperous elites would be largely oblivious to the impoverished majority.

This experience of Latin America made the sprawling cities of Asia seem strangely familiar. There were differences: São Paulo and Mexico City are more violent places, but environmental degradation seems even worse in Asia. Yet at times I would forget where I was. Cairo? Jakarta? Mexico City? Everywhere there are those same islands of wealth amid the poverty, like the green areas of Manila that are private golf clubs instead of public parks. There is the same struggle for survival as millions of new city-dwellers compete to find a decent place to live, a secure job, a school for their children, an appointment at an overcrowded medical clinic. And always there are legions of people whose lives are so precarious that they are reduced to begging.

The alternative for a lucky few is to migrate to a country where, they imagine, things will be better. A good part of the world's poor probably wish to go to the United States. And many do. Some, like the Russian Jews I accompanied on a flight from Moscow to New York, at least travel with a visa in their passports. Still farther away, in Vietnam, the hope of obtaining an entry visa leads hundreds to line up daily outside the United States consulate in Ho Chi Minh City (formerly Saigon), but only those who collaborated with the United States intervention in Vietnam are accepted. The "boat people" who took to the seas in the 1980s were unwilling to wait: they wanted to escape Vietnam and reach the United States, but instead most ended up adrift in other Asian countries or in prisons in Hong Kong.

Latin Americans at least have the option of walking into the United States across the border with Mexico. It is not easy, but millions have tried and millions have made it—it takes great determination and daring. For Central Americans, it means first crossing all of Mexico. One way of starting is the freight train that leaves the border of Guatemala and Mexico headed north every morning. I took this train for part of the way and was impressed by the youth of the migrants, often teenagers who were absolutely convinced that the United States was within their reach. Some were returning to California, having flown home for vacations in El Salvador. One man was on his way back to a job in Alaska.

The crossing into the United States, though, is becoming more difficult. The United States Border Patrol uses ever-more sophisticated devices to track groups of migrants entering the country at night. Many are caught and returned to Mexico

penniless, having lost the money they paid to a "coyote" guide to lead them across the border. But they keep trying, and the border patrolmen are often sympathetic. Many are first-generation Americans of Mexican extraction whose own parents probably first entered the United States illegally.

In Africa and the Middle East, on the other hand, Western Europe is the magnet. No less than the United States, Europe tries to keep out Third World migrants, but the migrants keep coming anyway. The land route across Turkey is preferred by many Iraqis, Afghans, Chinese, and Kurds, but for those in North and West Africa the quickest way is through Spain.

Some enter the Spanish enclaves of Ceuta and Melilla in northern Morocco and then find themselves stranded there. Many more pay for a place in tiny over-crowded boats that use darkness to cross the Straits of Gibraltar, a dangerous passage with treacherous currents and sudden storms. Those who reach Spain either stay to work as farm laborers or keep going to France. Some make it only as bodies washed ashore. Far away, parents wait to hear from them, even complaining about being forgotten, while their children have been buried in unmarked graves.

A good many are also stopped by the Spanish authorities. I was on board a Spanish customs helicopter one night when it caught a boatload of migrants in its searchlight. My heart went out to them. There were forty or so different life-stories that preceded this shared moment of panic and disappointment. For Spain, though, they represented a boatload of anonymous migrants who, this time at least, would not enter Europe.

Refugees and displaced persons, unlike migrants, are not dreaming of different lives. They are usually ordinary people—"innocent civilians," in the language of diplomats—going about their lives as farmers or students or housewives until their fates are violently altered by repression or war. Suddenly, along with losing their homes, jobs, and perhaps even some loved ones, they are stripped even of their identity. They become people on the run, faces on television footage or in photographs, numbers in refugee camps, long lines awaiting food handouts. It is a cruel contract: in exchange for survival, they must surrender their dignity.

They are also rarely able to put their lives together again, or at least not as before. Some become permanent refugees, permanent camp-dwellers, like the Palestinians in Lebanon. Their lives acquire a certain stability but, as victims of politics, they remain vulnerable to politics. Some can go home, but choose not to, having built alternative lives that offer more security. Others who do eventually return to their countries have become different people, perhaps more politicized, certainly more urbanized.

But no matter what their final destiny is, all are forced to live with what they have learned about human nature. They have seen friends and relatives tortured, murdered, or "disappeared," they have cowered in basements as their towns have been shelled, they have seen their homes burned to the ground. I would watch children laughing and playing soccer in refugee camps and wonder what hidden wounds they carried inside them. All too often, refugees have little say in the political, ethnic, or religious conflicts that degrade into atrocities. How can they be consoled when they have seen humanity at its worst?

In the Balkans, I found people shocked and bewildered. This was a region where people of different ethnic backgrounds and religious persuasion had seemingly learned to live together, so much so that mixed marriages were common. Yet, in a few short years, this world was shattered by fanaticism. And while political leaders, army commanders, and foreign diplomats played their games of power, millions were forced from their homes: Croats and Muslims from Bosnia, Serbs from Croatia and, most recently, Gypsies, Albanians, and Serbs from Kosovo. The sameness of the scenes was deeply depressing. I was overwhelmed by a sense of helplessness.

In Africa, this became a familiar feeling. If I had once thought that armed revolution could be justified, my experience of the Angolan civil war twenty-five years ago convinced me otherwise. It was a Cold War conflict fought in the name of ideology, with the Soviet Union via Cuba helping one side and Western countries via South Africa aiding the other side, but in reality it was nothing more than an exercise in cynicism. When I returned in 1997, it continued as what is now known as a "low-intensity" war, but its main victims remained civilians. And the political leaders were also unchanged, with one crucial difference: the very same people I once heard spouting idealistic slogans were now living entirely off corruption. I also entered southern Sudan for the first time in a decade, only to find that there too the victims of war were as numerous as ever. In some regions, it had become a land peopled by orphans.

In the 1970s, I spent time in Mozambique, which was then being torn apart by civil war. When I returned in the 1990s, at least there I found evidence of progress. A United Nations-sponsored peace agreement seemed to be holding, hundreds of thousands of refugees were heading home from camps in Malawi and South Africa. But for many, "home" had become these camps. They had grown used to living in communities where, for all the overcrowding, they had access to schools, medical clinics, water supplies, and even food handouts. They had become urbanized. When they now set off for Mozambique, many were no longer drawn by village life and farming. I met a woman crossing the Zambezi River with a baby strapped to her back. Her destination, she told me, was the capital city, Maputo, 750 miles (1,250 km) away.

In Central Africa, everything had deteriorated. When I first visited Rwanda and Burundi as an economist in 1971, Burundi was already rife with ethnic tensions and violence, but Rwanda seemed on the road to development. Yet in 1994, Rwanda was the scene of one of the greatest genocides of our century, a crime for which several European countries shared responsibility. After the massacres of the Tutsi by the Hutu, the Tutsi military takeover led Hutu to flee by the hundreds of thousands into Zaire (now Congo), Tanzania, and Burundi. Disease swept the new refugee camps and thousands more died in Zaire. Bodies were pushed into mass graves by earthmoving vehicles. The scale of the horror seemed to numb people to the very idea of death. I saw one man walking with a bundle in his arms, chatting to another man. When he arrived at the mass grave, he tossed the inert body of his baby onto the pile and walked away, still chatting.

When I again visited the region in 1997, with Tutsi-backed rebels now leading a successful drive against Zaire's perennial Mobutu dictatorship, hundreds of thousands of Hutu refugees had fled into the jungles of Central Africa. For a while, the outside world lost track of them. When I found them, their despair was total. Many—who knows how many?—had been murdered or had died of starvation and disease. Only their survival instinct kept them moving, fleeing. In the middle of this apocalyptic scene, I found a man with a fat wad of dollars who was offering his services as a money-changer: there was nothing to eat, but there was still money to be made.

It could be said that the photographs in this book show only the dark side of humanity. But some points of light can be spotted in the global gloom. For example, humanitarian agencies are able to work among destitute refugees and migrants around the world thanks to the contributions of ordinary people. It could also be argued that Western public opinion spurred NATO interventions in Bosnia and Kosovo because of the emotional impact of television pictures of burning villages and massacre sites. And yet in Rwanda, the West saw the killings and did nothing to stop them. Today, good and evil are inseperable because we know about both.

But is it enough simply to be informed? Are we condemned to be largely spectators? Can we affect the course of events?

I have no answers, but I believe that some answers must exist, that humanity is capable of understanding, even controlling, the political, economic, and social forces that we have set loose across the globe. Can we claim "compassion fatigue" when we show no sign of consumption fatigue? Are we to do nothing in face of the steady deterioration of our habitat, whether in cities or in nature? Are we to remain indifferent as the values of rich and poor countries alike deepen the divisions in our societies? We cannot.

My hope is that, as individuals, as groups, as societies, we can pause and reflect on the human condition at the turn of the millennium. The dominant ideologies of the twentieth century—communism and capitalism—have largely failed us. Globalization is presented to us as a reality, but not as a solution. Even freedom cannot alone address our problems without being tempered by responsibility, order, awareness. In its rawest form, individualism remains a prescription for catastrophe. We have to create a new regimen of coexistence.

More than ever, I feel that the human race is one. There are differences of color, language, culture, and opportunities, but people's feelings and reactions are alike. People flee wars to escape death, they migrate to improve their fortunes, they build new lives in foreign lands, they adapt to extreme hardship. Everywhere, the individual survival instinct rules. Yet as a race, we seem bent on self-destruction.

Perhaps that is where our reflection should begin: that our survival is threatened. The new millennium is only a date in the calendar of one of the great religions, but it can serve as the occasion for taking stock. We hold the key to humanity's future, but for that we must understand the present. These photographs show part of this present. We cannot afford to look away.

*Sebastião Salgado*
Paris, July 1999

# ACKNOWLEDGEMENTS

During Sebastião Salgado's reportages about the phasing-out of manual labor around the globe, condensed in the book *Workers*, he was repeatedly struck by how political instability and economic change were provoking massive movements of people all over the world. The plight of these people— principally migrants and refugees—touched Sebastião. Every time he came back to Paris, we had long discussions about this often tragic phenomenon. Little by little, we understood that the lives of these people on the move should be the central axis of our next cycle of work.

In 1992, we began our research. With the information garnered, and with the help of our friend René Lefort, we were able to structure the project and prepare a formal proposal on the subject. It would require Sebastião to travel for six years. The year 2000, the turn of the millenium, seemed like a logical moment to present what he had found.

For this project to succeed, a complex support system had to be constructed. In 1994, Sebastião and I founded Amazonas Images, a Paris-based photo agency, to handle all of his work, and, more immediately, to organize and develop this project.

We have many people and organizations to thank for their unflagging faith in *Migrations* and the exhibitions accompanying its publication.

Early on, we turned to the magazines that had supported us with *Workers*. We explained the new project and obtained backing from several of them as well as from some new ones. Each made a prior financial commitment to publish separate reportages that emerged from Sebastião's continuing work on the book, thus providing a portion of the resources we needed to finance the project. Many of these reportages in turn underscored the fact that Sebastião's work was very much linked to topical events, that it was right for immediate publication as much as for later inclusion in this book.

We wish to express our gratitude to these publications: *Rolling Stone* (United States); *The New York Times Sunday Magazine* (United States); *Paris Match* (France); *Stern* (Germany); *El País Semanal* (Spain); *Folha de São Paulo* (Brazil); *Visão* (Portugal); *Nieuwe Revu* (Netherlands); *Vrij Nederland* (Netherlands); and *"D" di la Repubblica* (Italy).

Amazonas Images was responsible for "servicing" these publications. In Paris, we would follow the news and research stories to support Sebastião's travels. He would prepare a basic itinerary in his original proposal, but flexibility was important. Once, after a joint trip to Brazil early in 1994, I flew to Paris, and, hours later, he flew to Johannesburg. His plan was to join refugees from Mozambique who were returning home. But when I reached Paris, I heard the news that a wave of ethnic violence had suddenly engulfed Rwanda and hundreds of thousands of people were fleeing the country for neighboring Tanzania. Immediately I left a message for Sebastião at the Johannesburg airport. After we spoke, he changed directions and headed for Tanzania—in this case more than most, time was of the essence.

Wherever he was, he would send his film to Paris to be developed. In cases of breaking news, like the Rwandan genocide, we at Amazonas Images would do the editing and printing and the reportages would be with our partner magazines within two or three days.

To ensure that Sebastião's photographs reached as large an audience as possible, we chose a number of press- and photo-agencies to represent us around the world. We thank them for their proficiency and cooperation: Focus Presseagentur (Germany); ABC Press (Netherlands); PPS (Japan); Network (UK); Contrasto (Italy); Scanpix (Norway); Apeiron (Greece); and Contact Press Images (France, Spain, and United States).

We always made a point of providing copies of Sebastião's reportages to the humanitarian organizations that were involved in the different crises. Frequently, they shared information with Sebastião and offered him logistical support. We wish to express our special appreciation to: the United

Nations High Commissioner for Refugees; the International Organization of Migration; Médecins sans Frontières; UNICEF; Norwegian People Aid; Christian Aid, and Save the Children Foundation, UK.

Eastman Kodak Company, which provided immeasurable support for *Workers*, again showed confidence in this project. We are grateful to Guy Bourreau of the Professional Department of Kodak France for his assistance in providing all the film and photographic paper used for reportages and exhibitions.

Leica Camera also proved unstinting in its support for this project, not only by providing Sebastião with cameras but also by being ready and willing to repair cameras damaged during his trips. Our special thanks to Yvon Plateau, our longtime contact at Leica-France, and to H. G. von Zydowitz and Ralph Hagenauer of Leica-Germany.

Every year, the Maison Européenne de la Photographie in Paris has acquired a number of photographs, not only for the purpose of building up its collection, but also with the intention of supporting and stimulating the project. Their confidence is warmly appreciated.

Amazonas Images assumed responsibility for editing *Migrations*. We were helped by the experience we had acquired in editing Sebastião's ongoing reportages, in designing and editing his book *Terra*, and in preparing exhibitions of his photographs around the world. But in the end, publication of this book (which is in fact two books) was made possible by the talent and dedication of the team that our agency was lucky enough to pull together. Marcia Navarro Mariano, who has worked with us for many years, again played a pivotal role of coordination. Françoise Piffard, who joined us in 1994 after working for both Contact Press Images and Magnum Photos in New York, brought her skilled eye as a photo editor and her experience in handling press relations. Dominique Granier approached printing with a great sense of artistry. Our thanks also go to numerous photo technicians whose commitment to excellence was unwavering: Isabelle Menu, Pascal Bois, and Adrien Bouillon, who were experts in printing; and those who developed Sebastião's films: Didier Carré, and the Imaginoir and Pictorial Service laboratories. We are also grateful to Sylvia Martins for sharing her computer skills and to the interns Isabel D'Elia de Almeida and Rita Delorenzo Morais.

We are proud to be associated with the publishers who are co-editing this book in several countries: Aperture Foundation in the United States, the United Kingdom, and other English-speaking territories; Editions de la Martinière in France; Companhia das Letras in Brazil; Contrasto/Leonardo Arte in Italy; Editorial Caminho in Portugal; Zweitausendeins in Germany; and Fundación Retevision in Spain.

Sebastião and I have again counted on the enthusiastic encouragement of our friend Alan Riding, European Cultural Correspondent of *The New York Times*.

We also wish to add a special word of thanks to Jean Genoud, whose Genoud Enterprise d'arts graphiques in Lausanne, Switzerland, printed this book (as it also did *Workers* and *Terra*). While we have learned to expect the extraordinary quality of his work, we particularly value his advice and friendship.

Finally, we wish to thank our sons Juliano and Rodrigo, our daughter-in-law Chloé, and our grandson Flavio for their patience, support, and love through yet another long project during which all too often our eyes have been turned toward the world and away from our family.

*Lélia Wanick Salgado*
Director, Amazonas Images

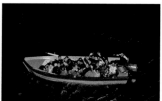

# I - Migrants and Refugees: The Survival Instinct

### Pages 21 to 151

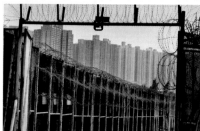

Most migrants leave their homes filled with hope; refugees usually do so out of fear, yet in their different ways all are victims of forces beyond their control: poverty and violence.

Most Third-World migrants head for cities, but the most ambitious set their sights on the United States and Europe. Their journeys are long and fraught with danger, but for Mexicans, Moroccans, Vietnamese, Russians, and many others the dream of a better life does not easily die. Other people become refugees against their will. Wars have uprooted Kurds, Afghans, Bosnians, Serbians, and Kosovars and, like the Palestinians who have spent decades in refugee camps, these people often yearn to return home. For some, though, the break with the past is permanent: from refugees they become exiles, and from exiles they too become migrants.

# II - The African Tragedy: A Continent Adrift

### Pages 153 to 247

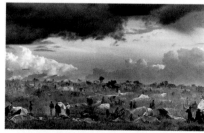
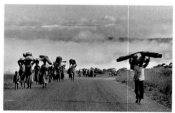

Africa has been traumatized by suffering and despair, its peoples deeply scarred by poverty, hunger, corruption, despotism, and war.

Thirty years after I first visited the continent, things are generally worse. Mozambique is an exception: decades of civil war have now finally ended, allowing hundreds of thousands of refugees to return home. But wars continue to ravage Angola and southern Sudan, forcing millions to flee. At times, it seems that the United States and Europe have dismissed Africa as beyond salvation. Certainly, they did little to stop the genocide in Rwanda in 1994 in which it is estimated that one million Tutsi died. Rwanda's problems then spilled into Zaire, with hundreds of thousands of Hutu refugees becoming fresh victims of Central Africa's ethnic politics.

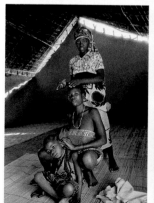

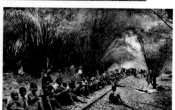

## III - Latin America: Rural Exodus, Urban Disorder

### Pages 249 to 331

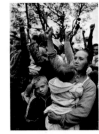 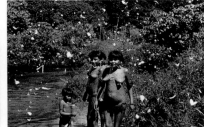

Latin America's recent history has been shaped by the migration of tens of millions of peasants to urban areas. Most are driven out by poverty because the best farming land is concentrated in the hands of a rich minority. Some refuse to give in: the Indians of the Amazon struggle to hold on to their tribal land; Zapatista rebels fight to recover lost land in southern Mexico; Brazil's "movement of the landless" dares to seize private estates despite repression. But for most, the battle is lost: Ecuador's mountain villages are peopled almost solely by women and children because all the men have migrated. And the consequence is vast, unmanageable metropolises, like Mexico City and São Paulo, that are surrounded by shantytowns crowded with migrants, where even the privileged are besieged by urban violence.

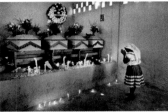 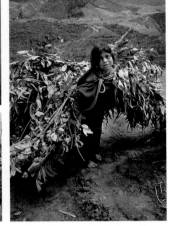 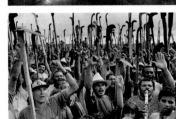 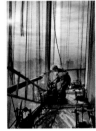 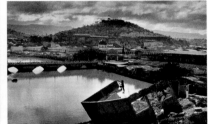

## IV - Asia: The World's New Urban Face

### Pages 333 to 431

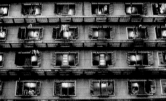 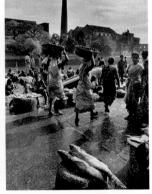

The flight from rural poverty has given Asia a new urban profile. For peasants in India's state of Bihar, for farmers on the Filipino island of Mindanao, for fishermen in Vietnam, cities have become irresistible magnets. From Cairo to Shanghai, from Istanbul to Jakarta, from Bombay to Manila, migration (swollen by high birth rates) has spawned megacities on the scale of Mexico City and São Paulo. In Asia, though, the change has come even more suddenly, with sprawling shantytowns and glitzy new financial centers appearing almost simultaneously. Shanghai is just one city that has been transformed beyond recognition in barely a decade. The living conditions of most recent migrants are precarious, yet most believe they have taken a step toward a better life.

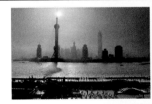 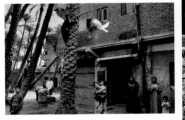 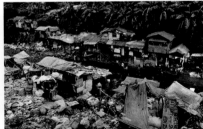 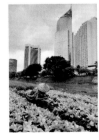 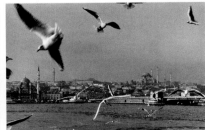

I

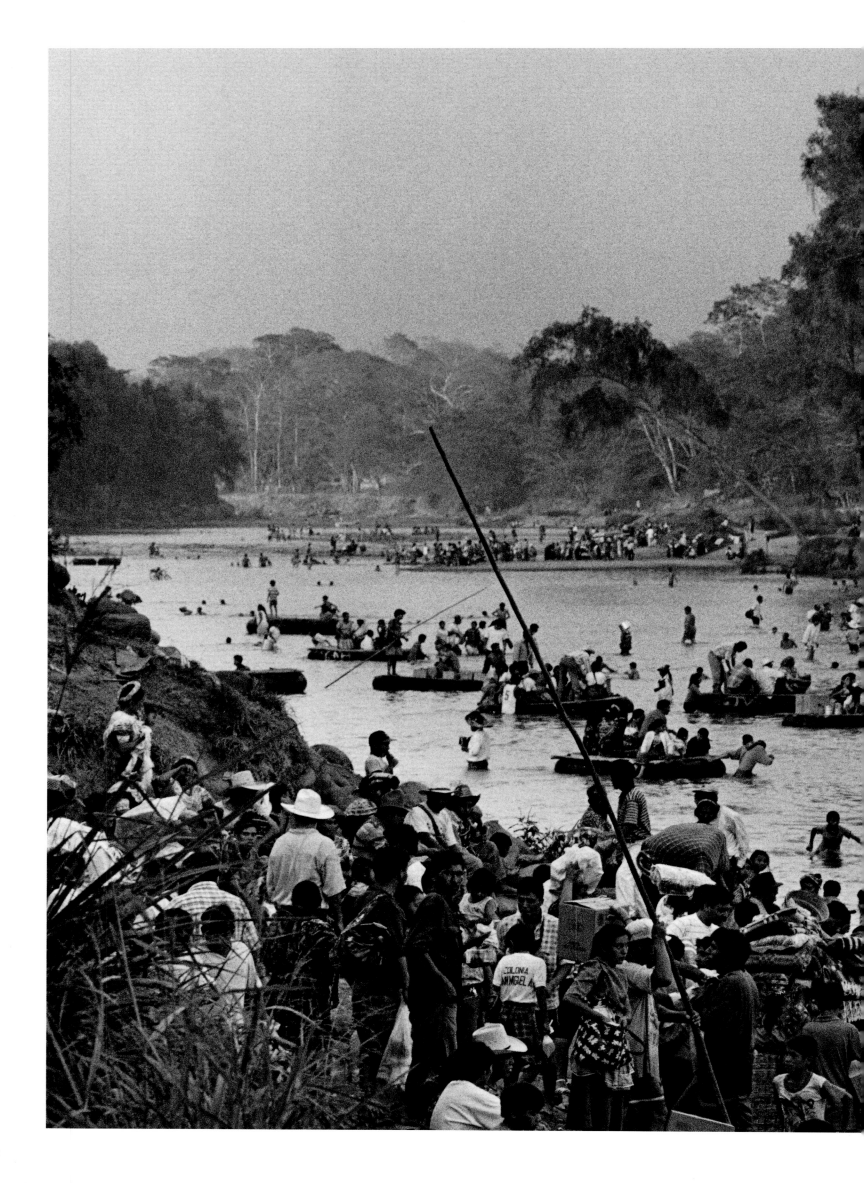

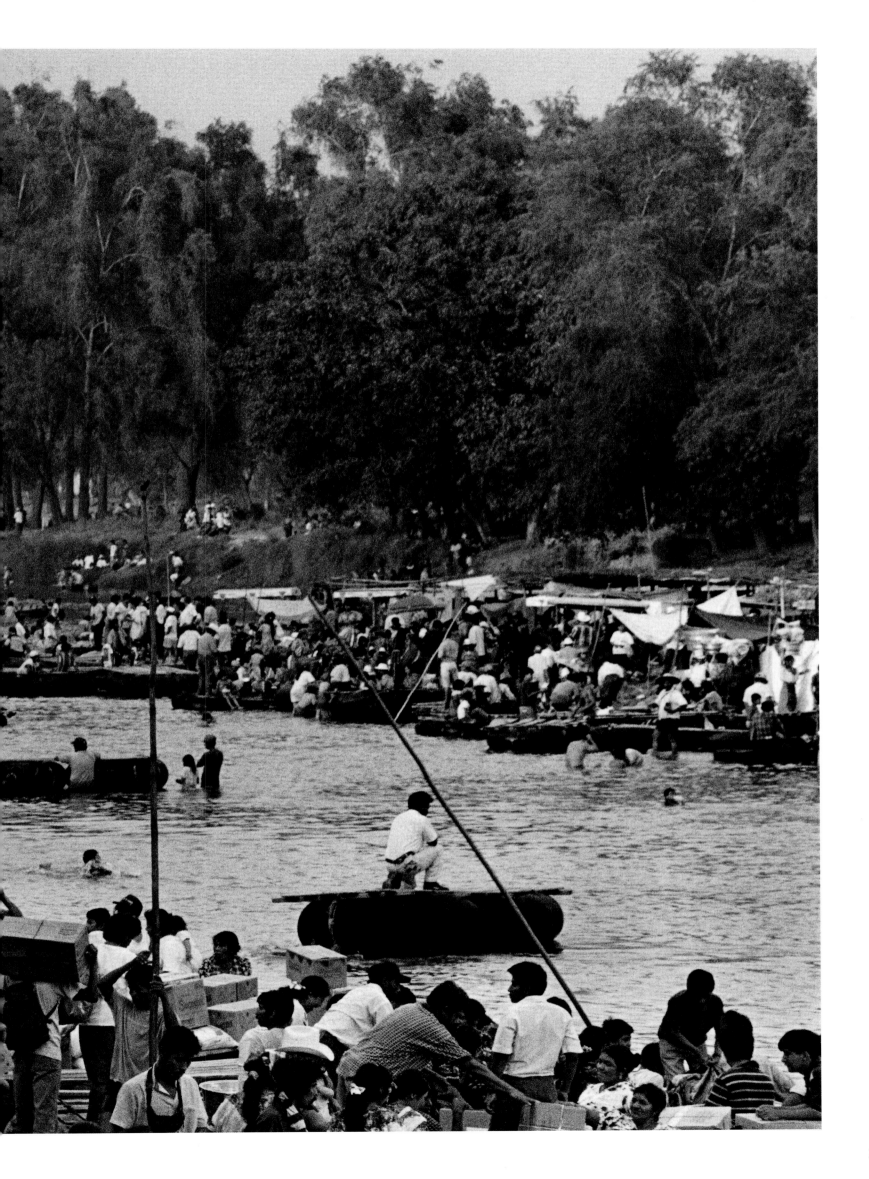

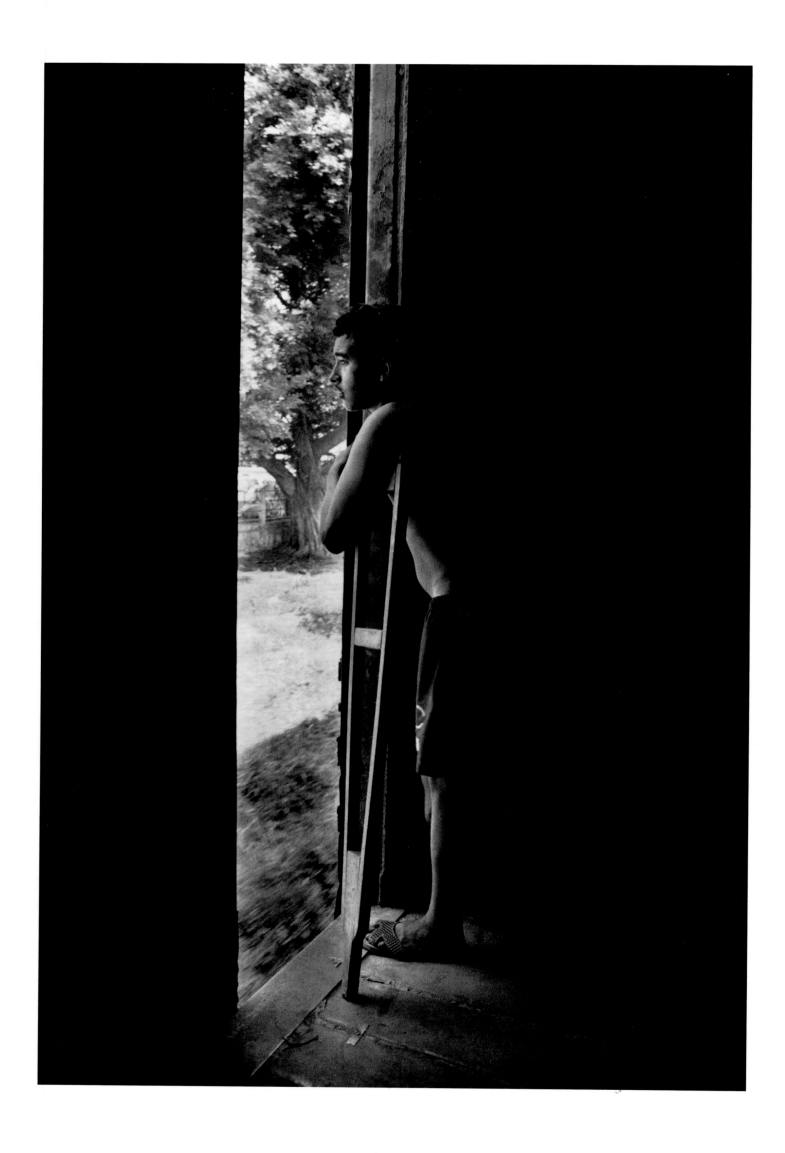

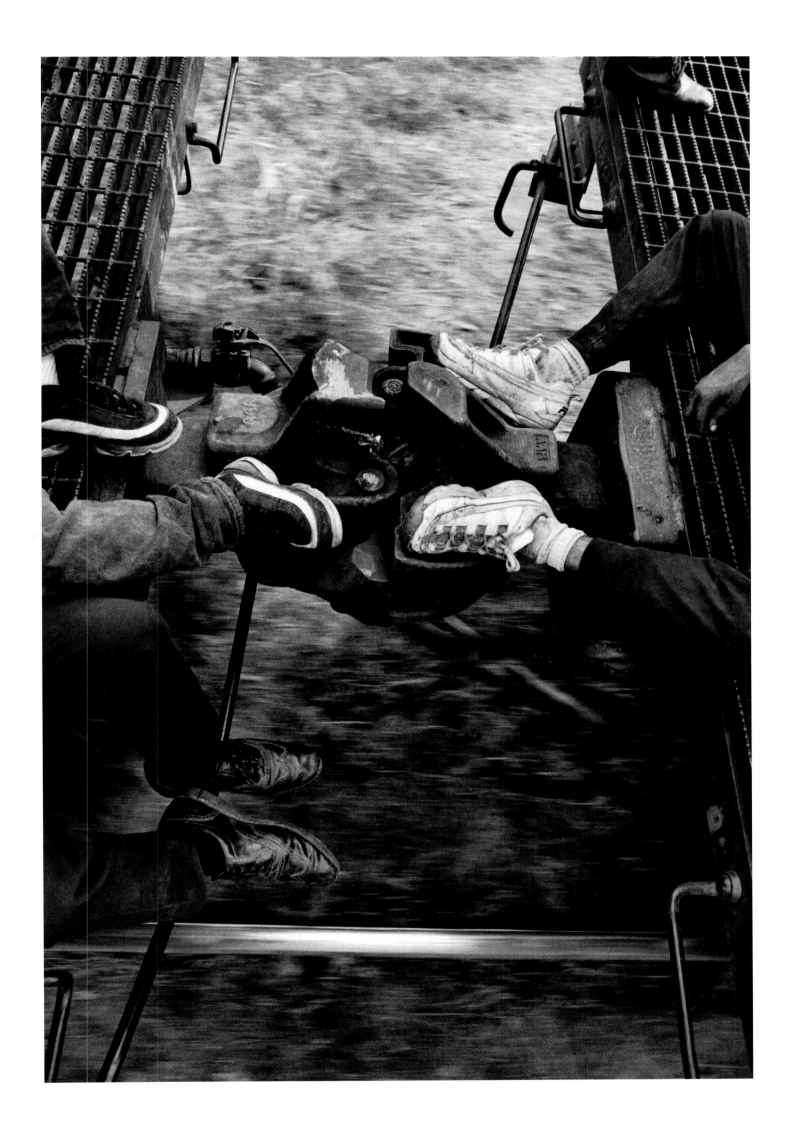

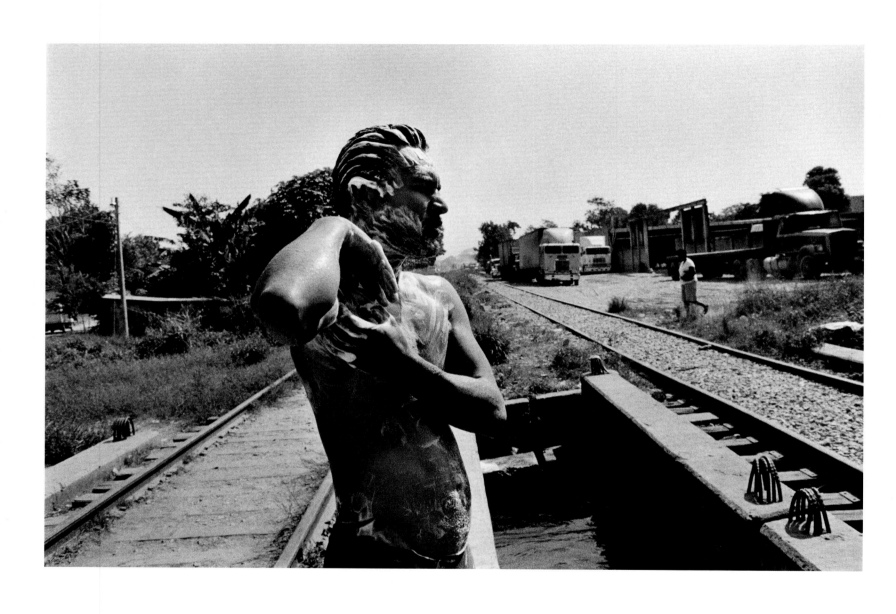

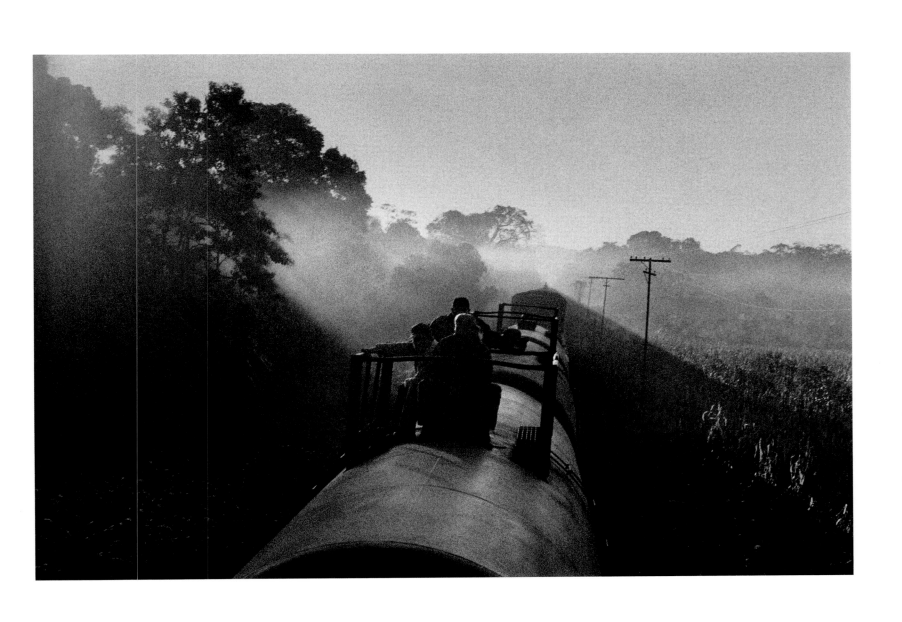

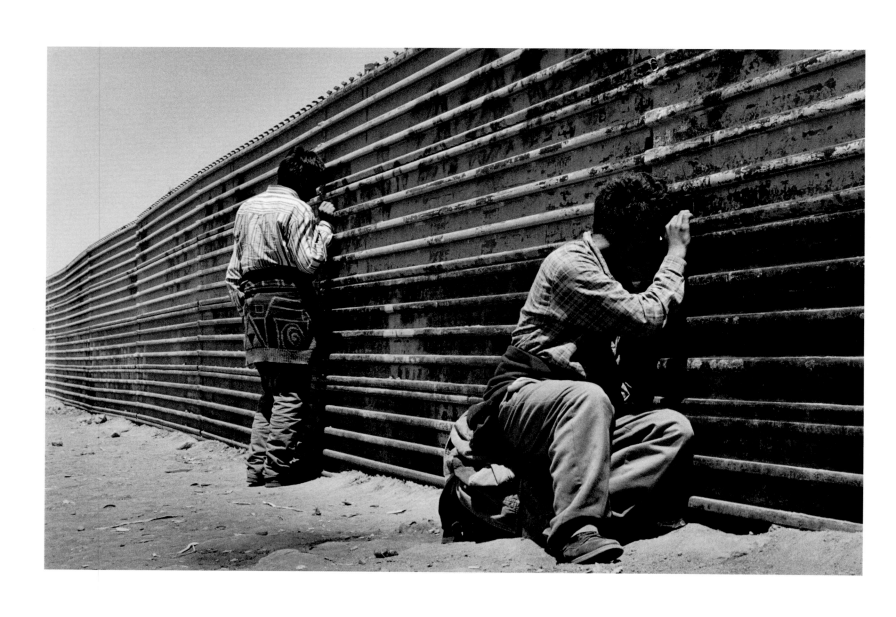

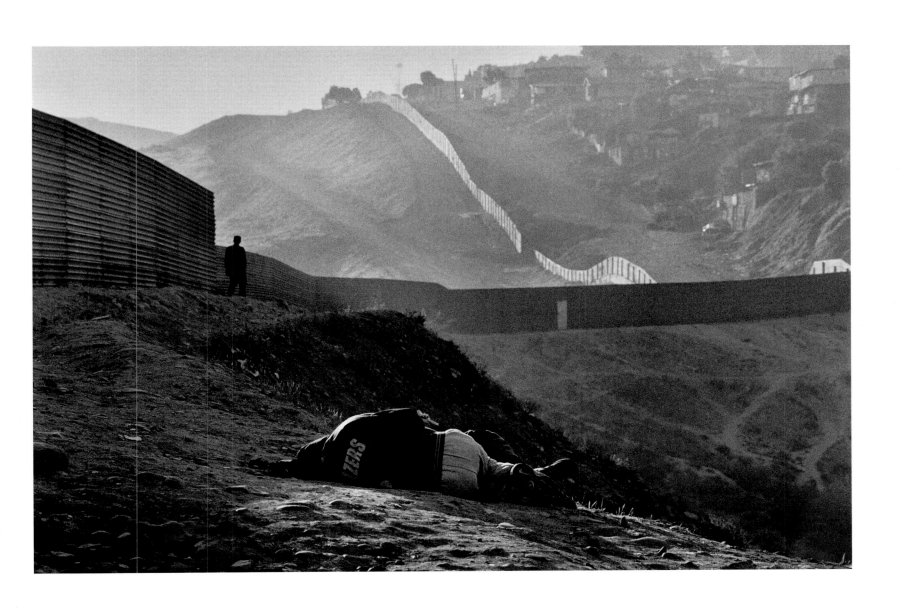

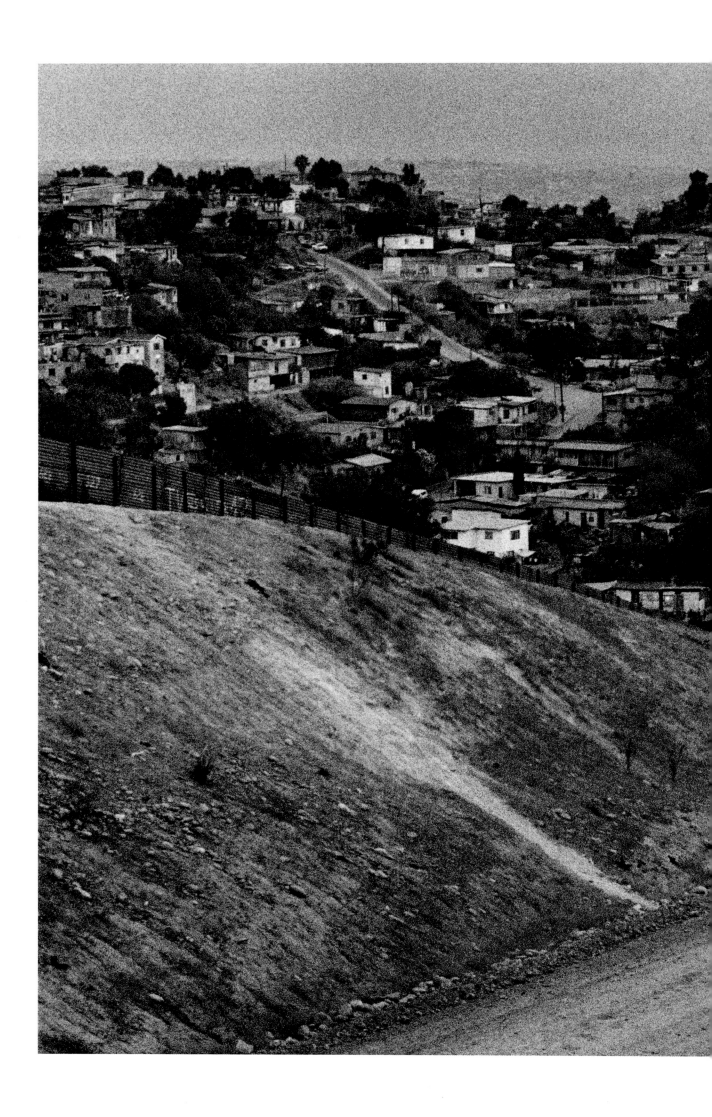

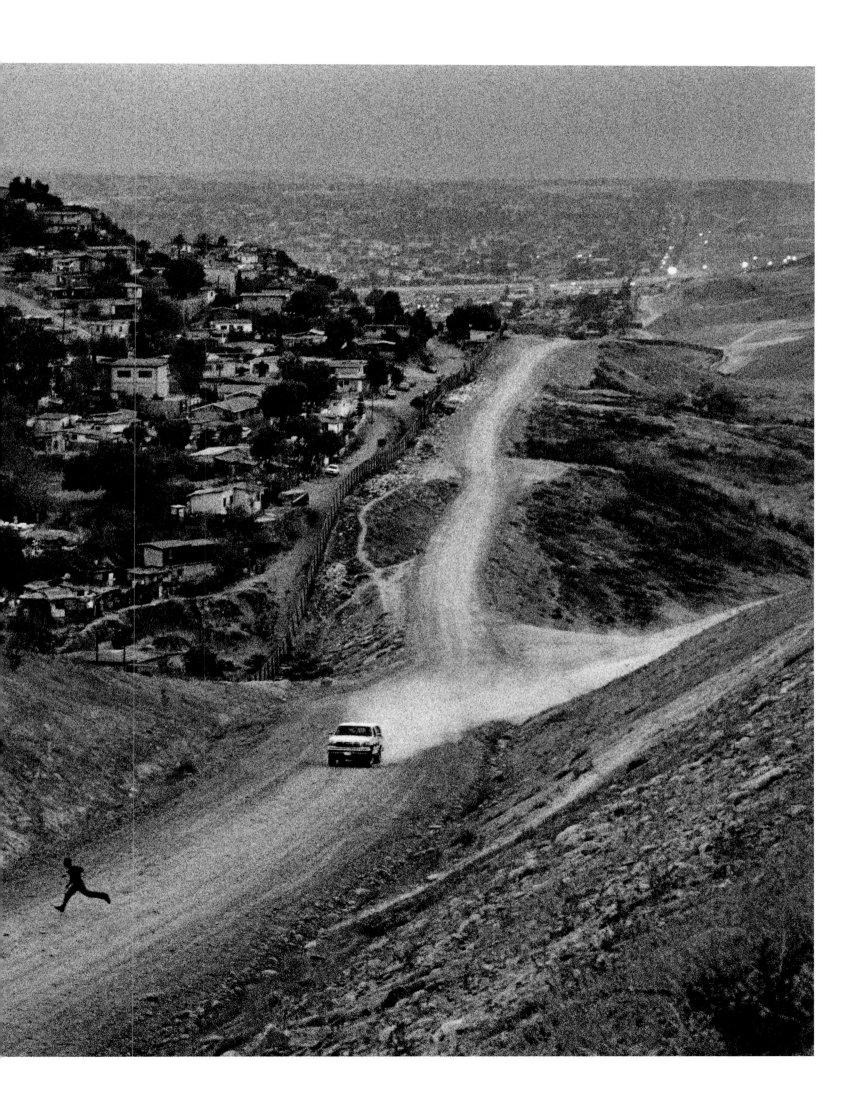

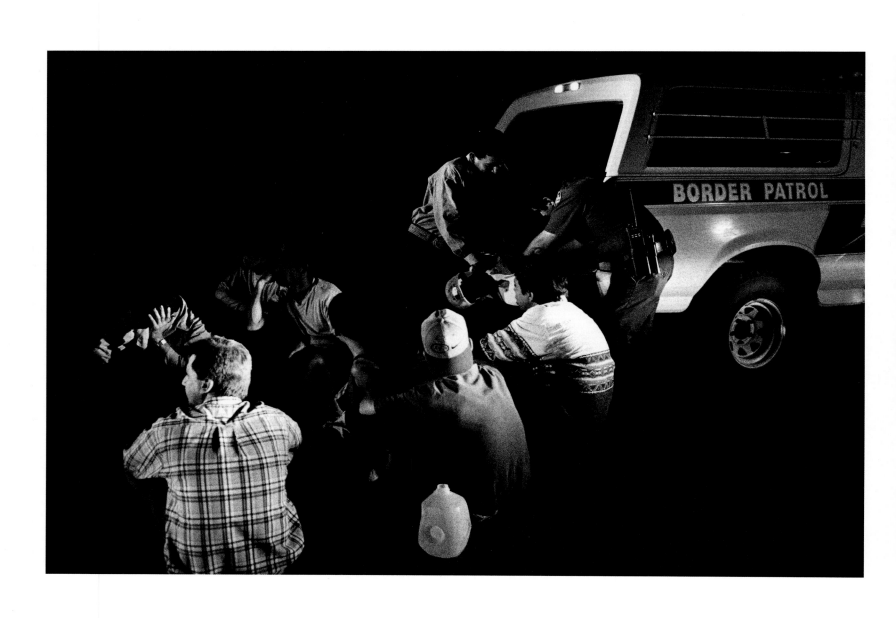

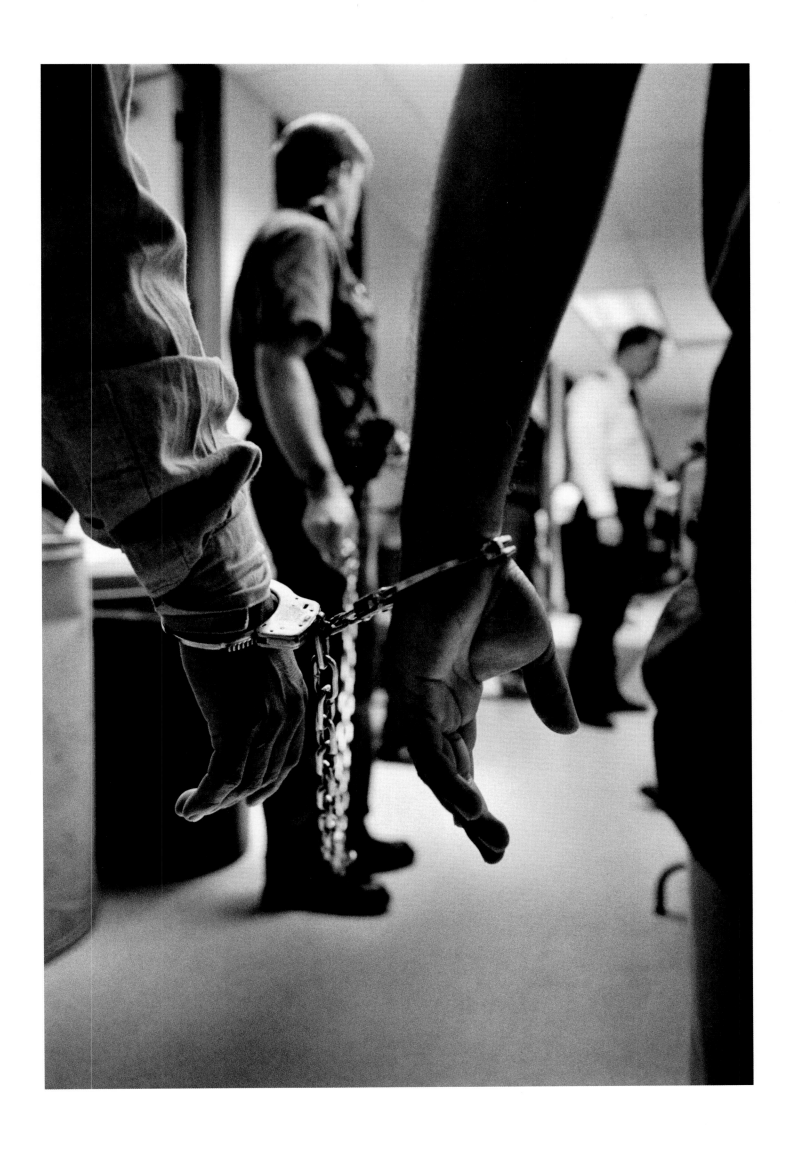

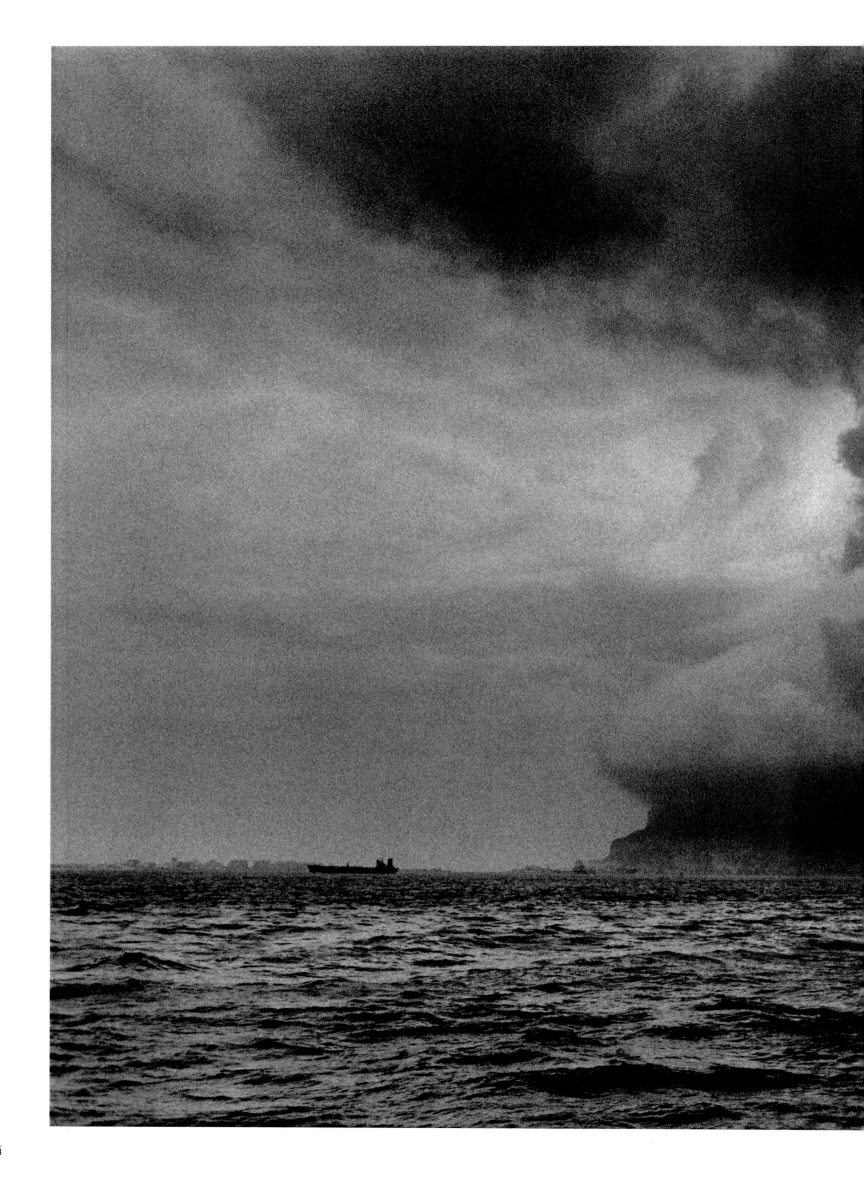

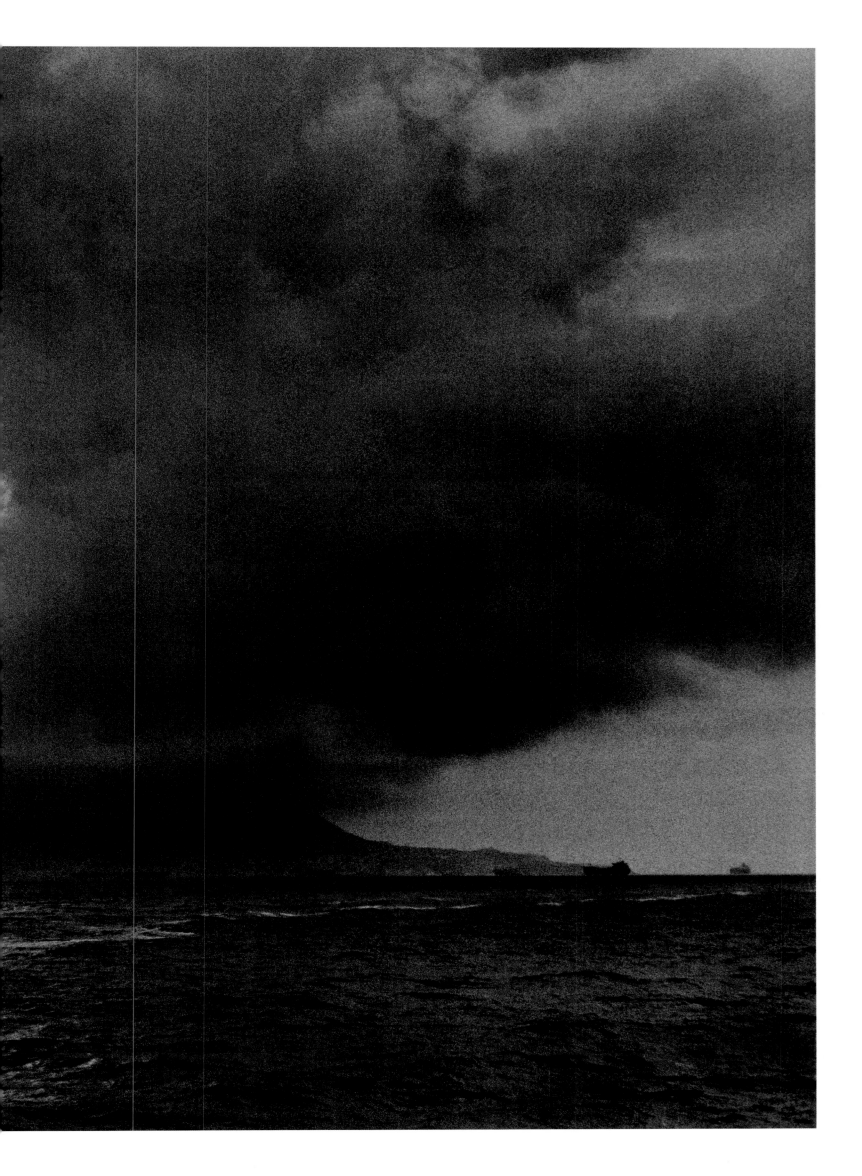

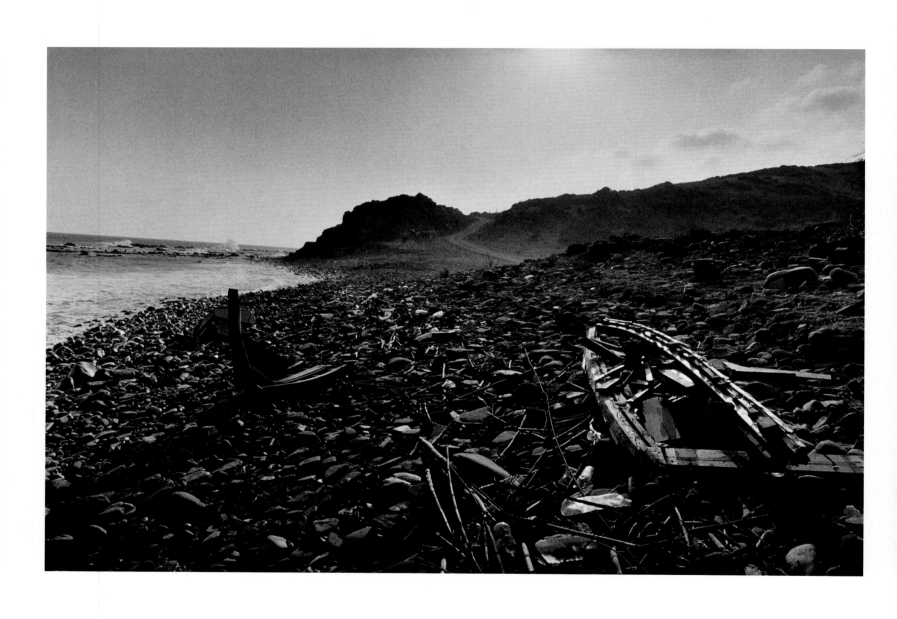

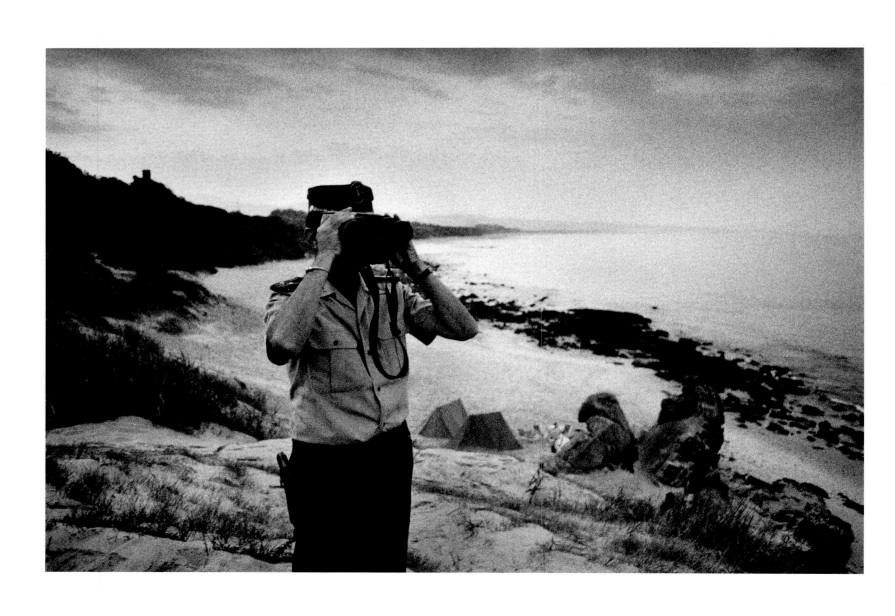

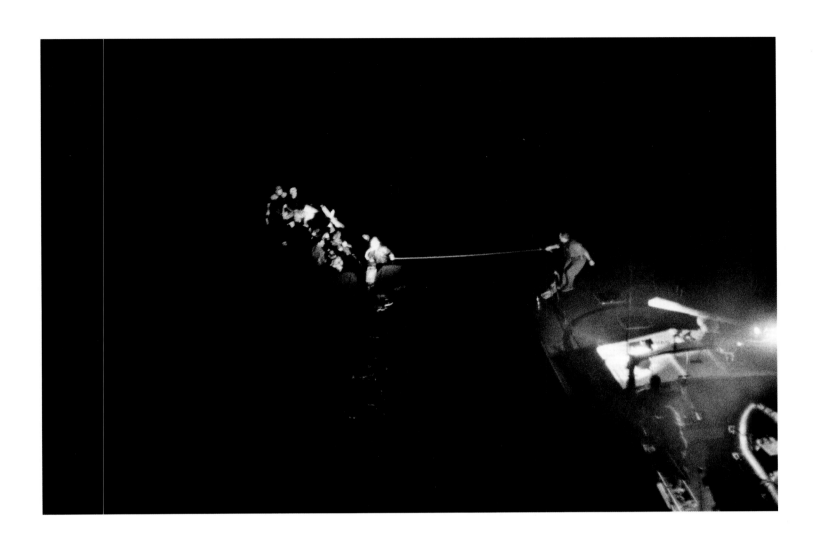

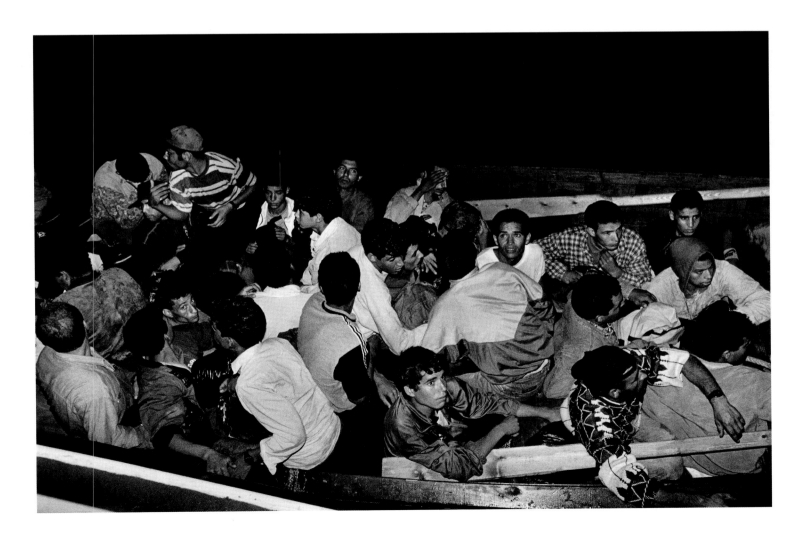

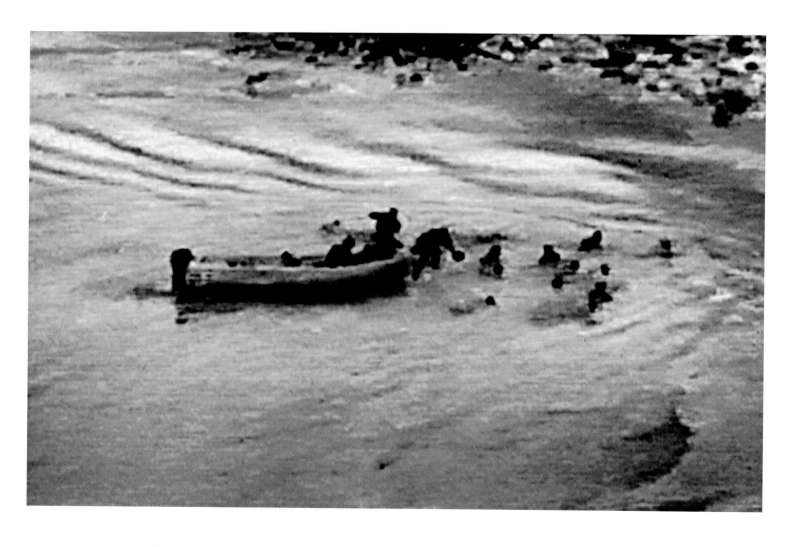

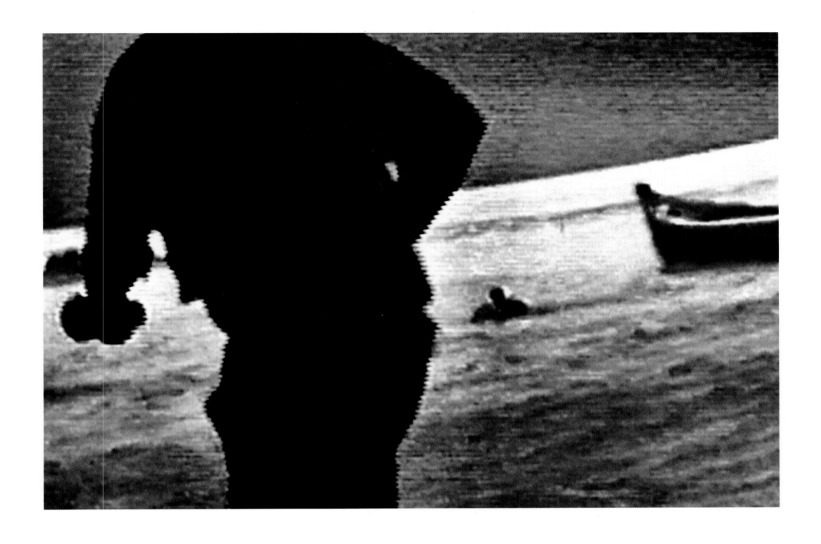

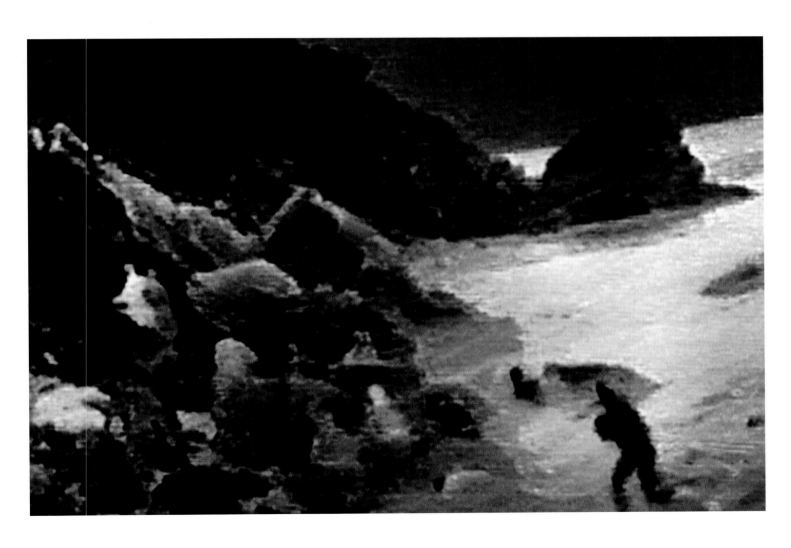

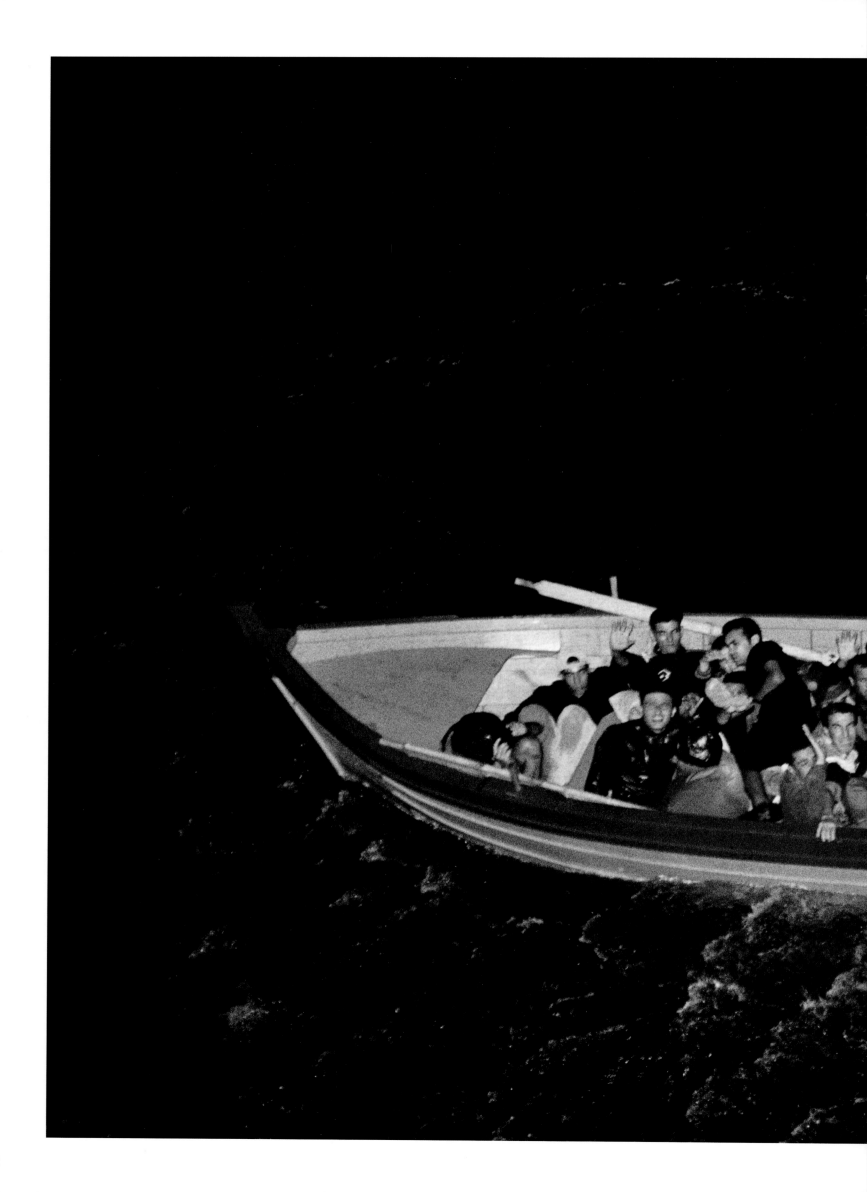

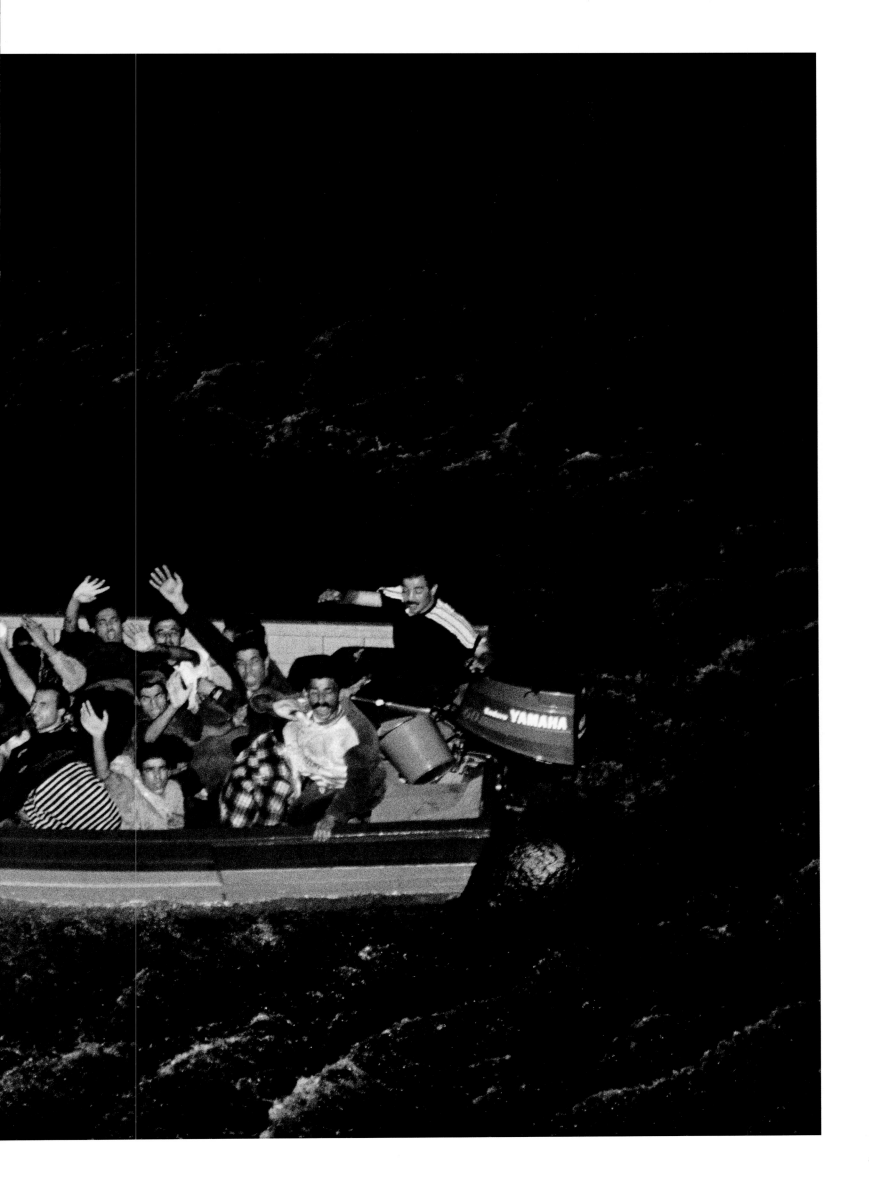

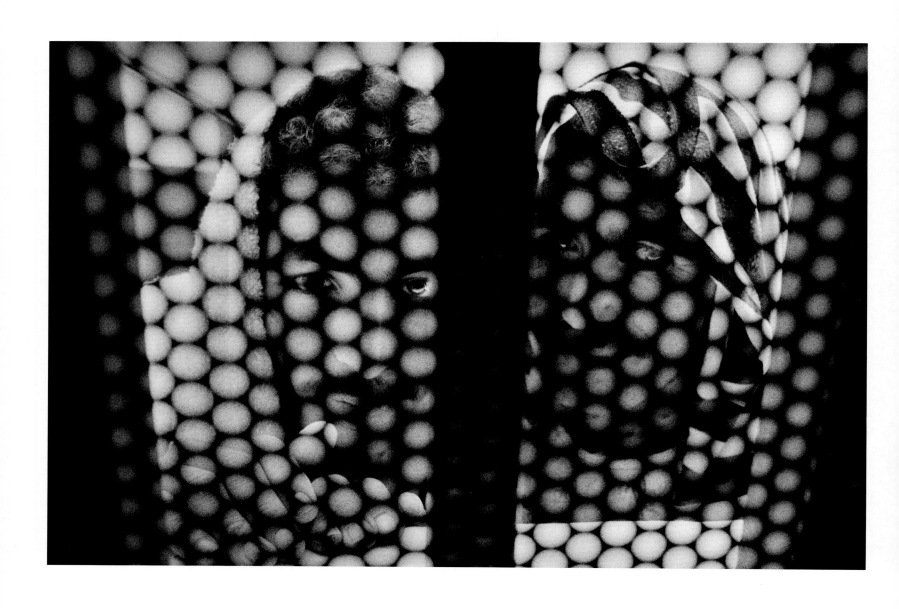

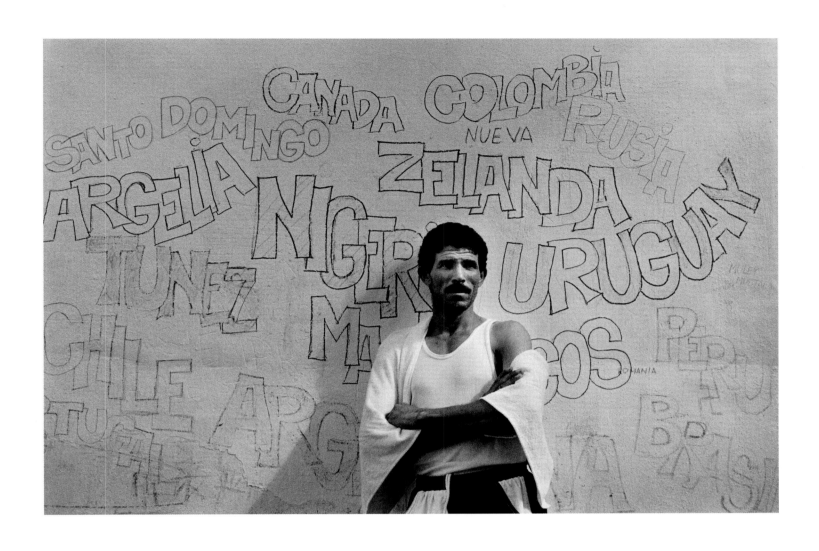

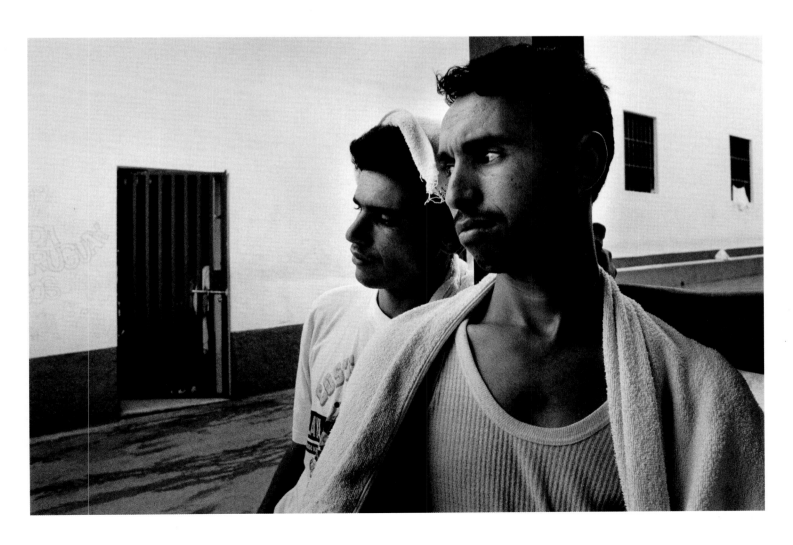

45

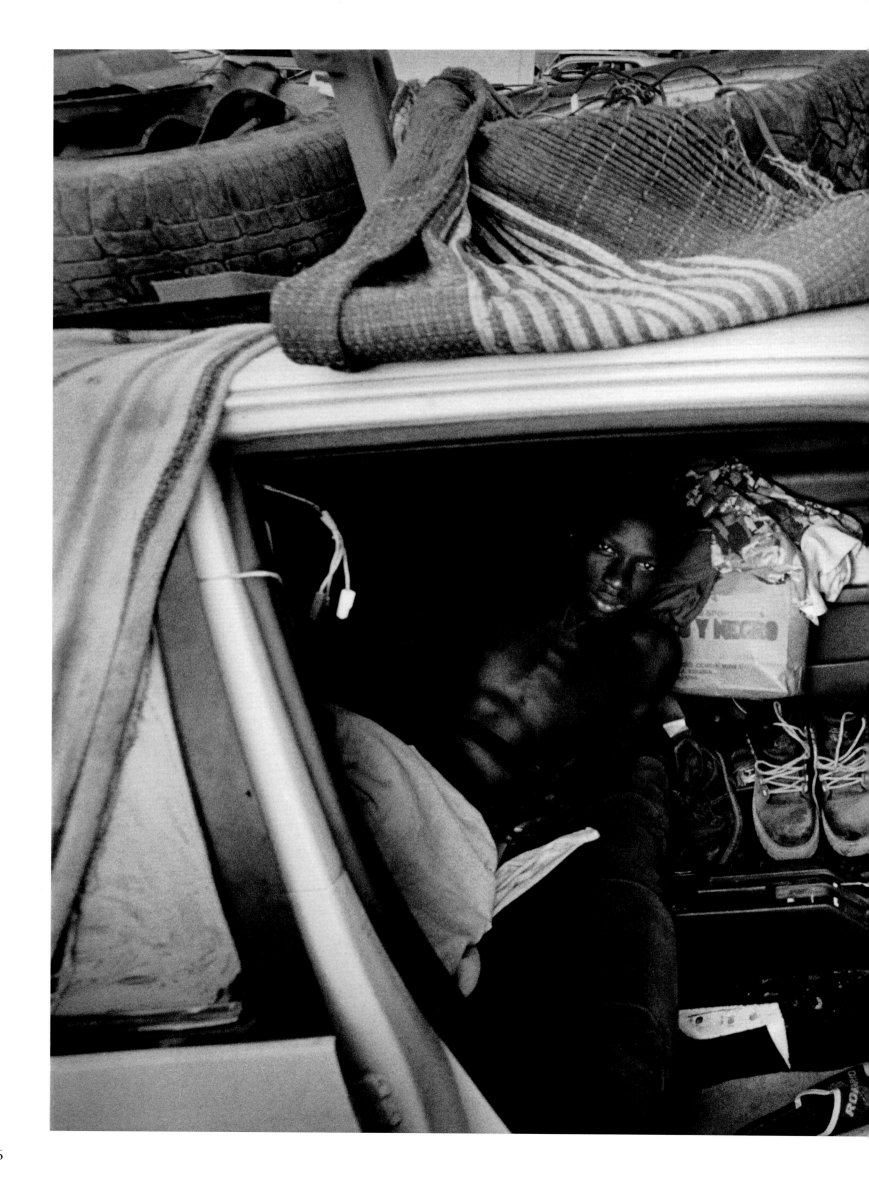

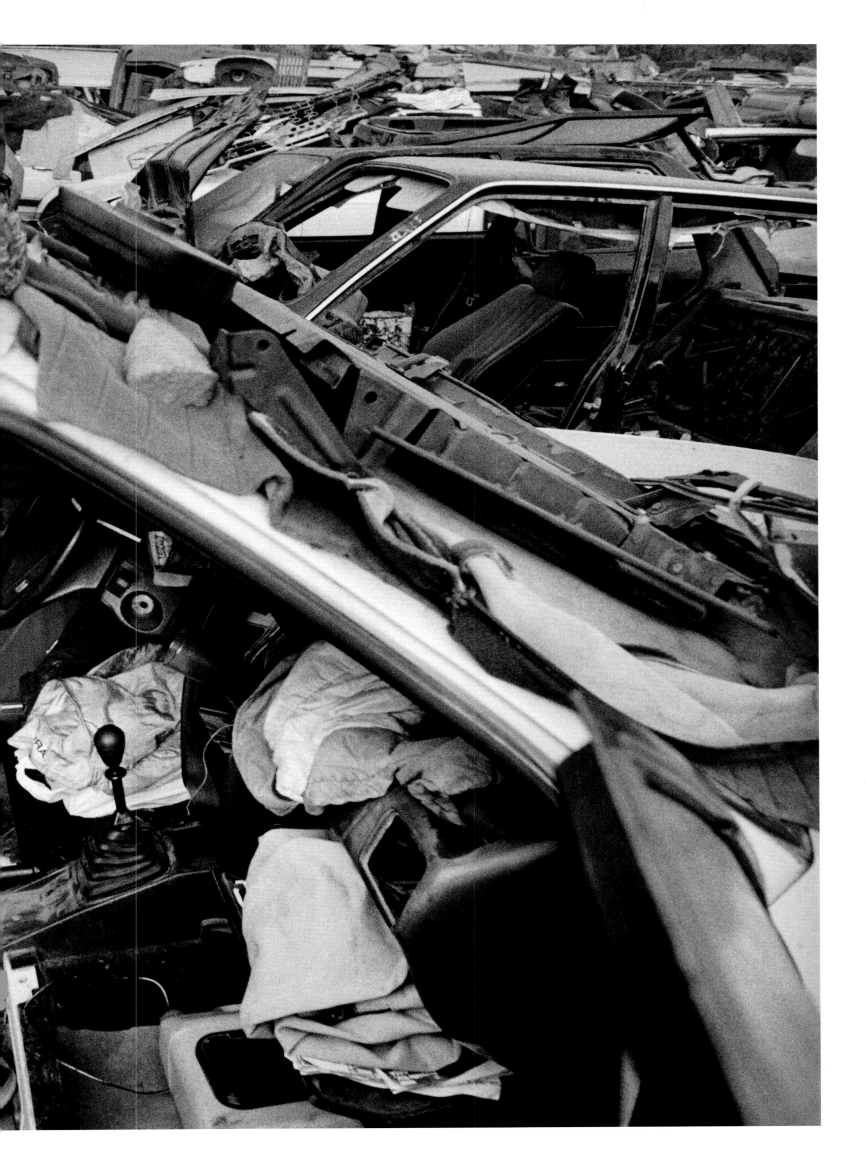

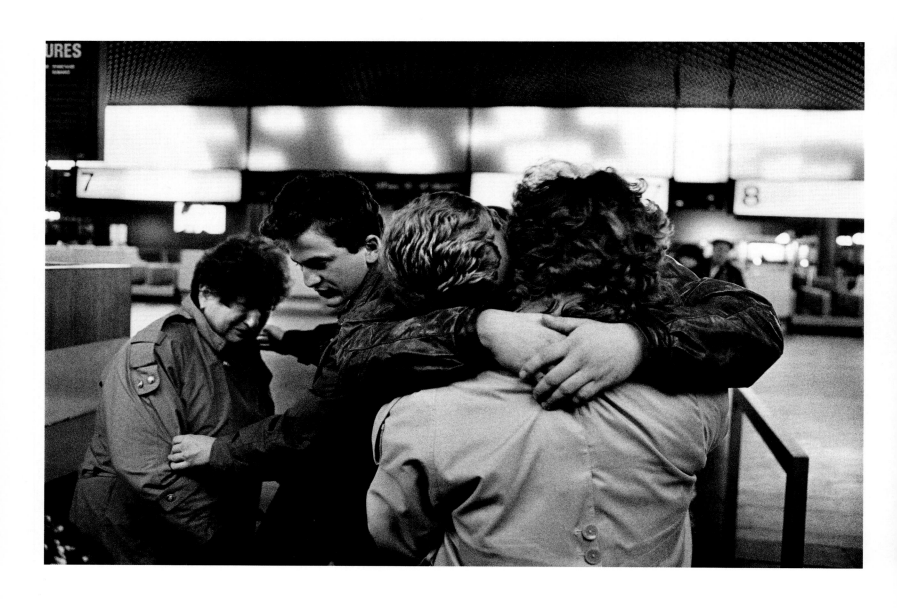

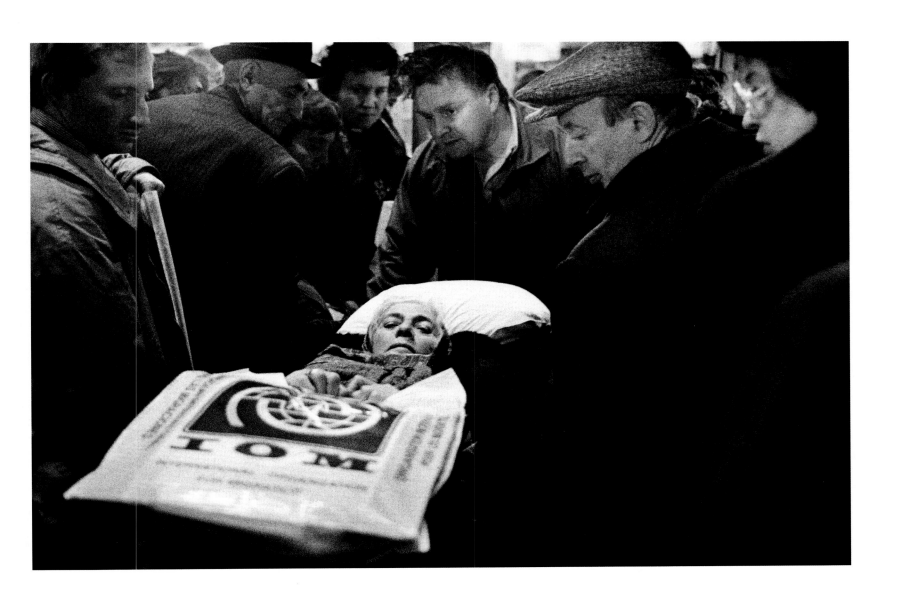

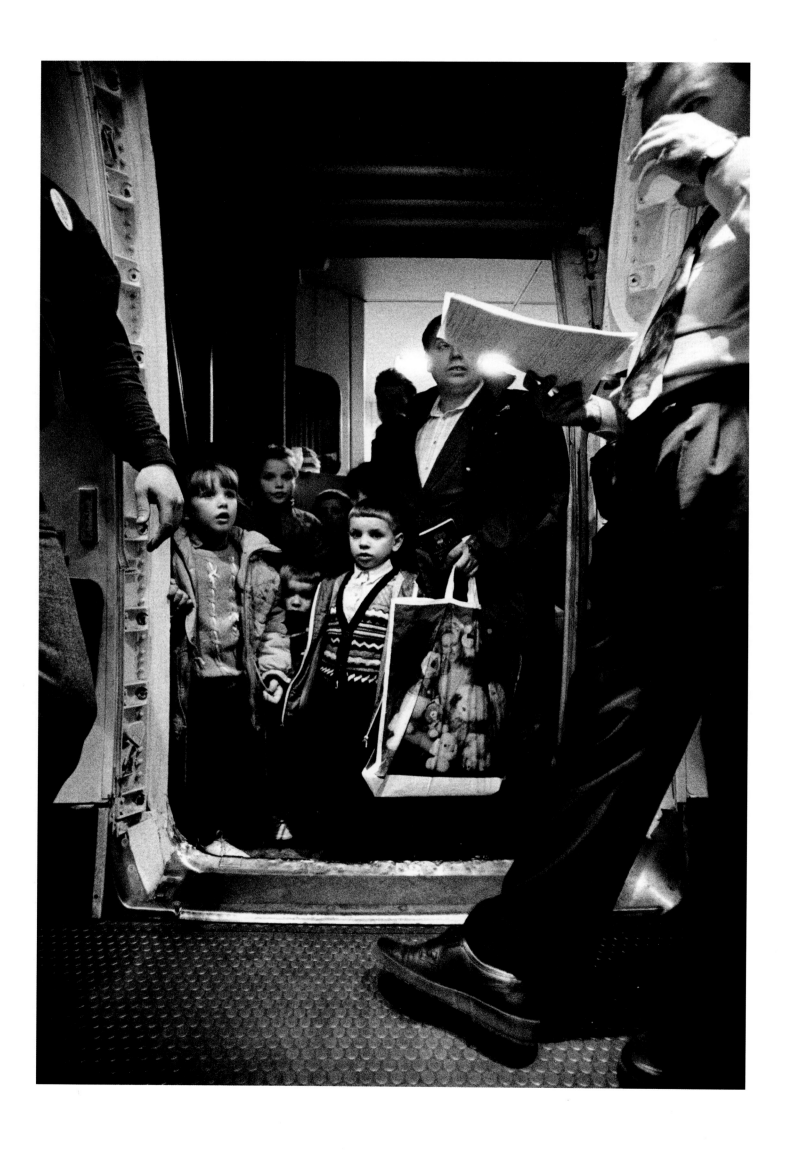

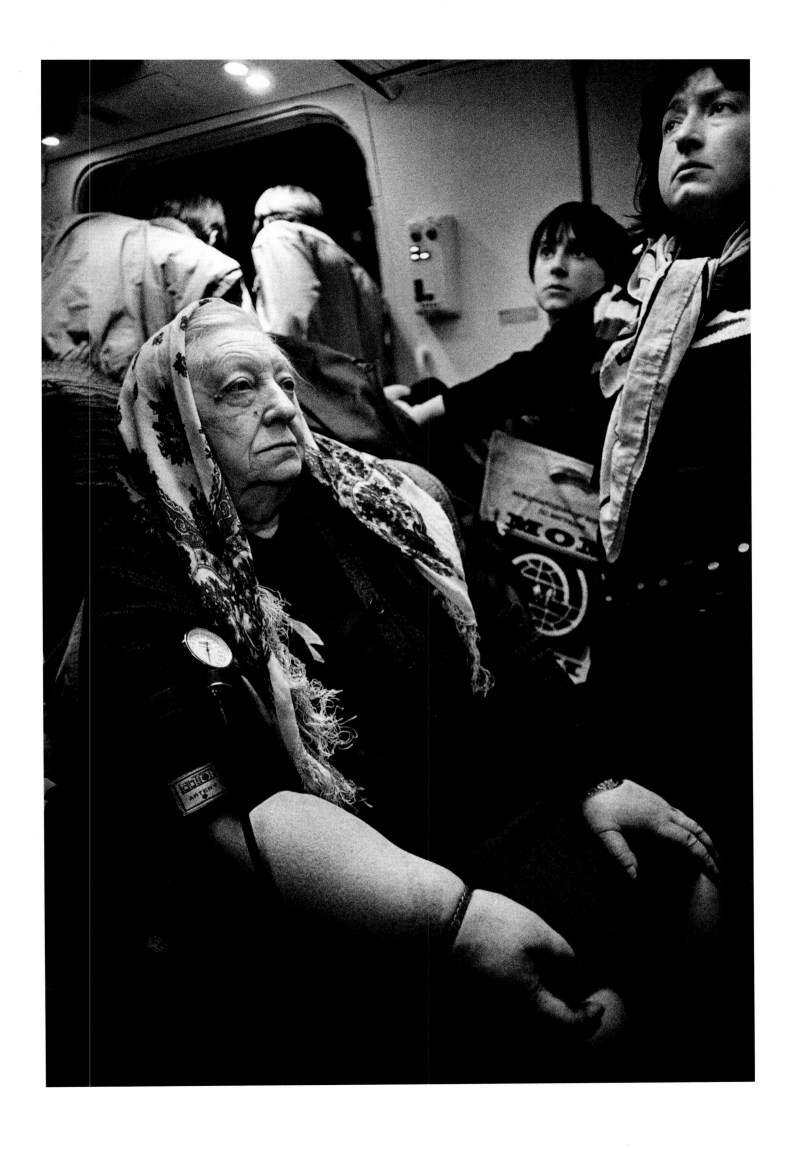

51

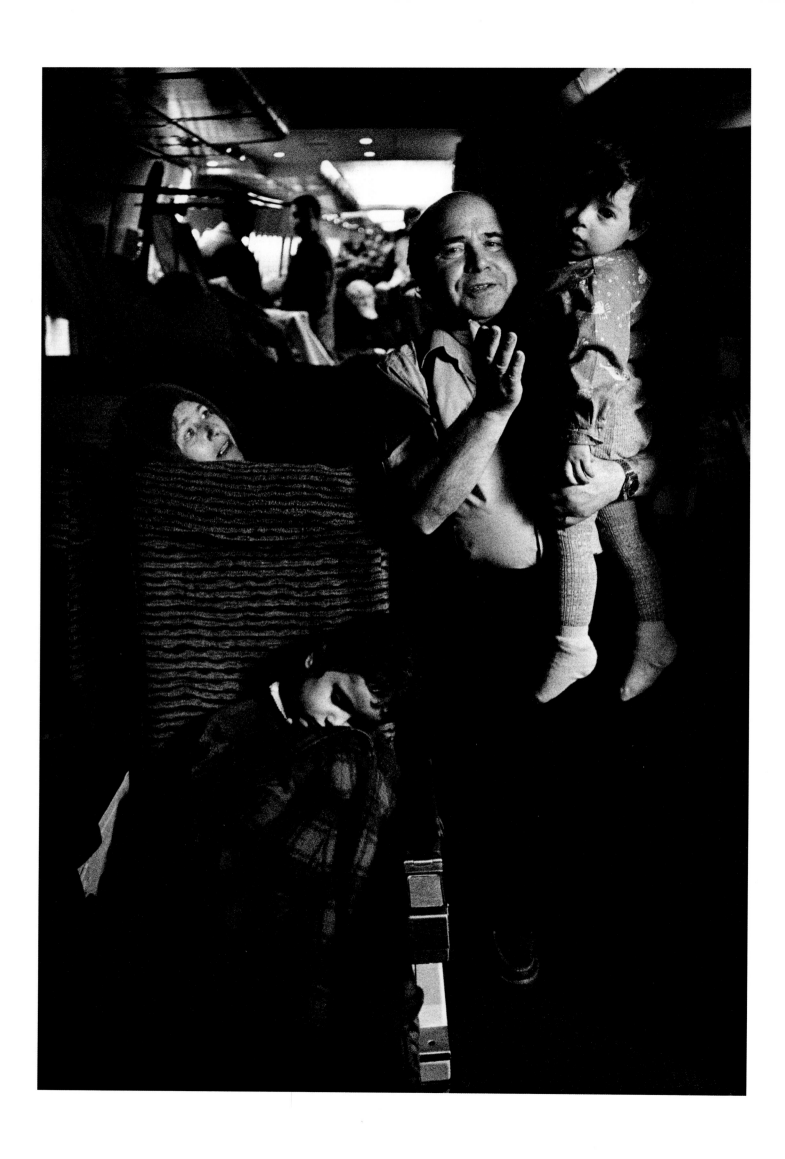

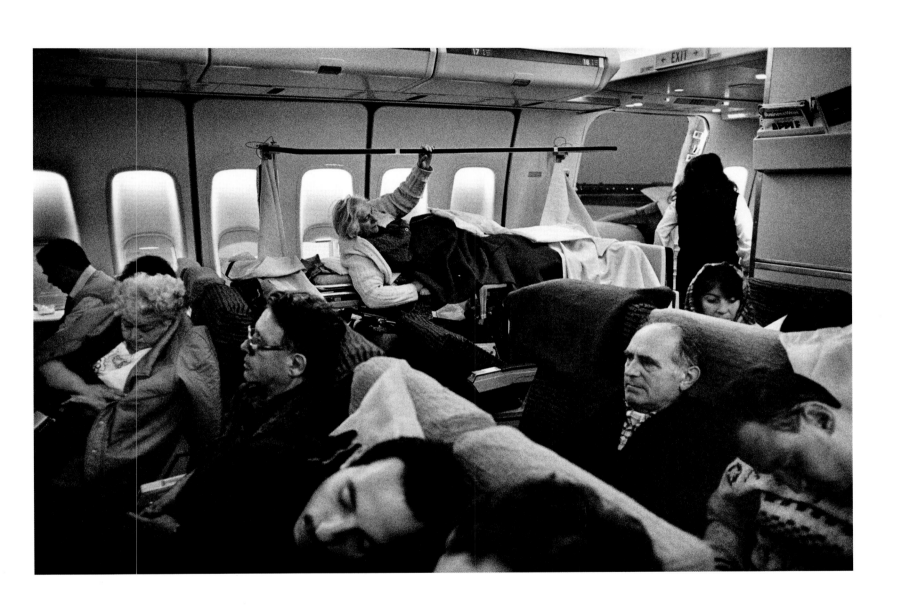

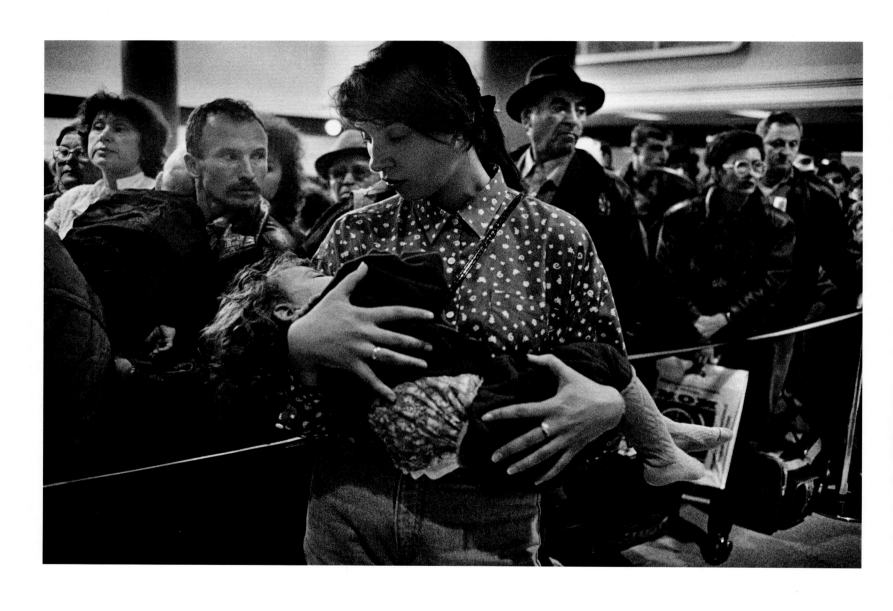

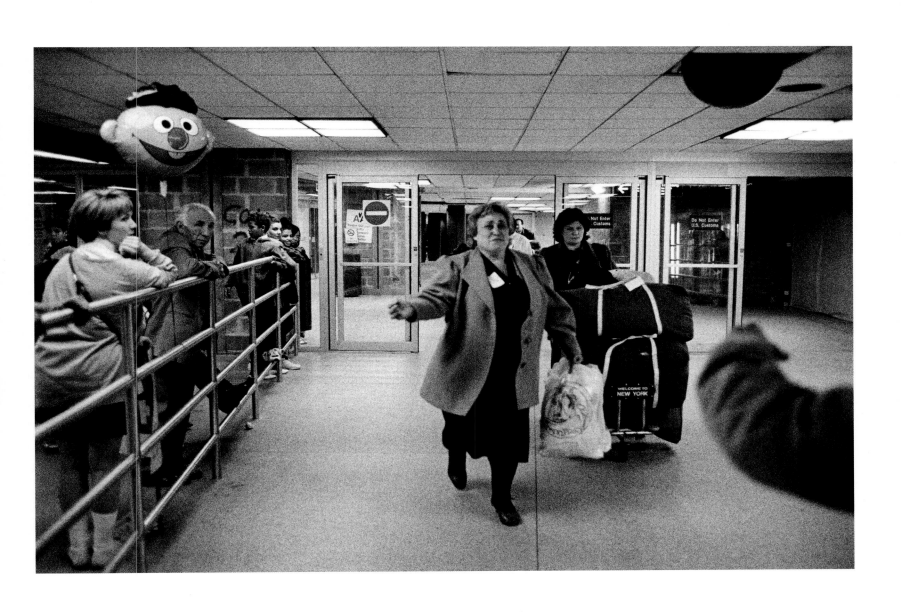

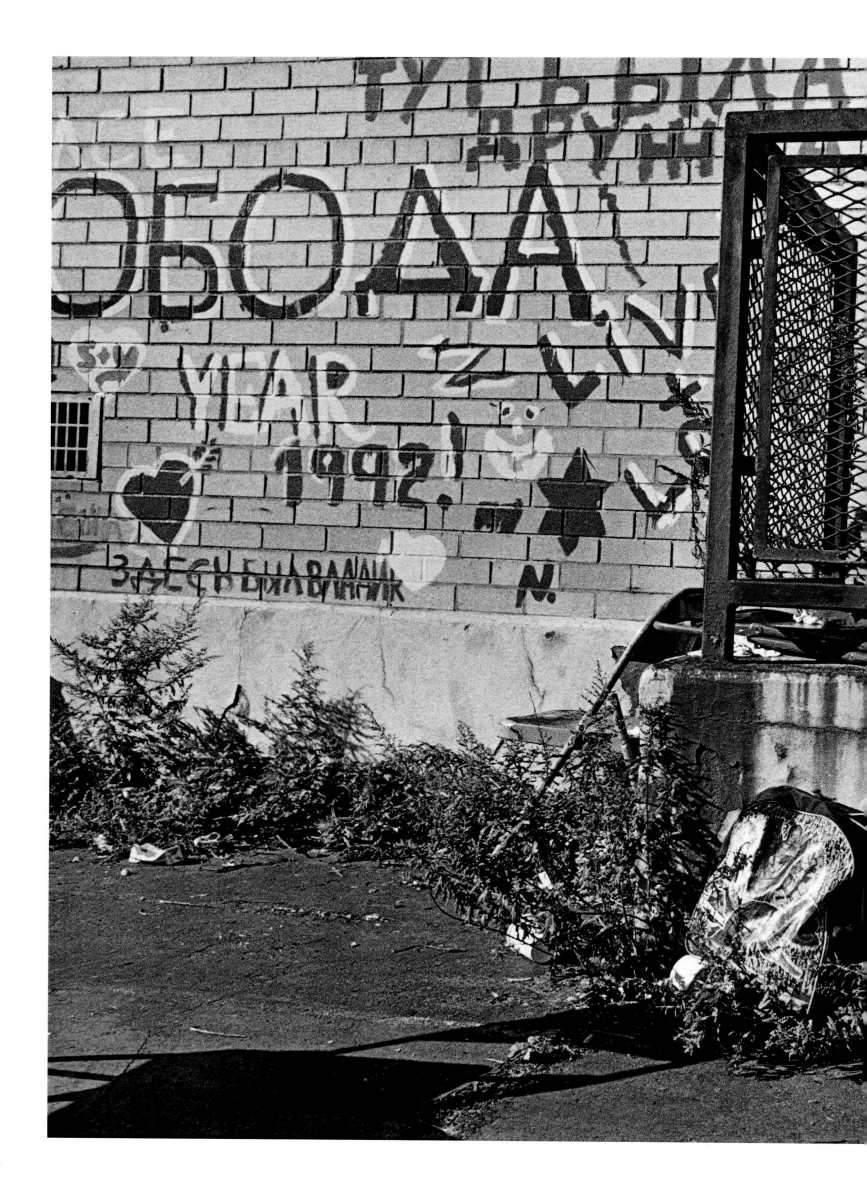

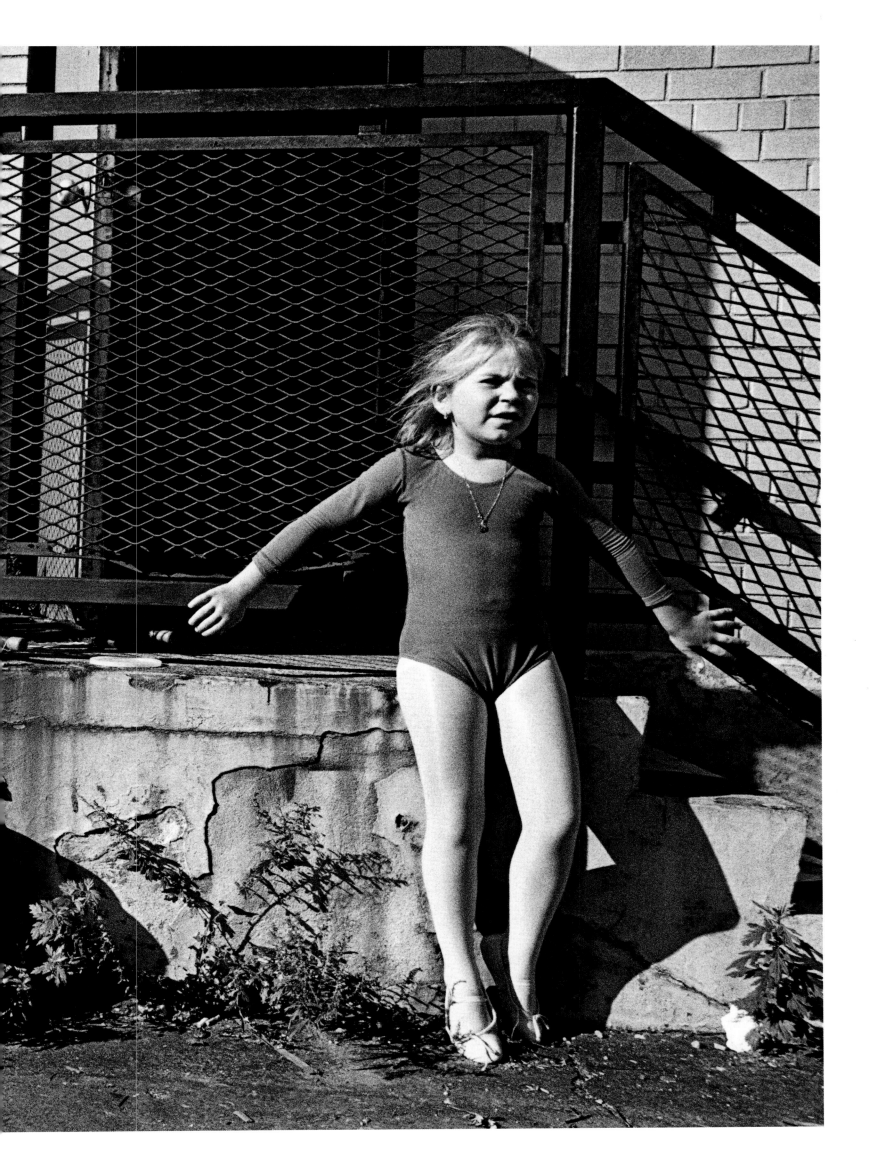

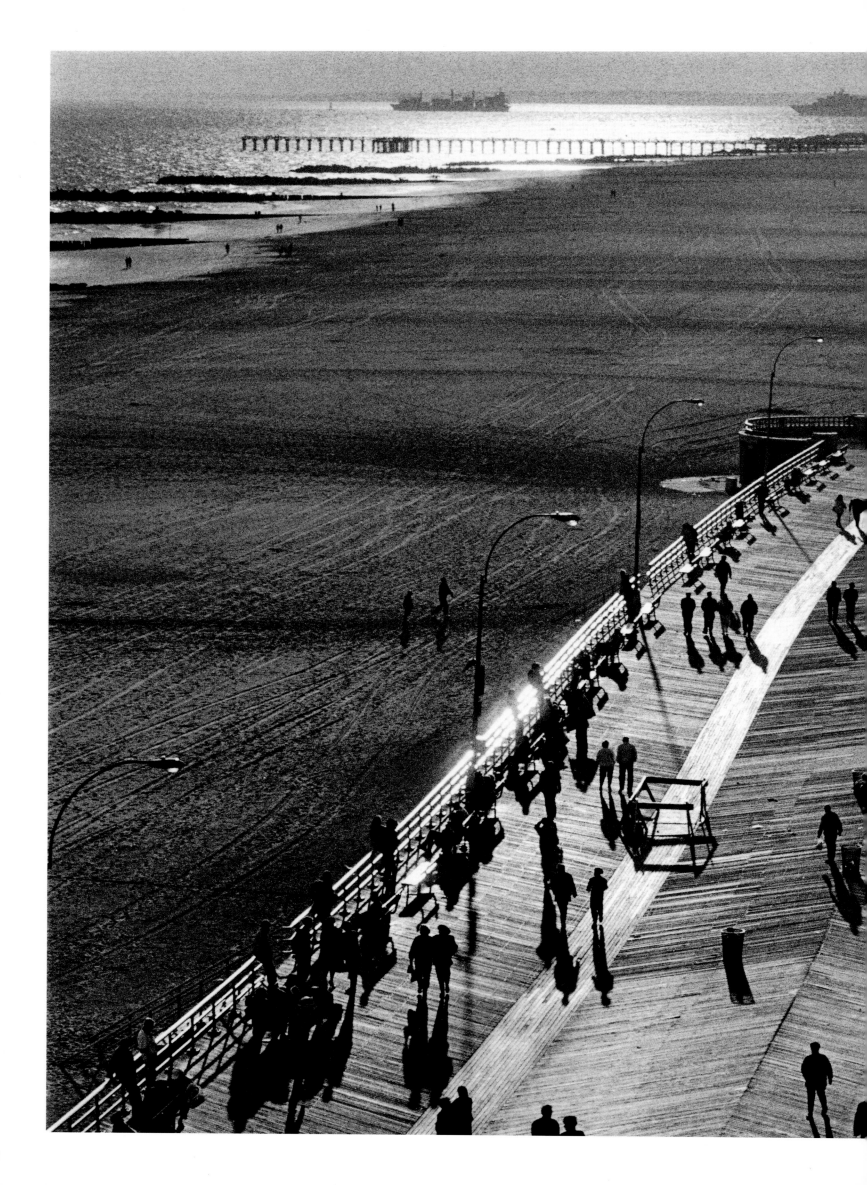

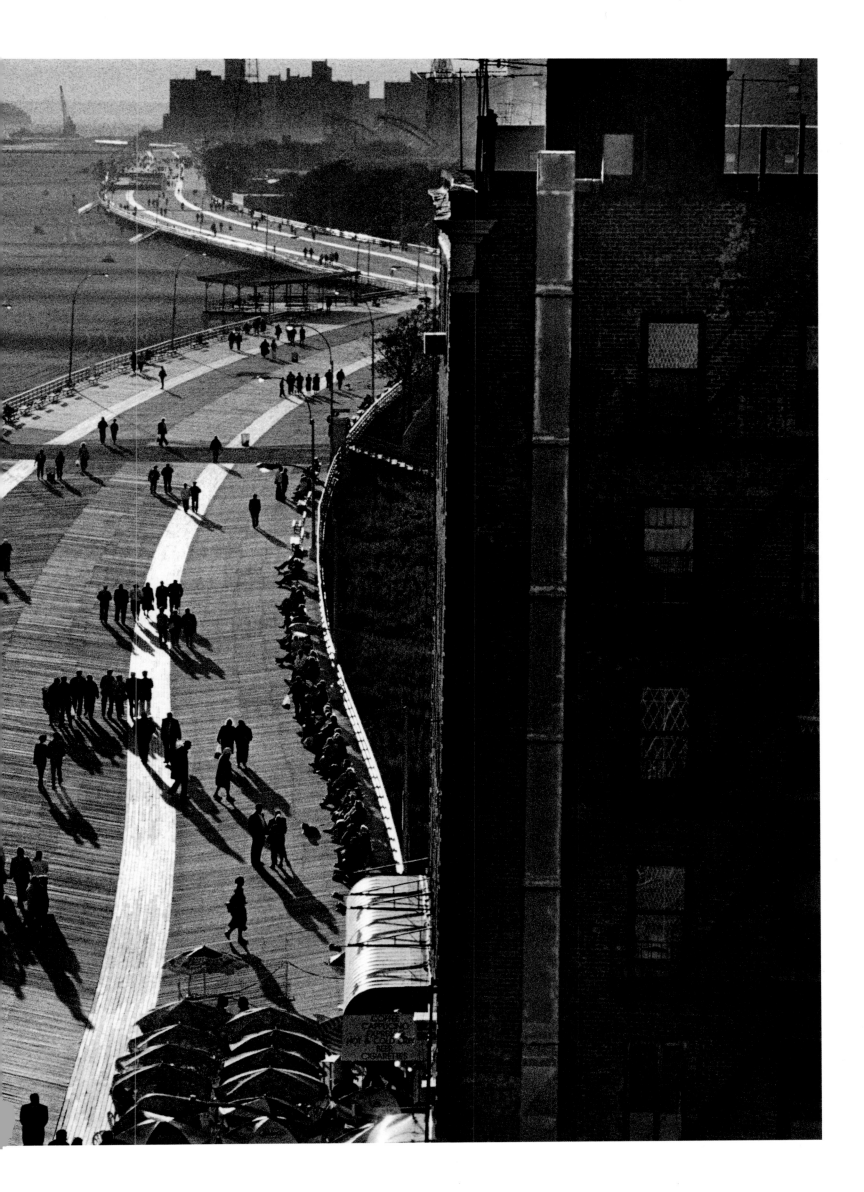

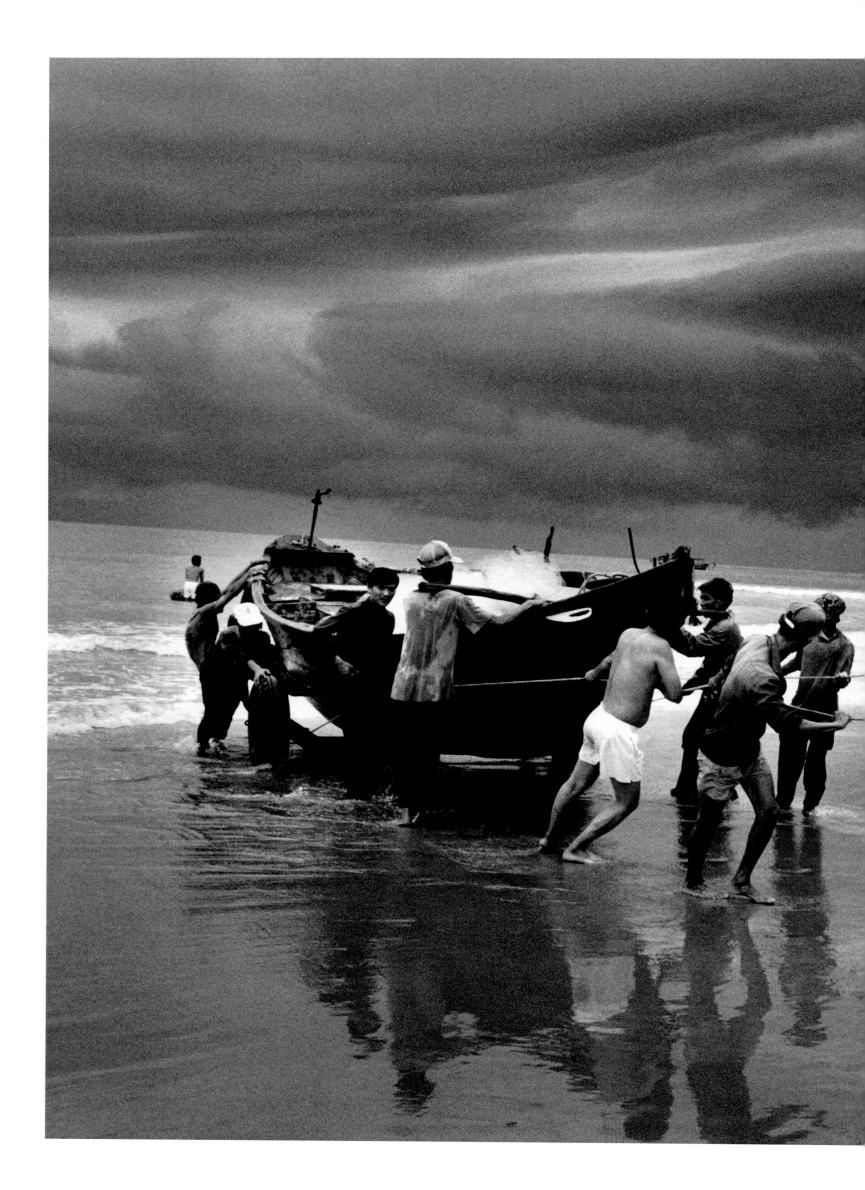

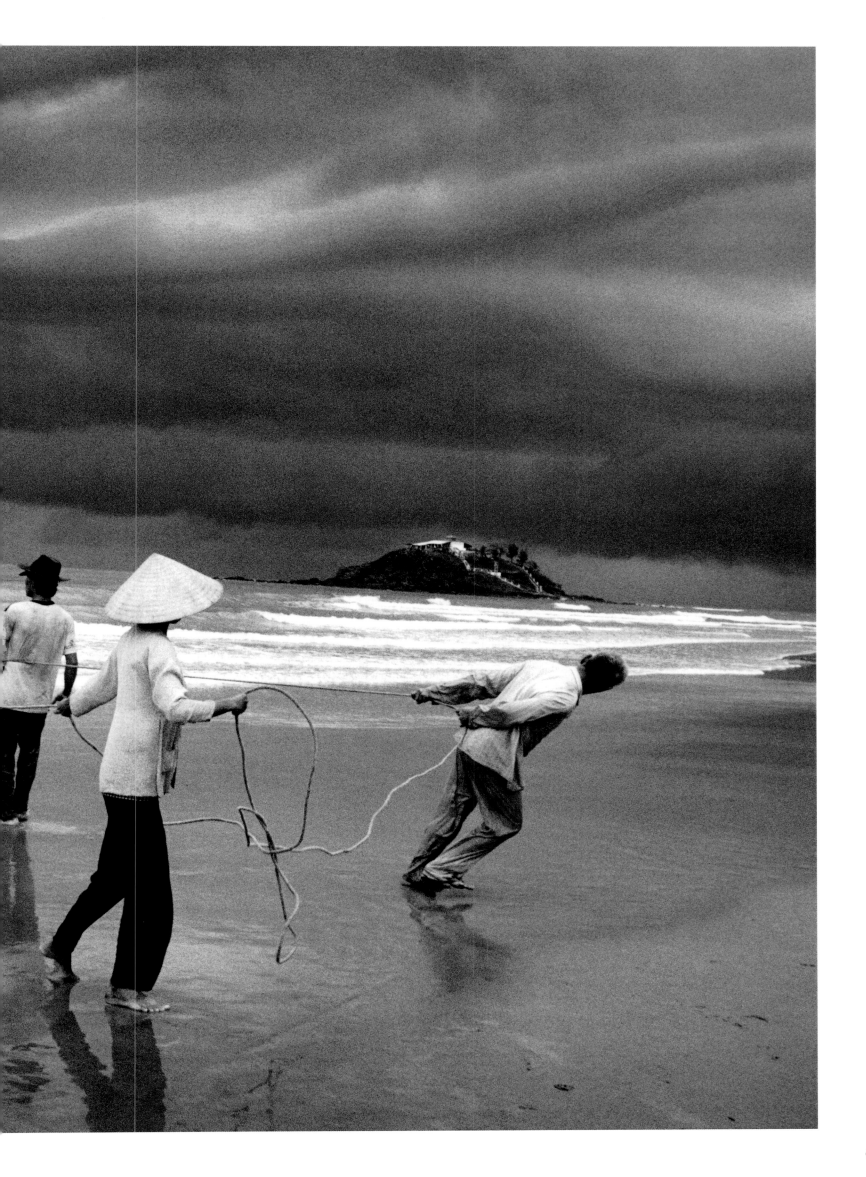

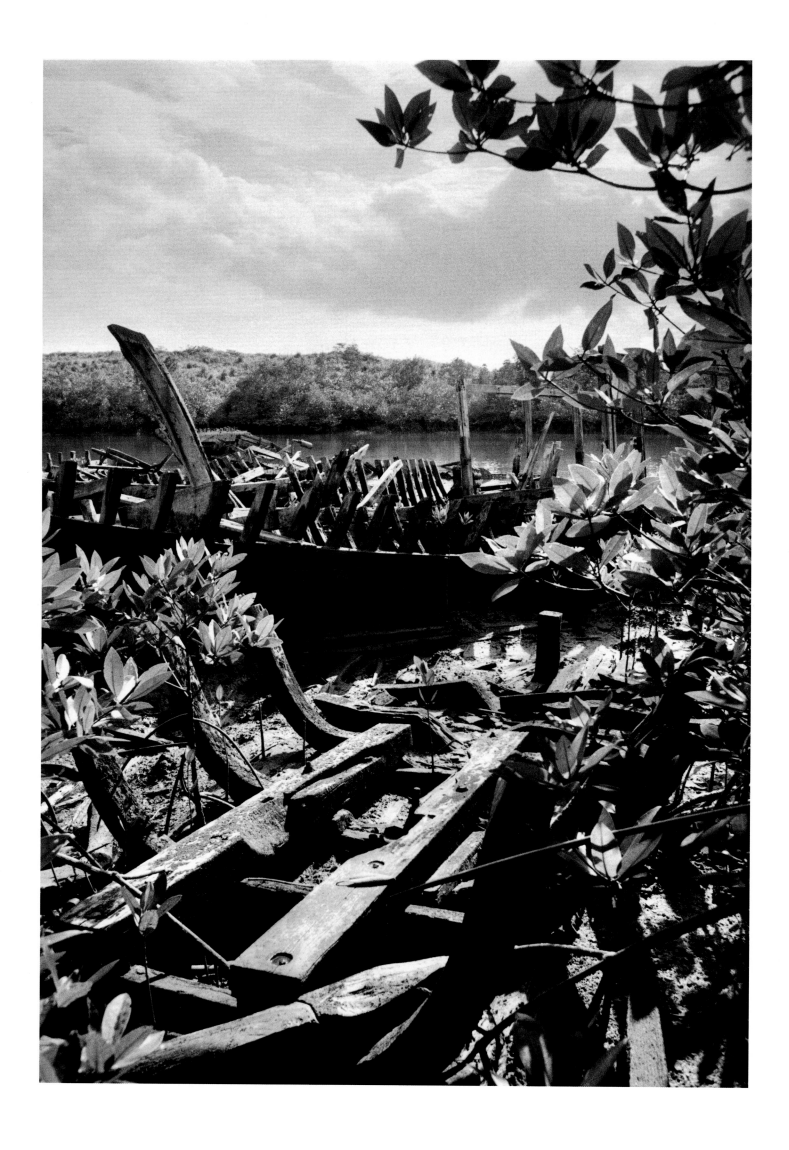

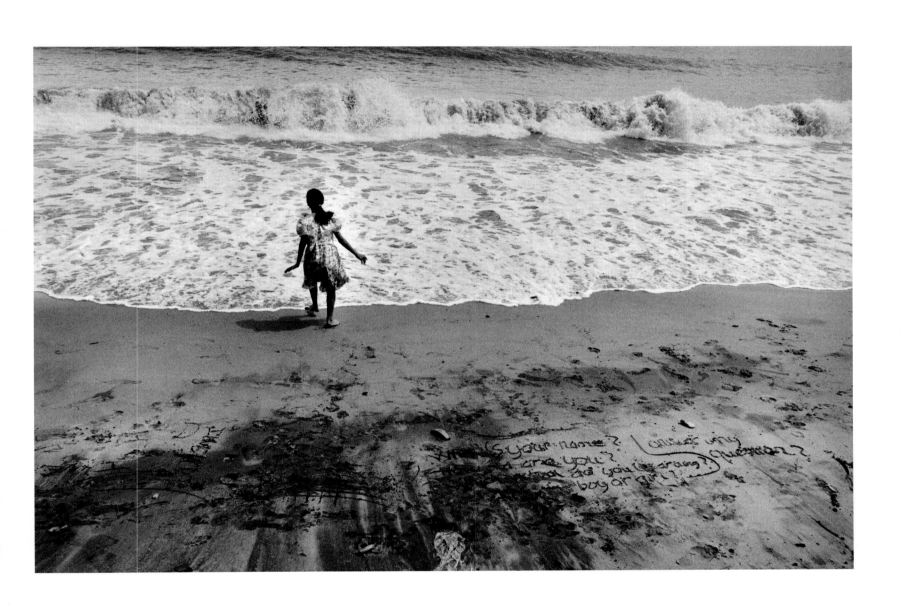

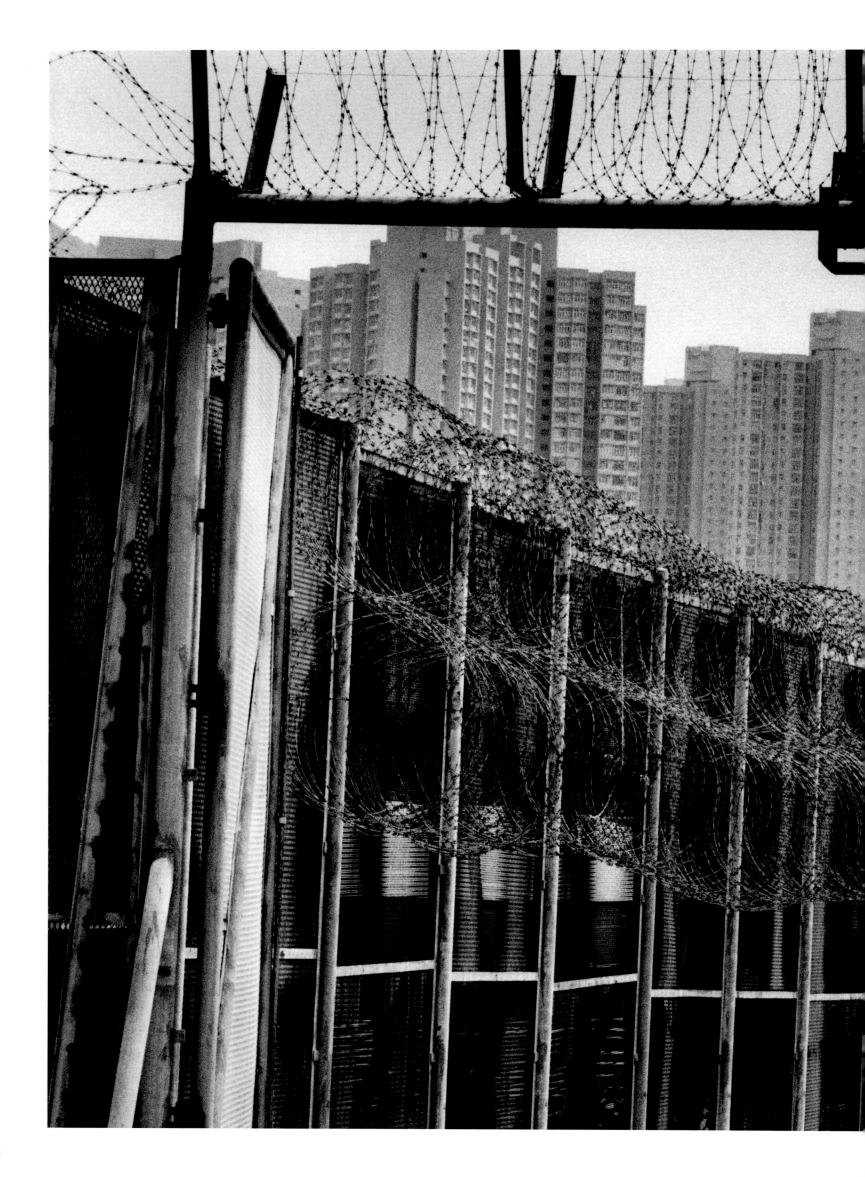

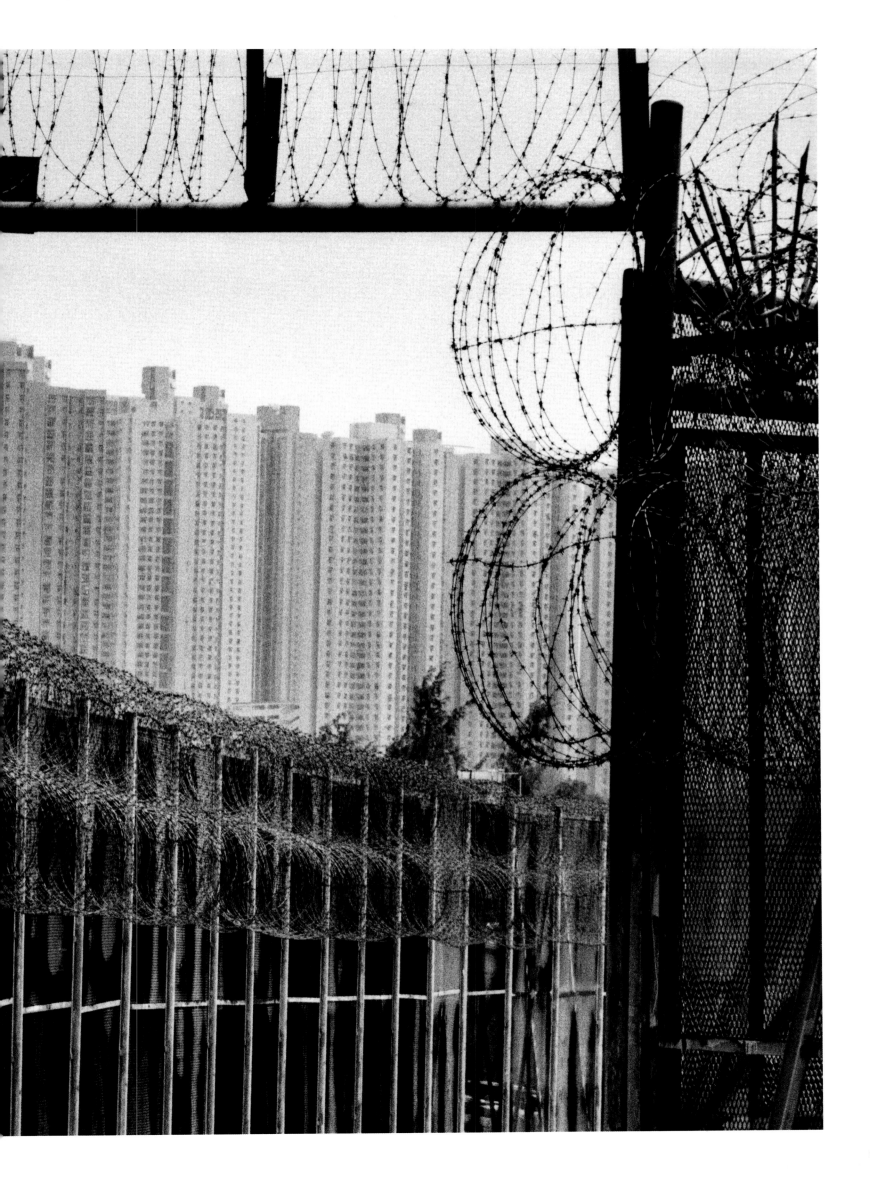

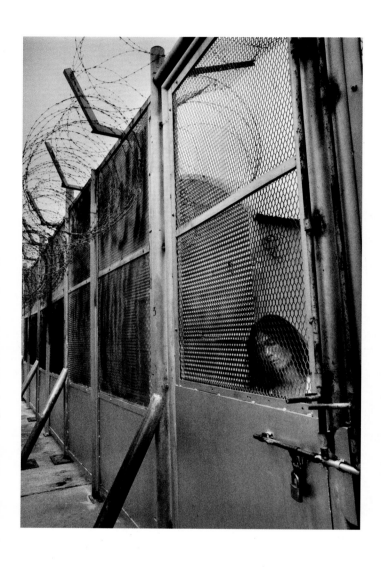

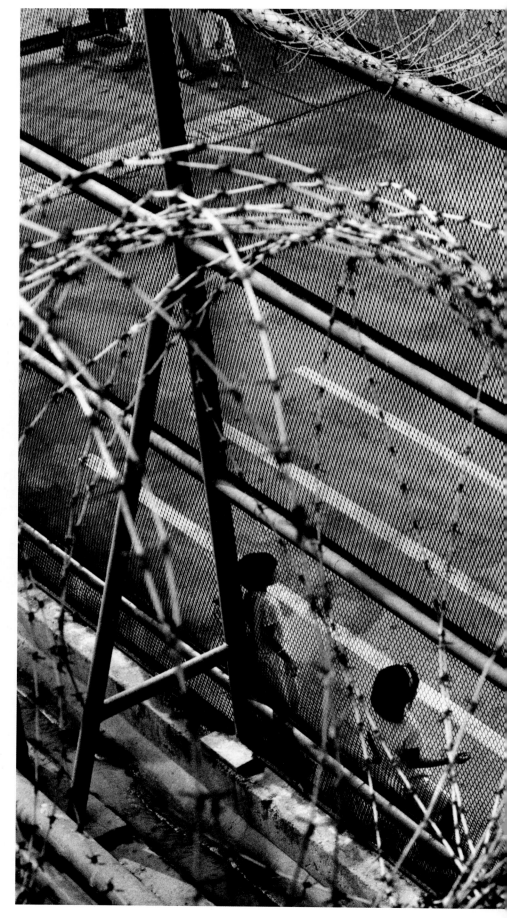

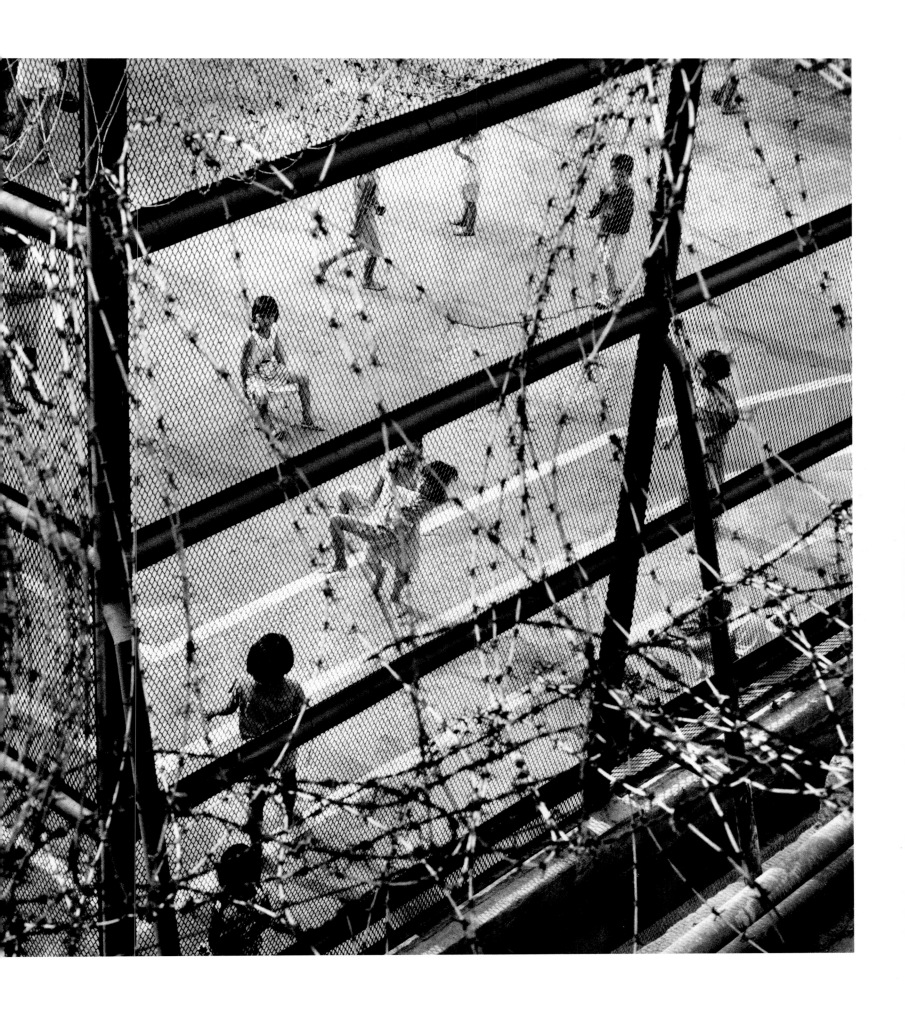

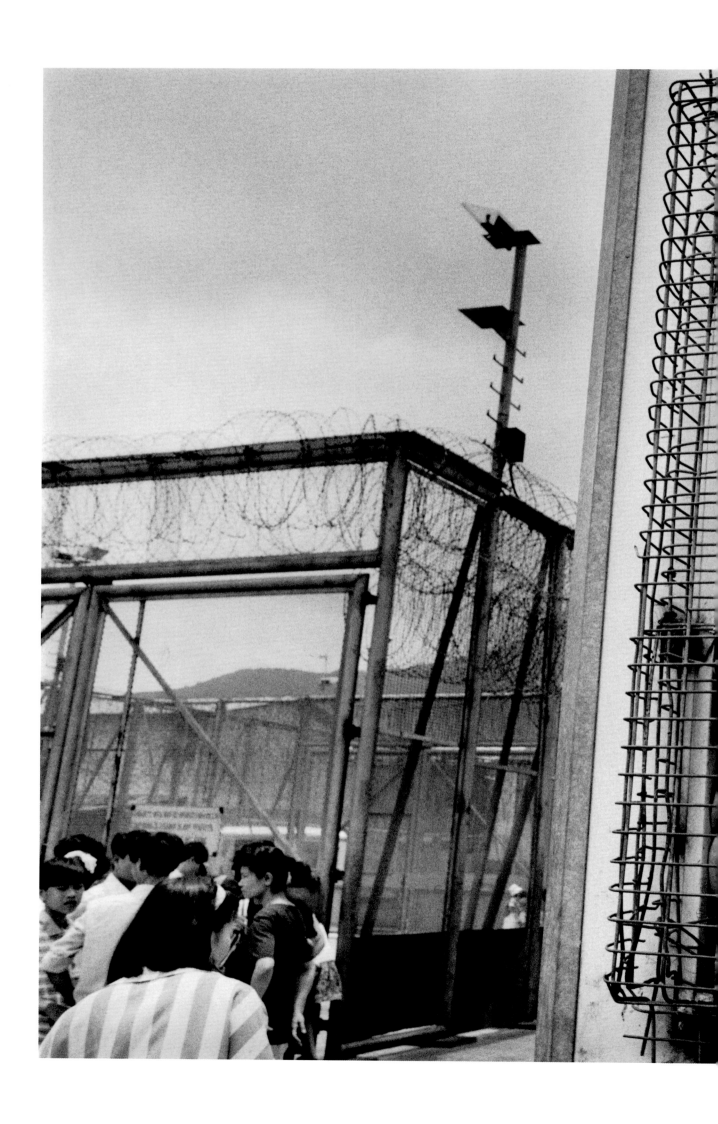

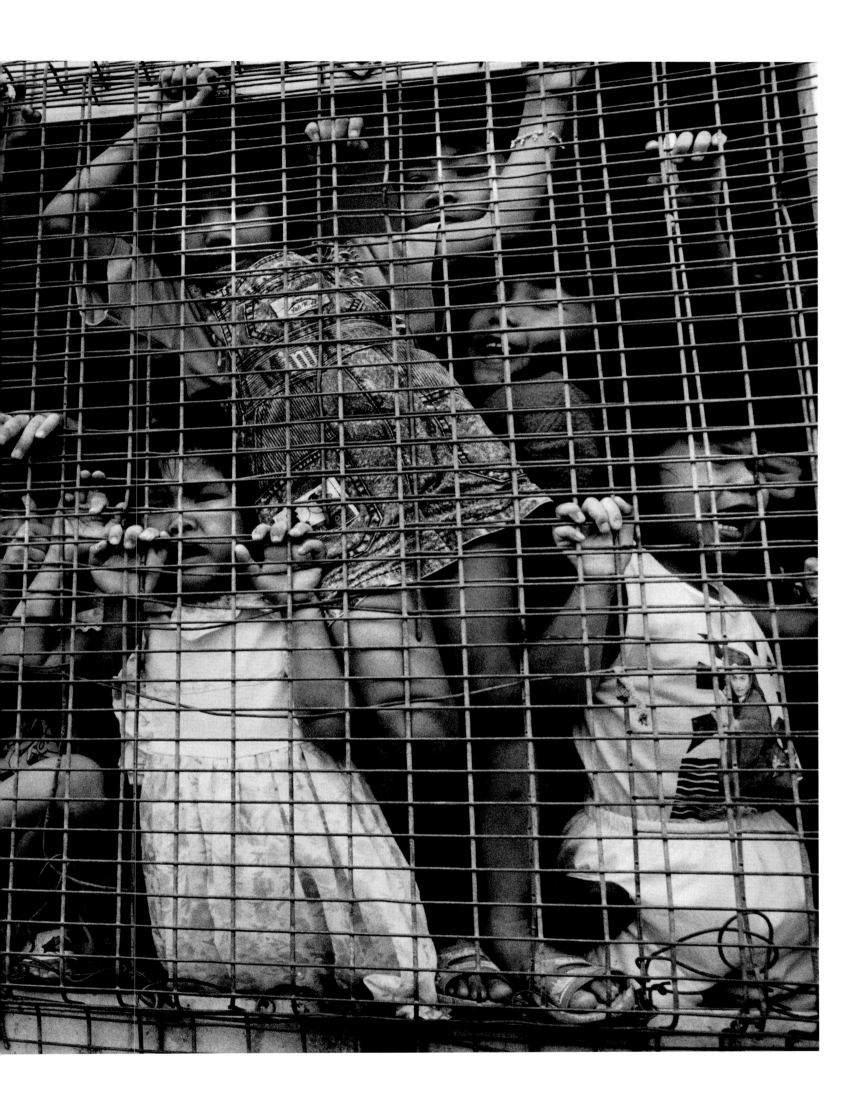

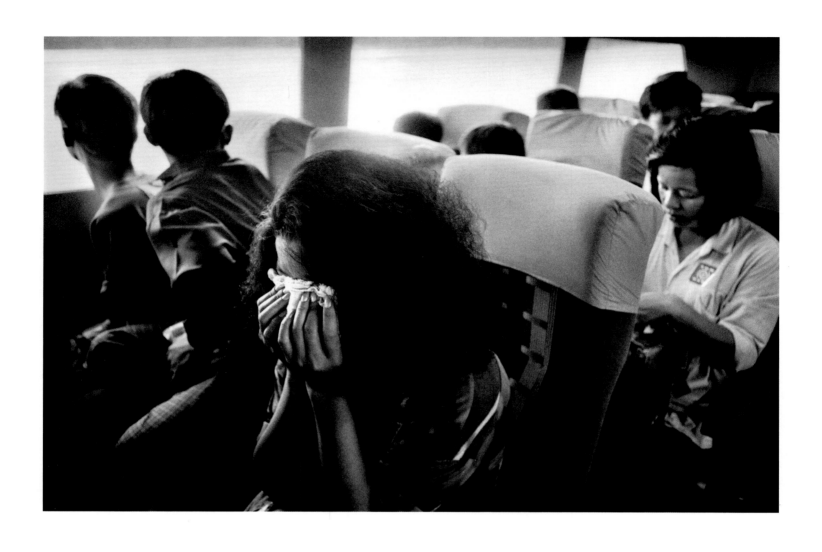

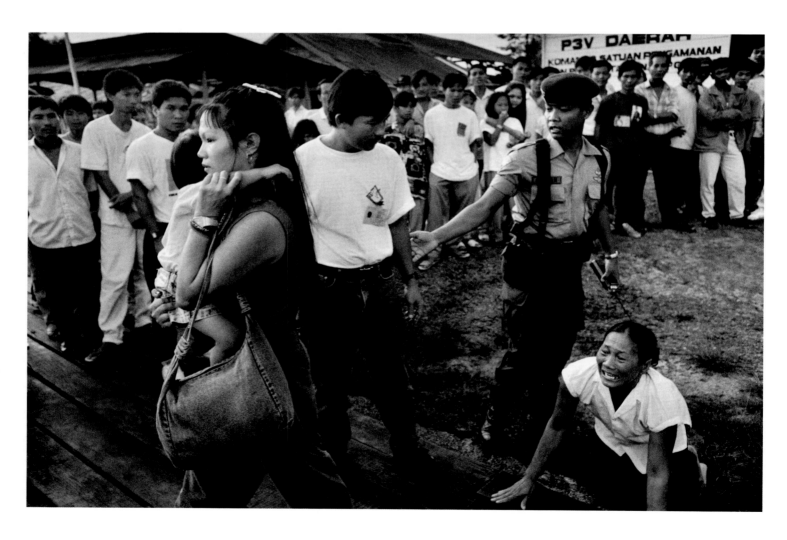

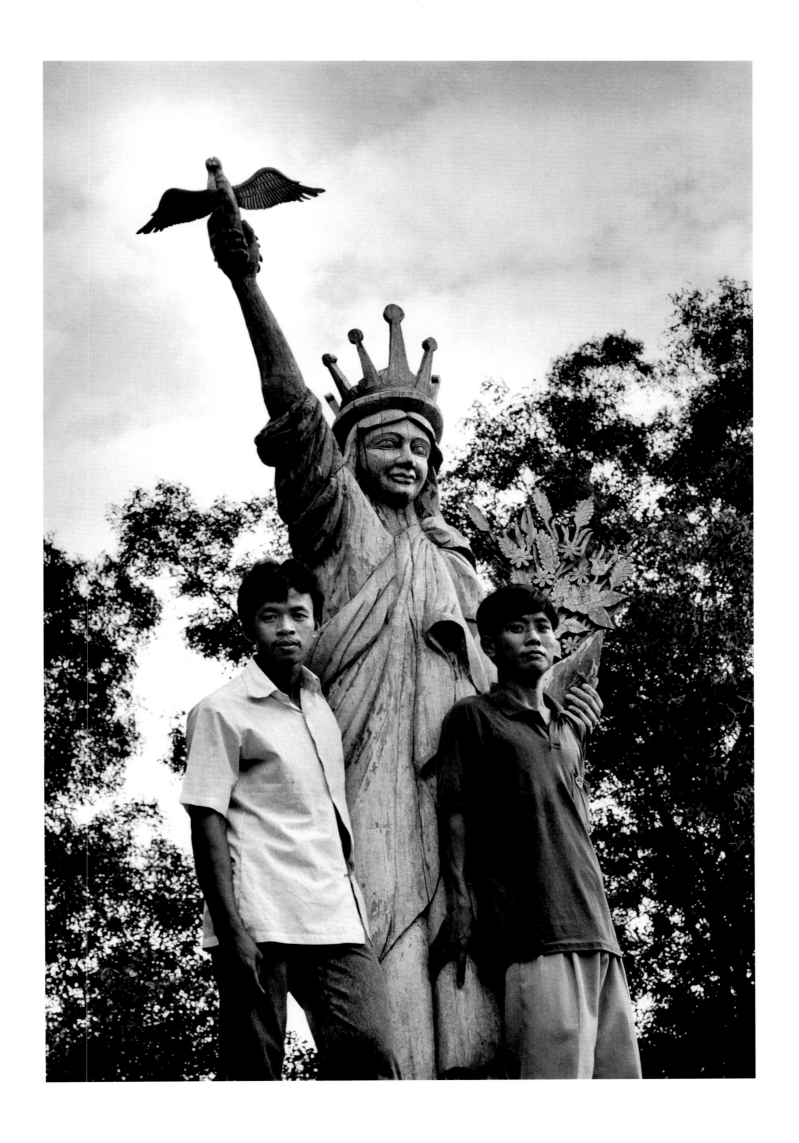

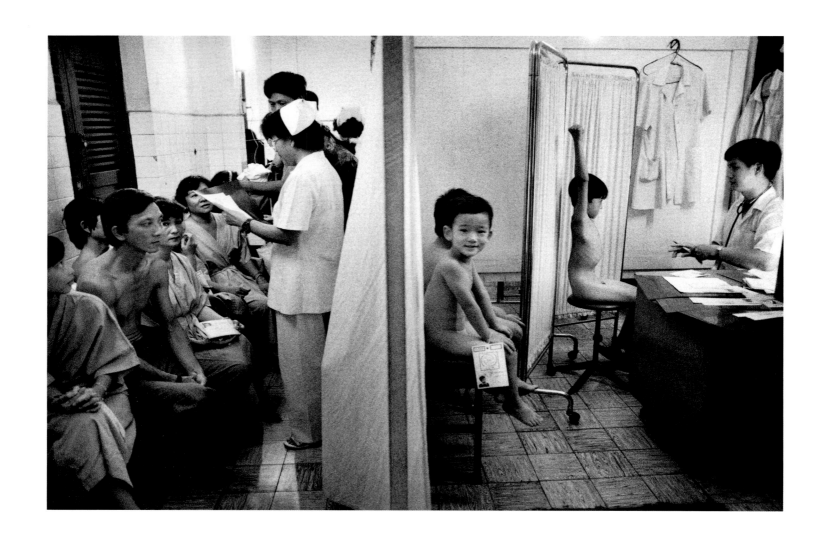

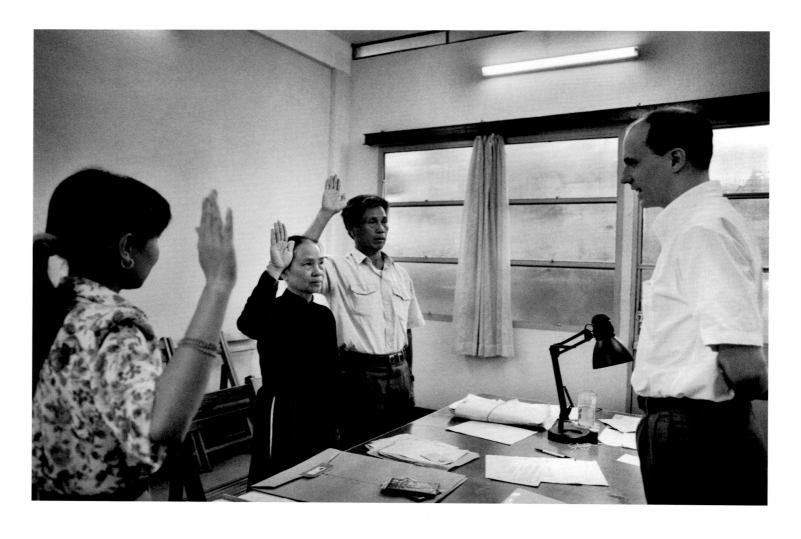

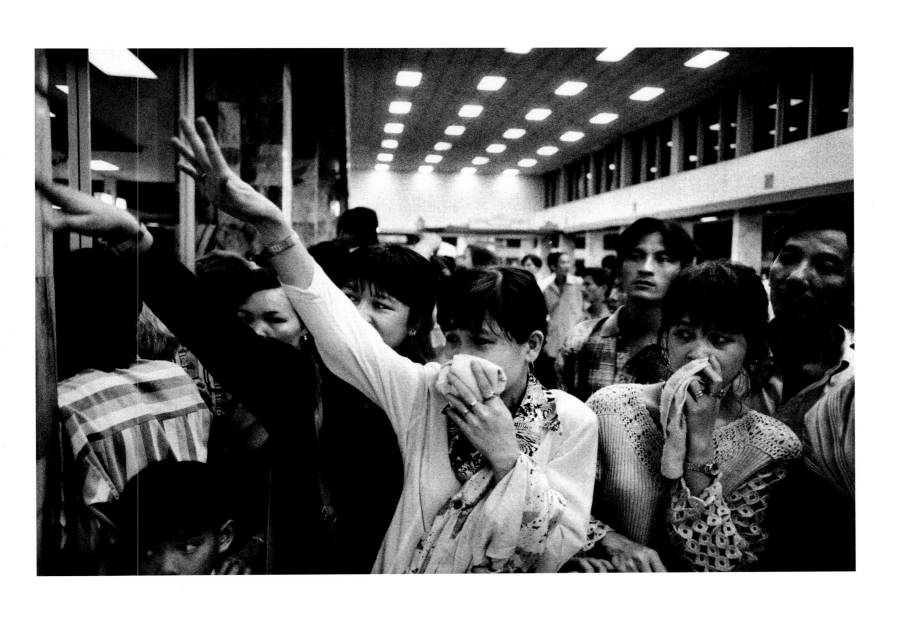

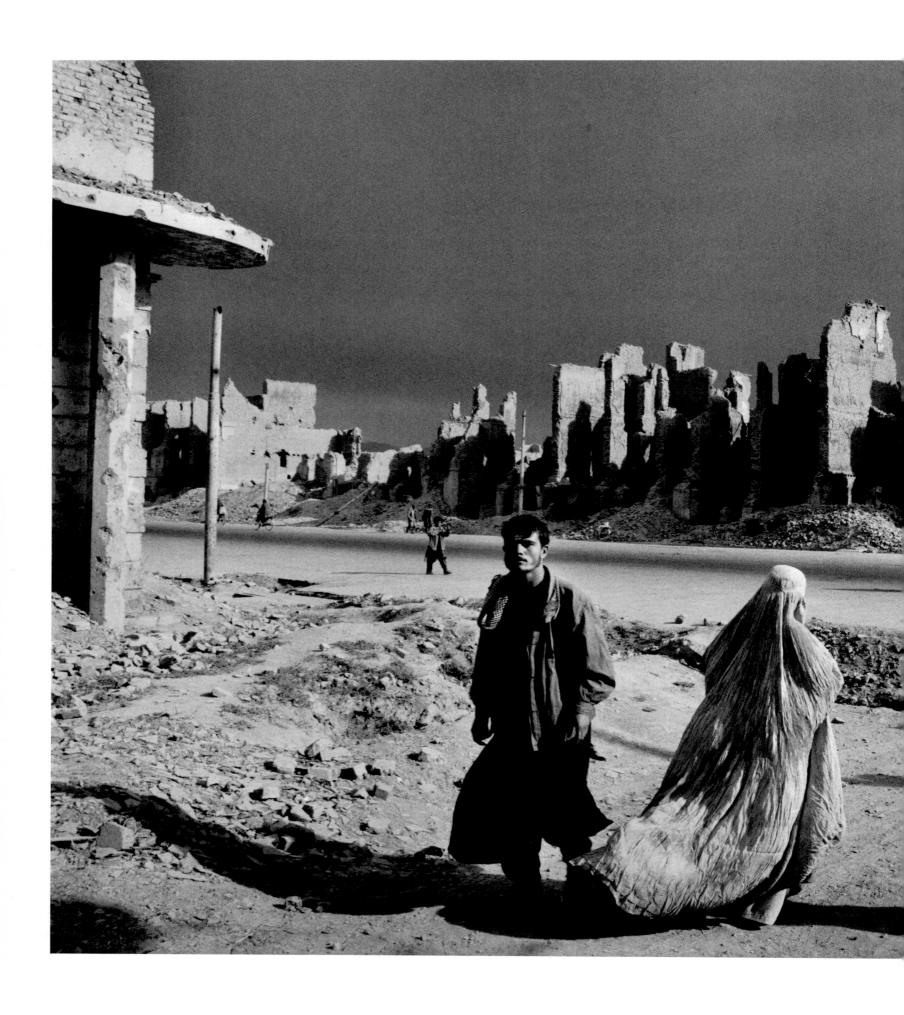

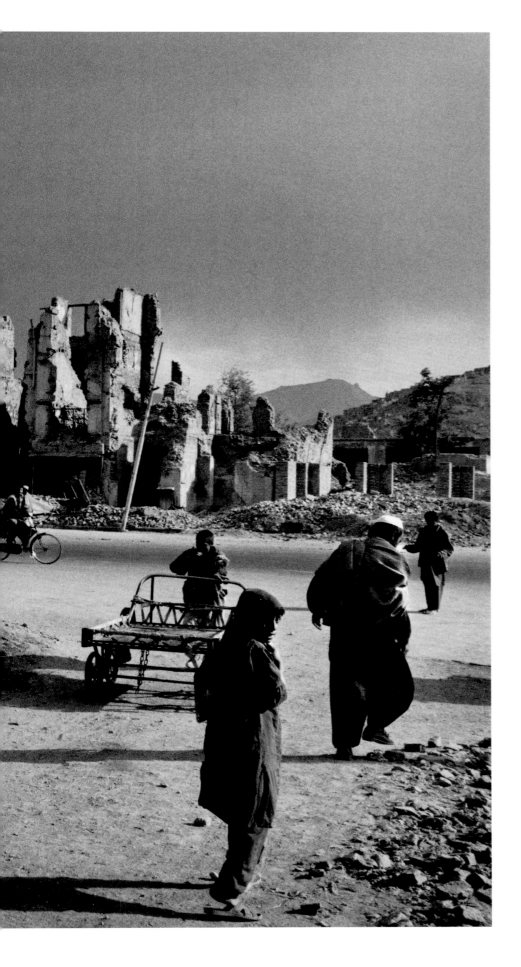

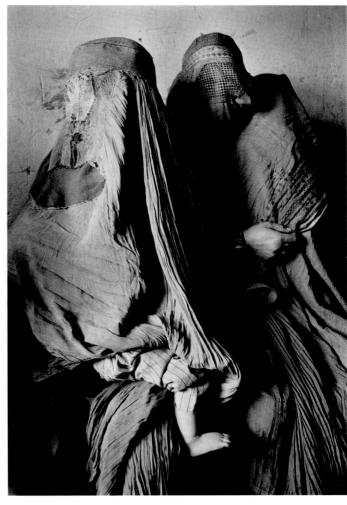

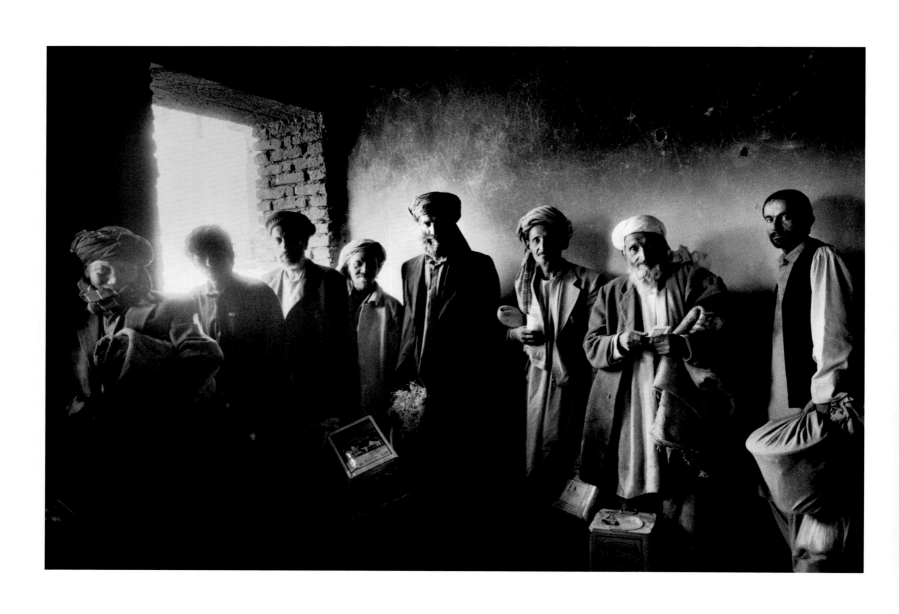

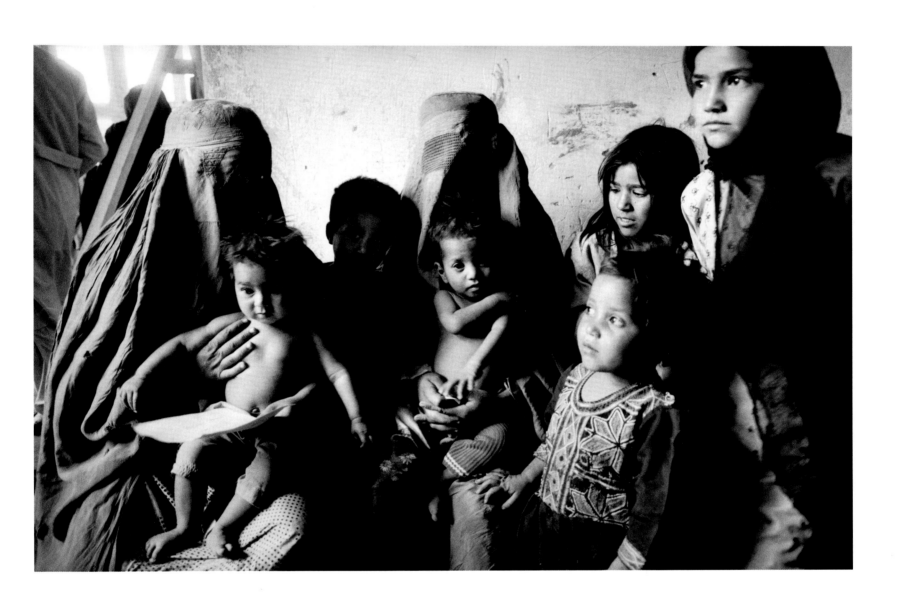

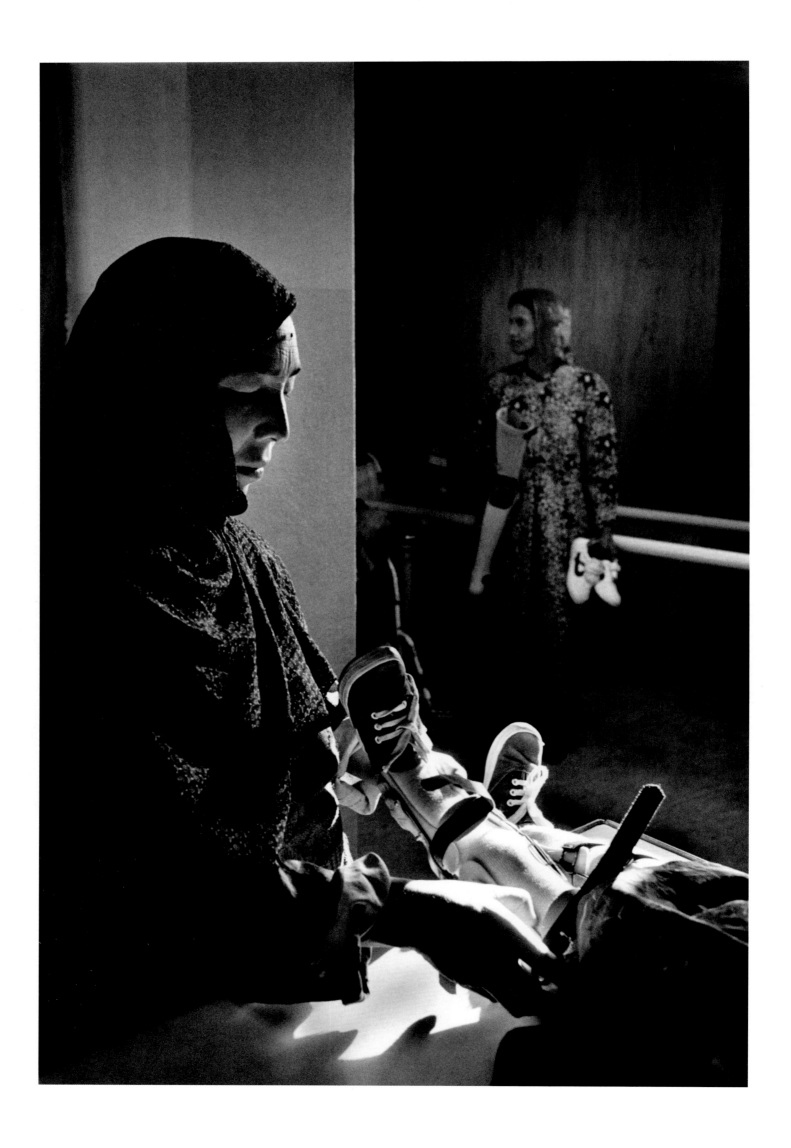

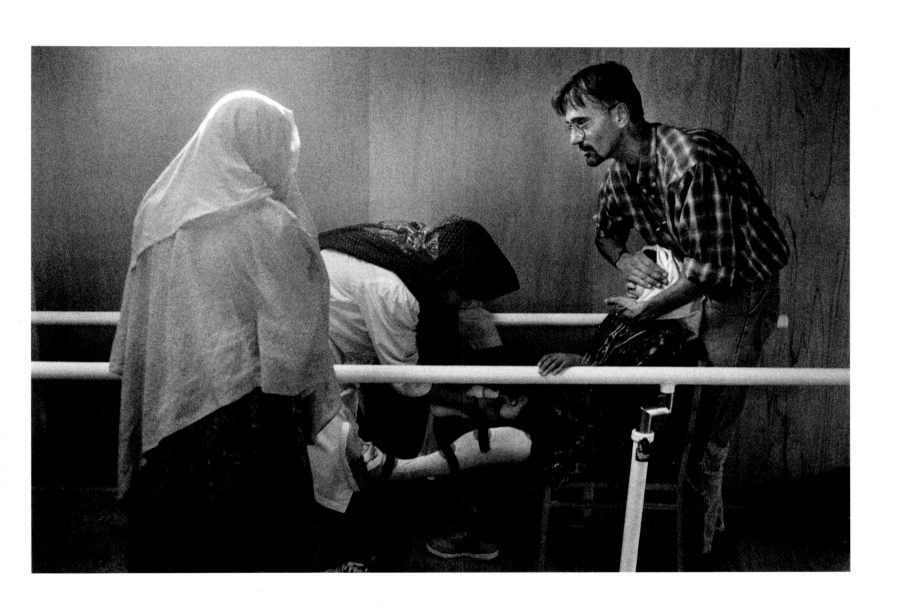

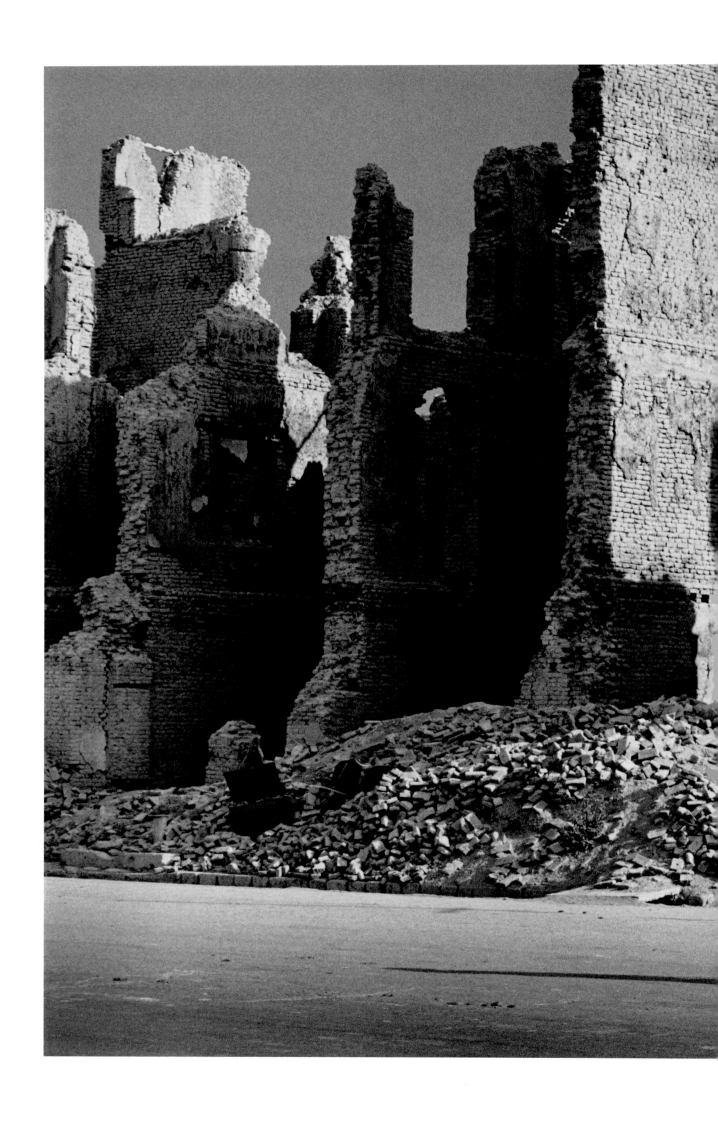

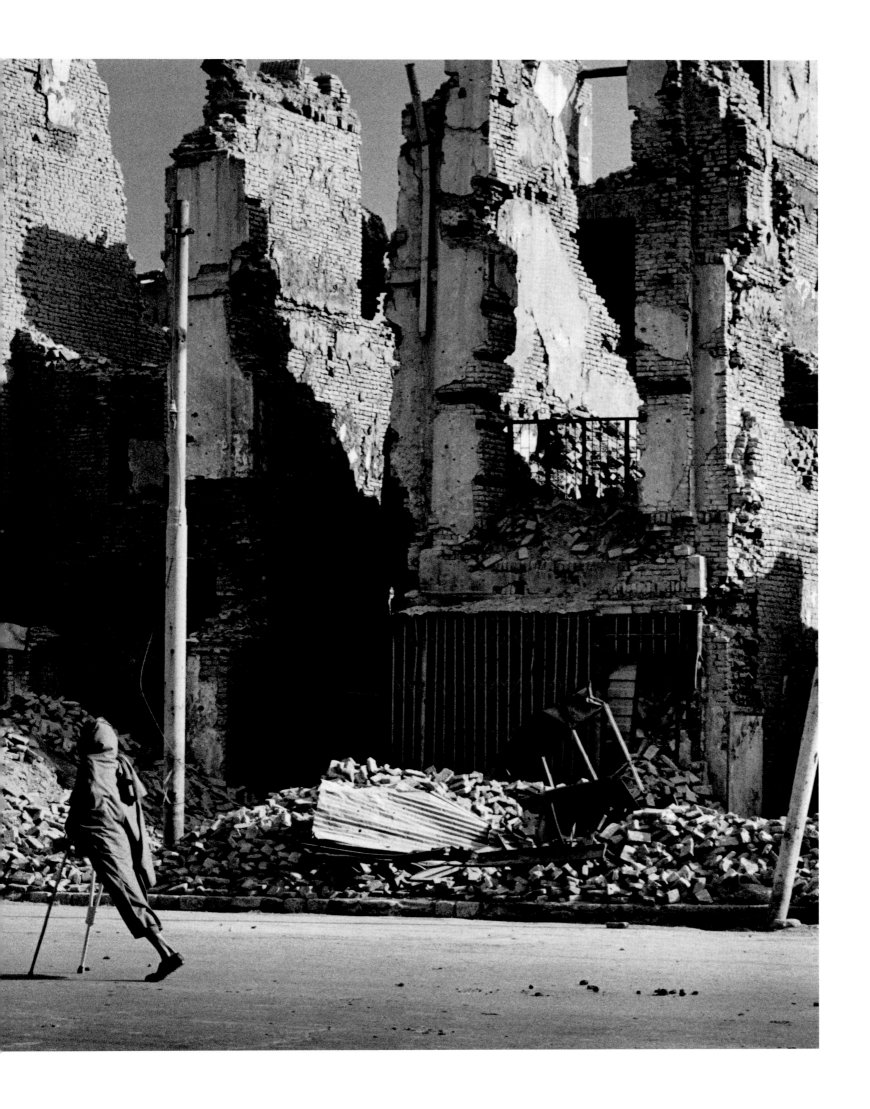

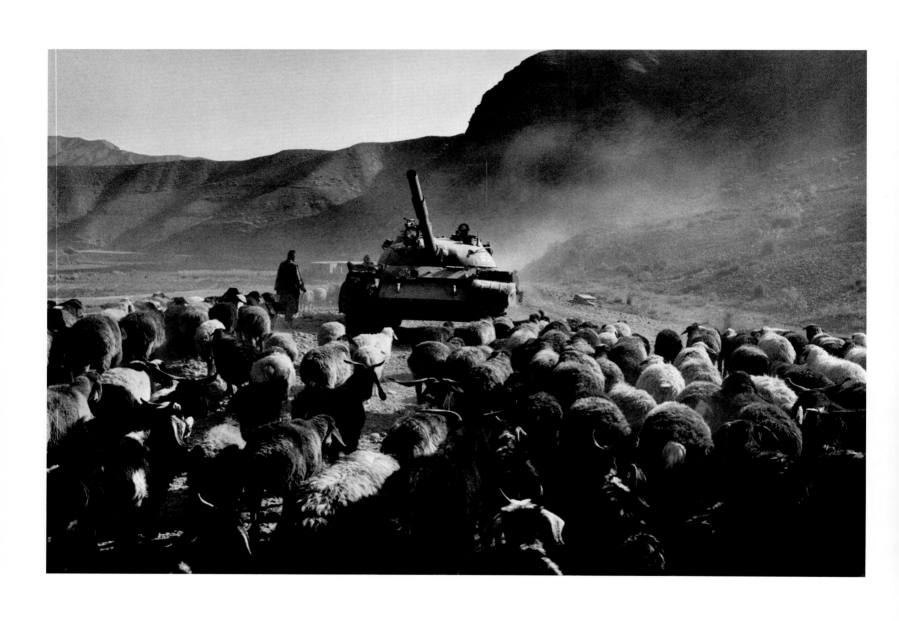

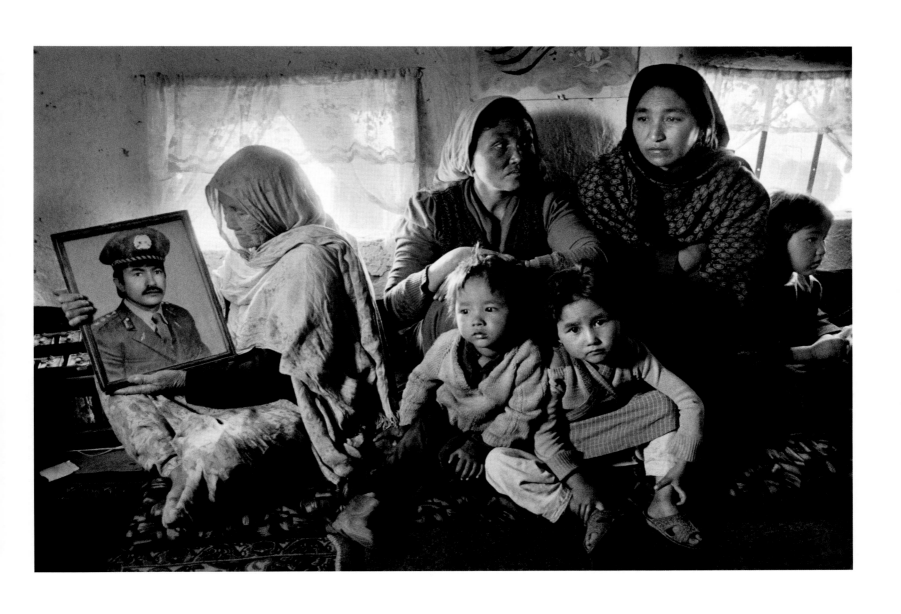

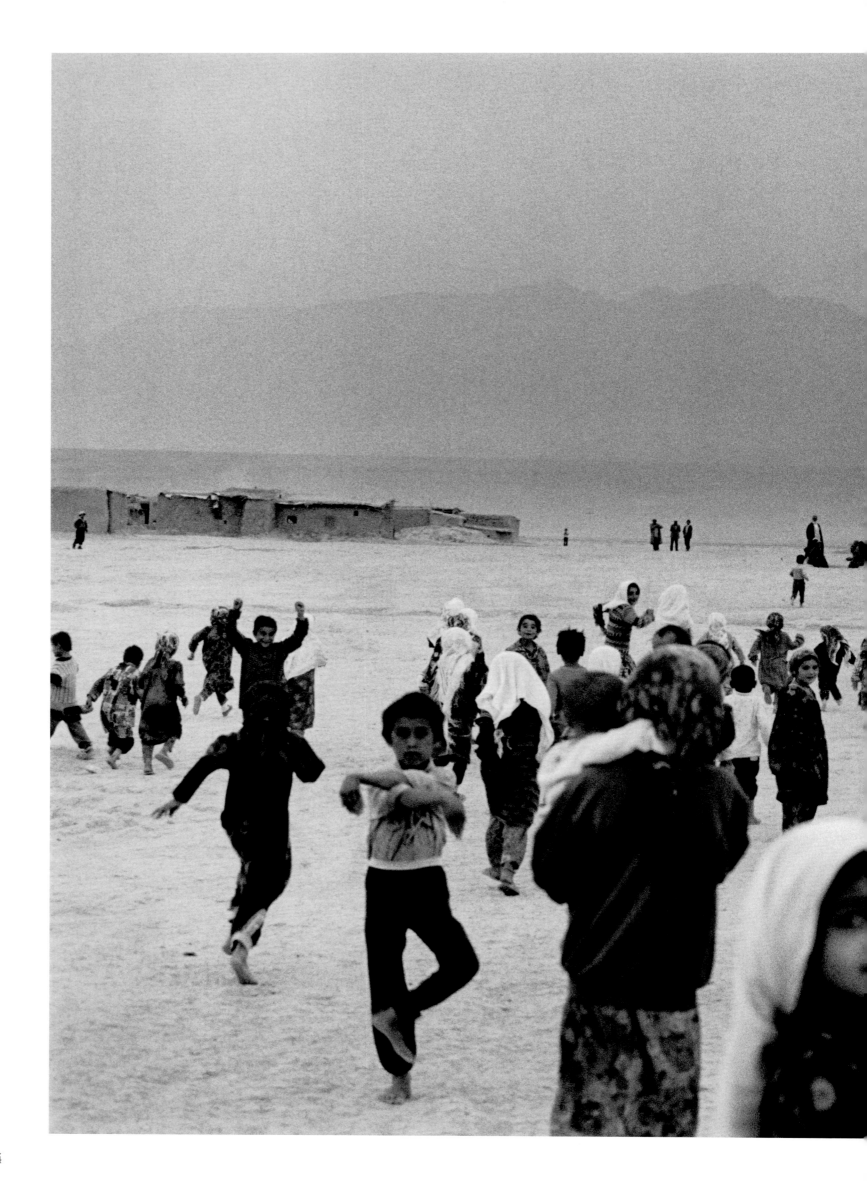

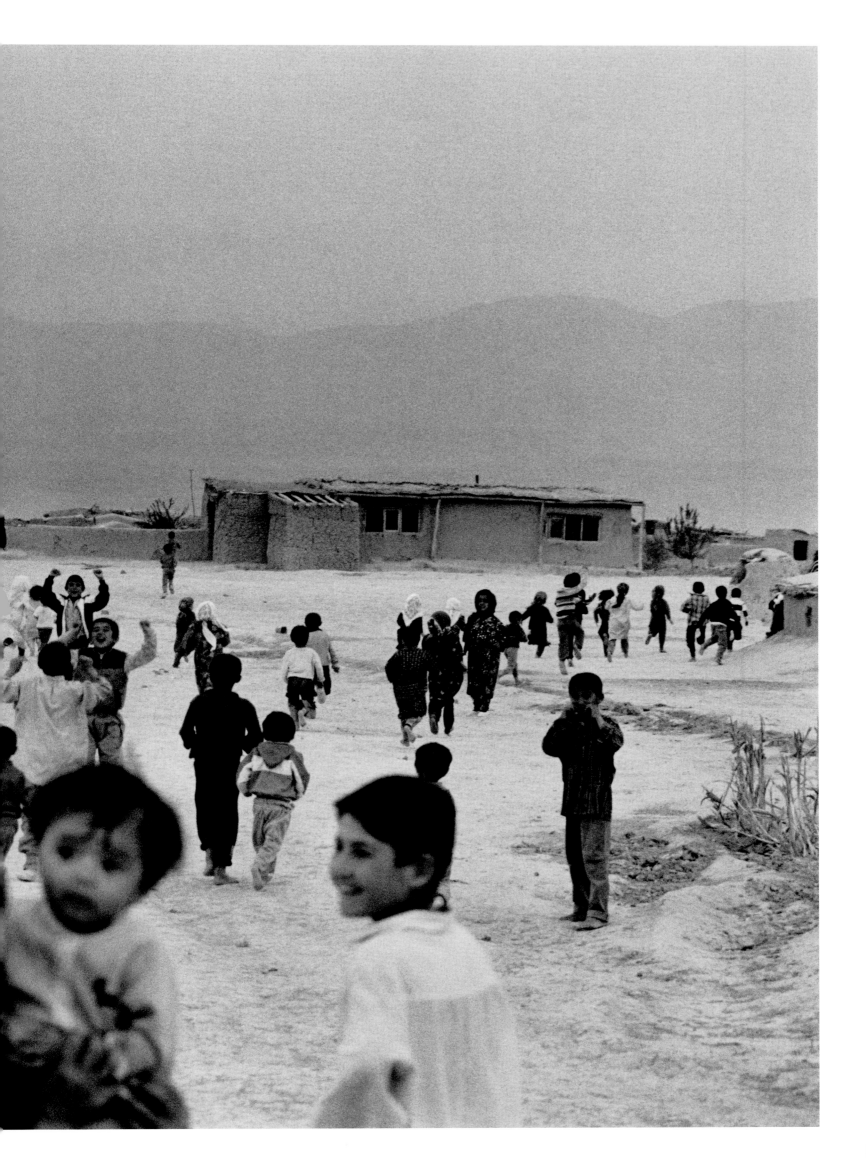

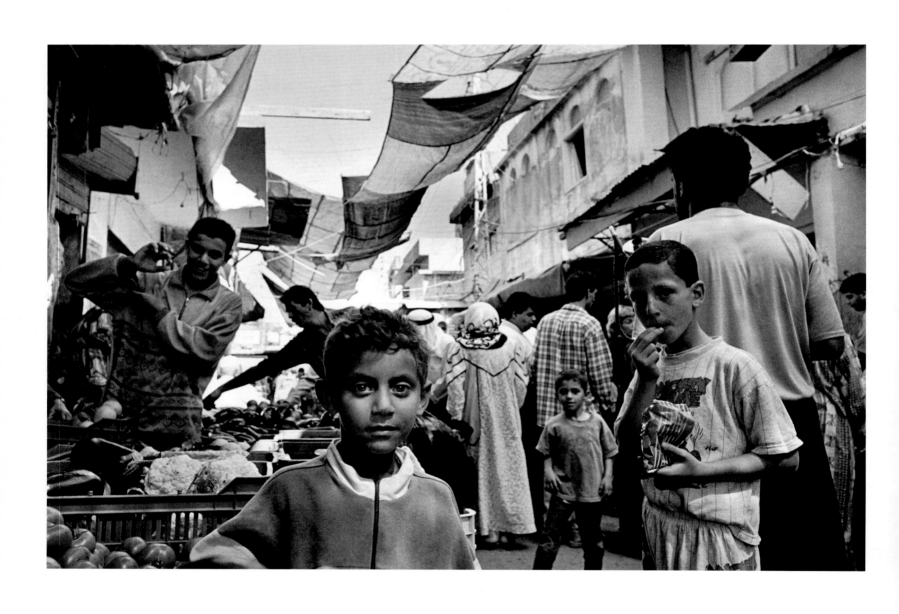

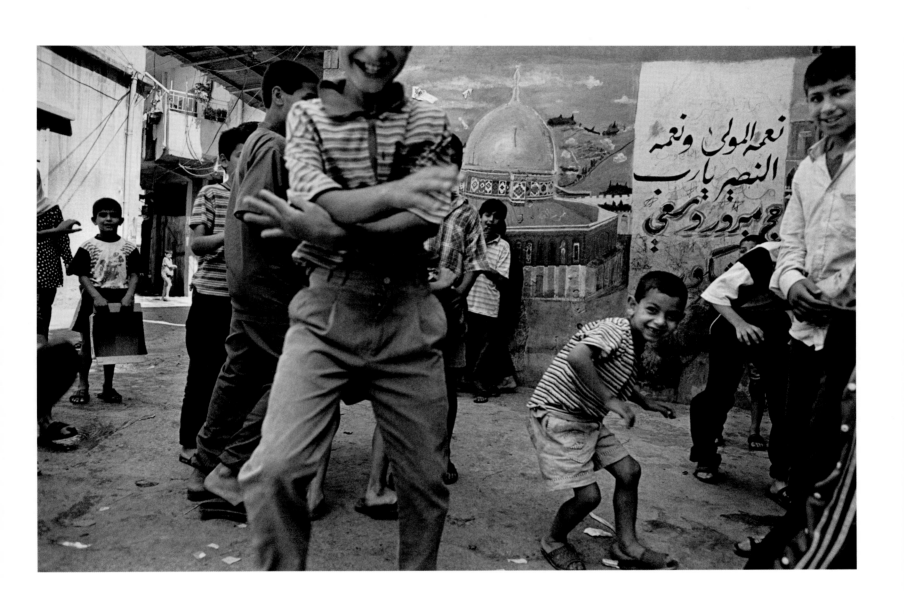

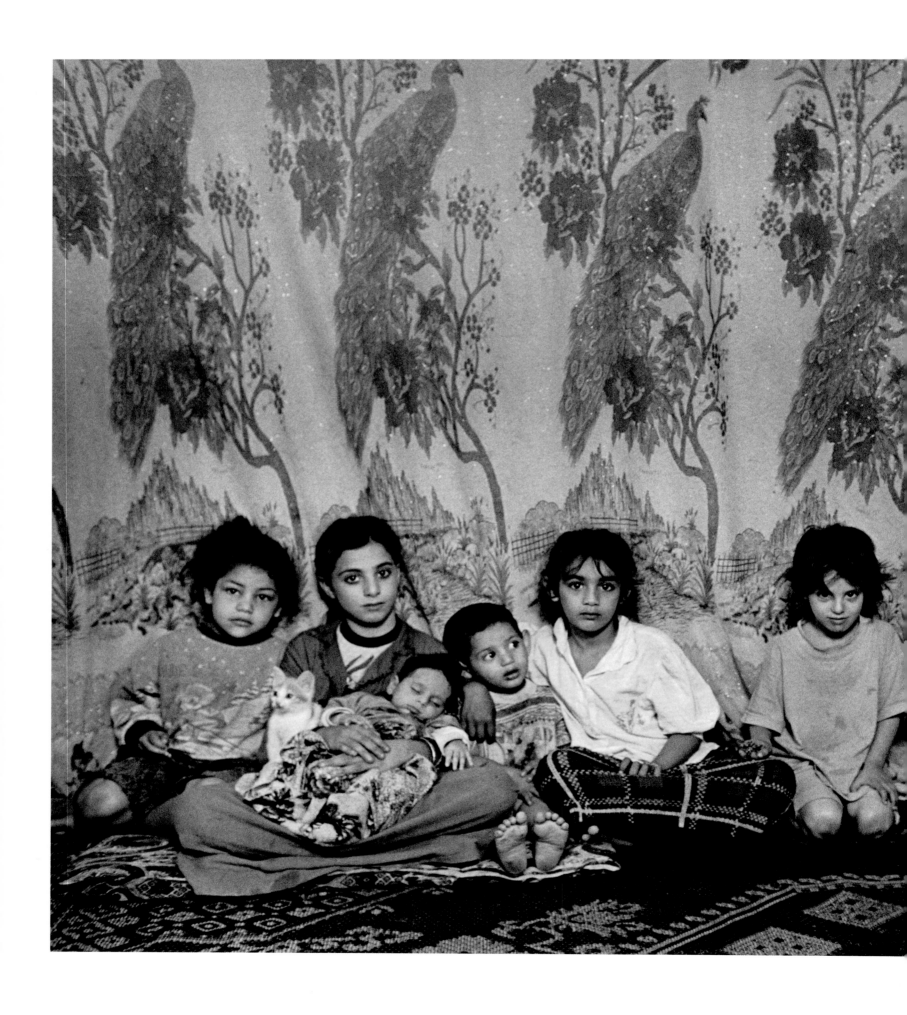

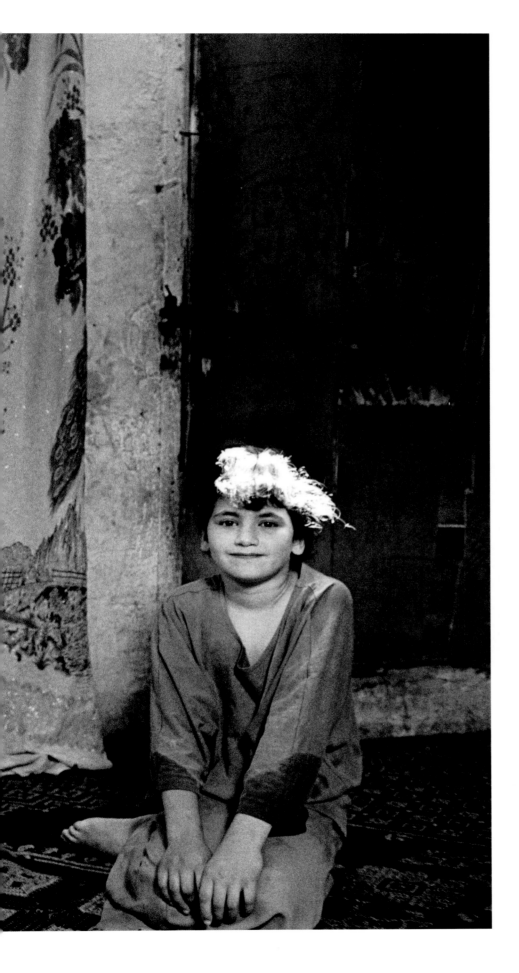

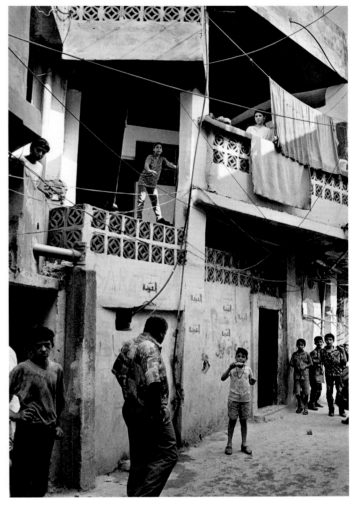

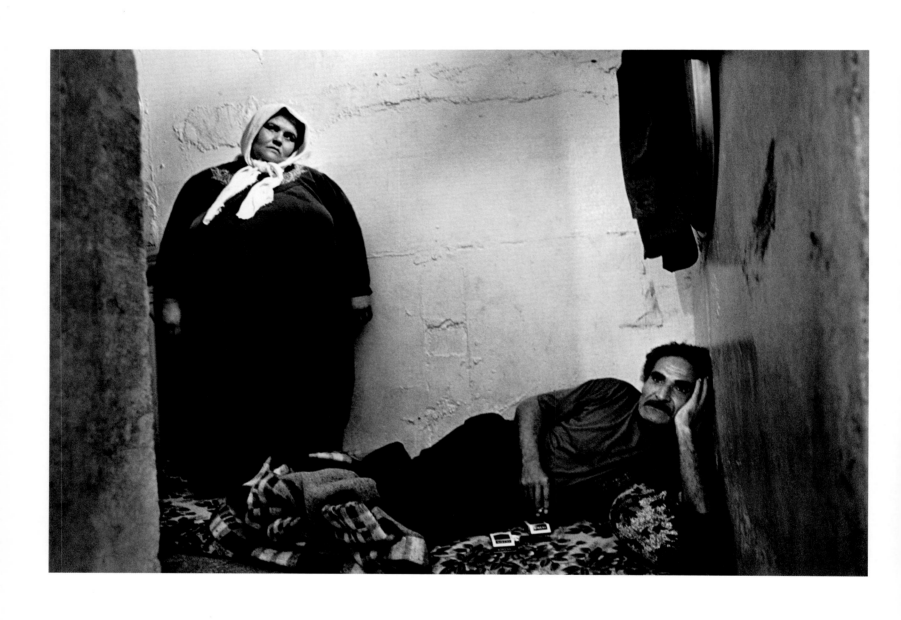

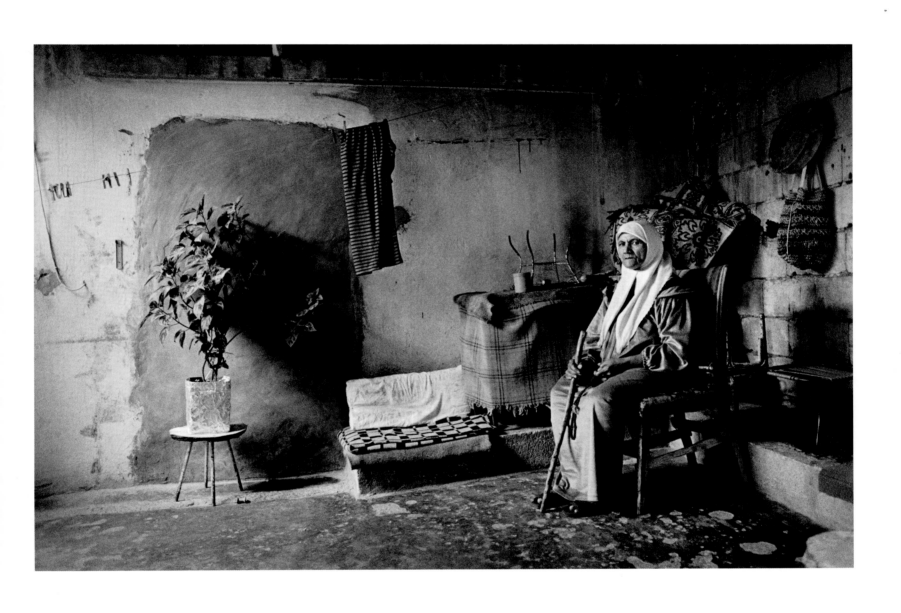

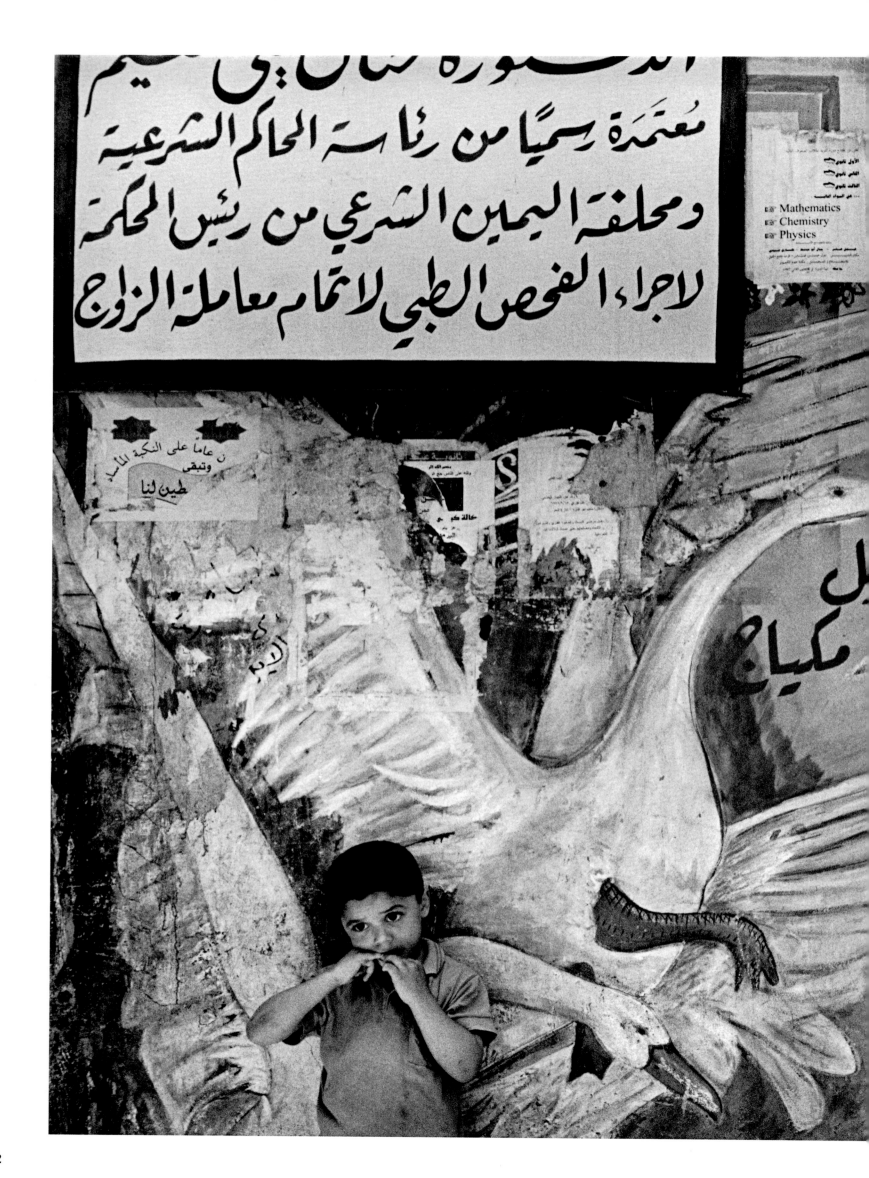

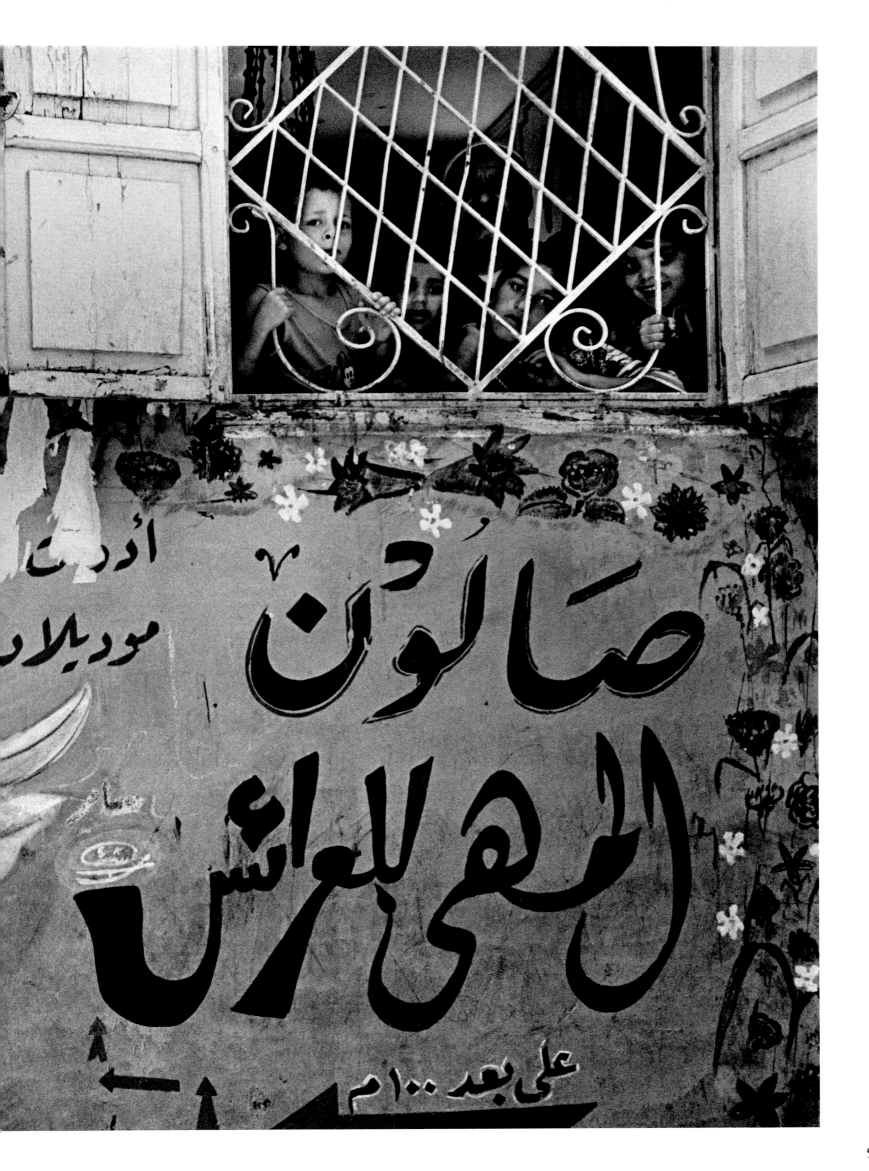

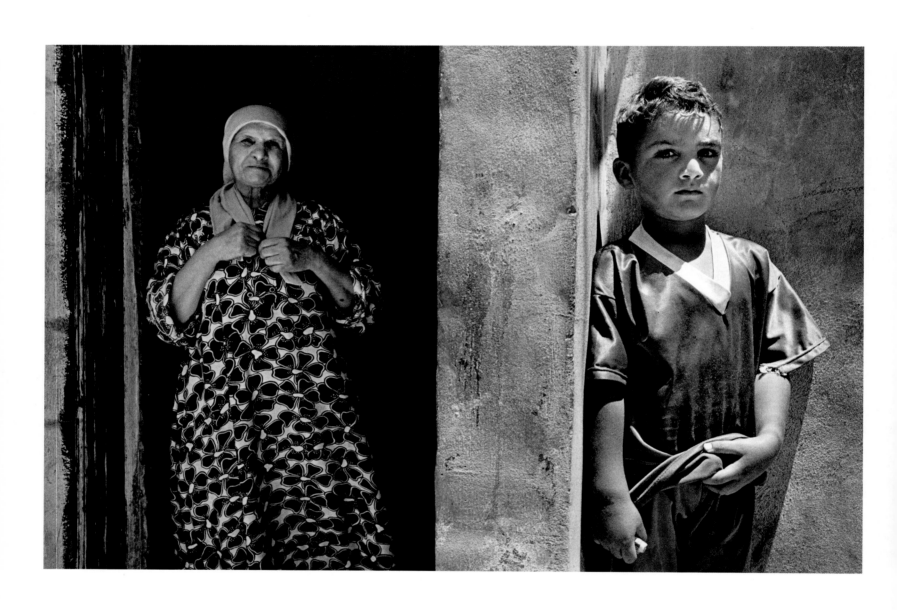

94

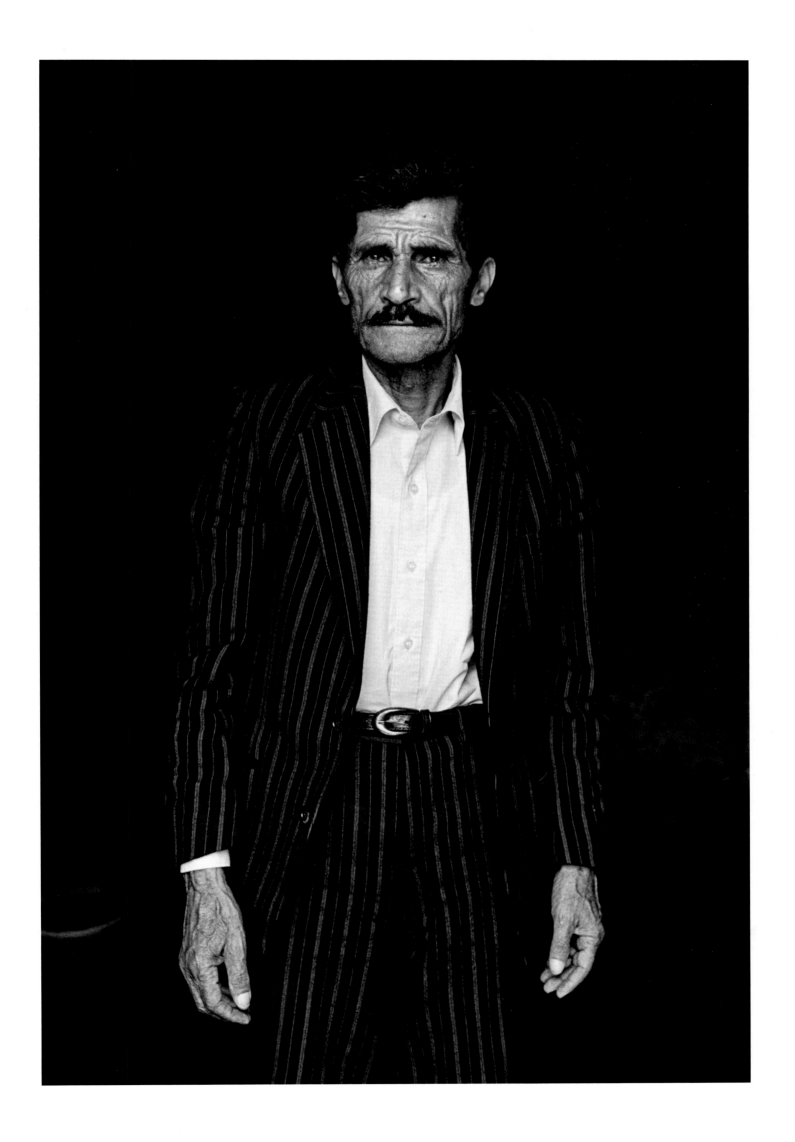

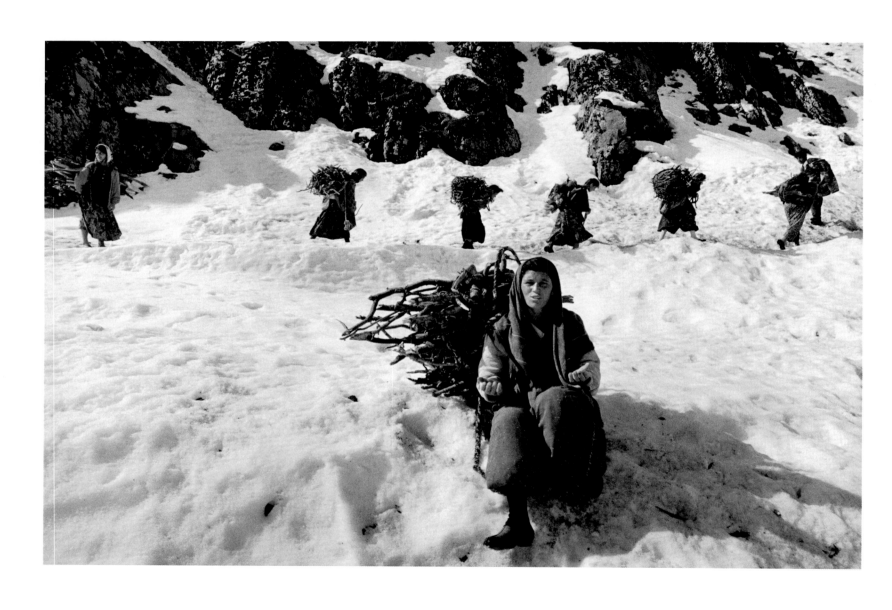

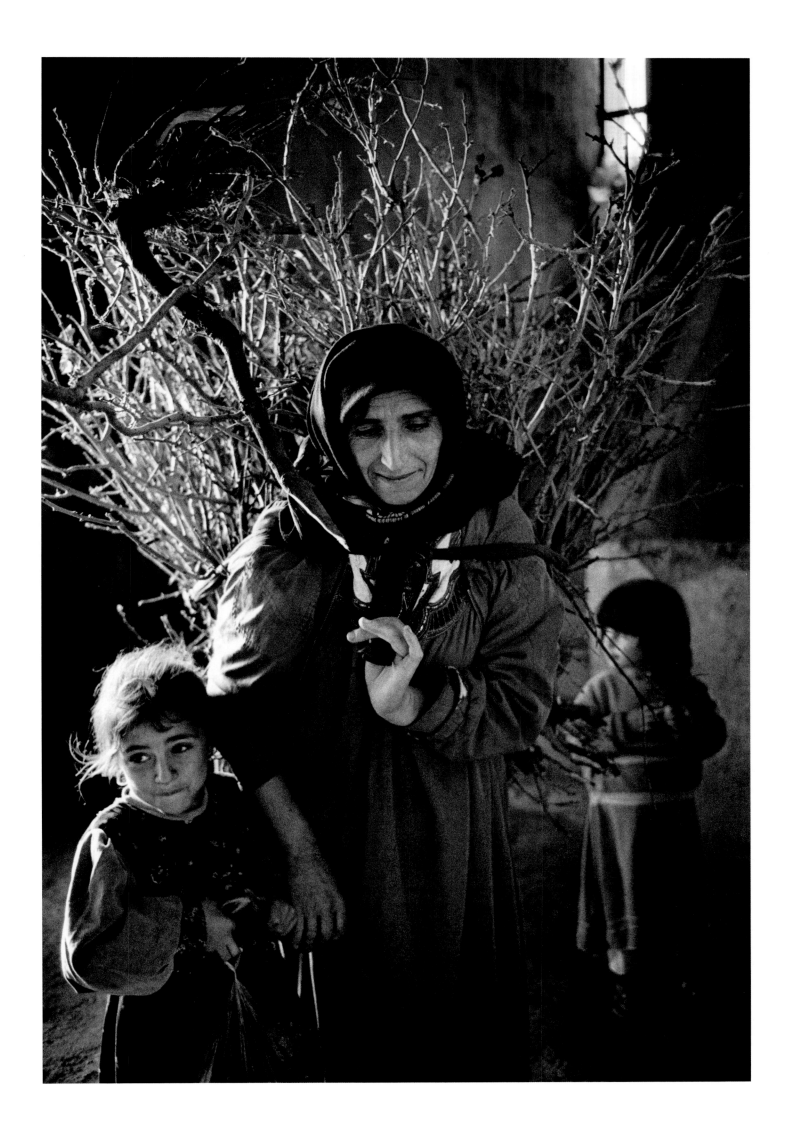

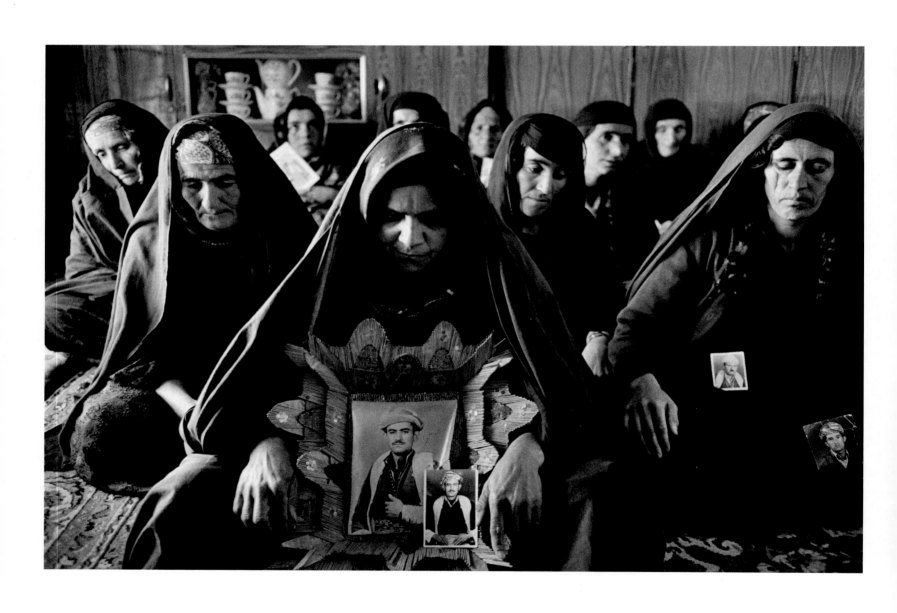

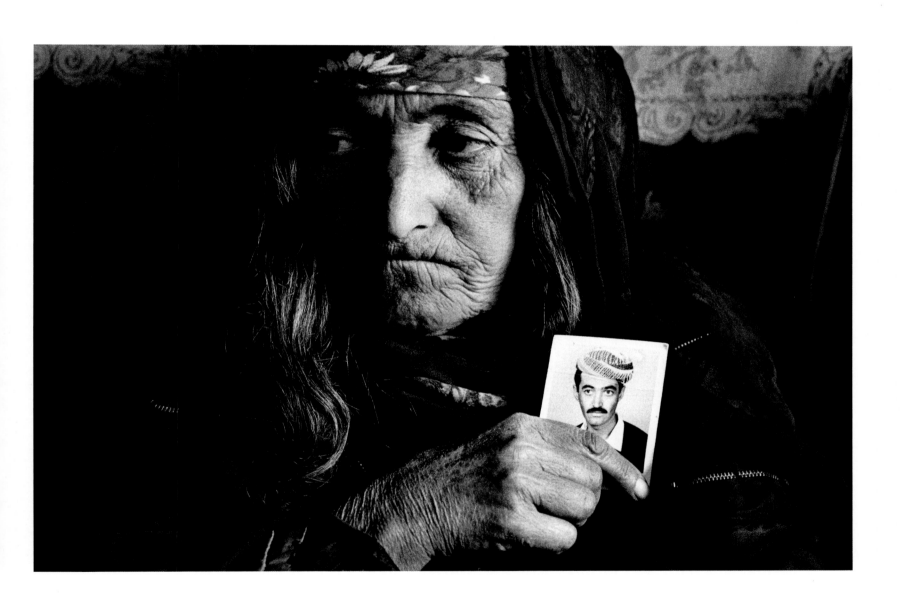

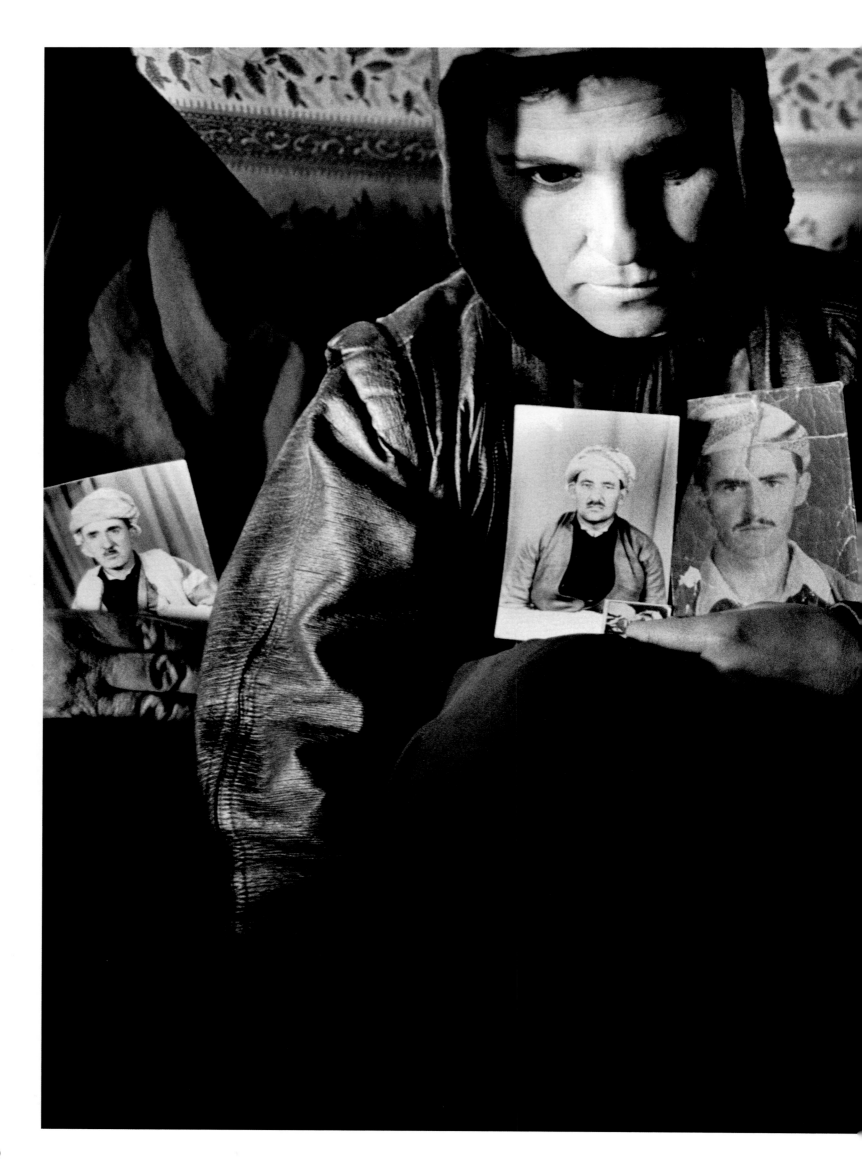

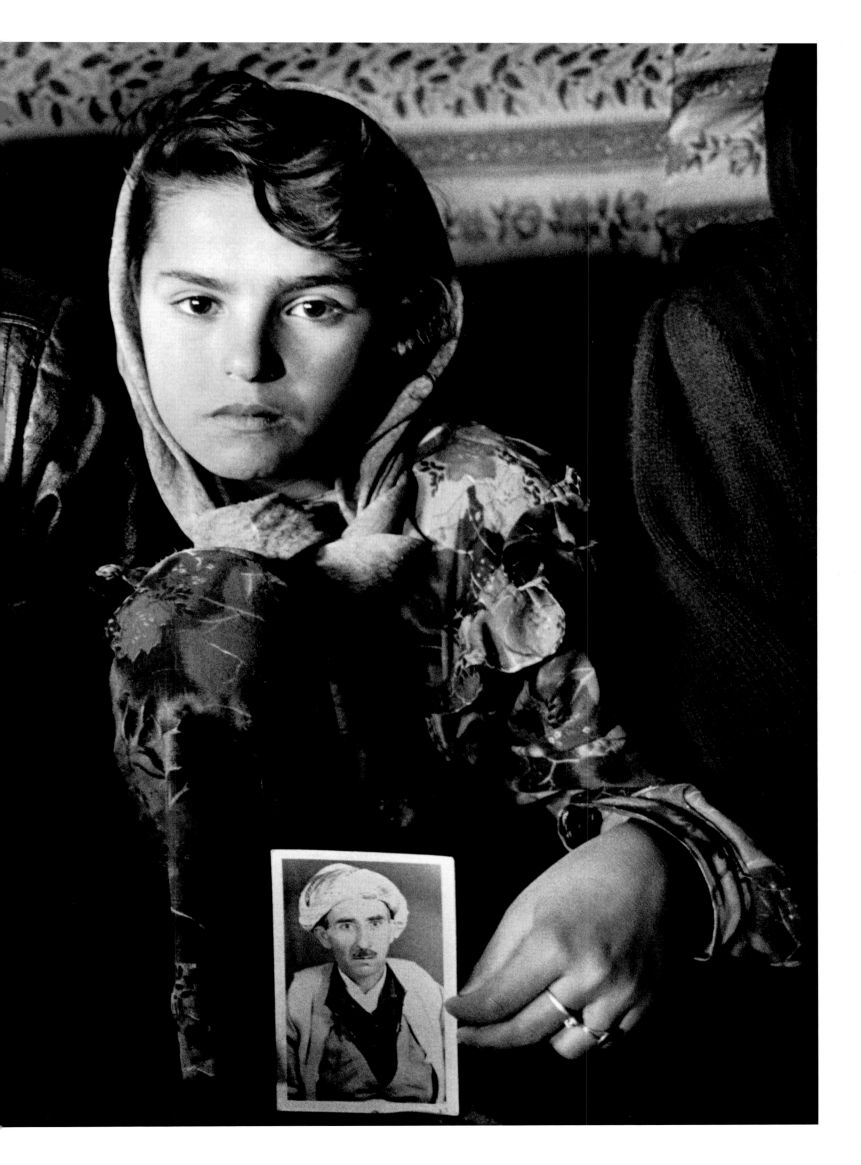

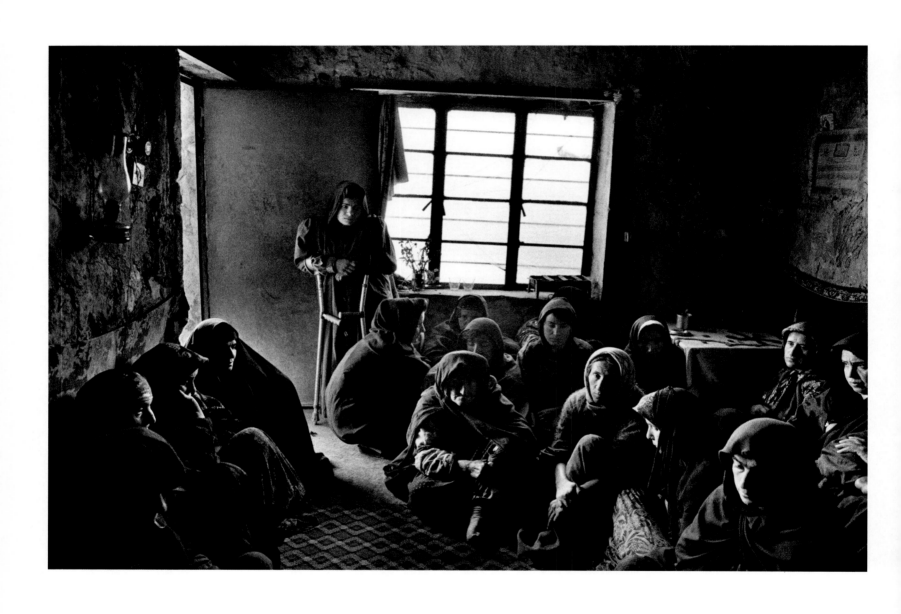

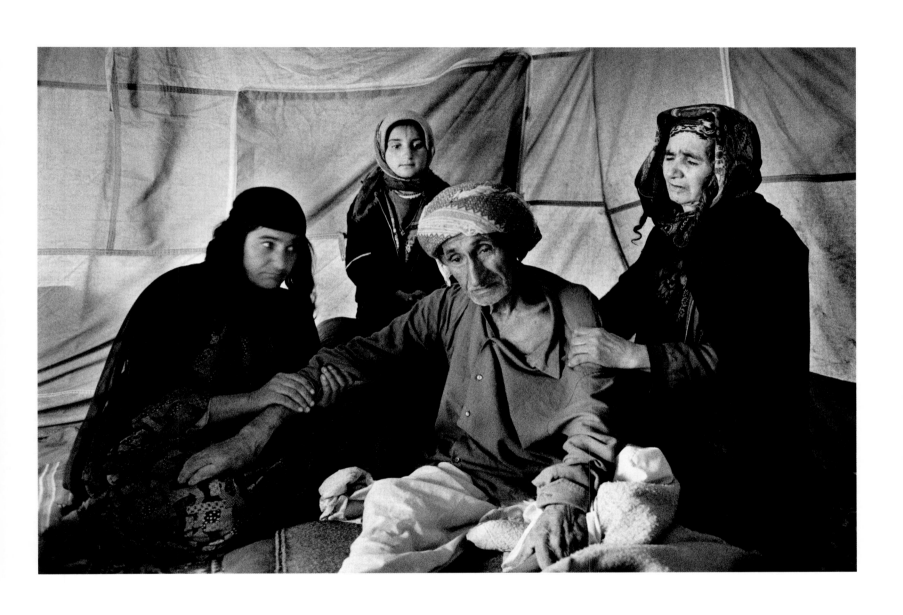

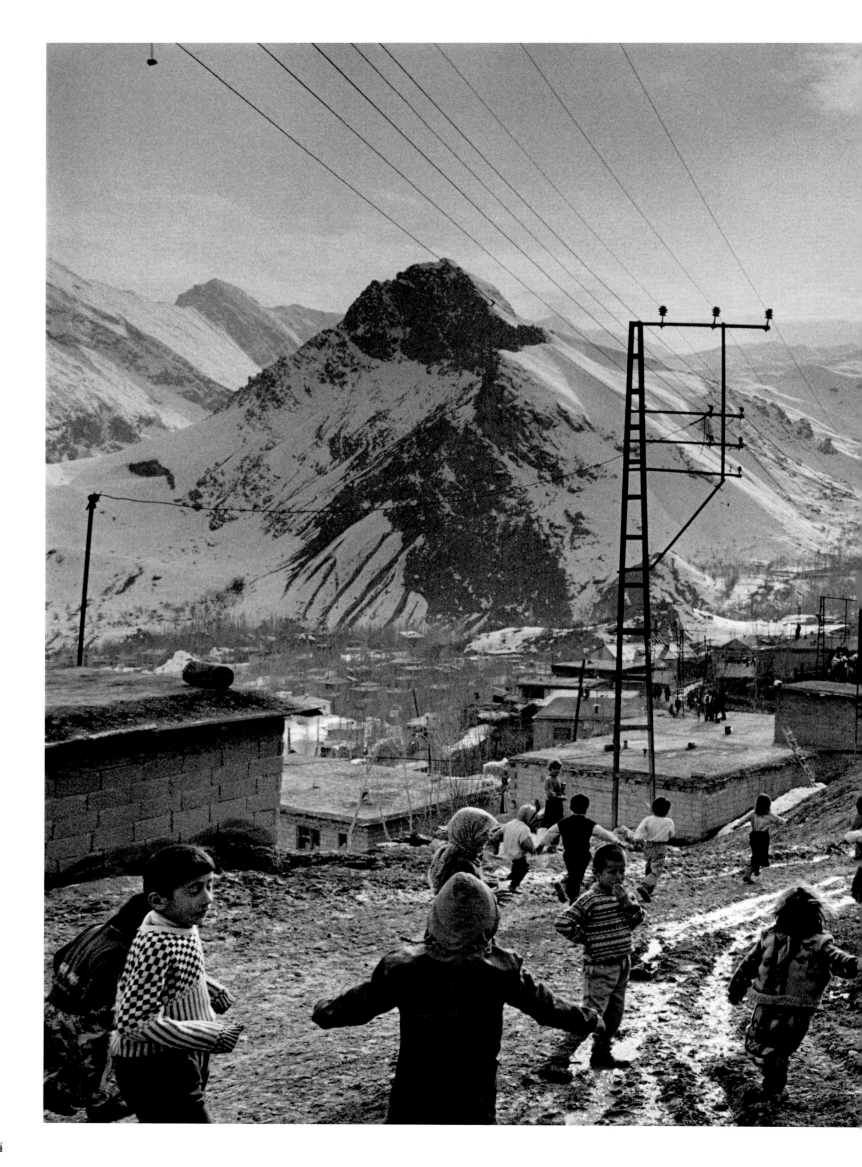

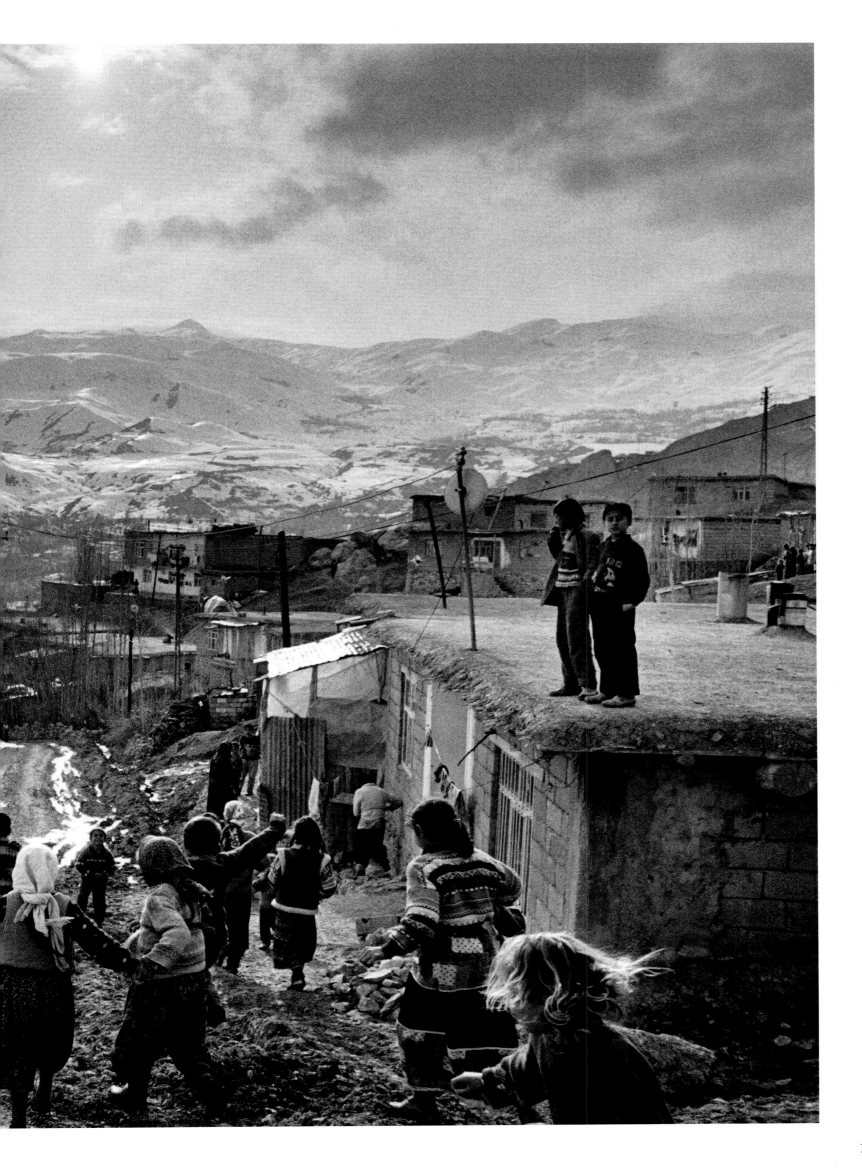

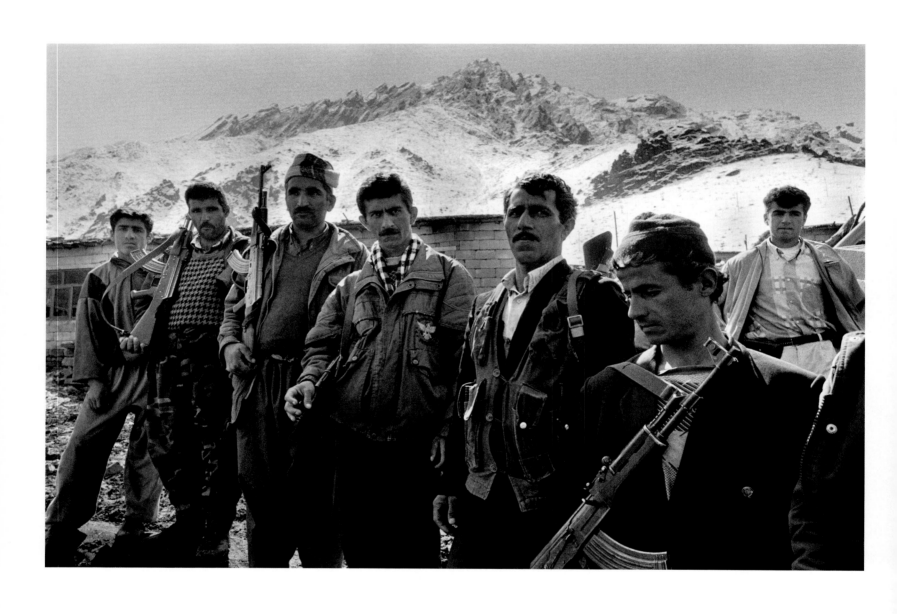

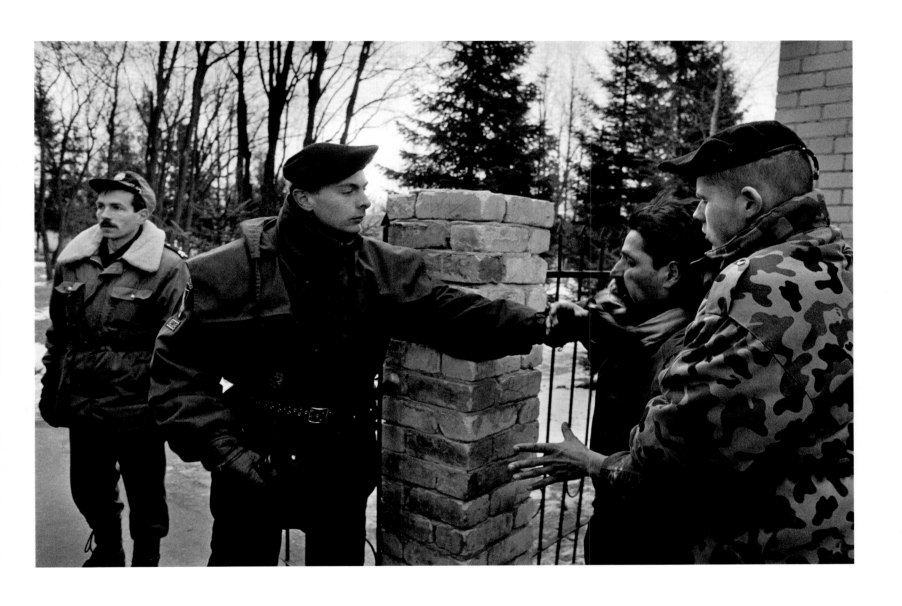

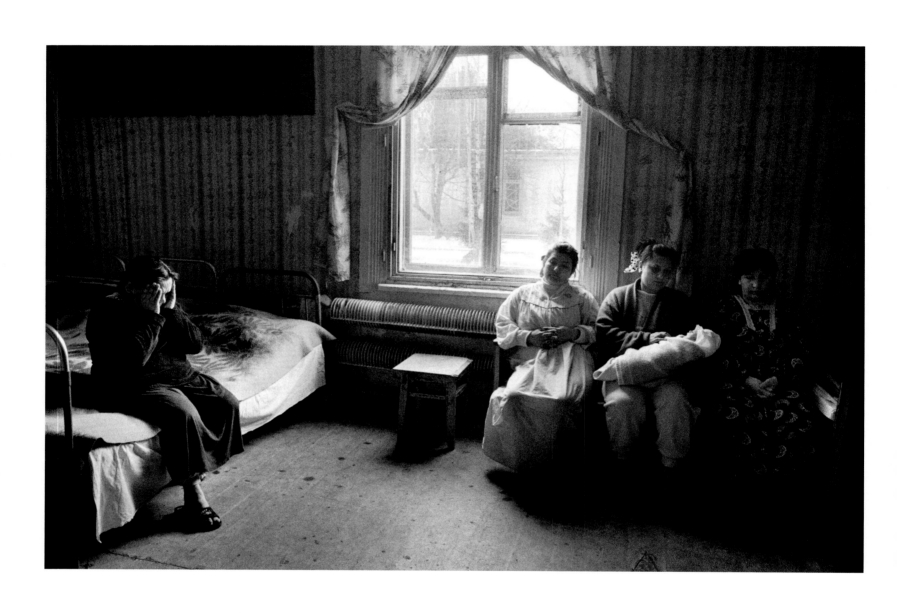

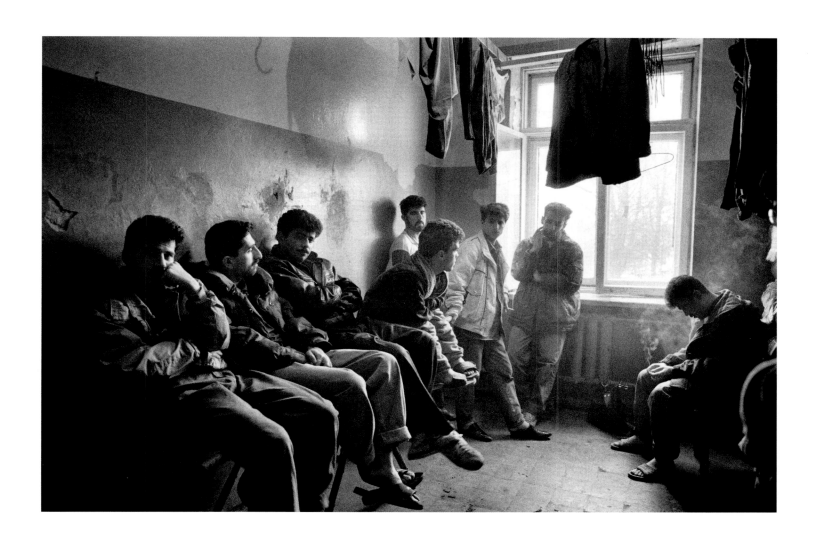

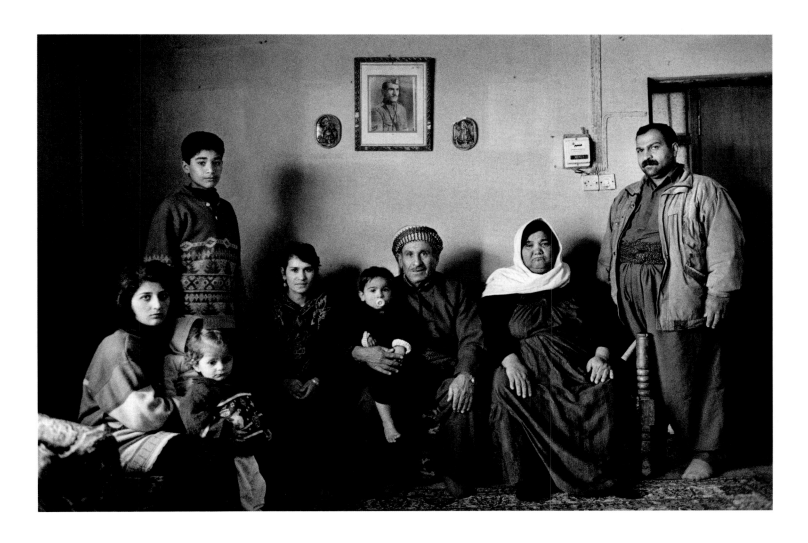

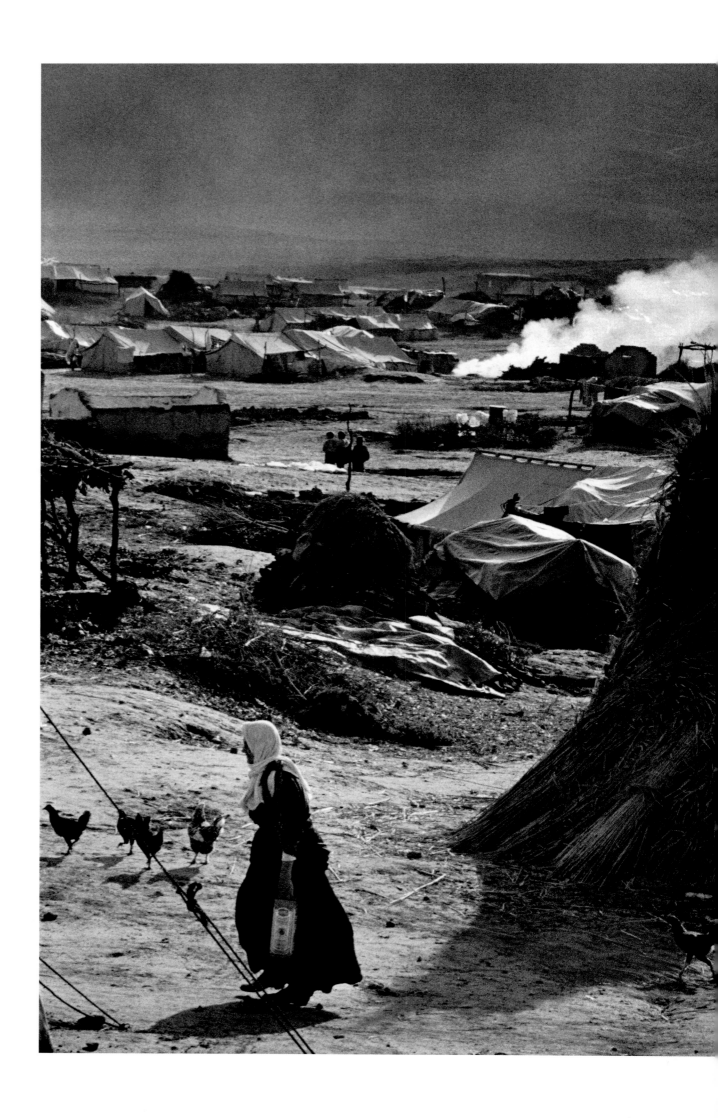

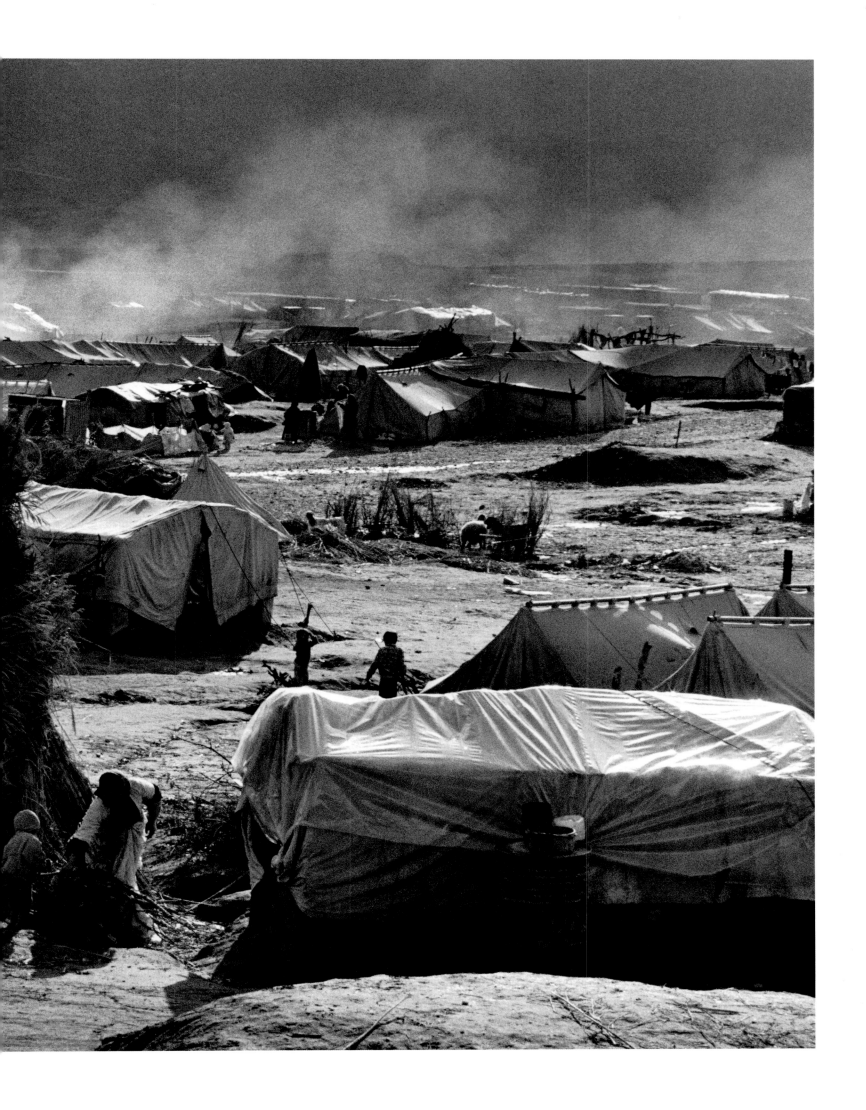

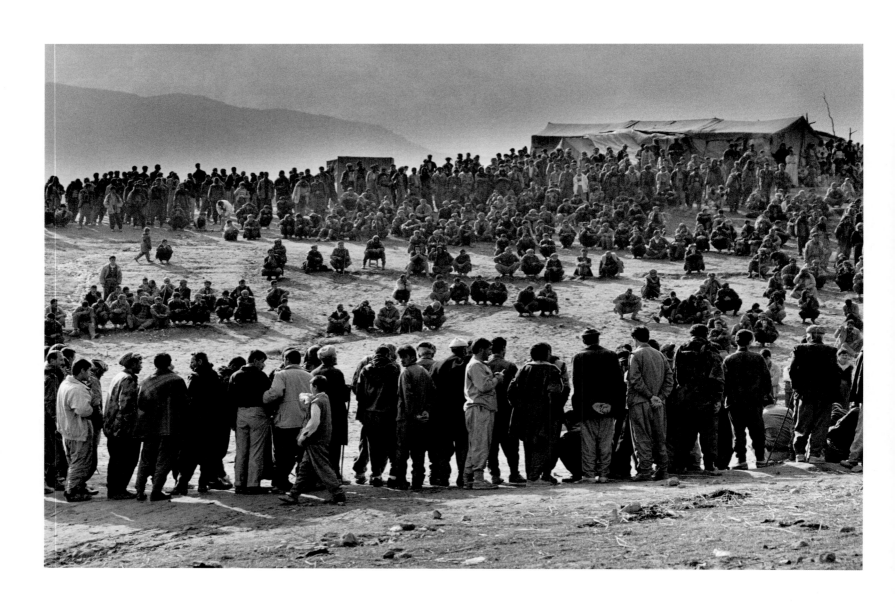

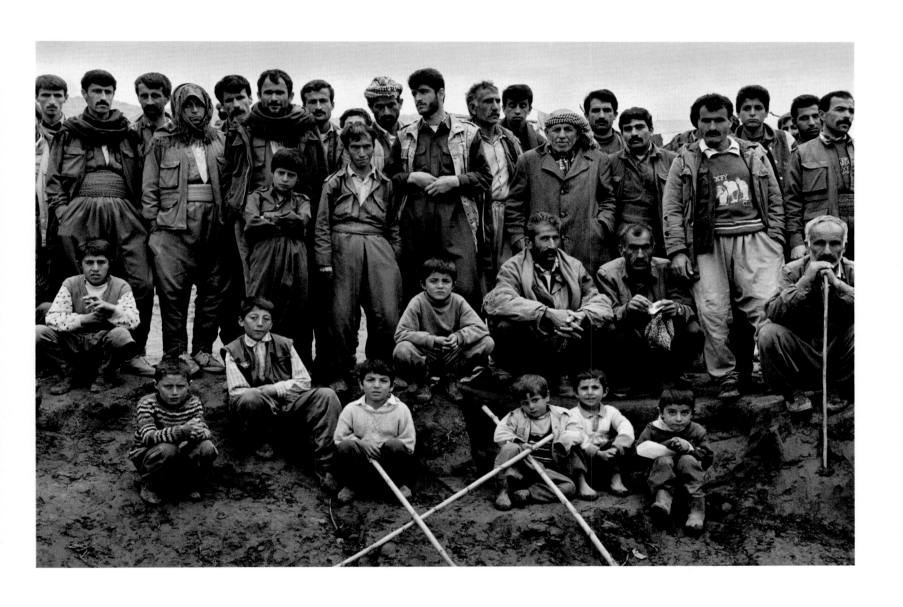

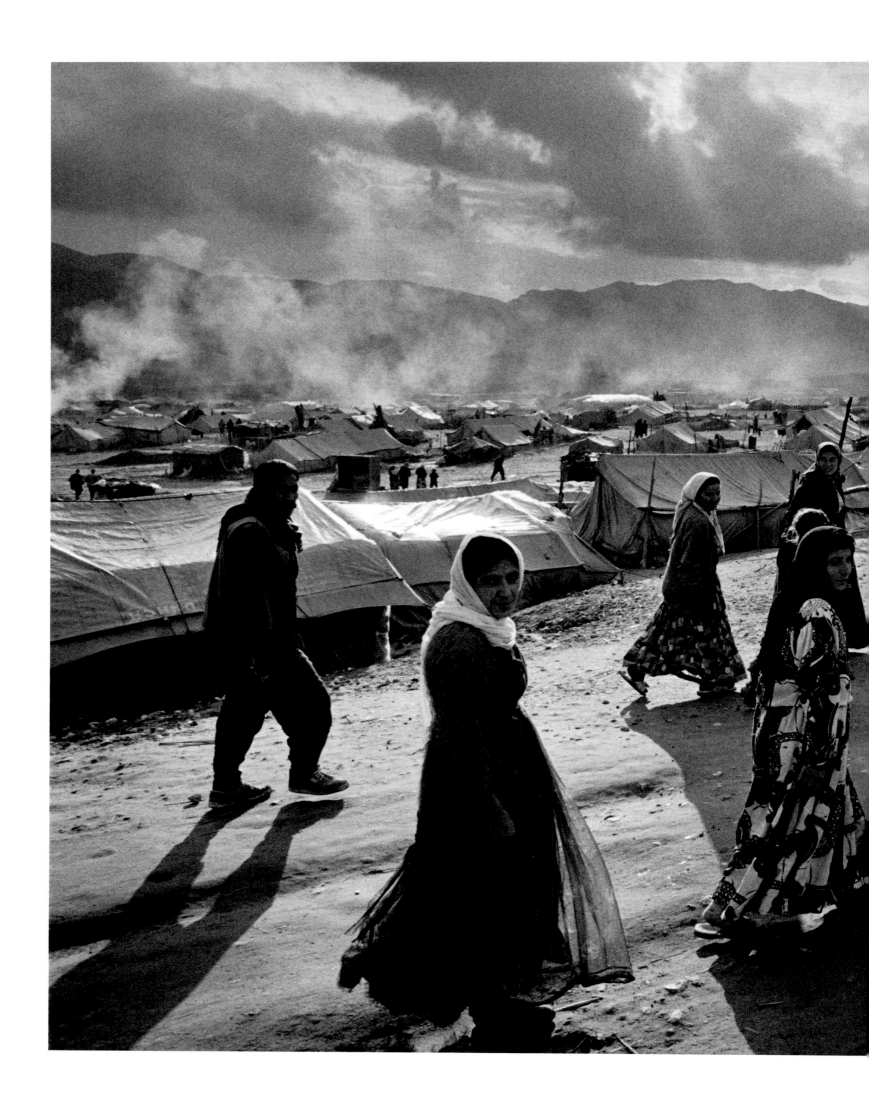

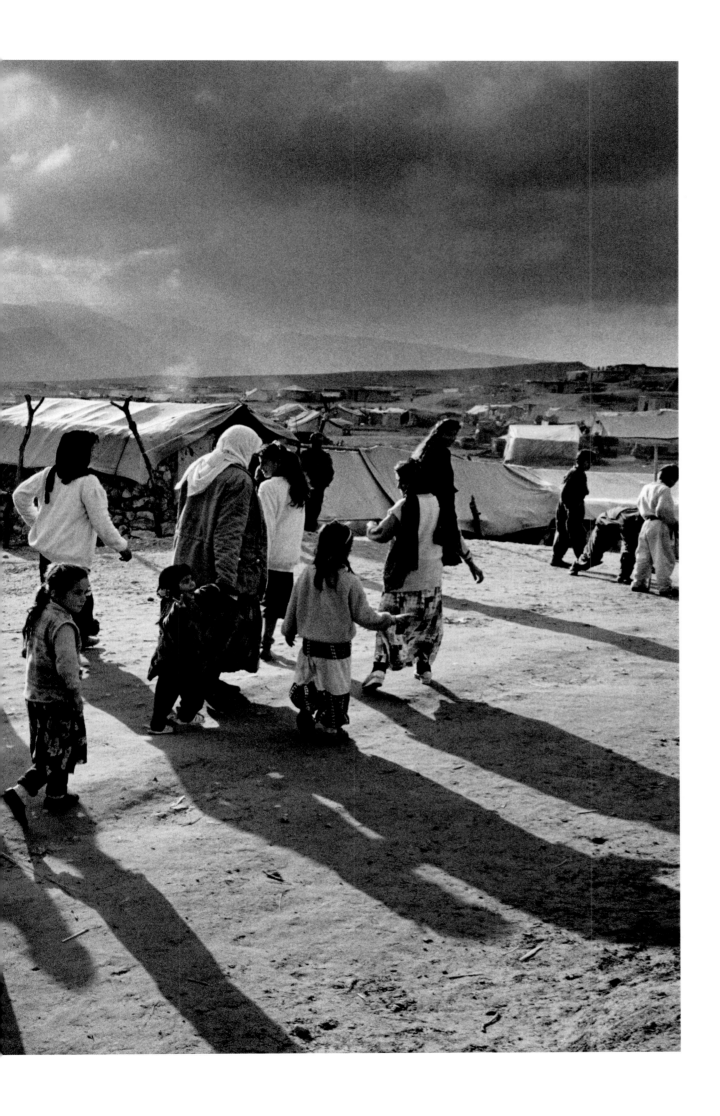

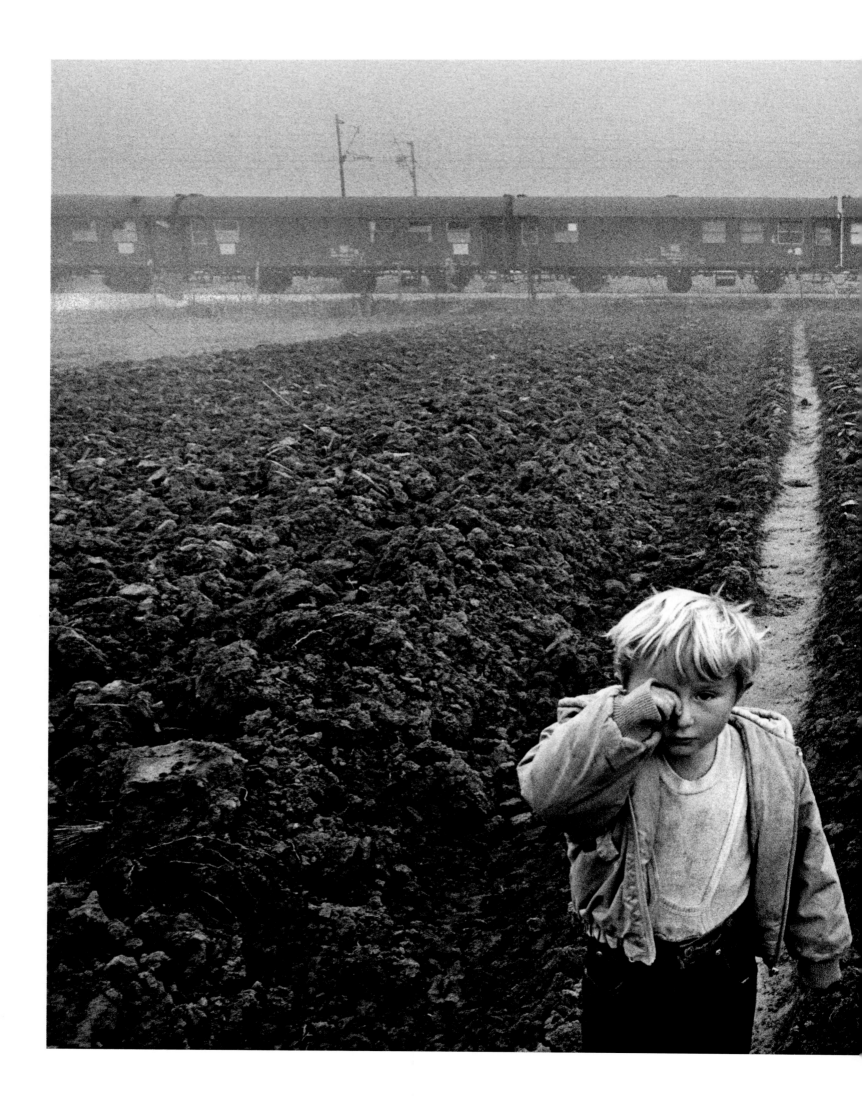

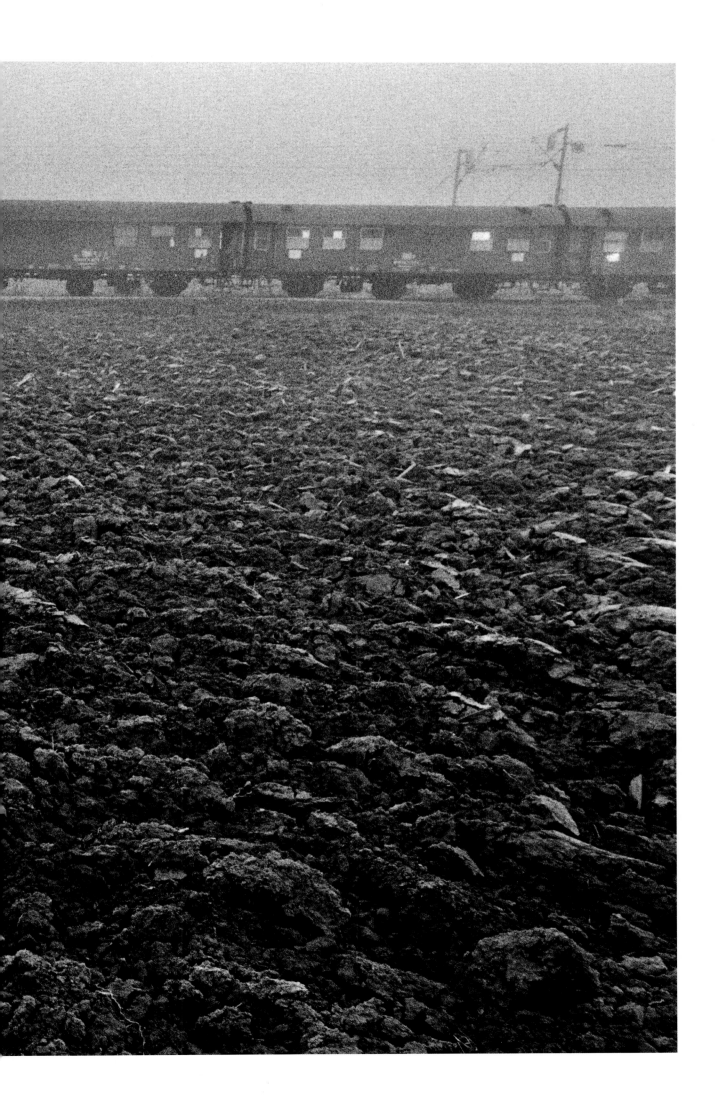

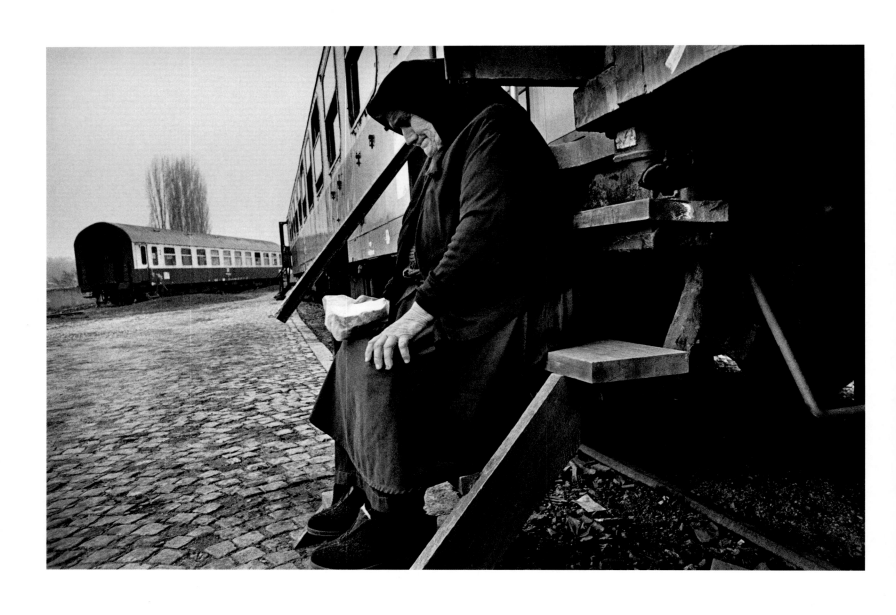

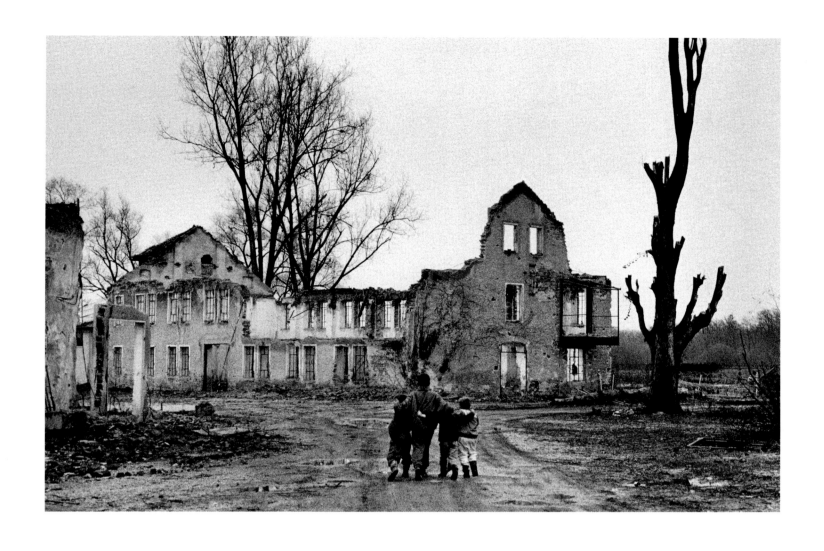

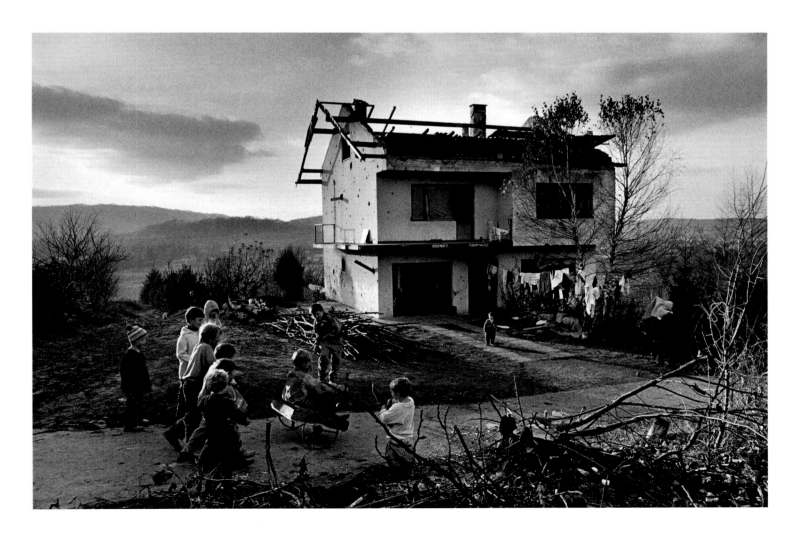

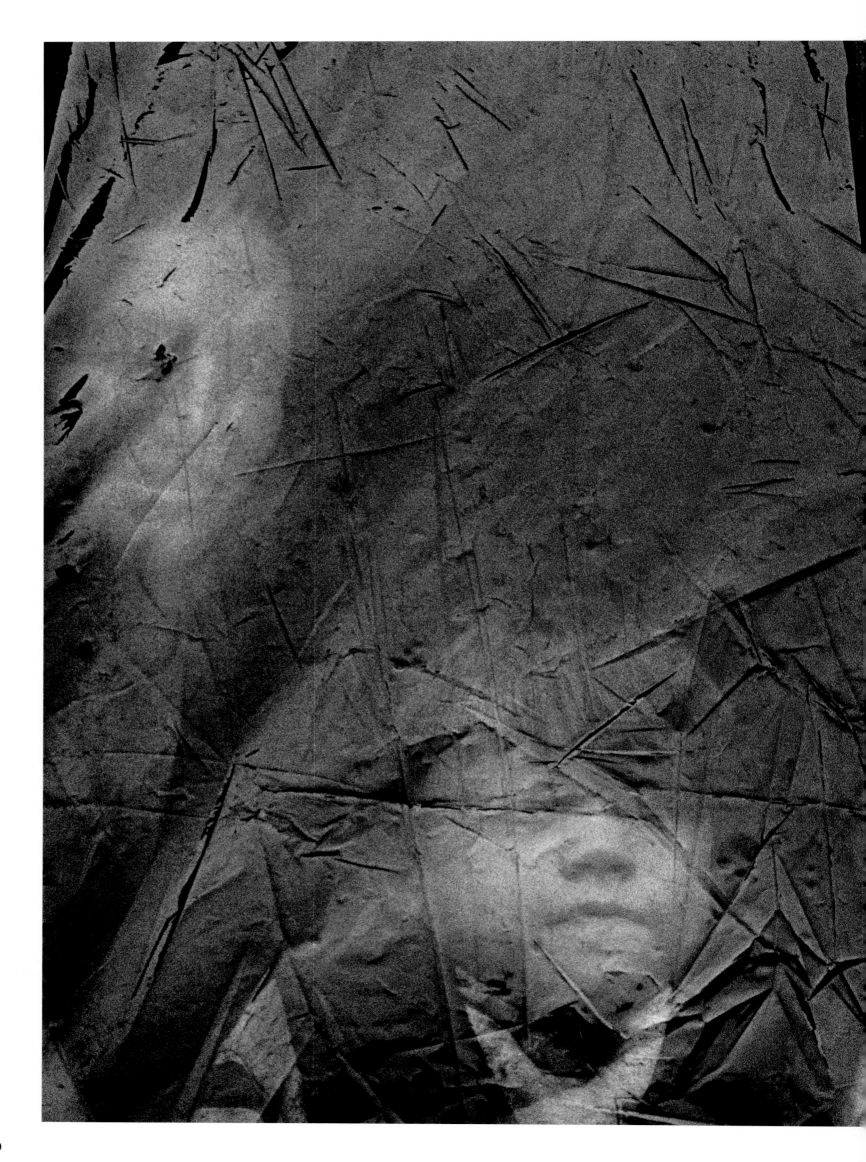

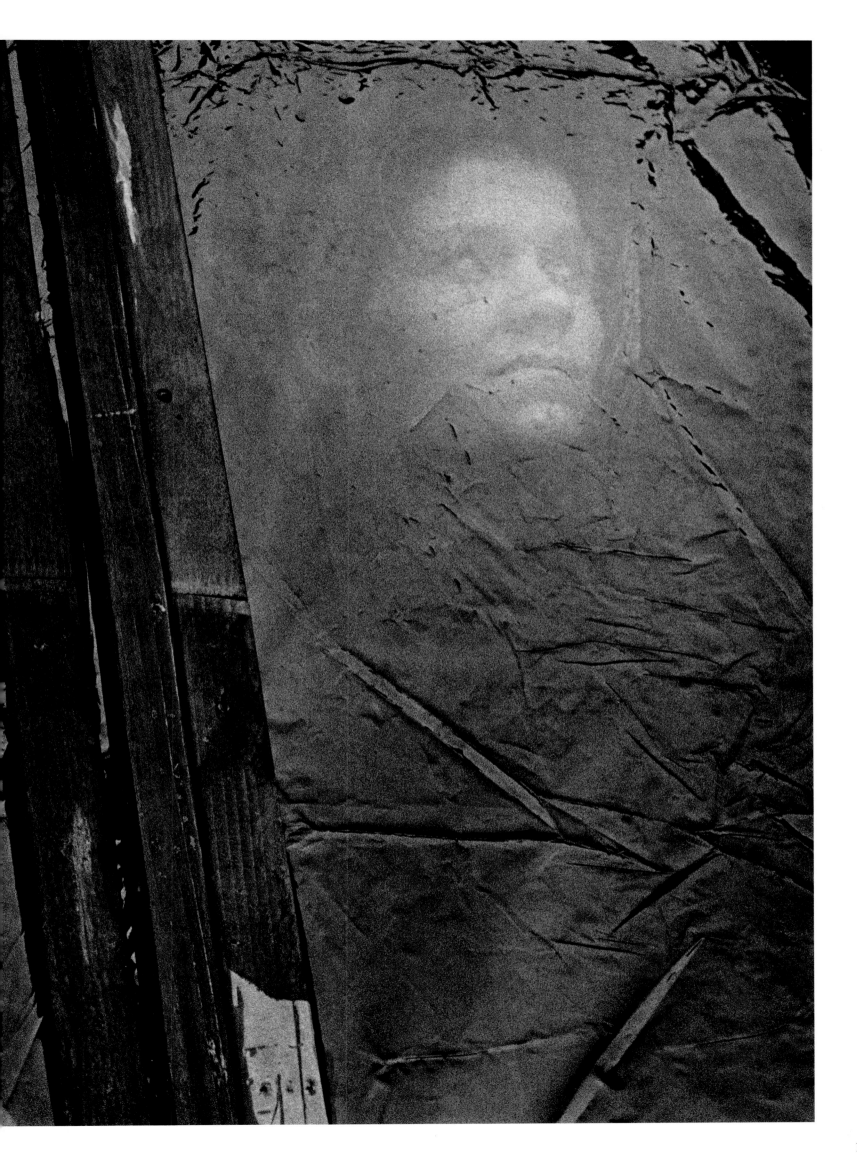

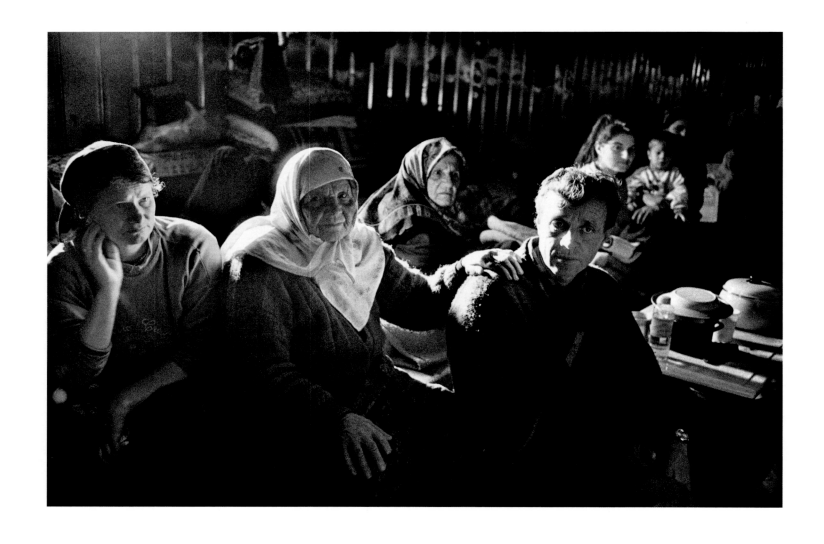

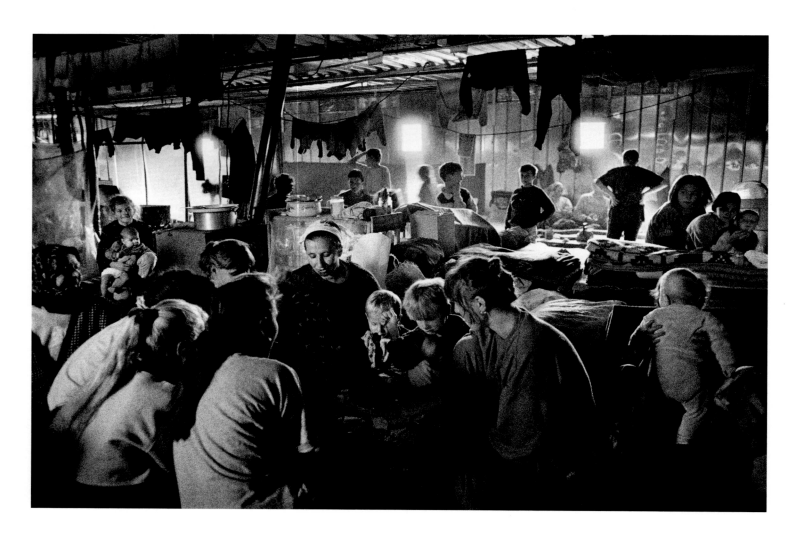

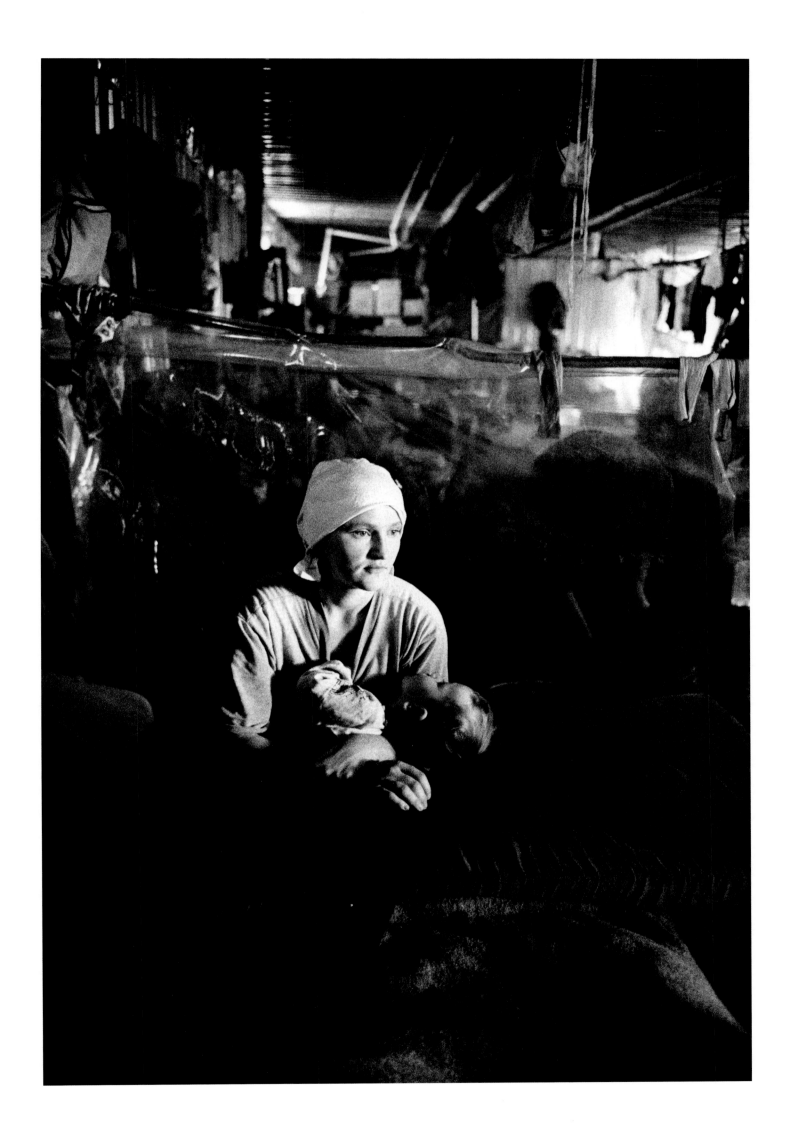

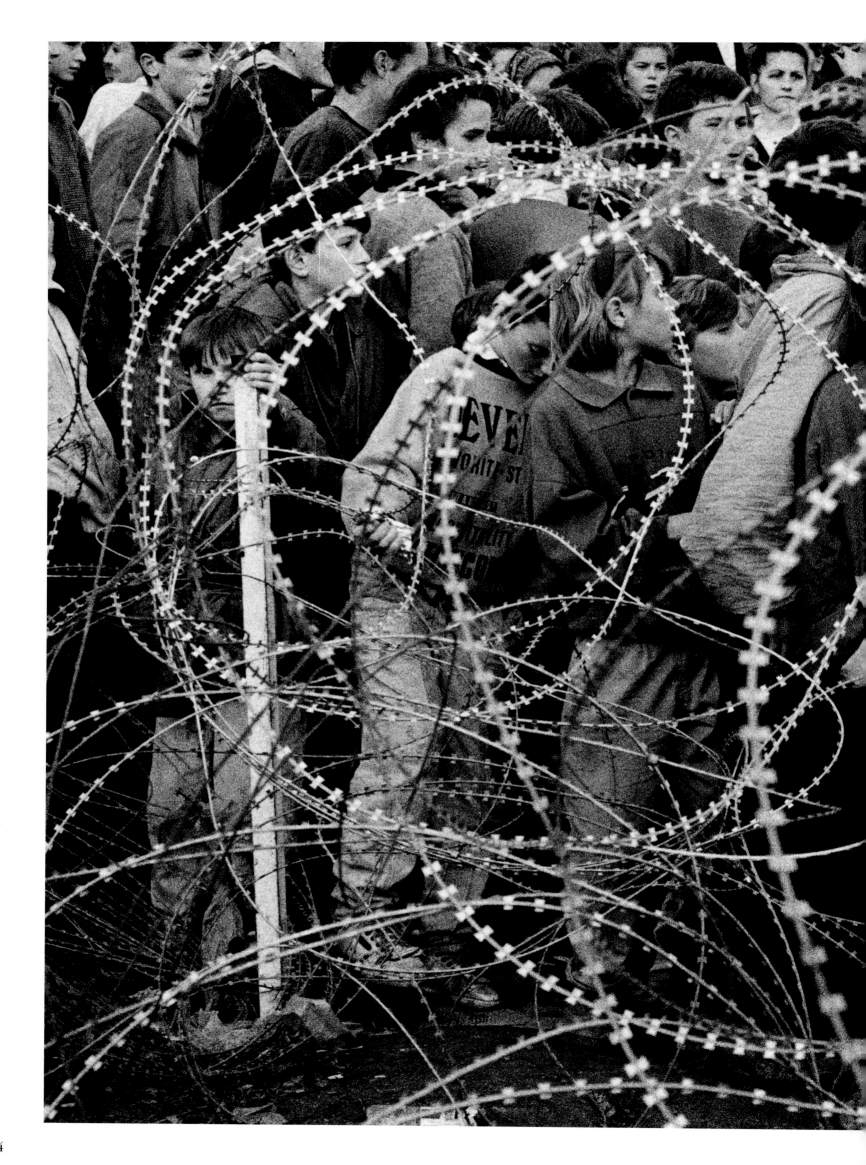

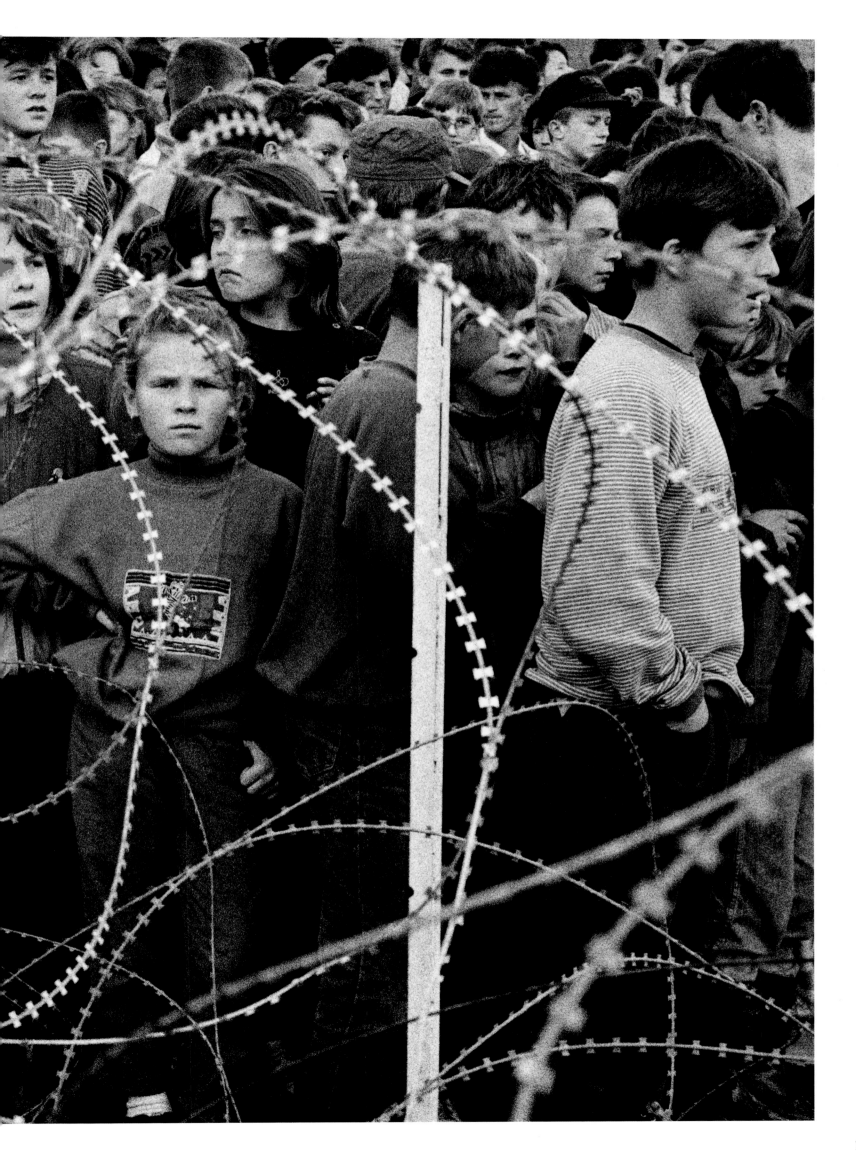

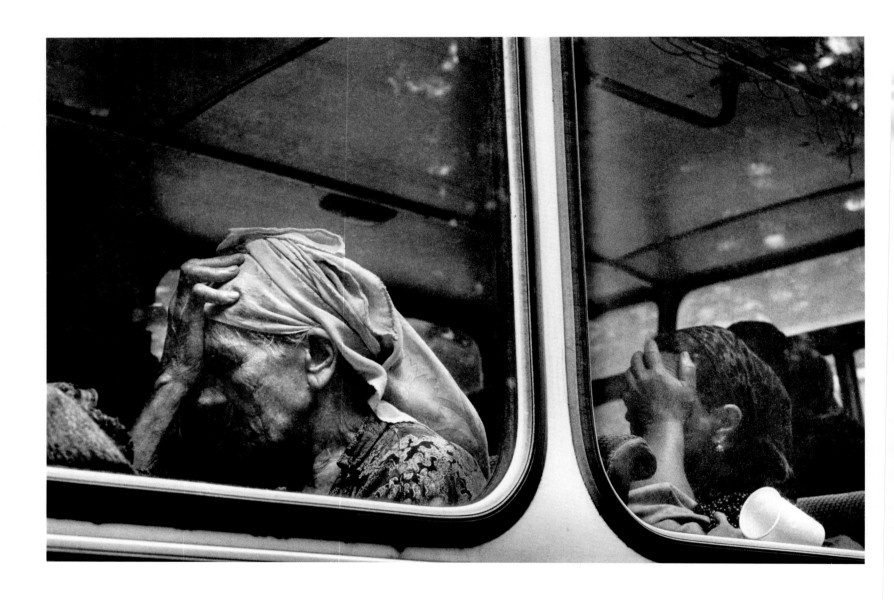

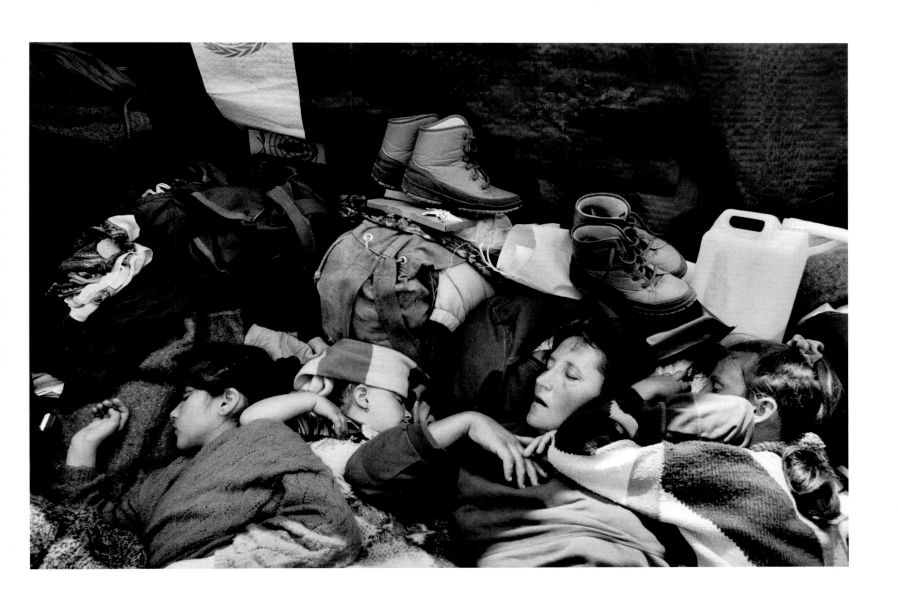

127

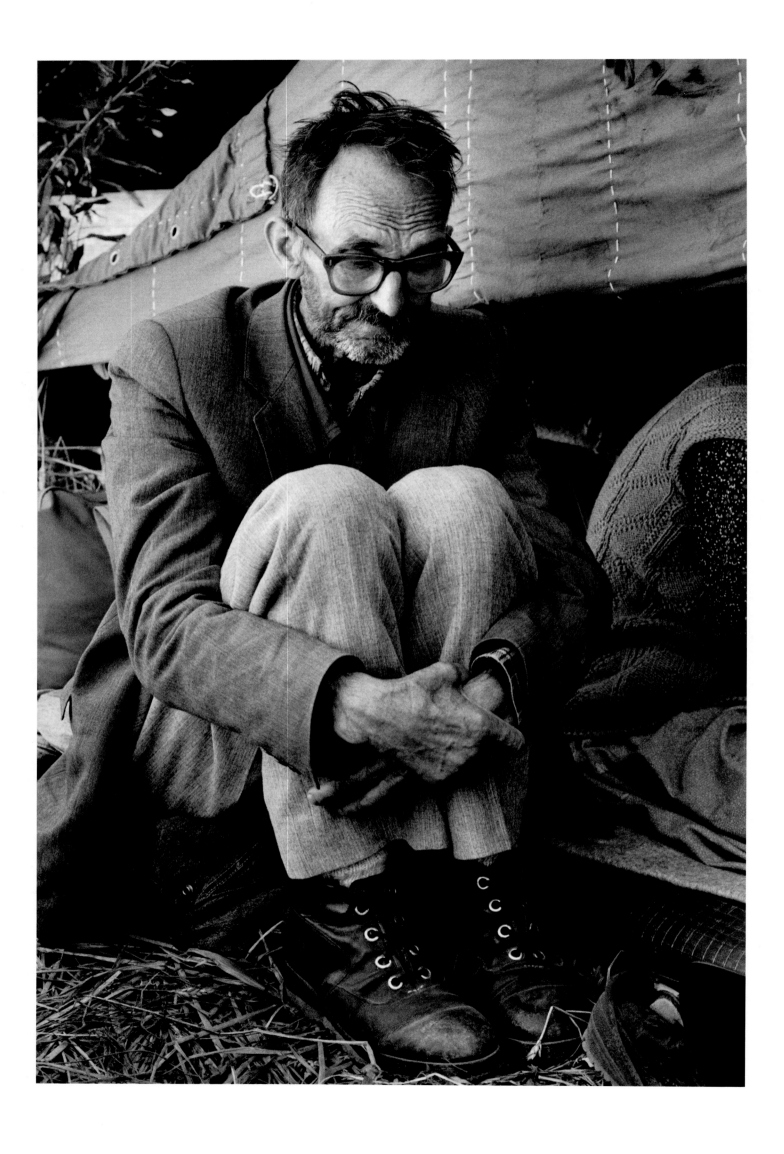

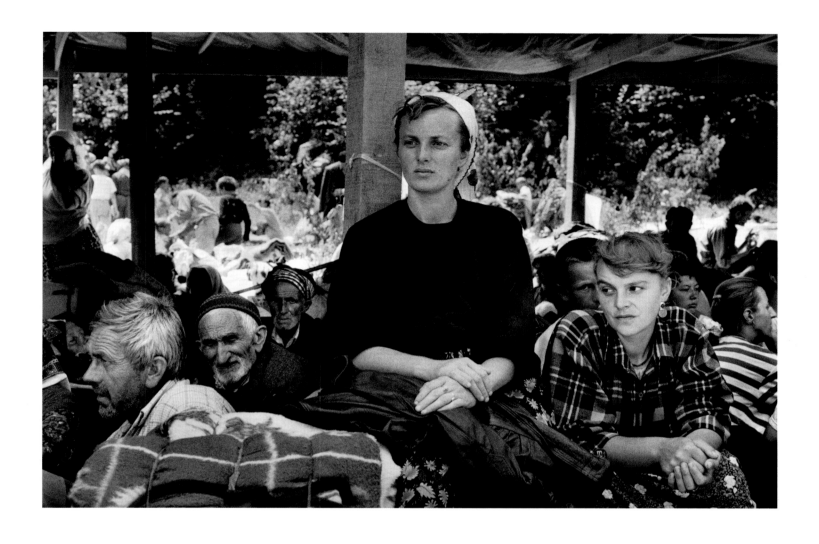

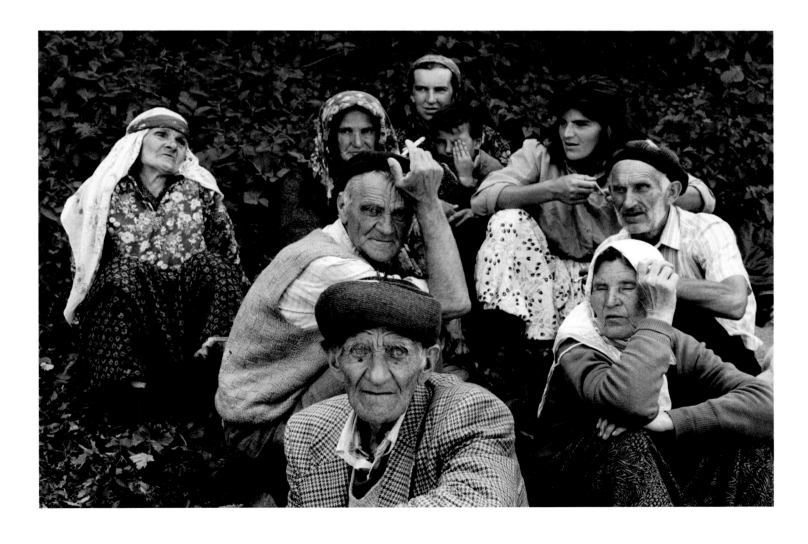

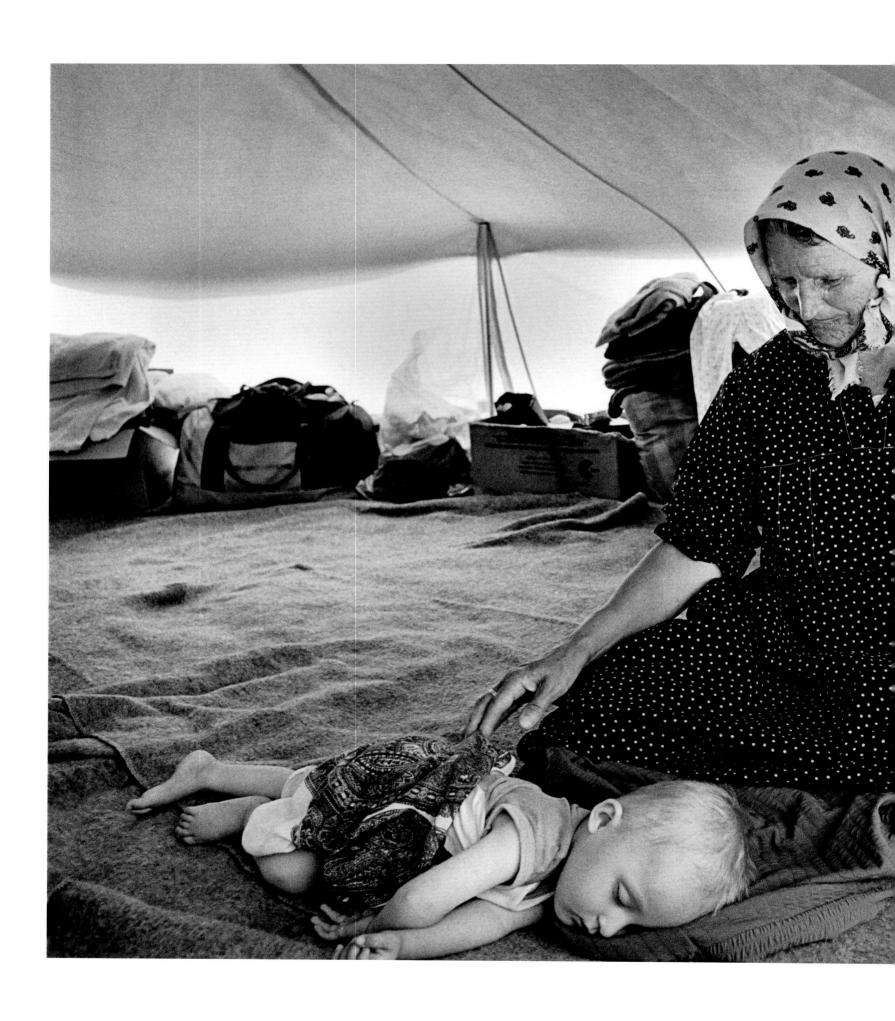

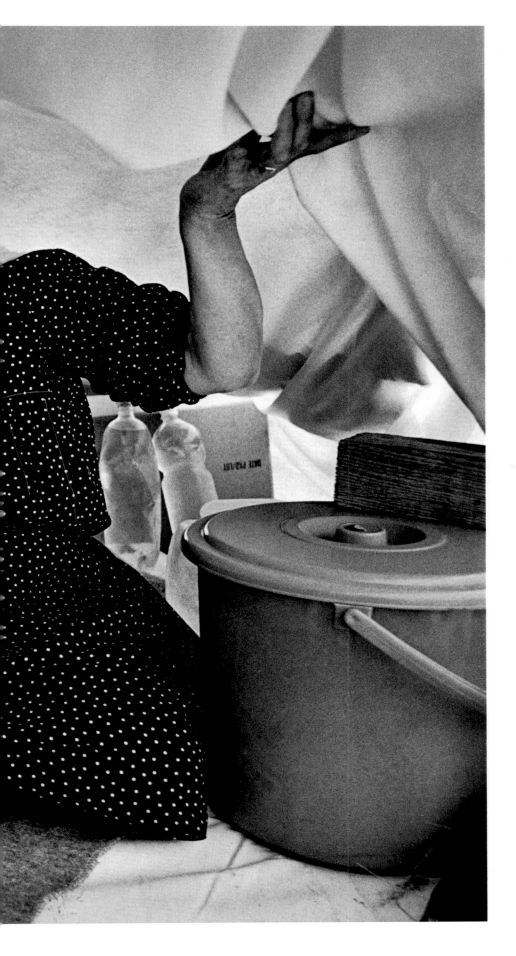

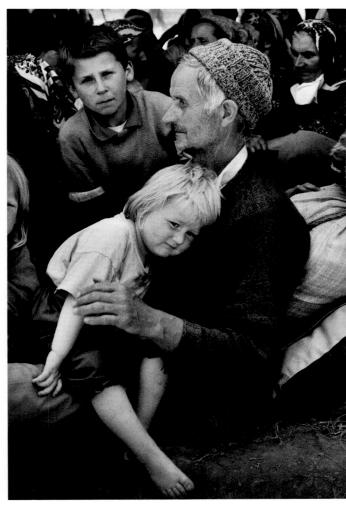

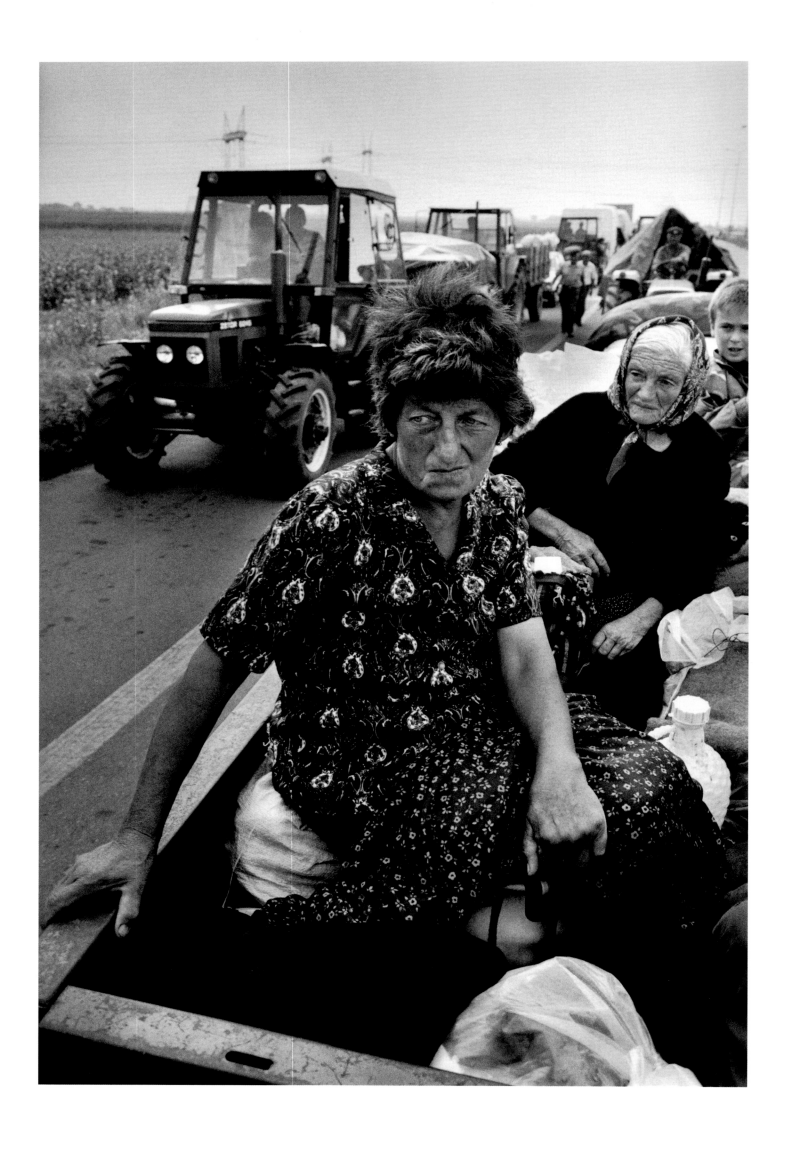

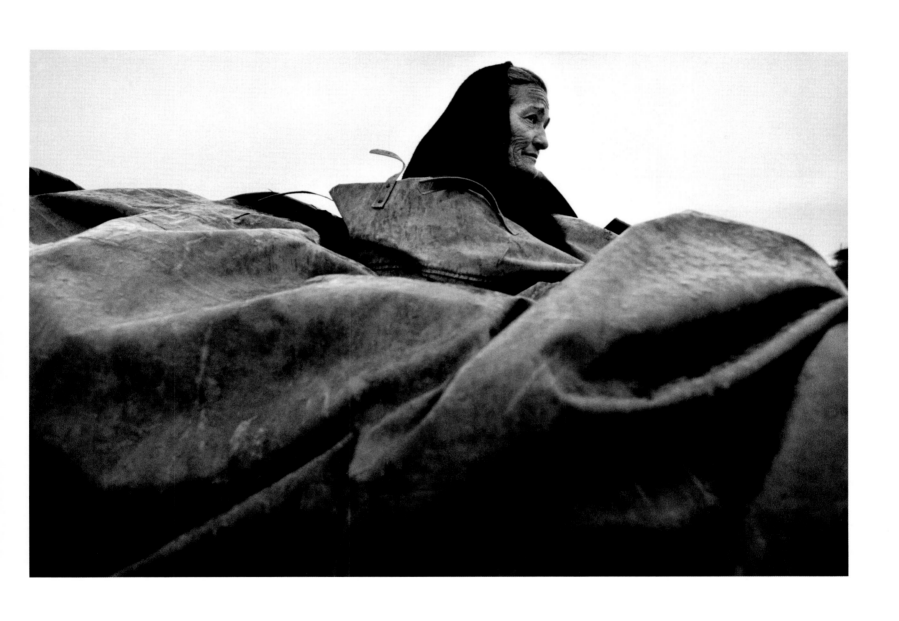

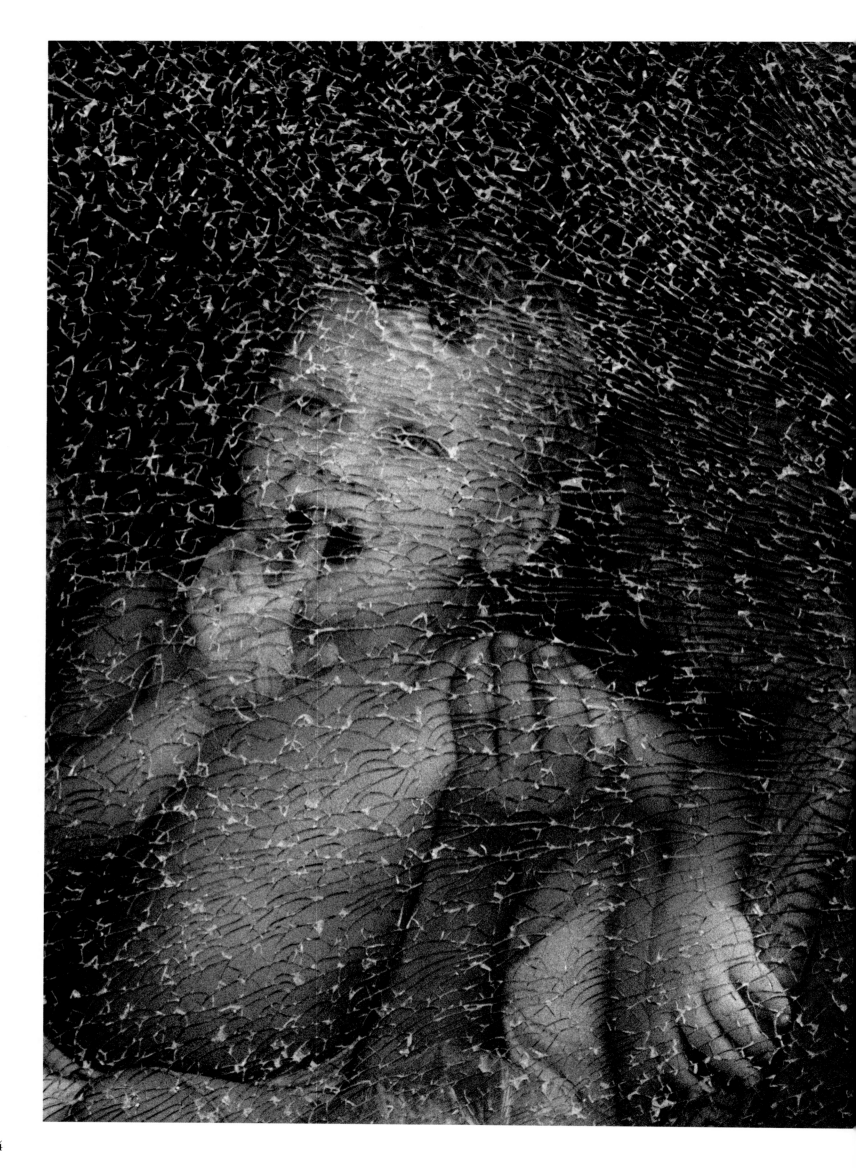

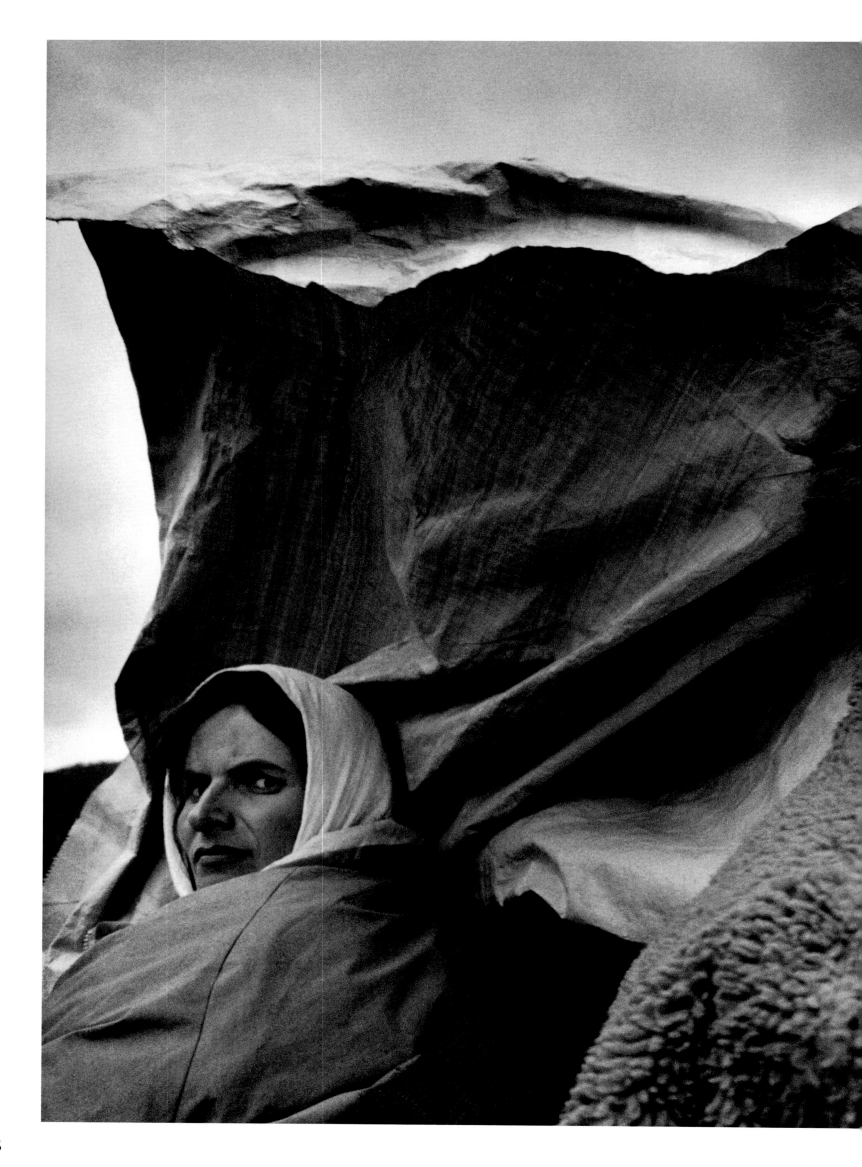

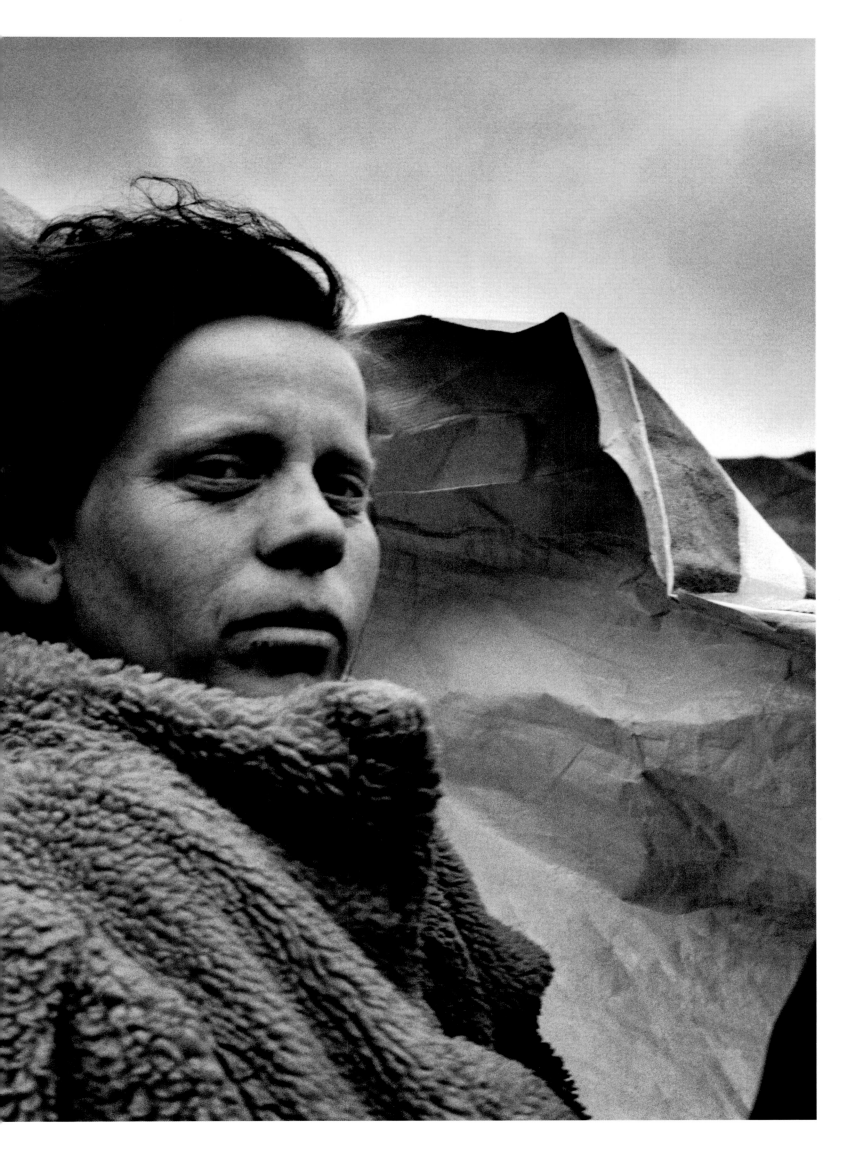

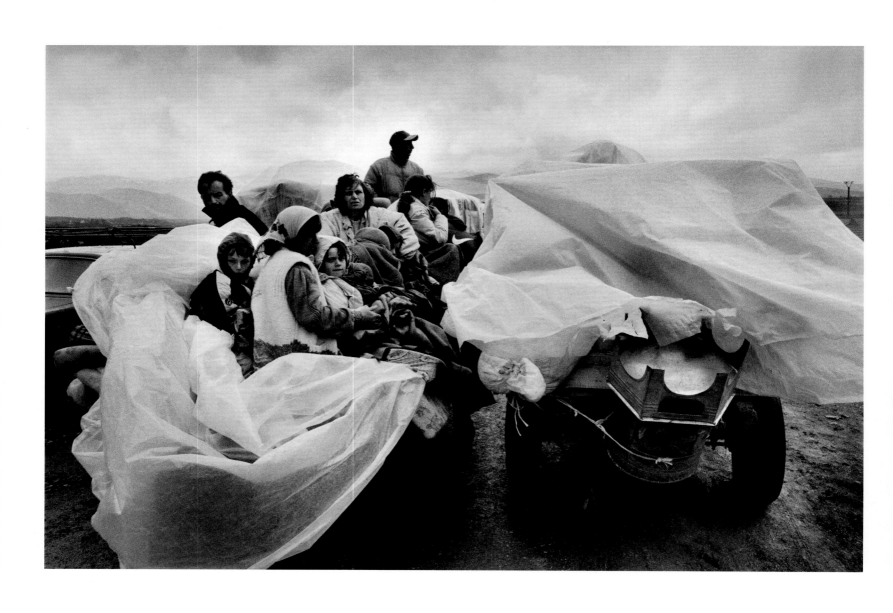

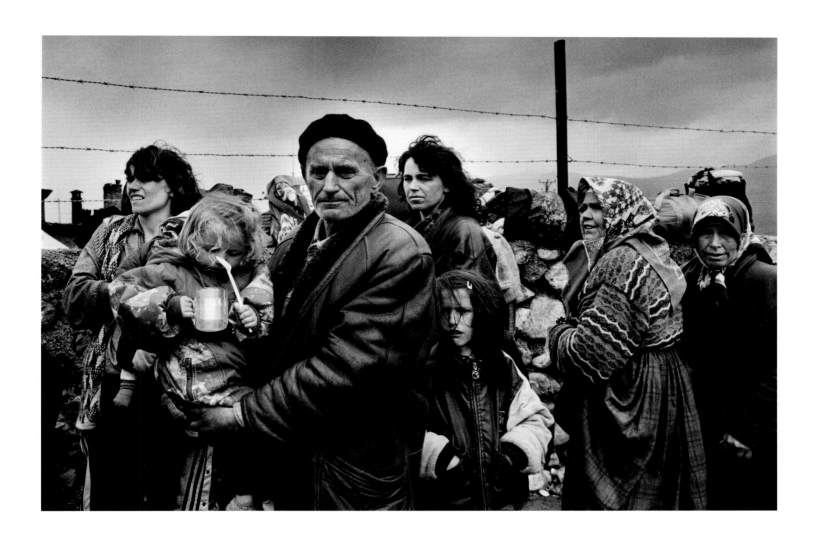

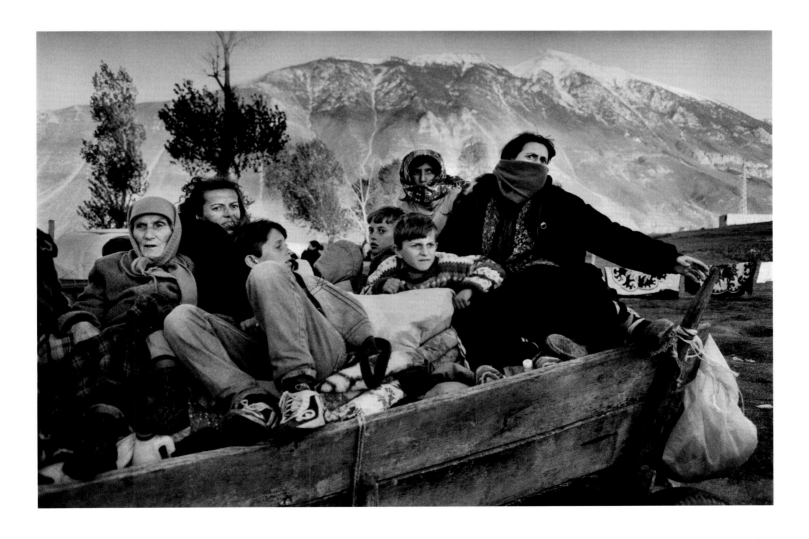

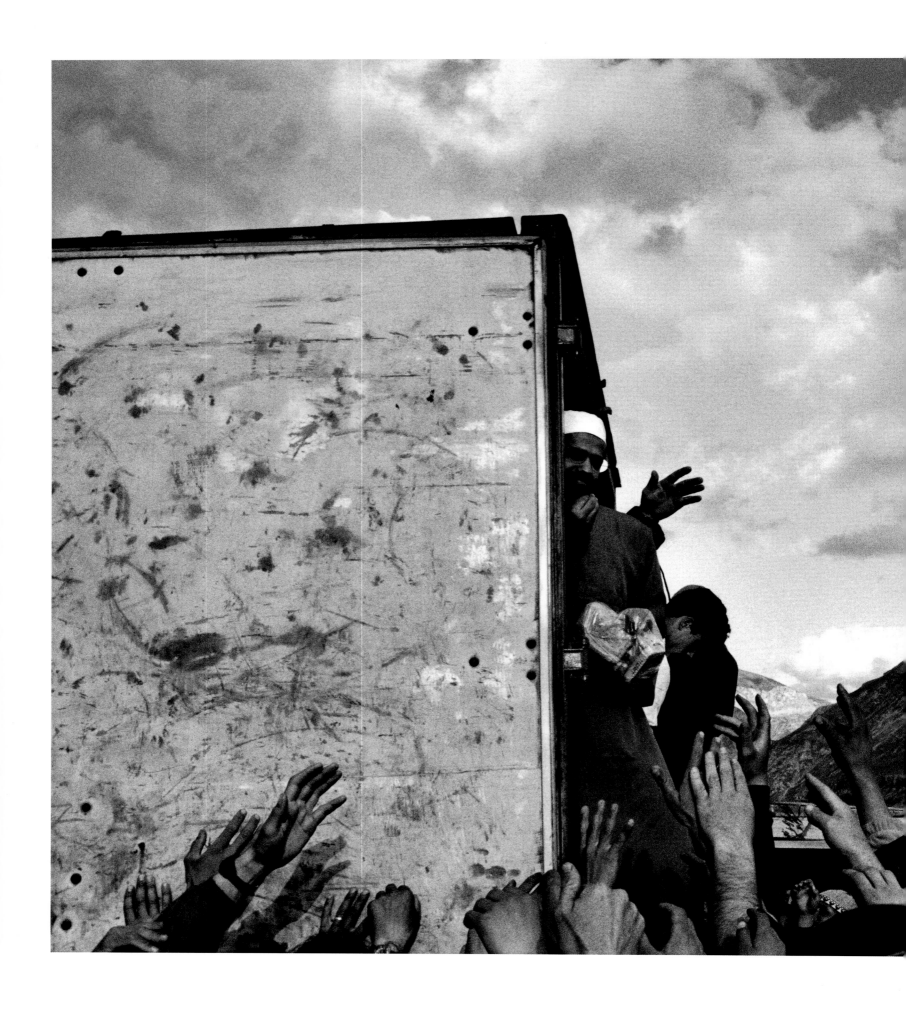

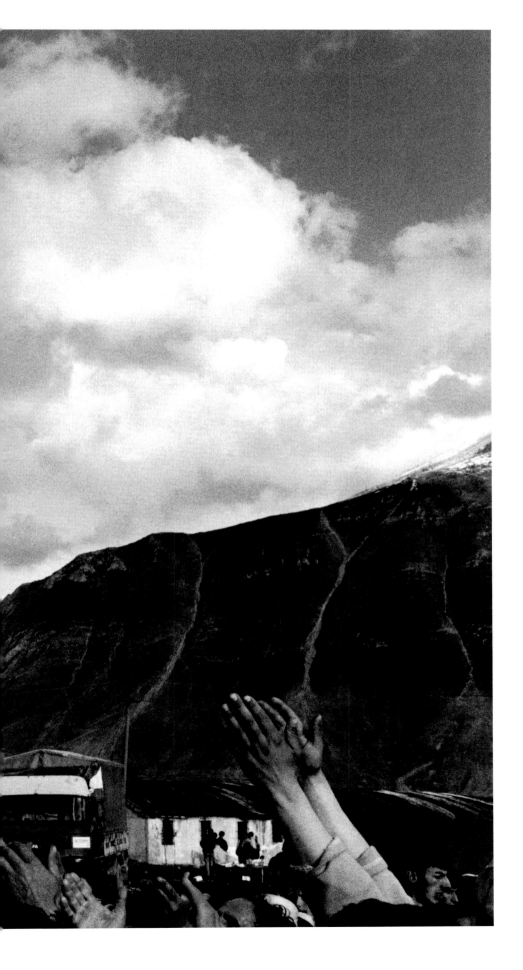

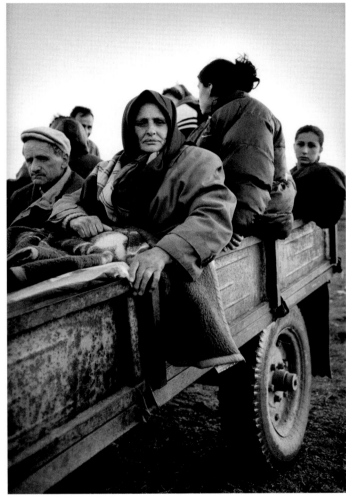

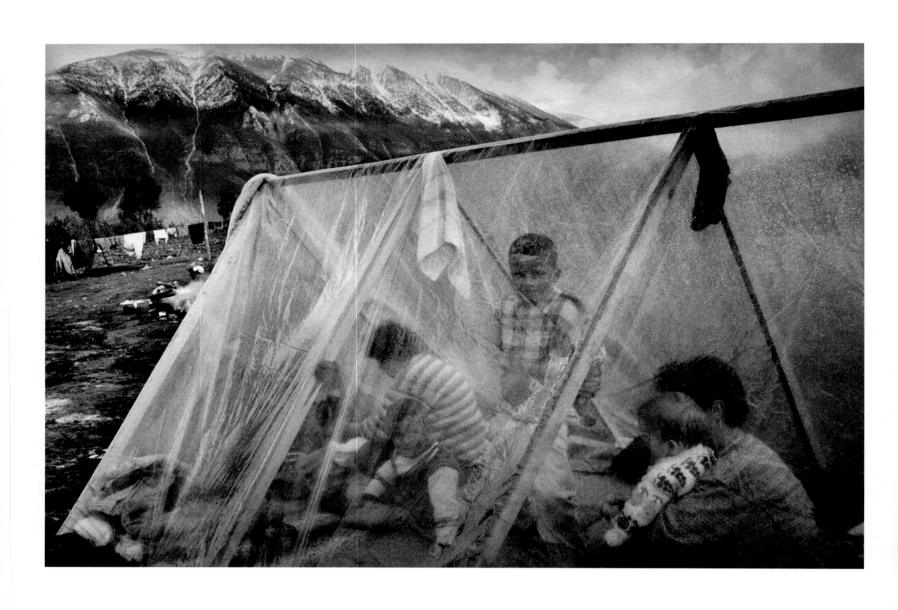

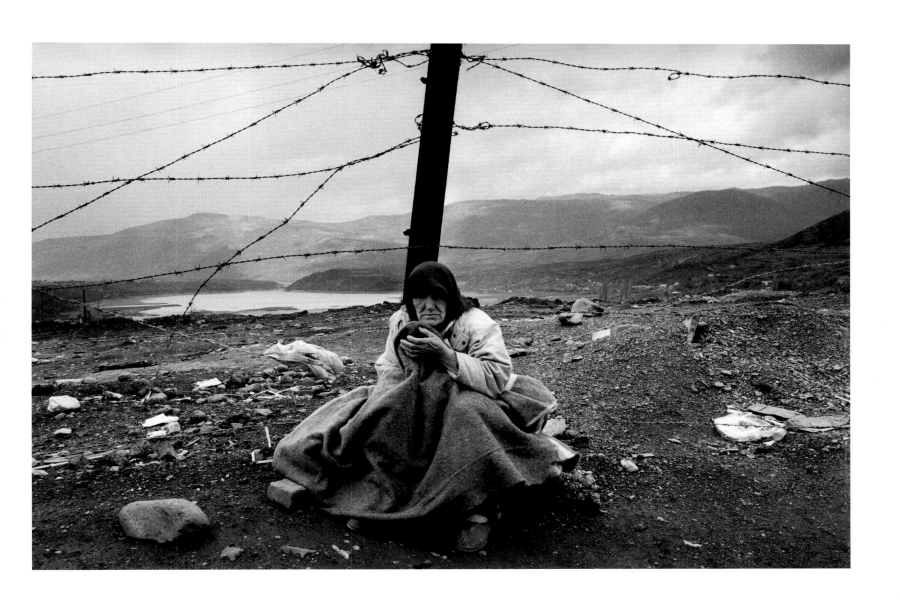

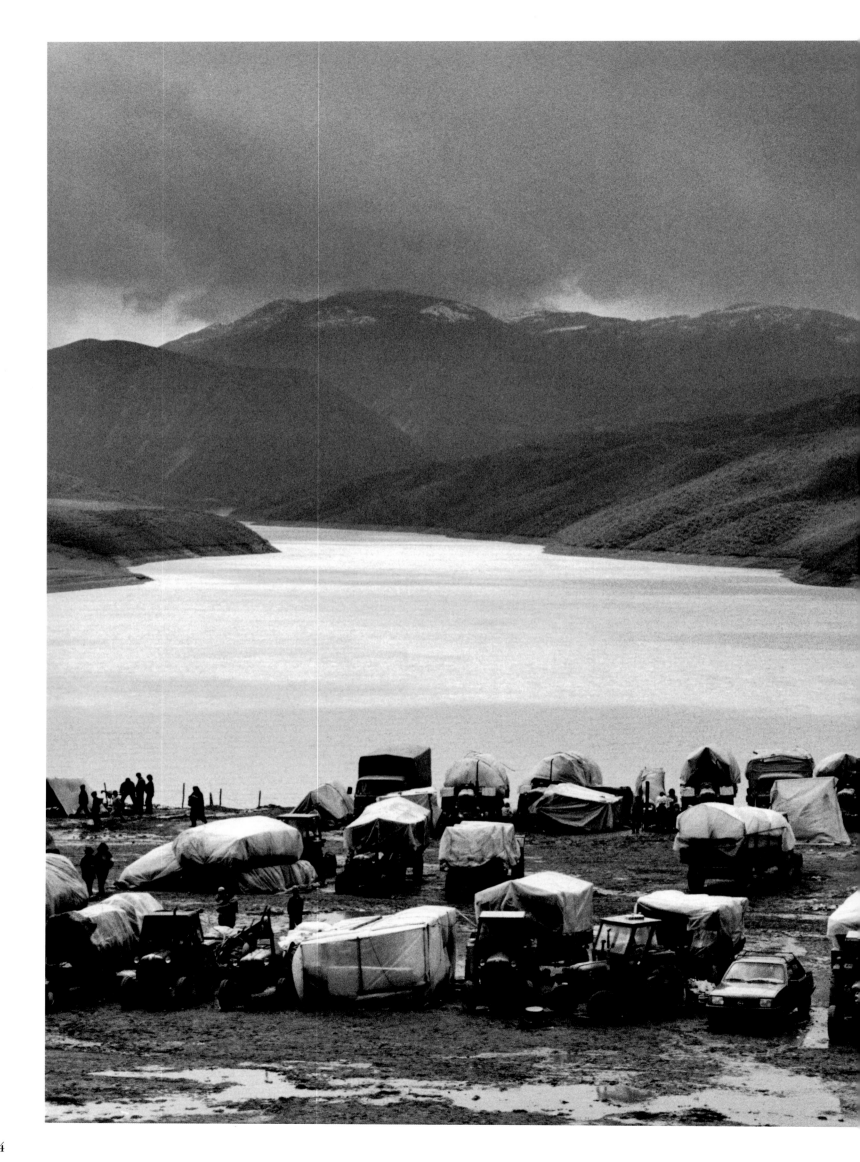

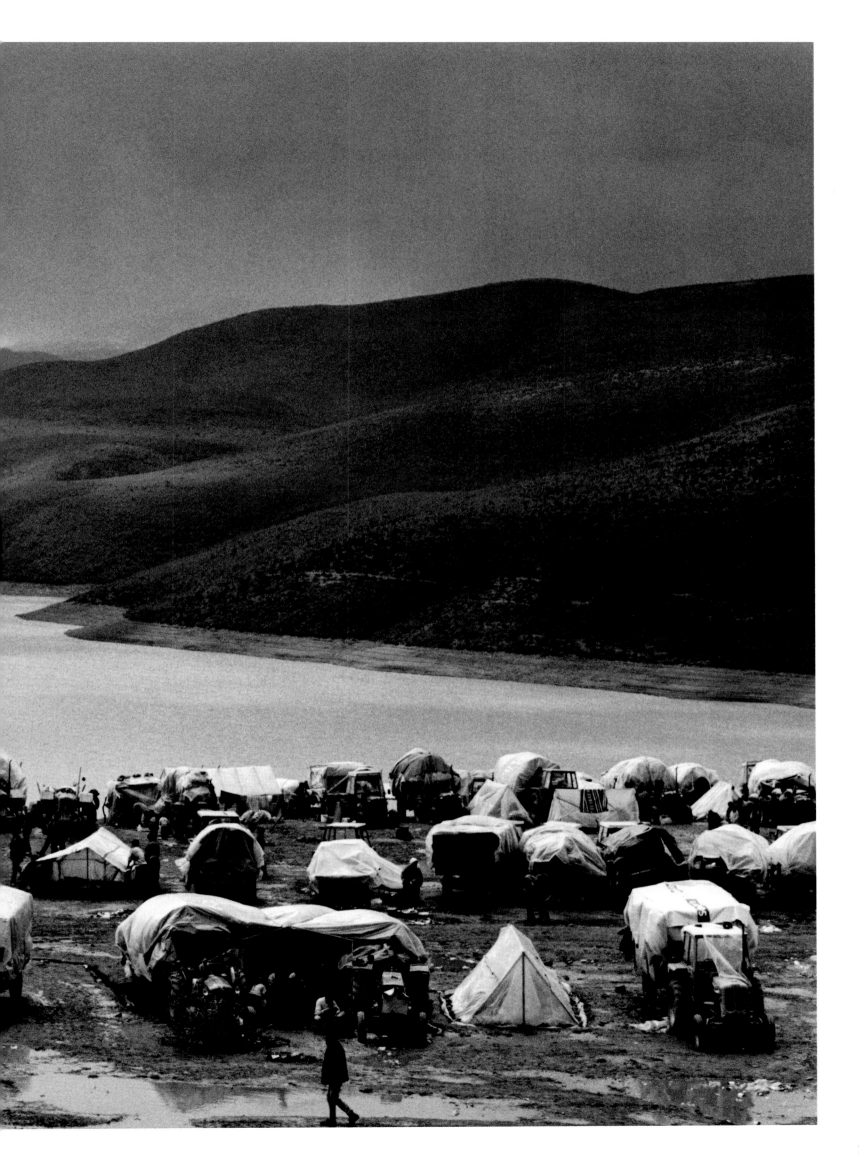

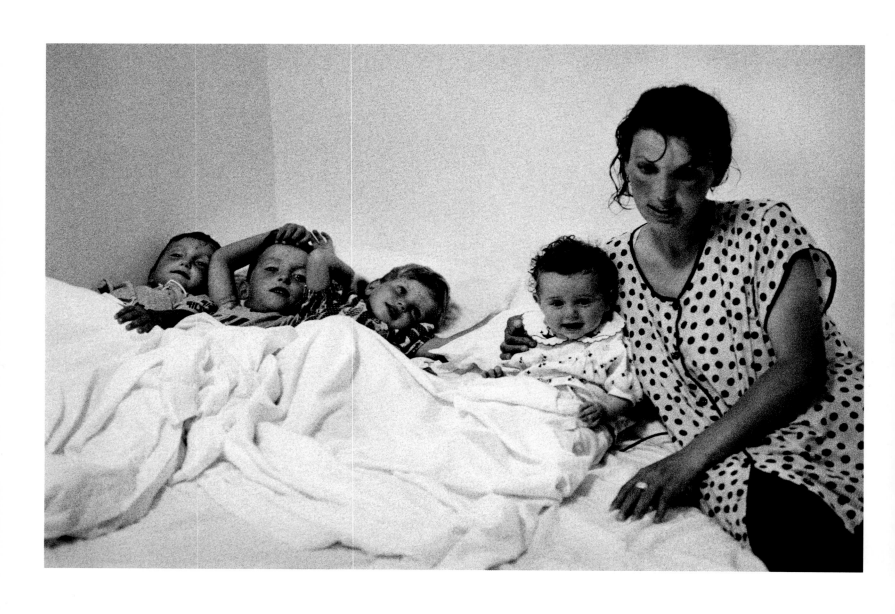

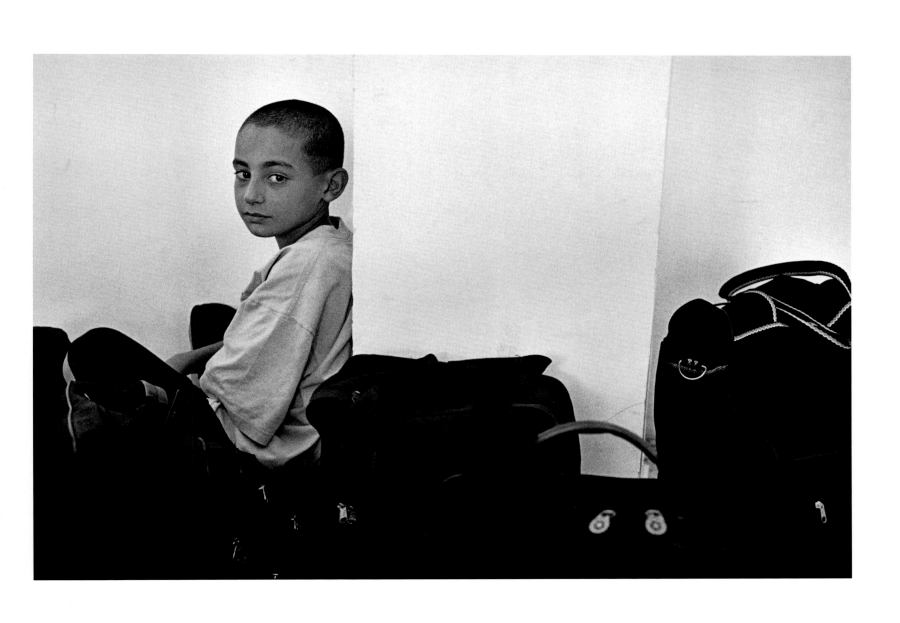

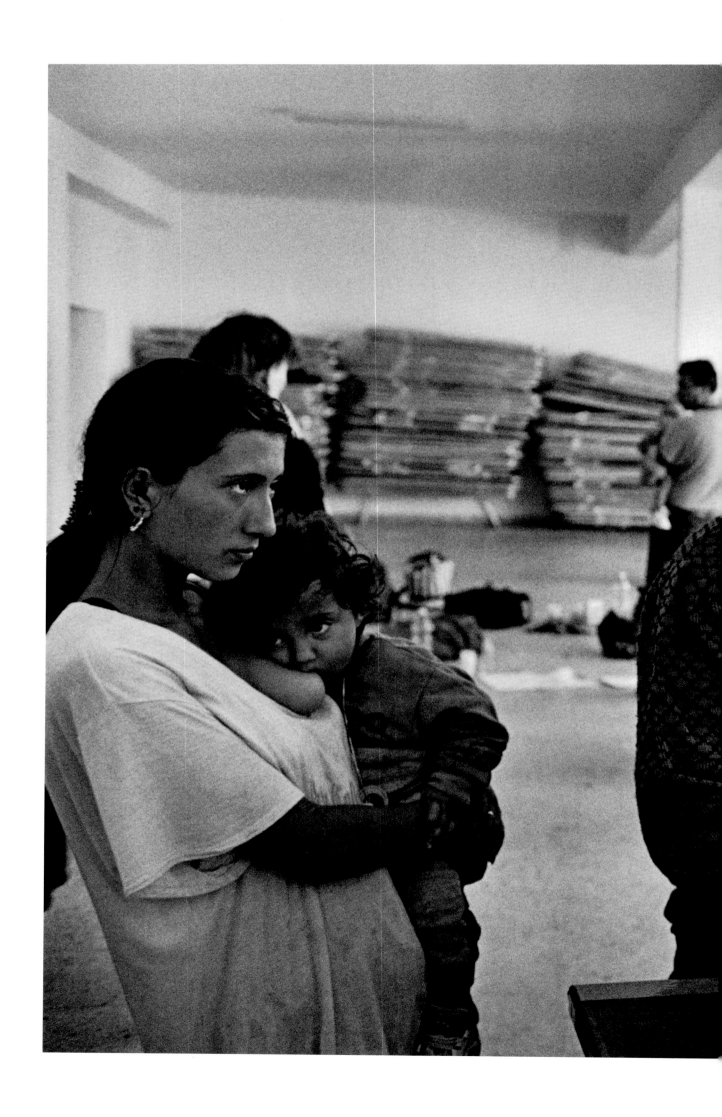

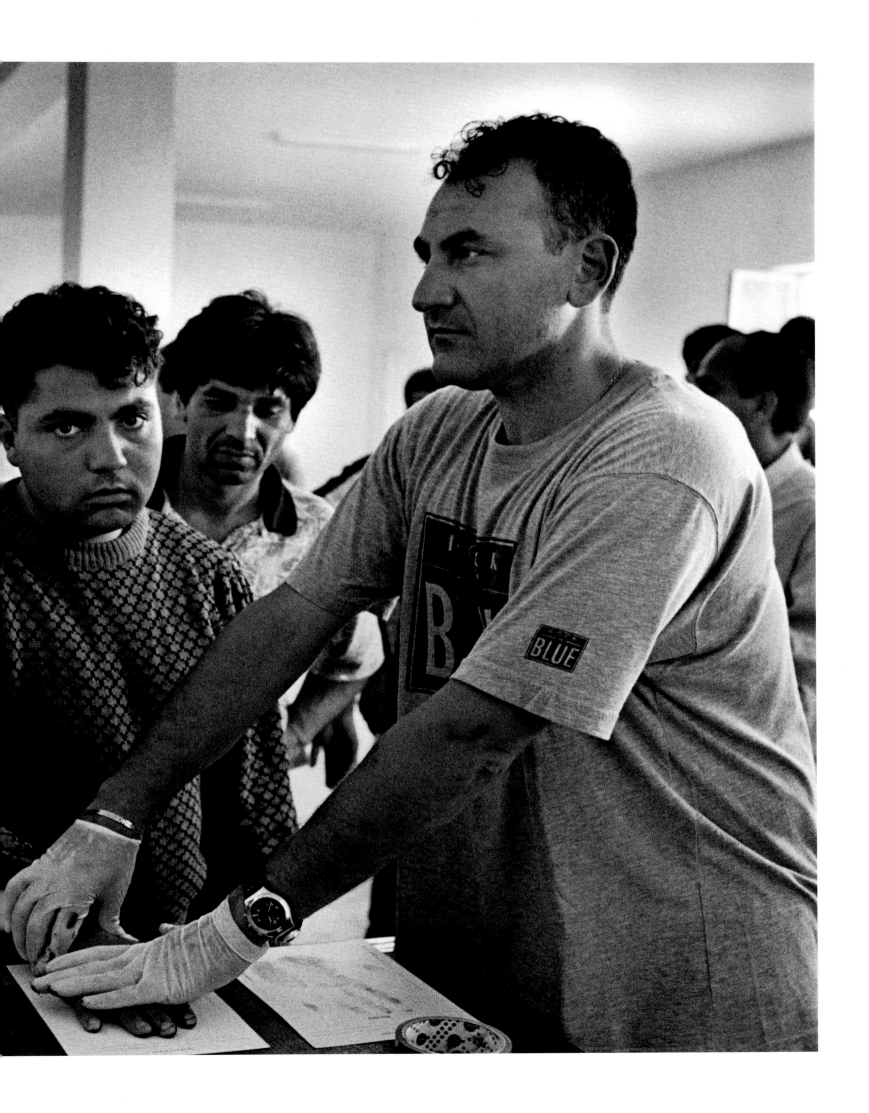

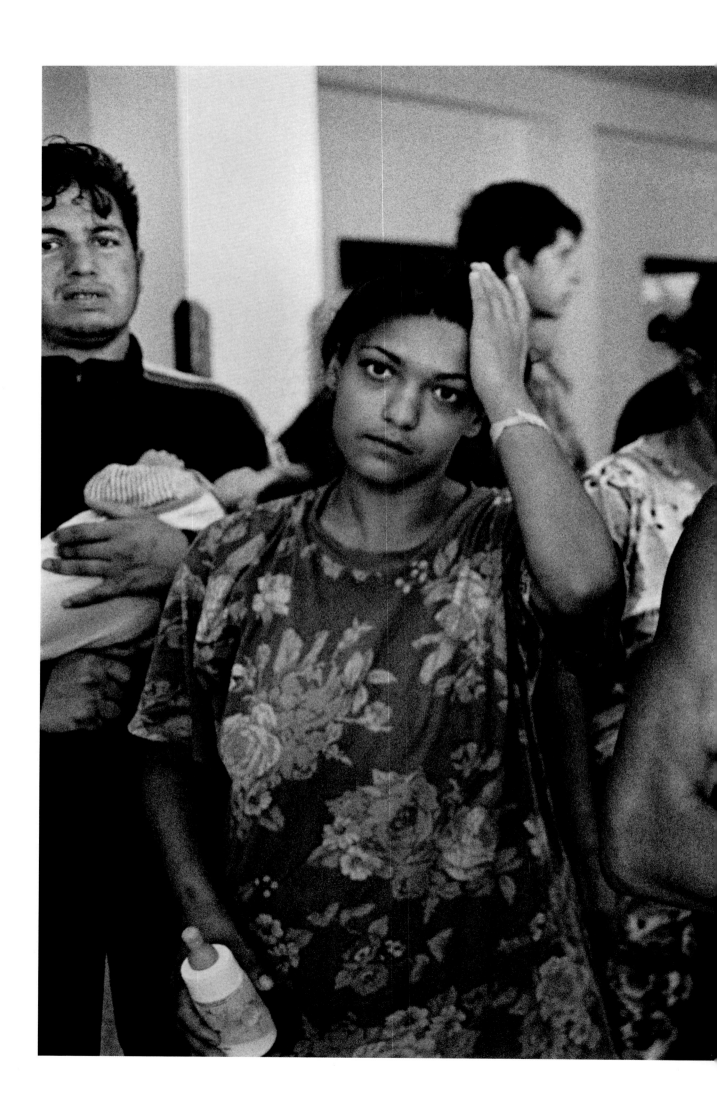

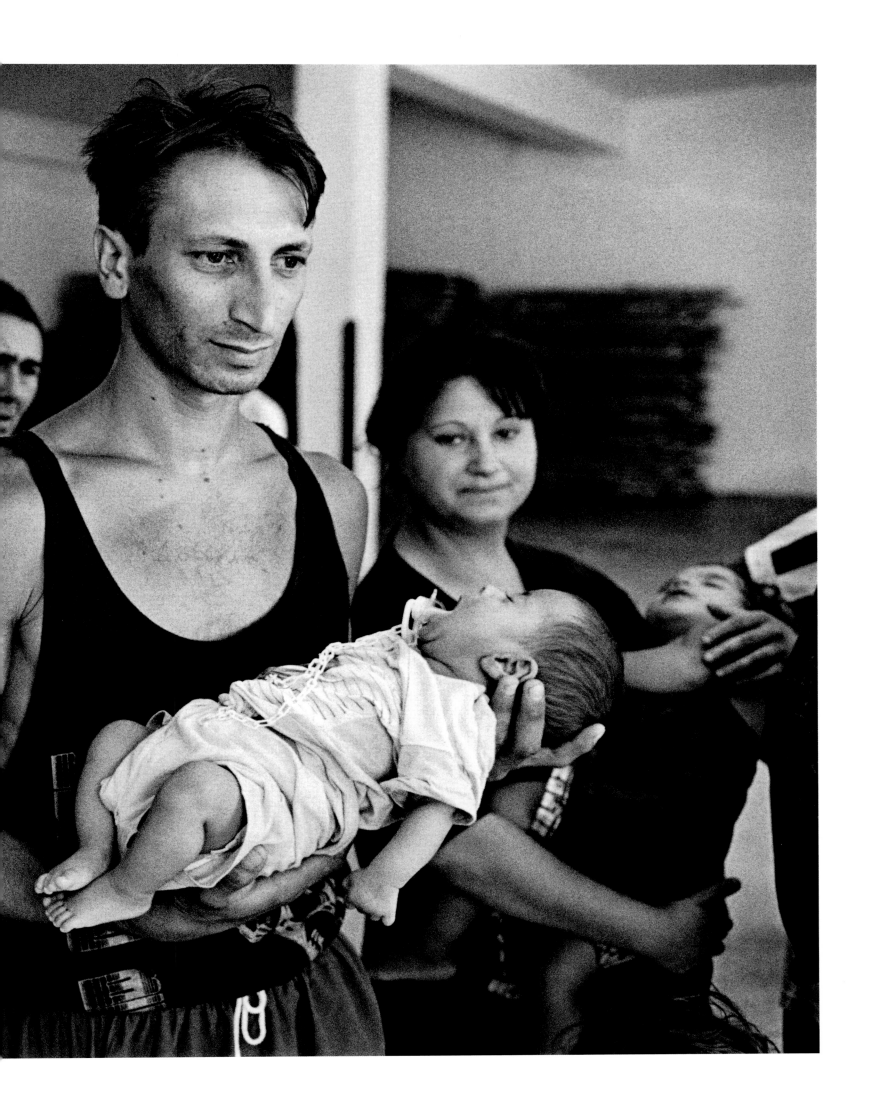

II

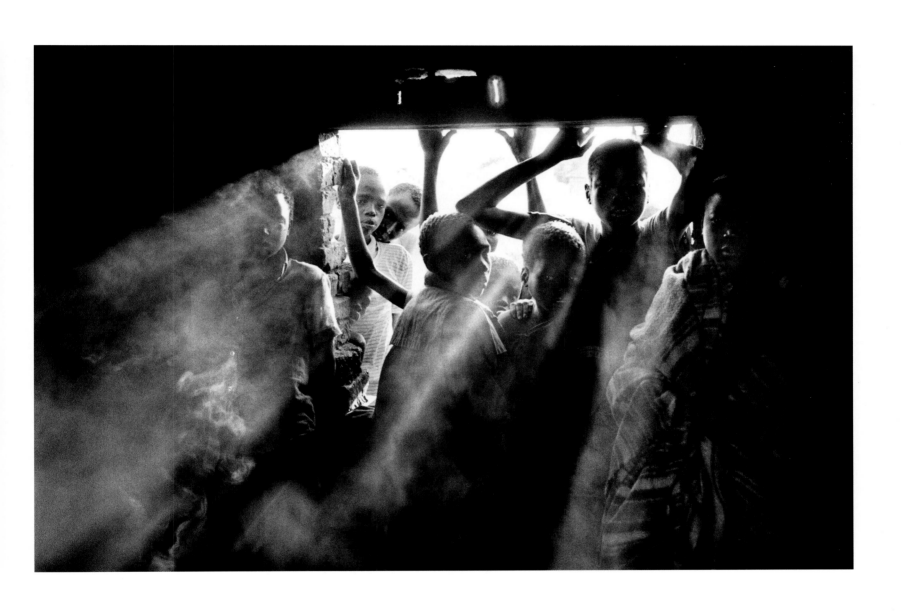

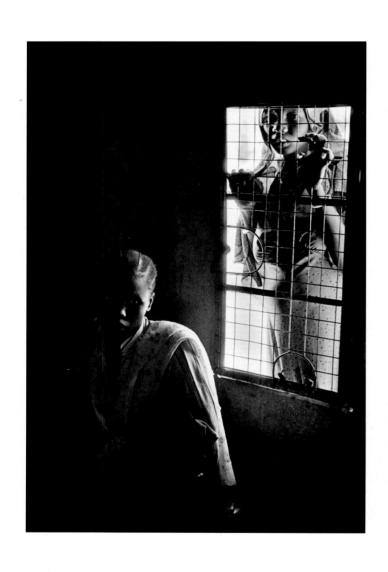

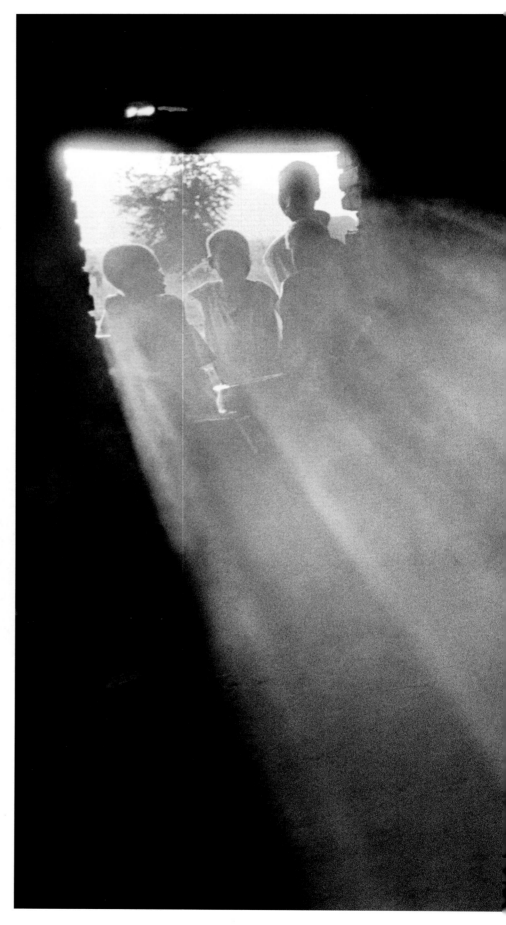

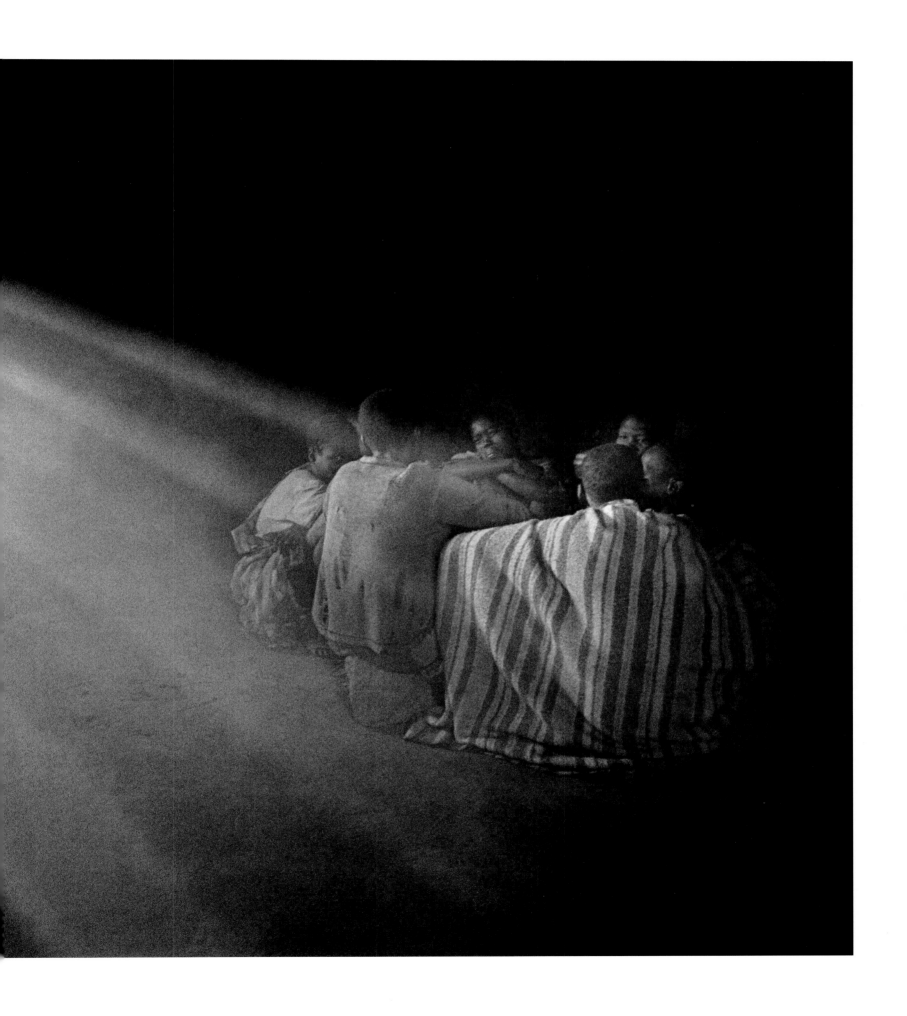

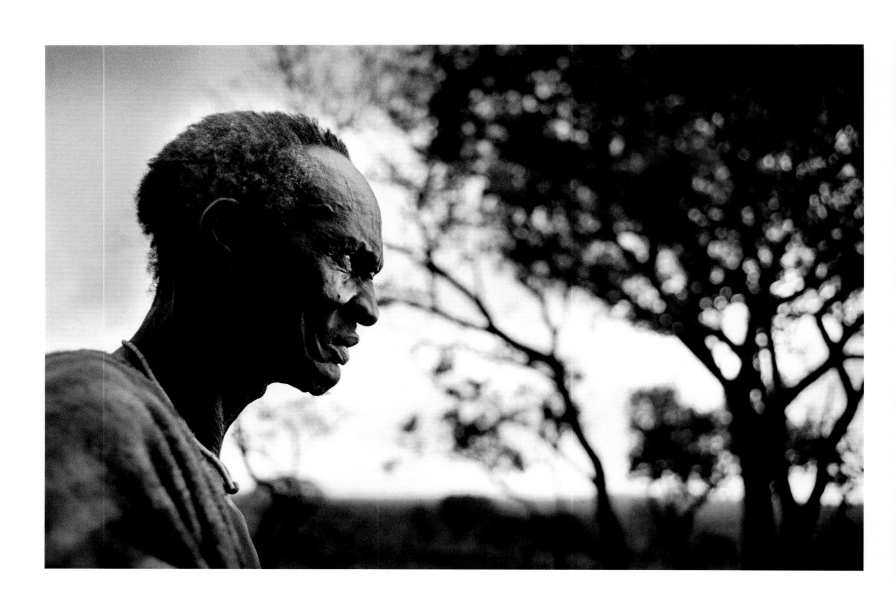

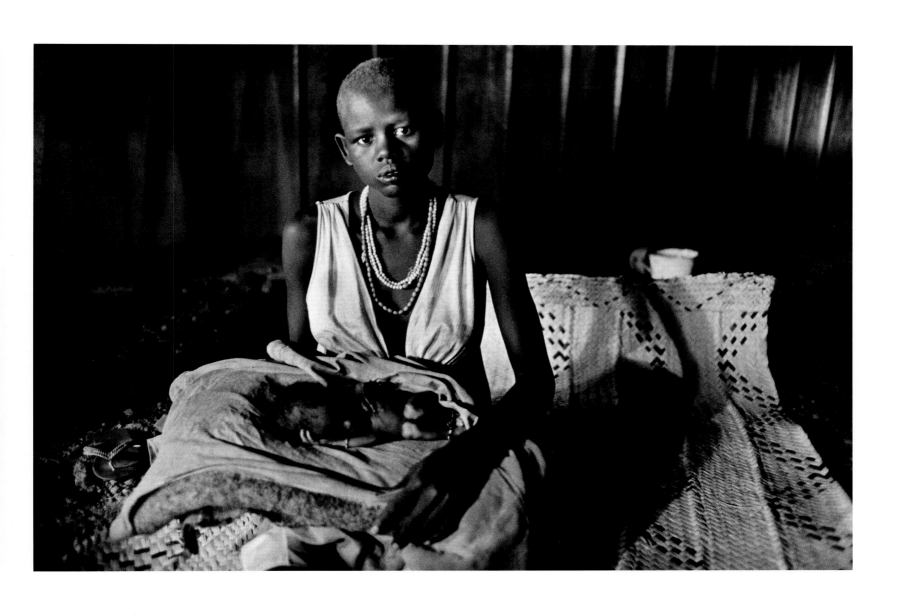

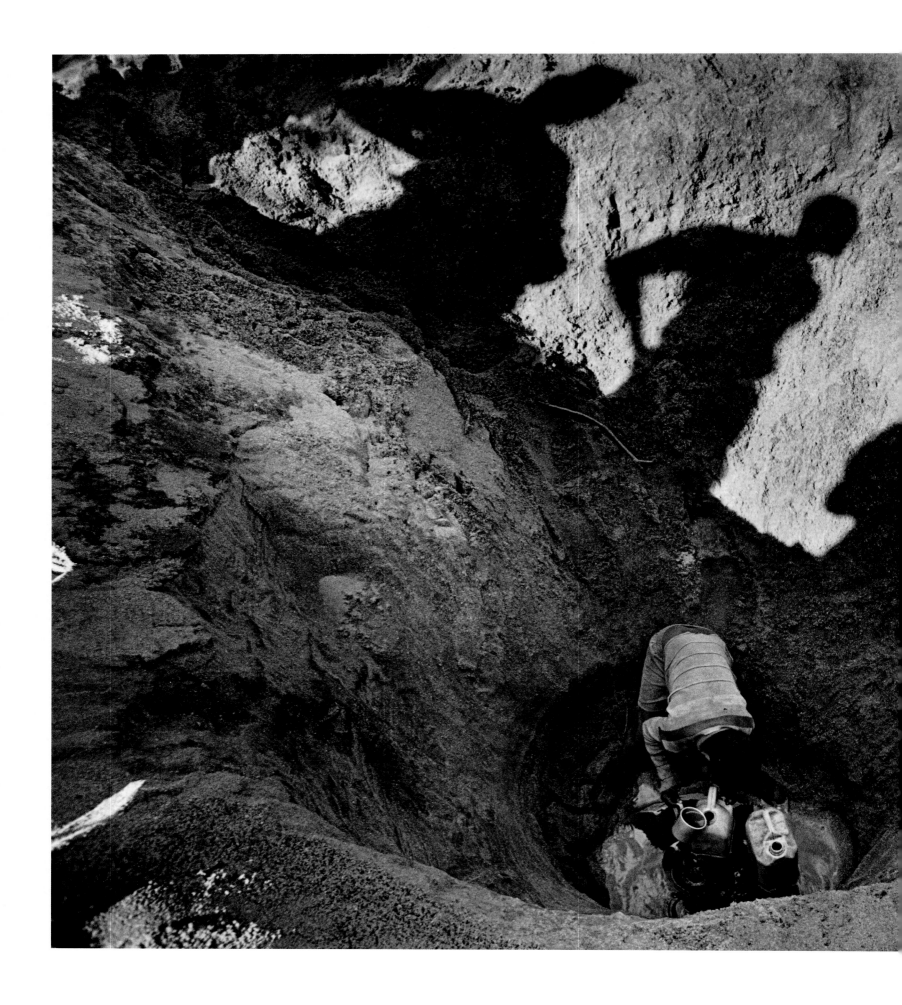

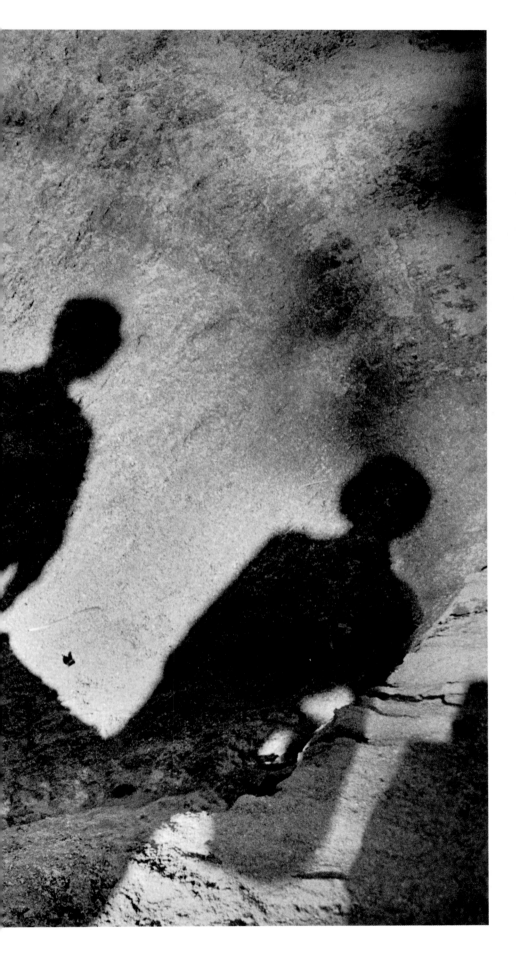

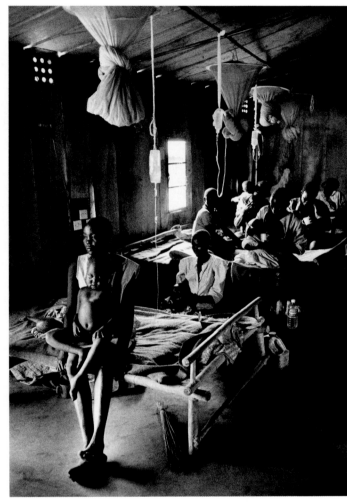

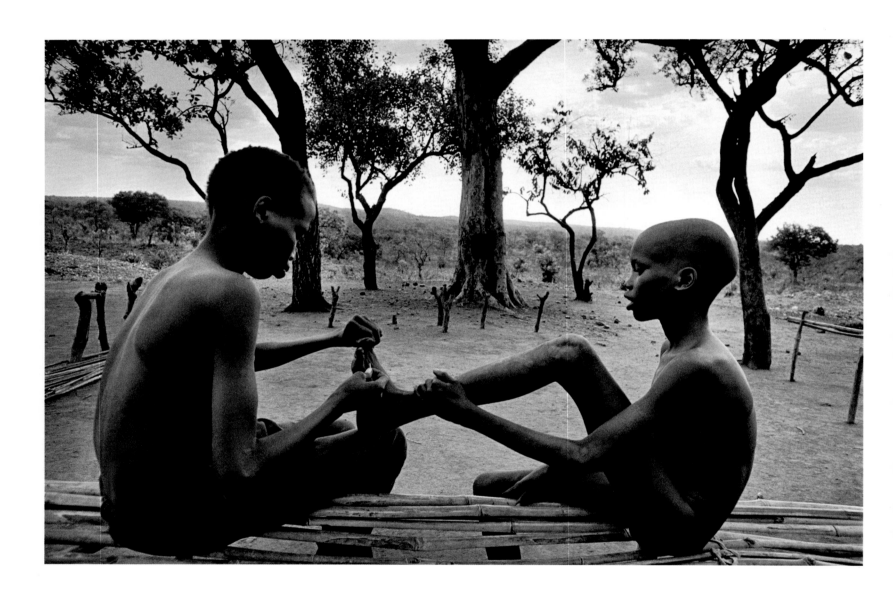

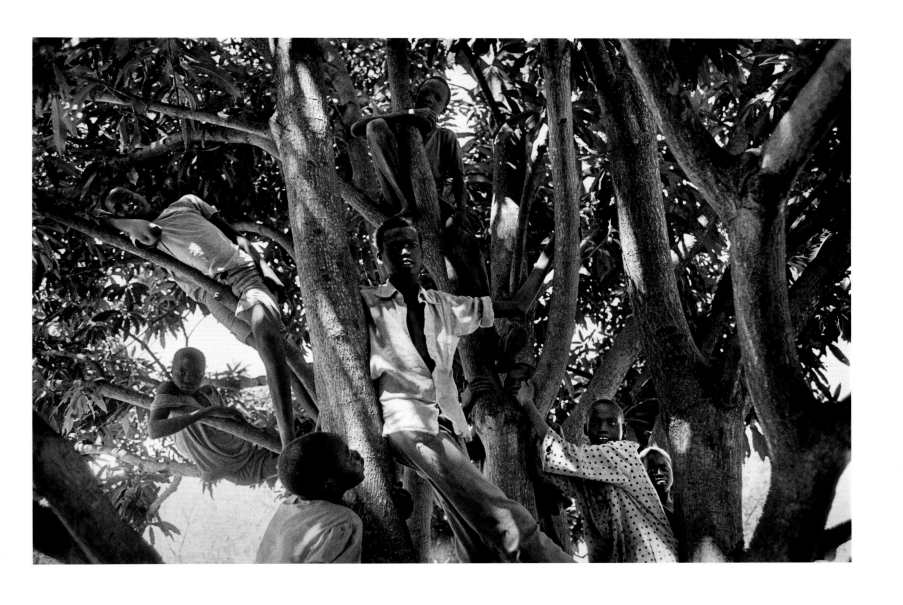

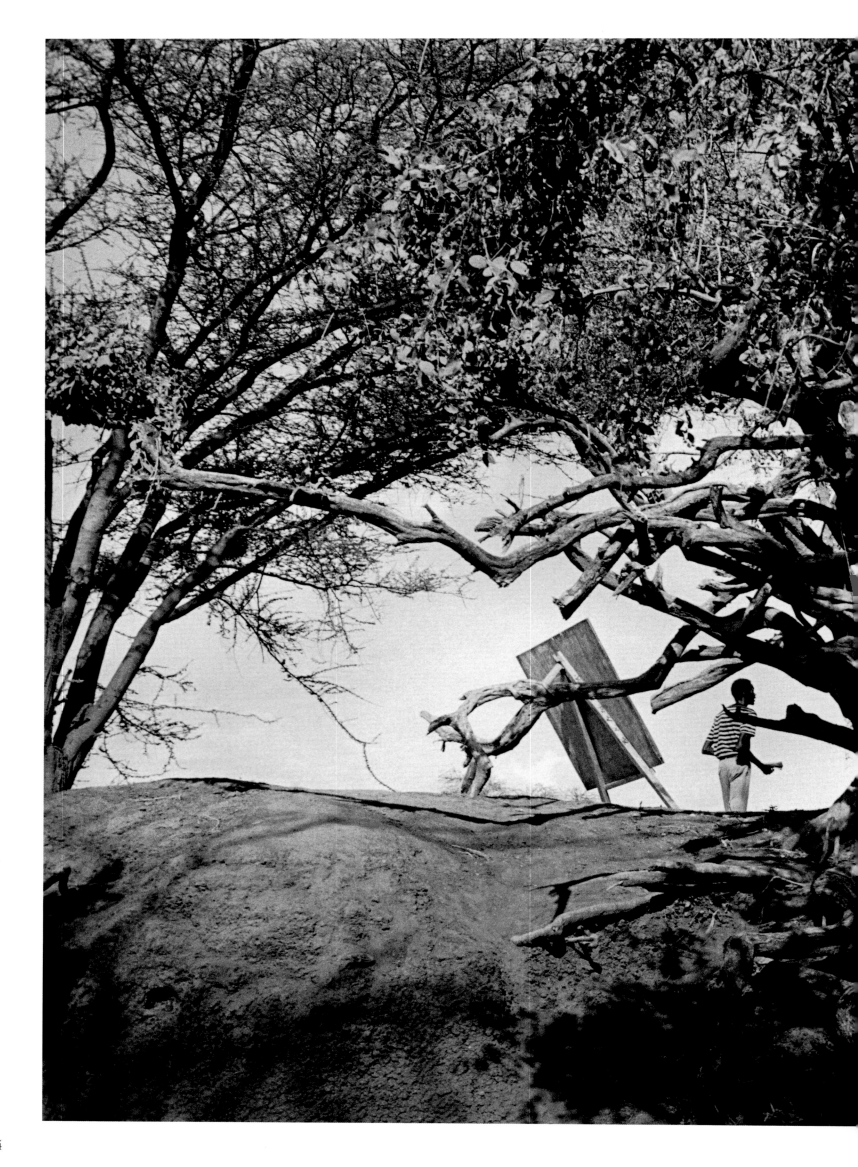

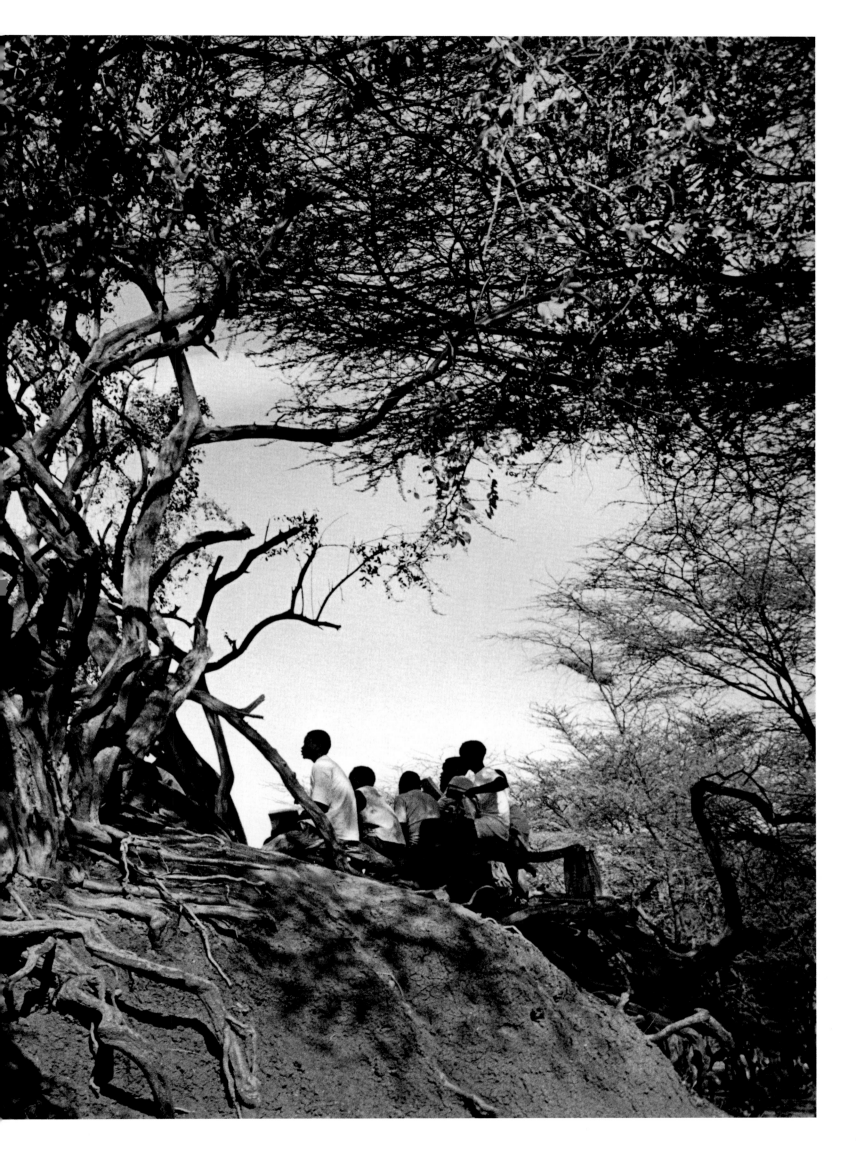

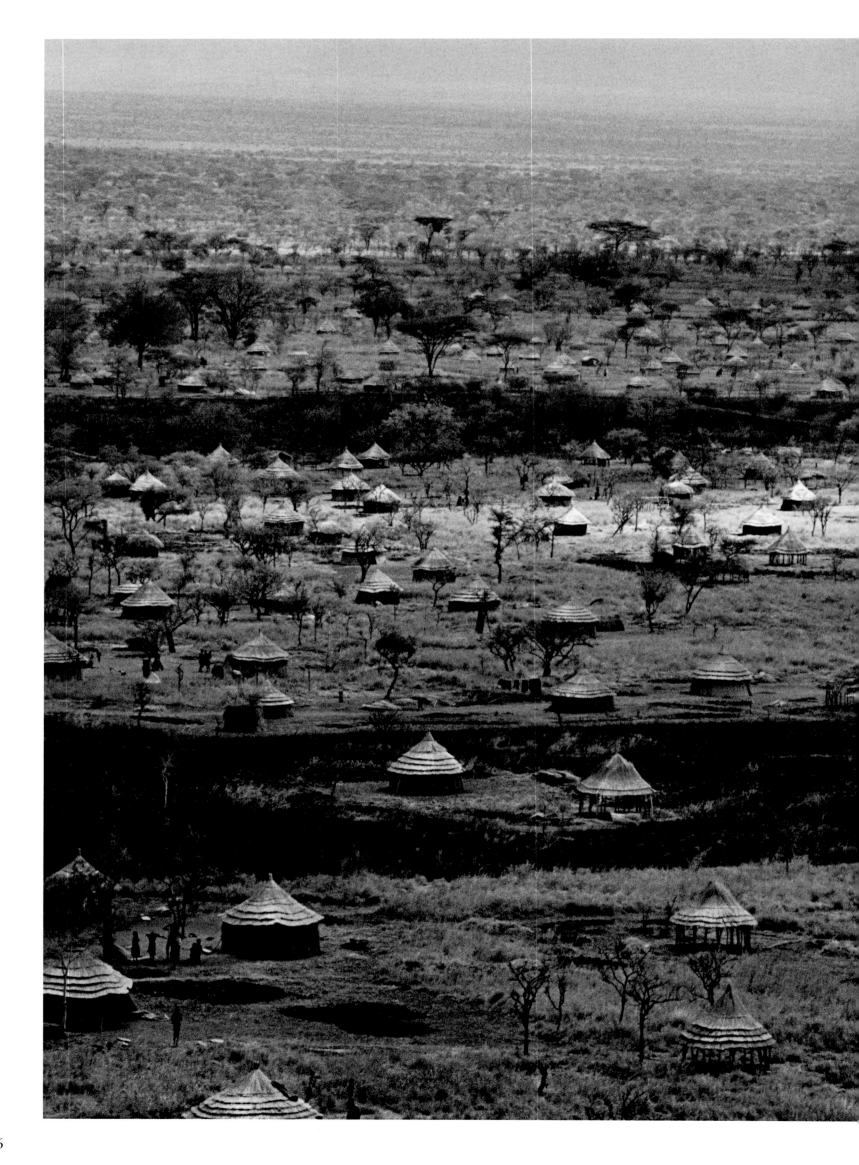

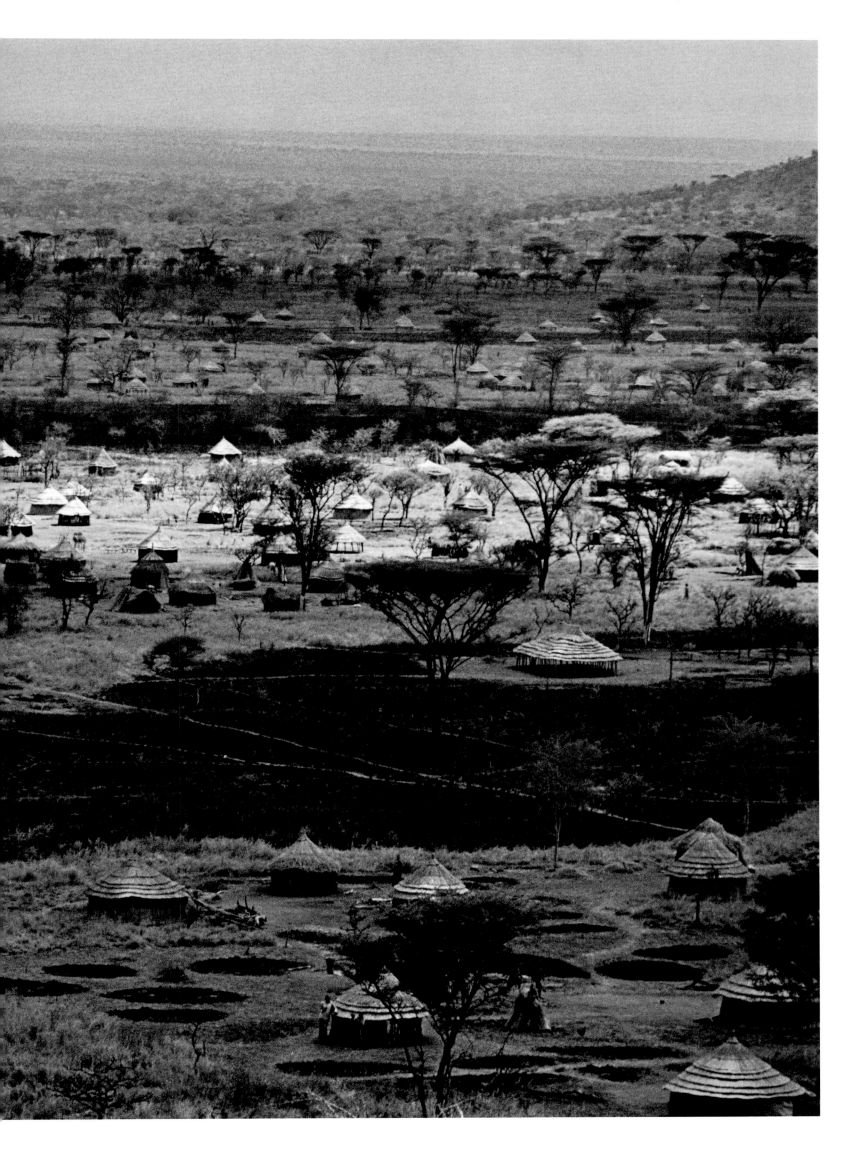

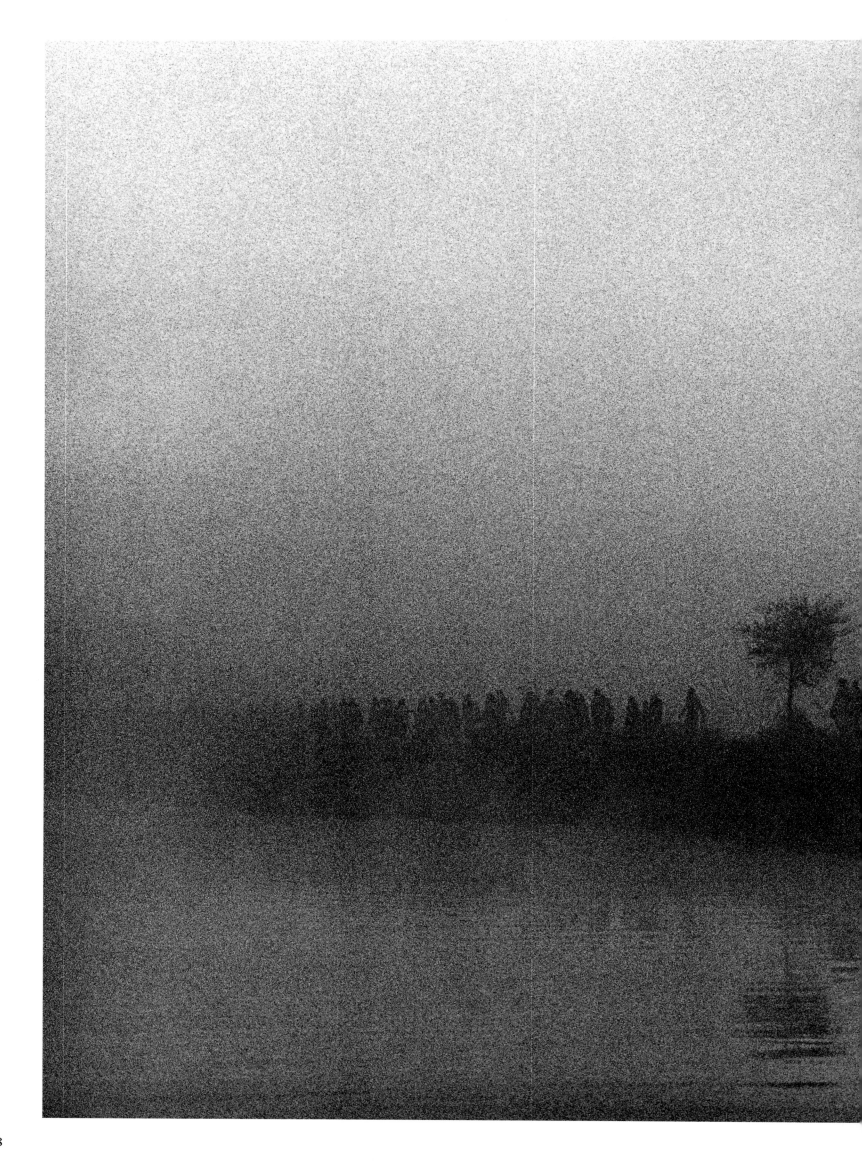

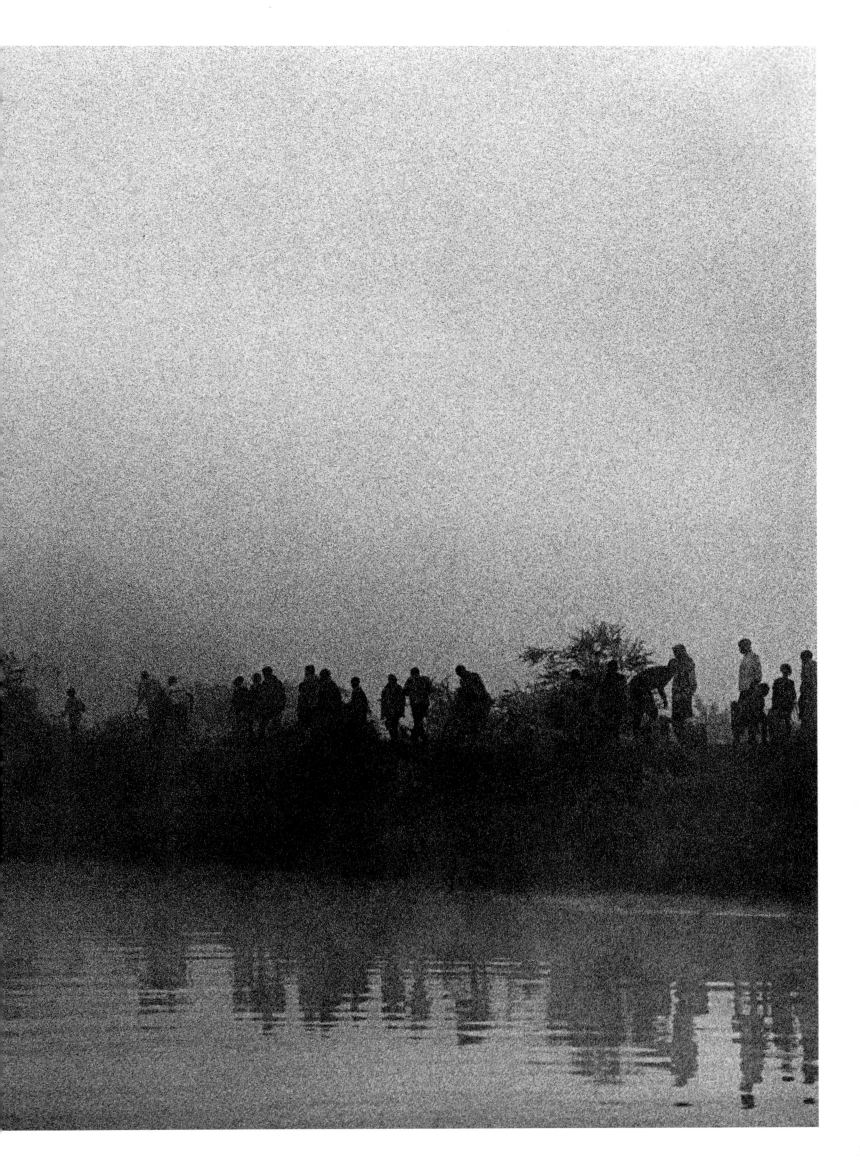

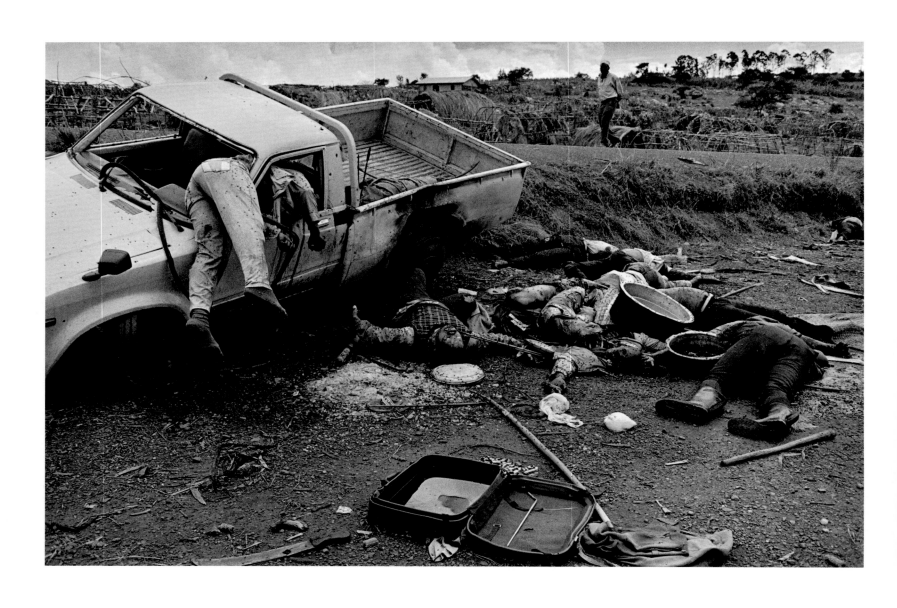

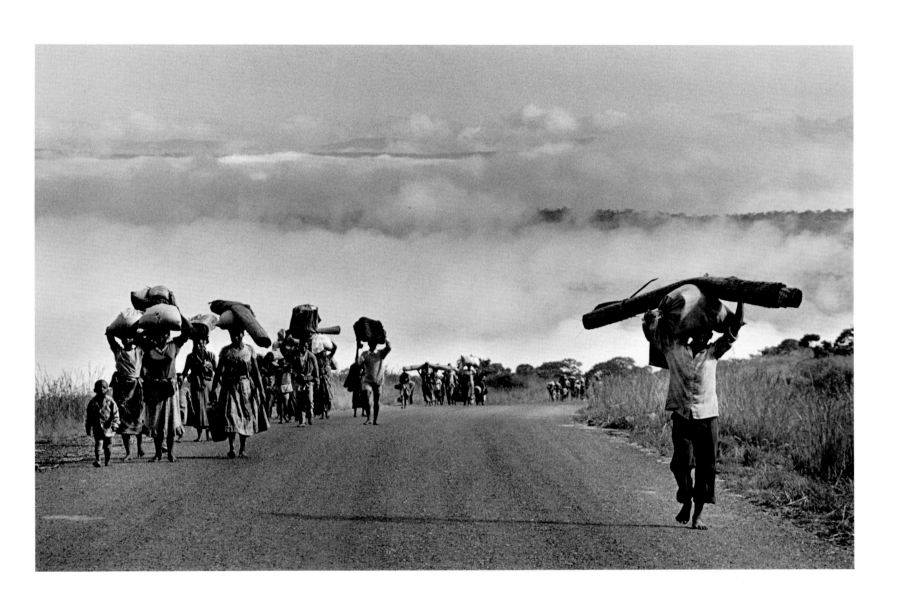

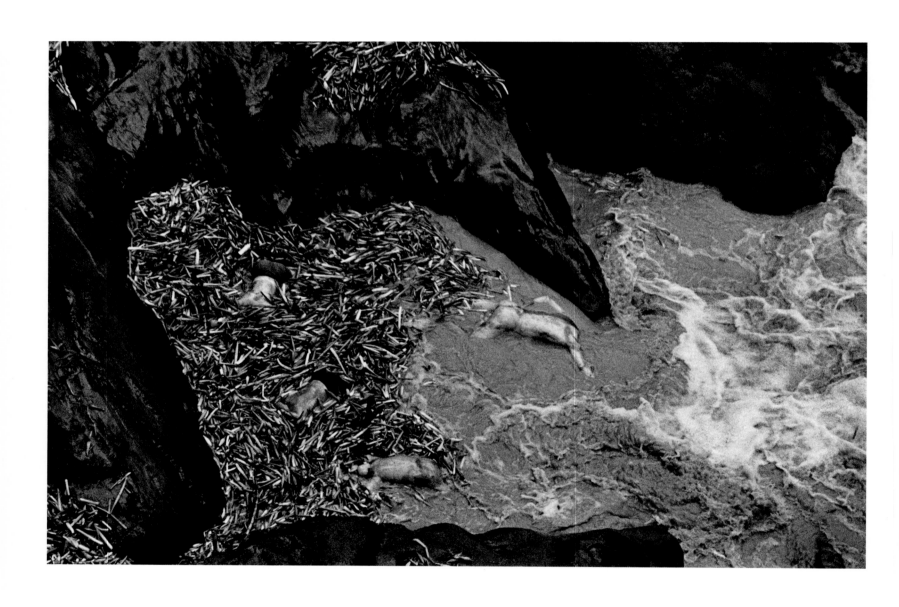

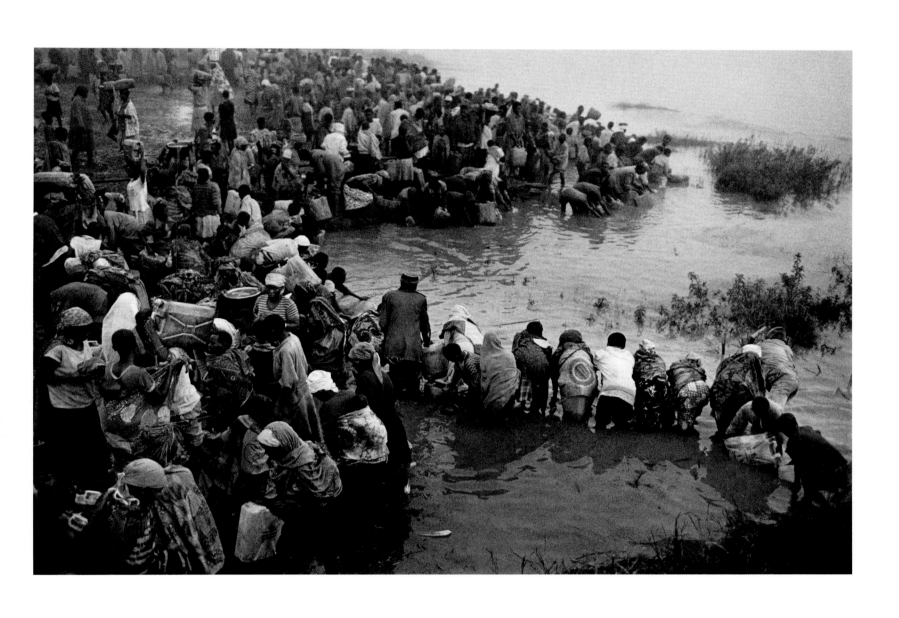

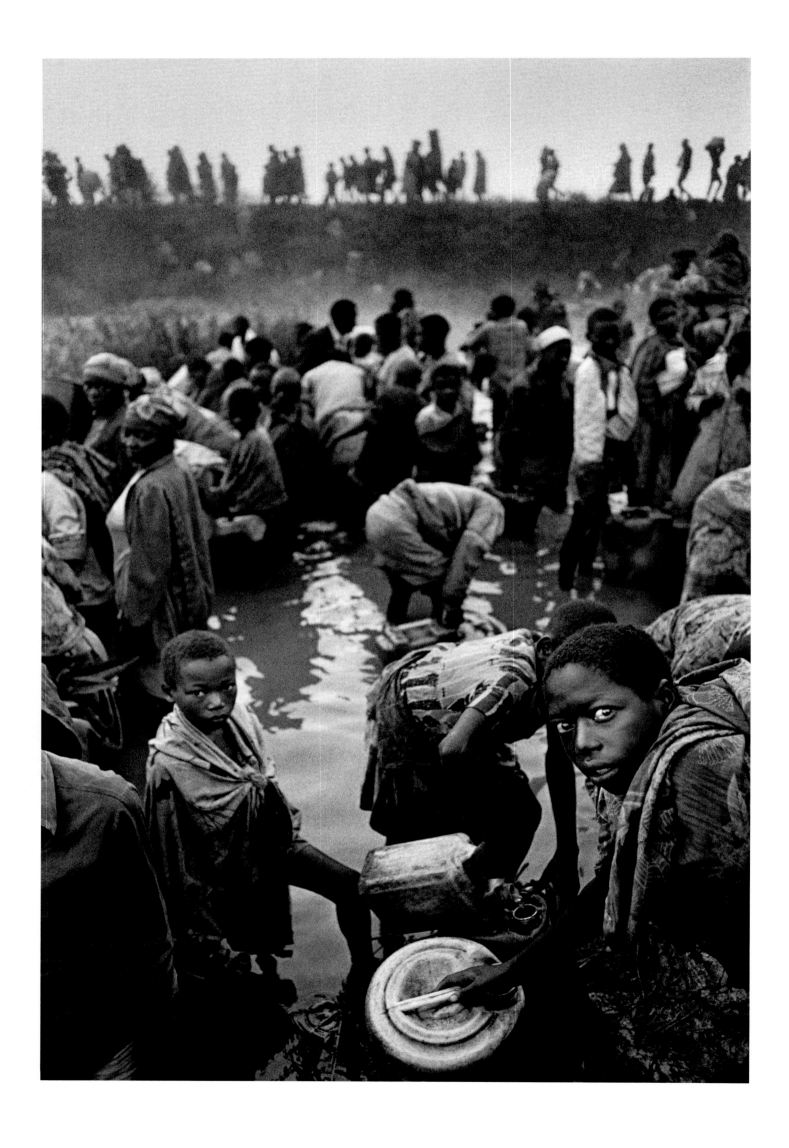

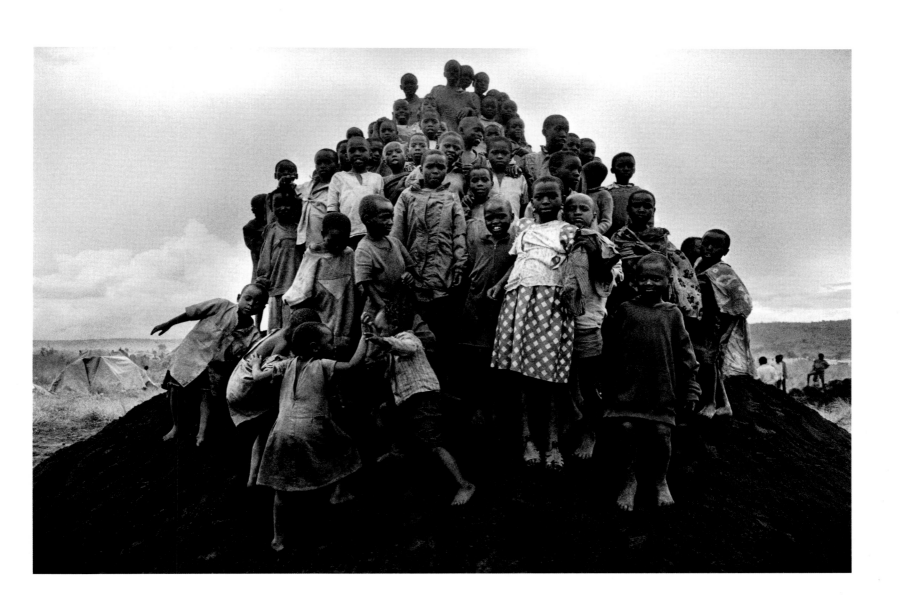

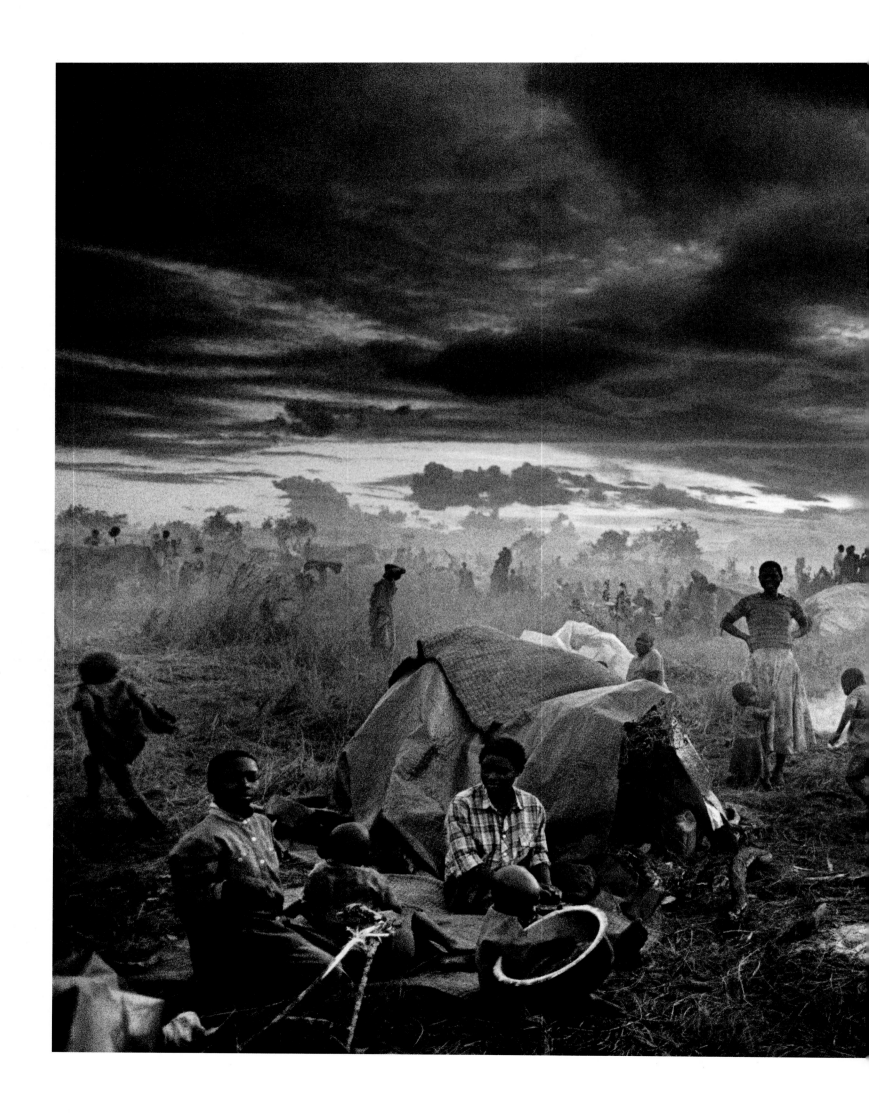

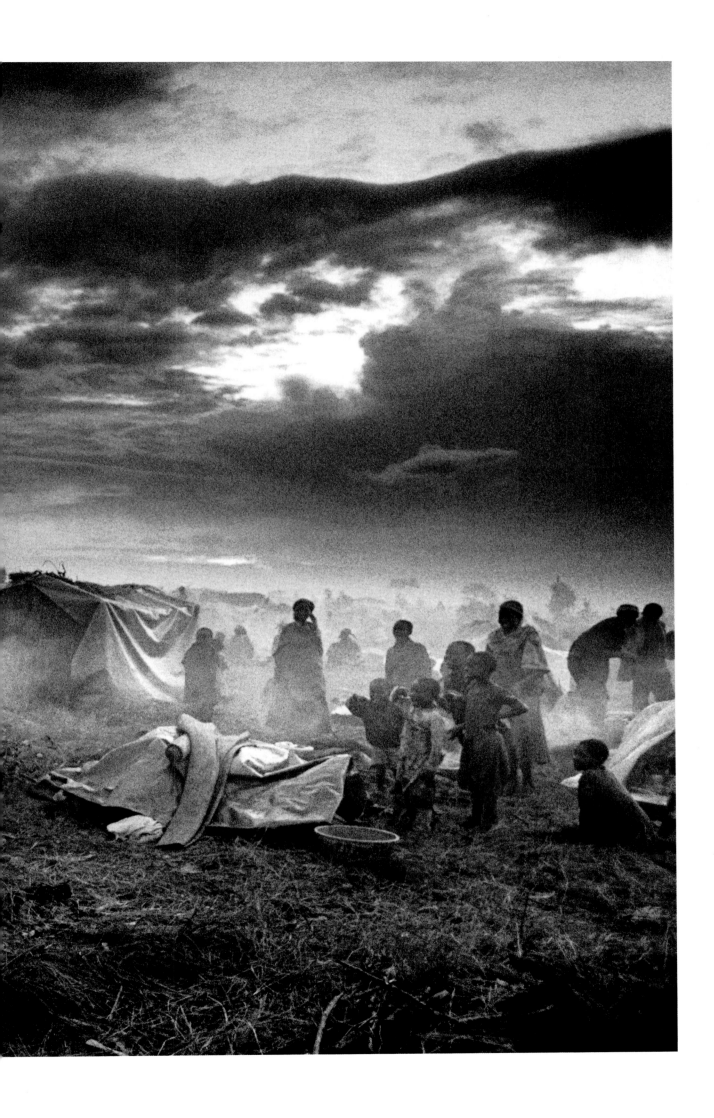

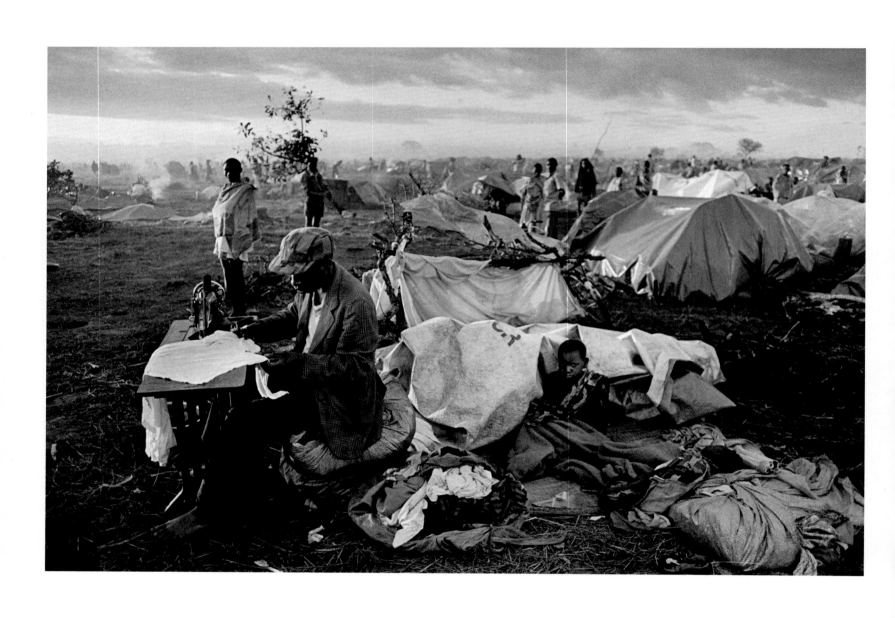

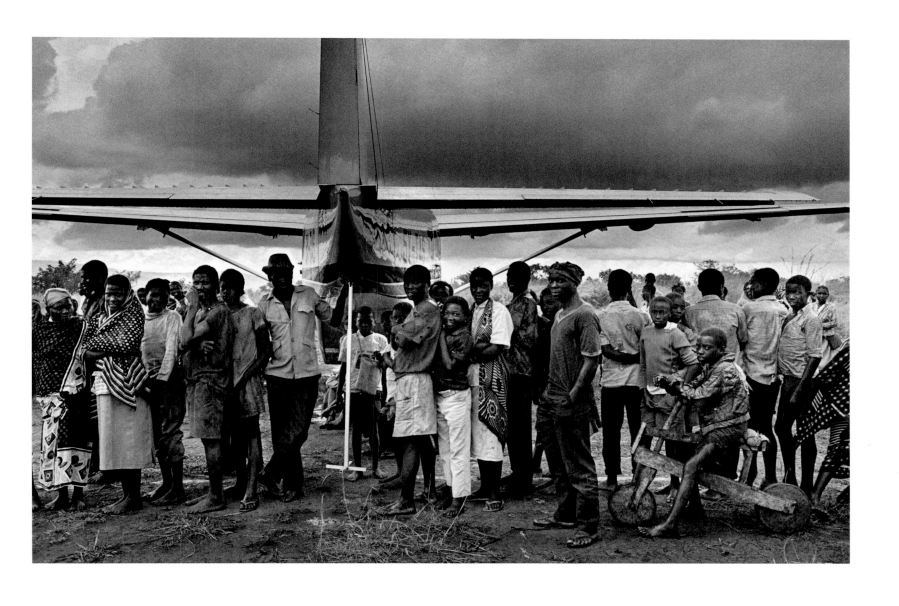

179

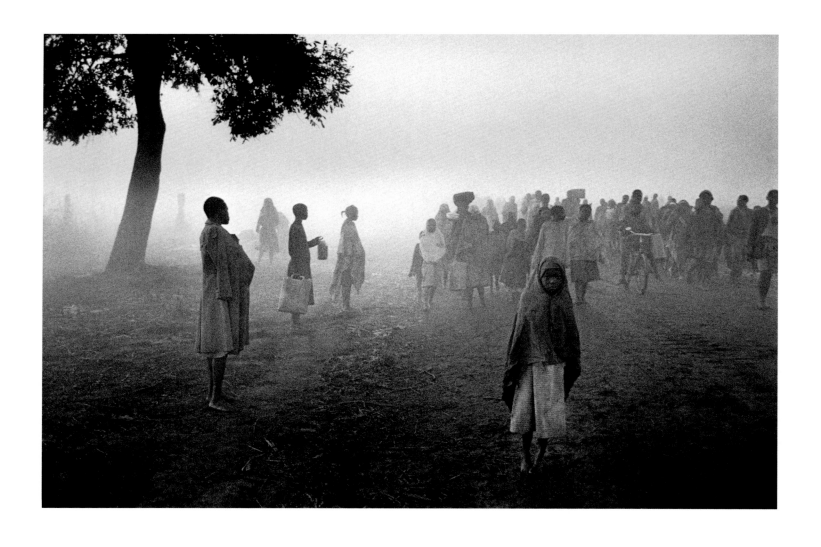

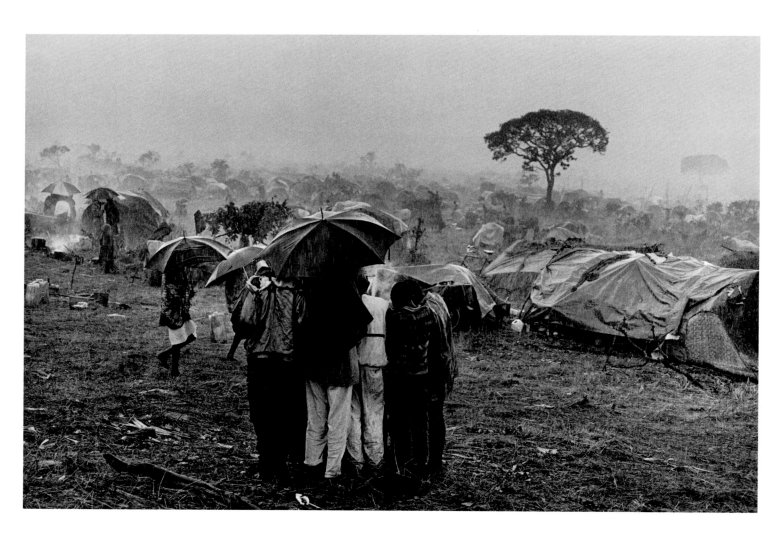

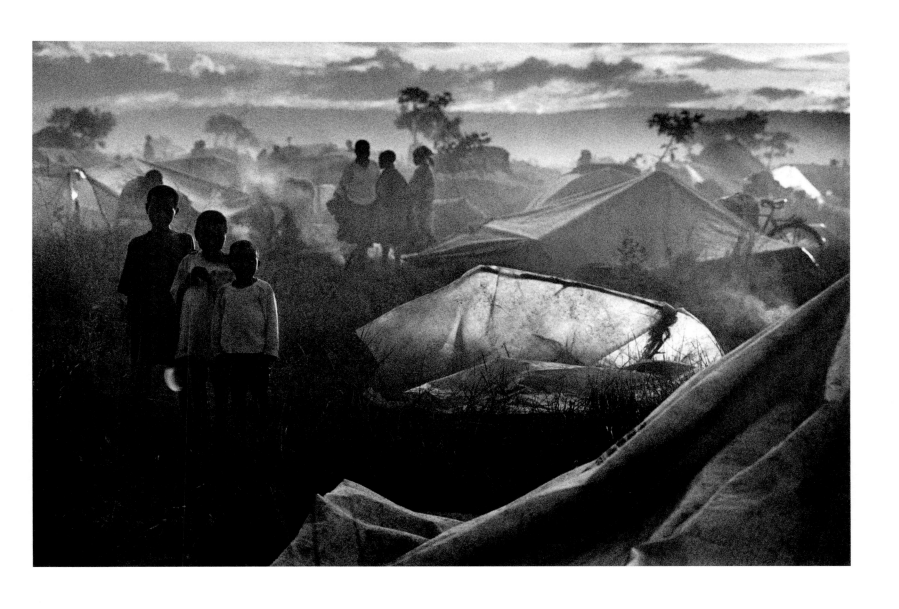

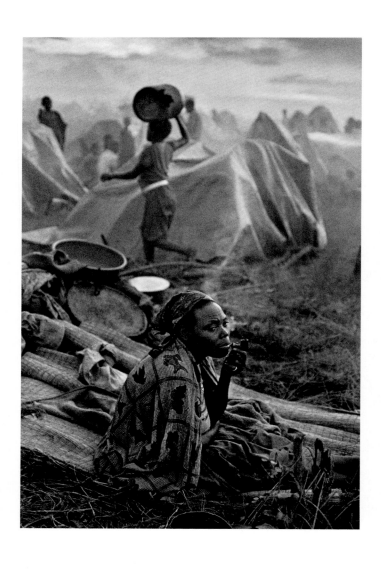

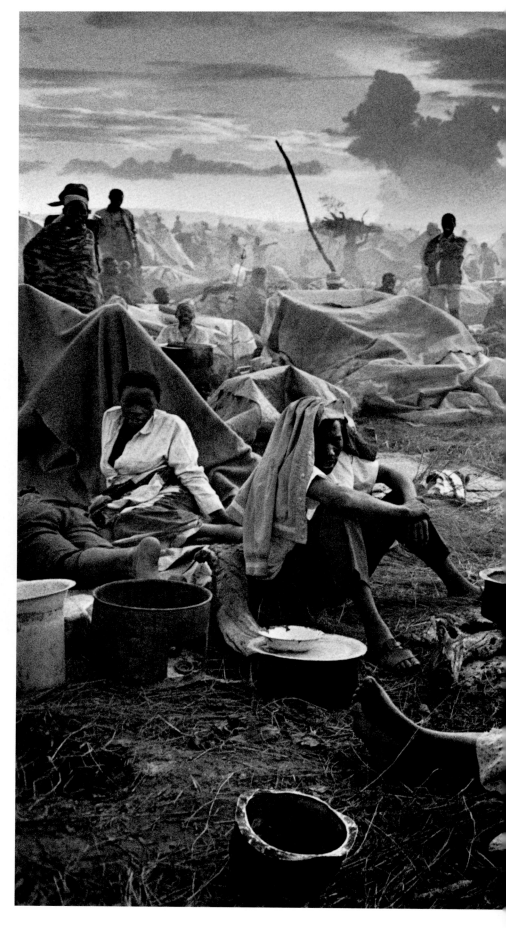

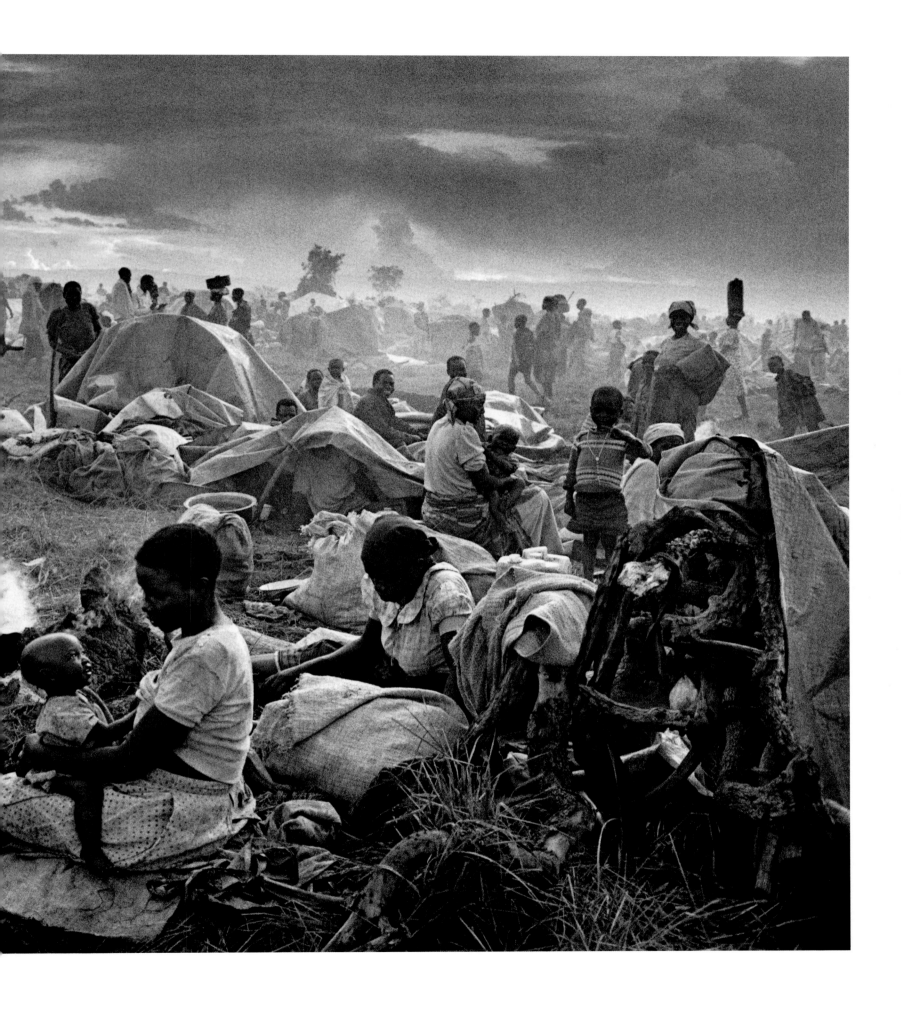

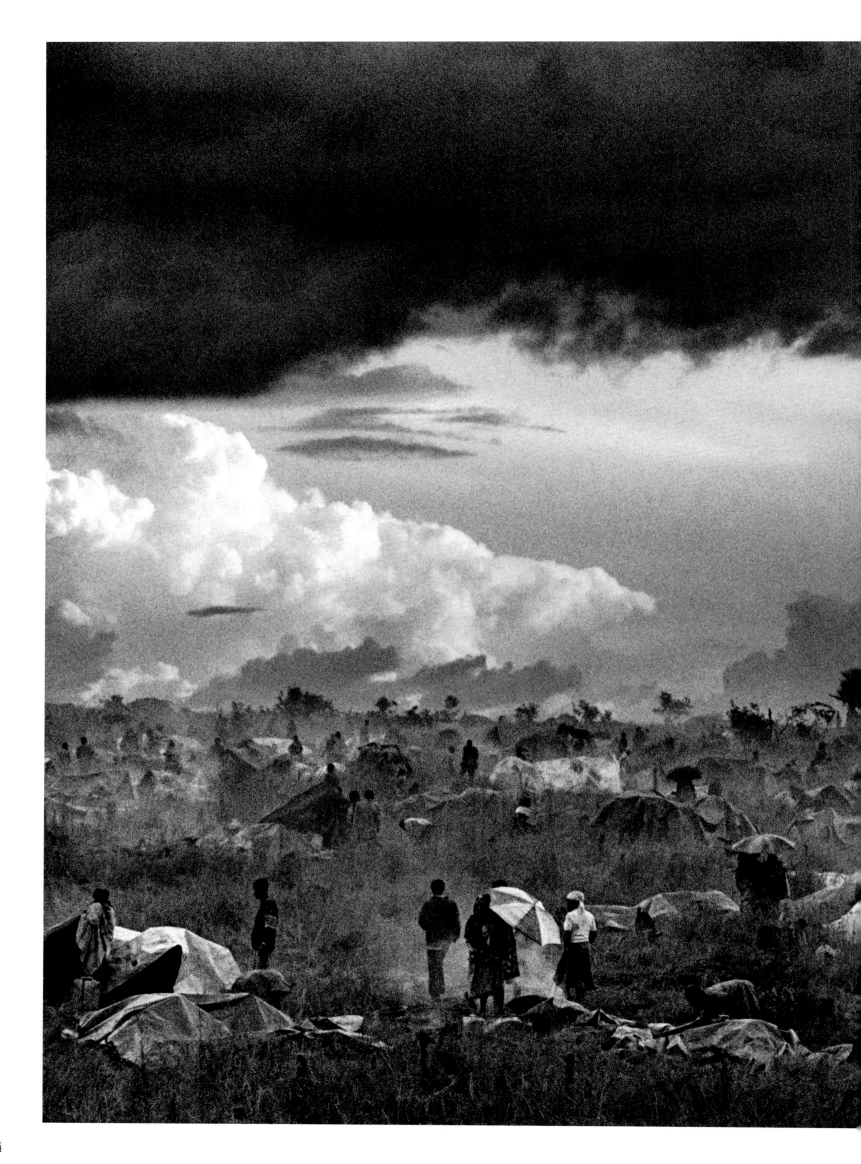

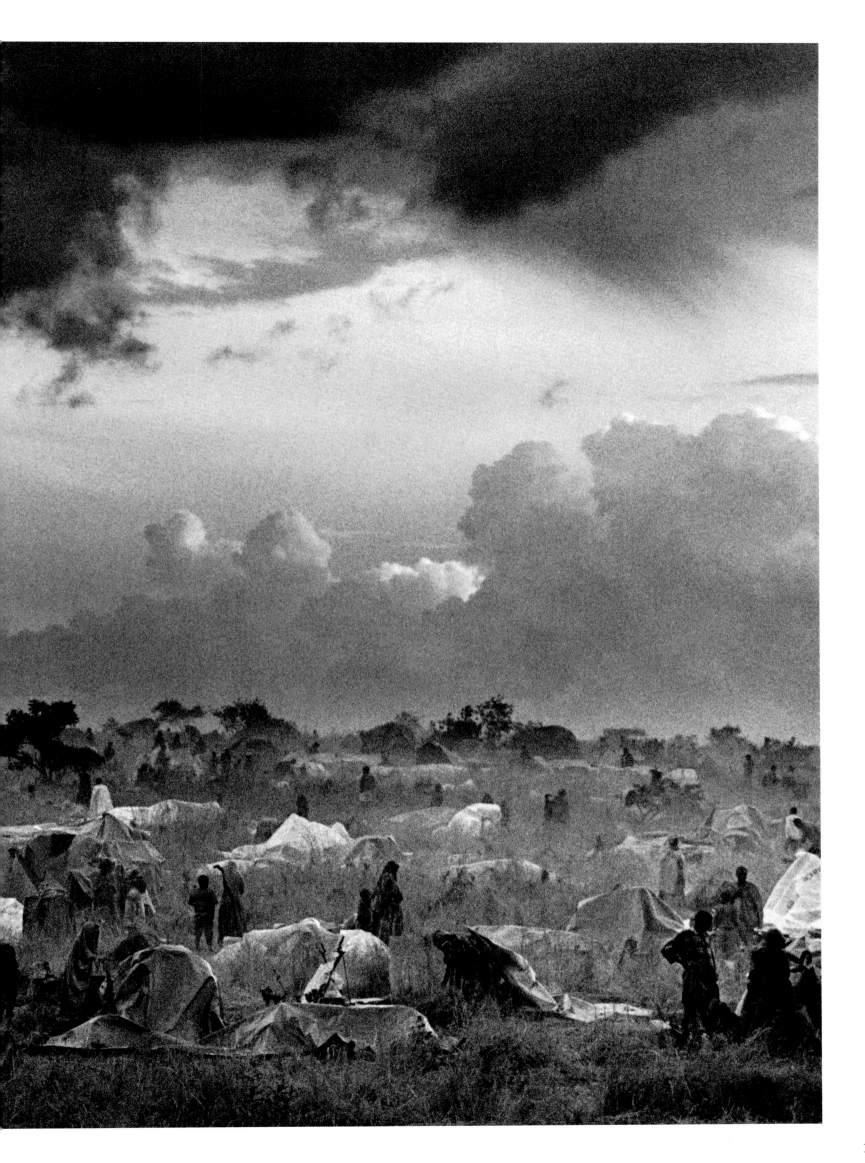

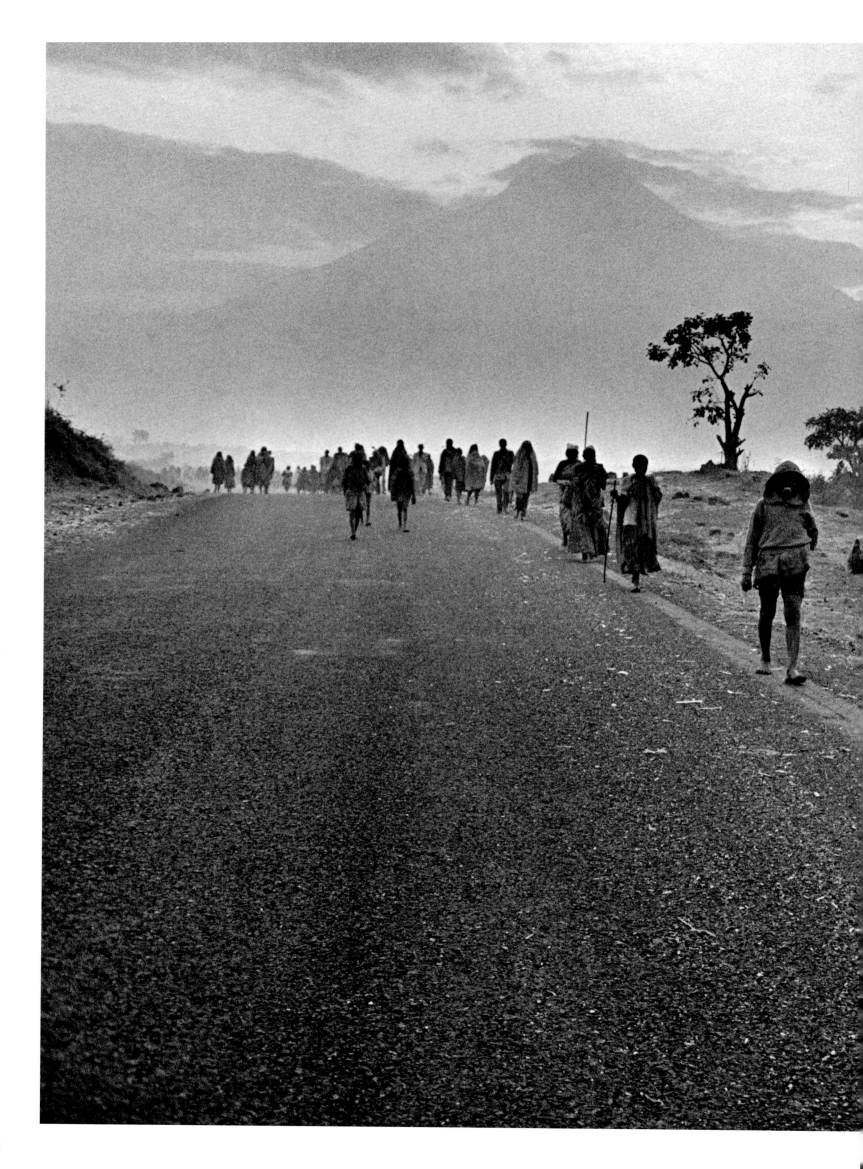

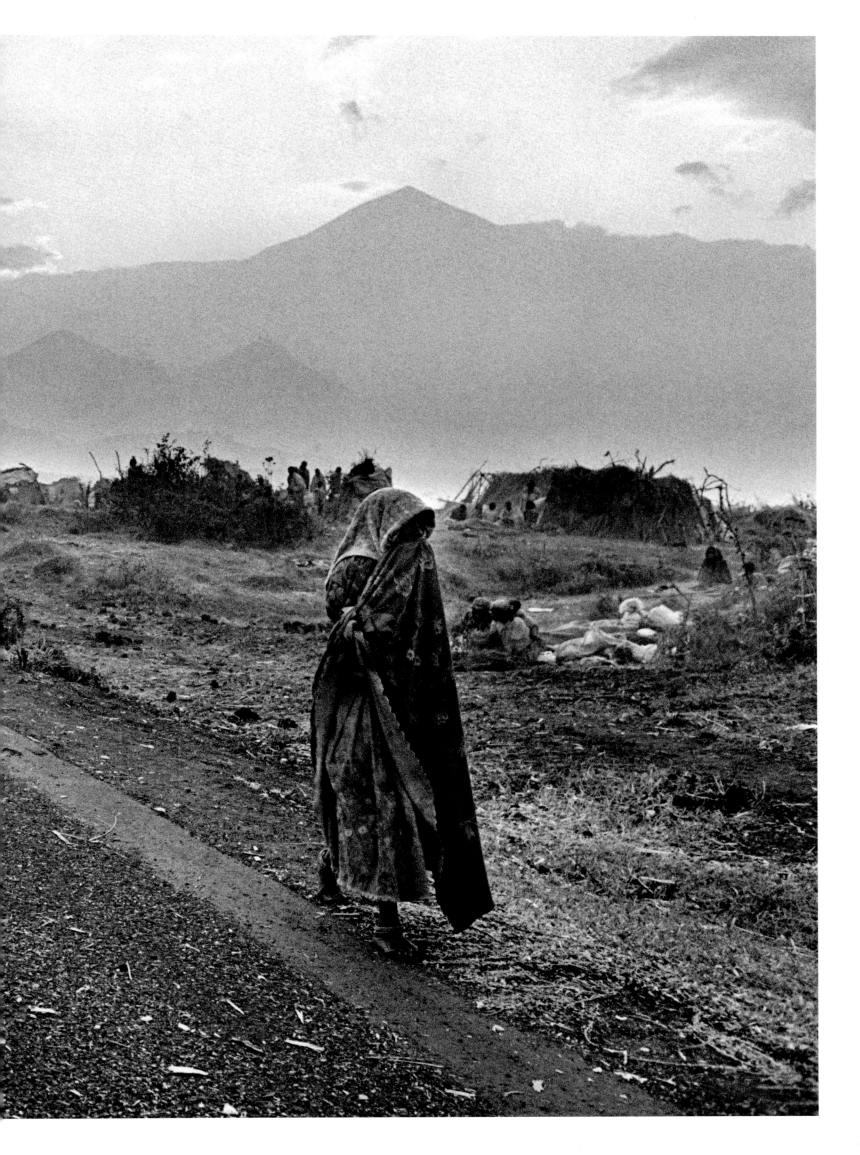

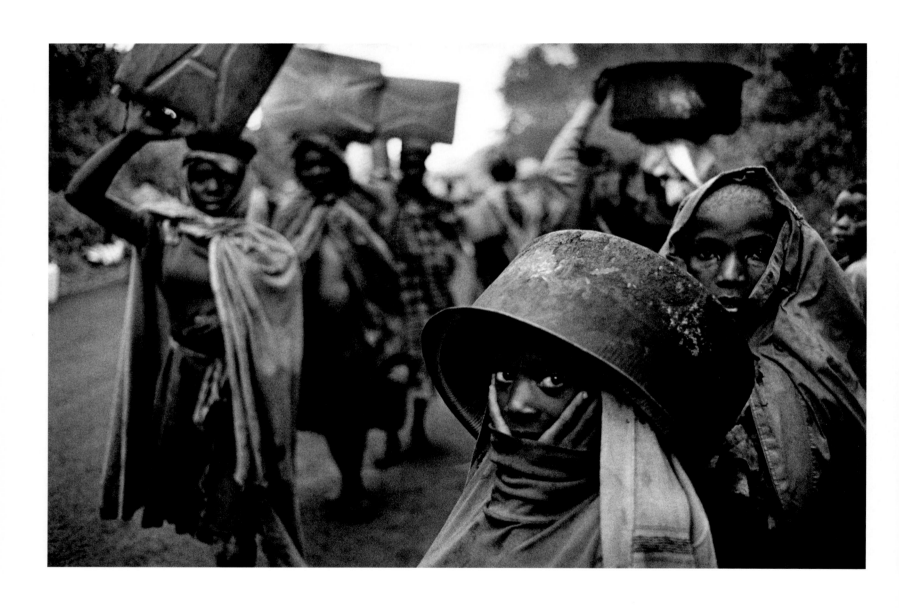

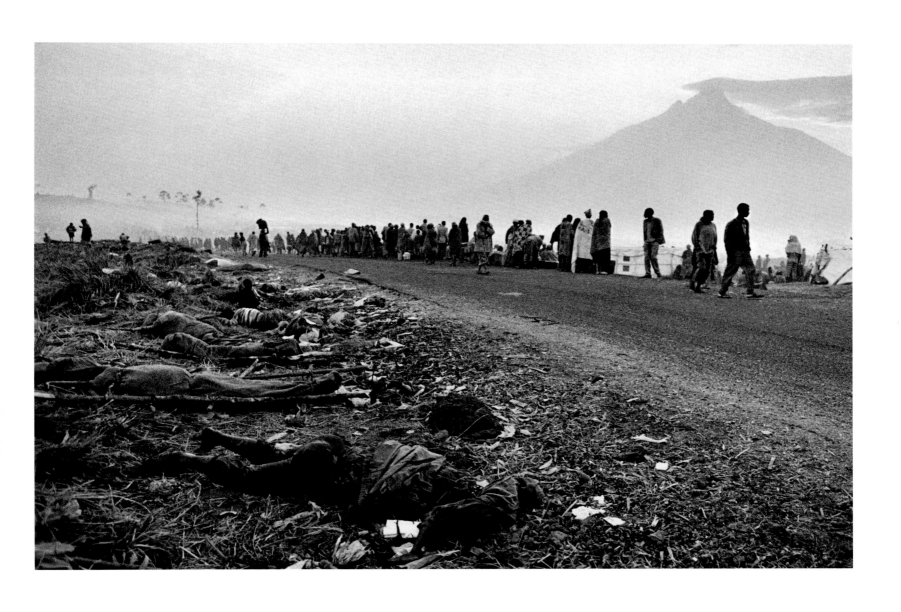

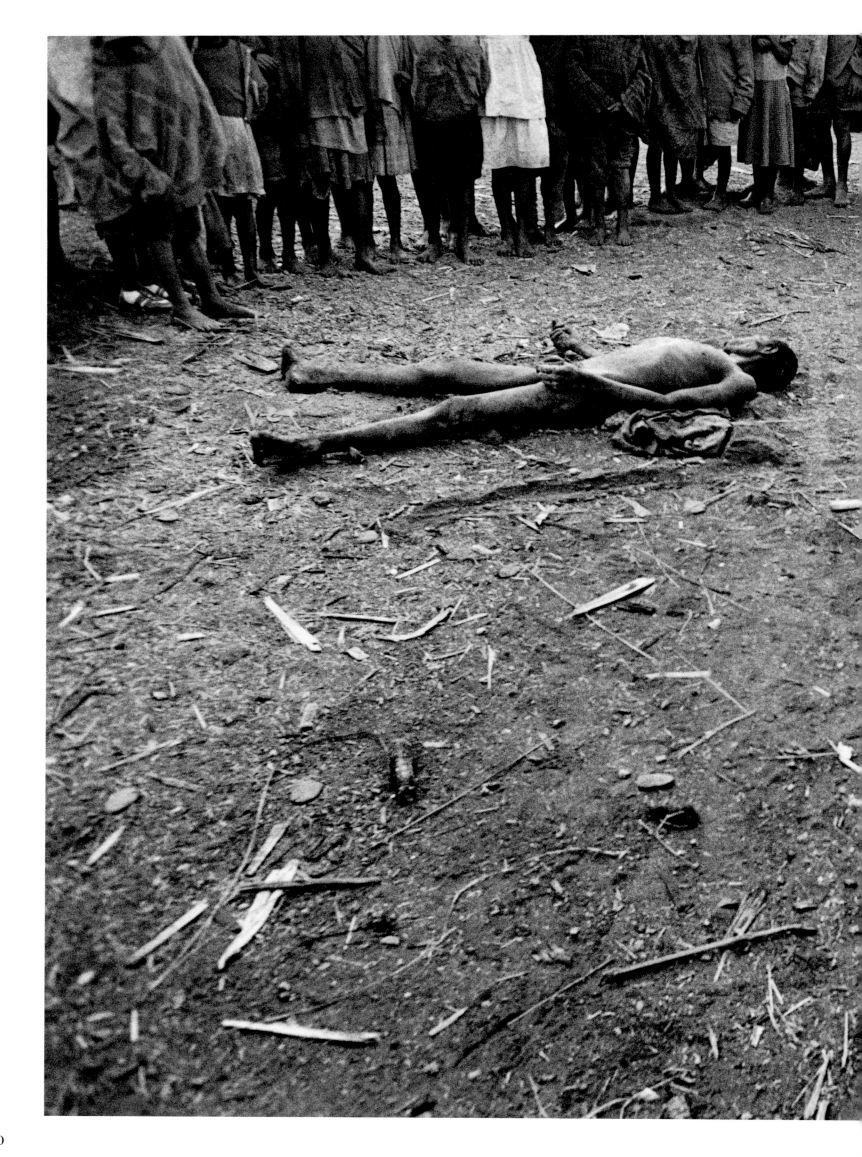

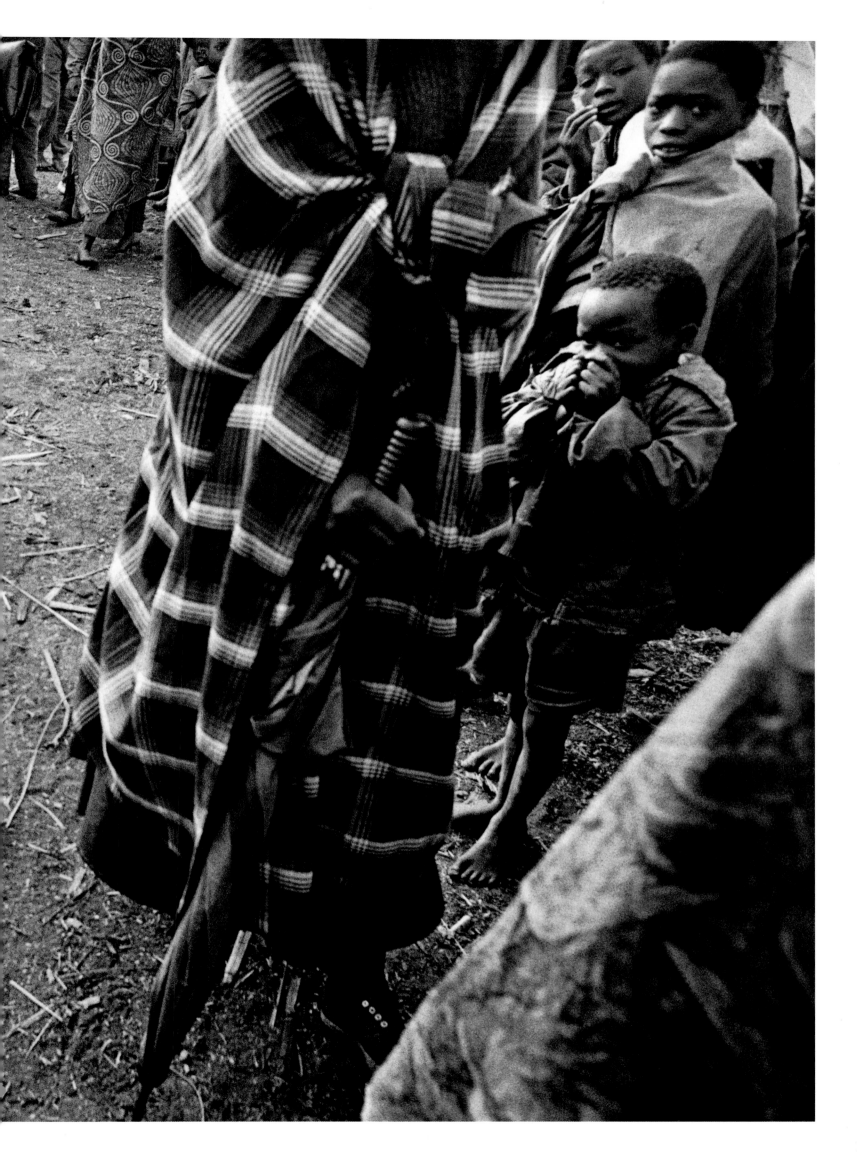

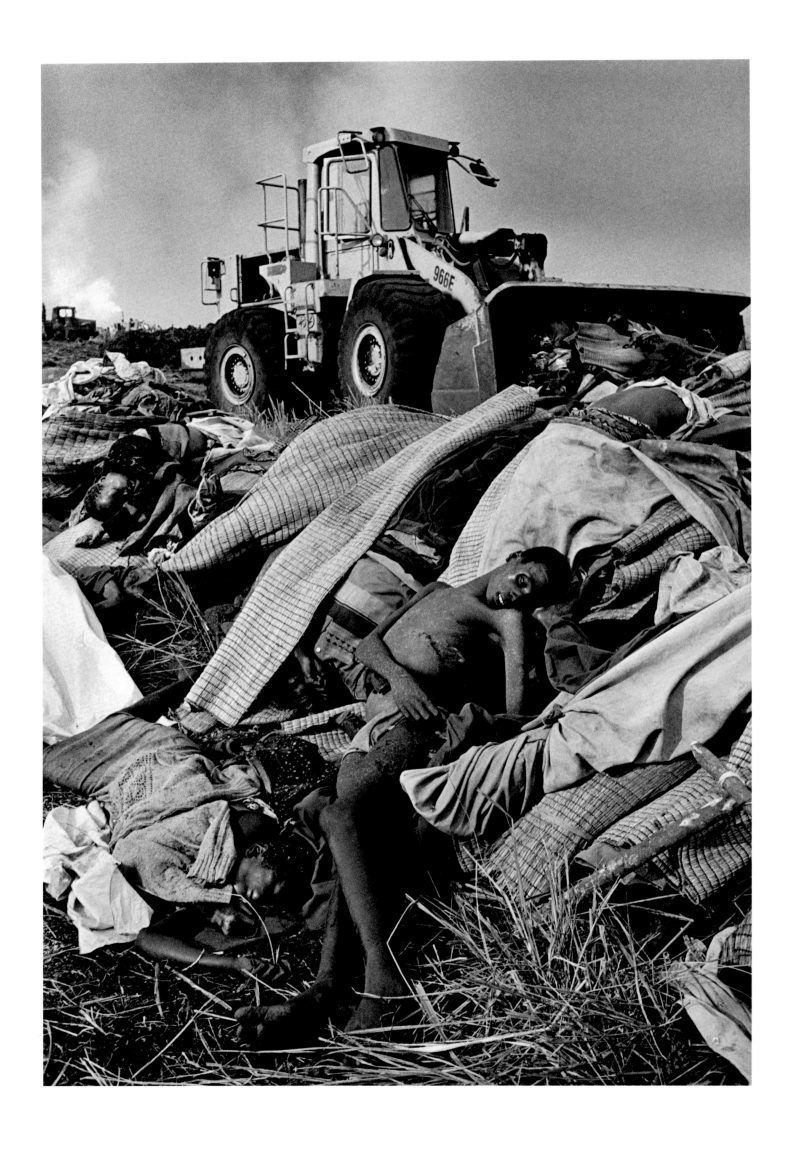

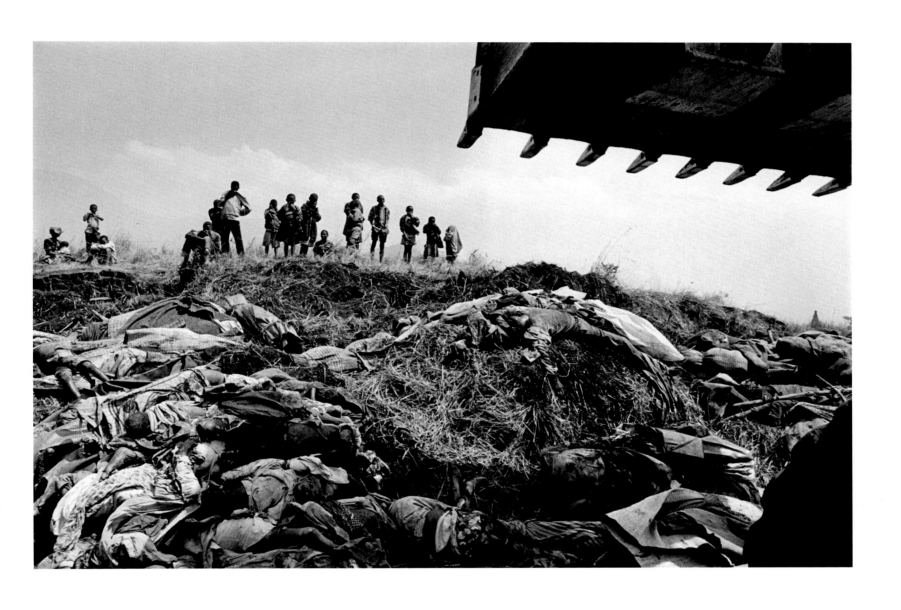

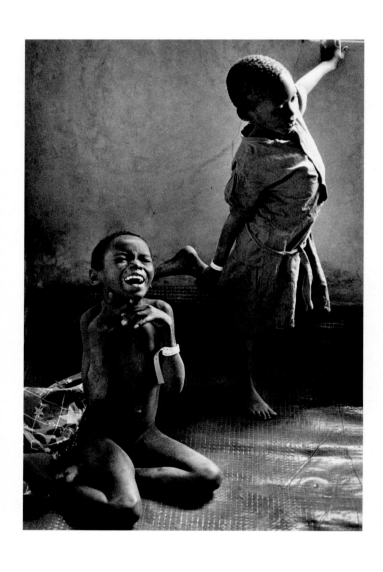

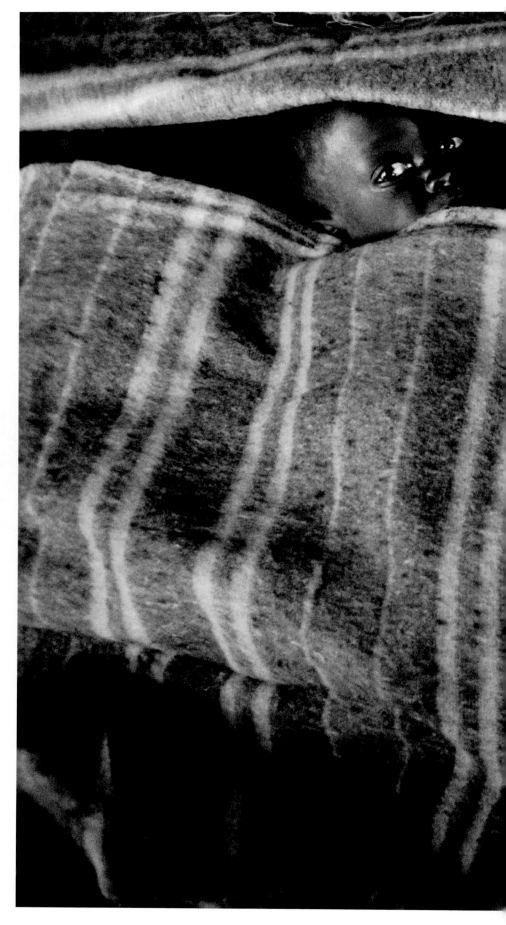

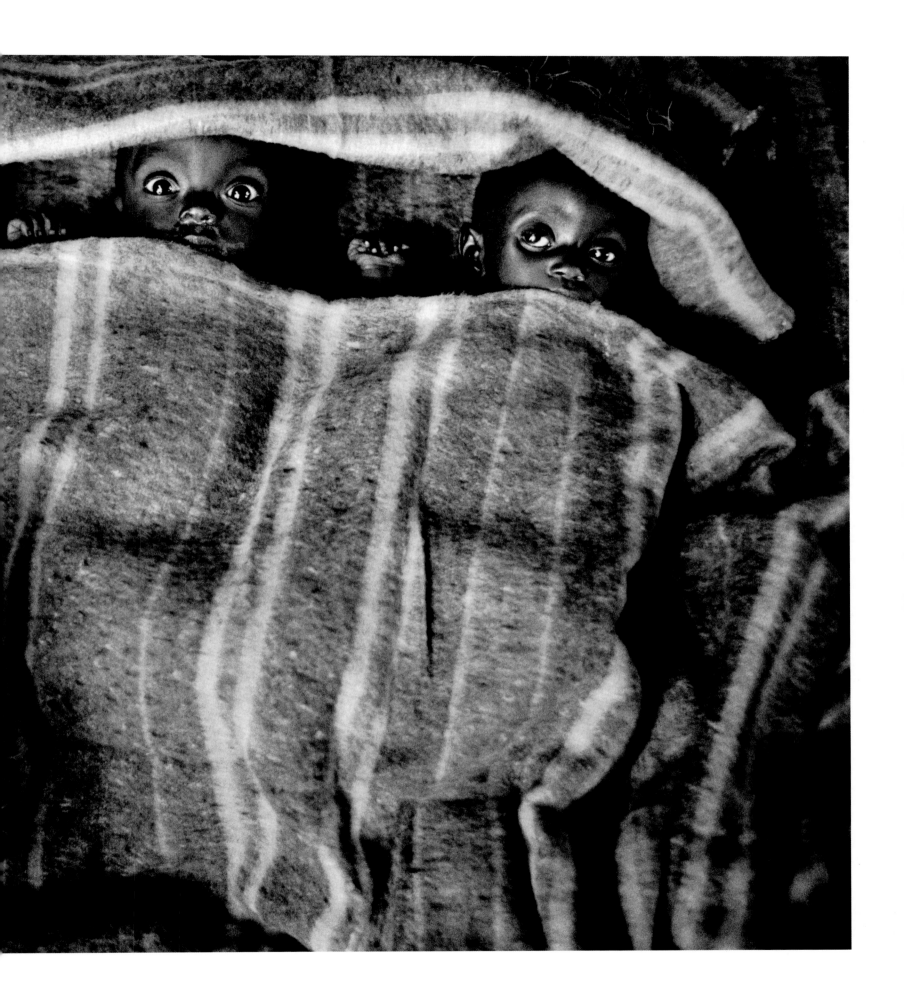

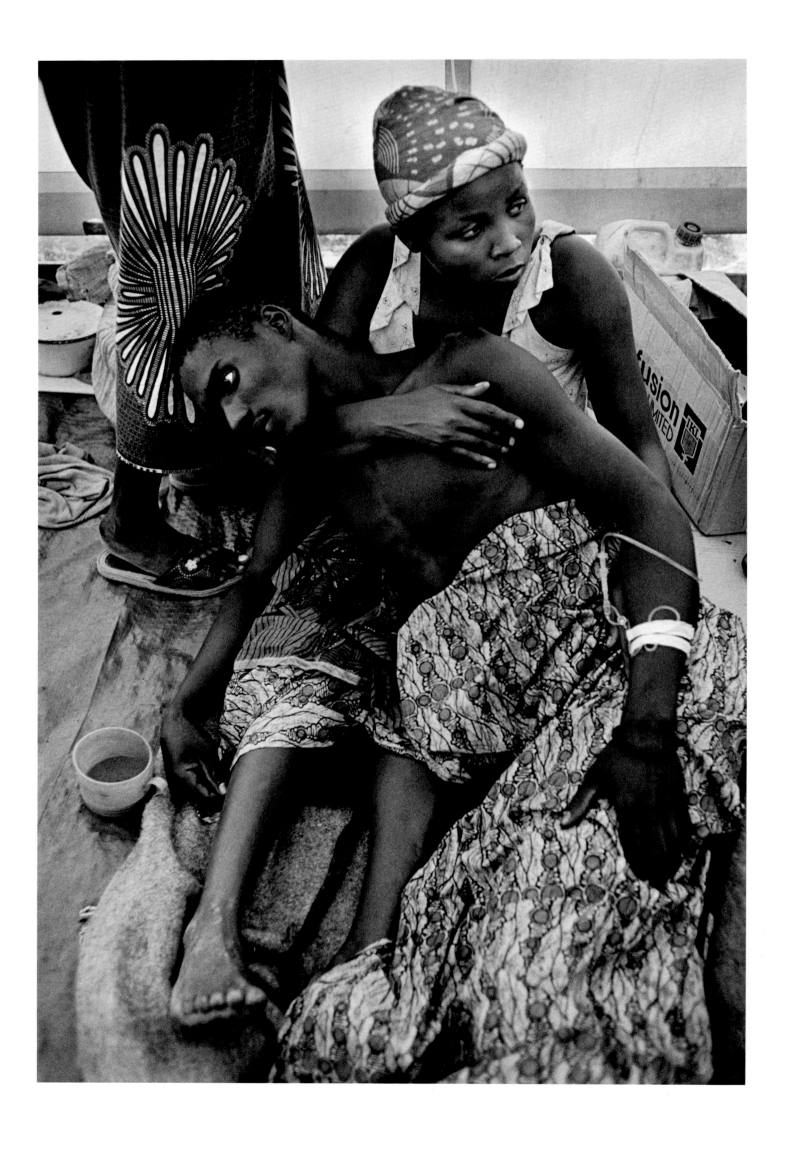

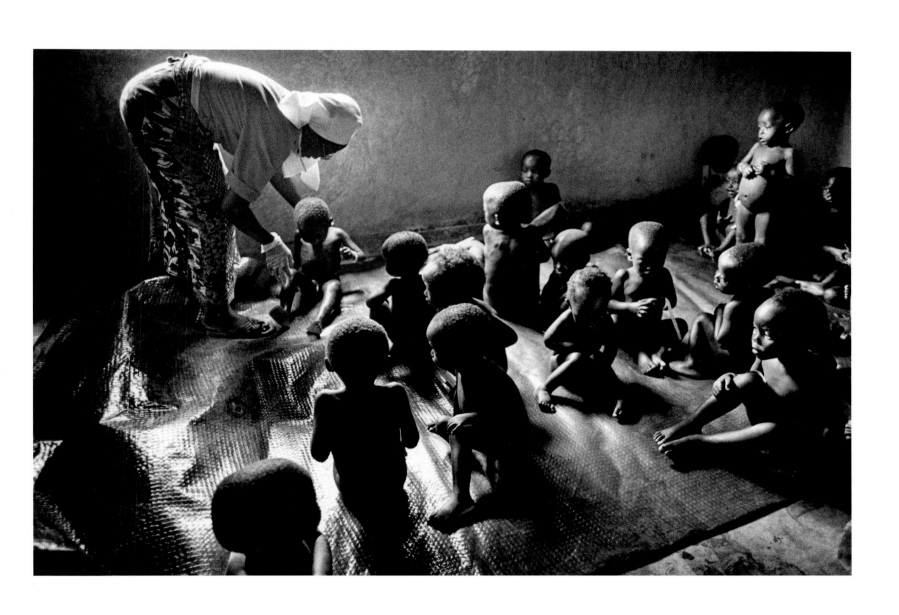

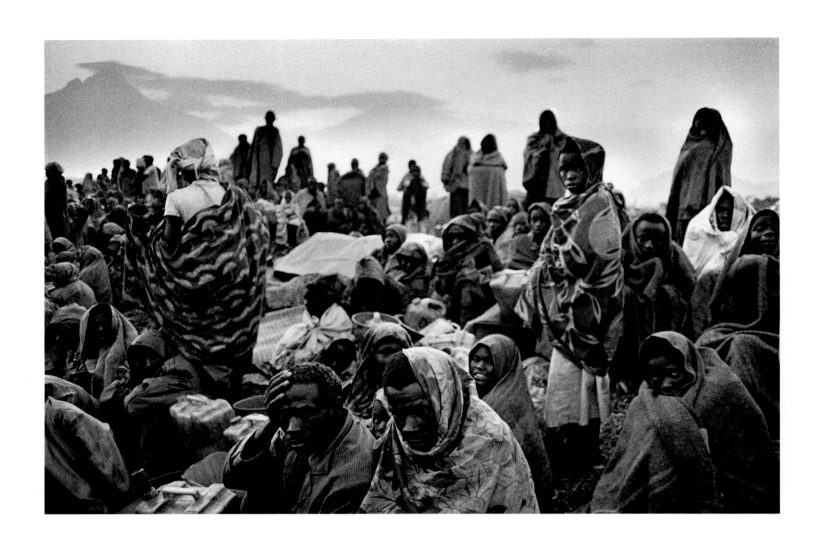

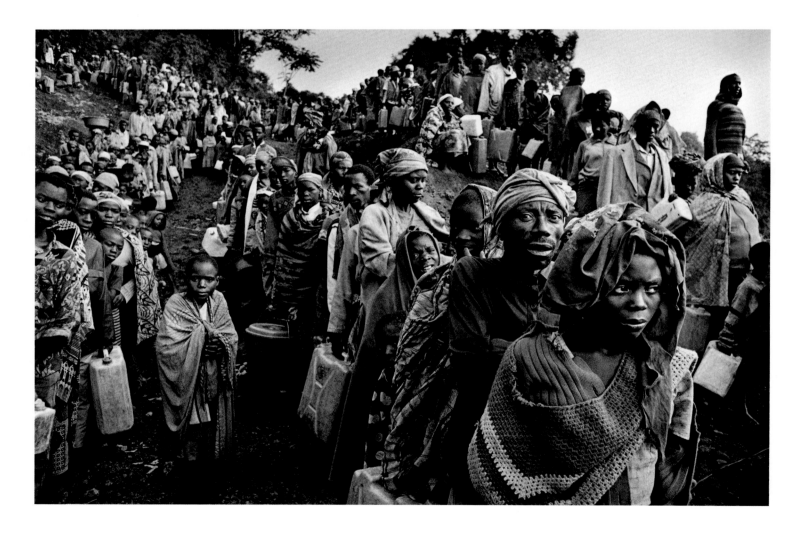

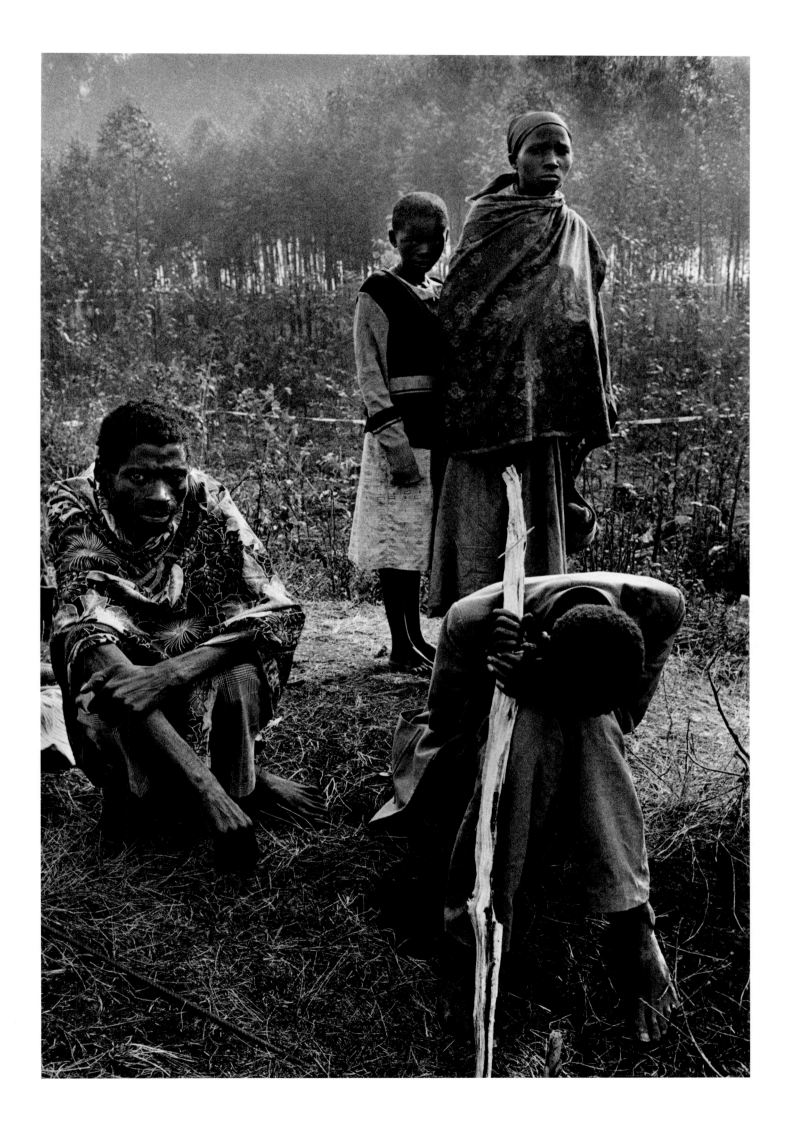

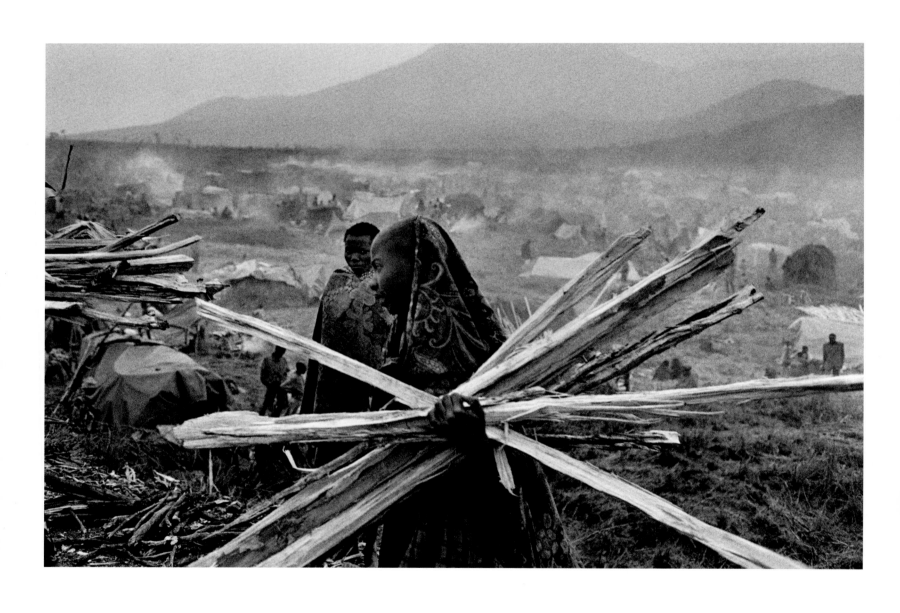

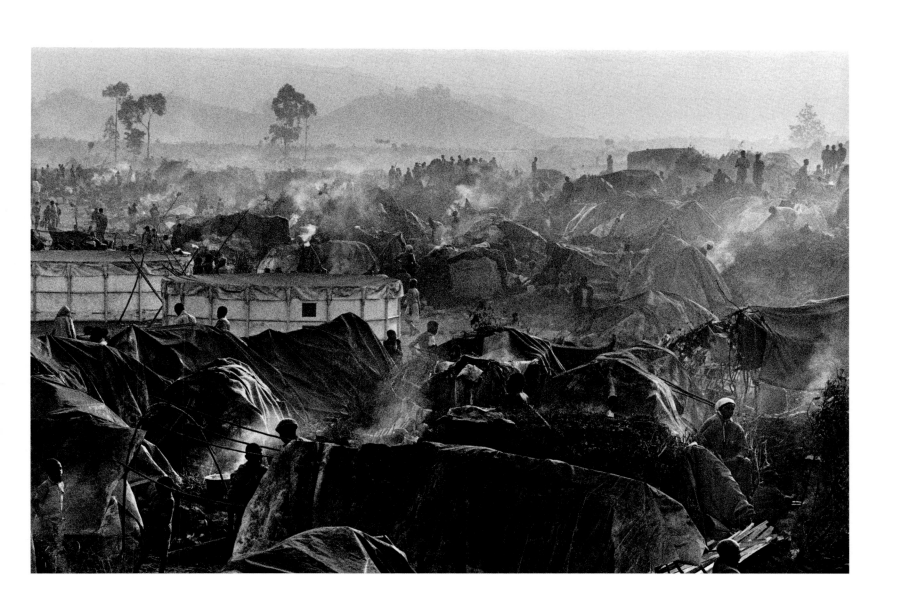

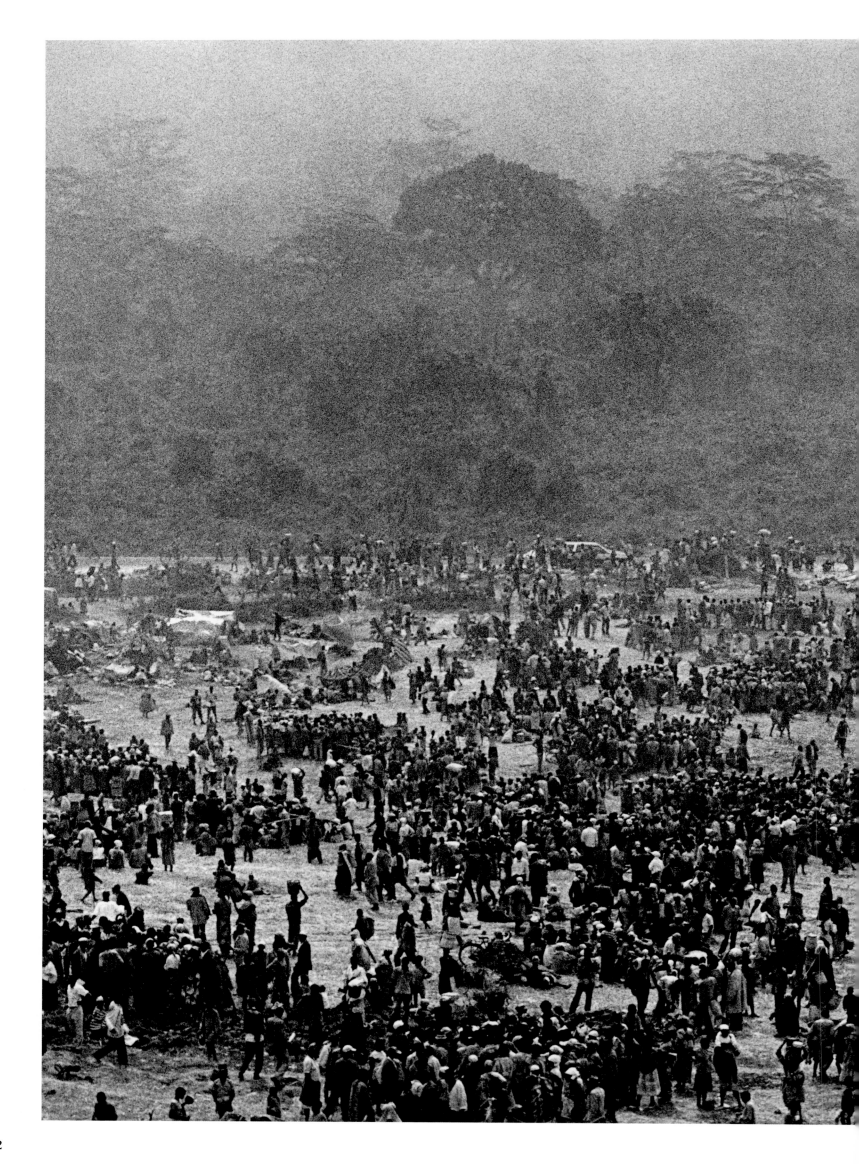

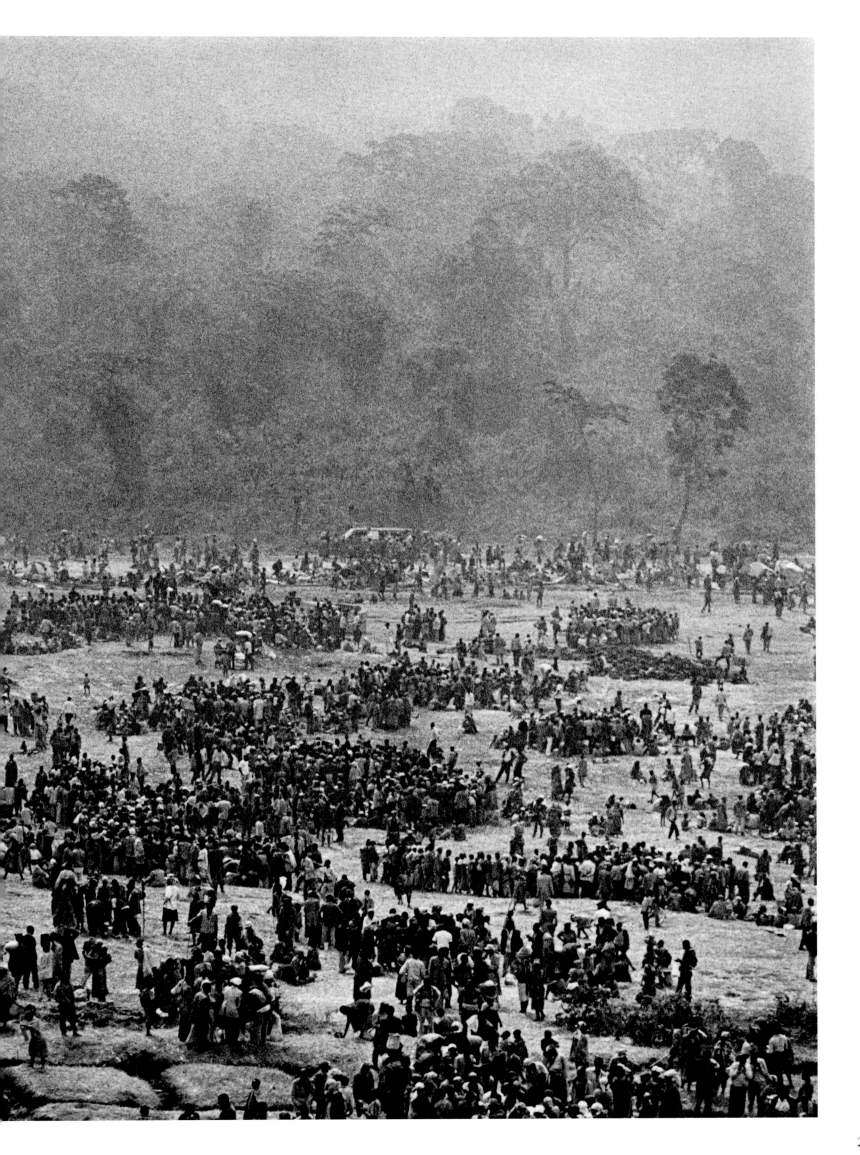

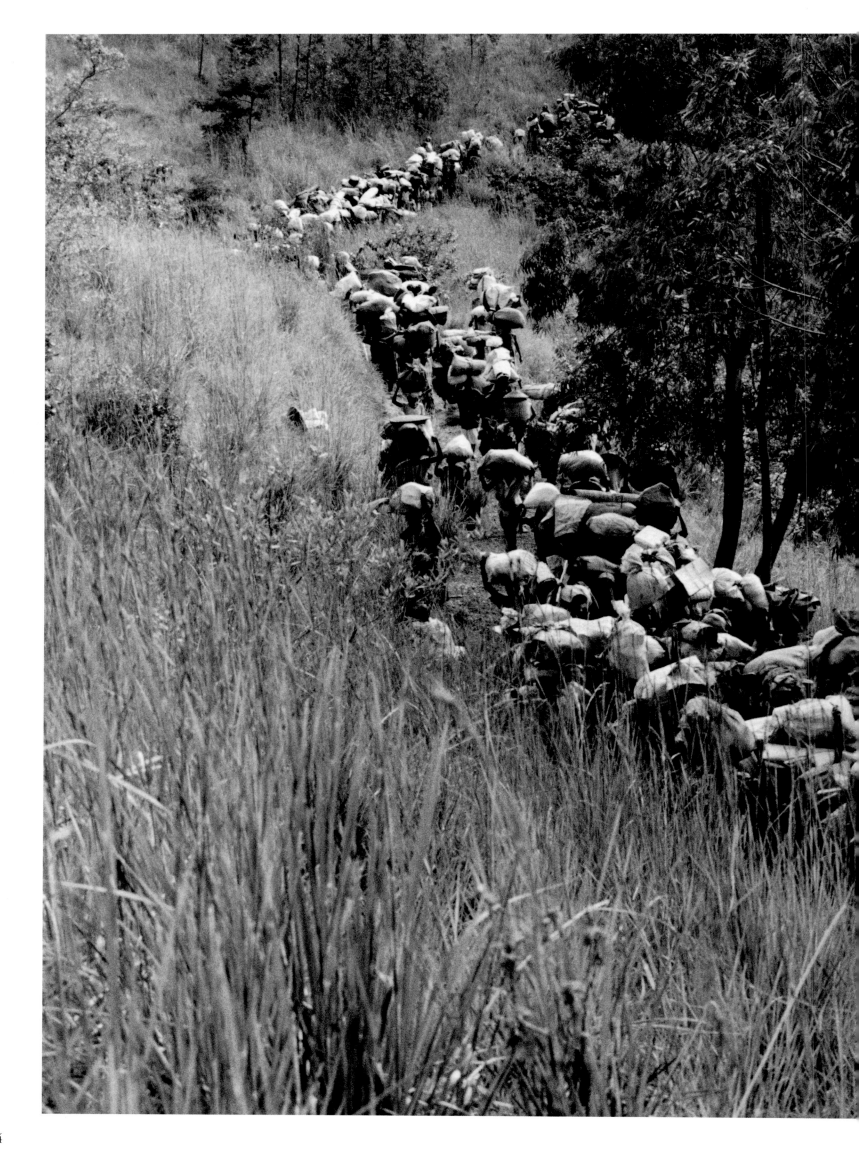

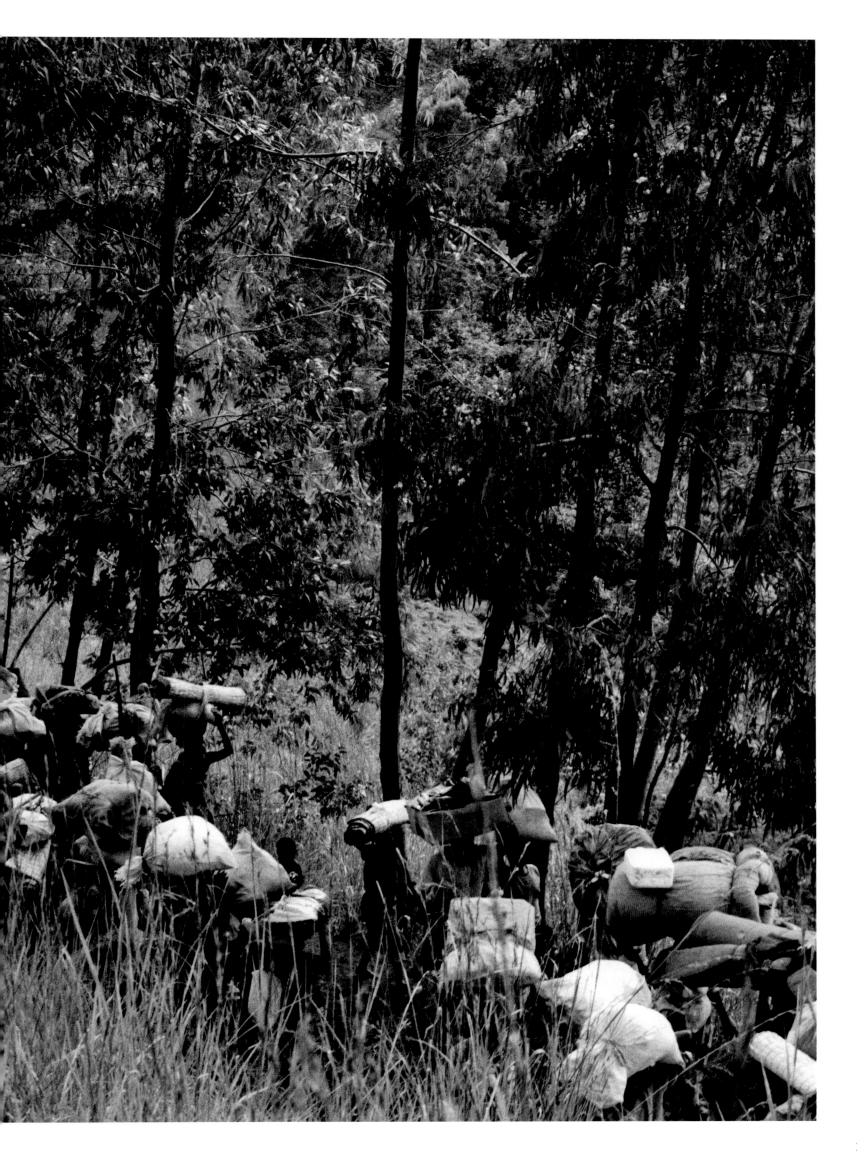

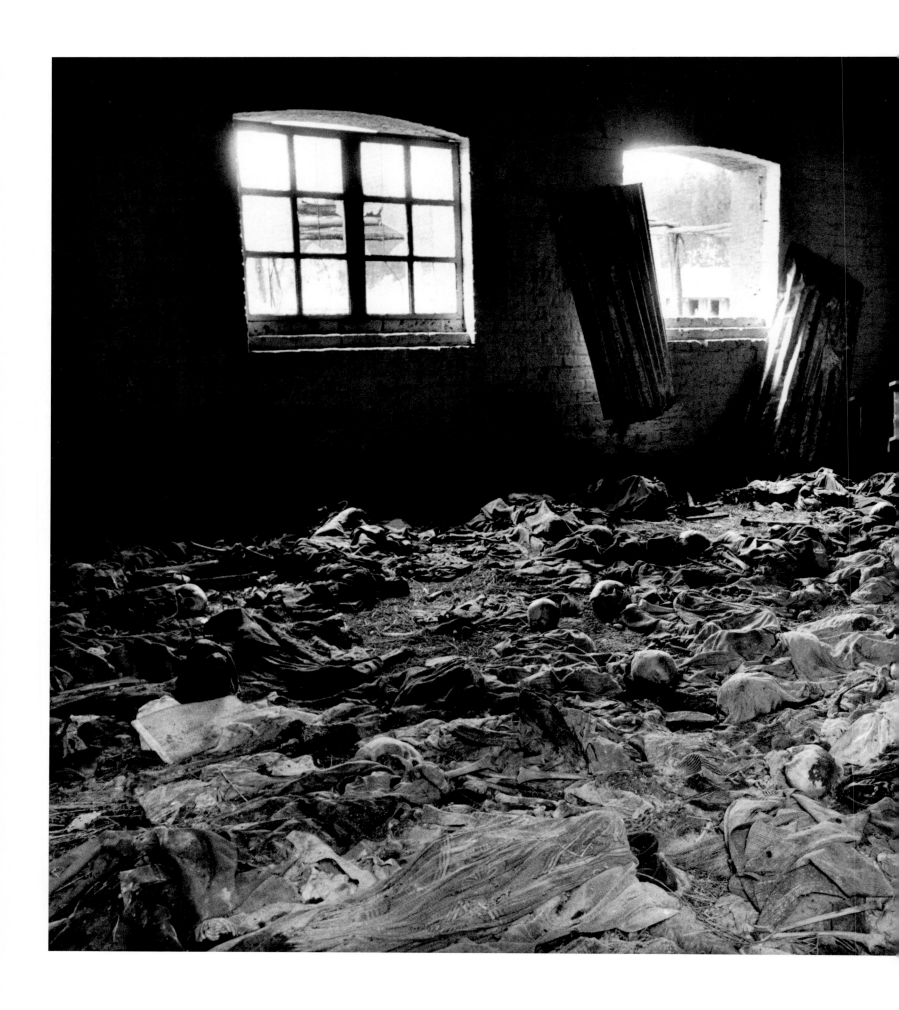

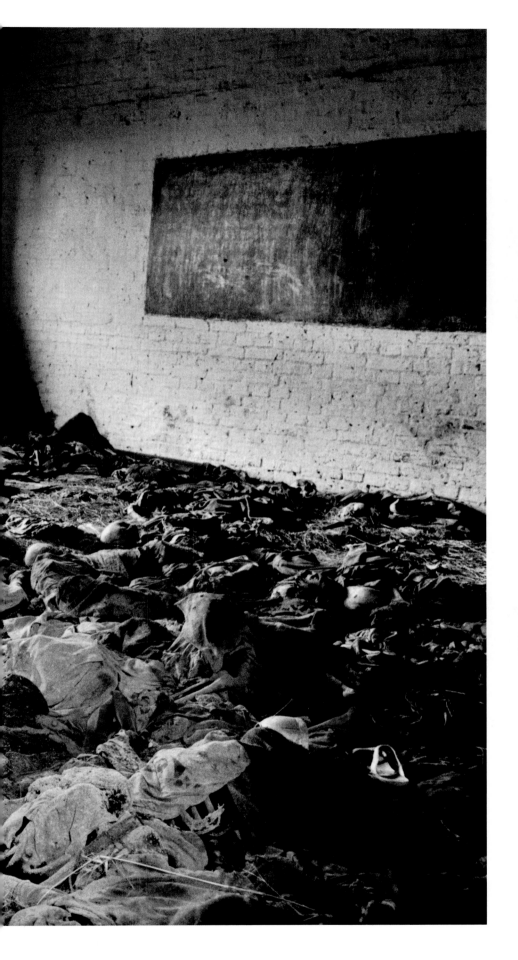

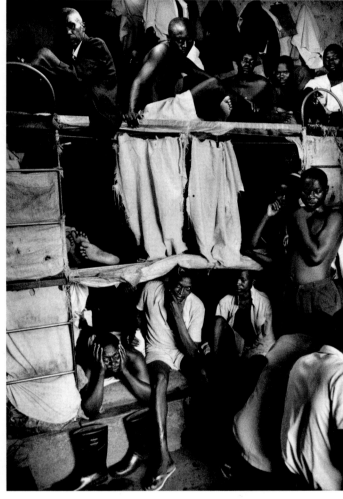

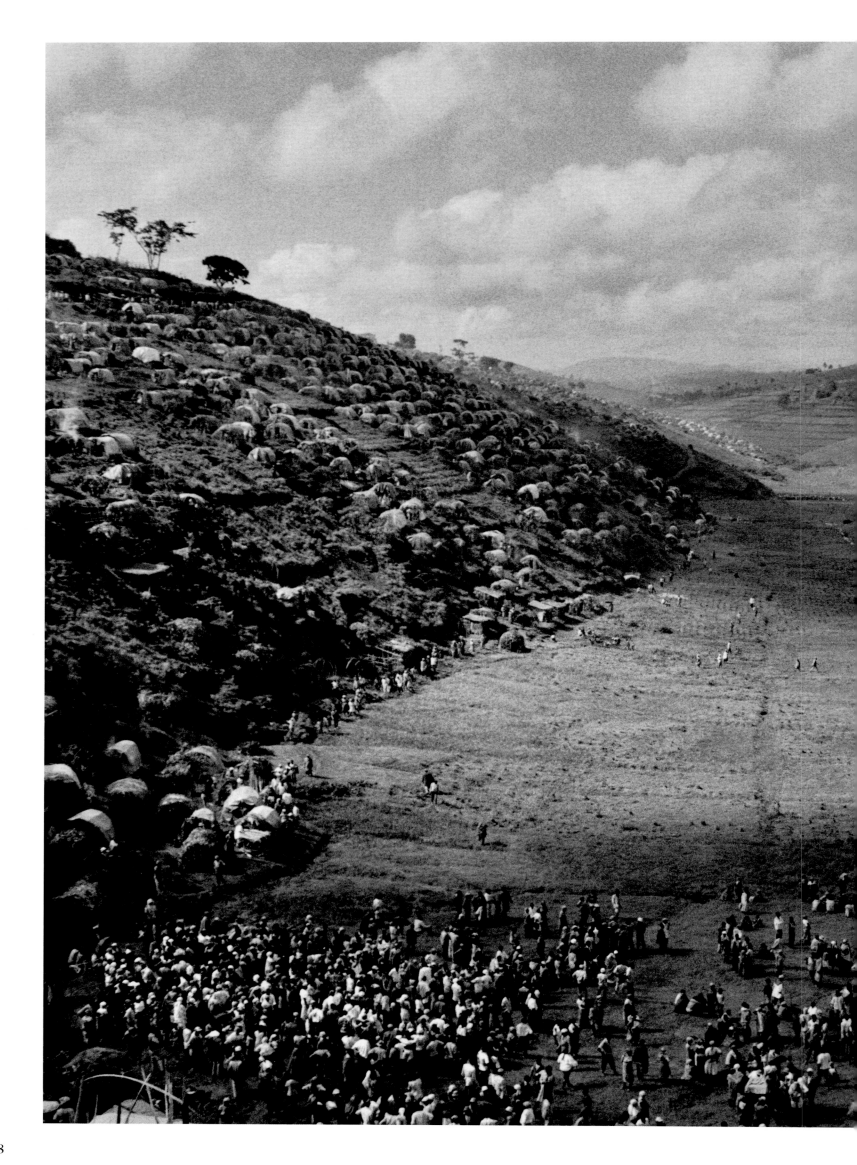

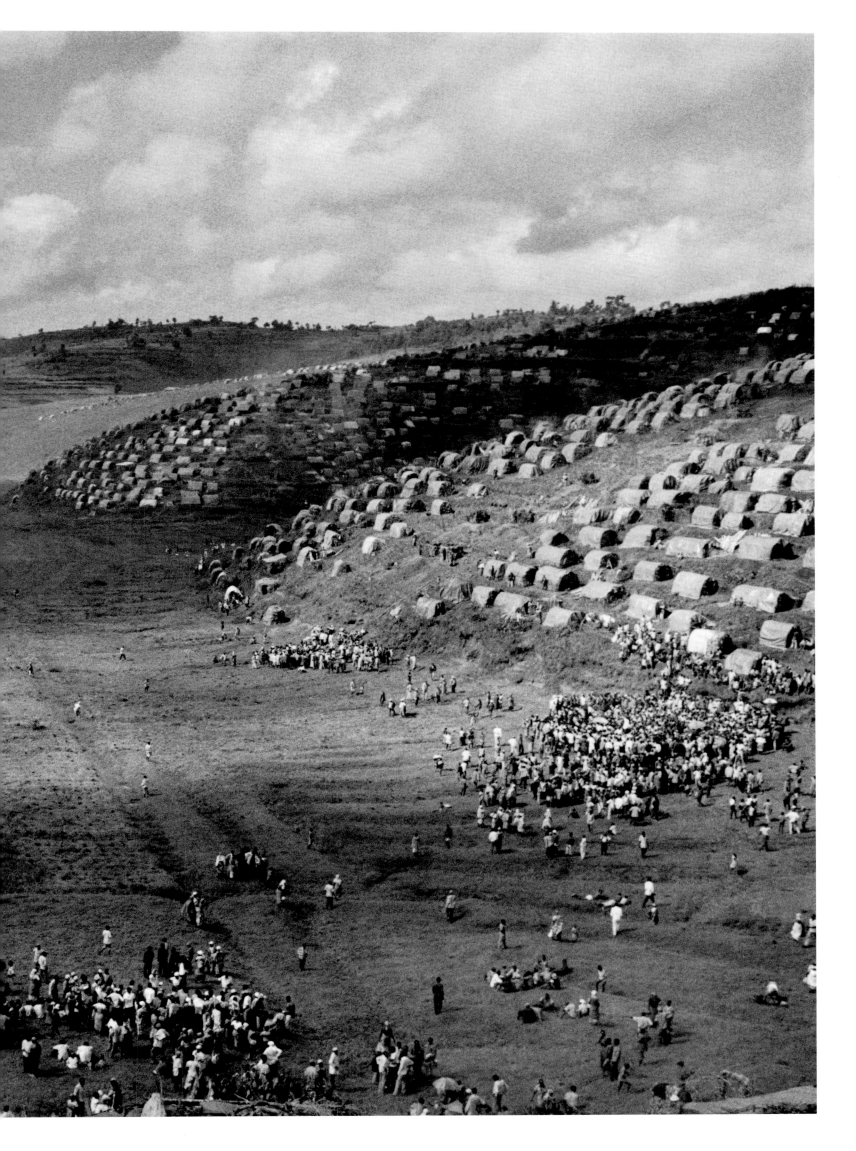

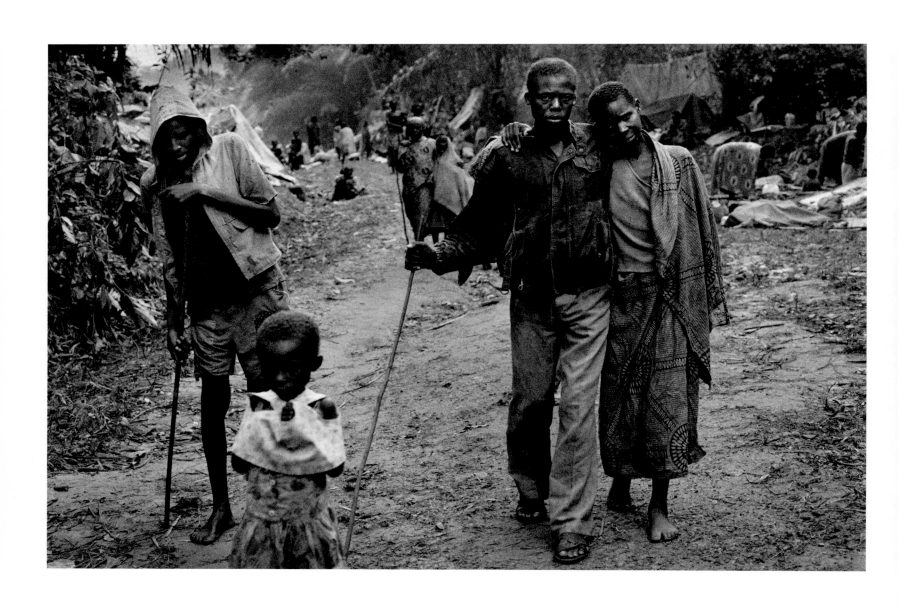

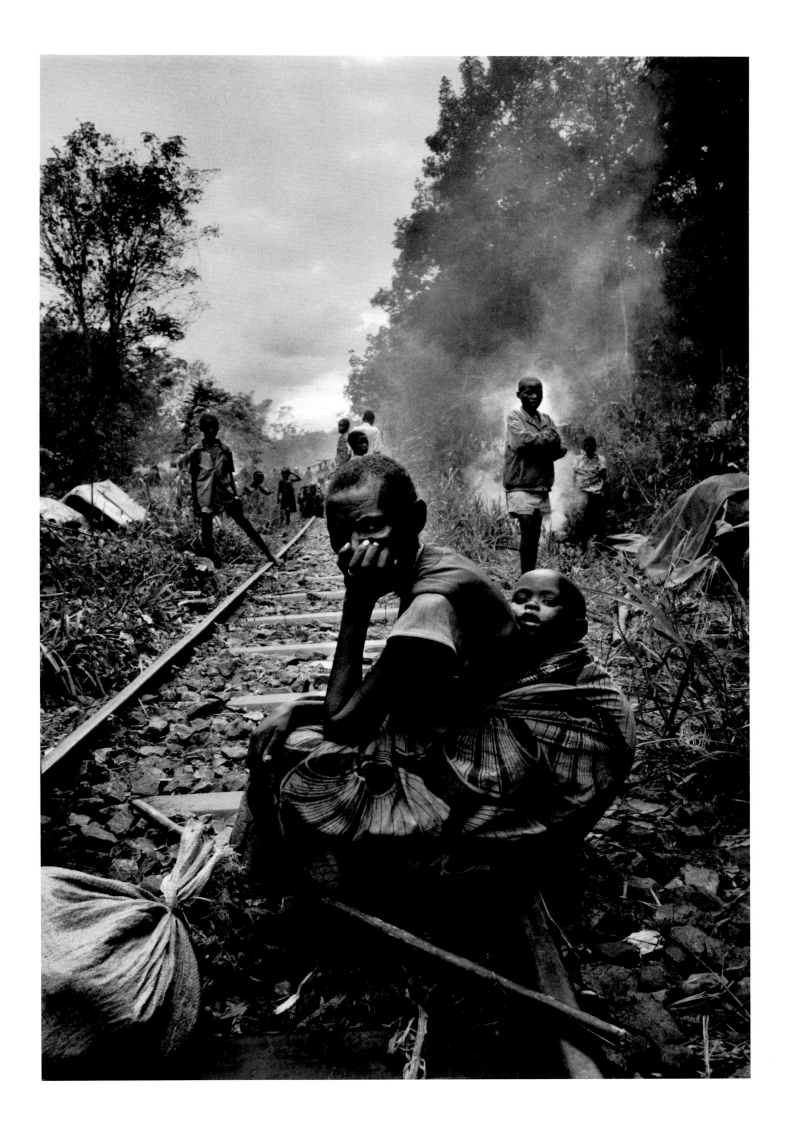

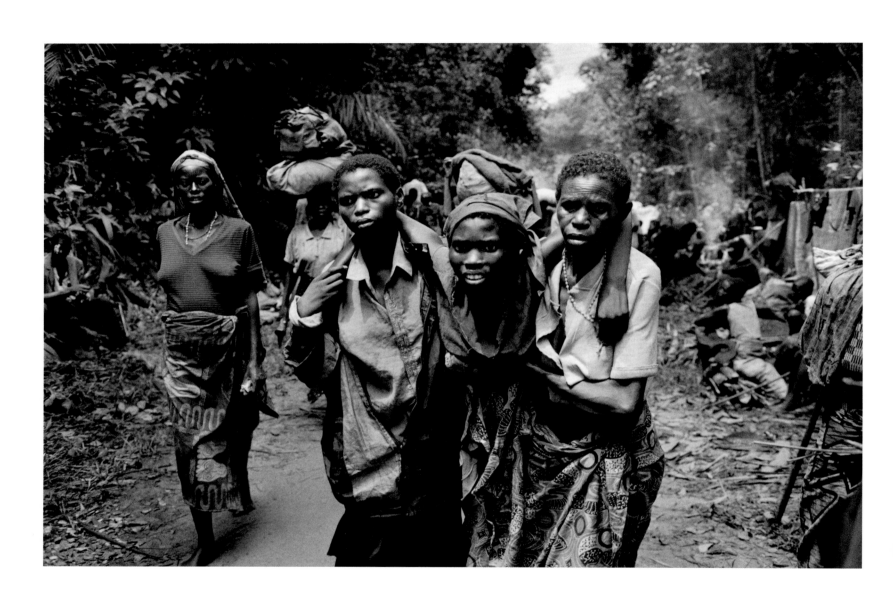

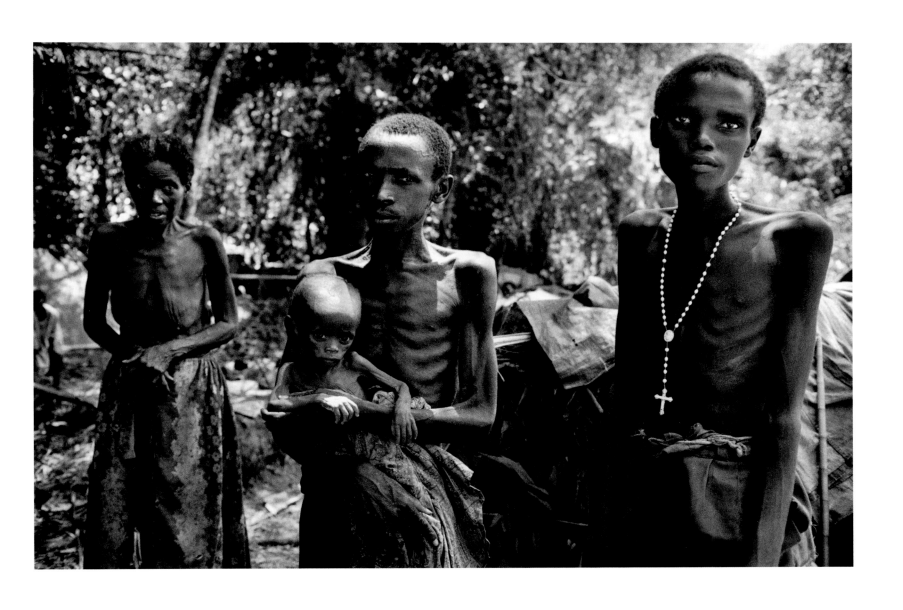

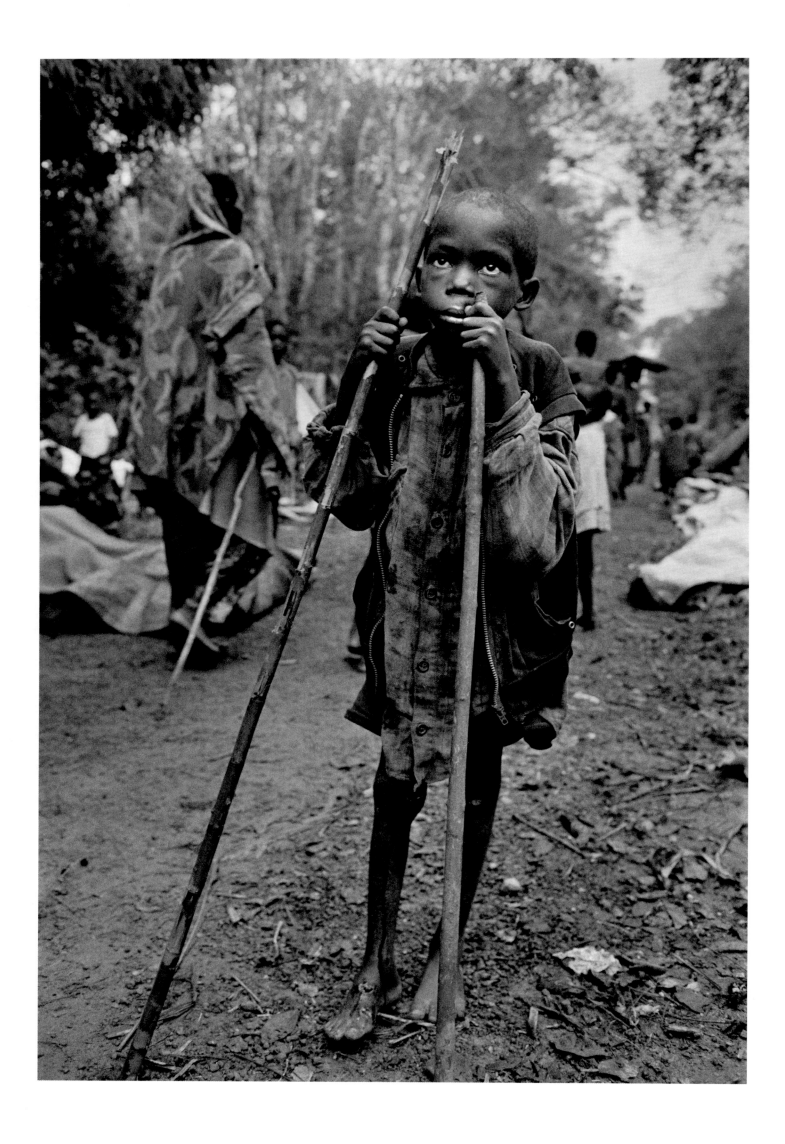

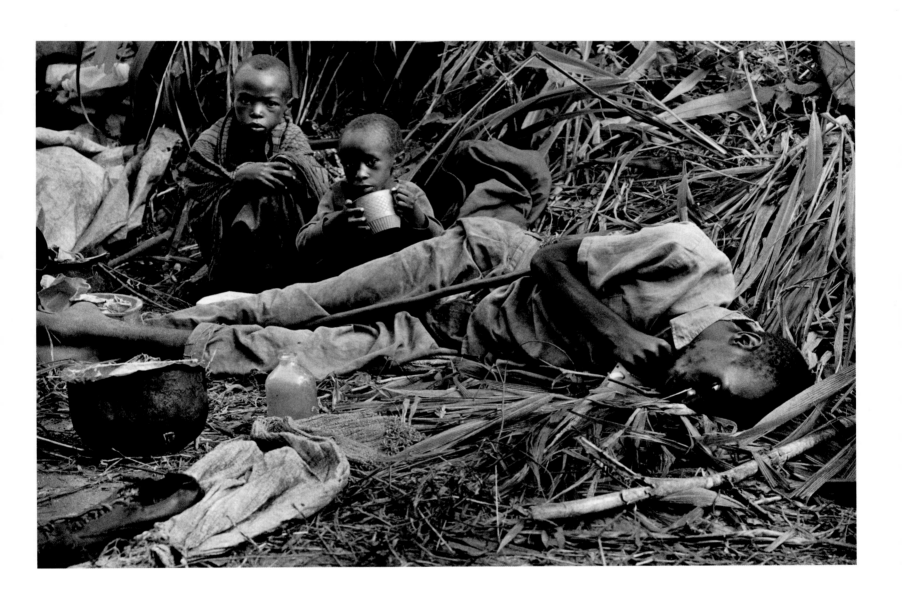

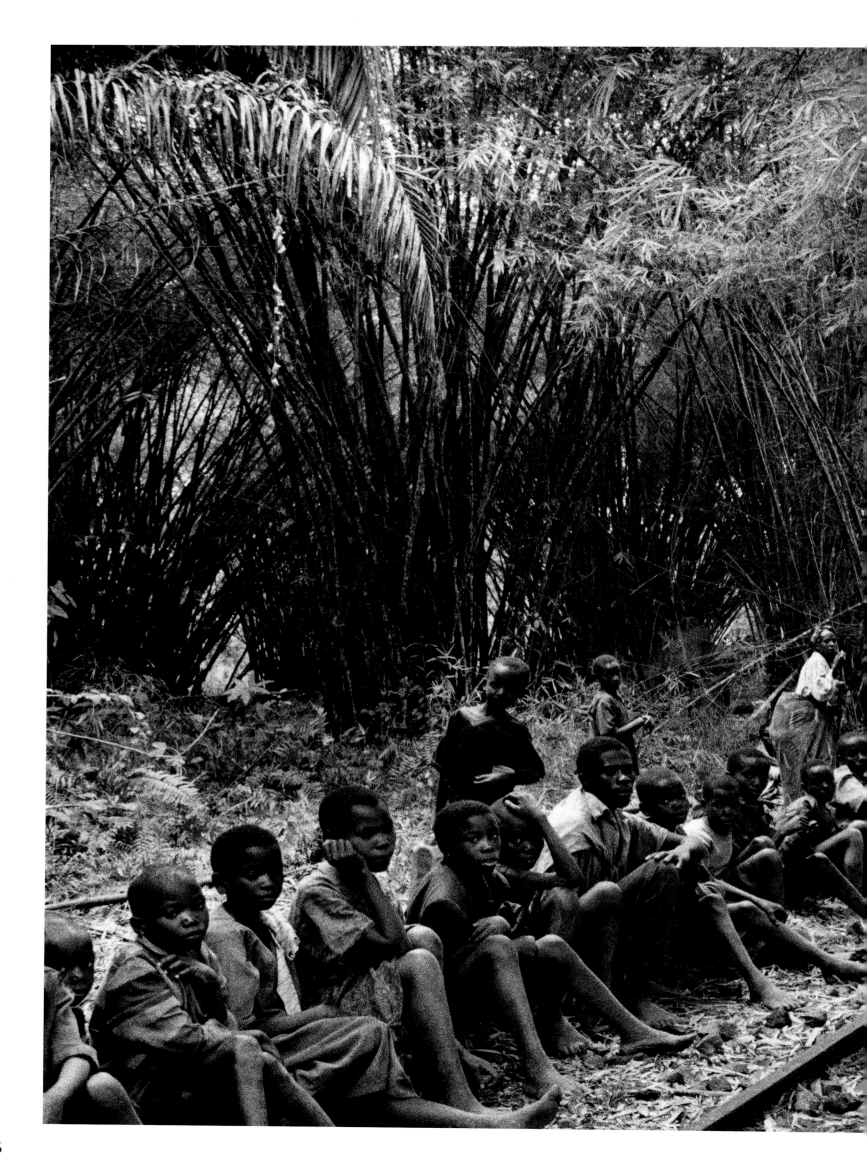

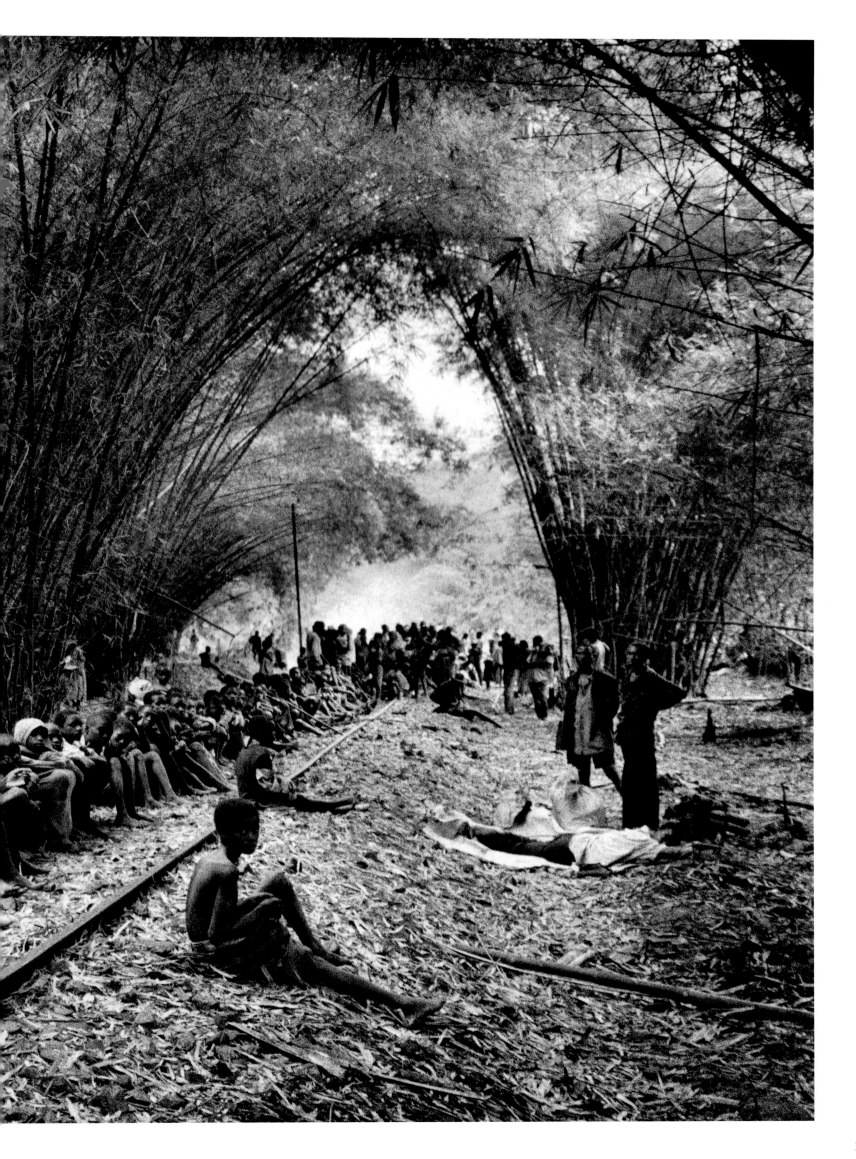

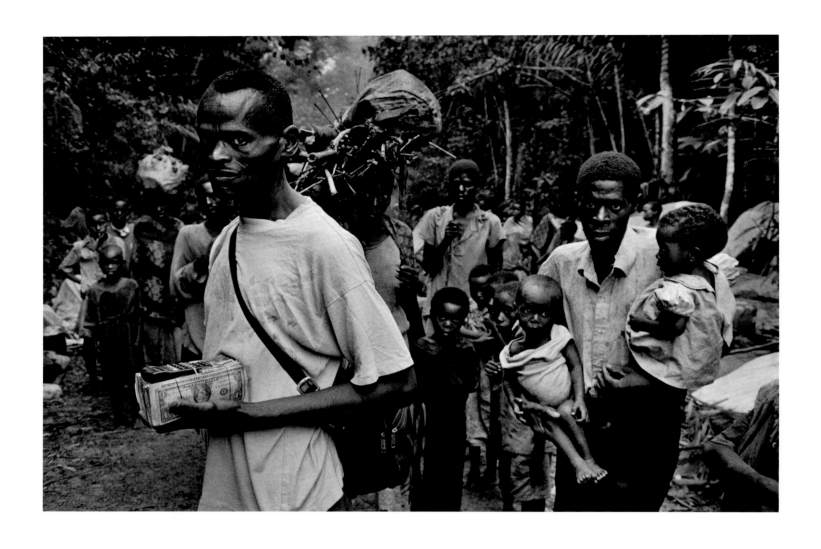

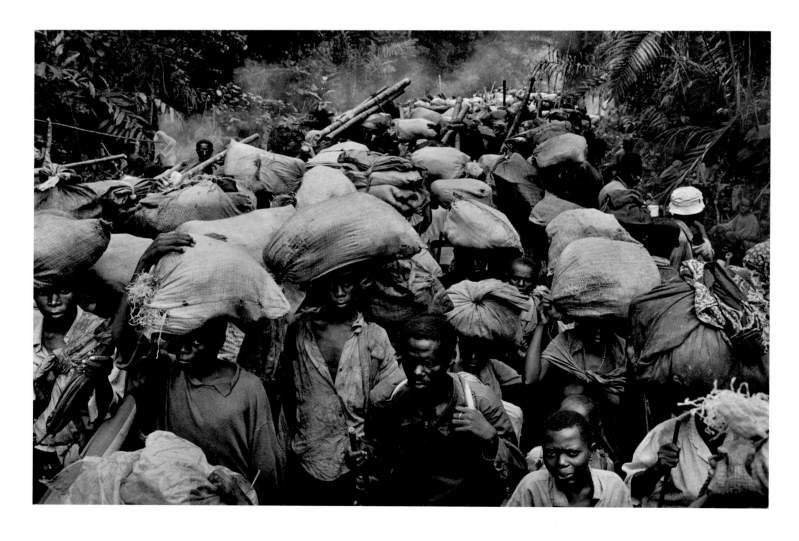

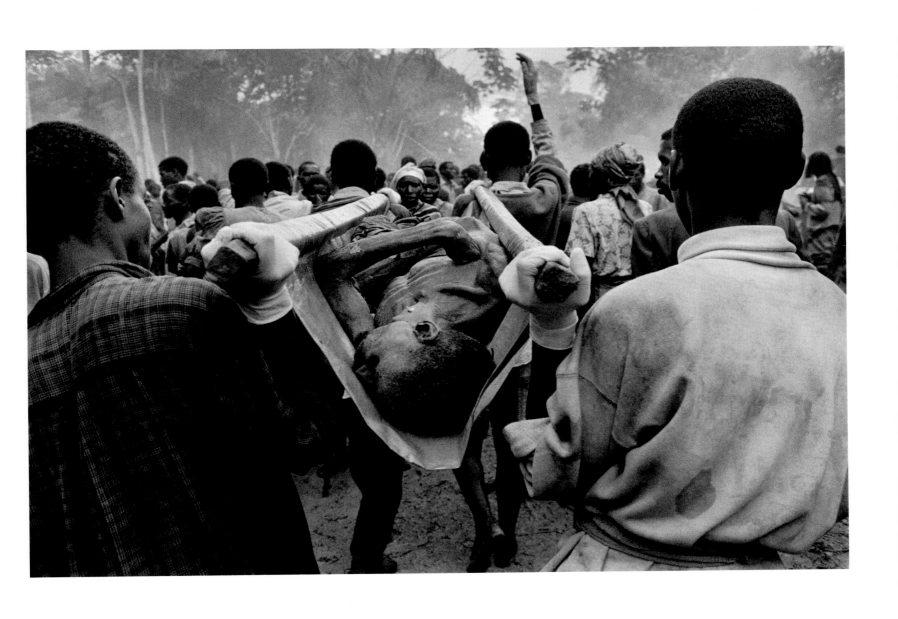

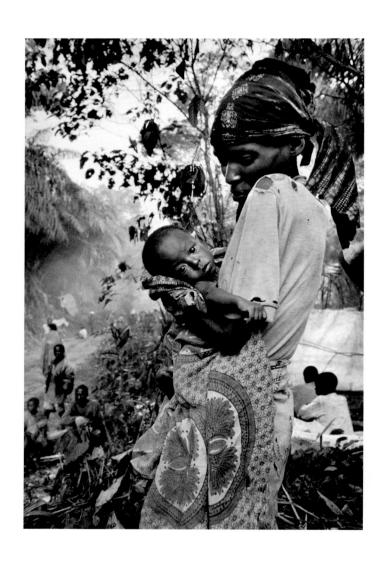

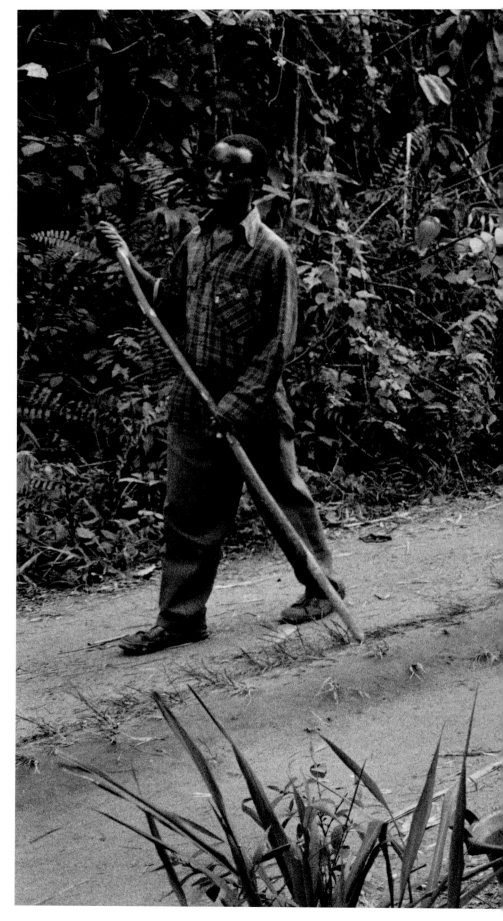

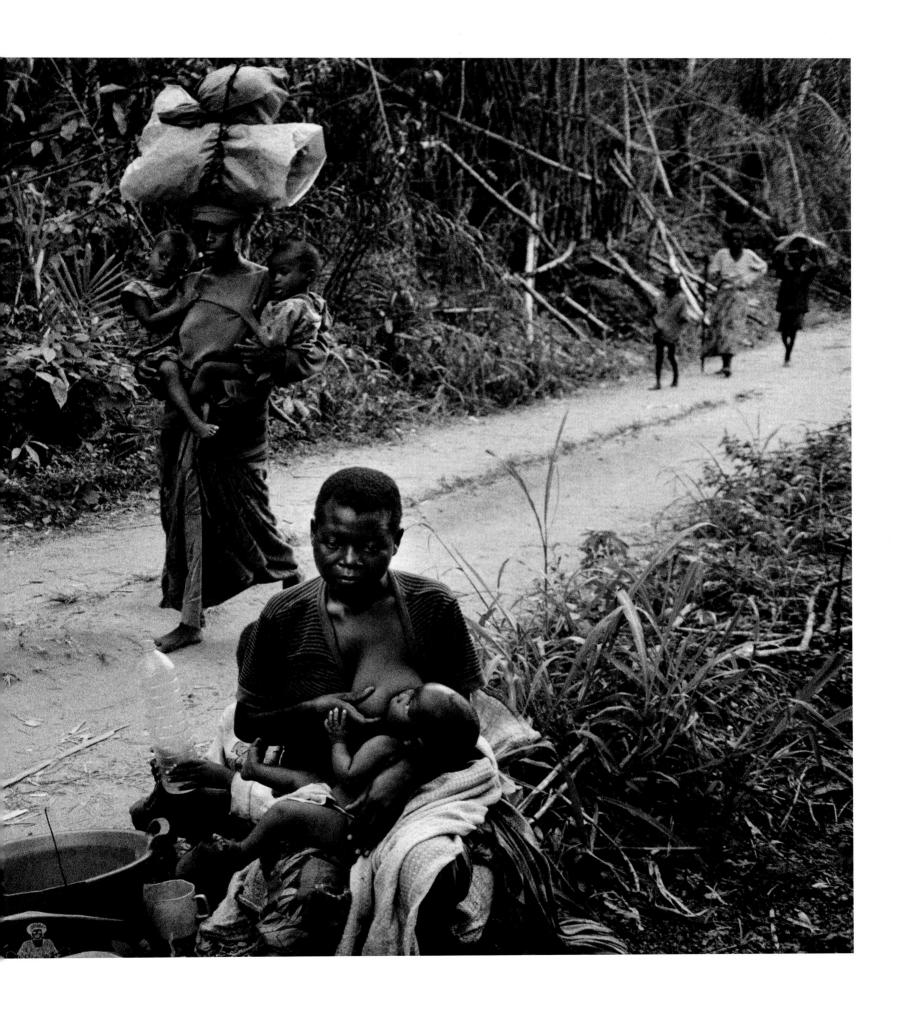

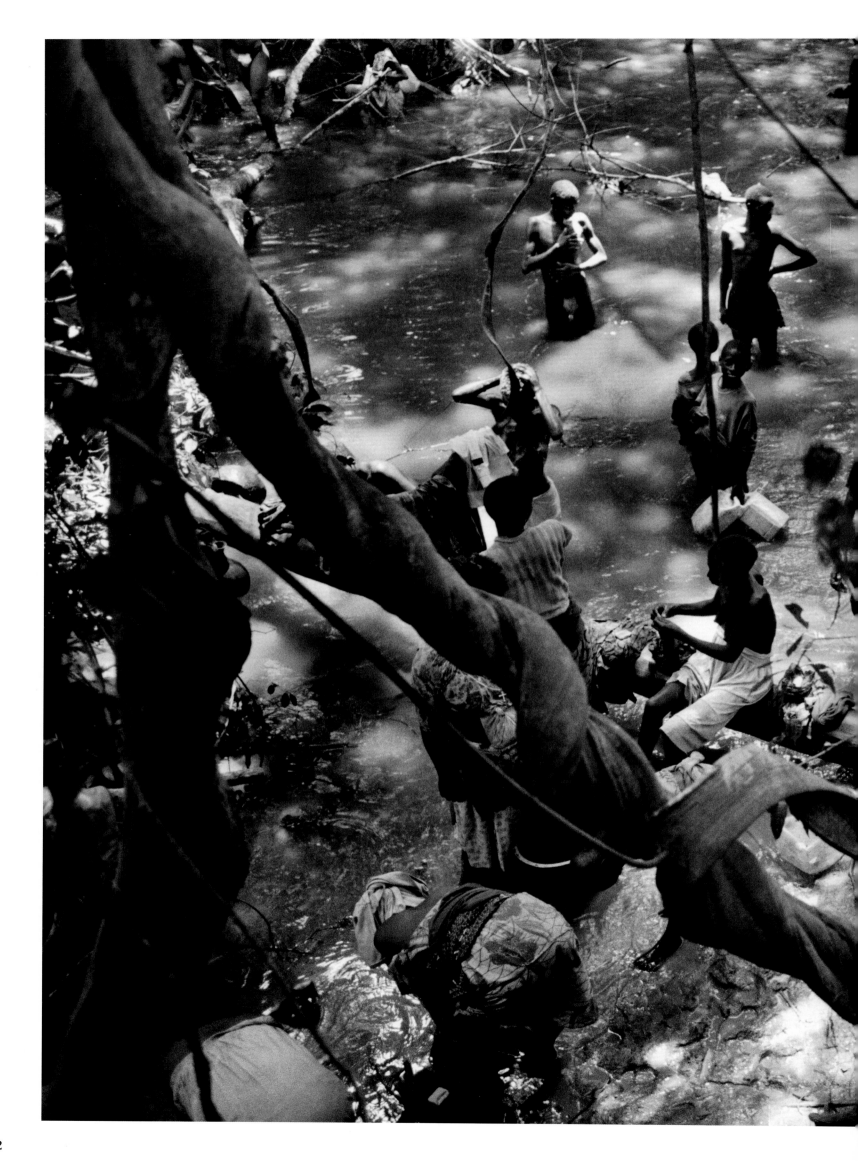

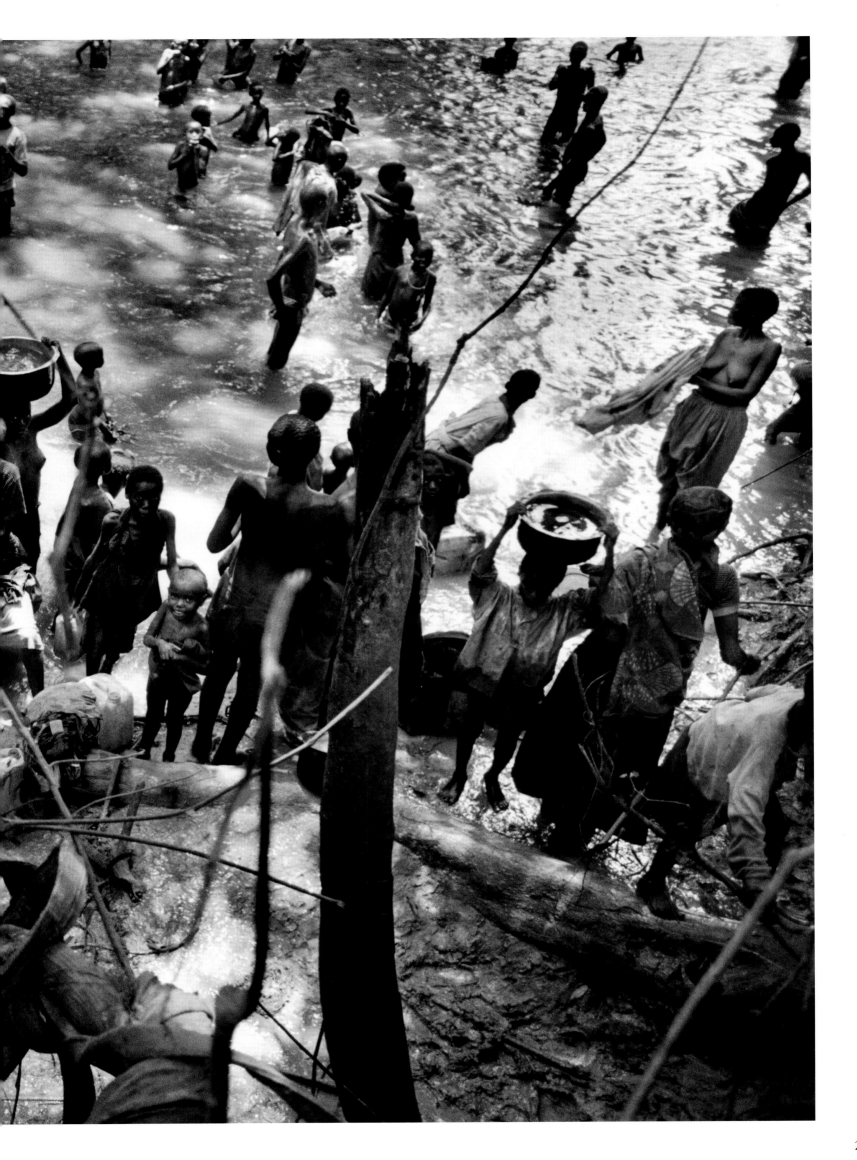

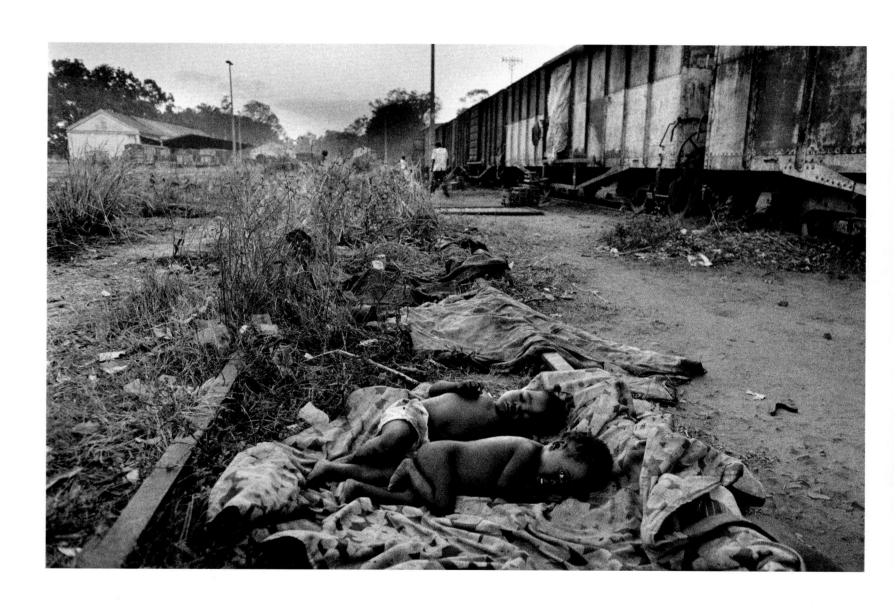

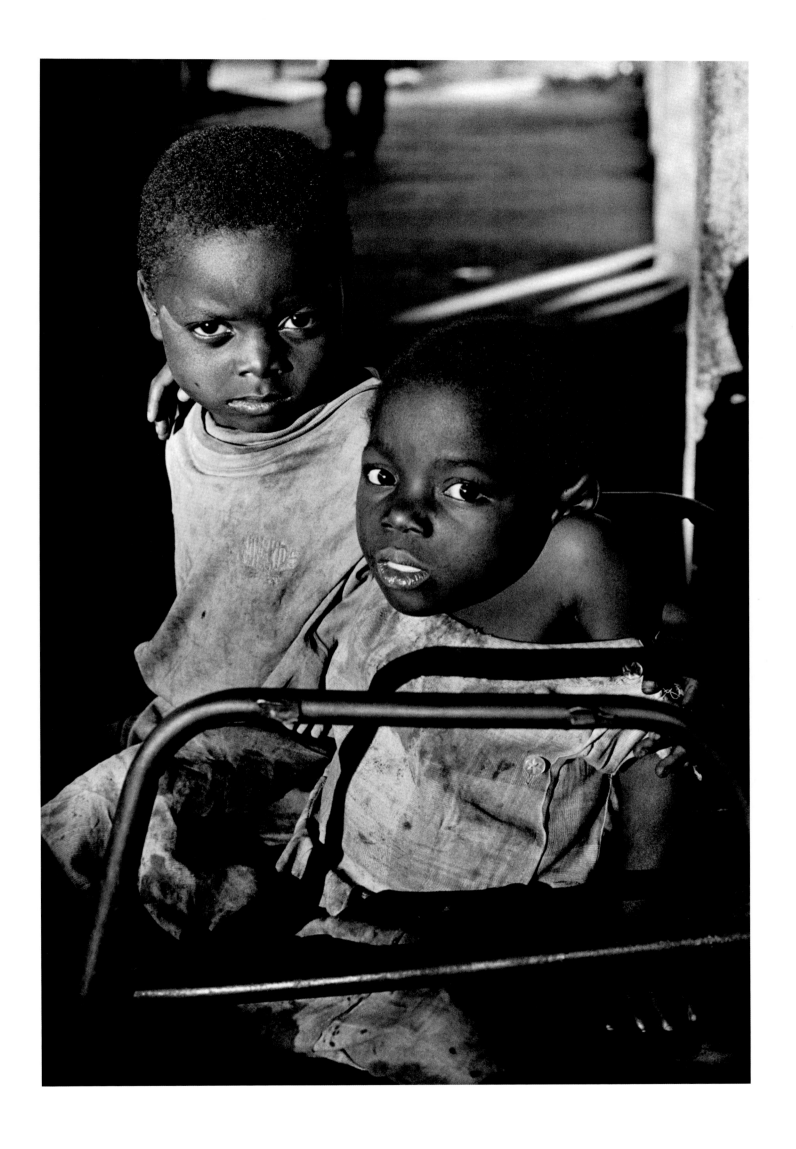

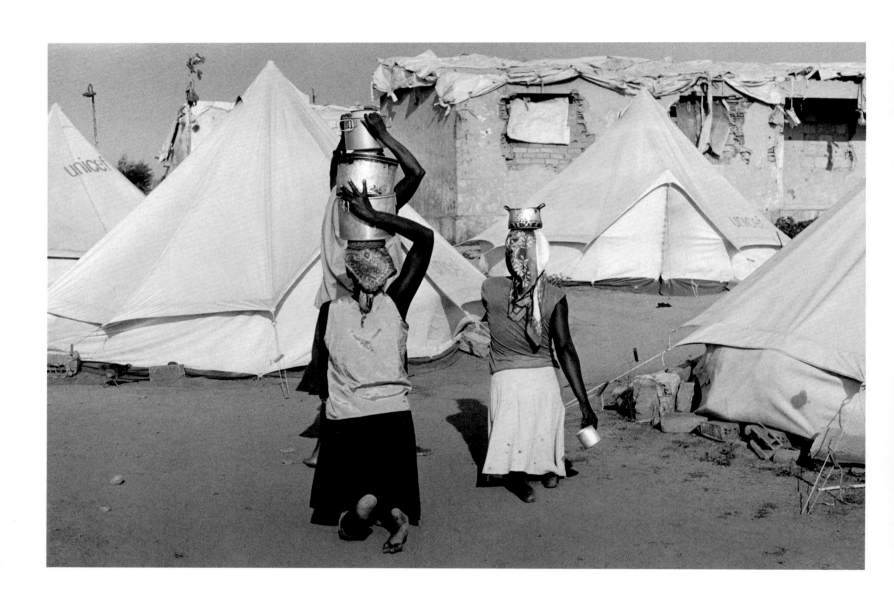

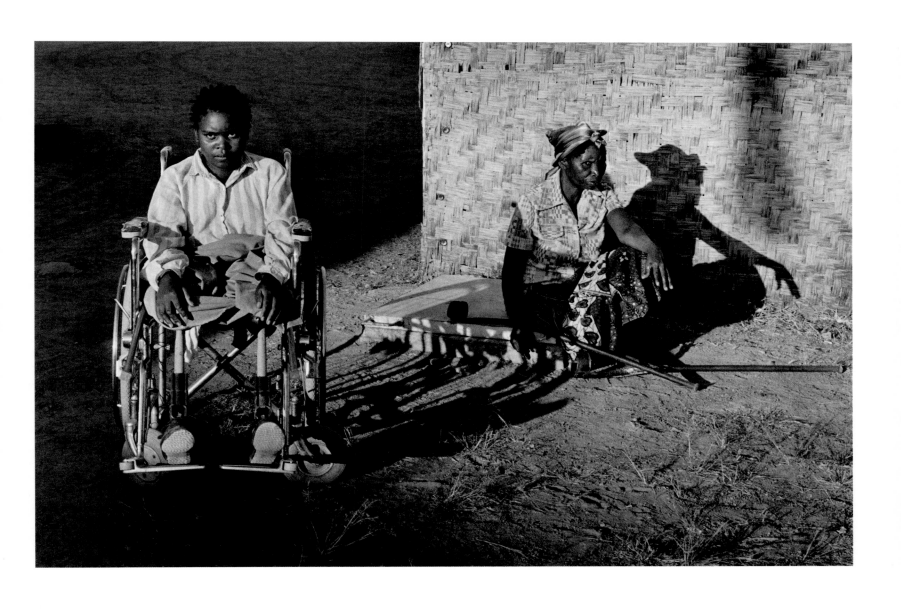

227

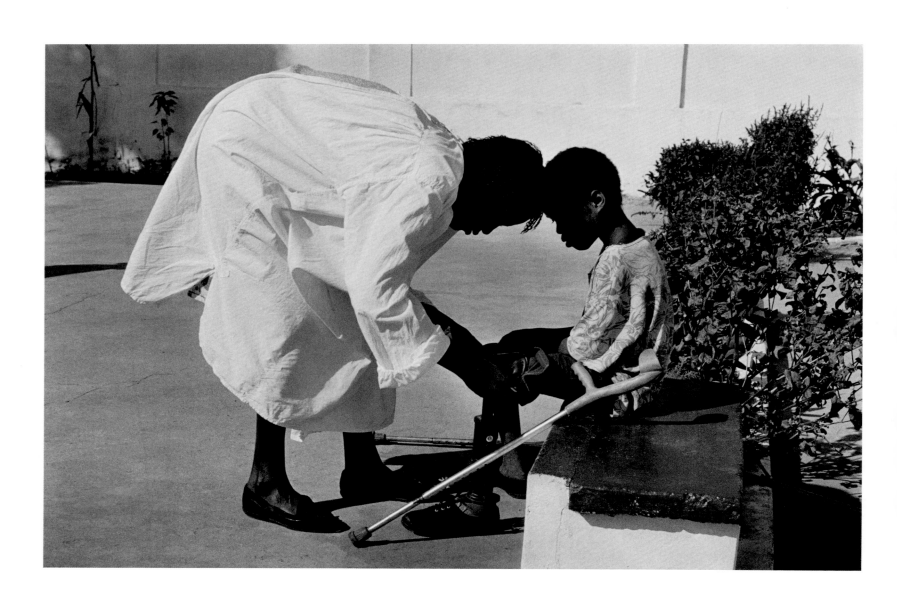

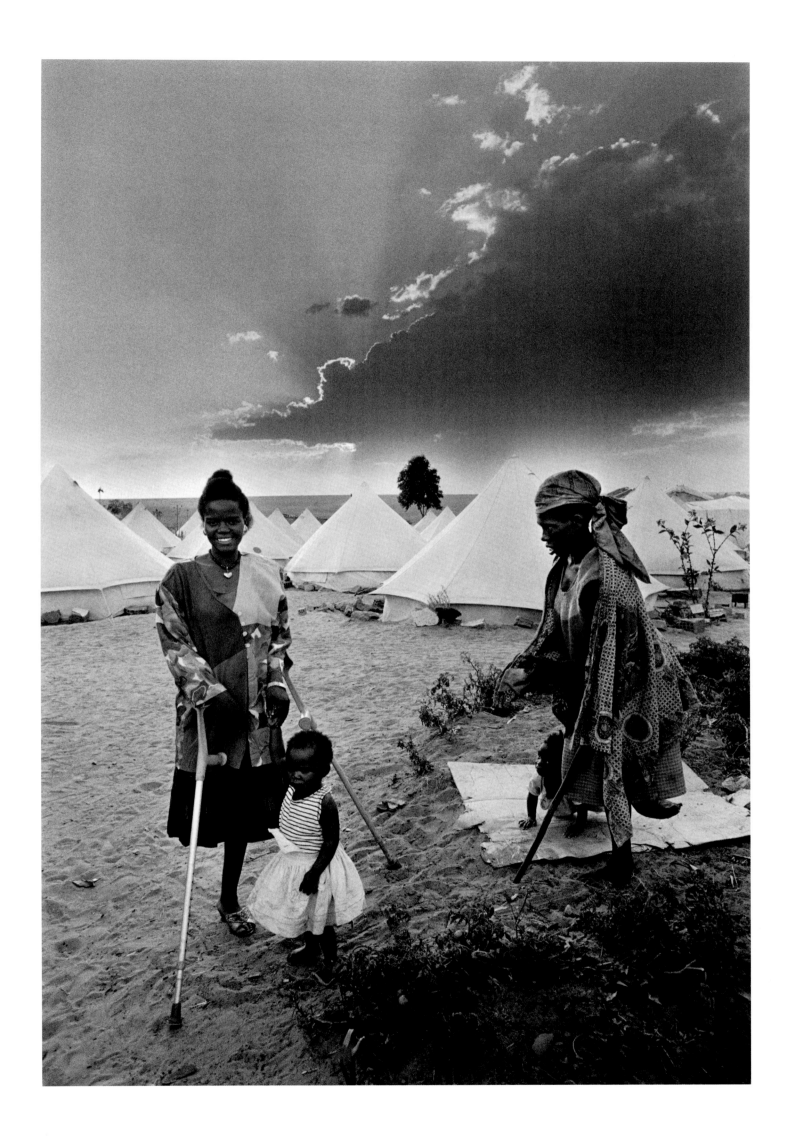

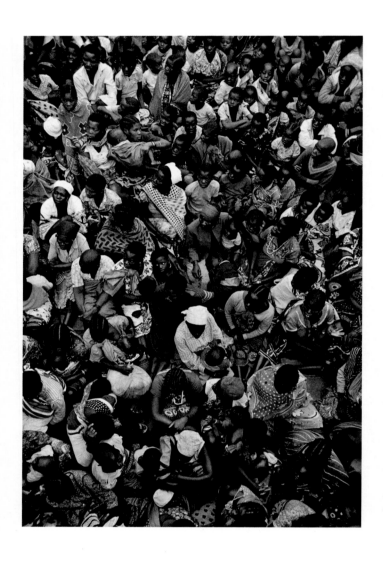

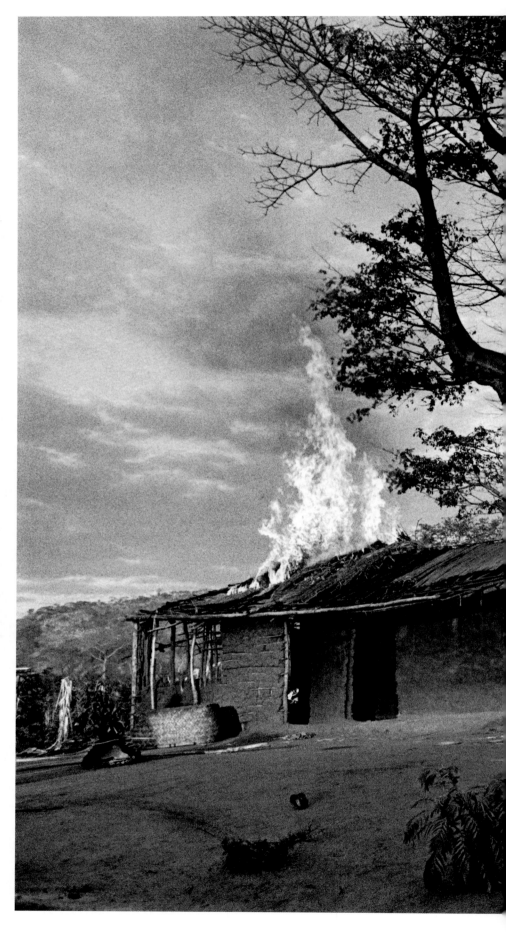

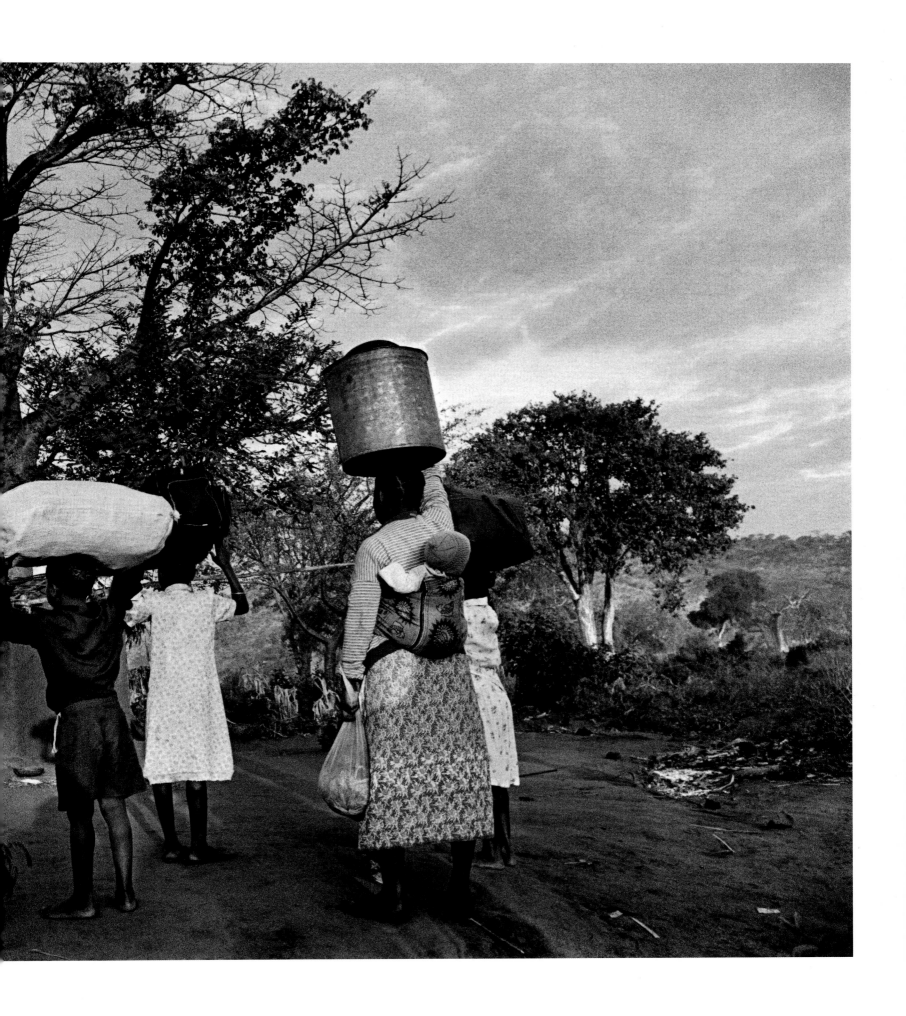

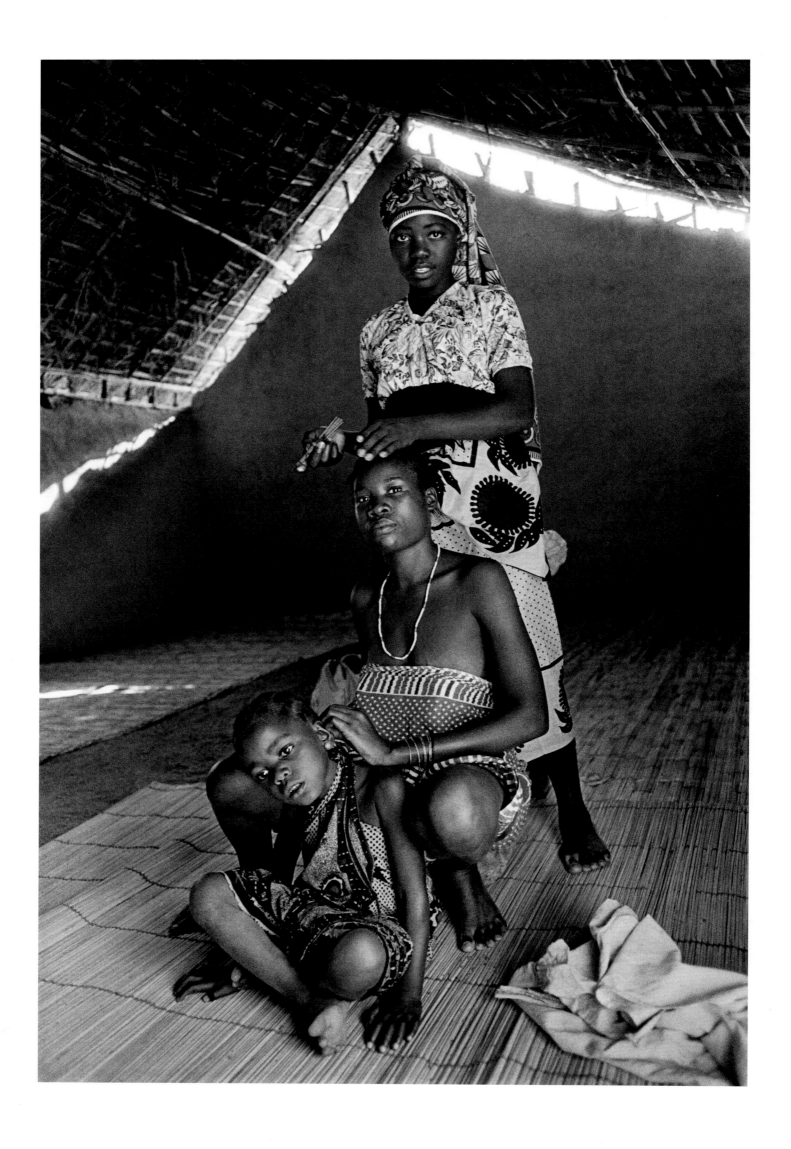

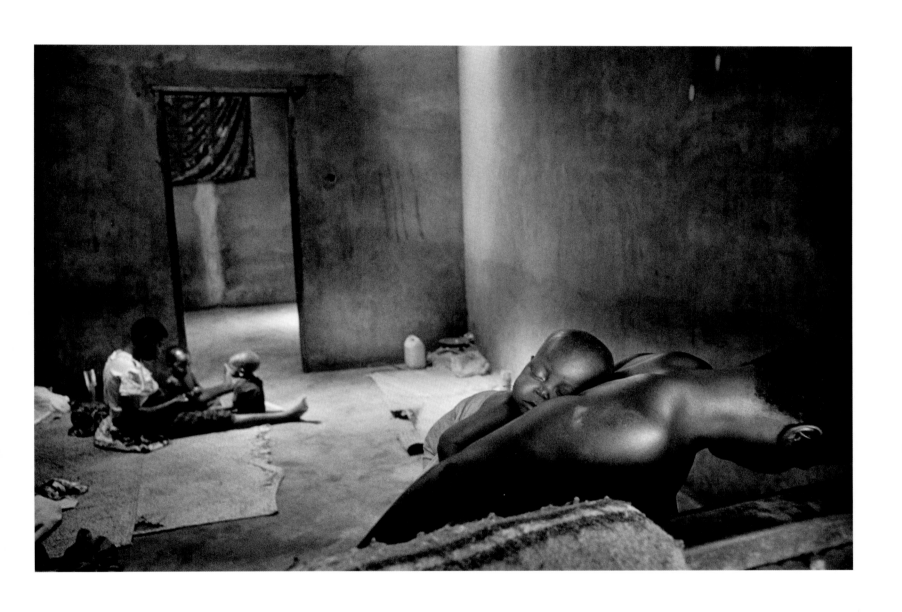

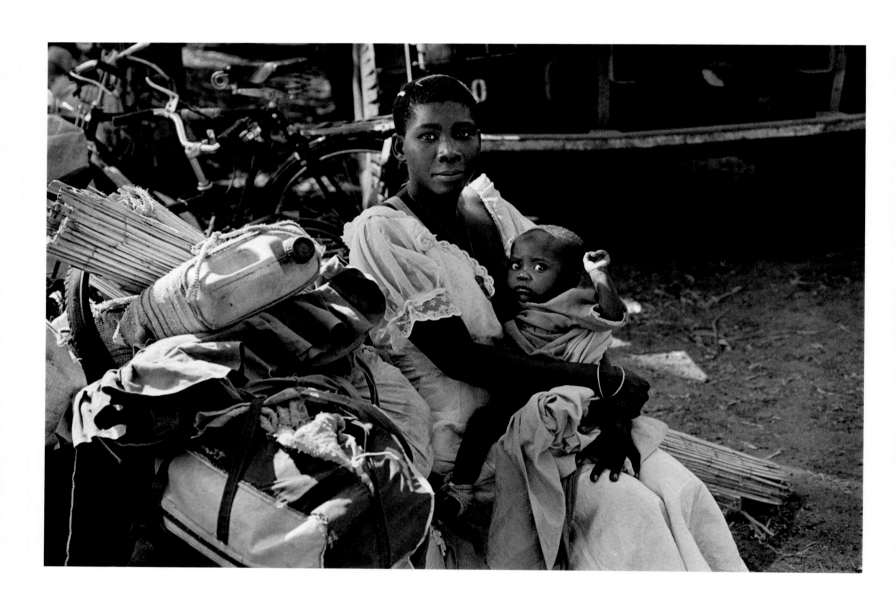

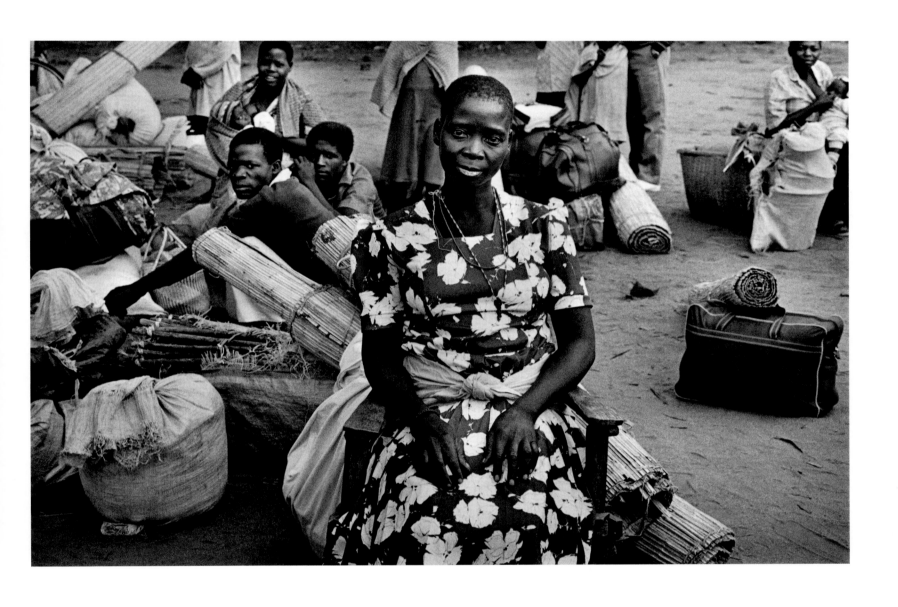

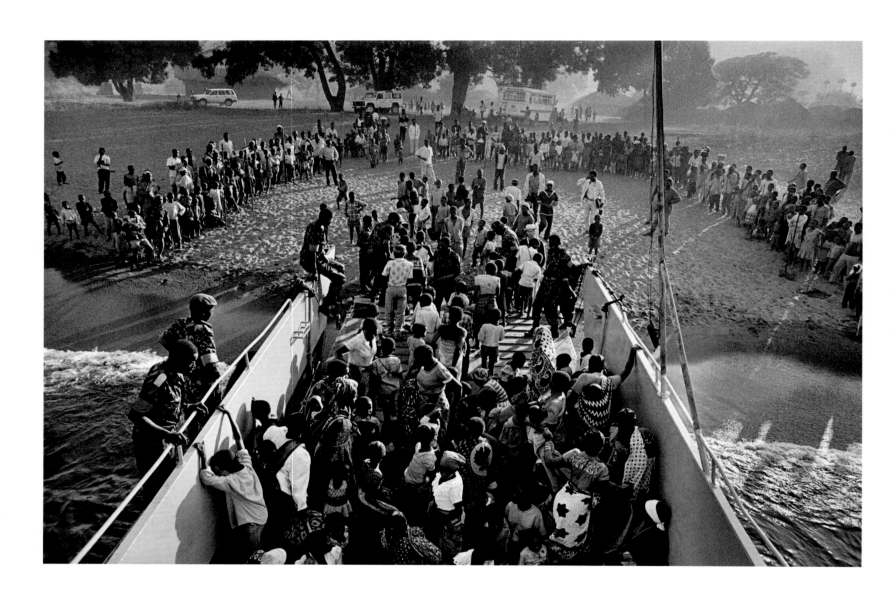

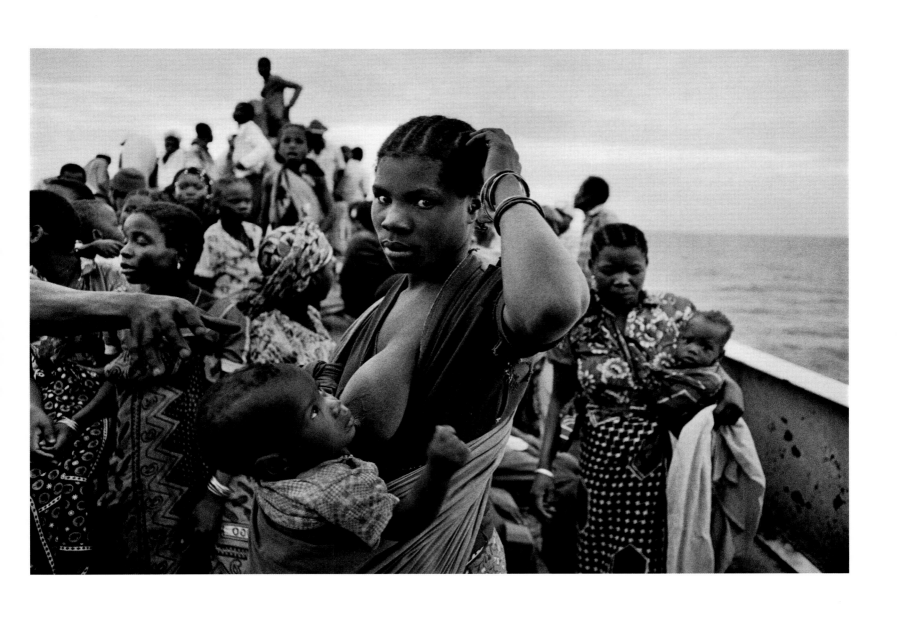

237

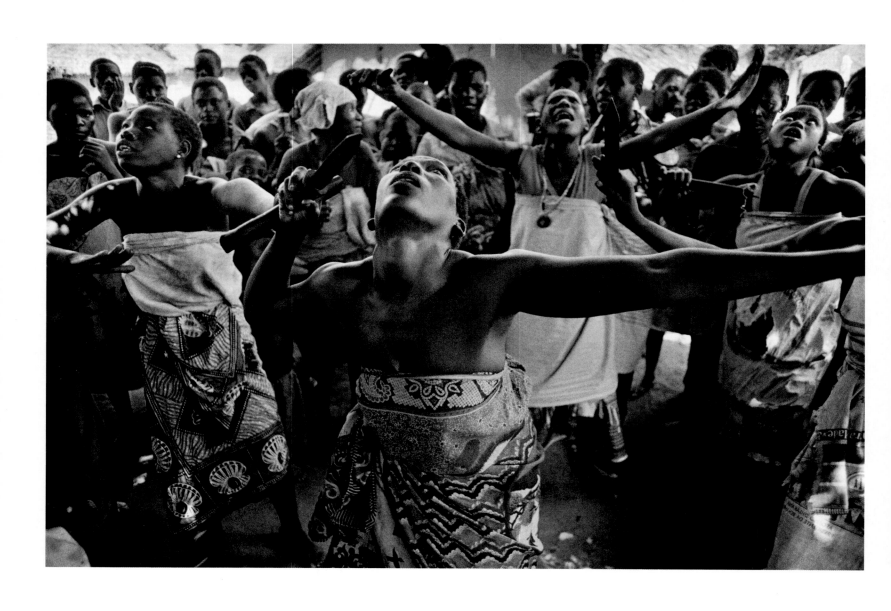

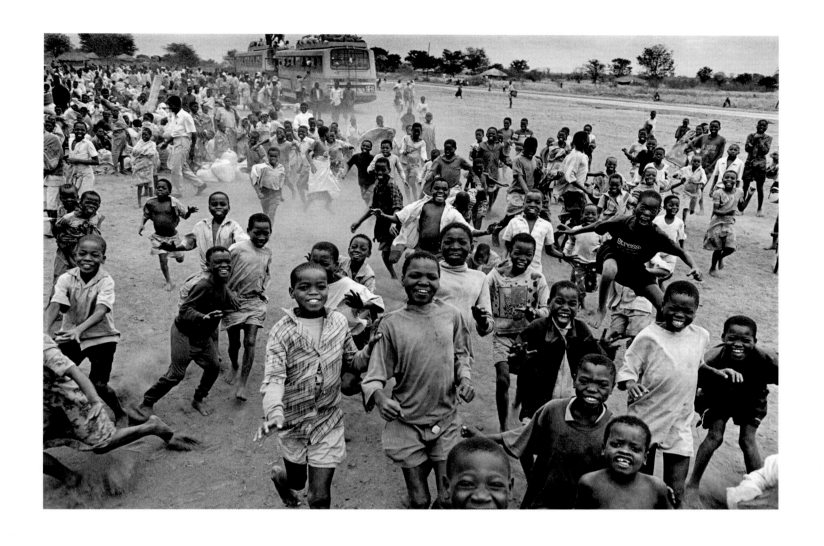

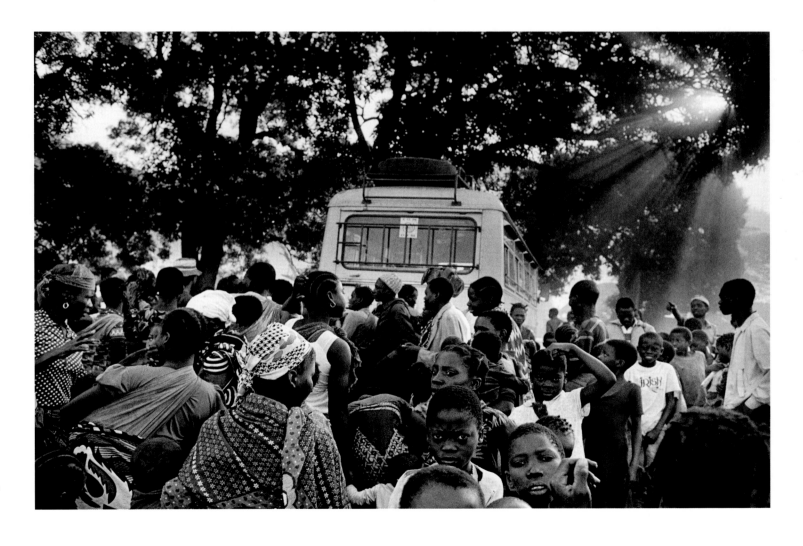

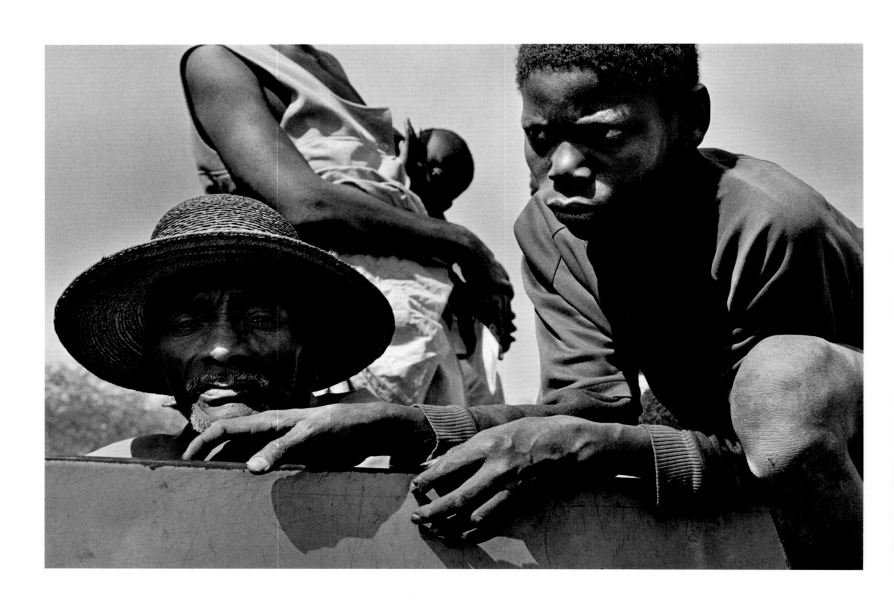

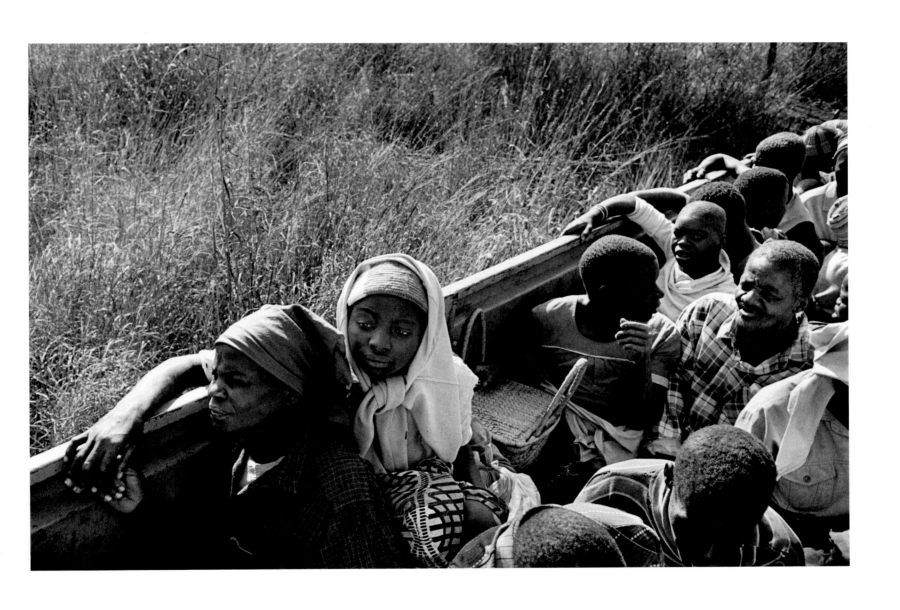

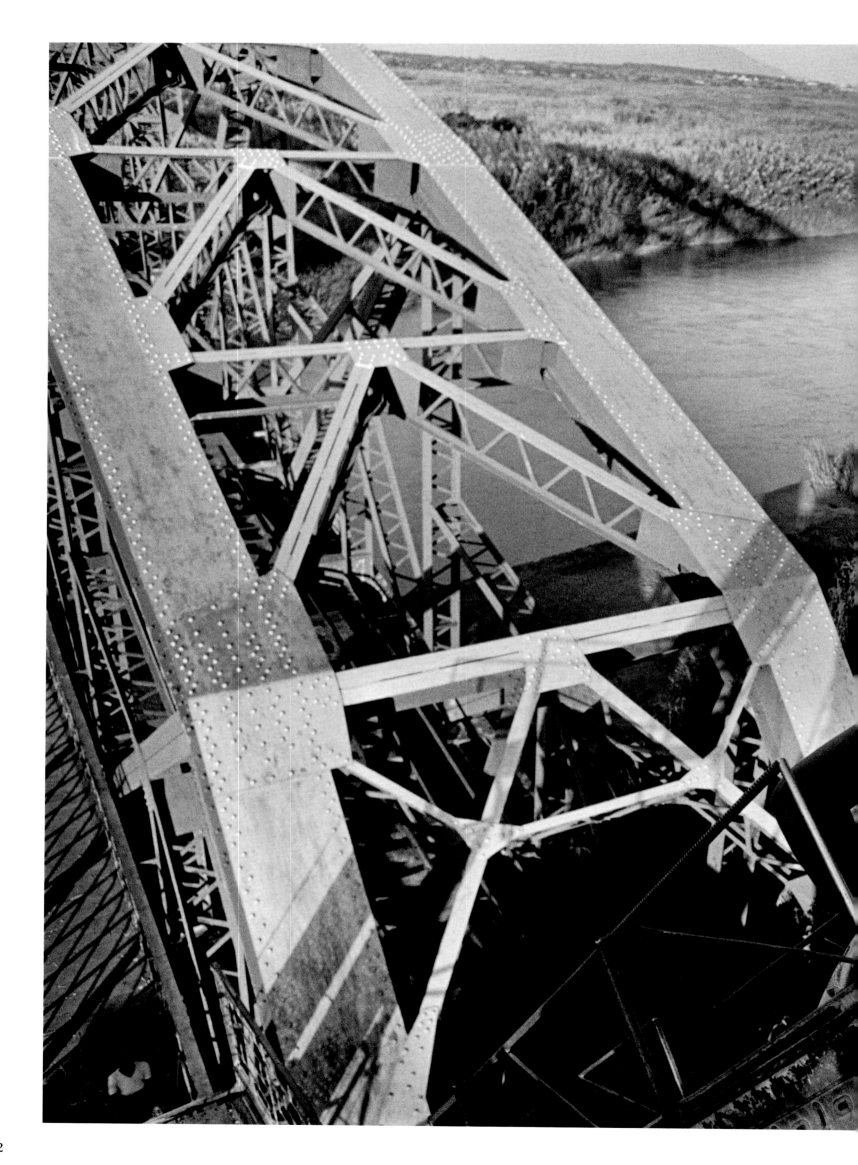

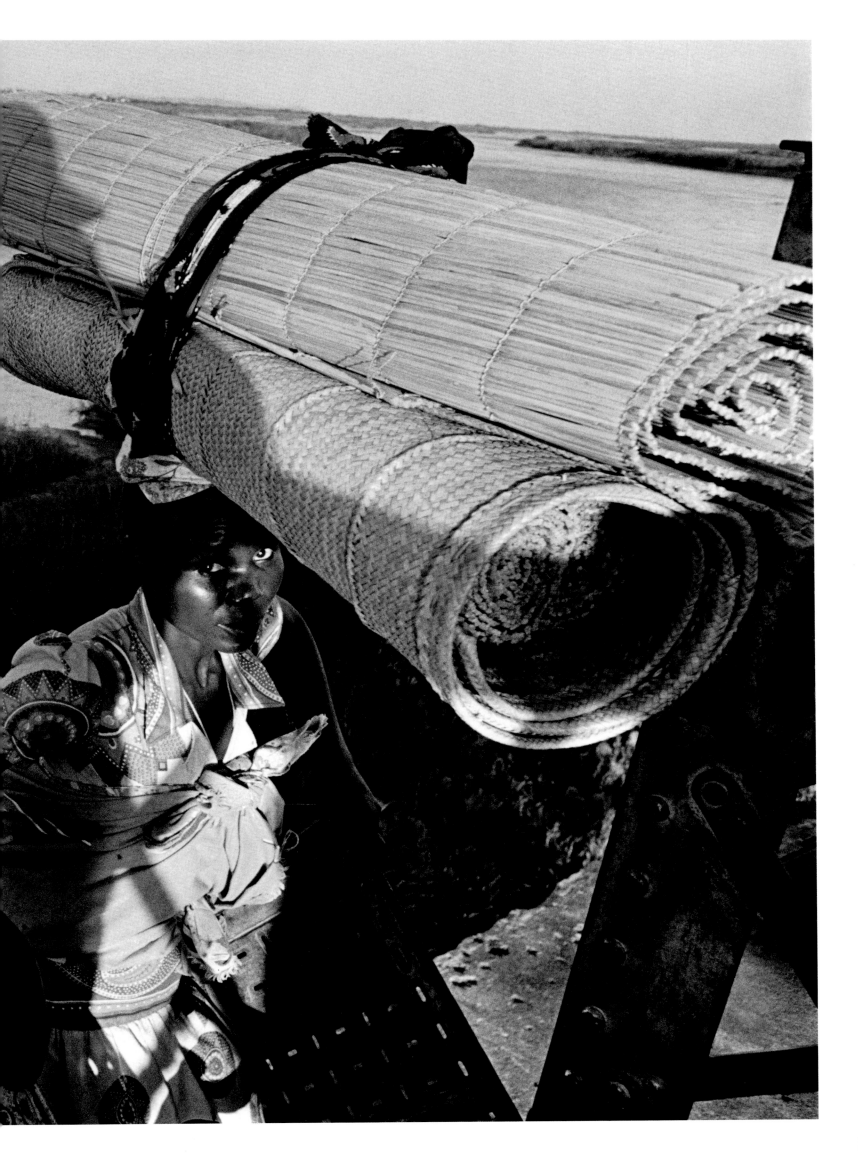

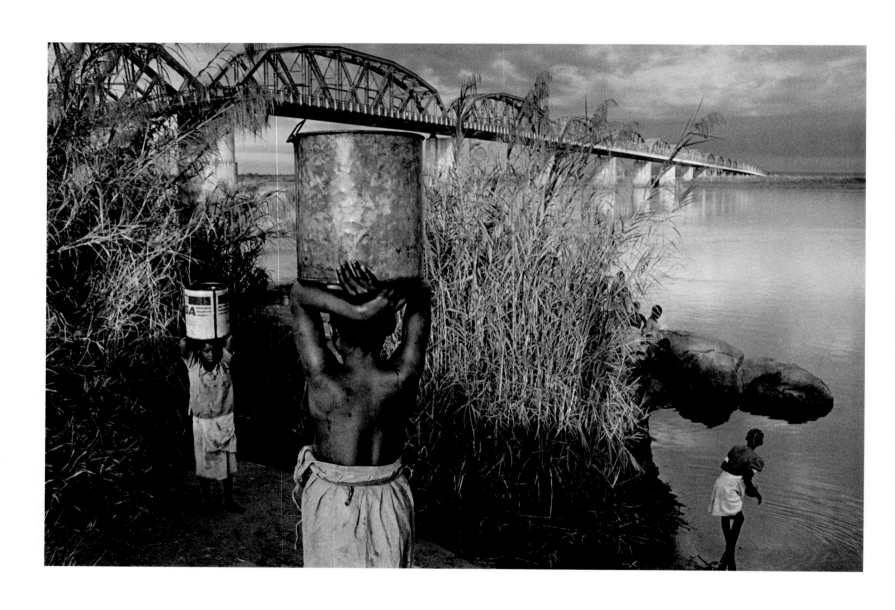

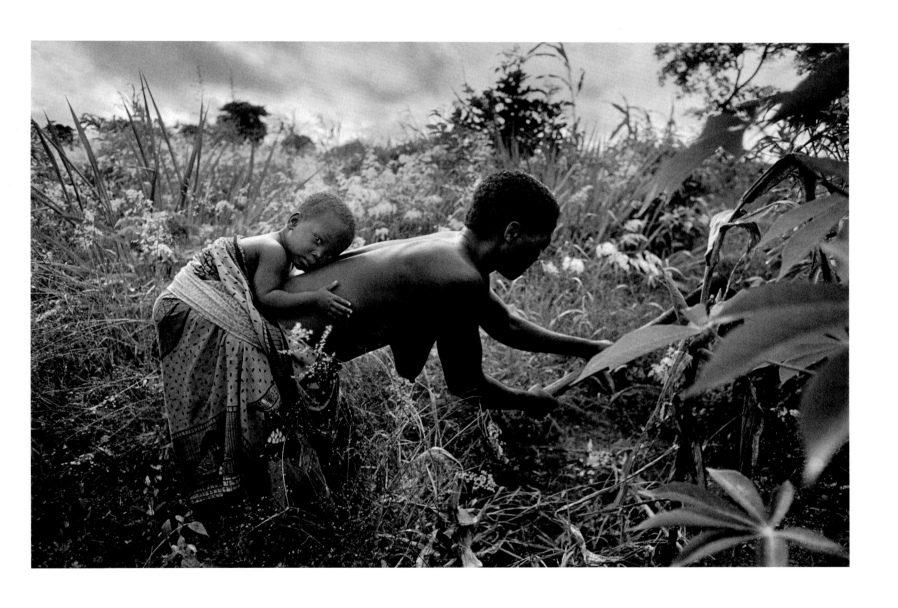

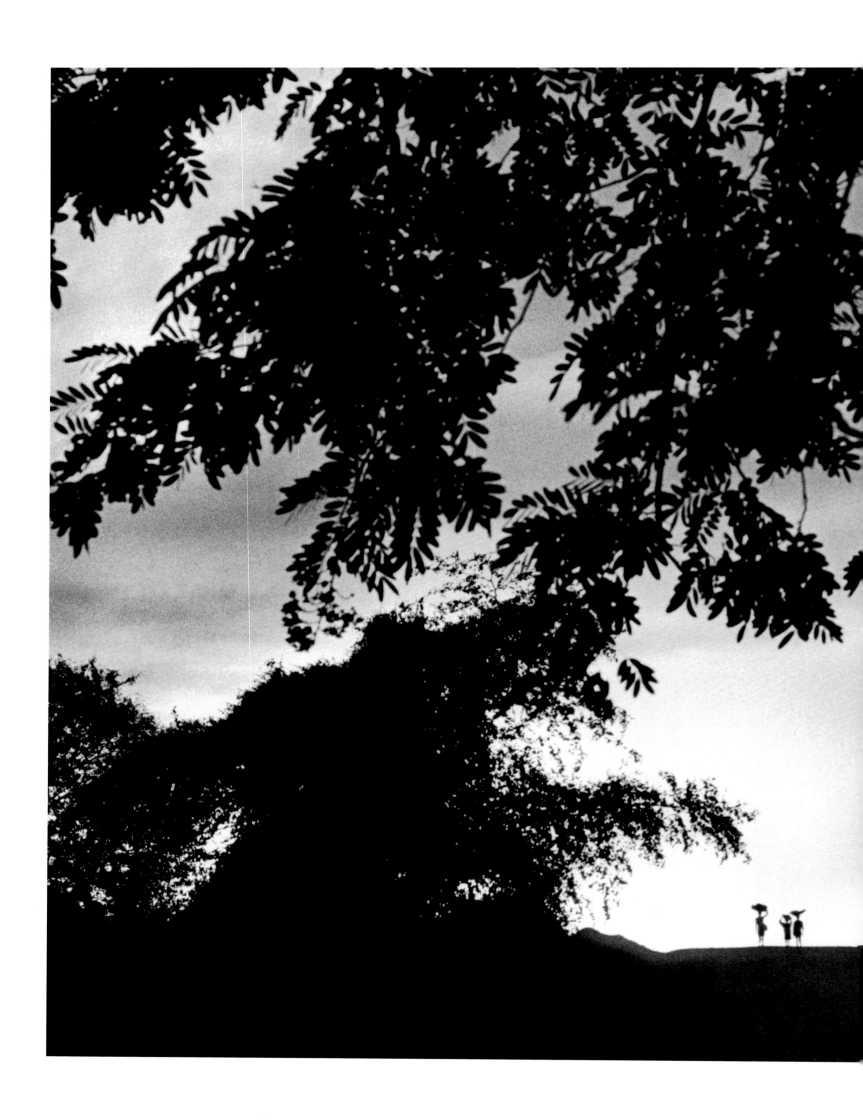

III

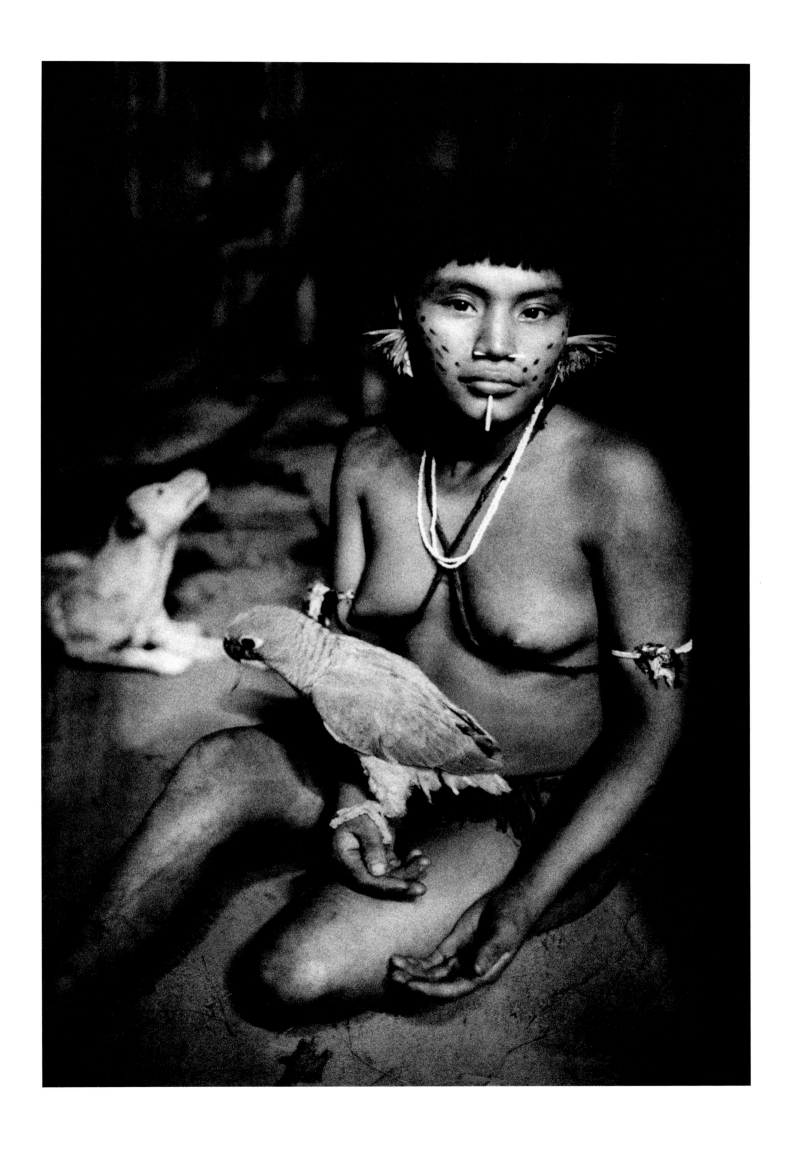

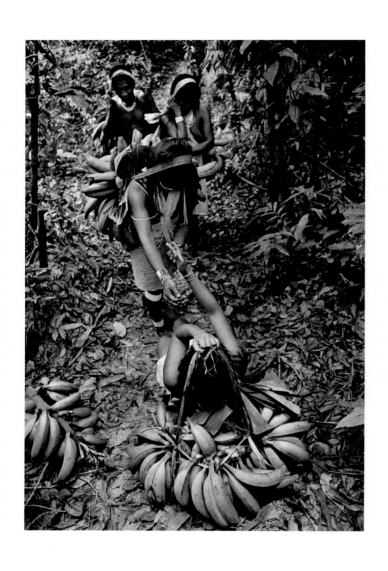

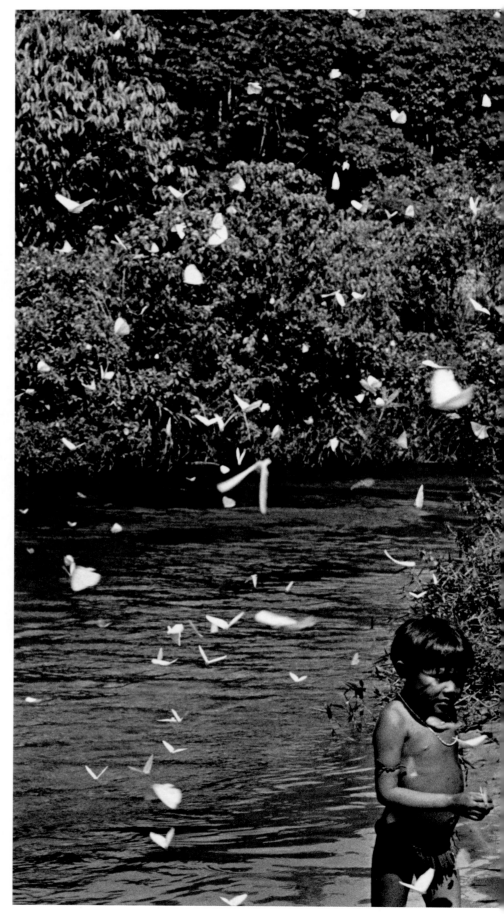

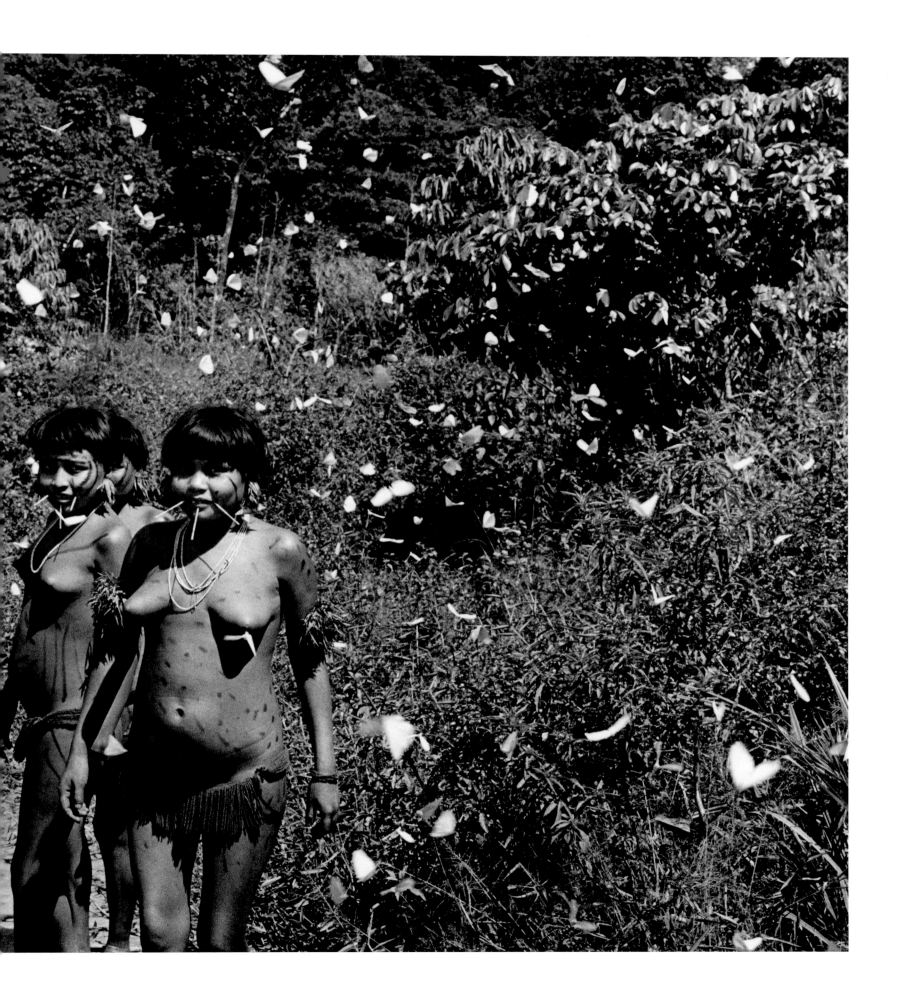

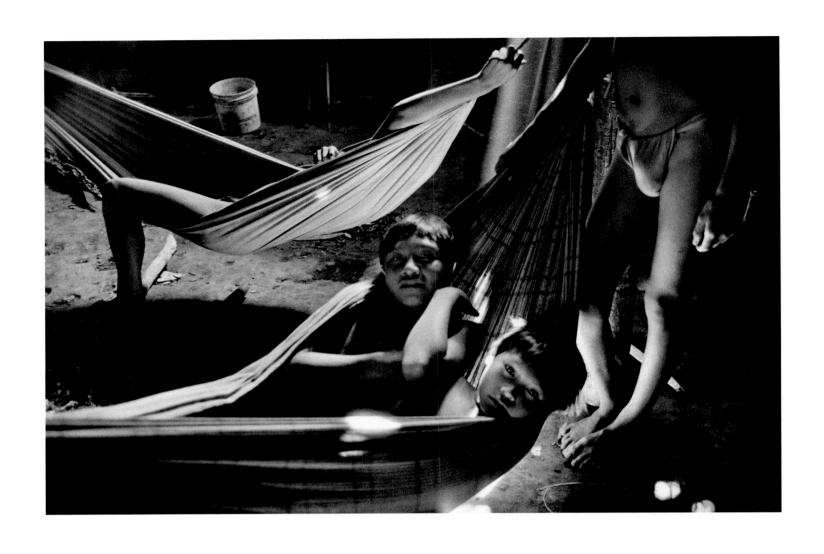

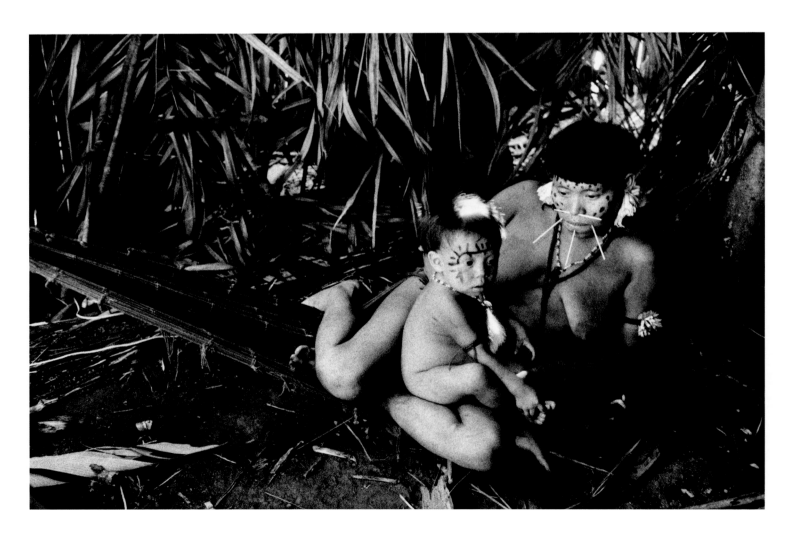

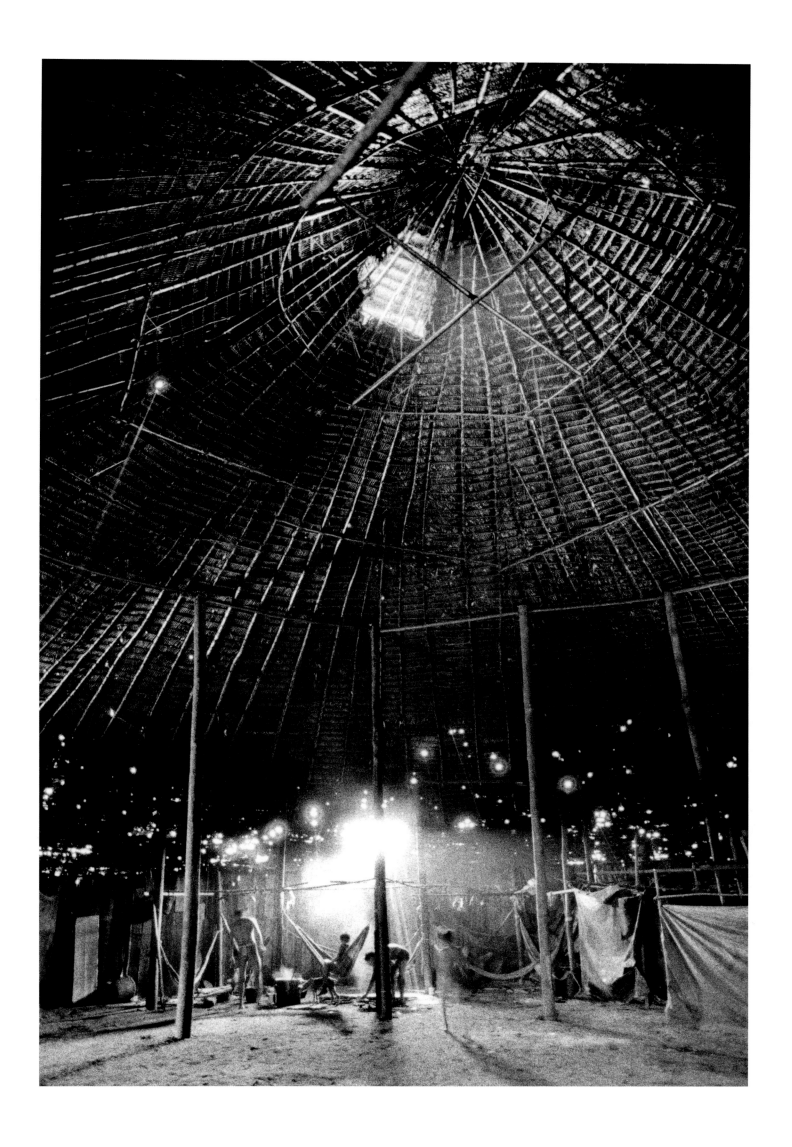

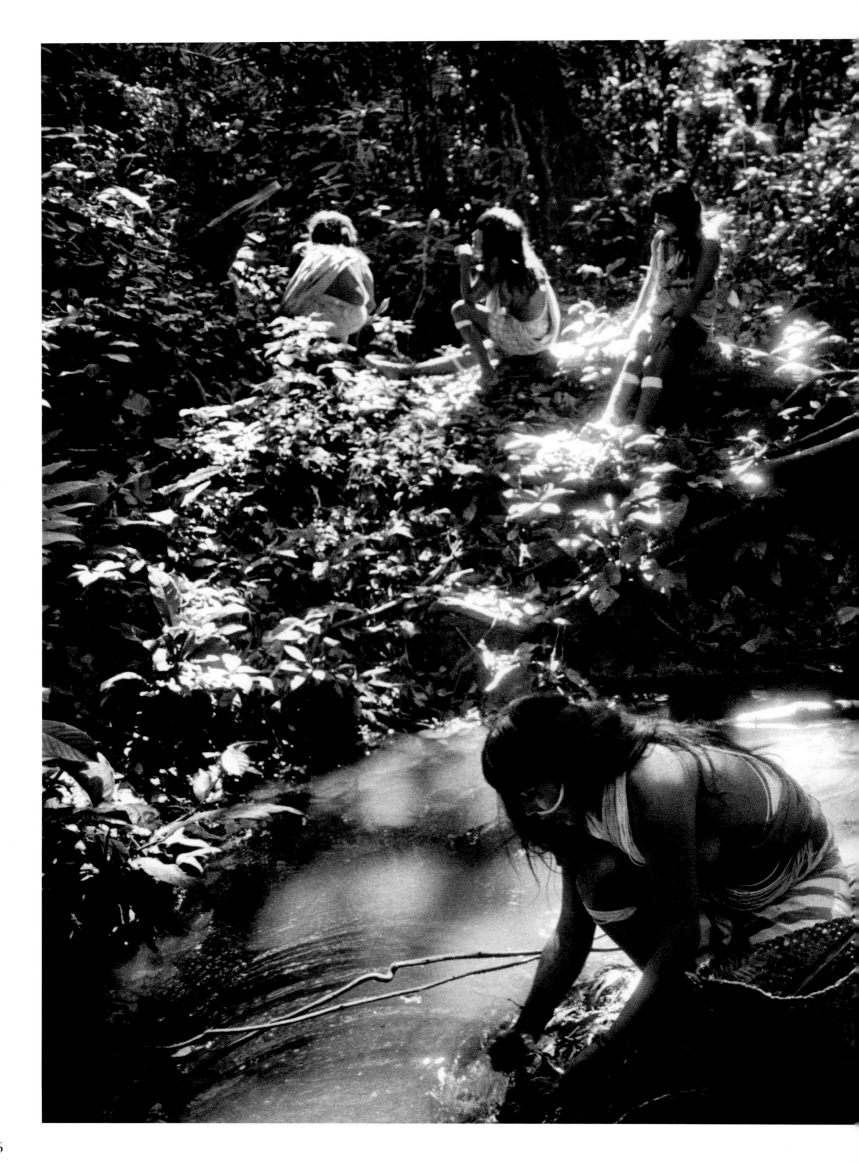

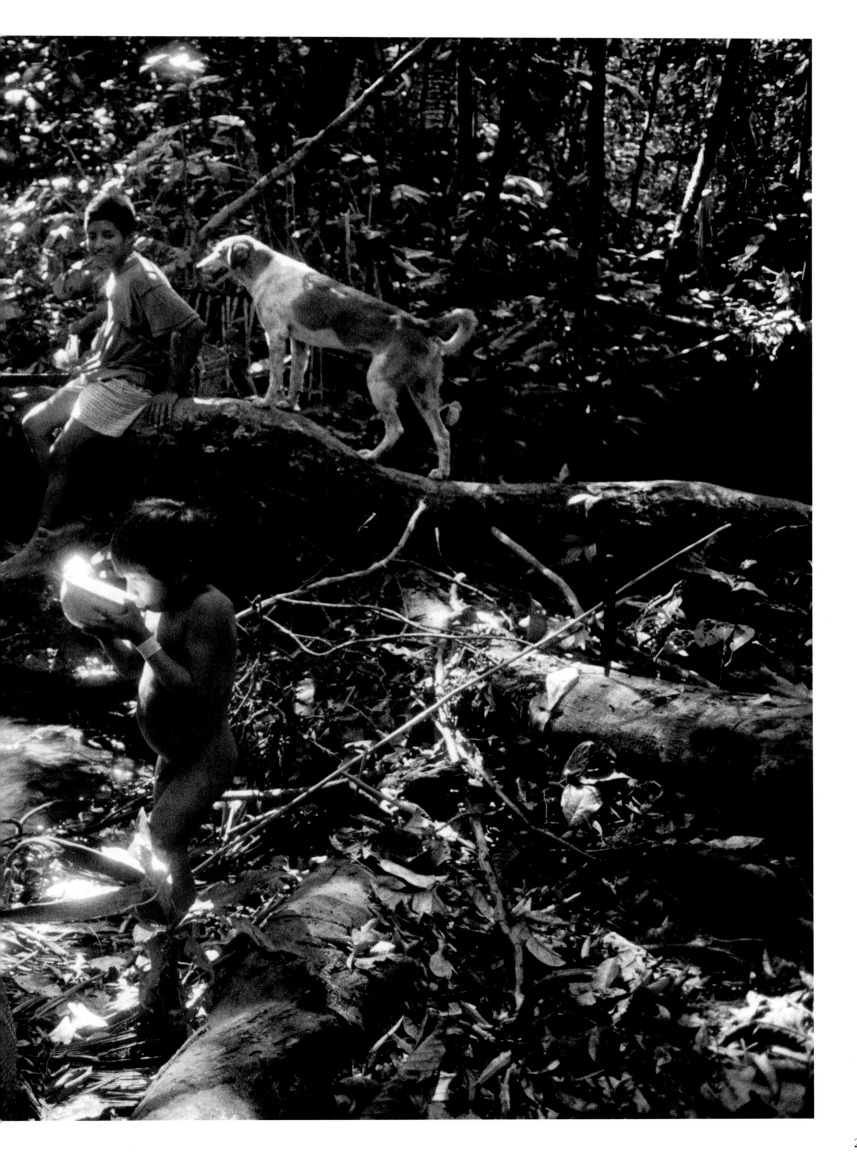

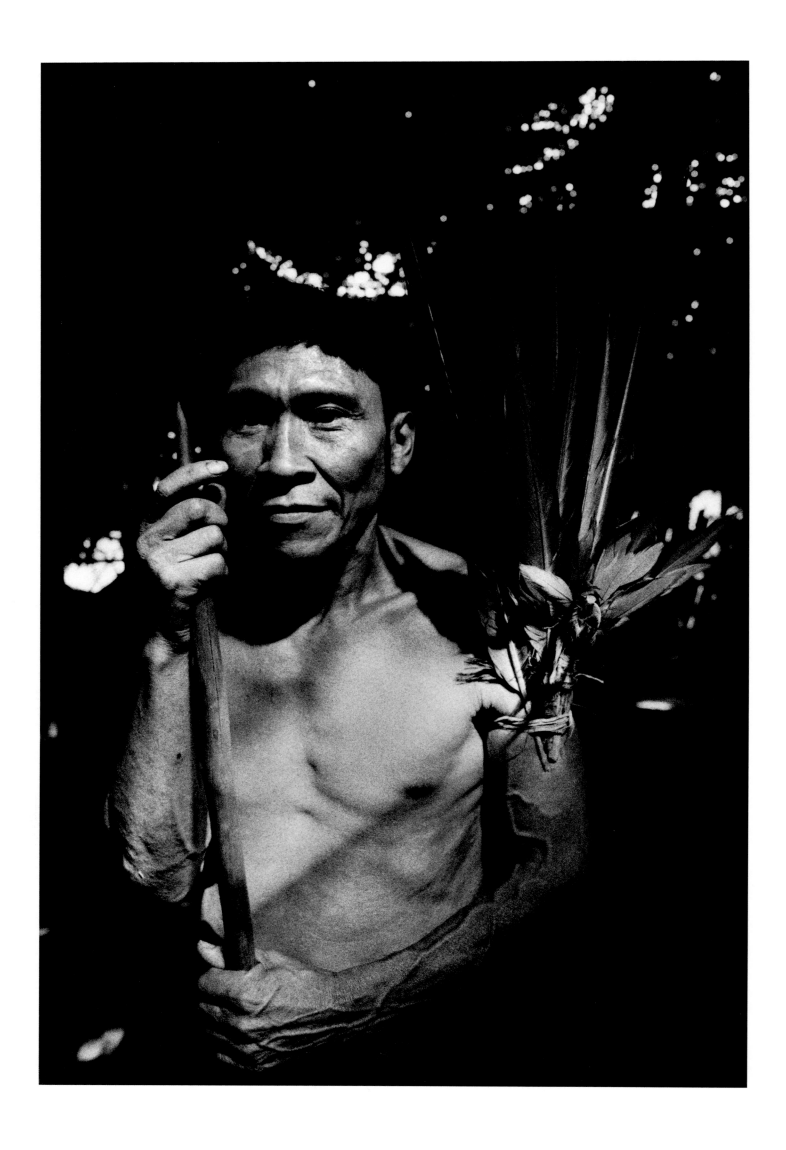

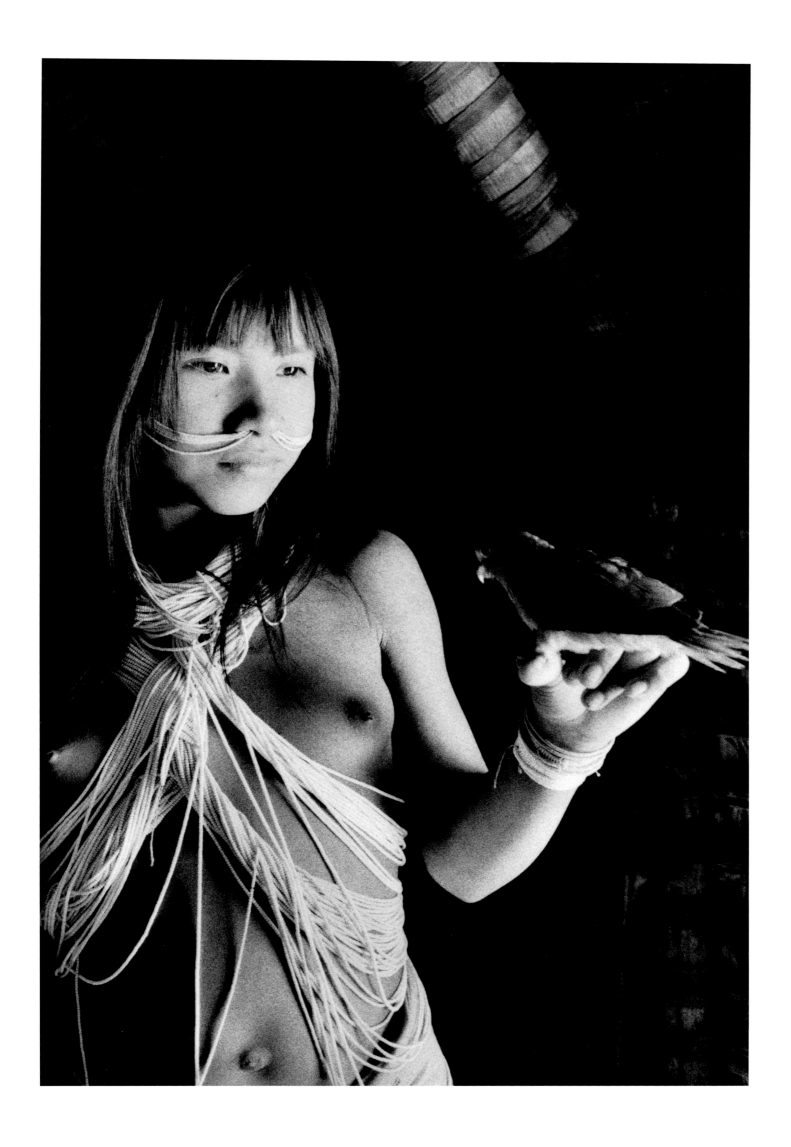

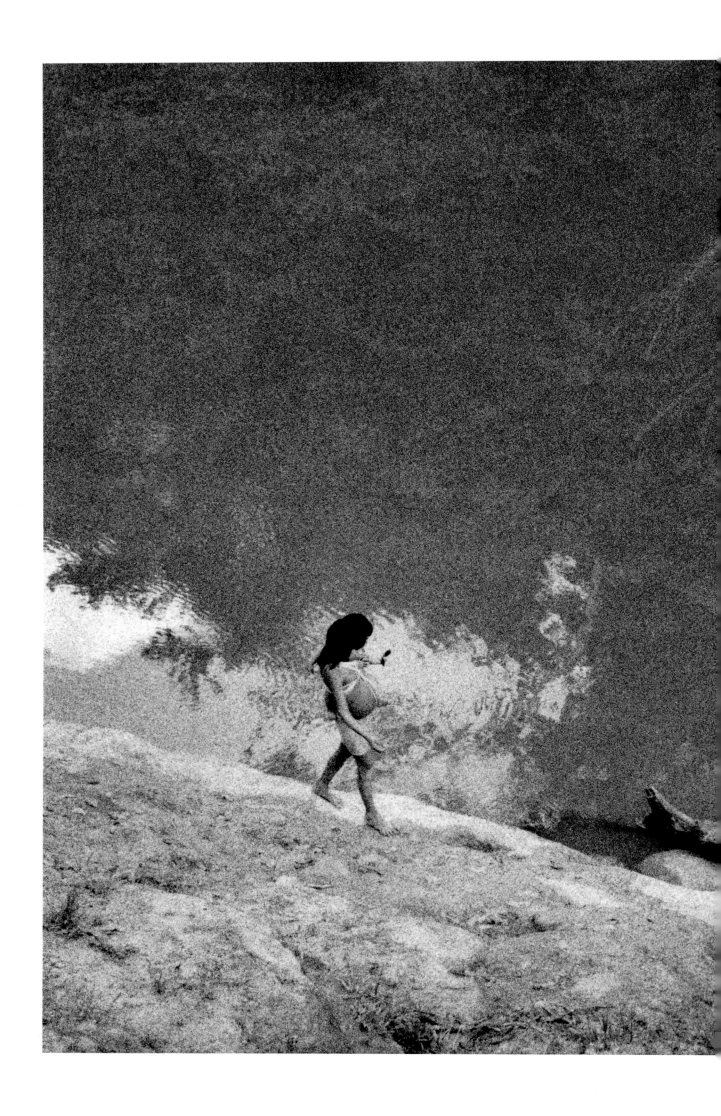

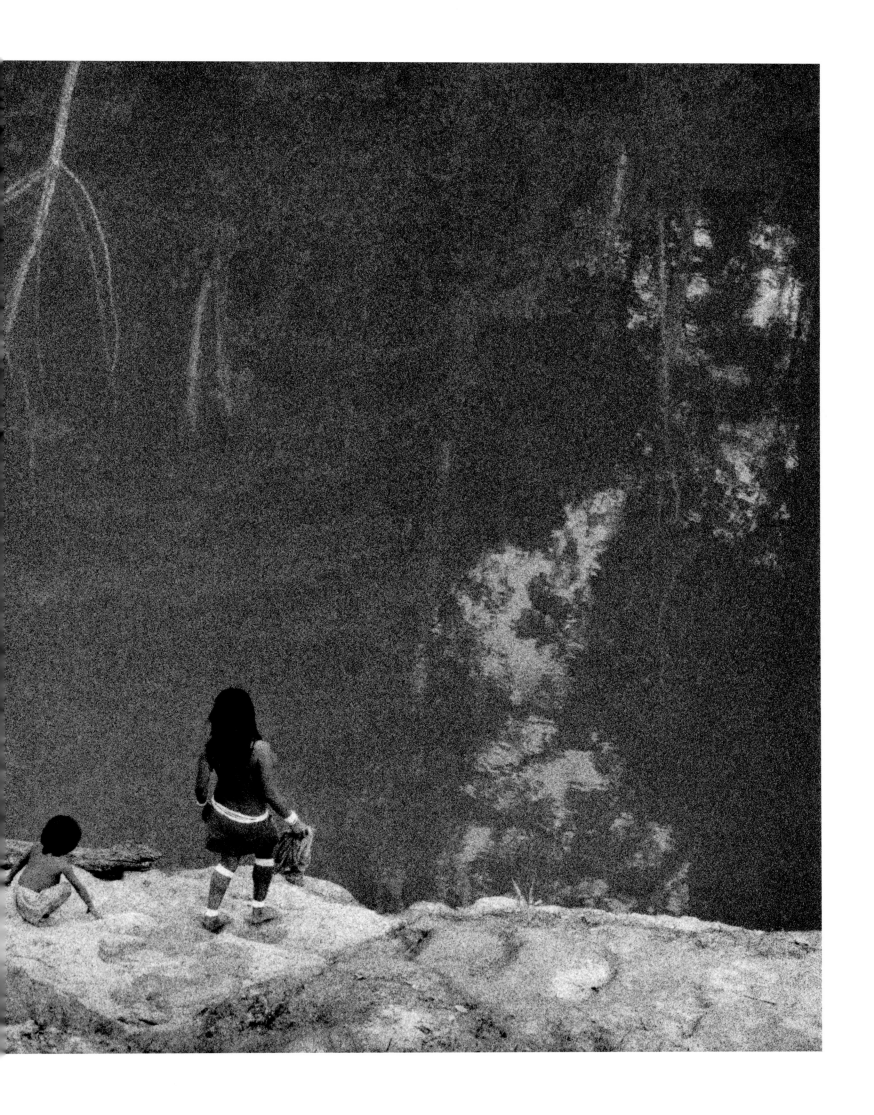

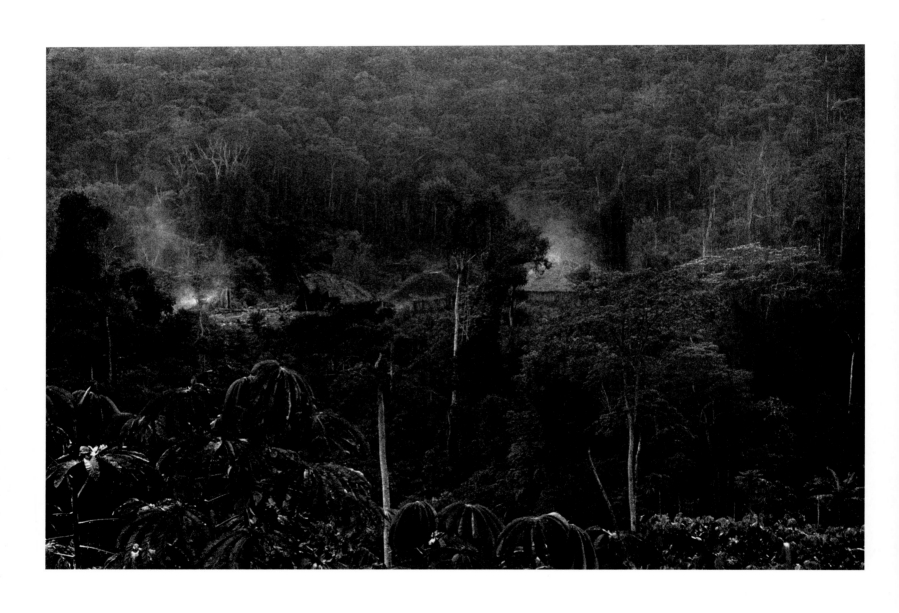

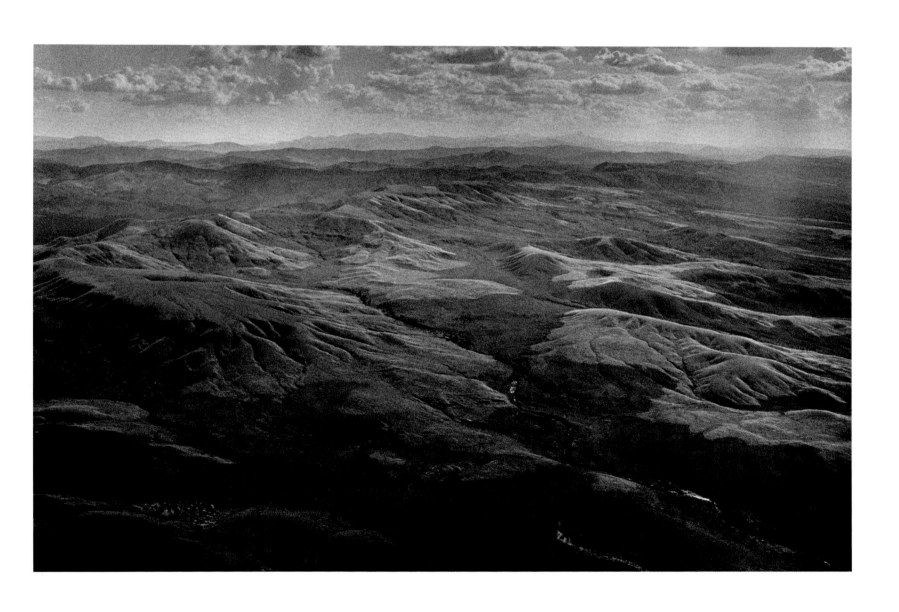

263

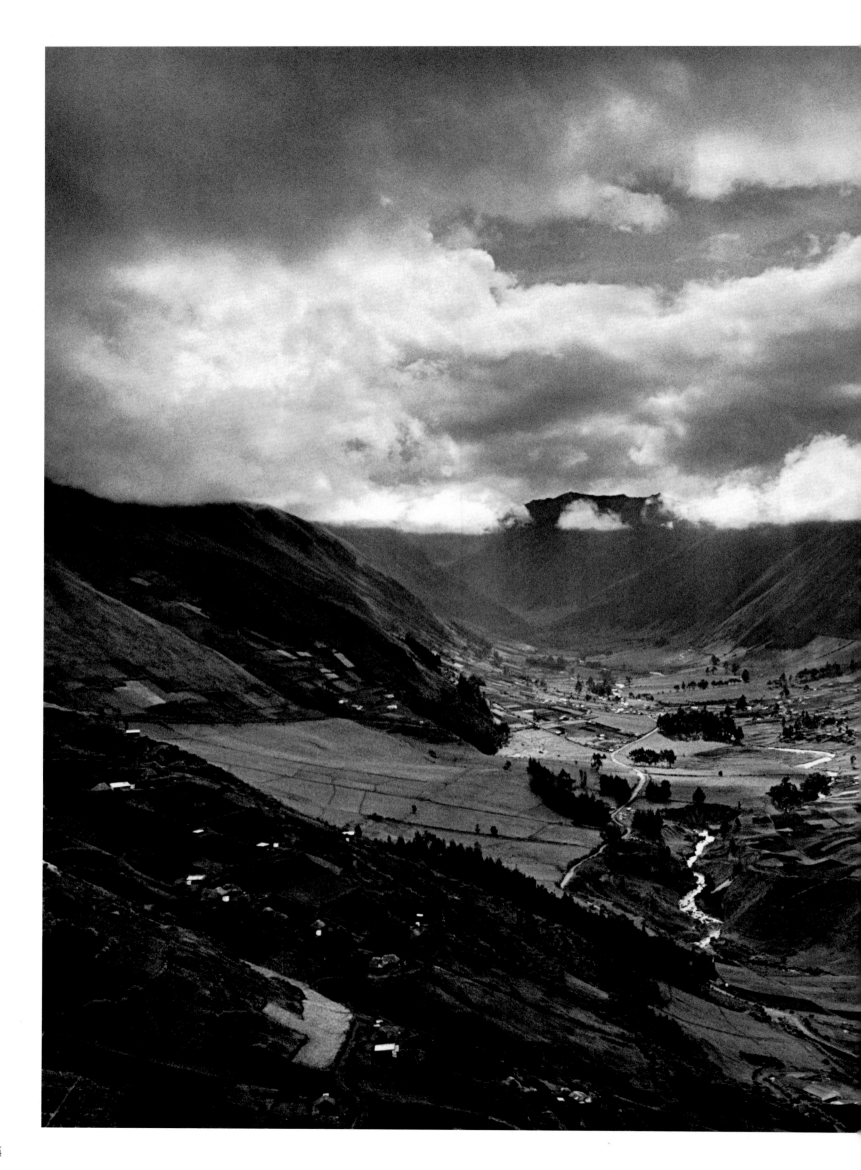

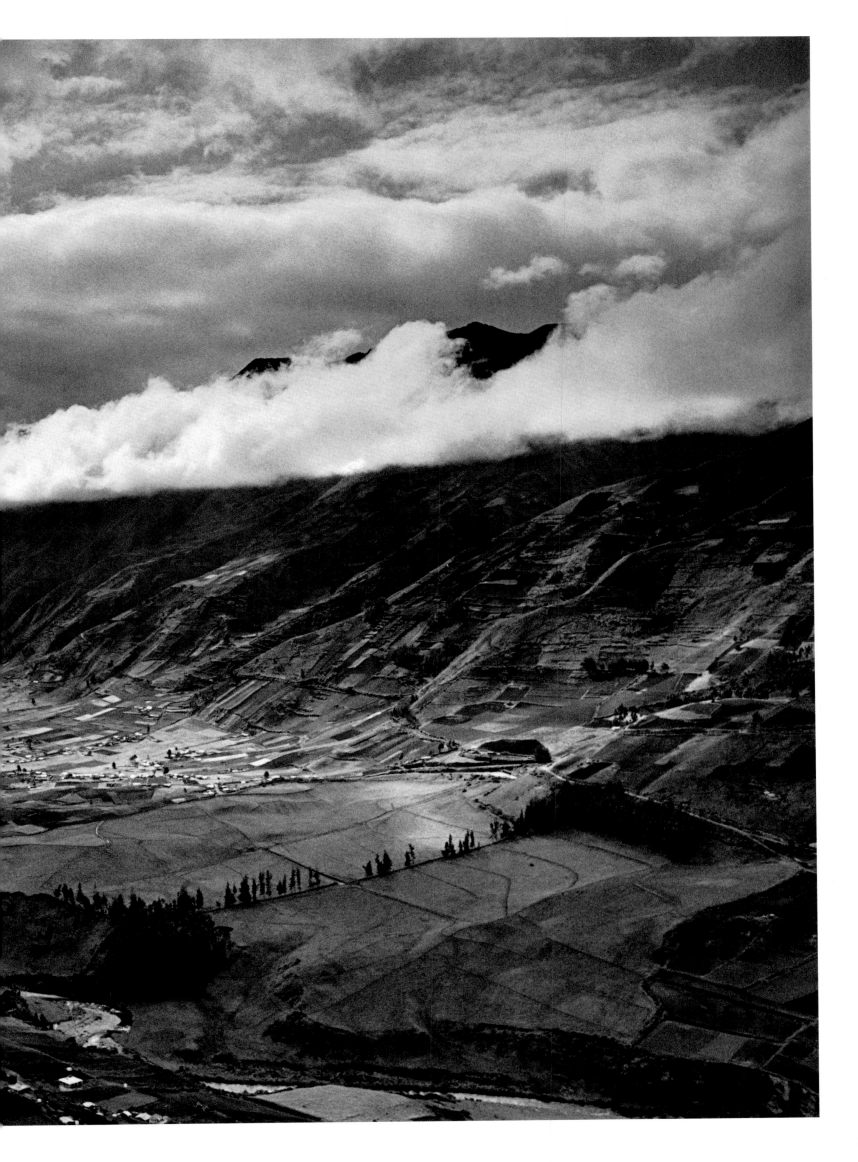

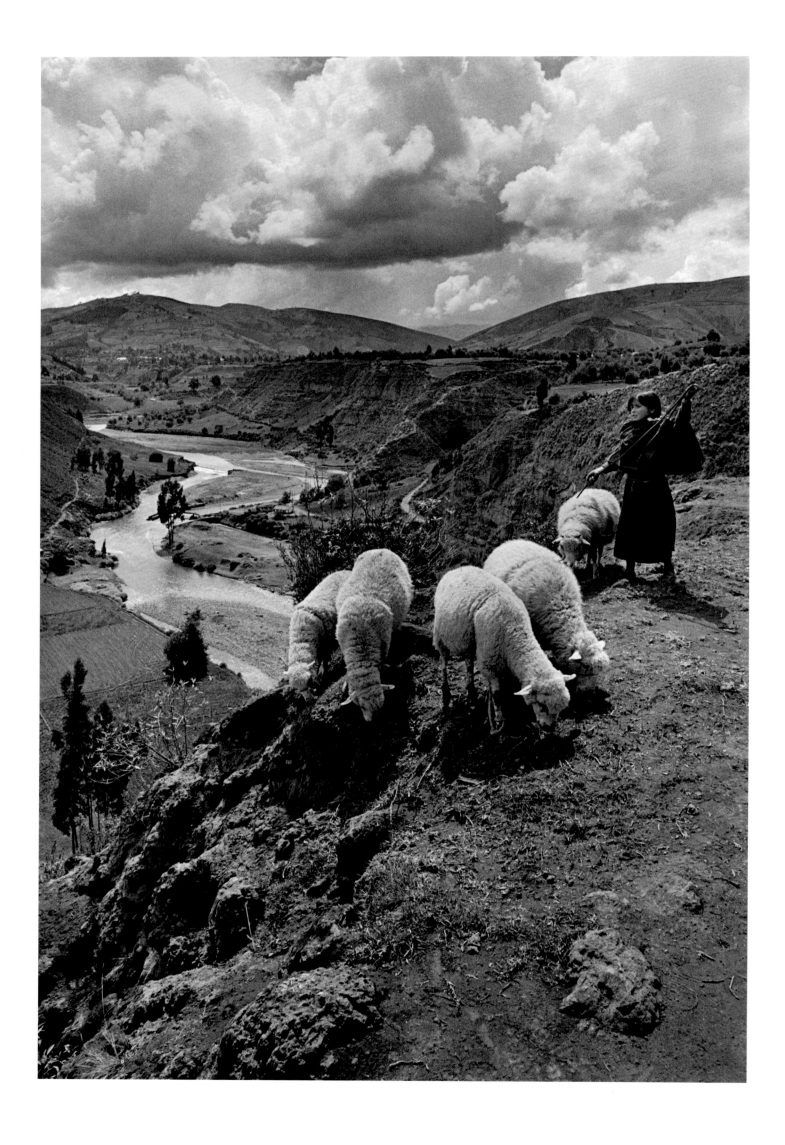

266

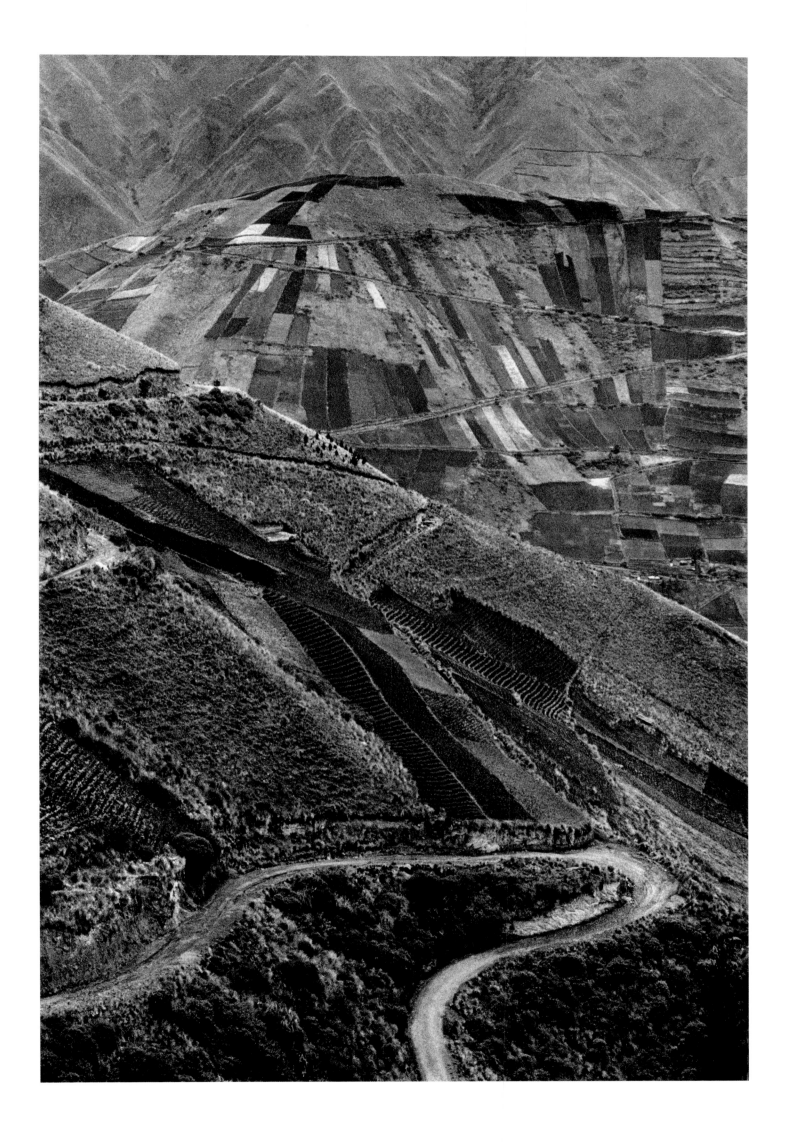

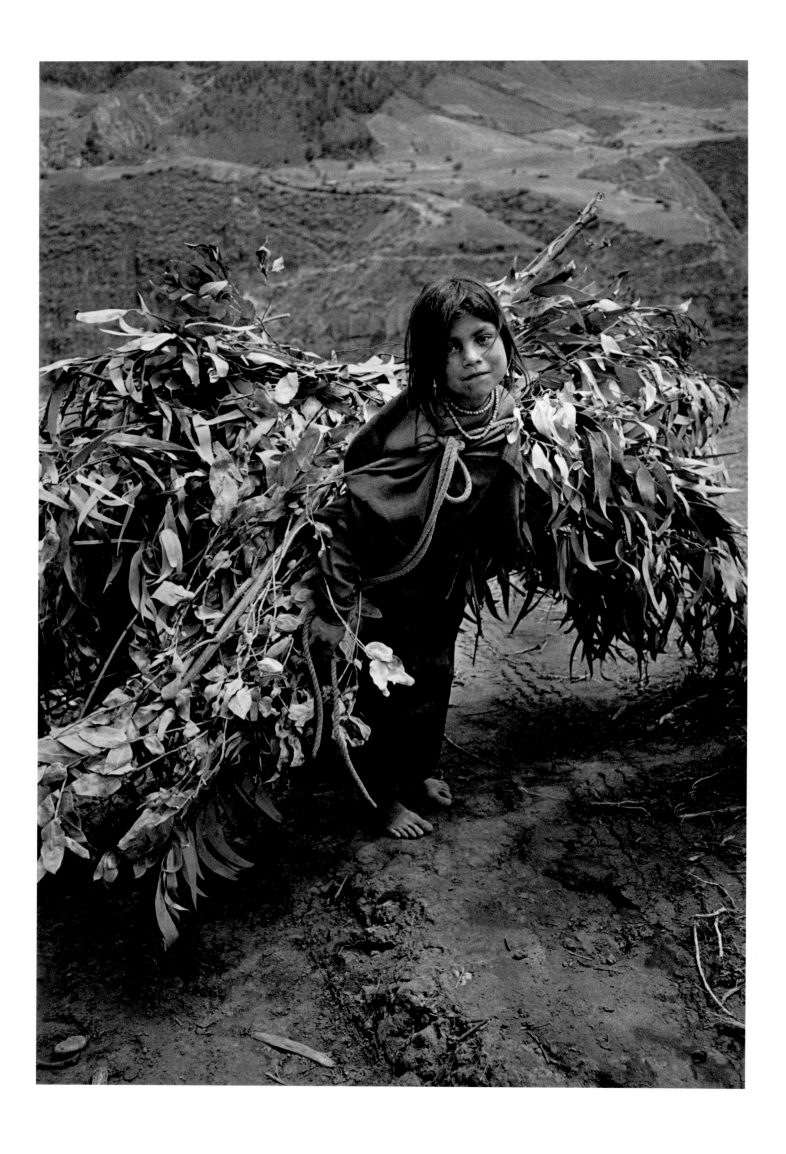

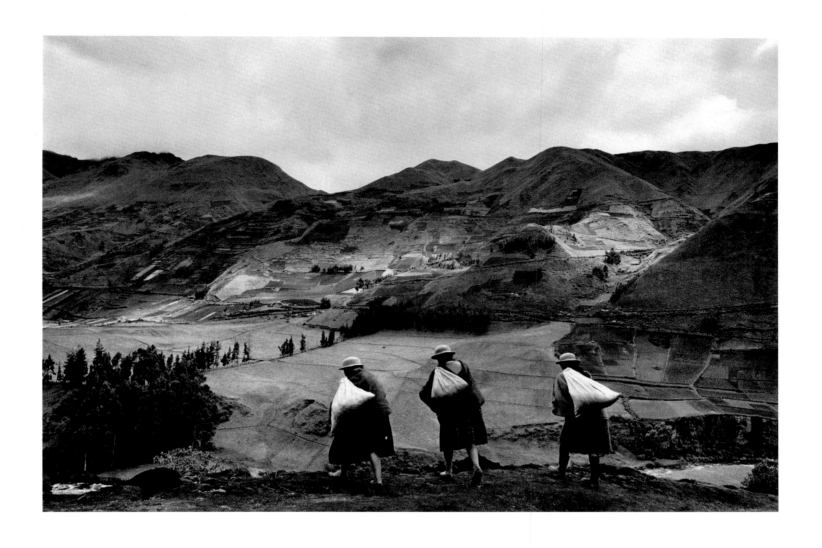

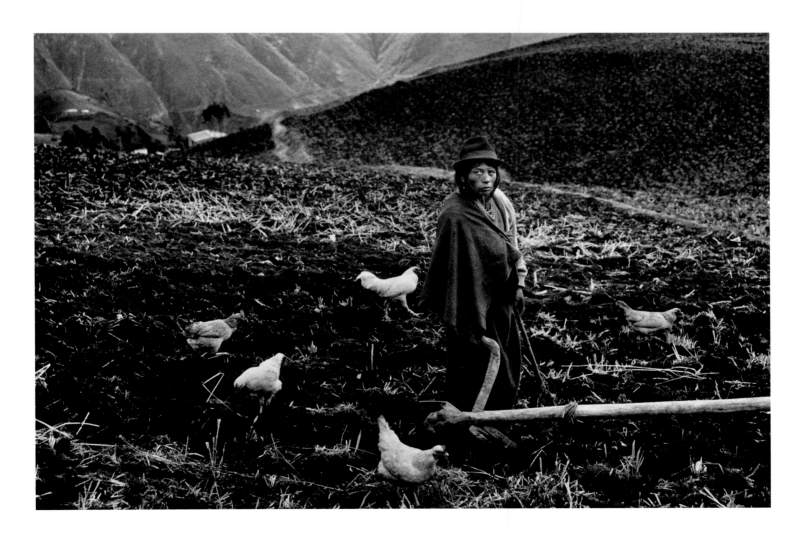

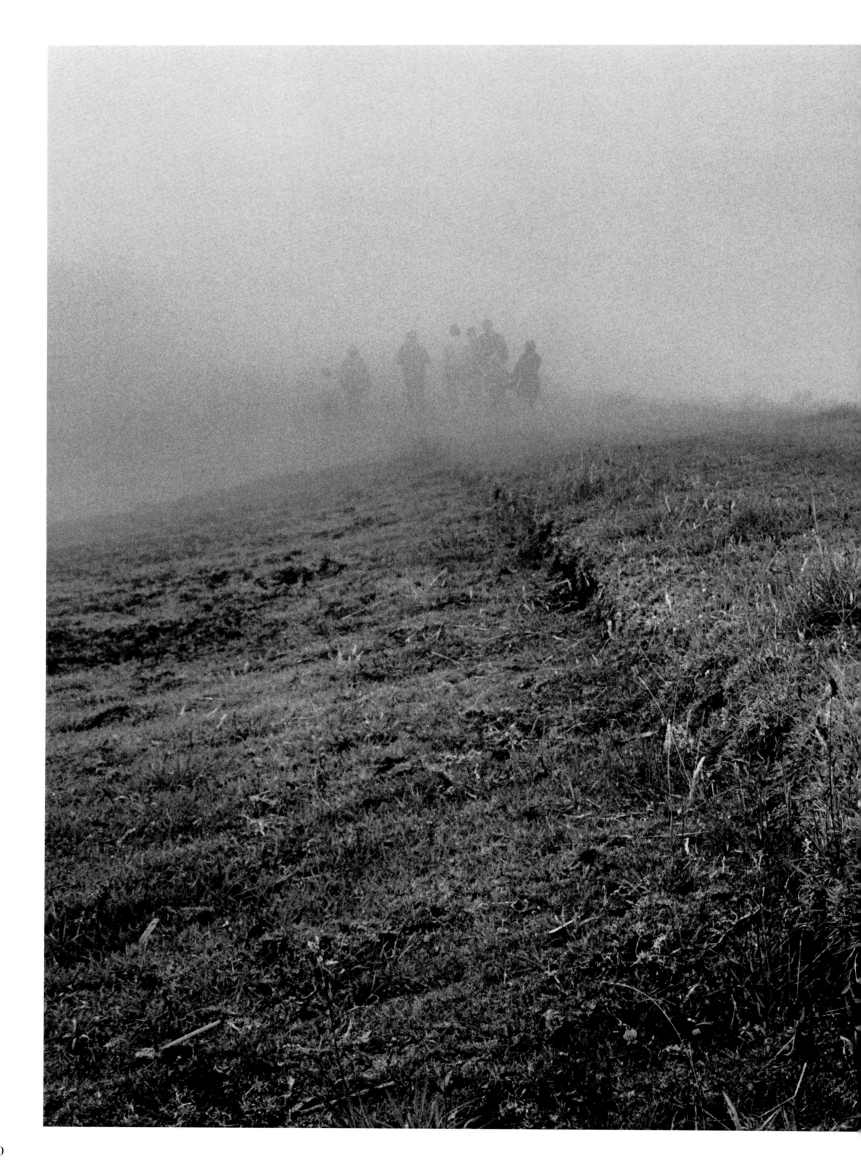

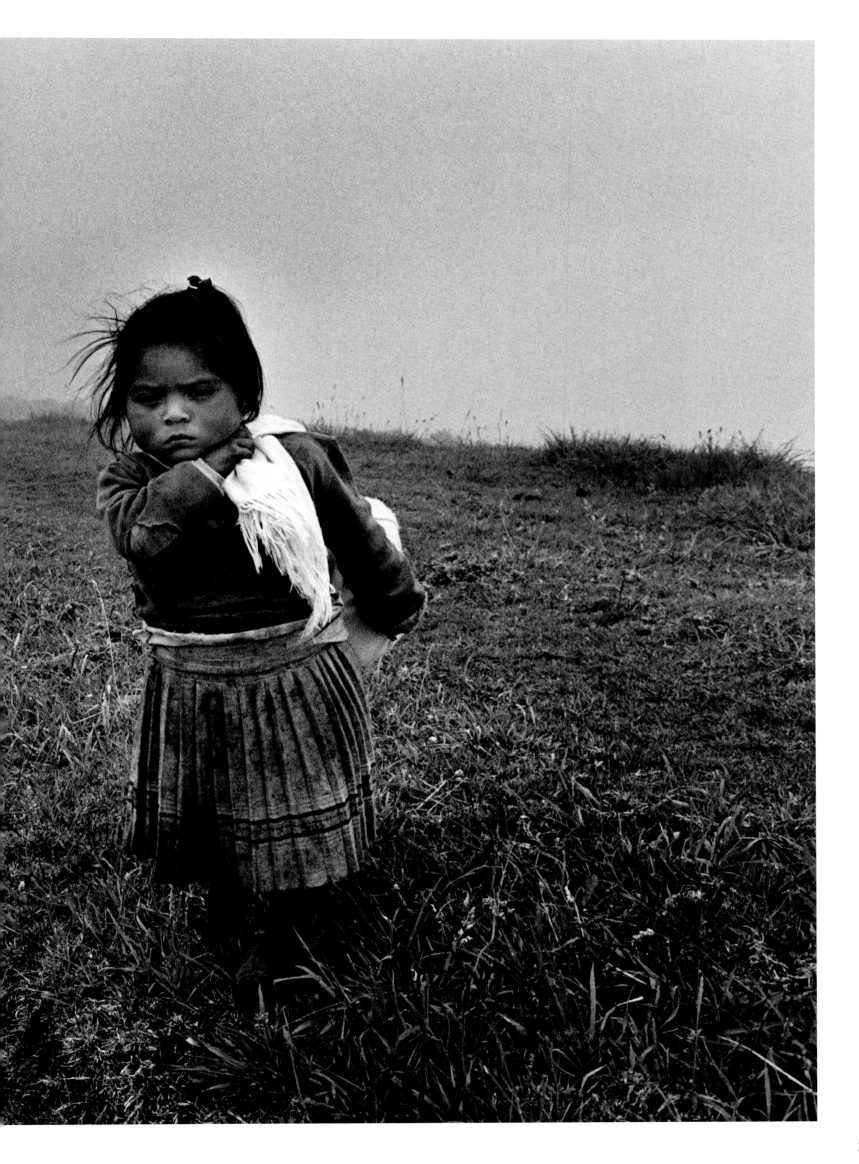

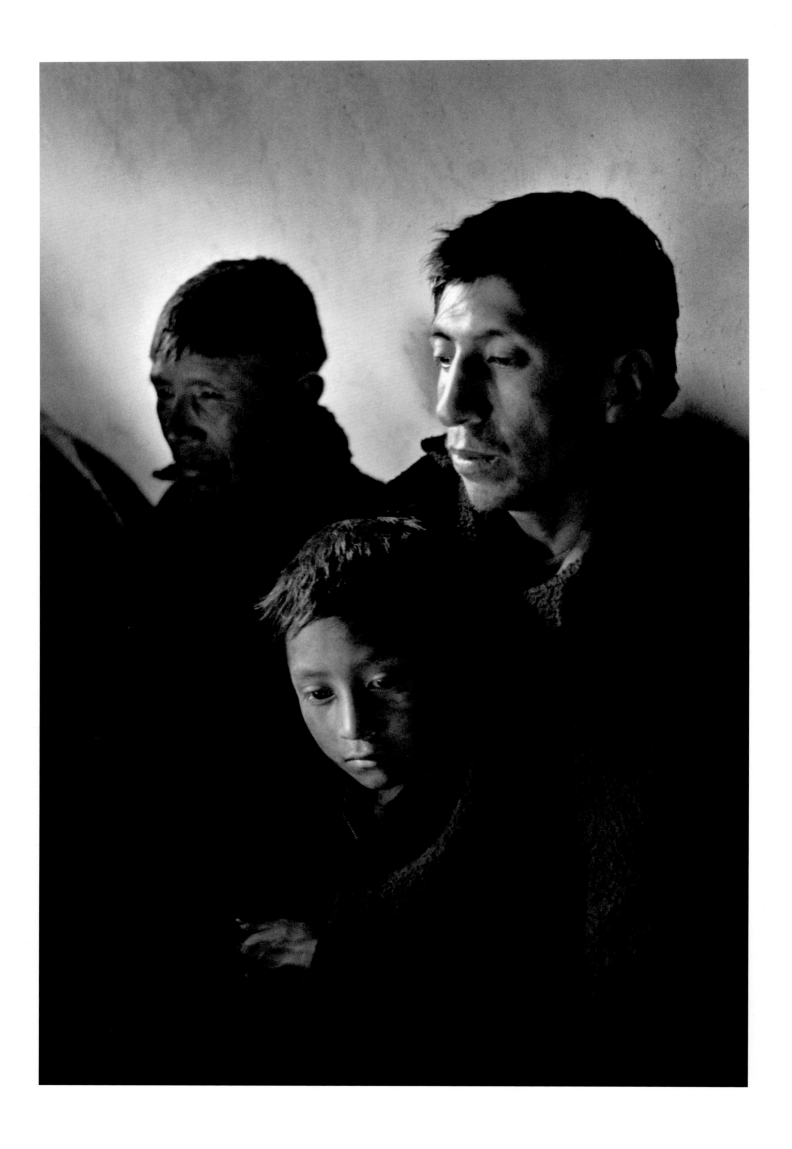

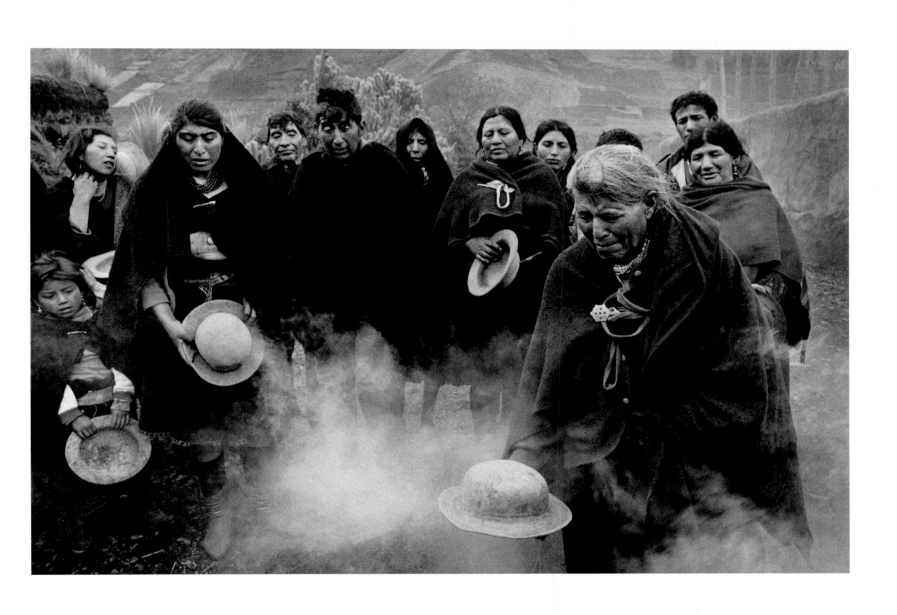

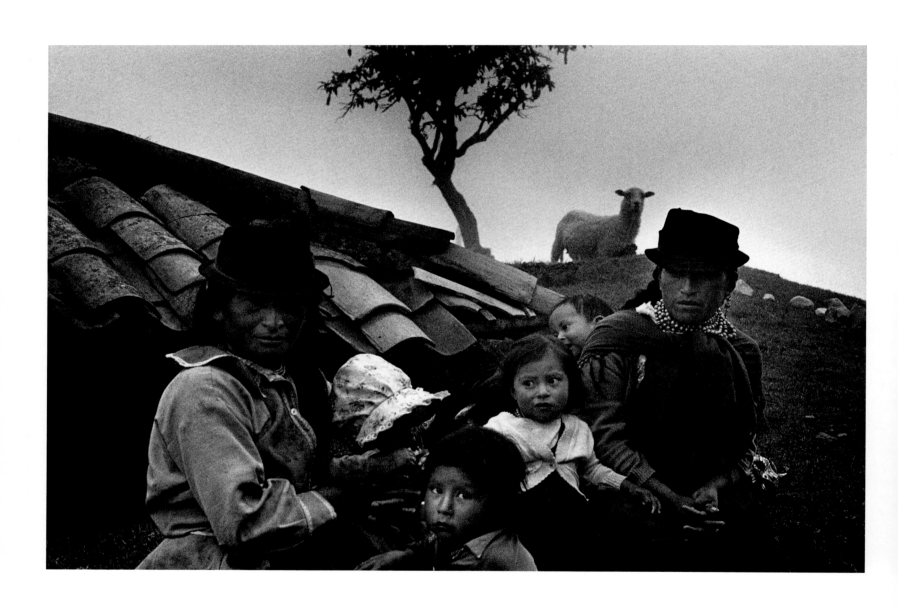

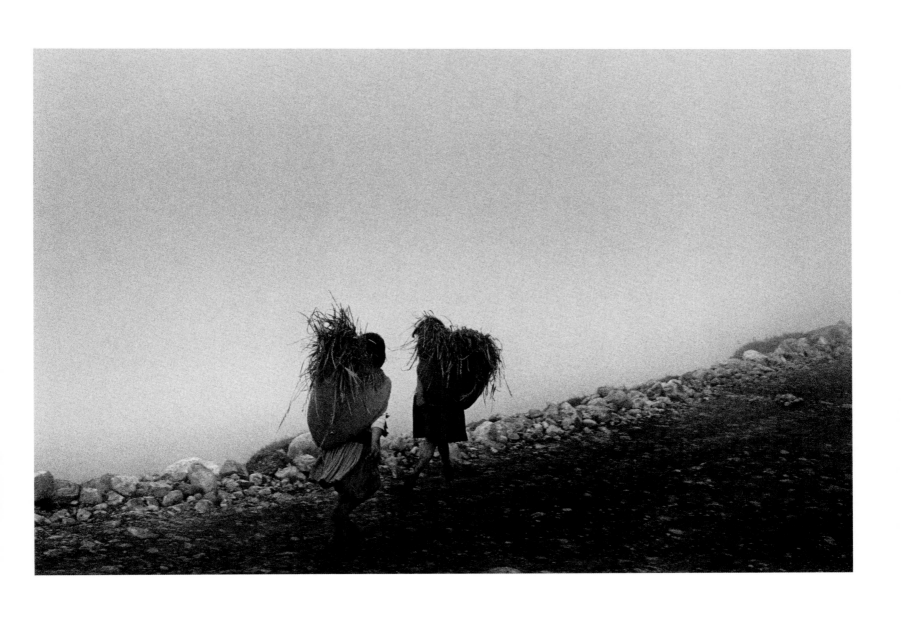

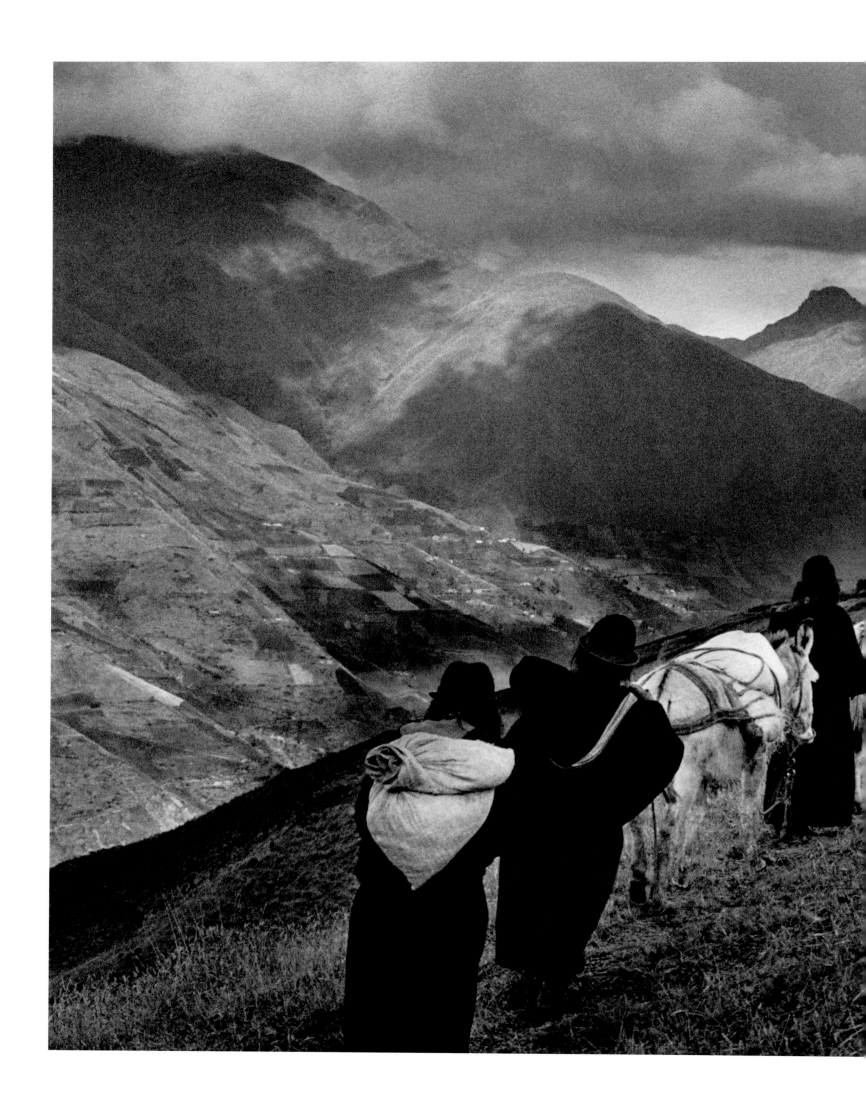

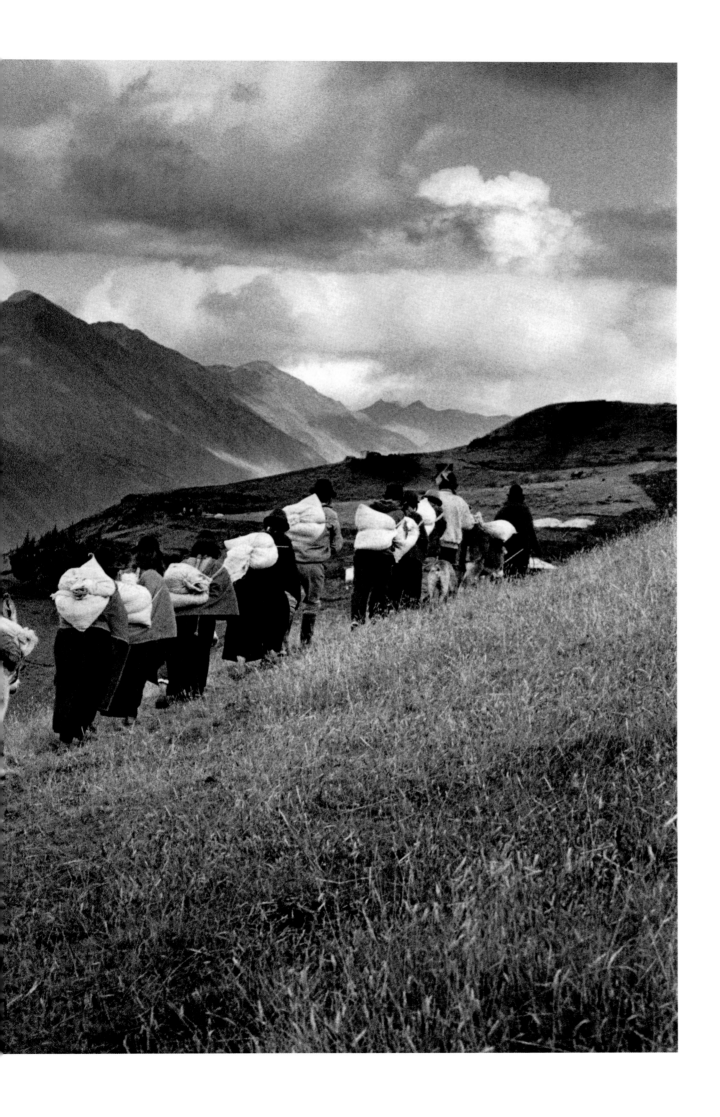

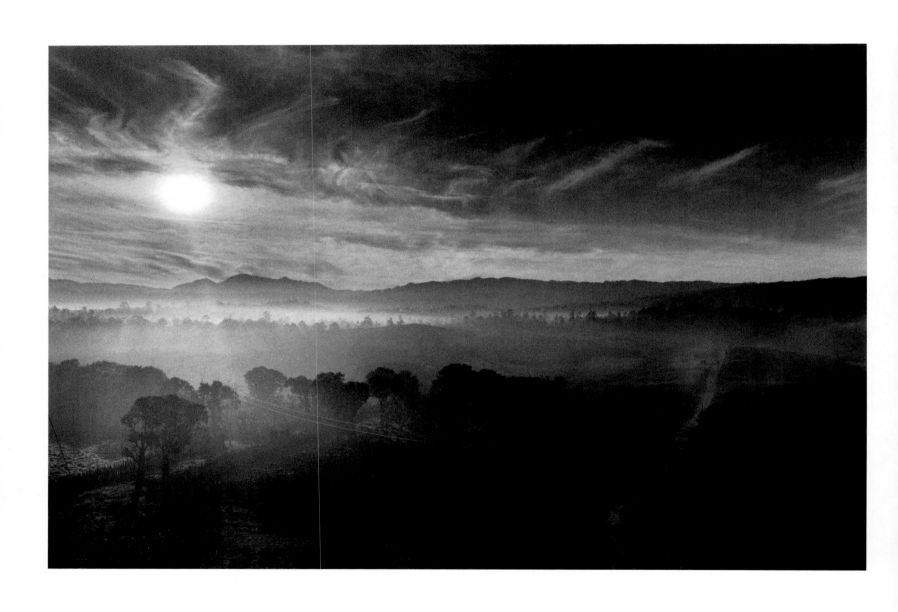

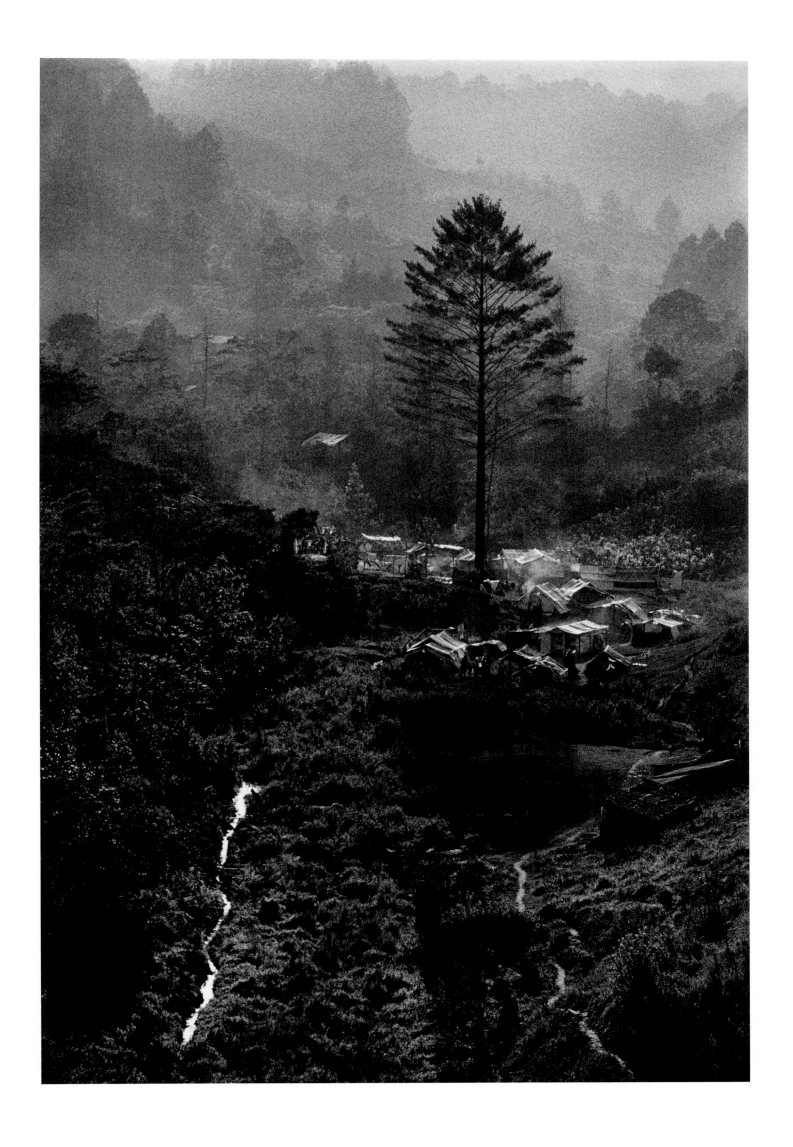

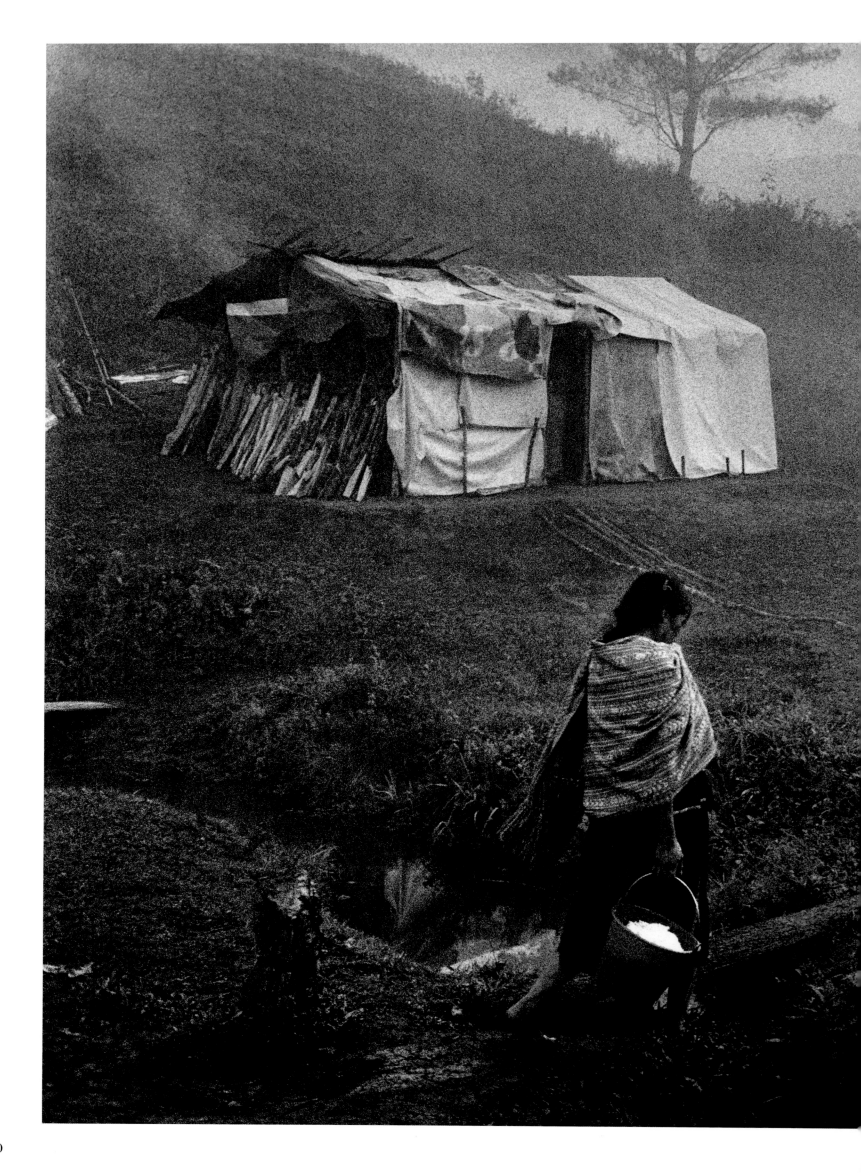

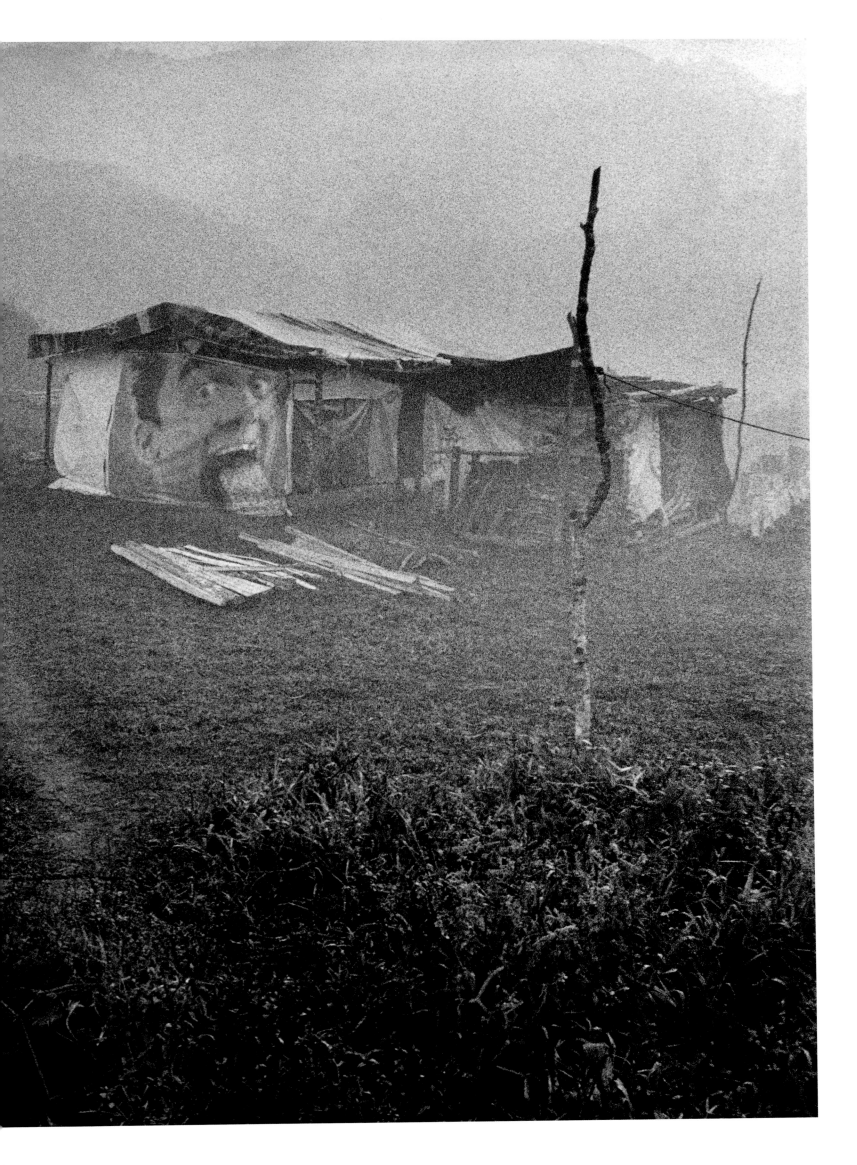

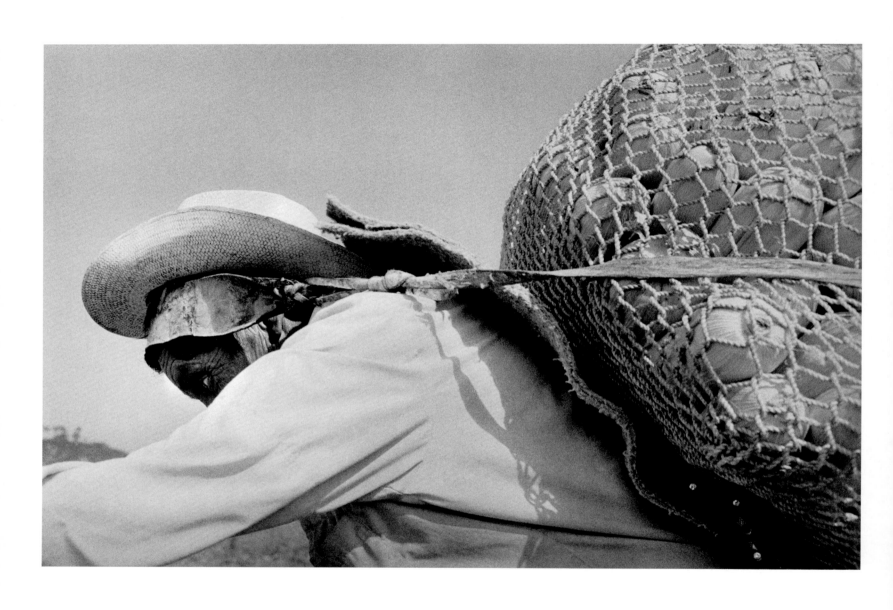

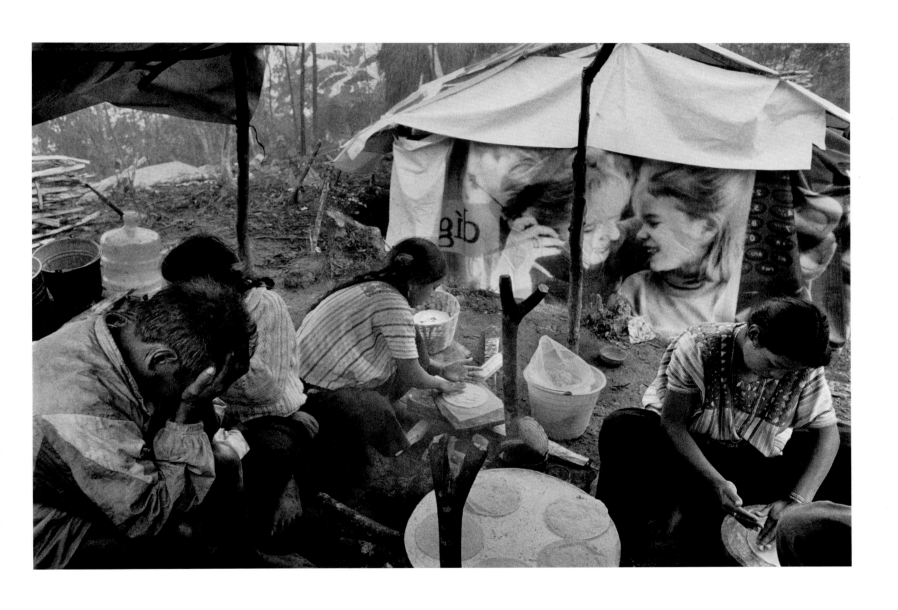

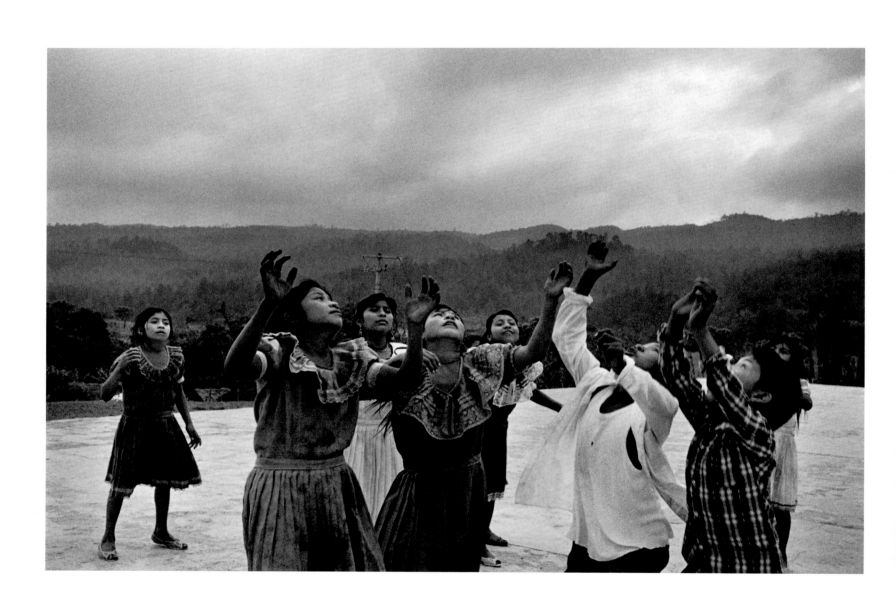

284

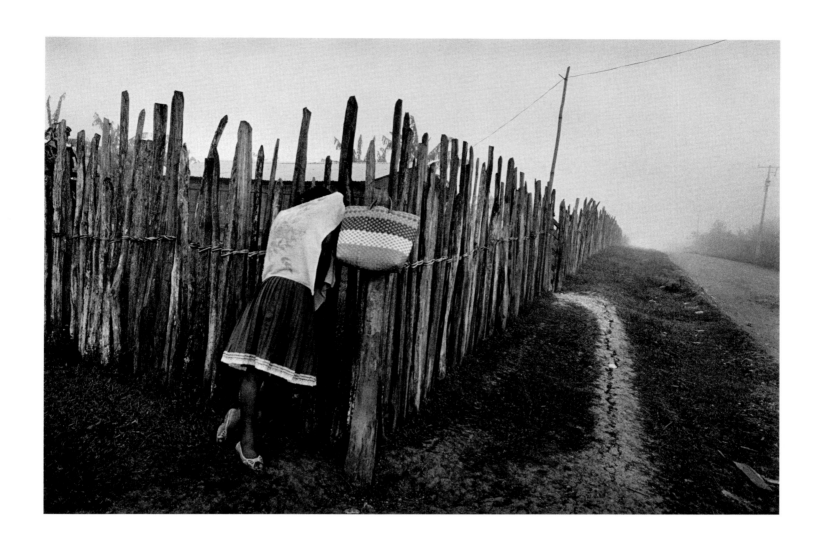

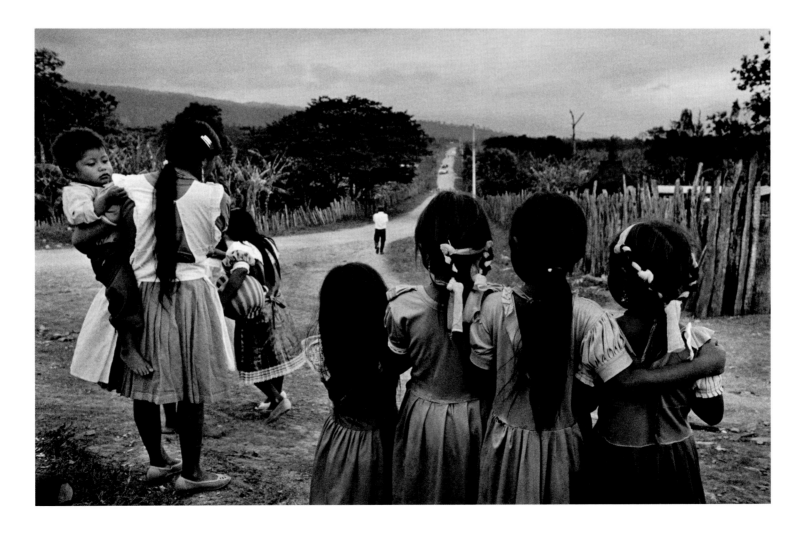

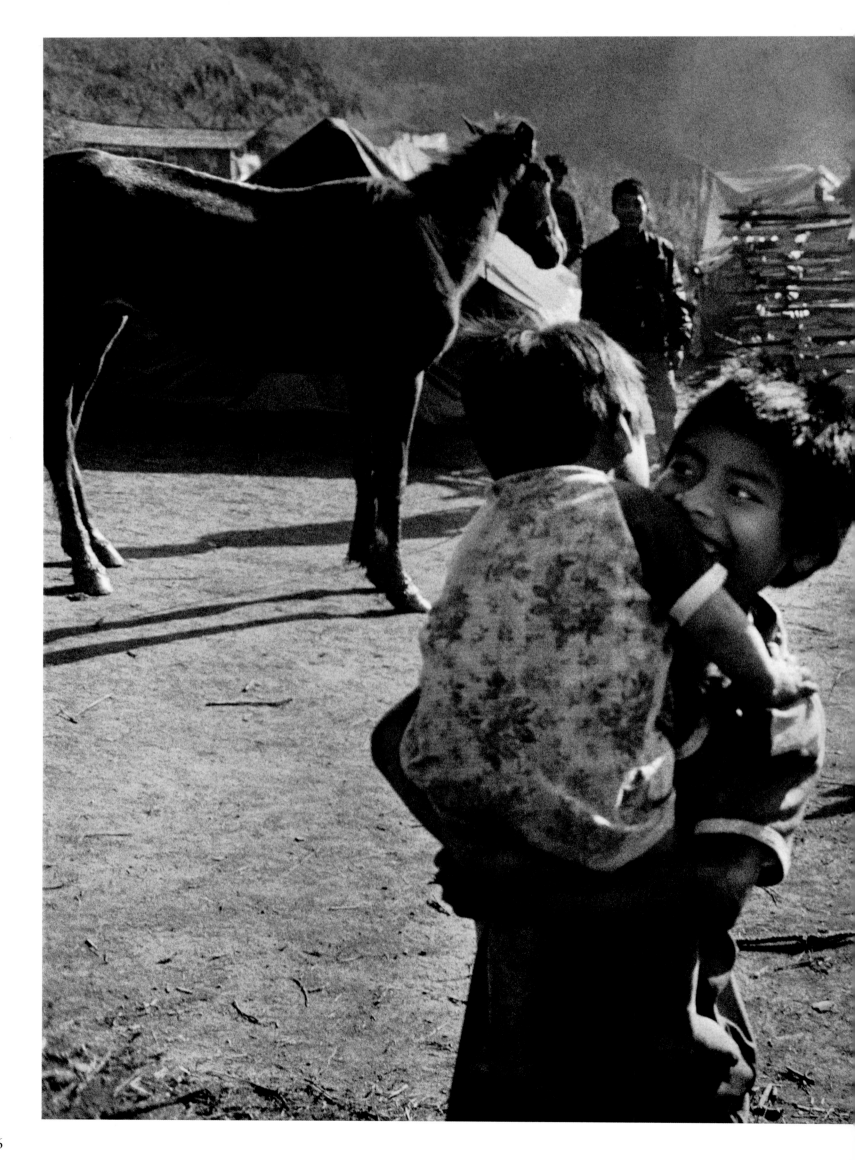

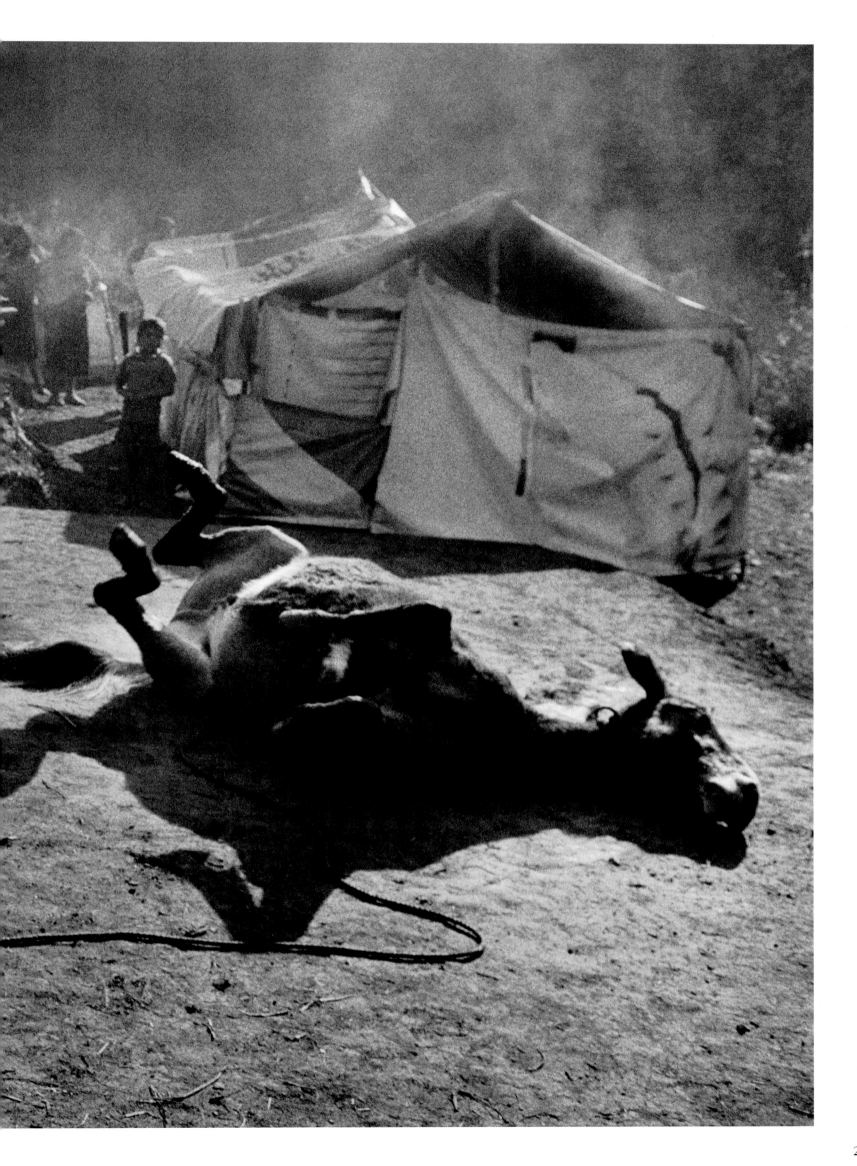

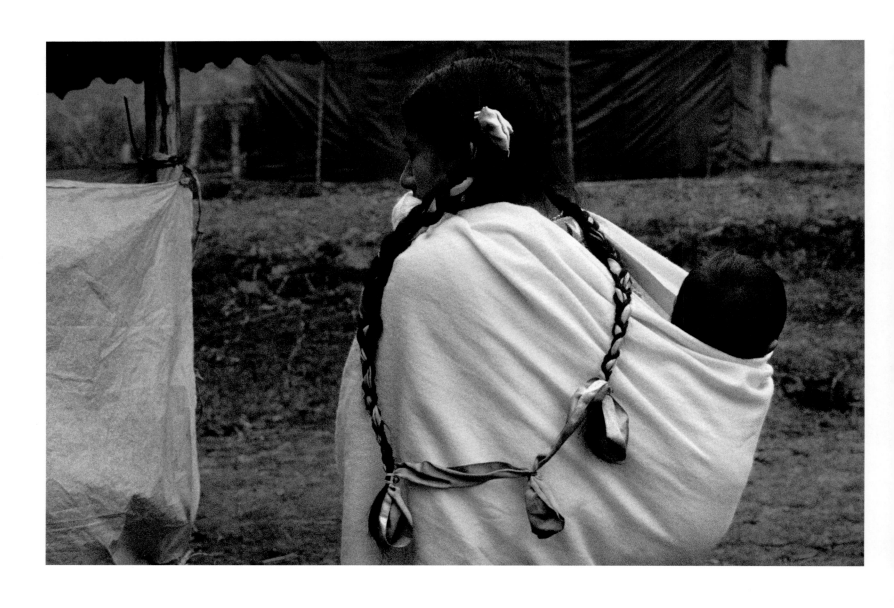

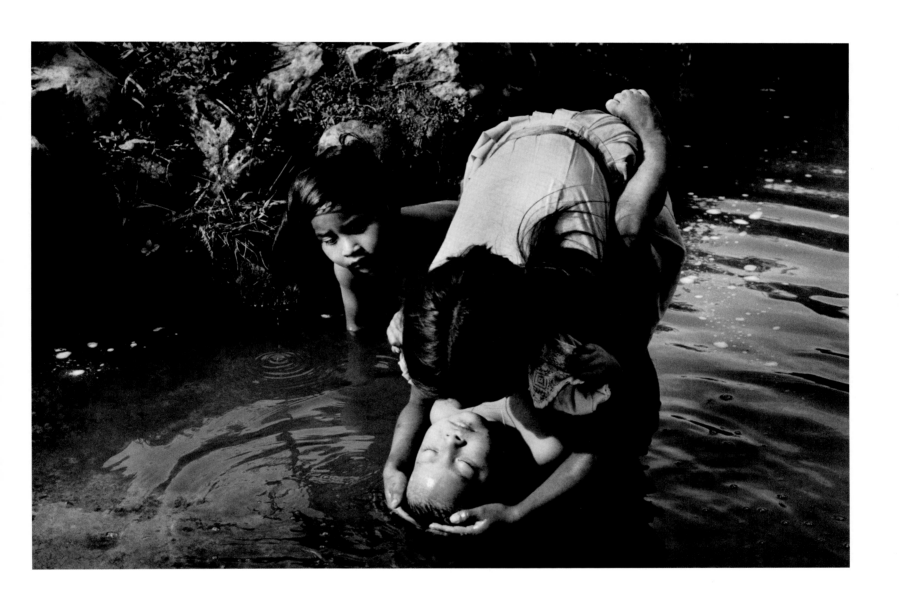

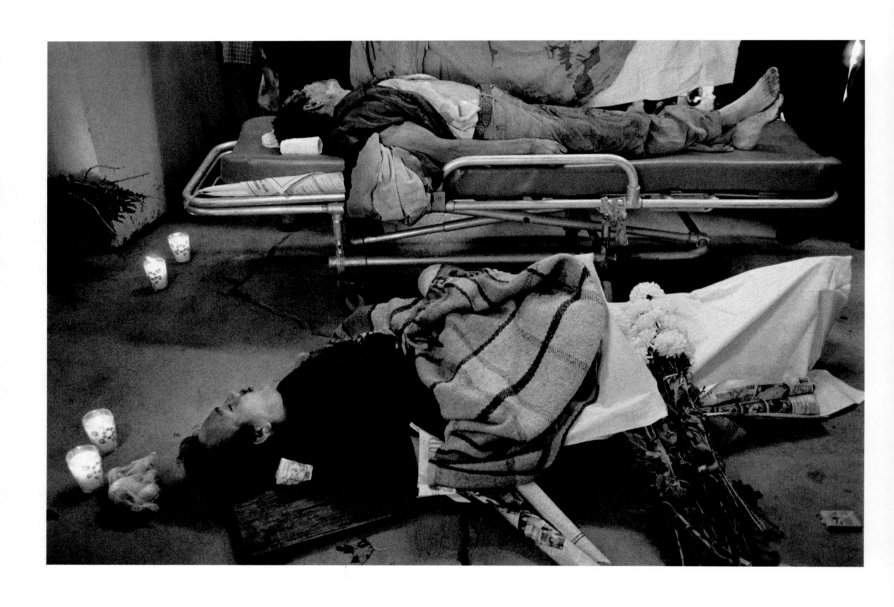

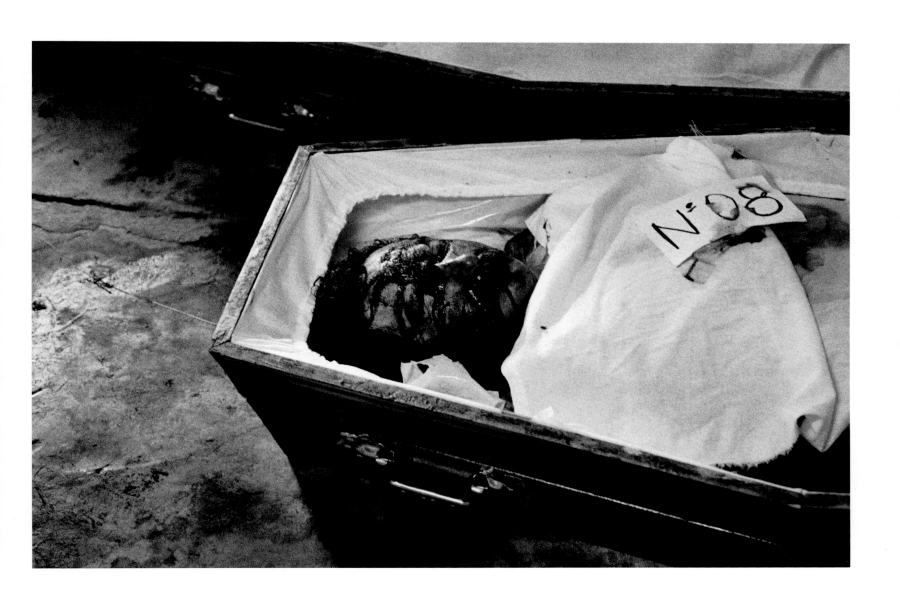

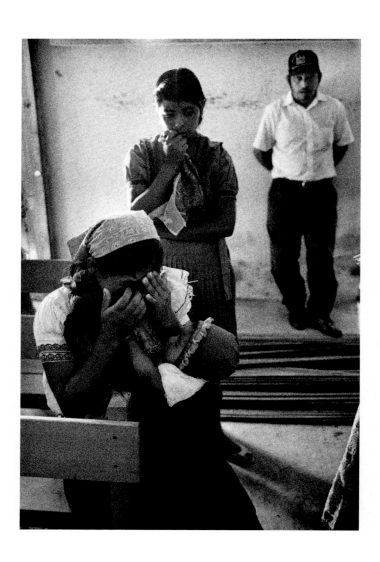

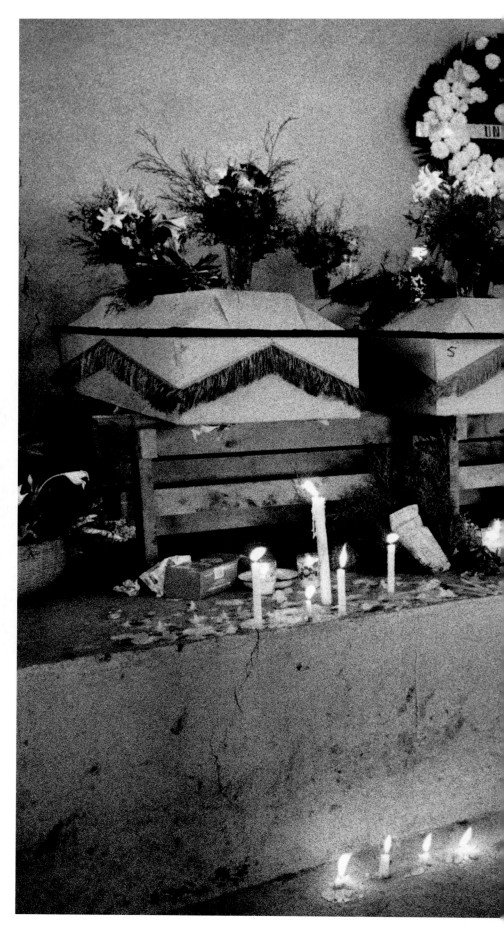

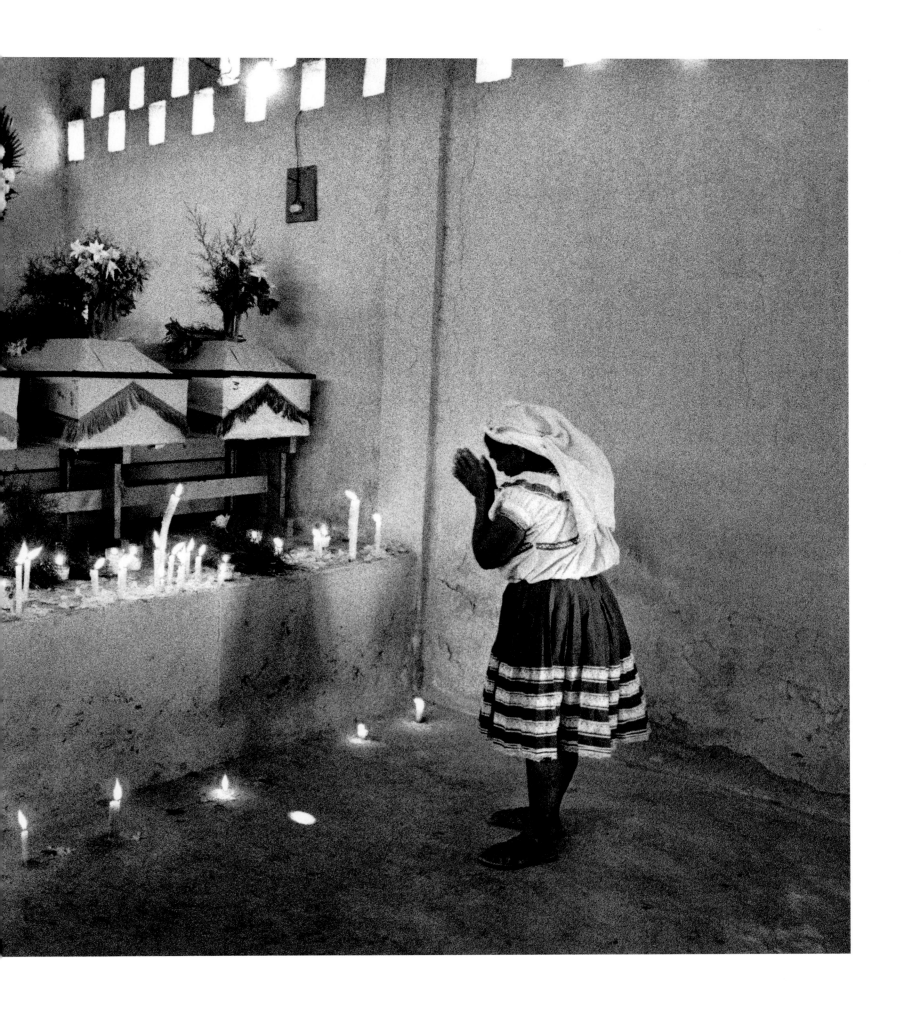

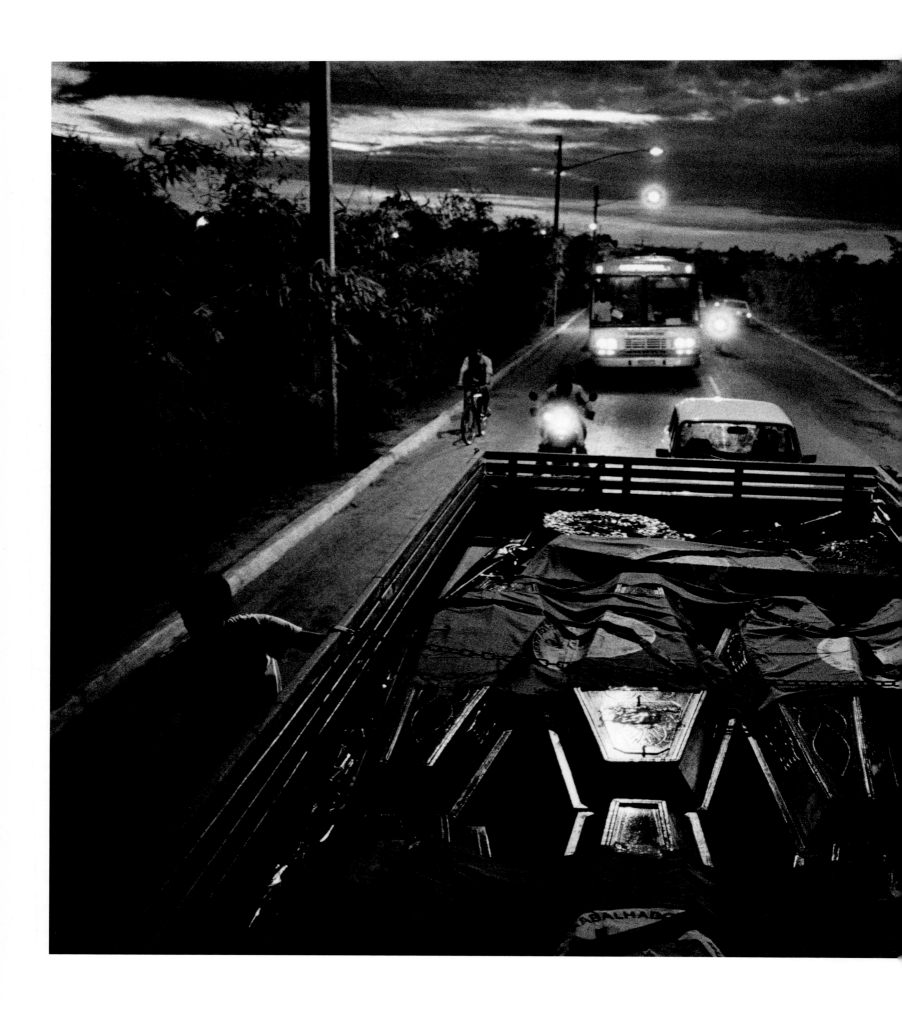

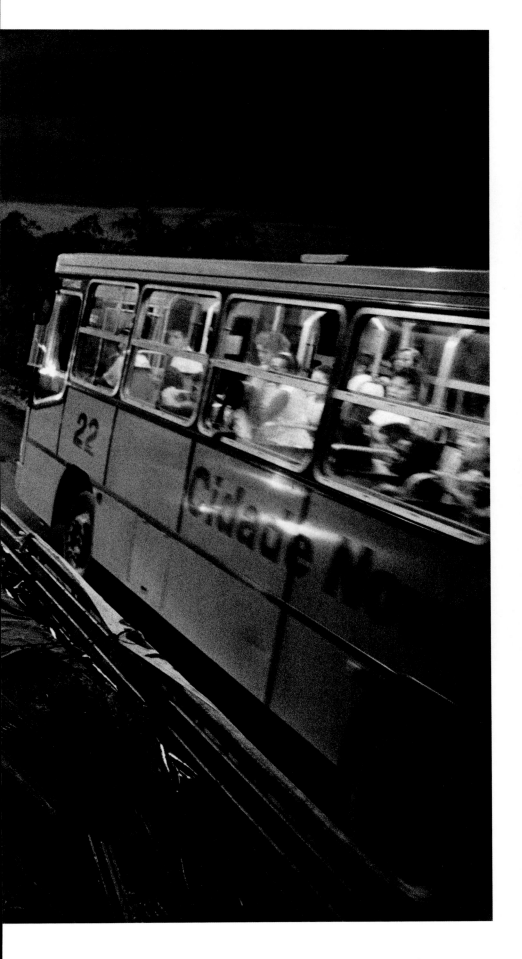

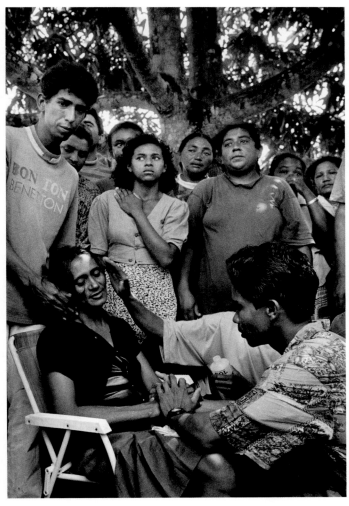

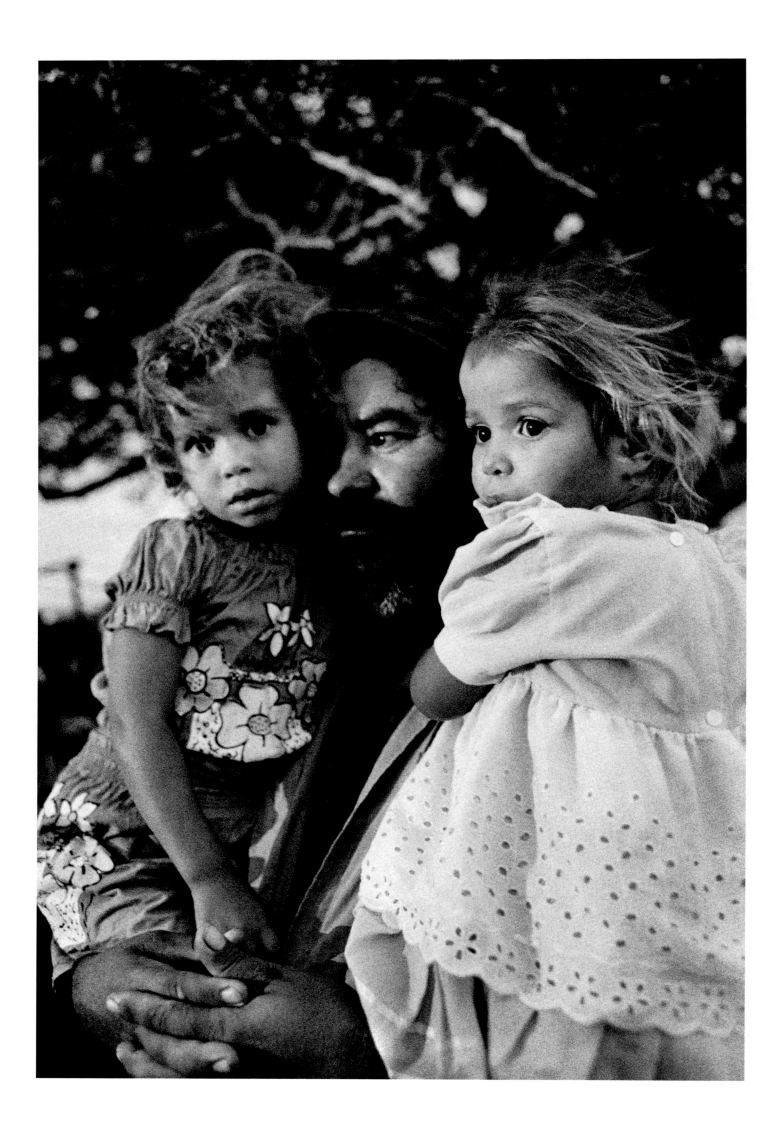

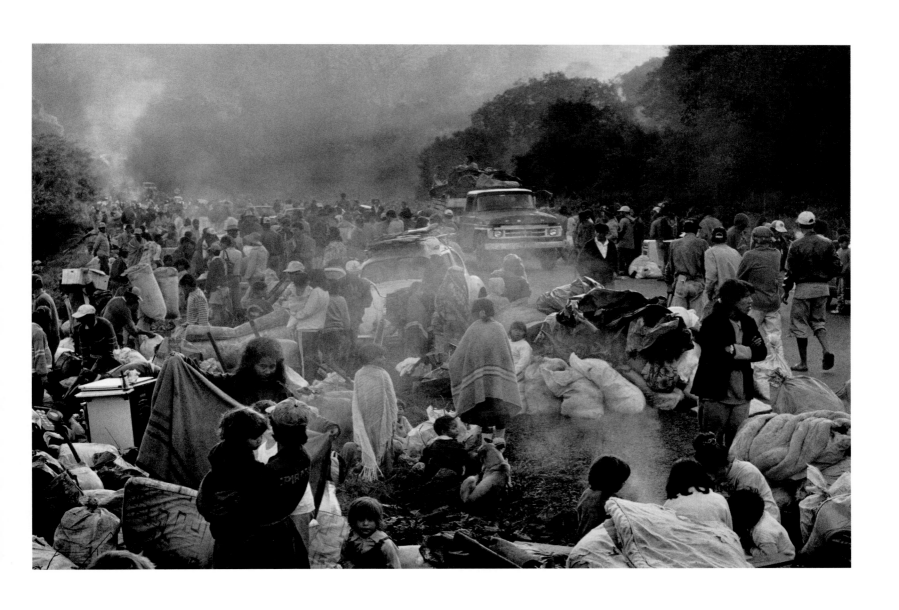

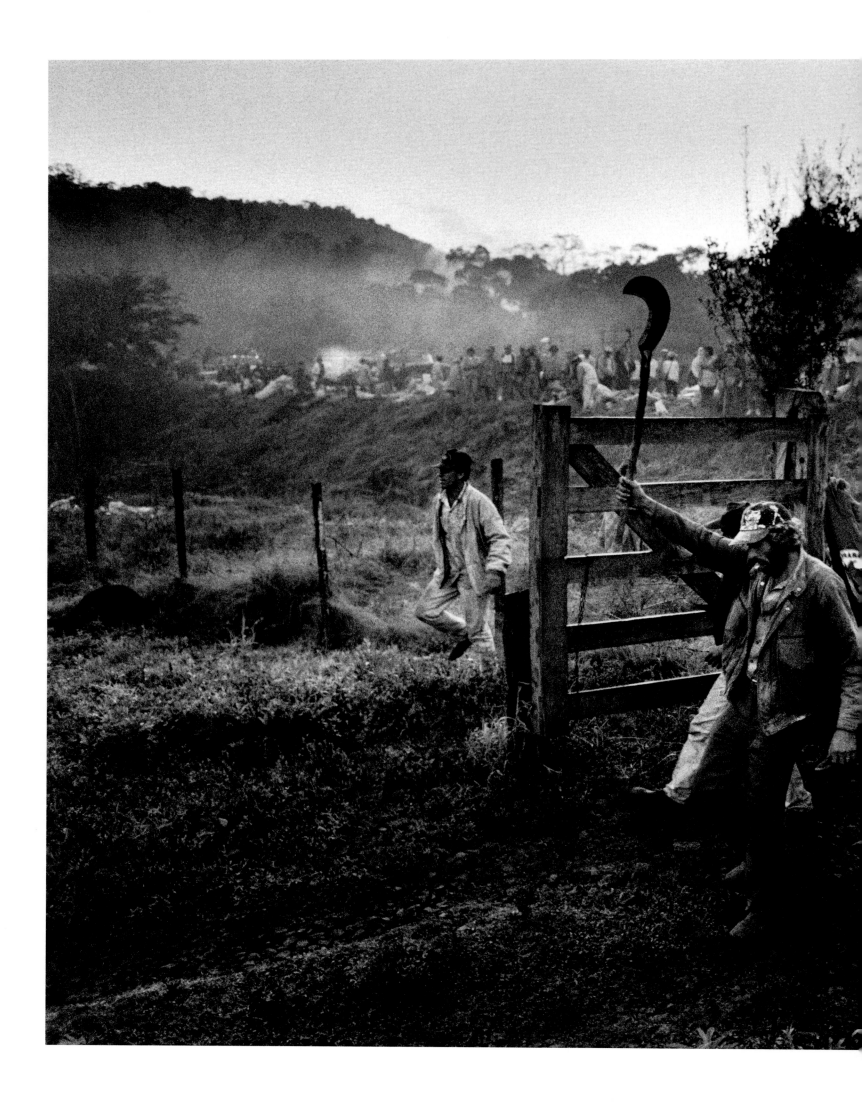

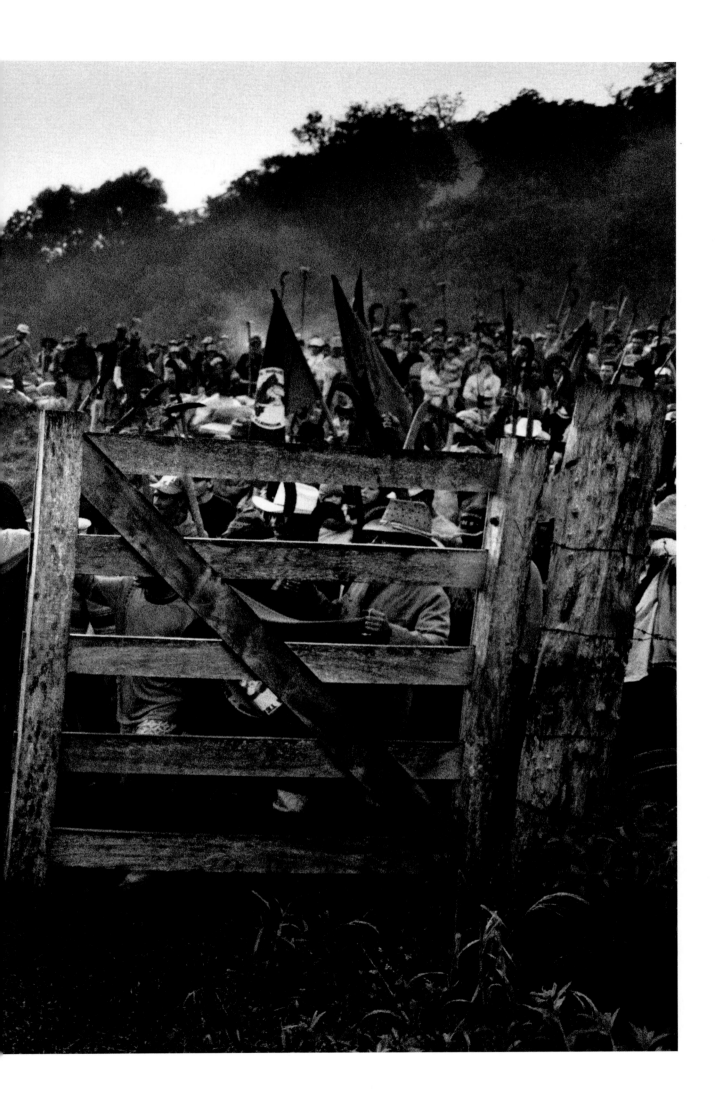

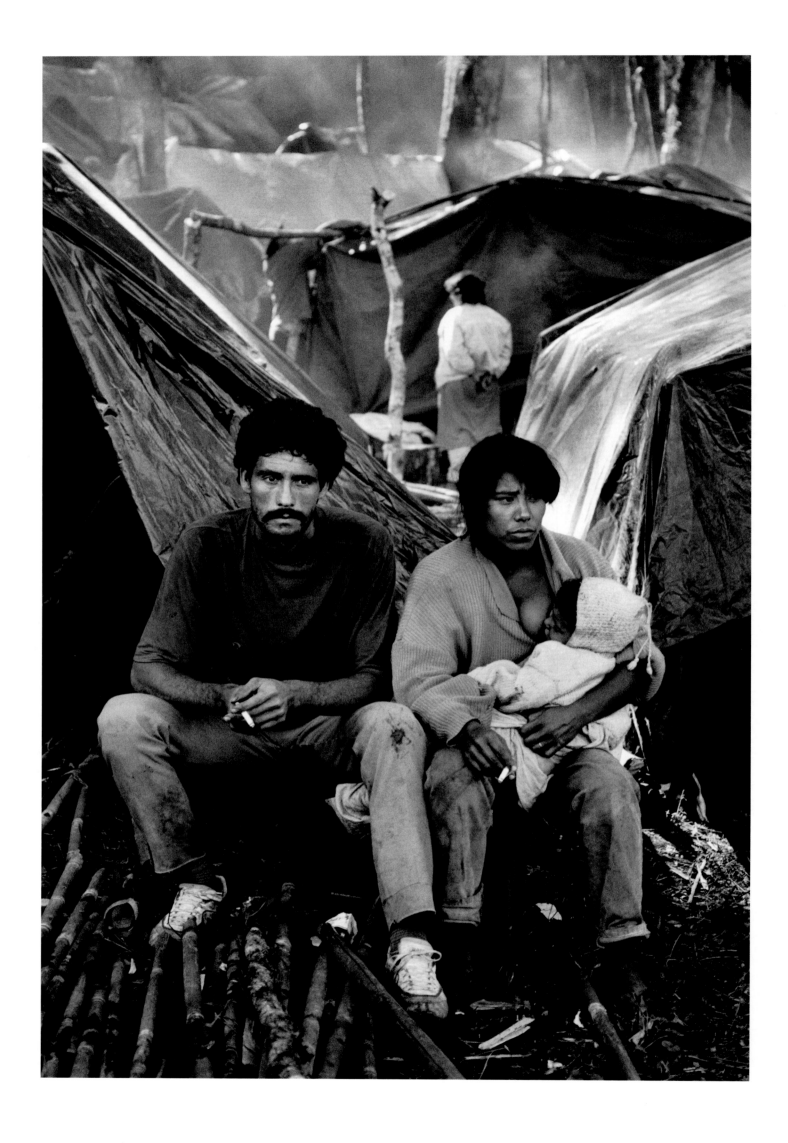

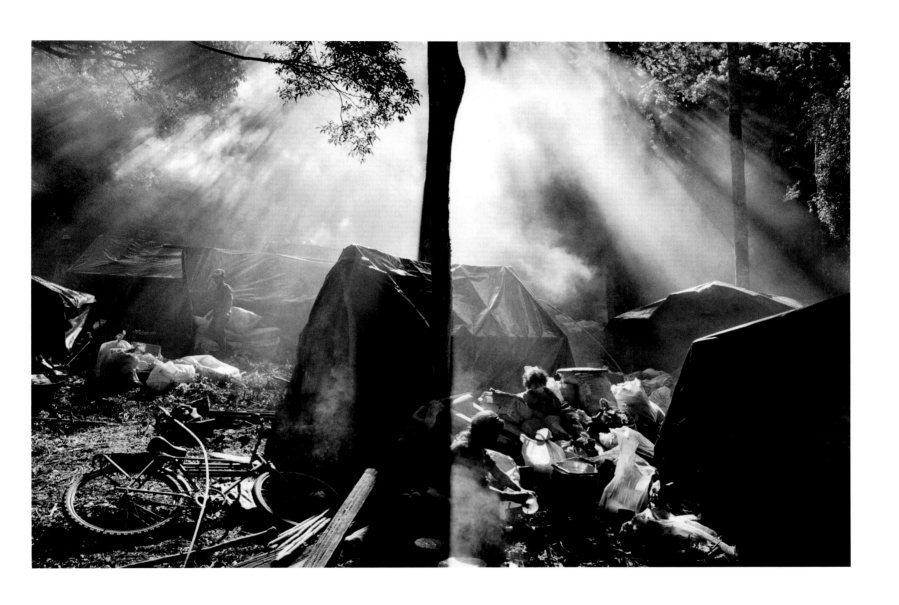

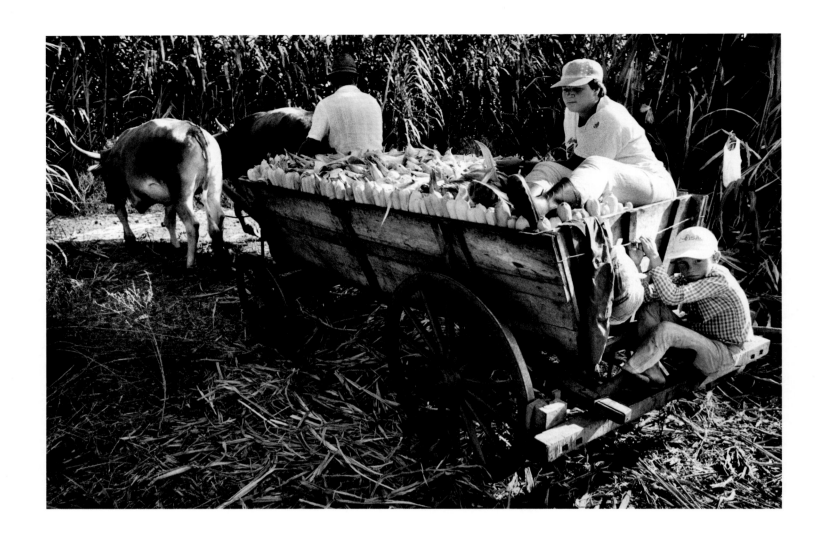

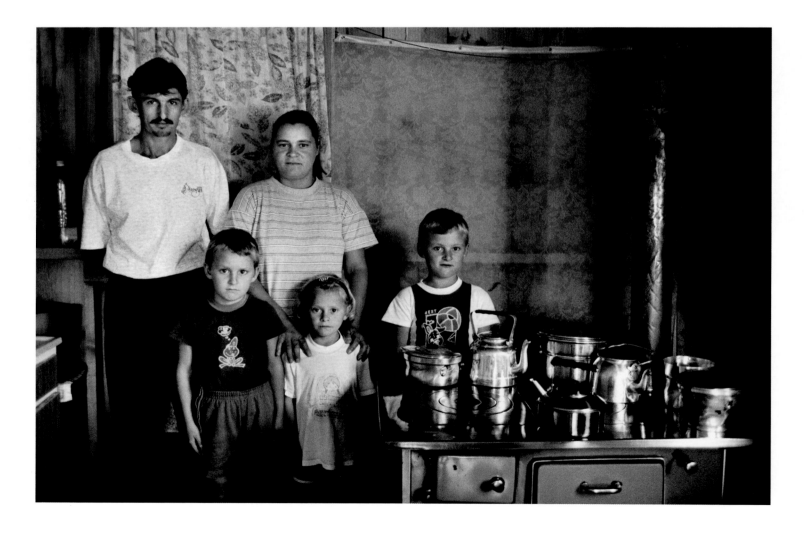

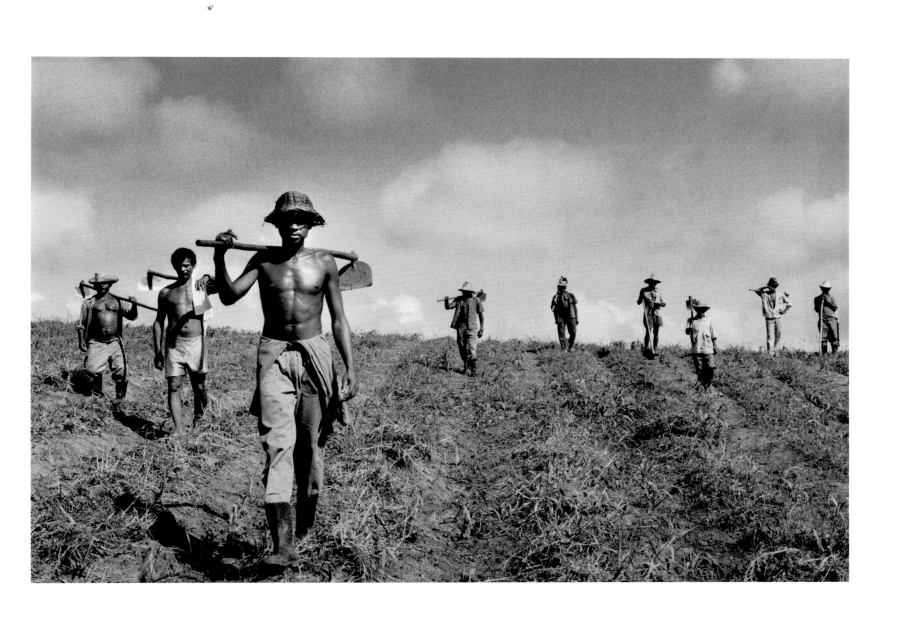

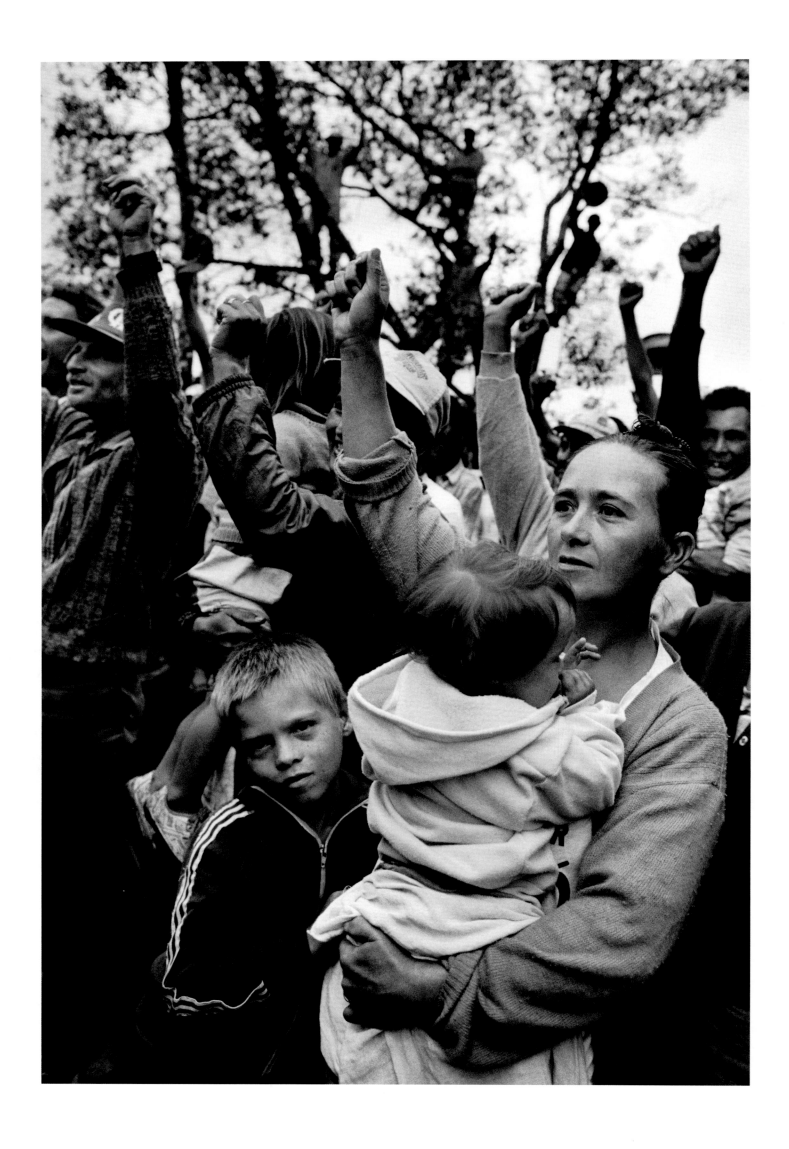

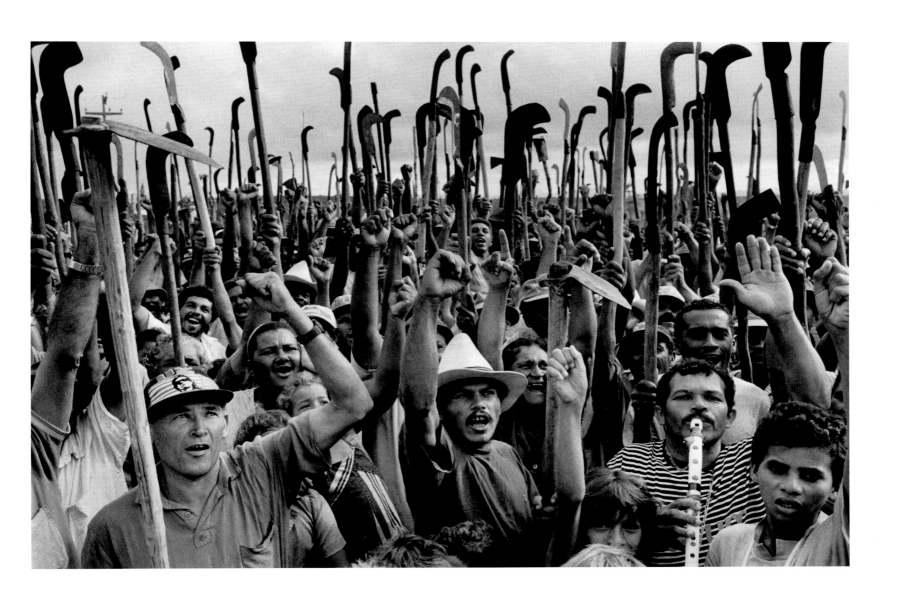

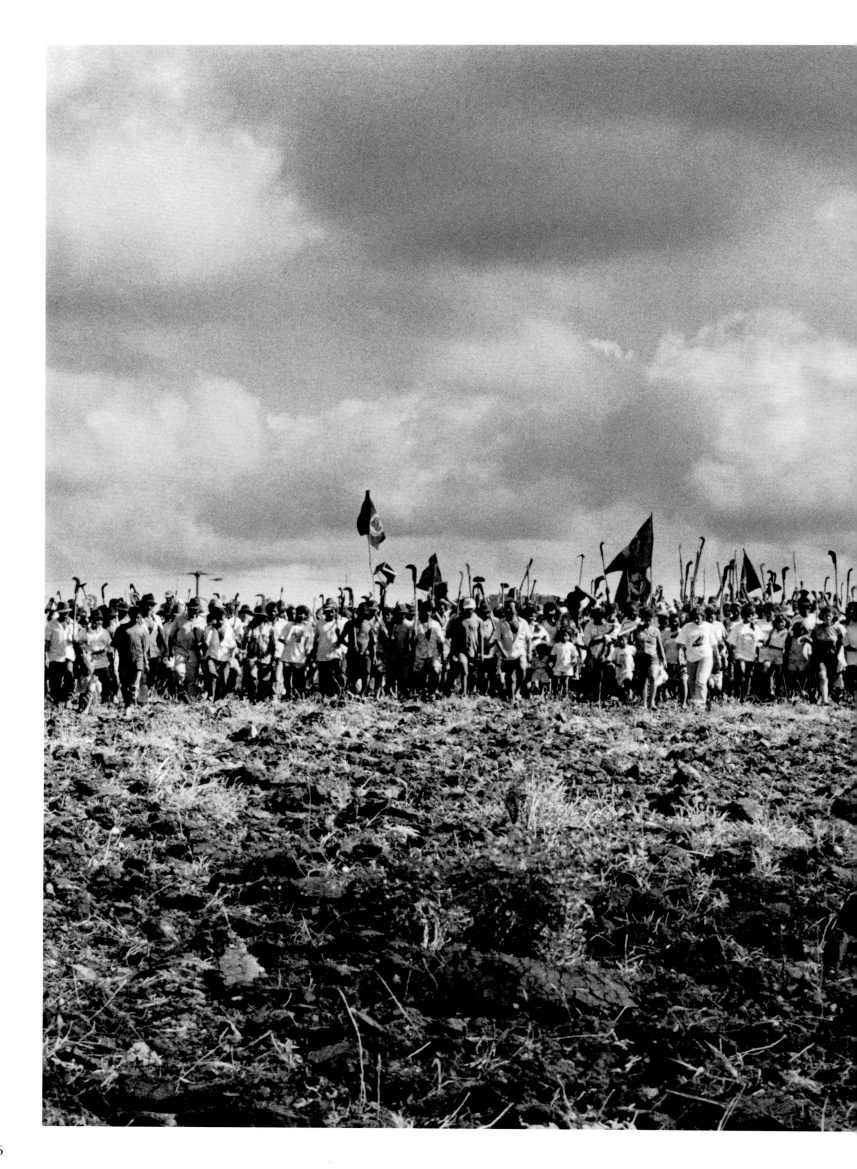

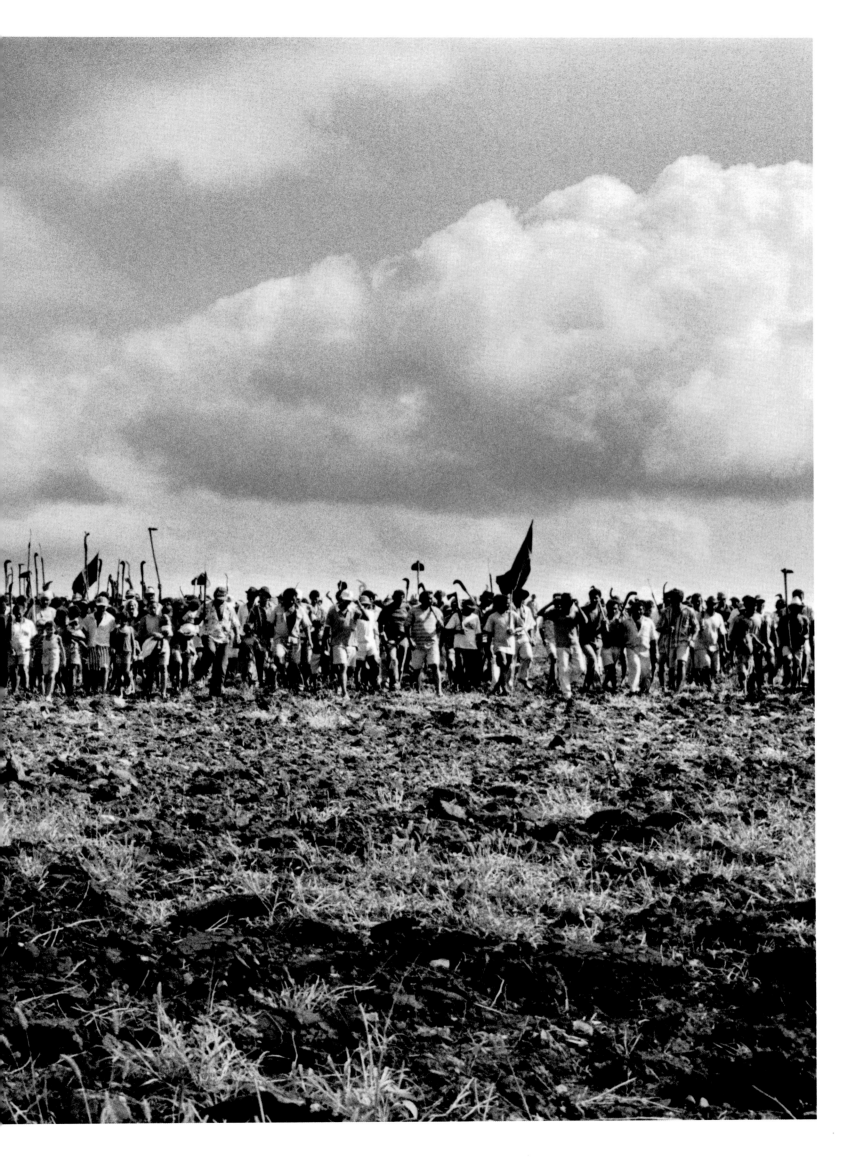

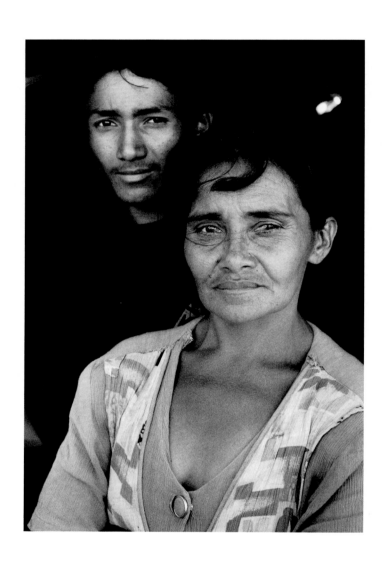

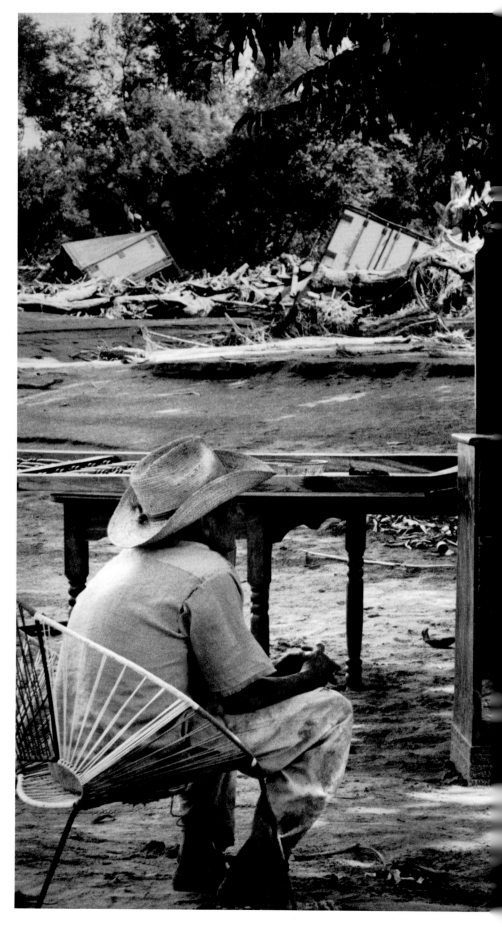

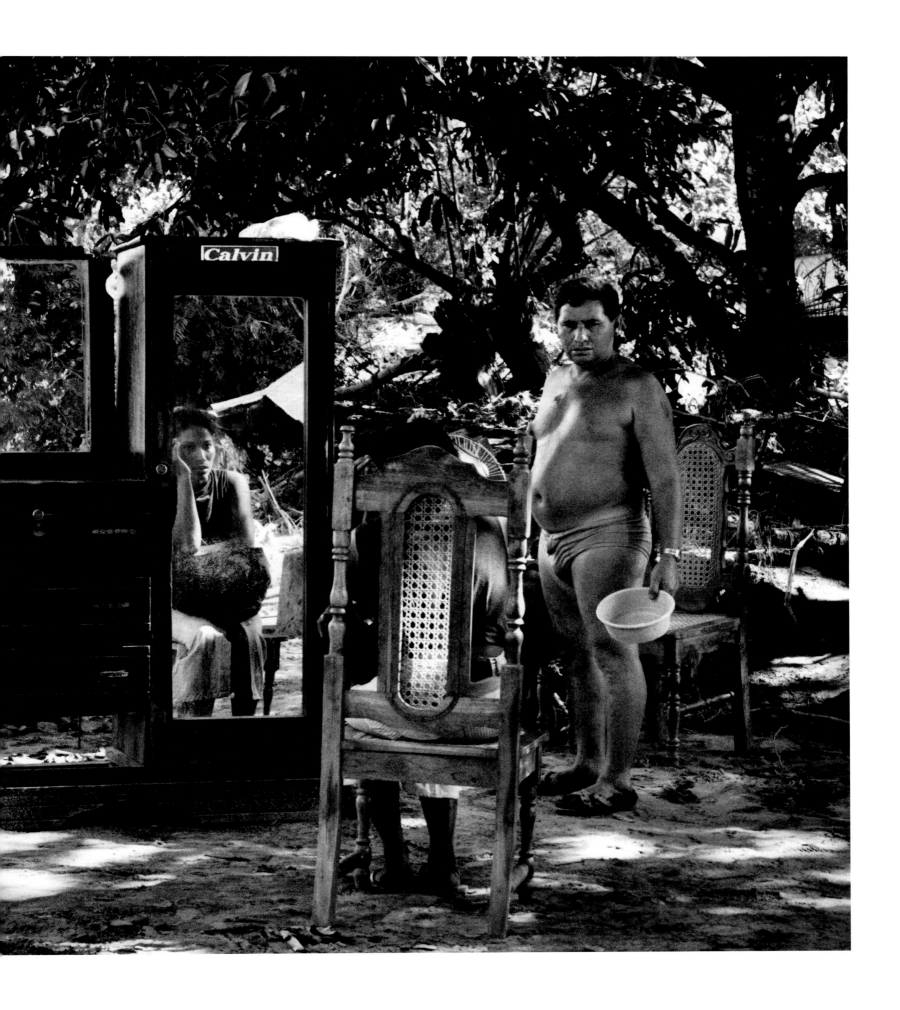

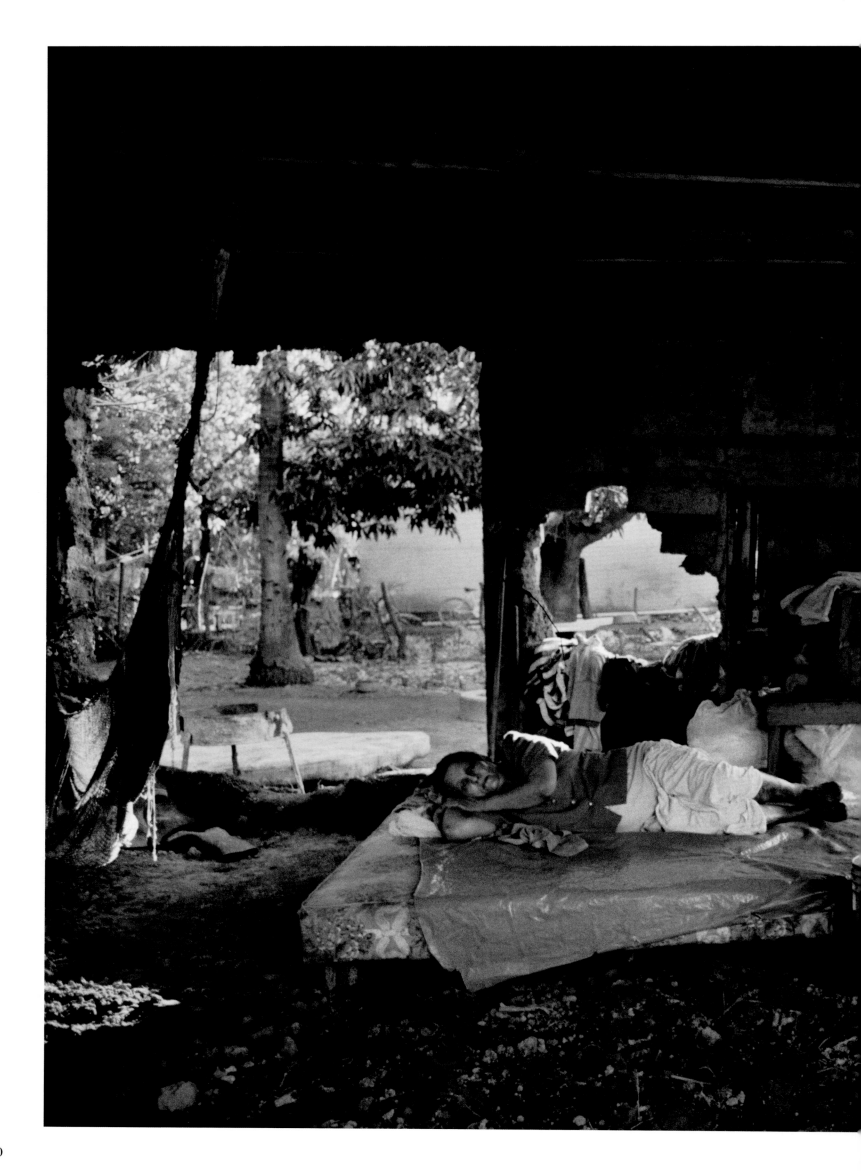

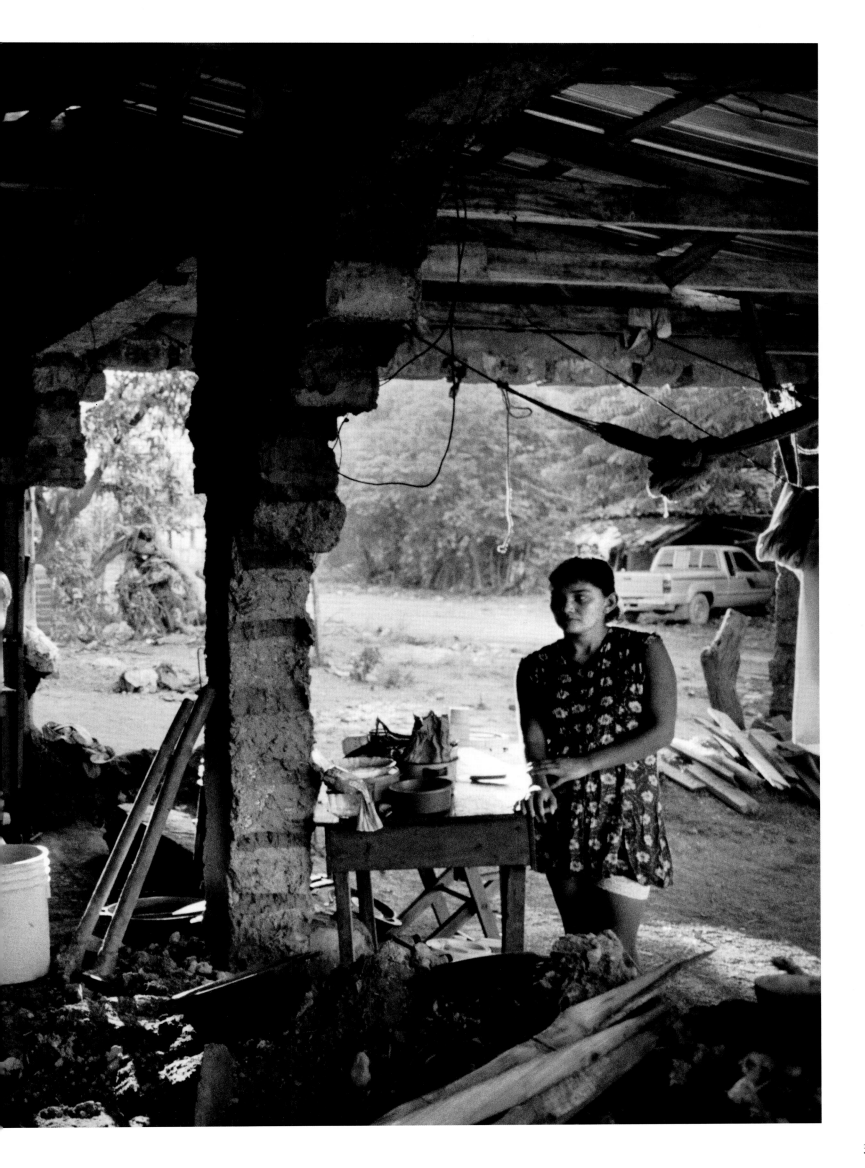

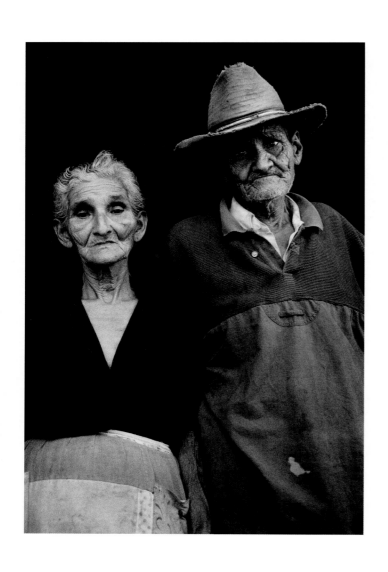

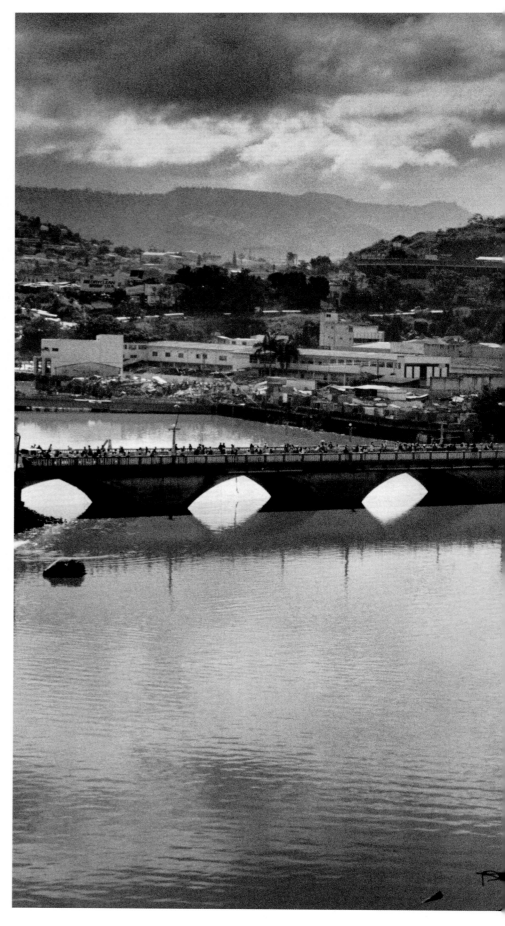

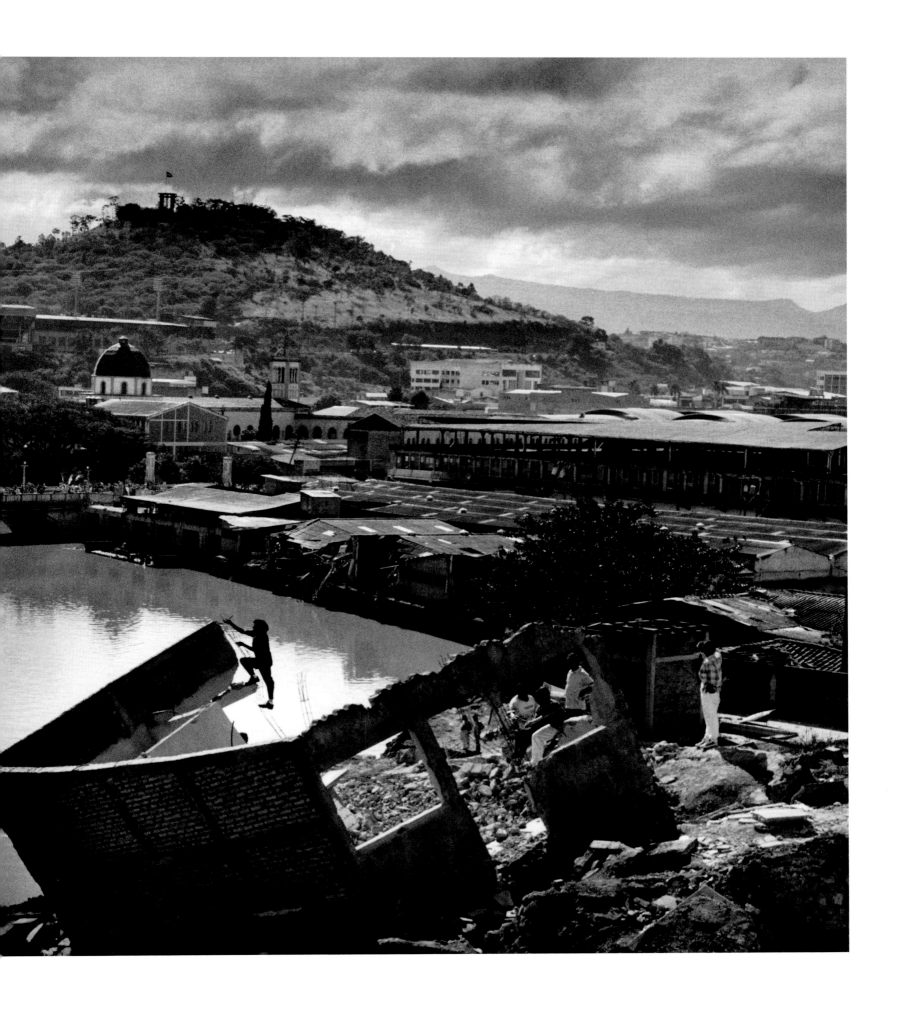

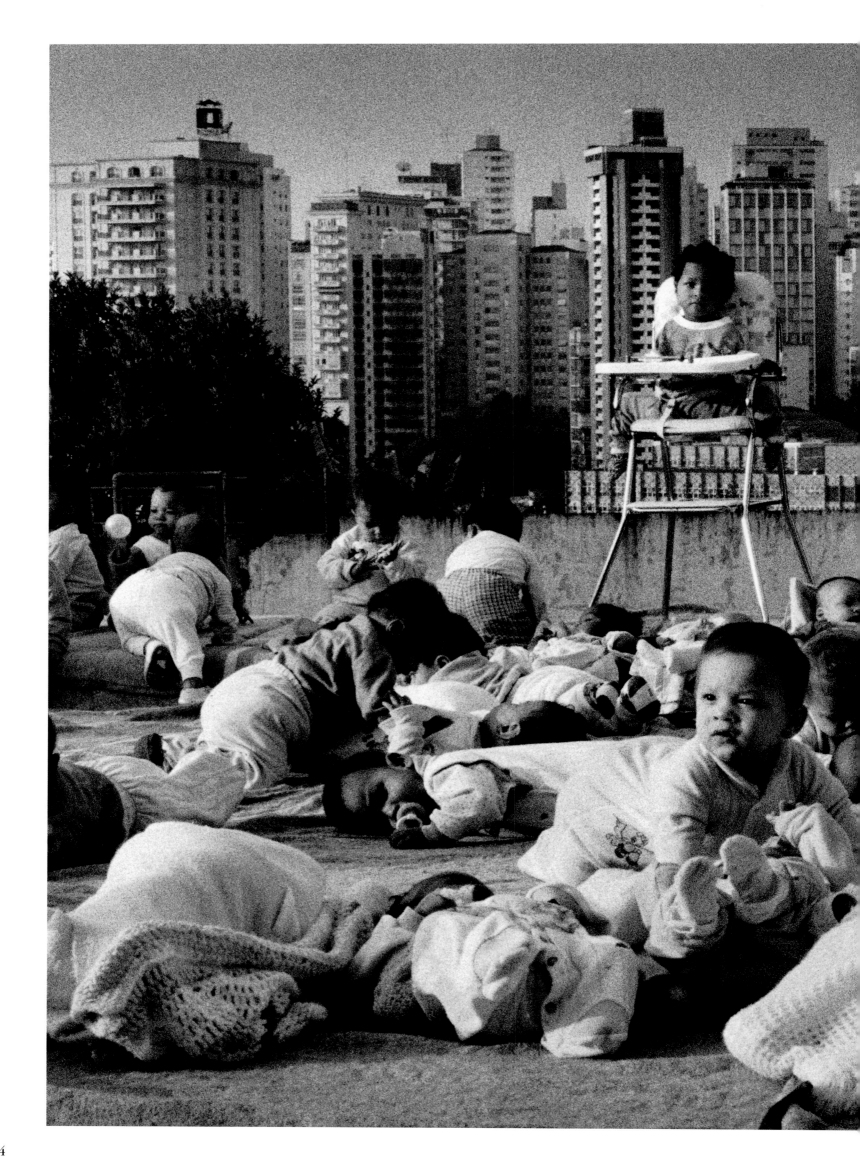

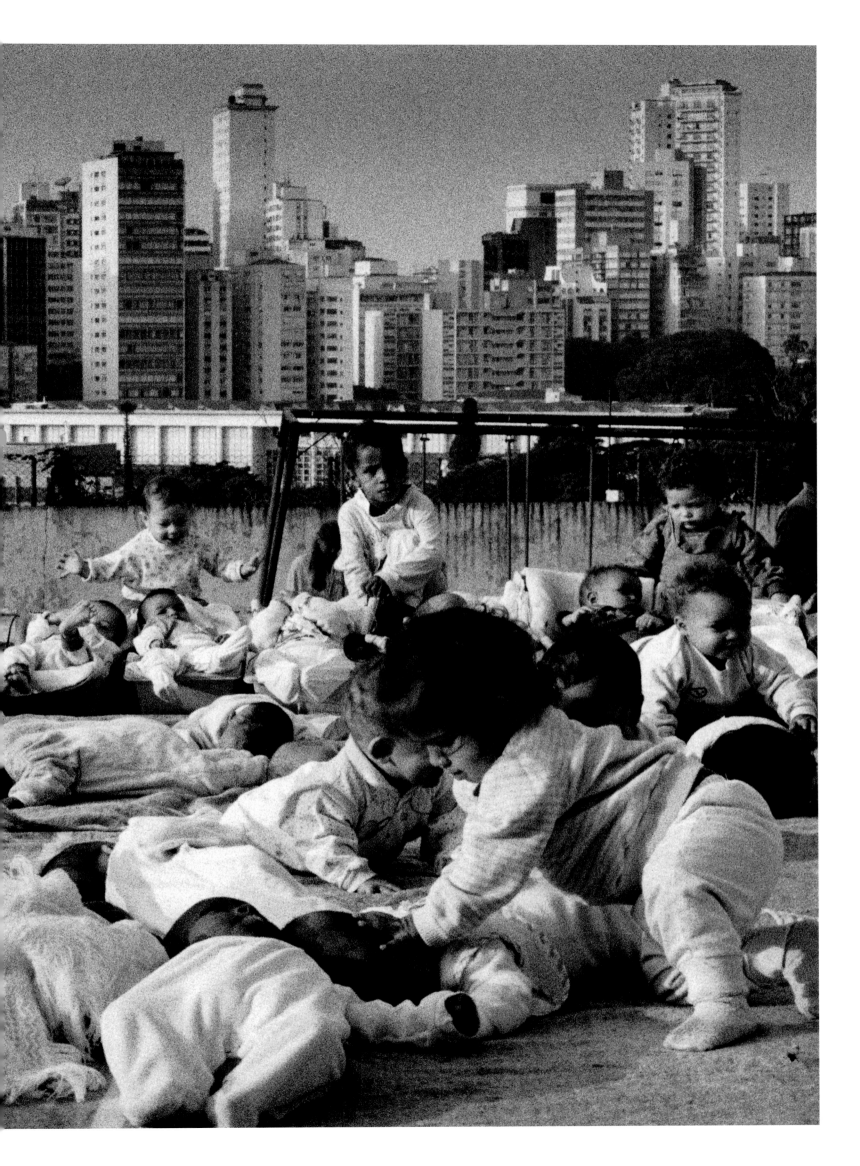

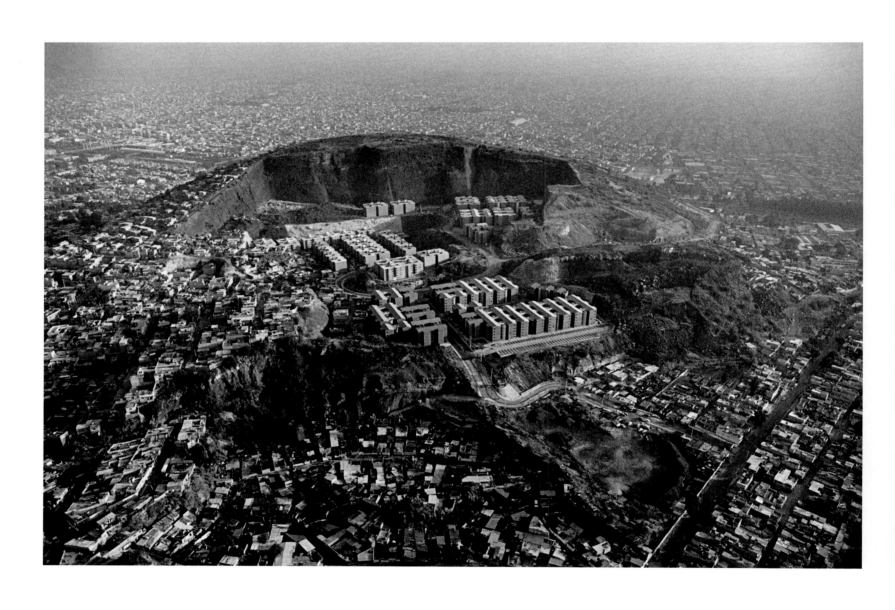

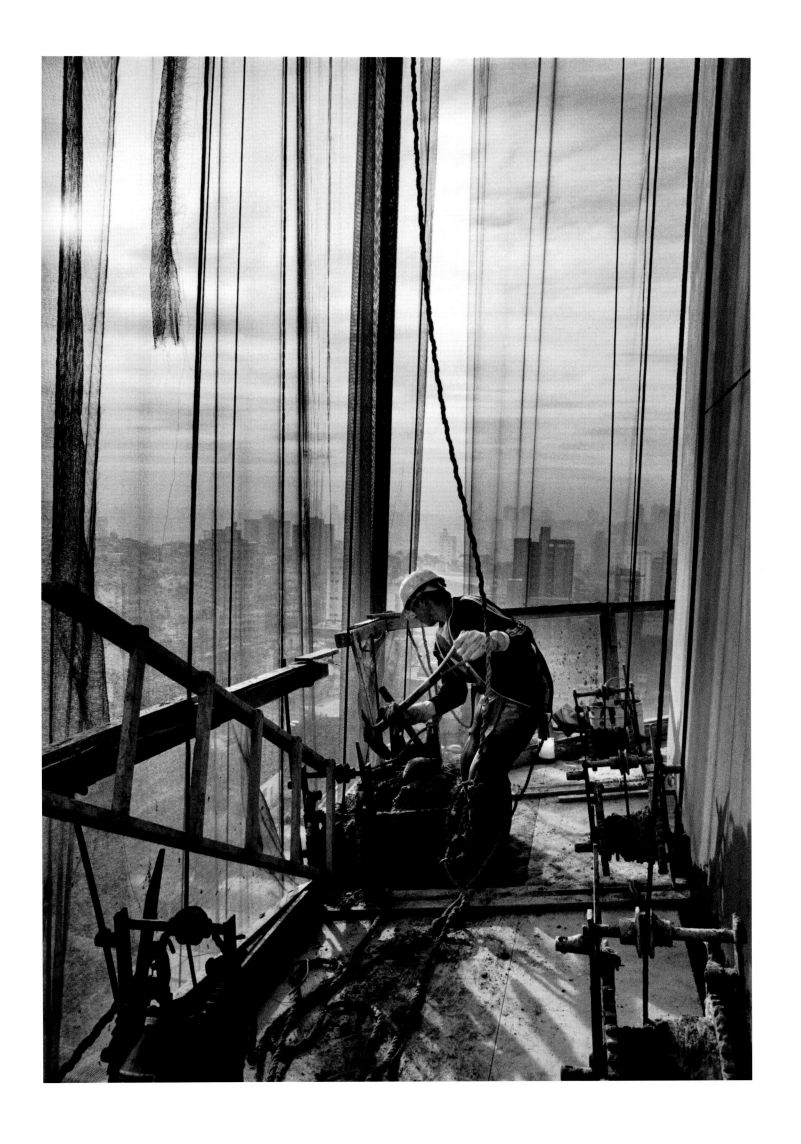

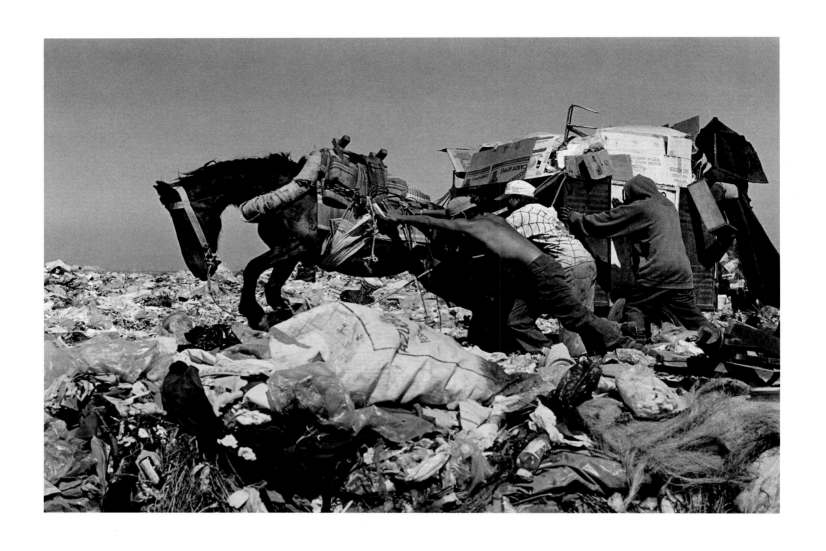

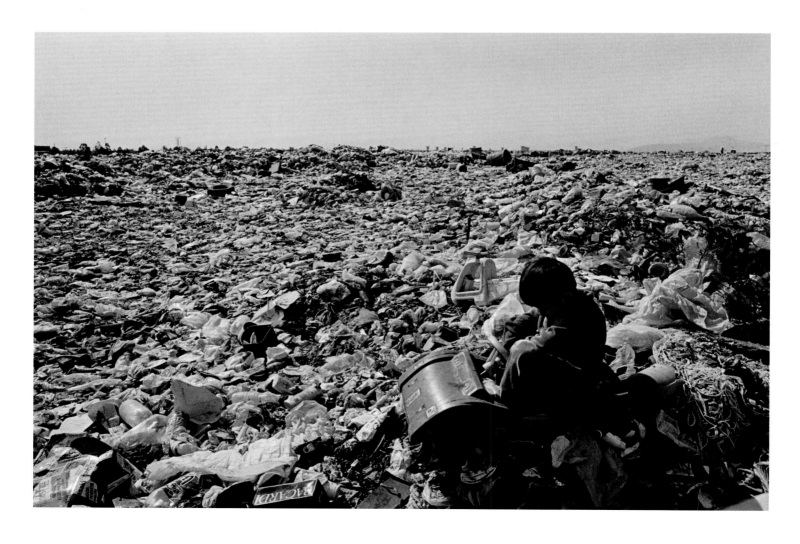

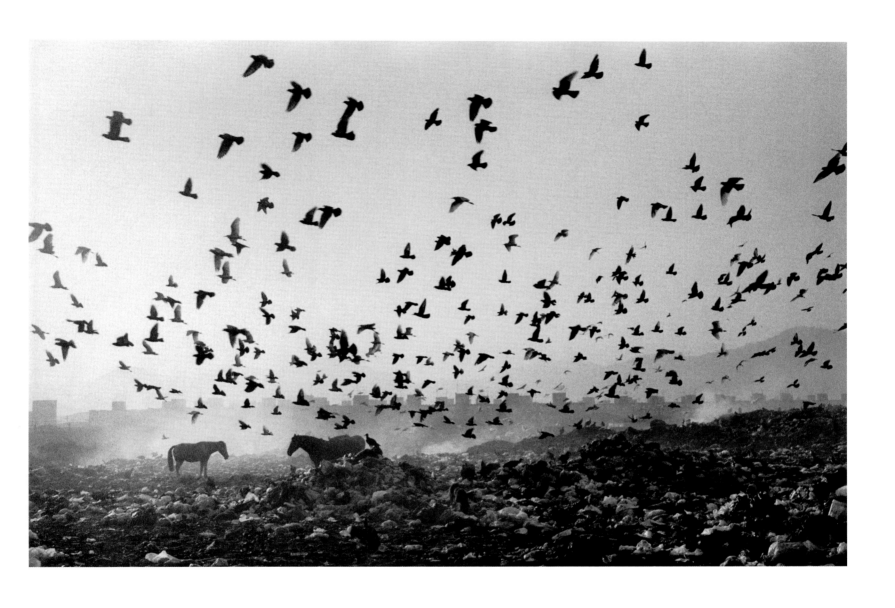

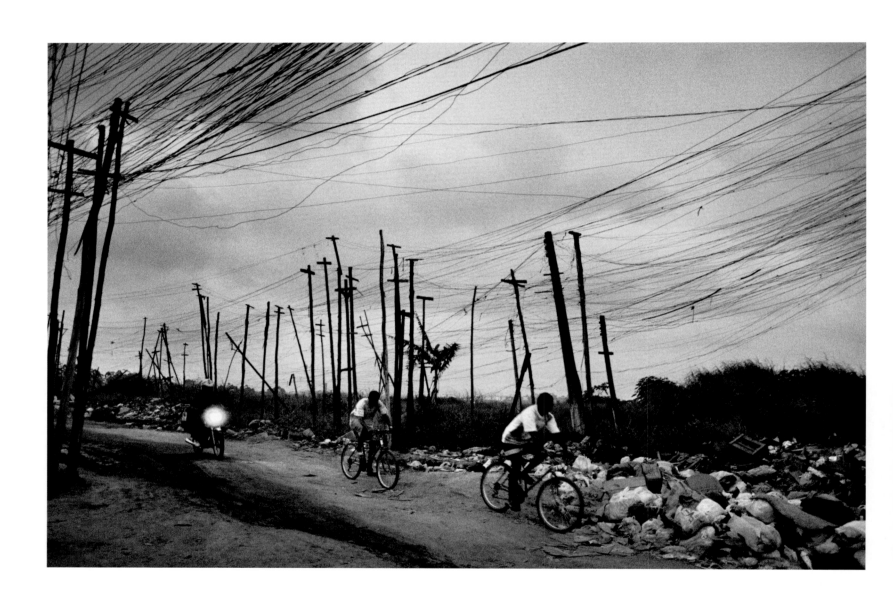

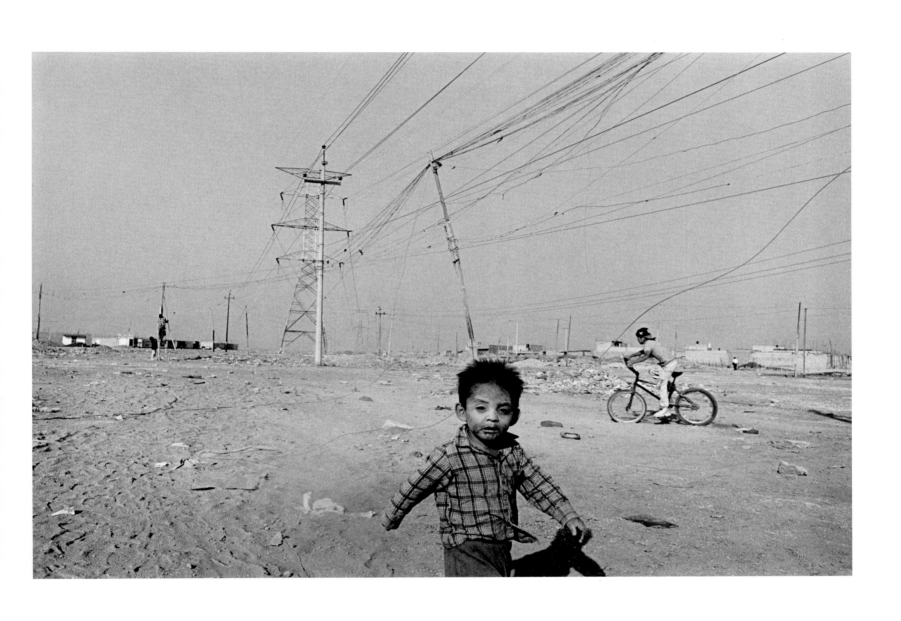

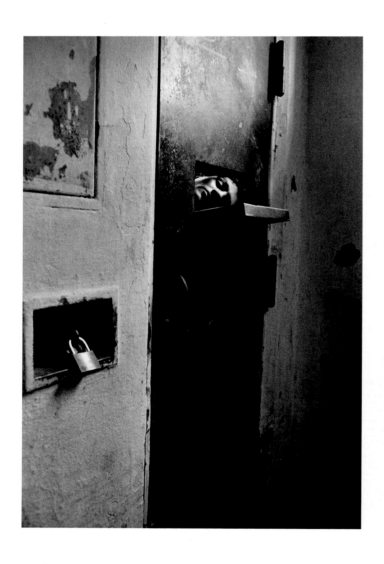

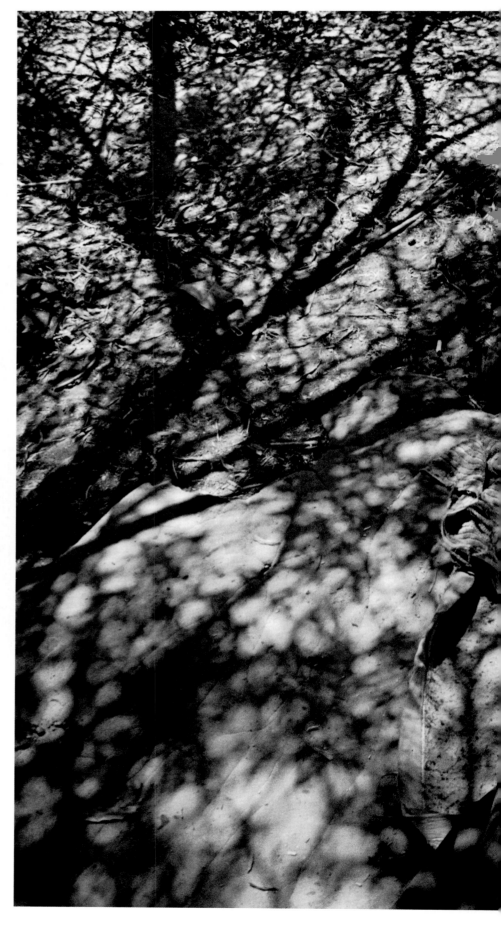

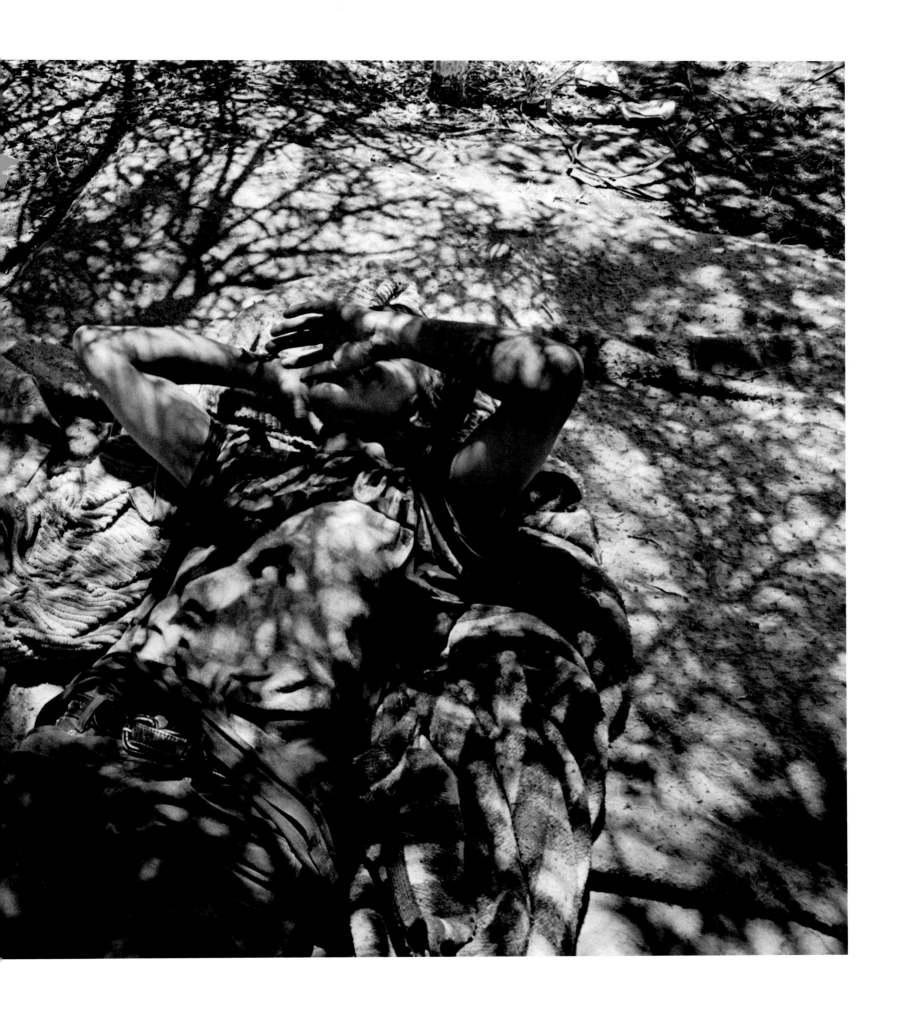

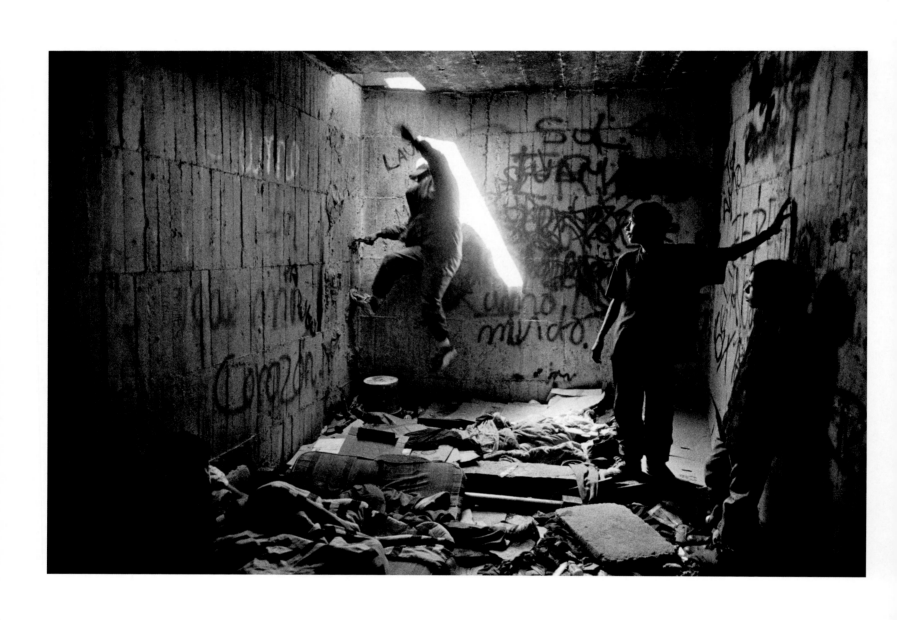

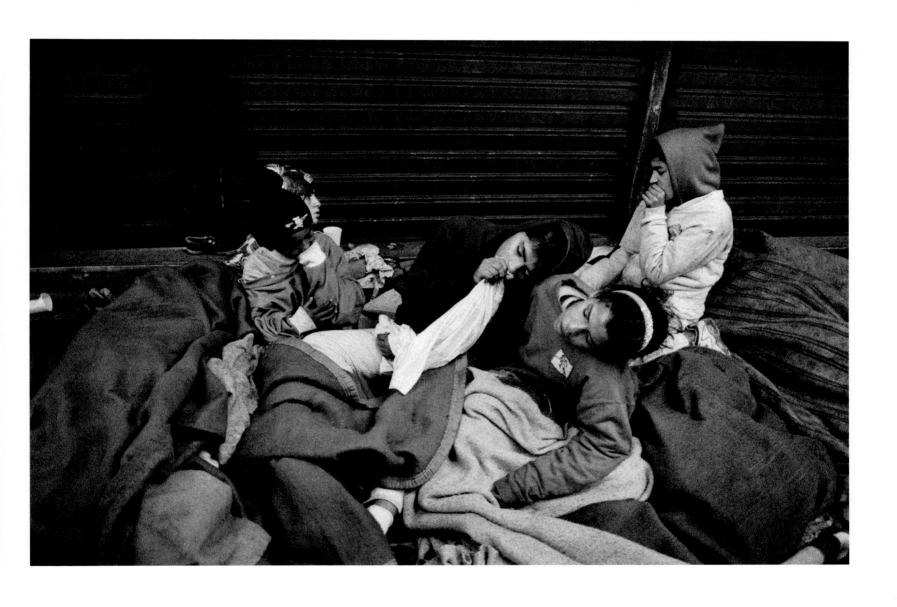

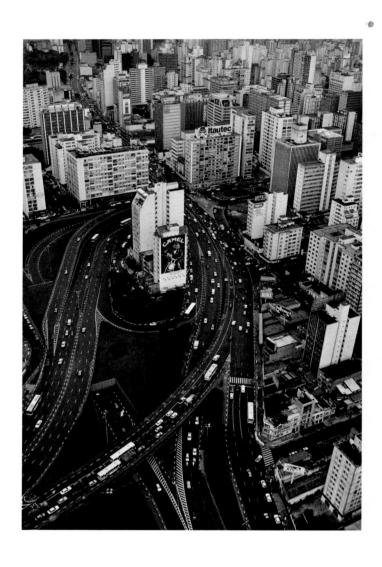

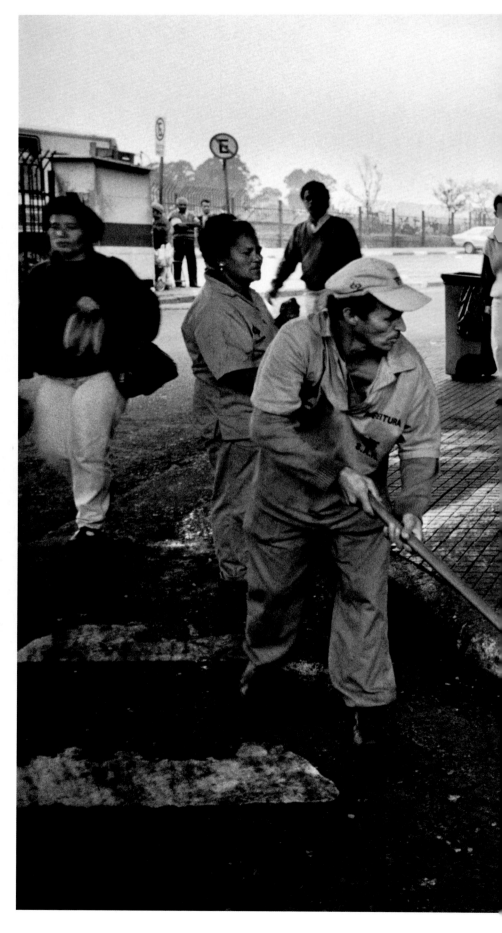

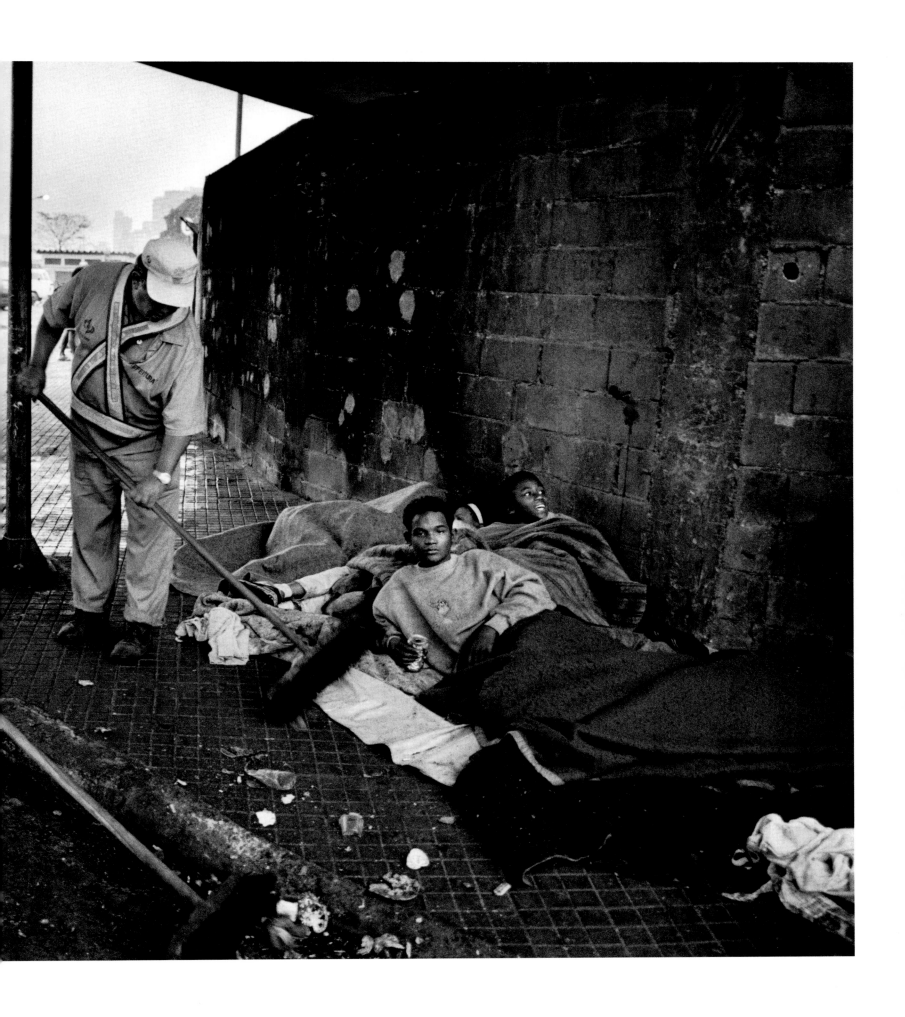

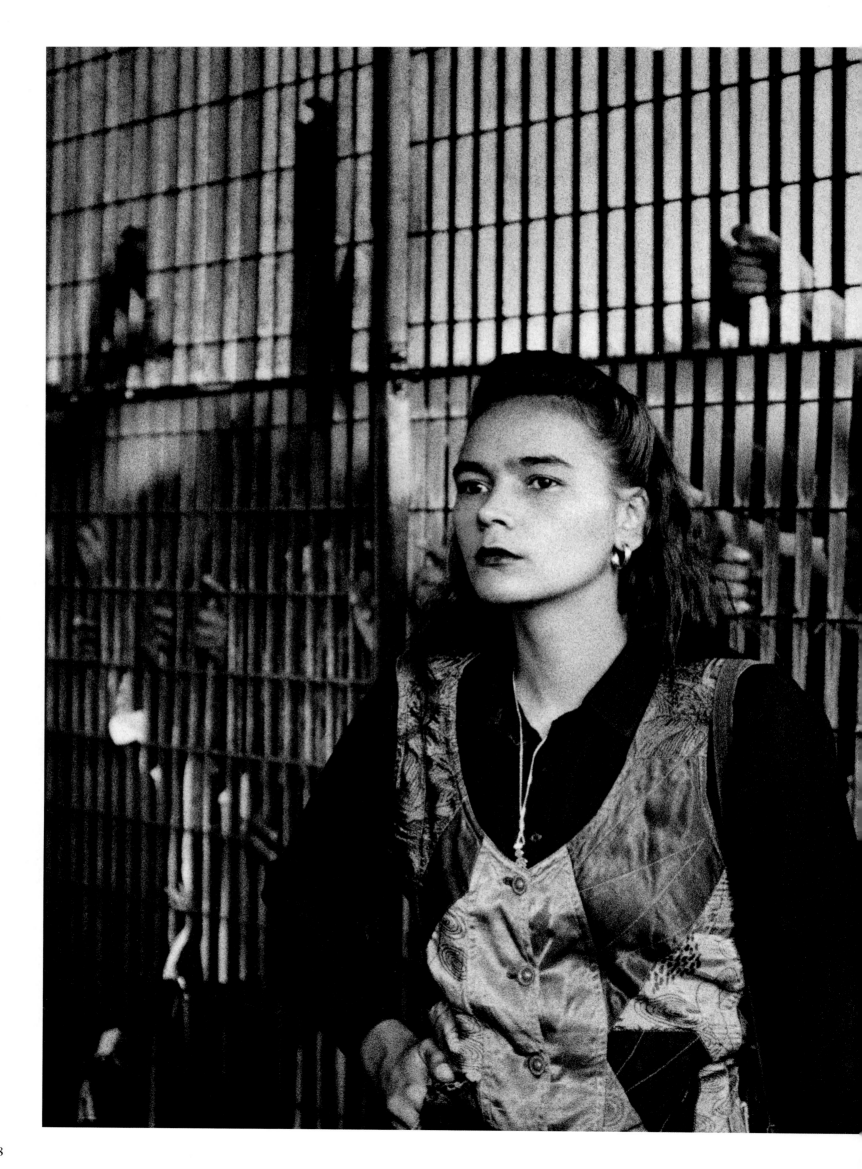

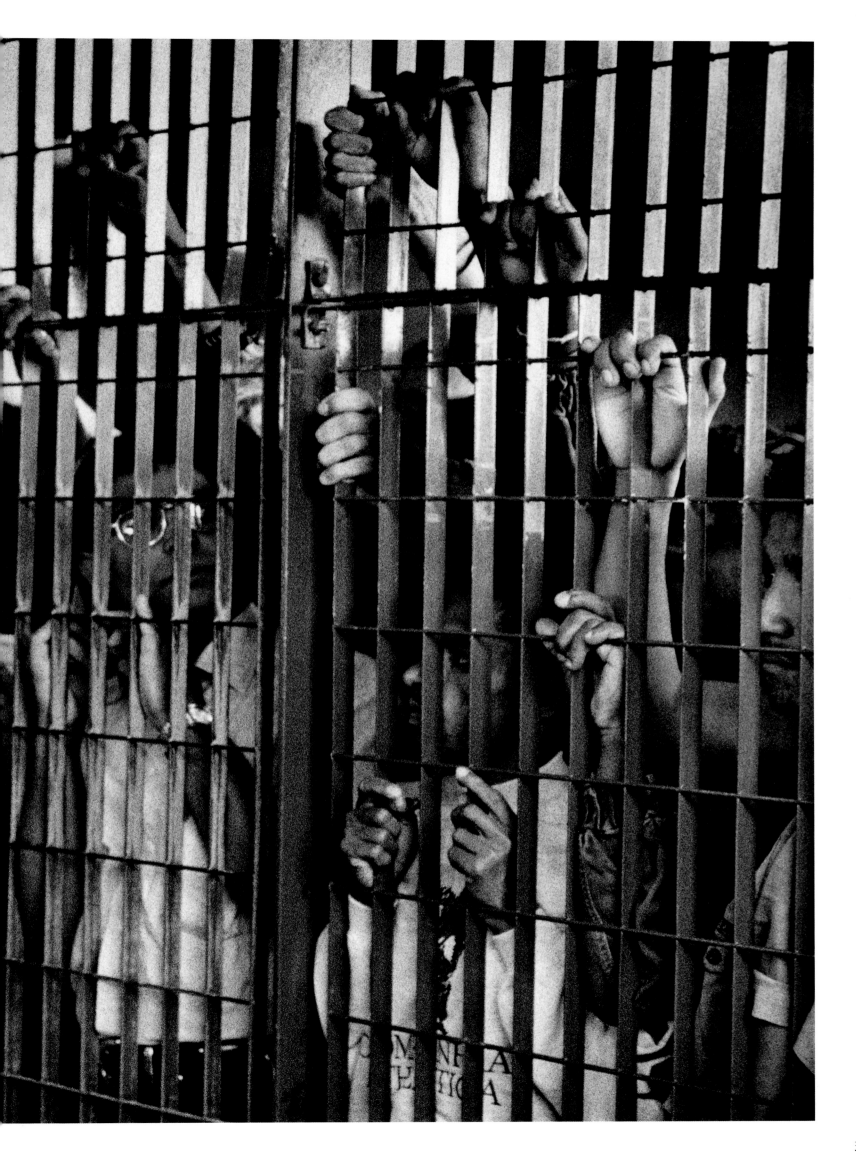

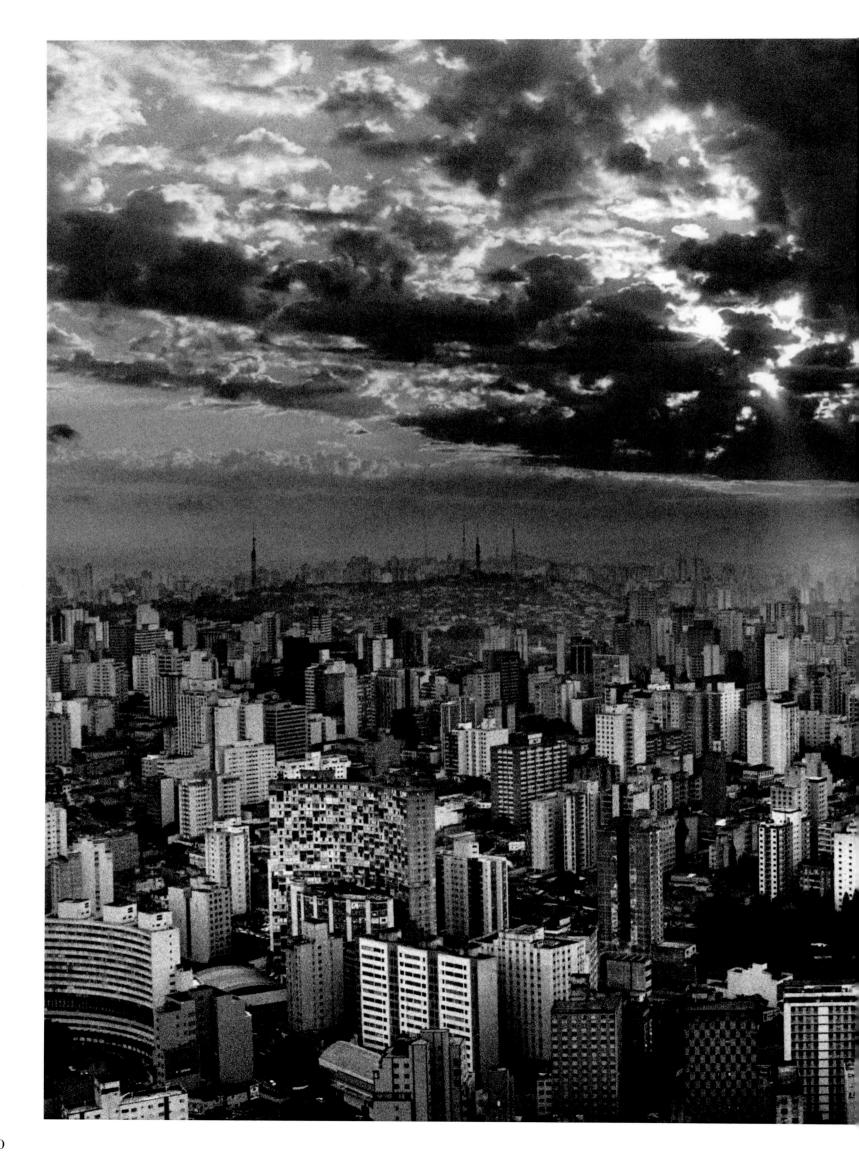

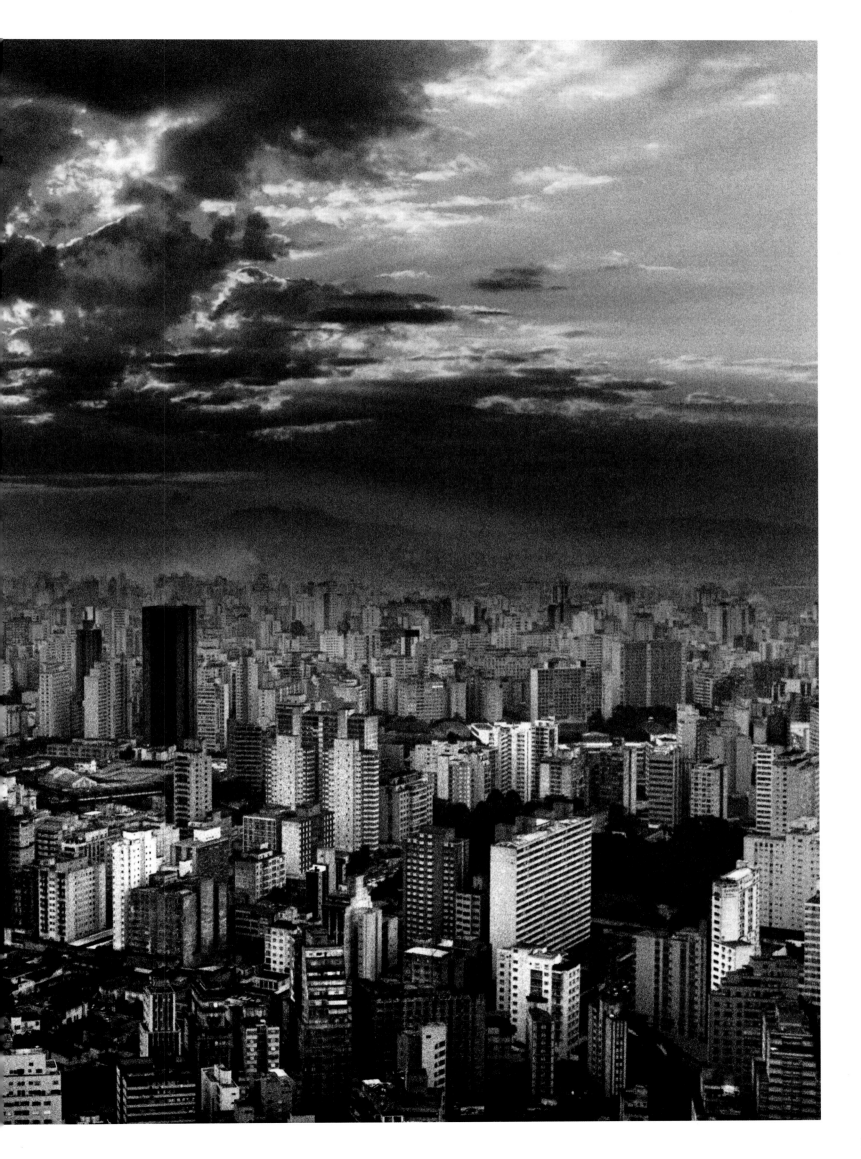

IV

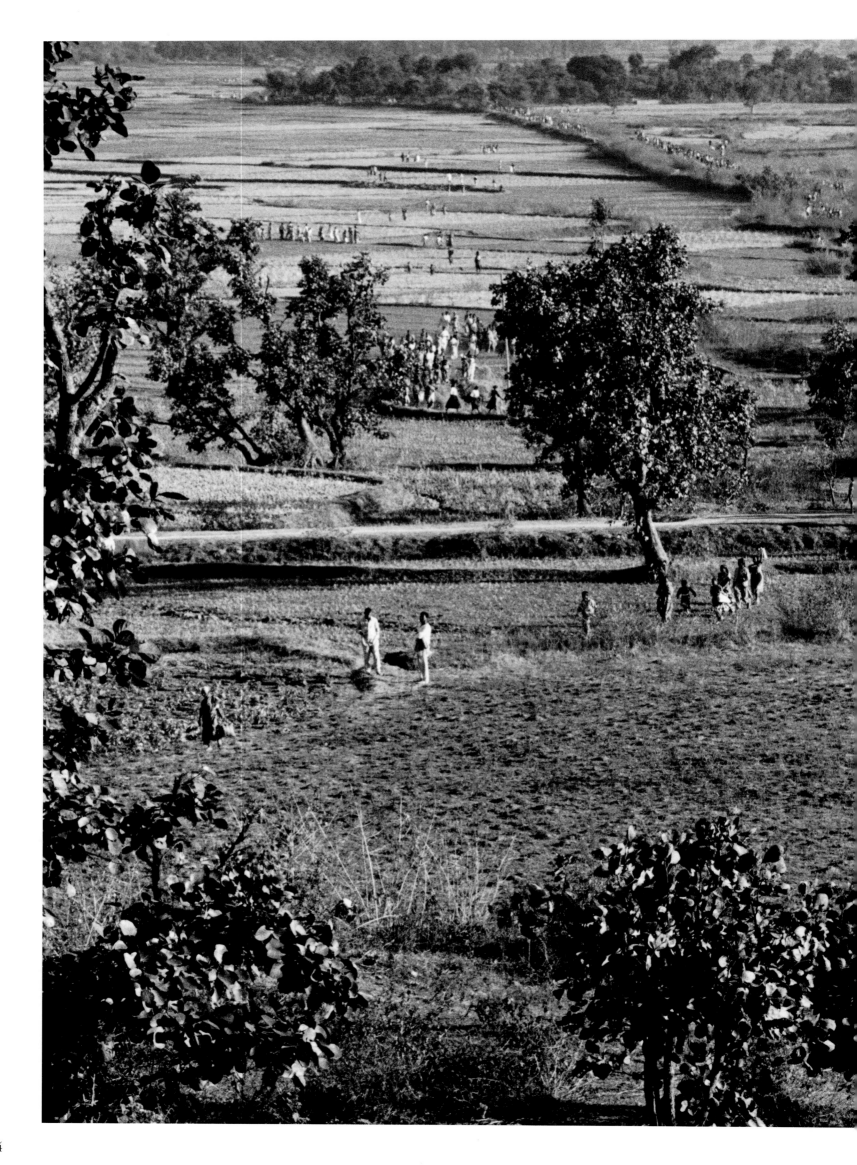

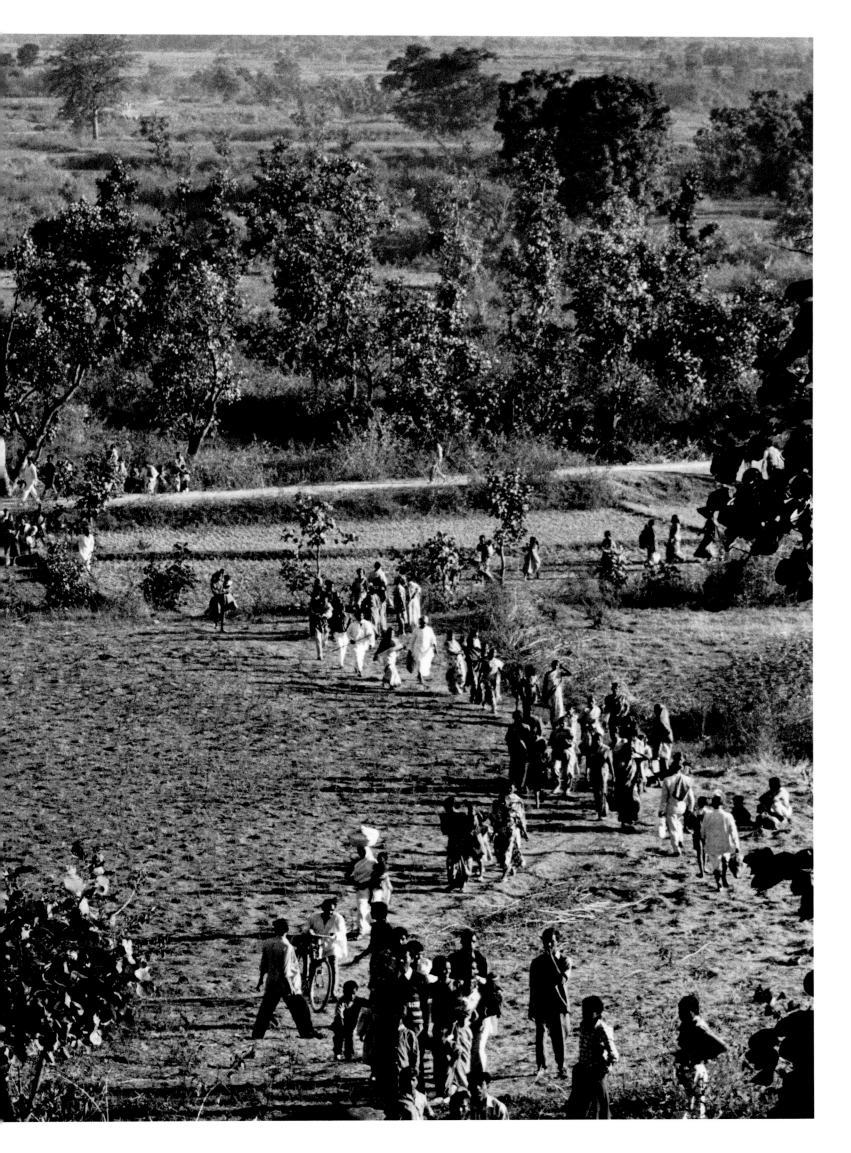

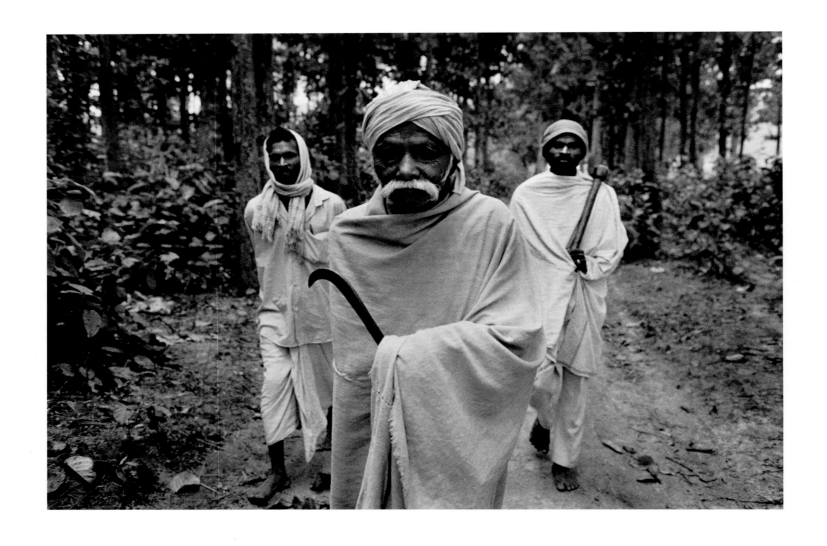

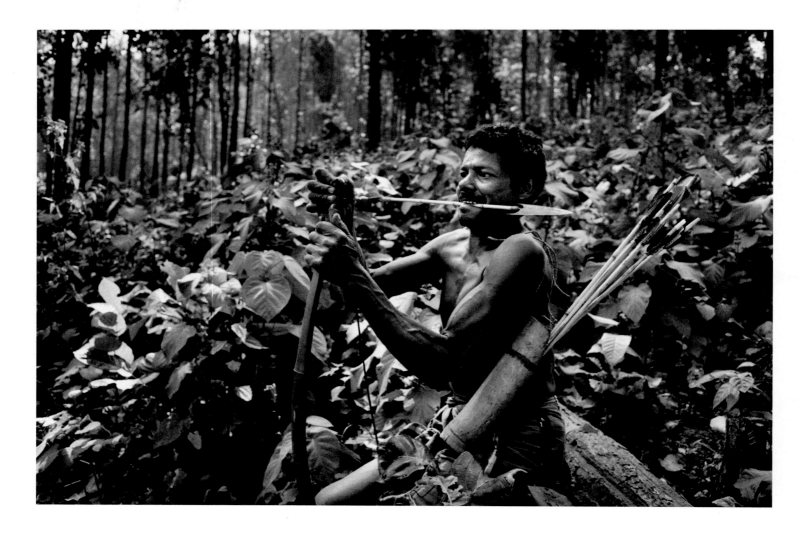

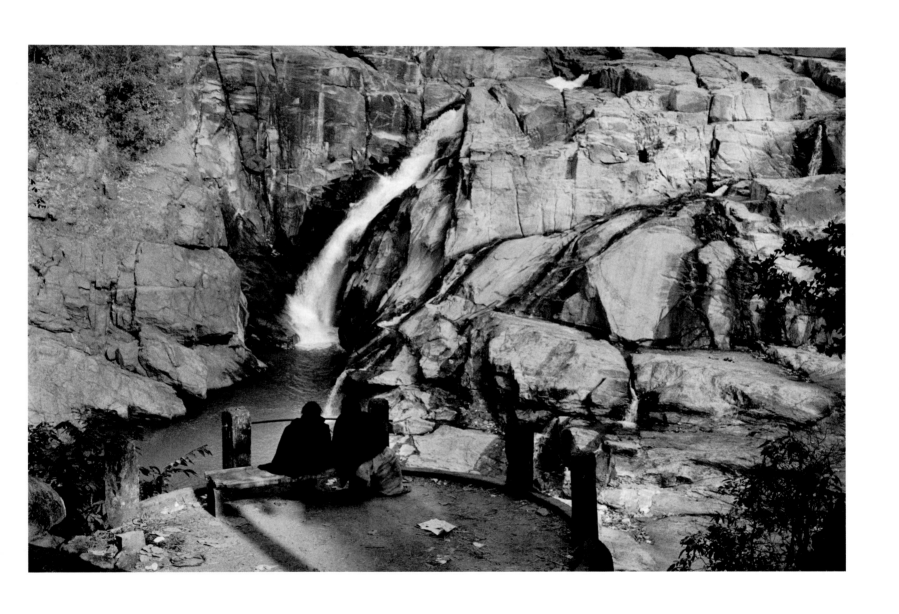

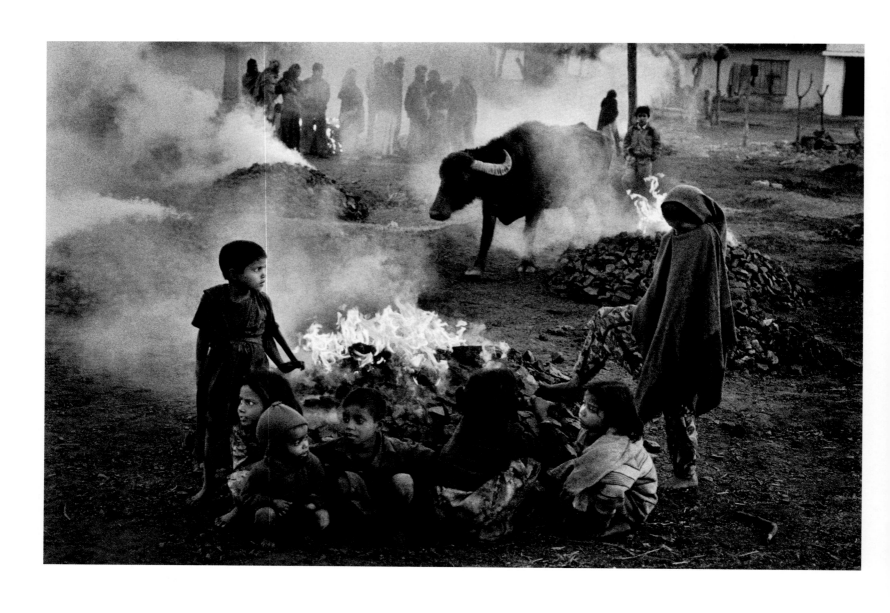

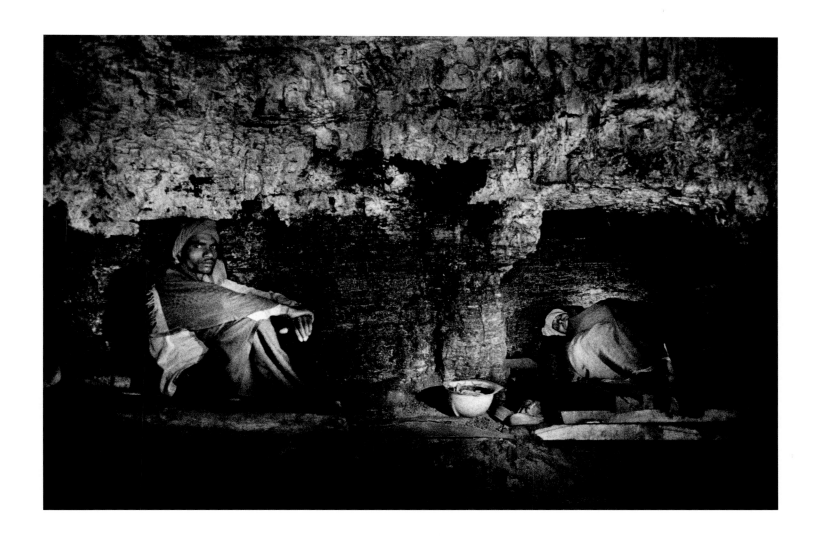

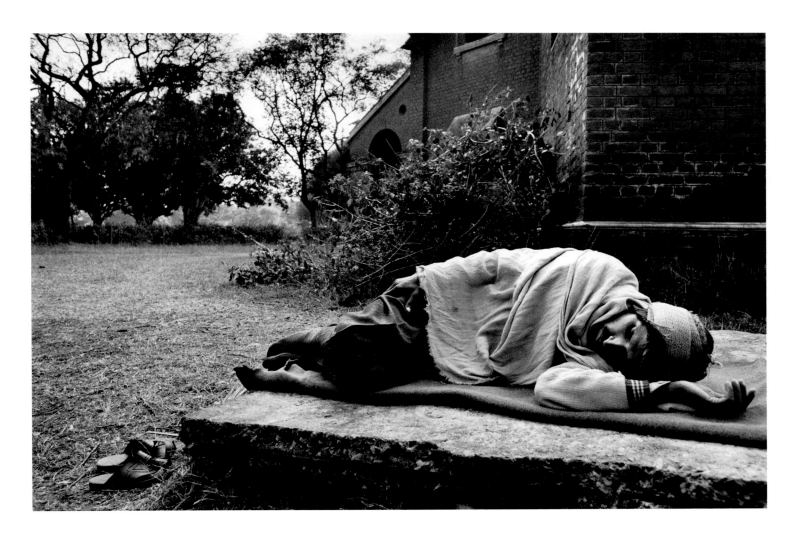

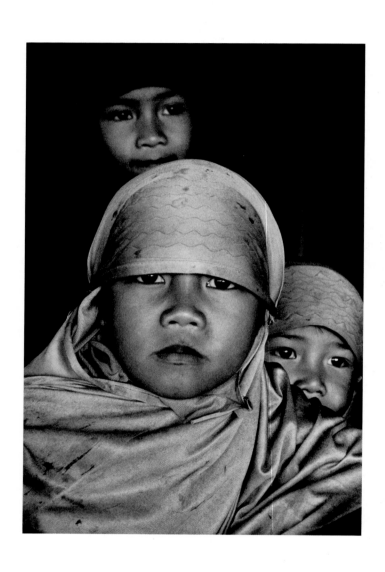

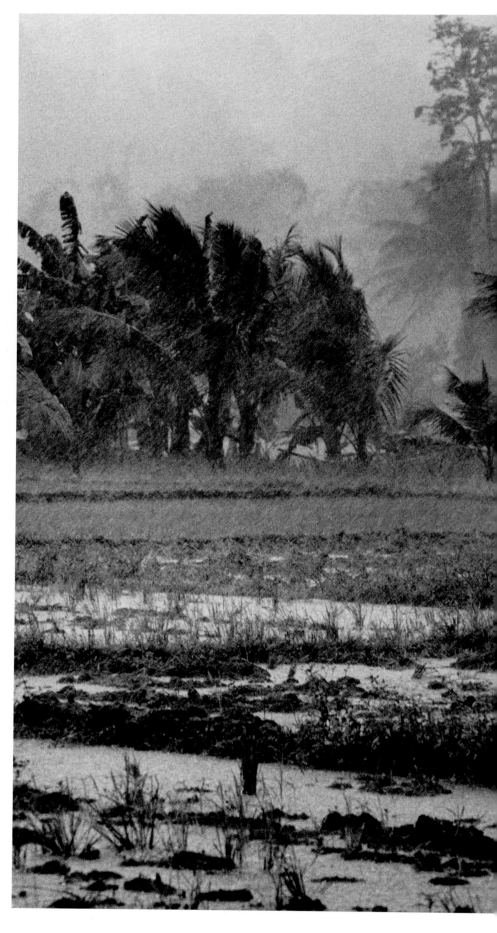

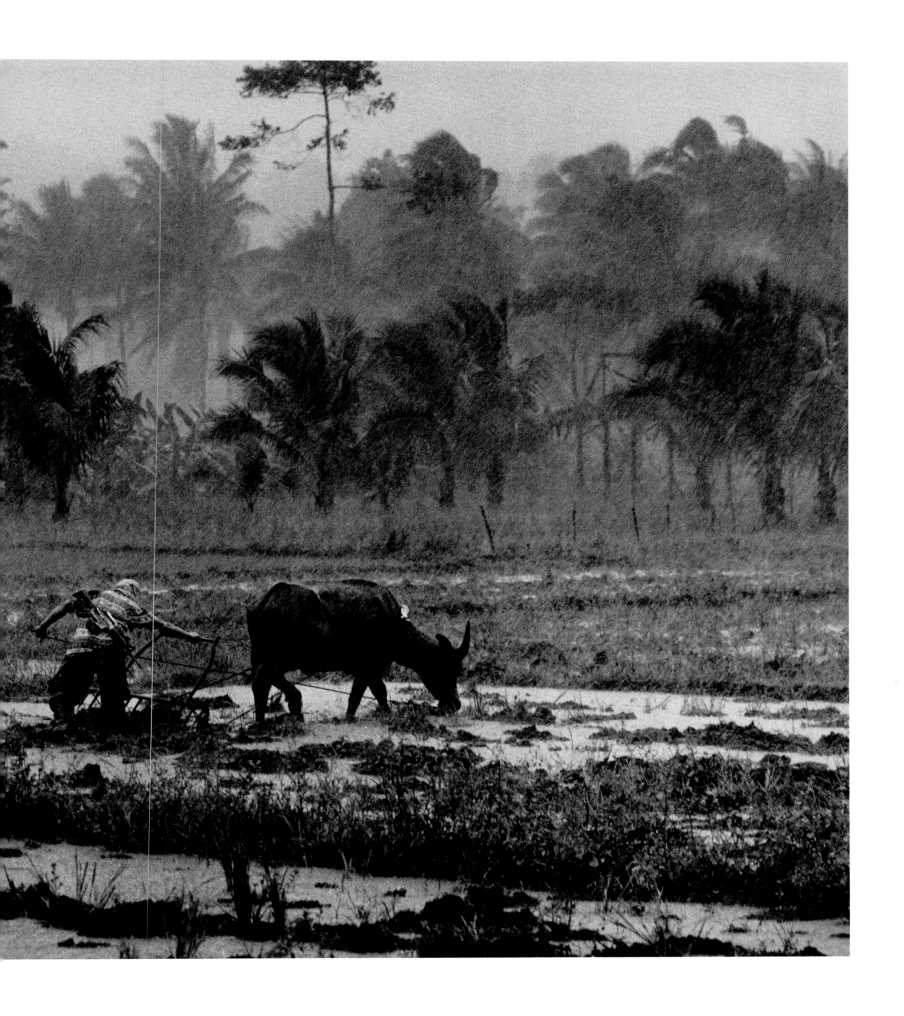

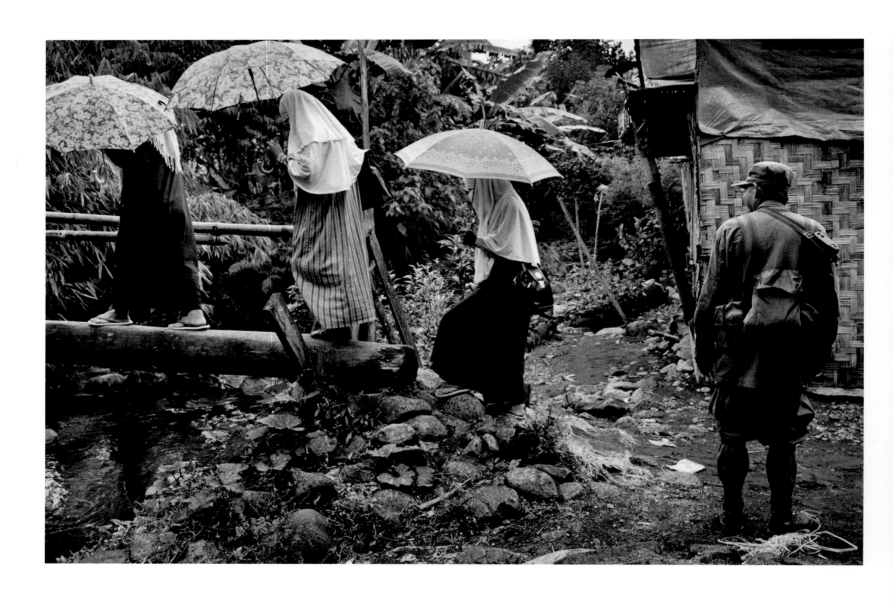

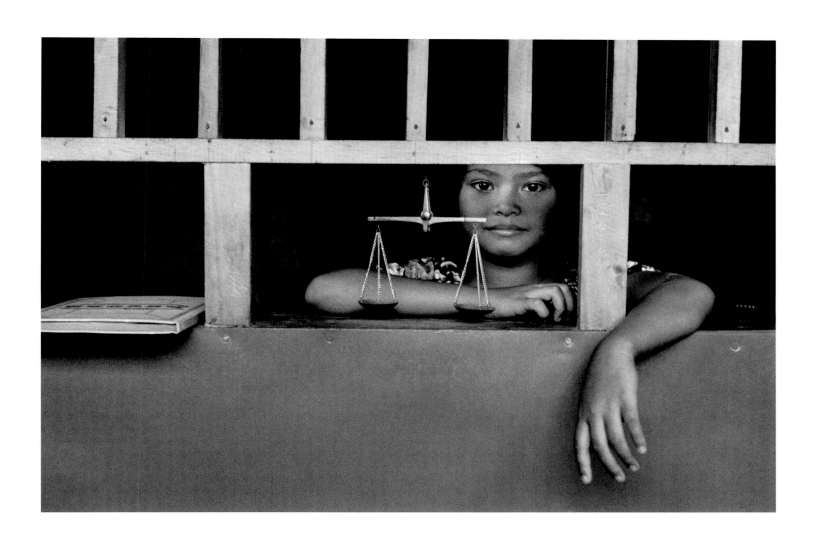

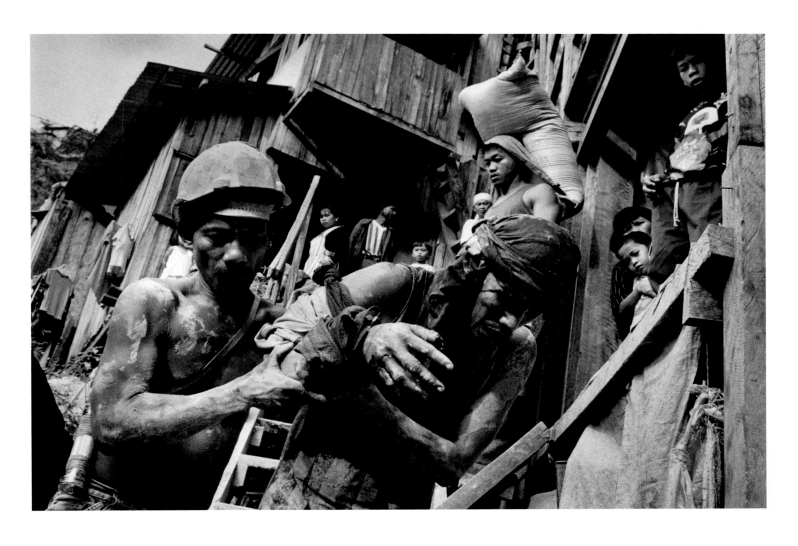

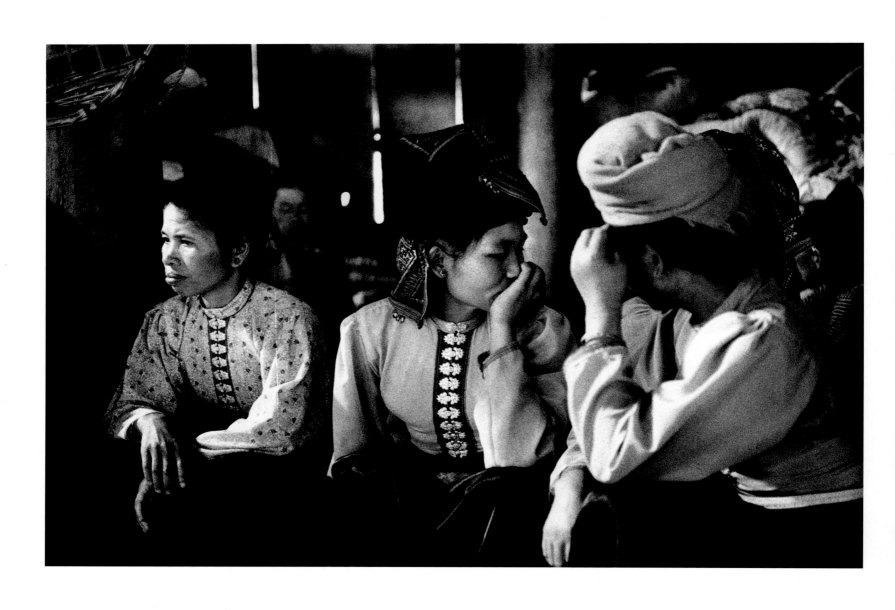

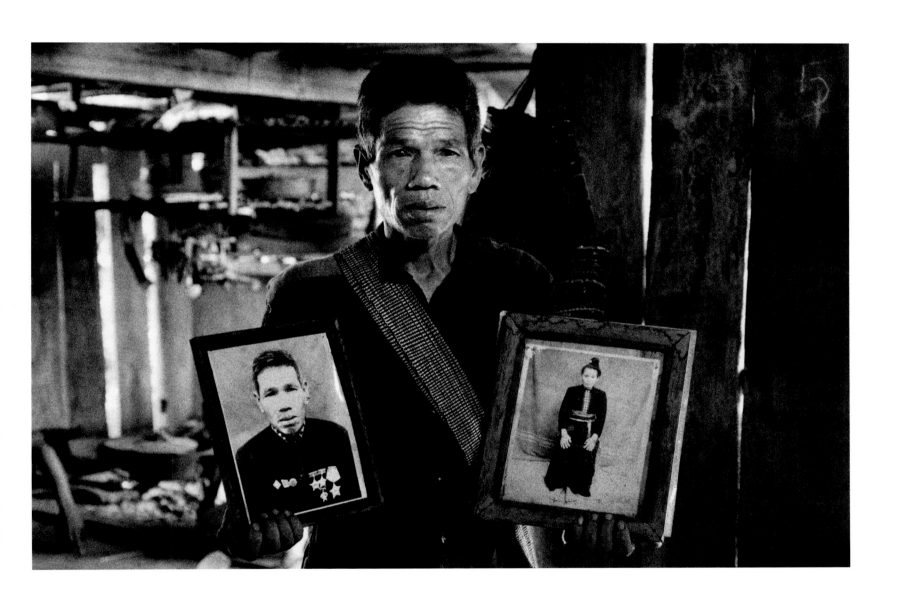

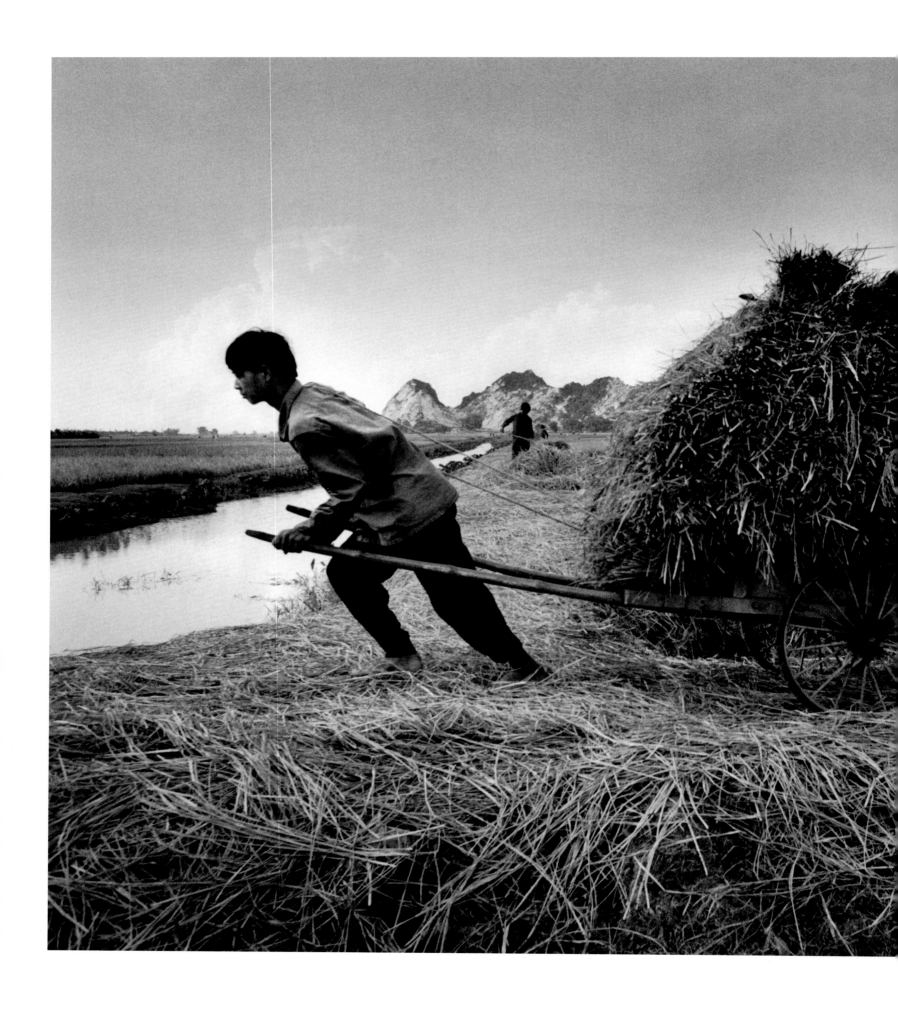

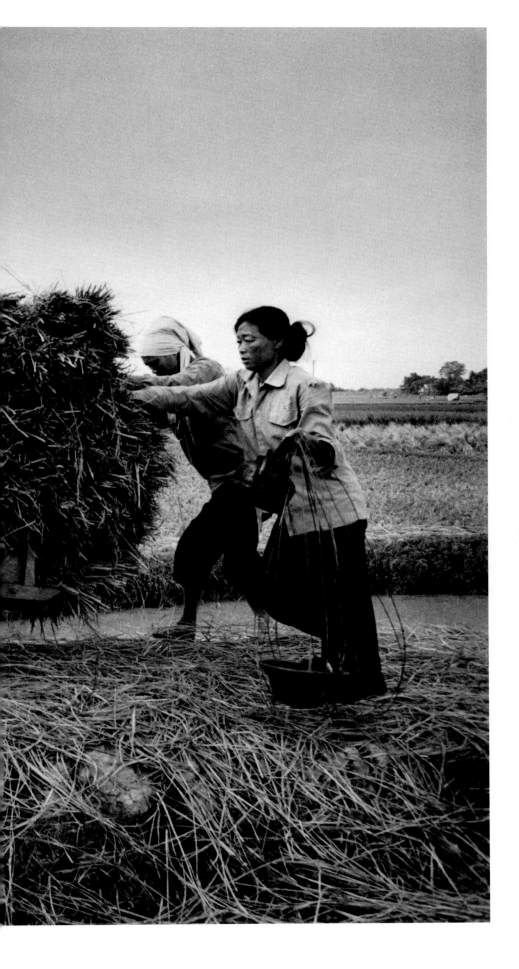

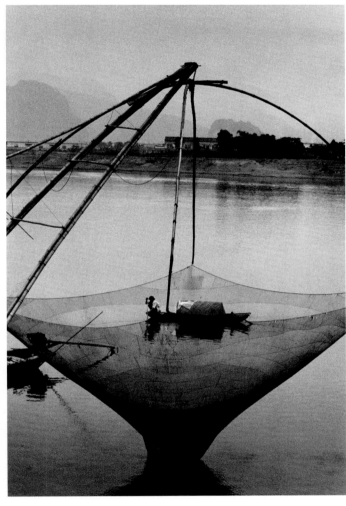

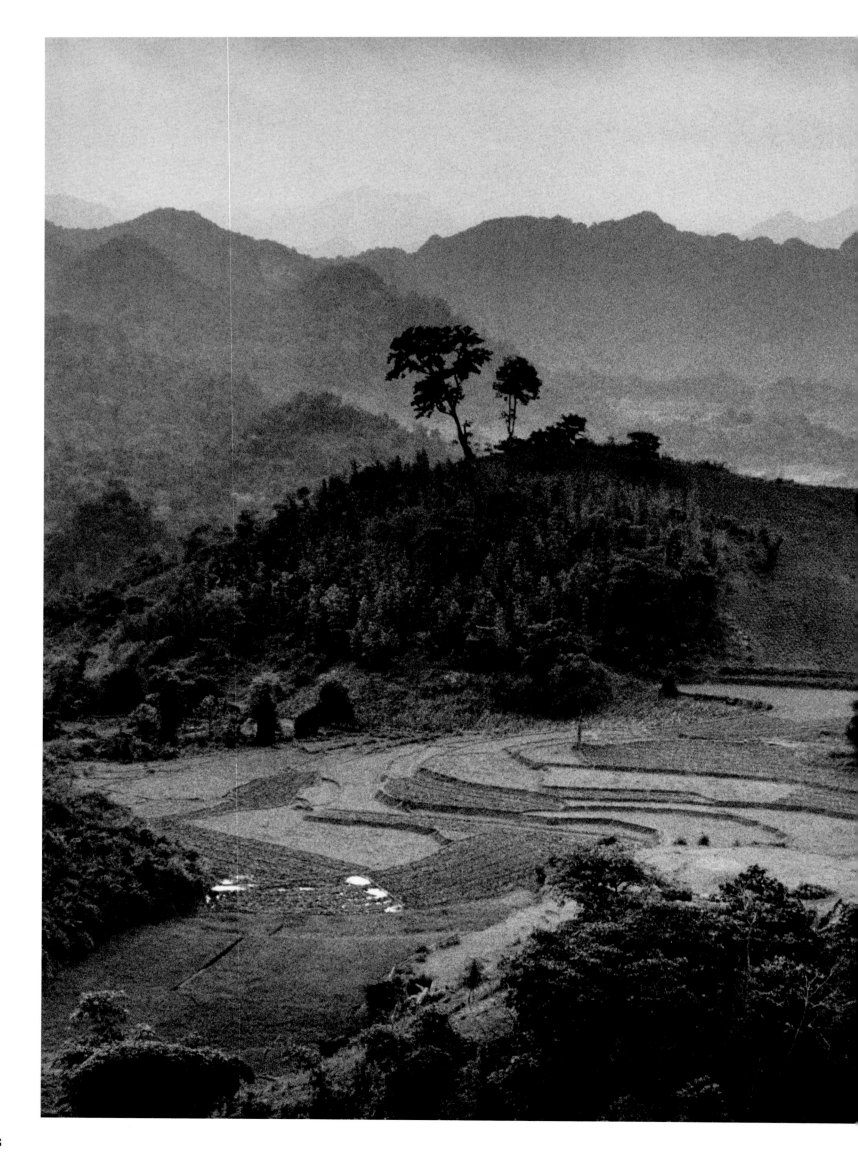

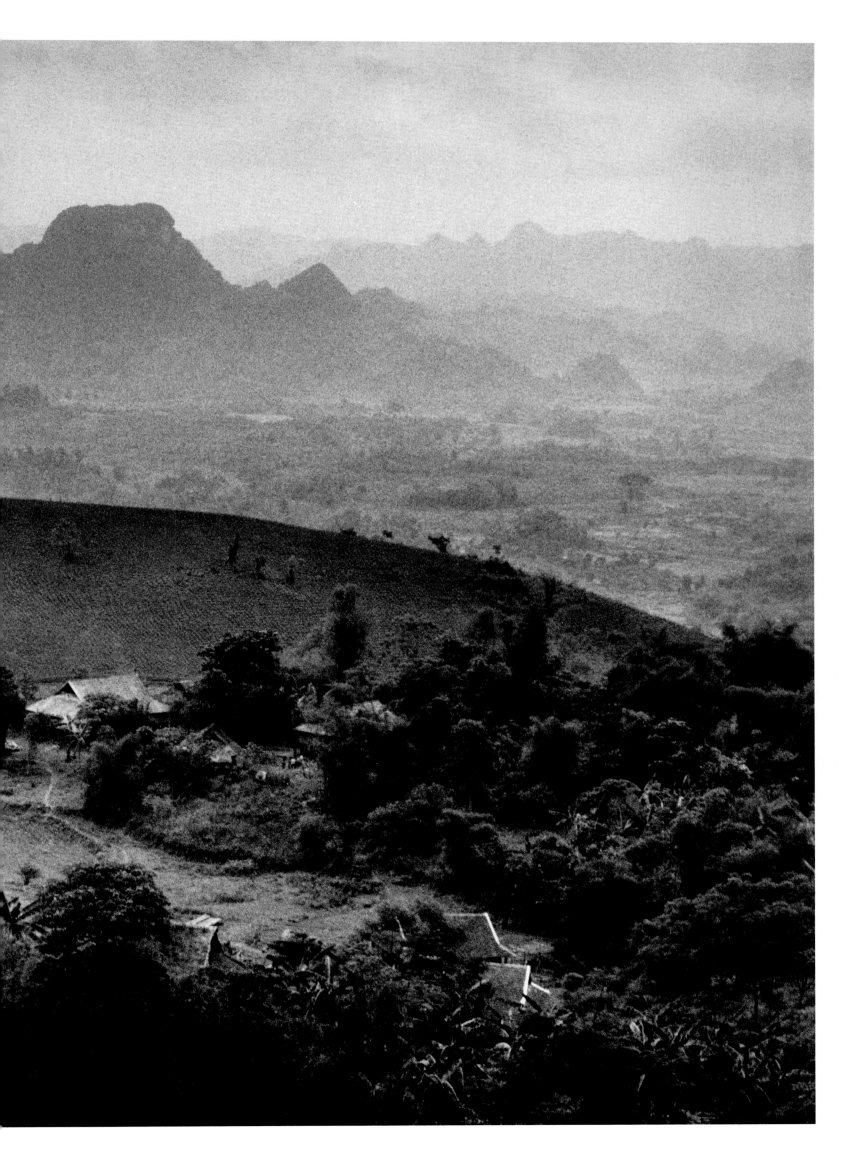

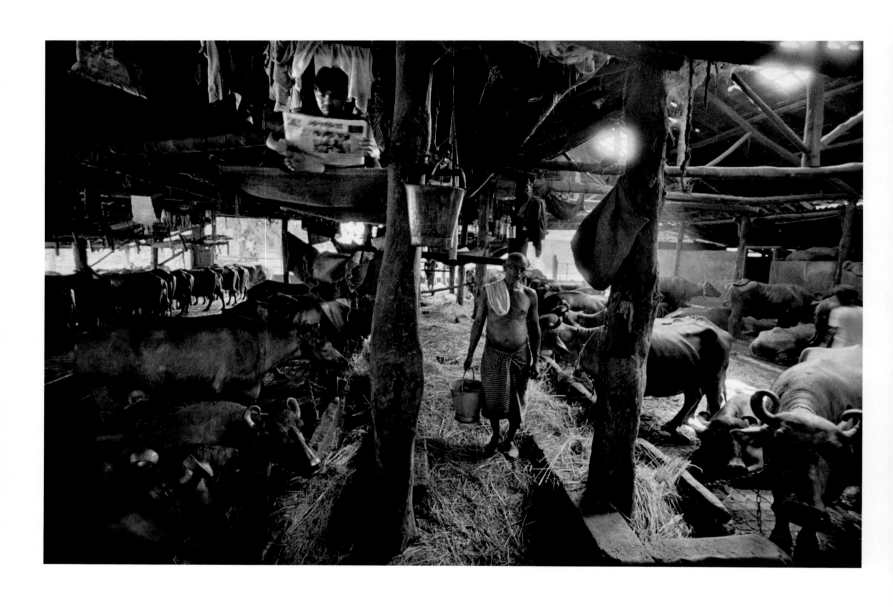

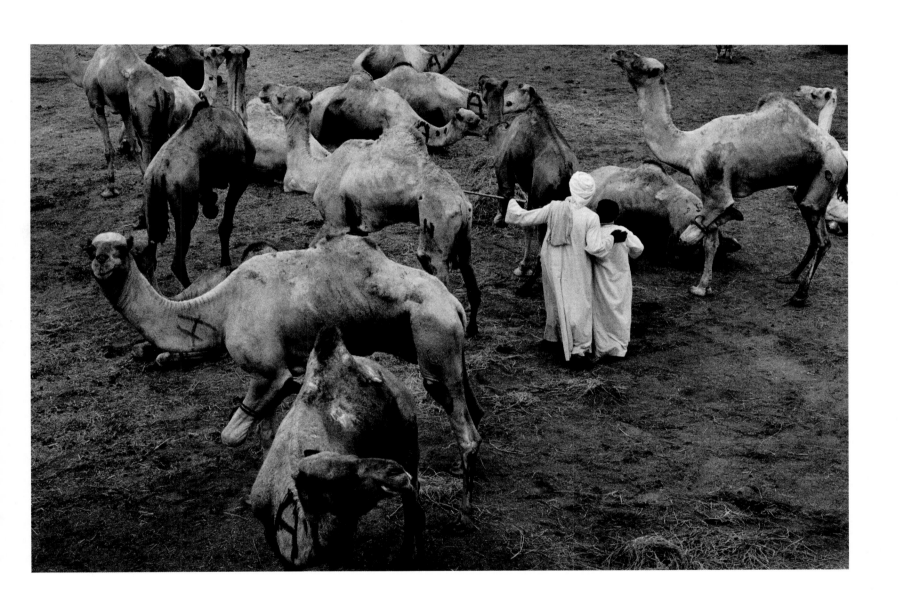

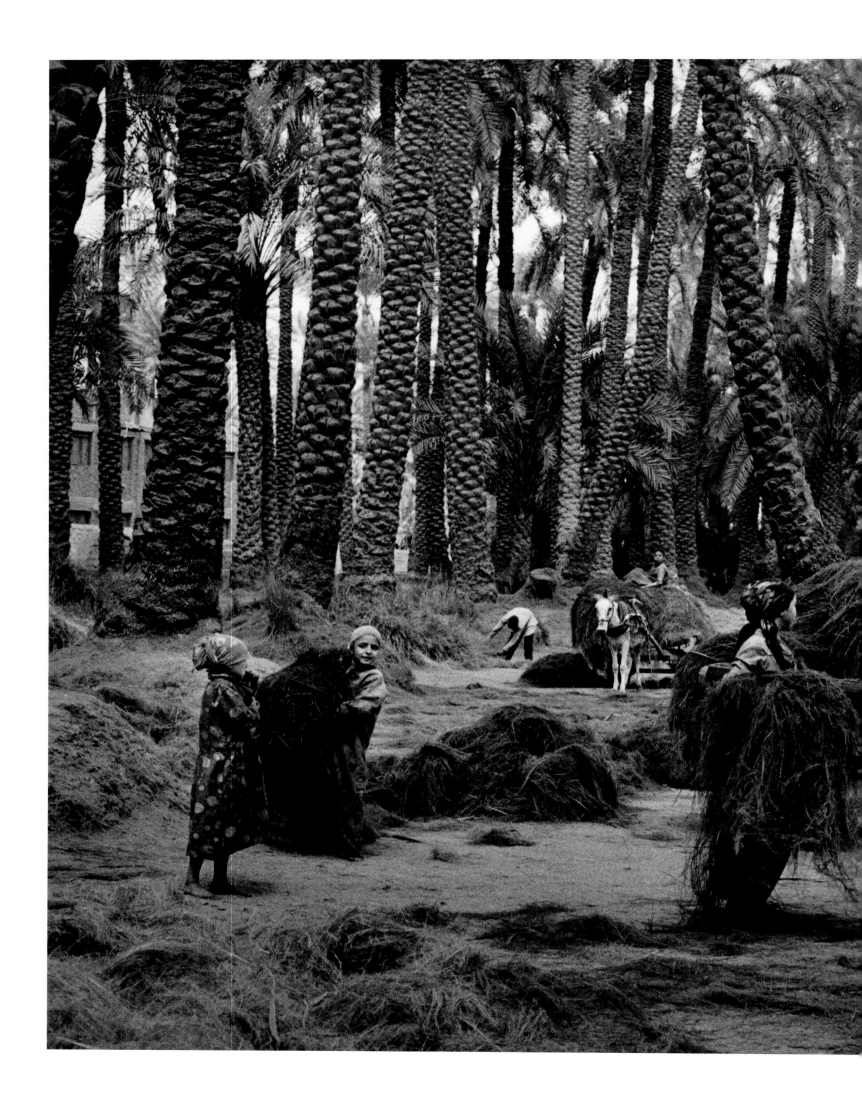

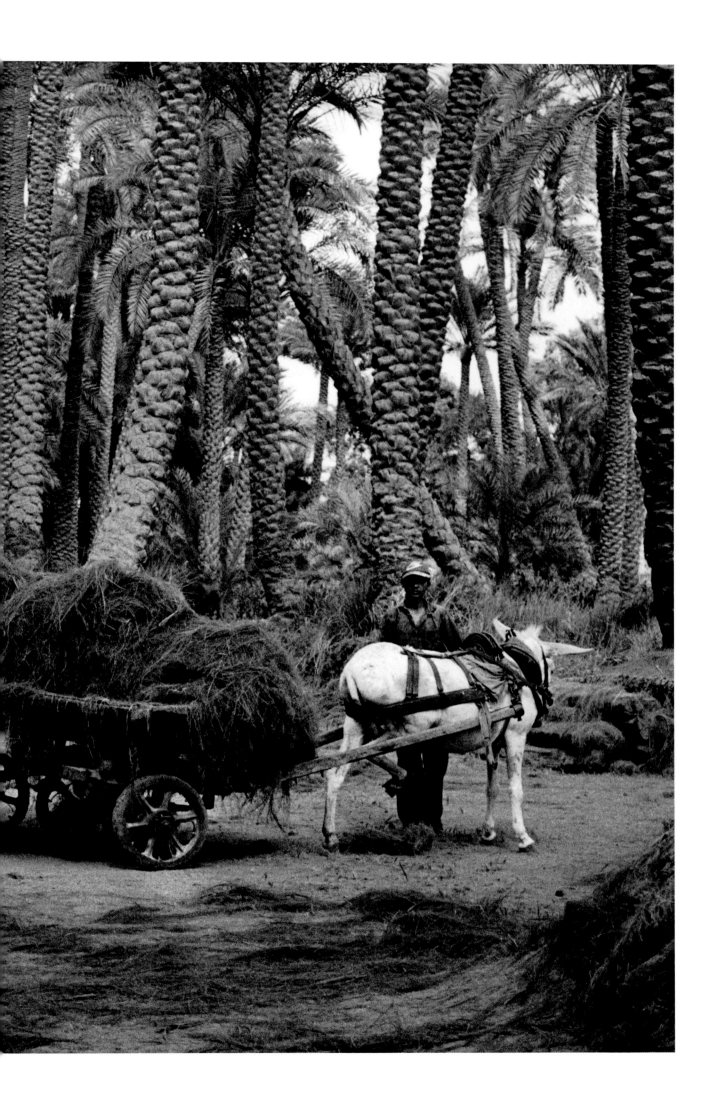

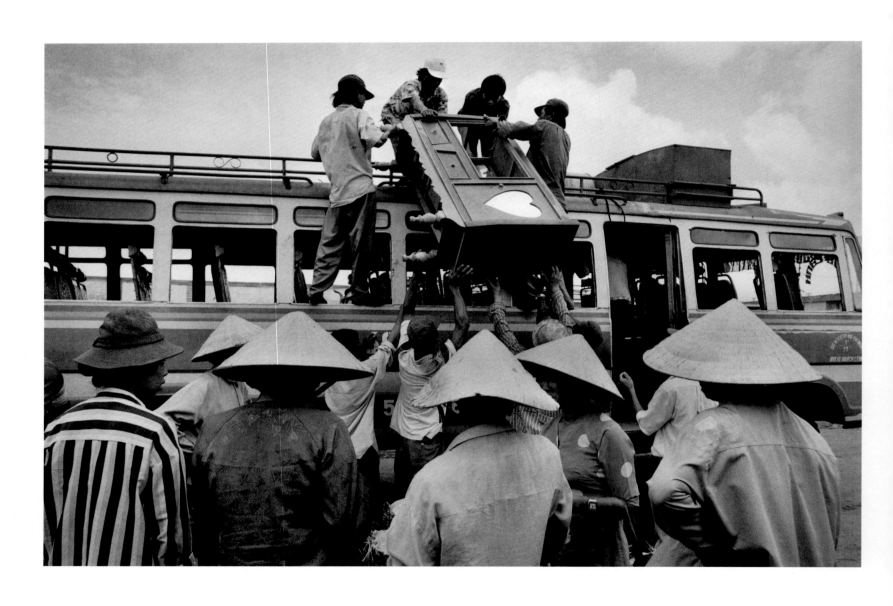

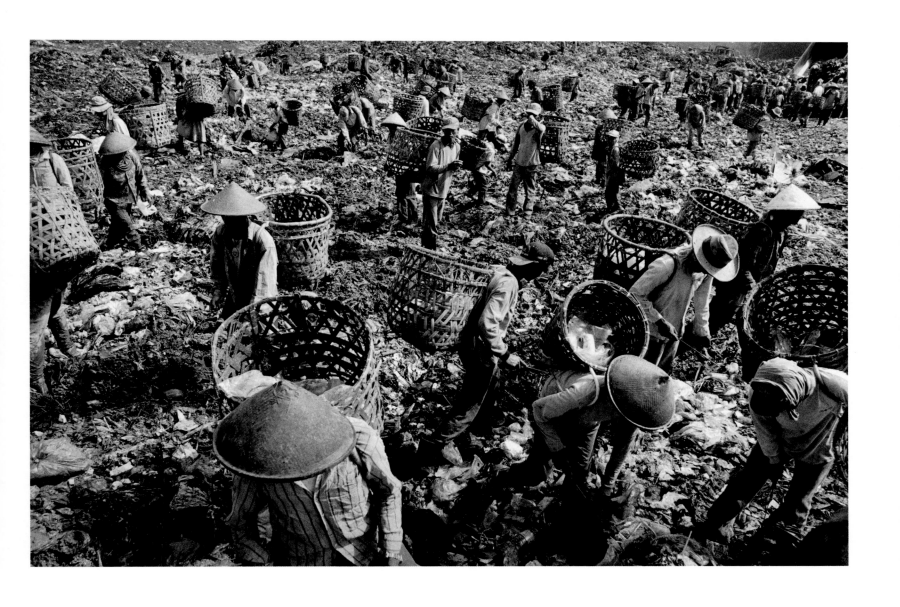

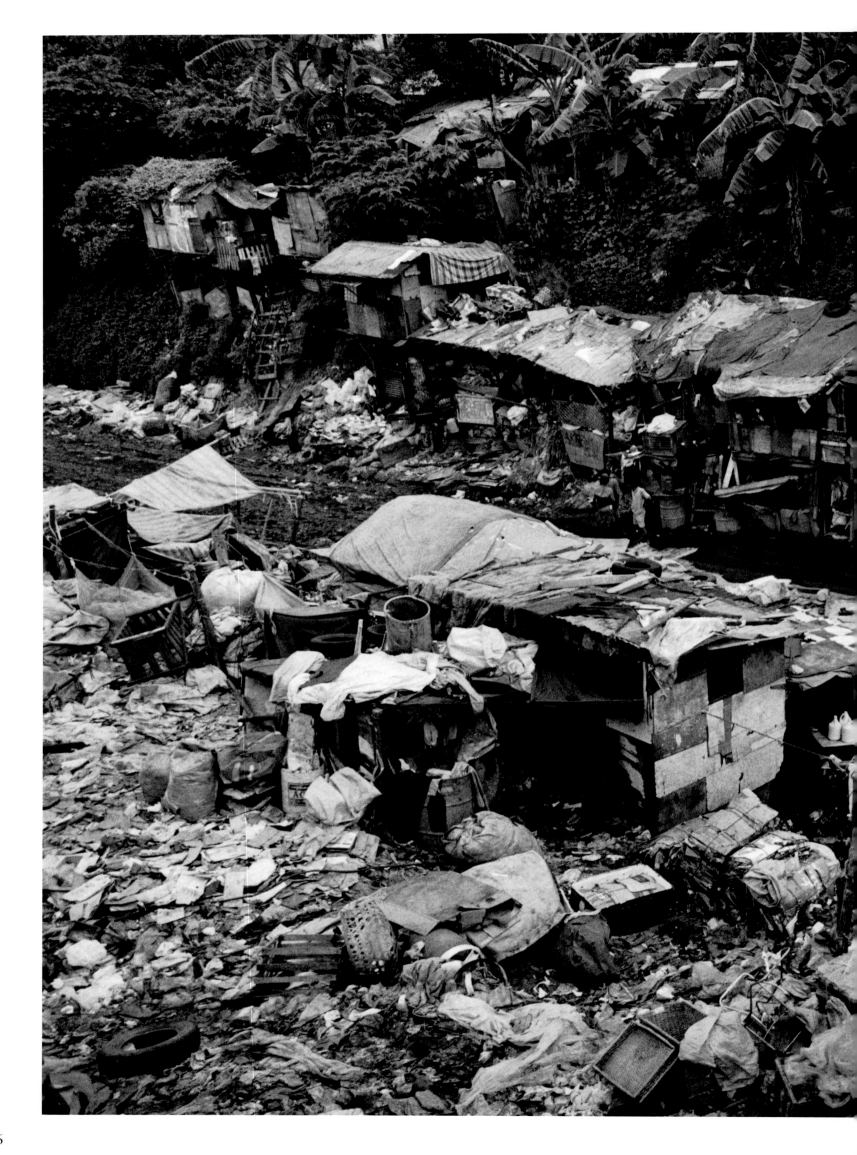

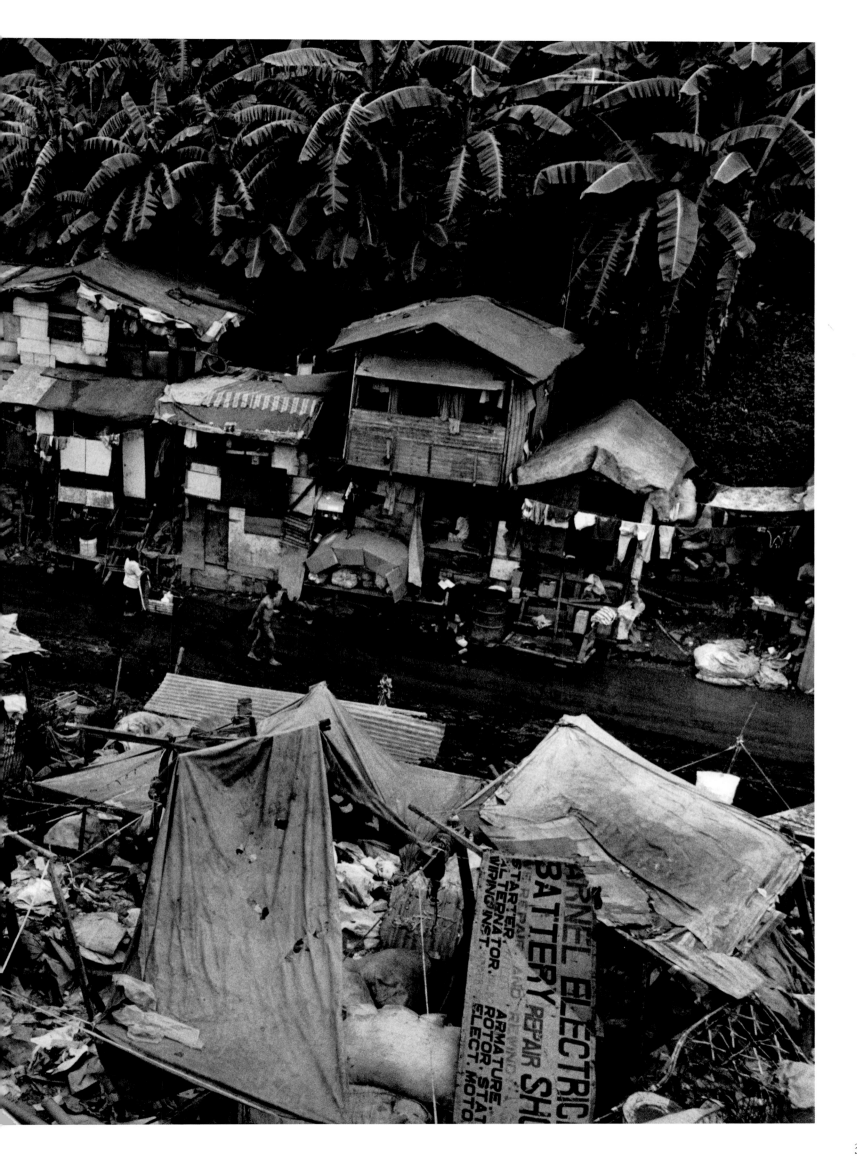

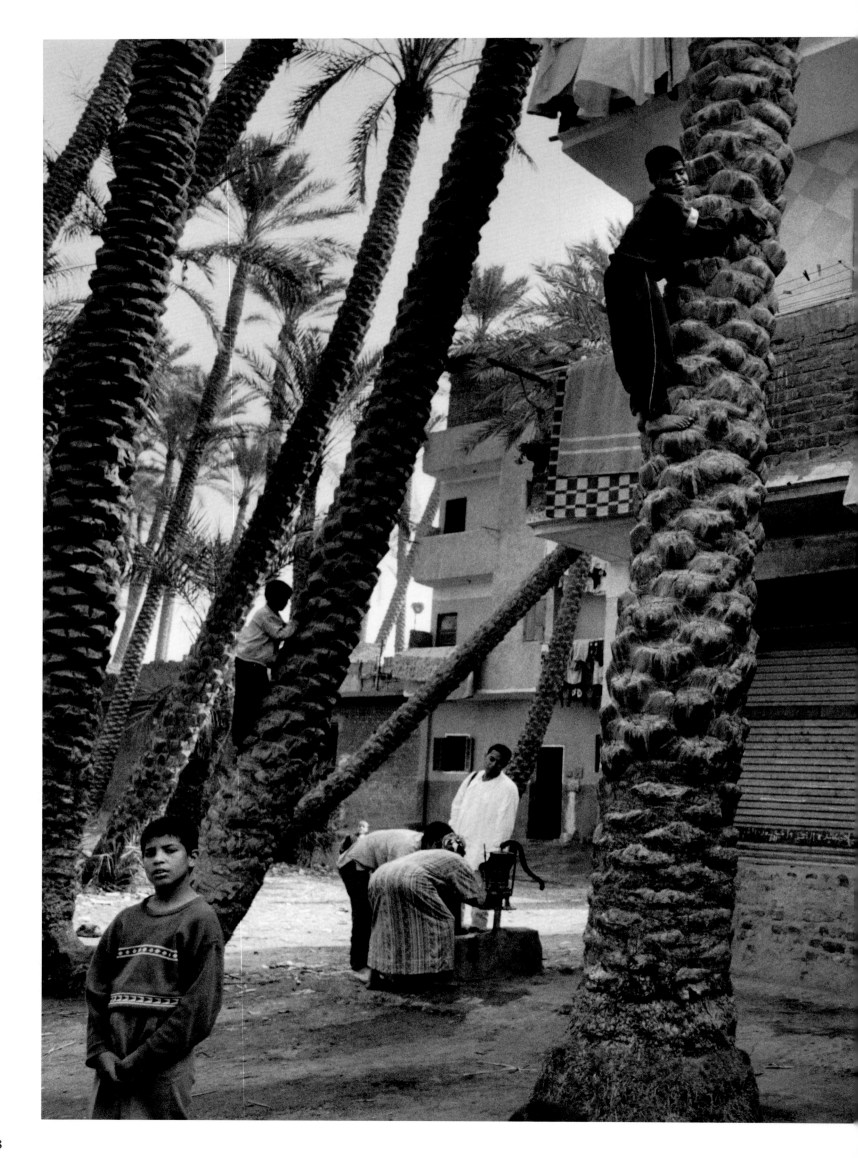

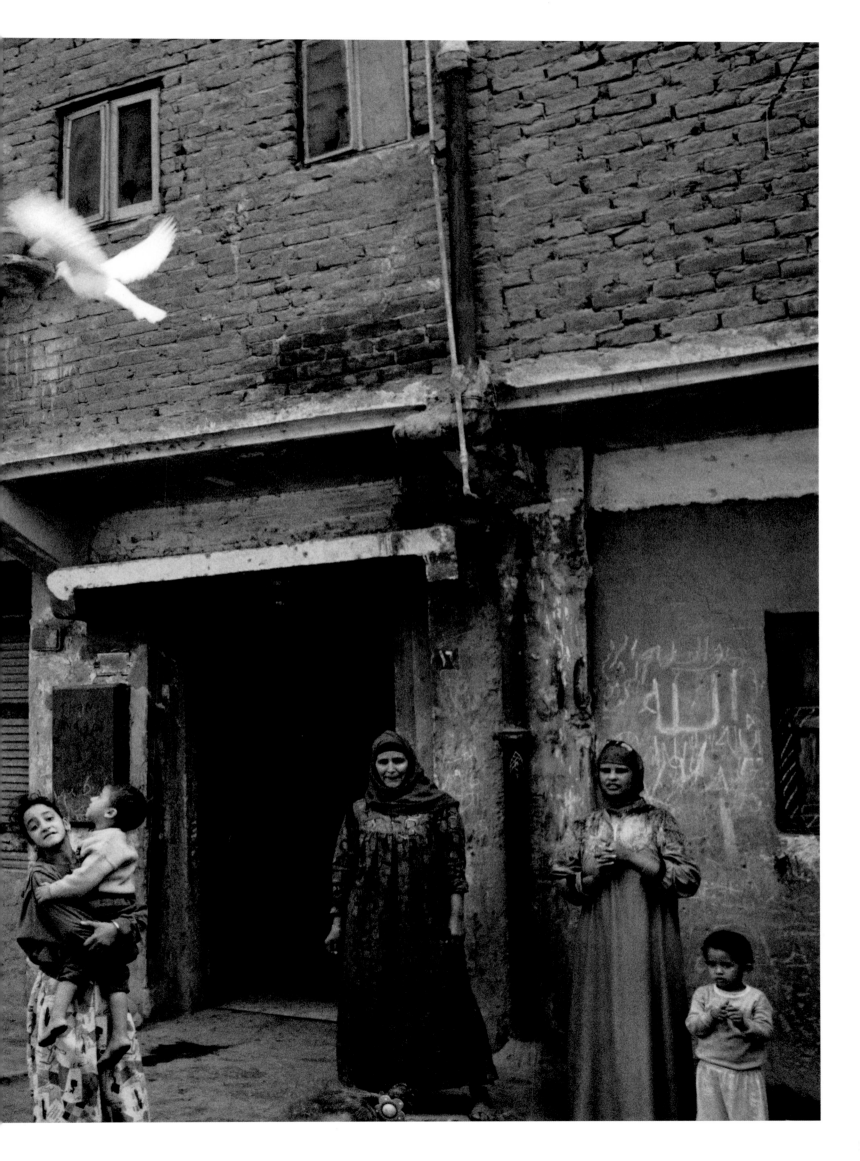

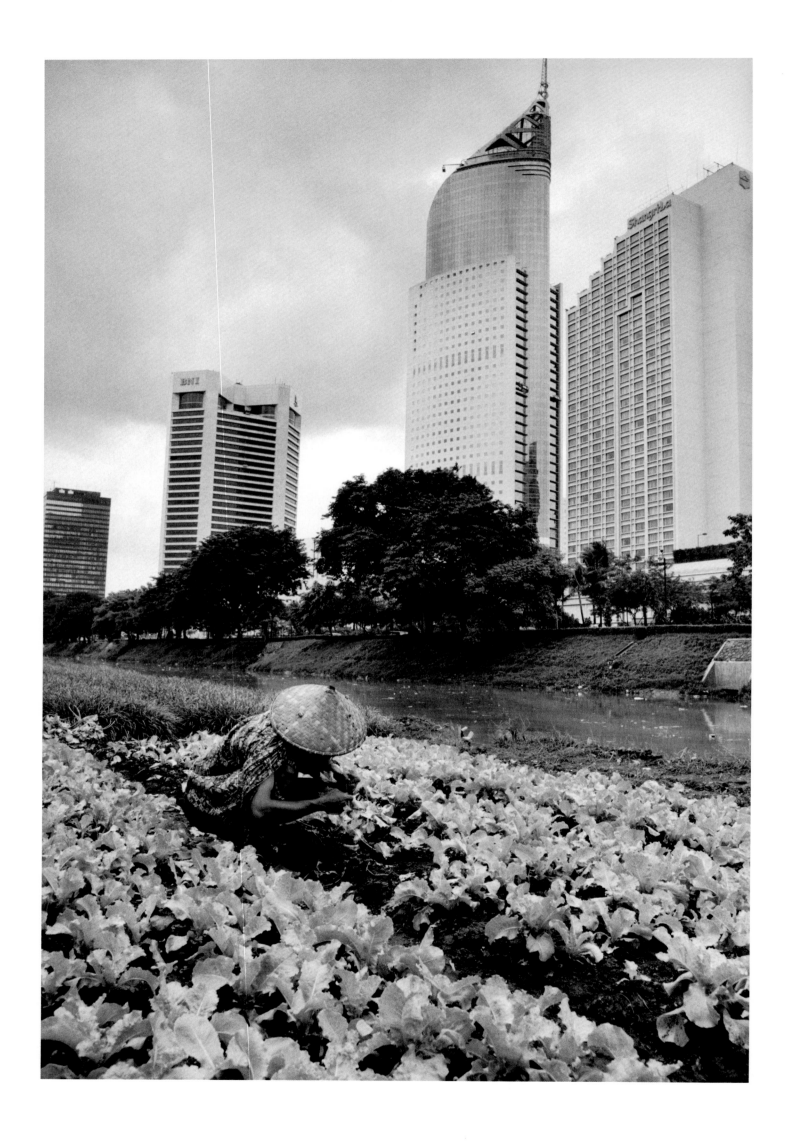

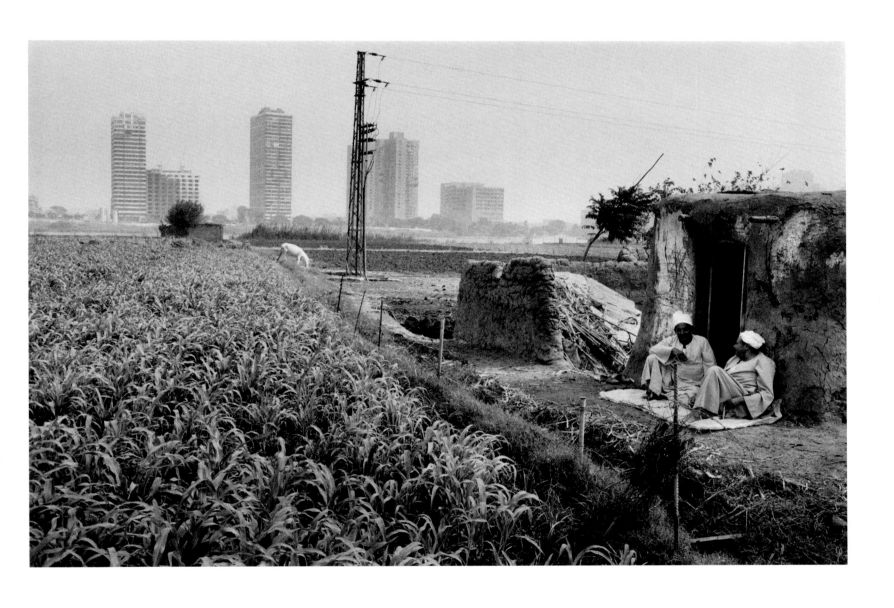

361

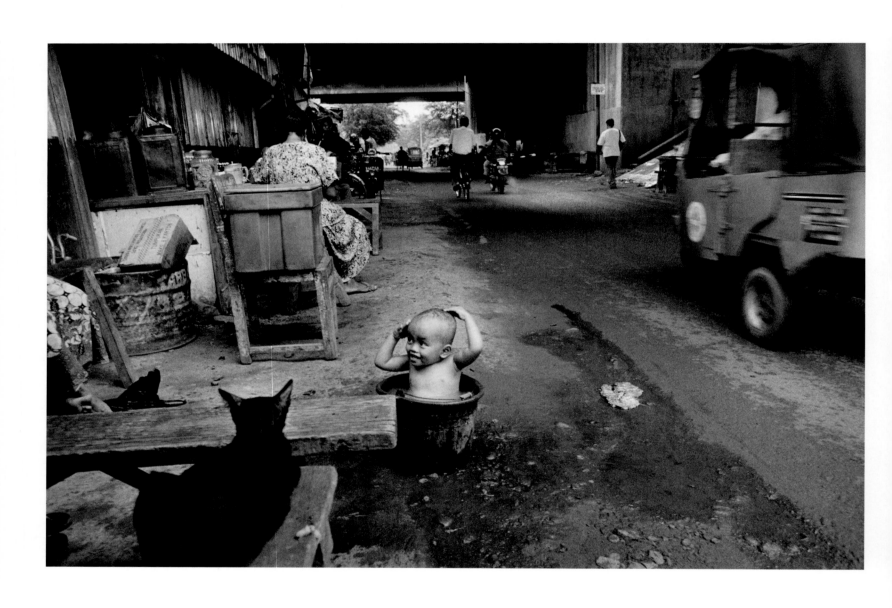

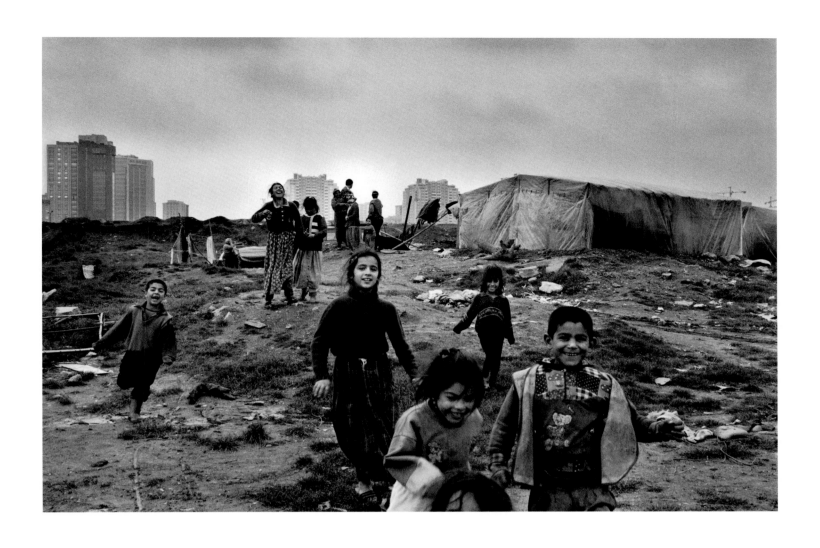

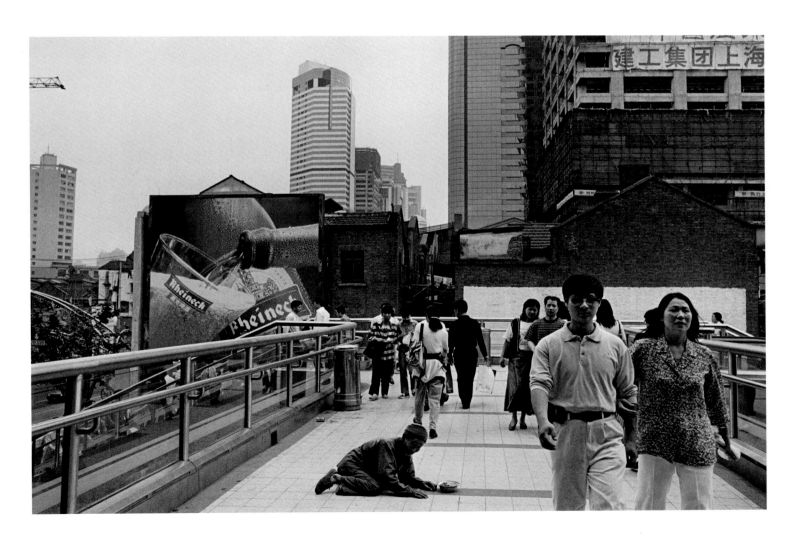

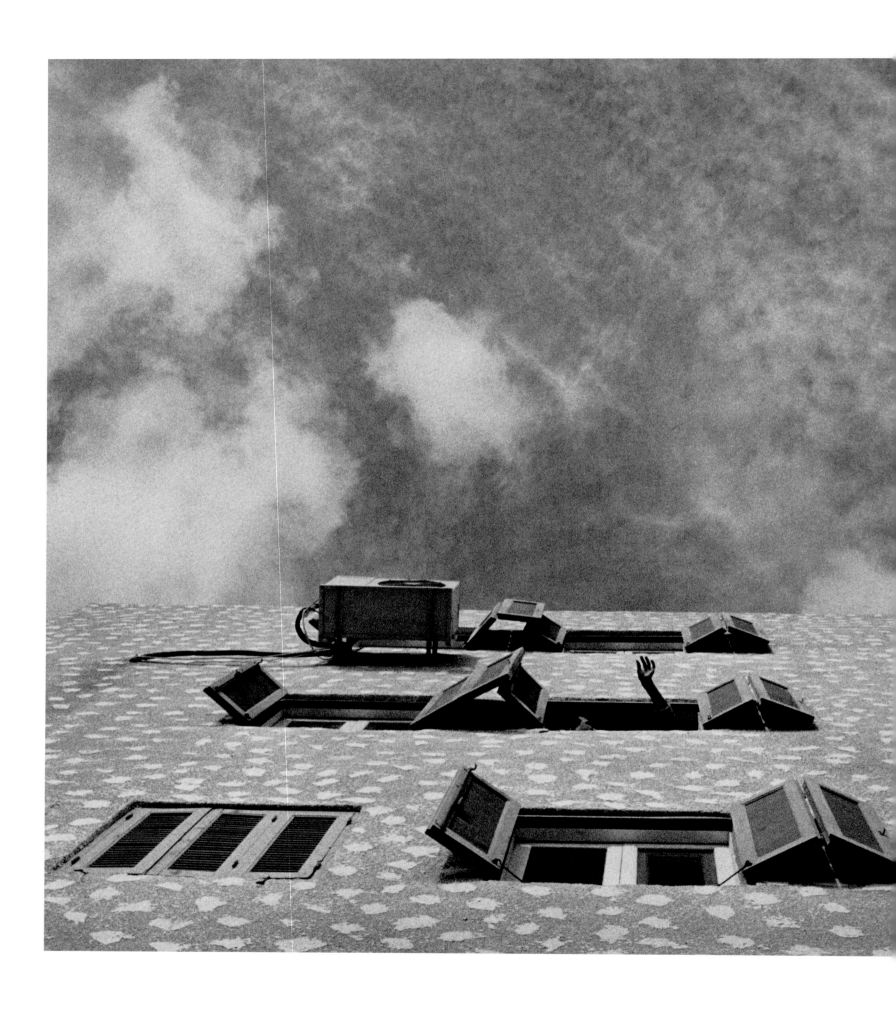

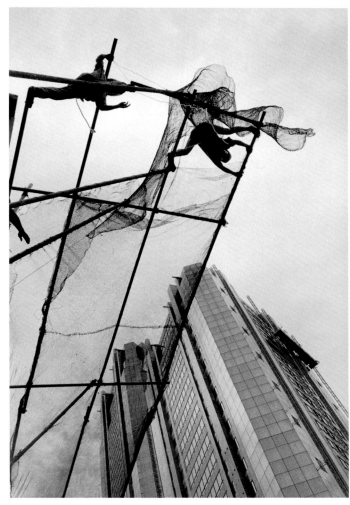

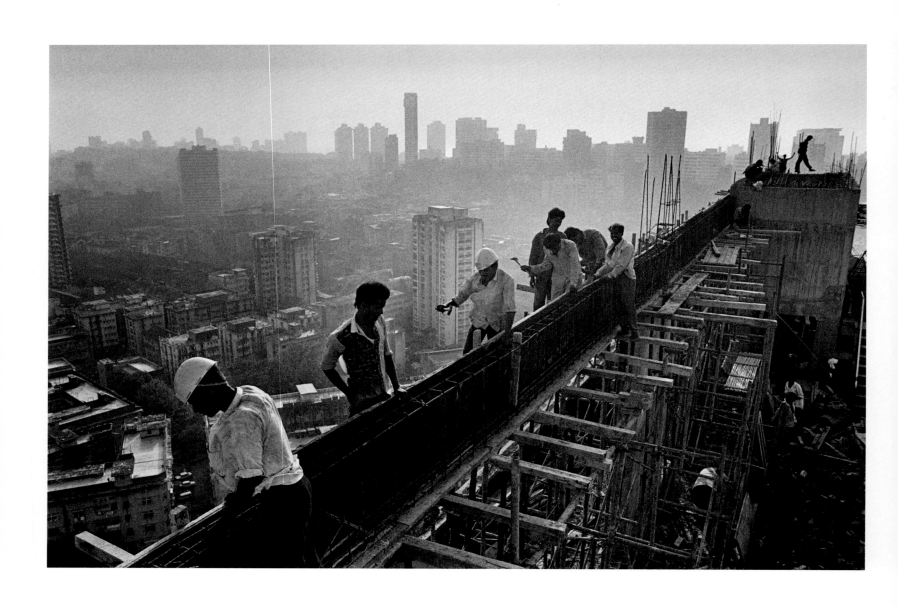

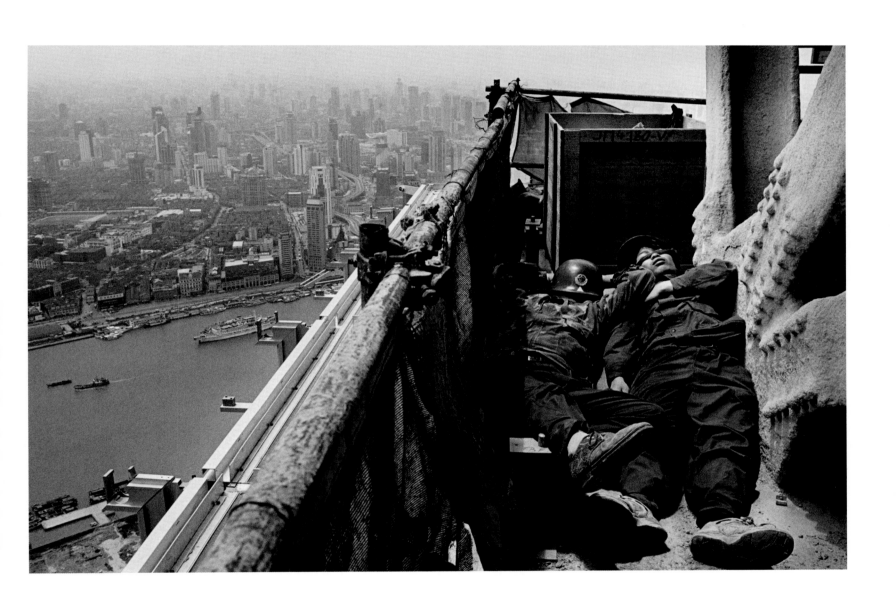

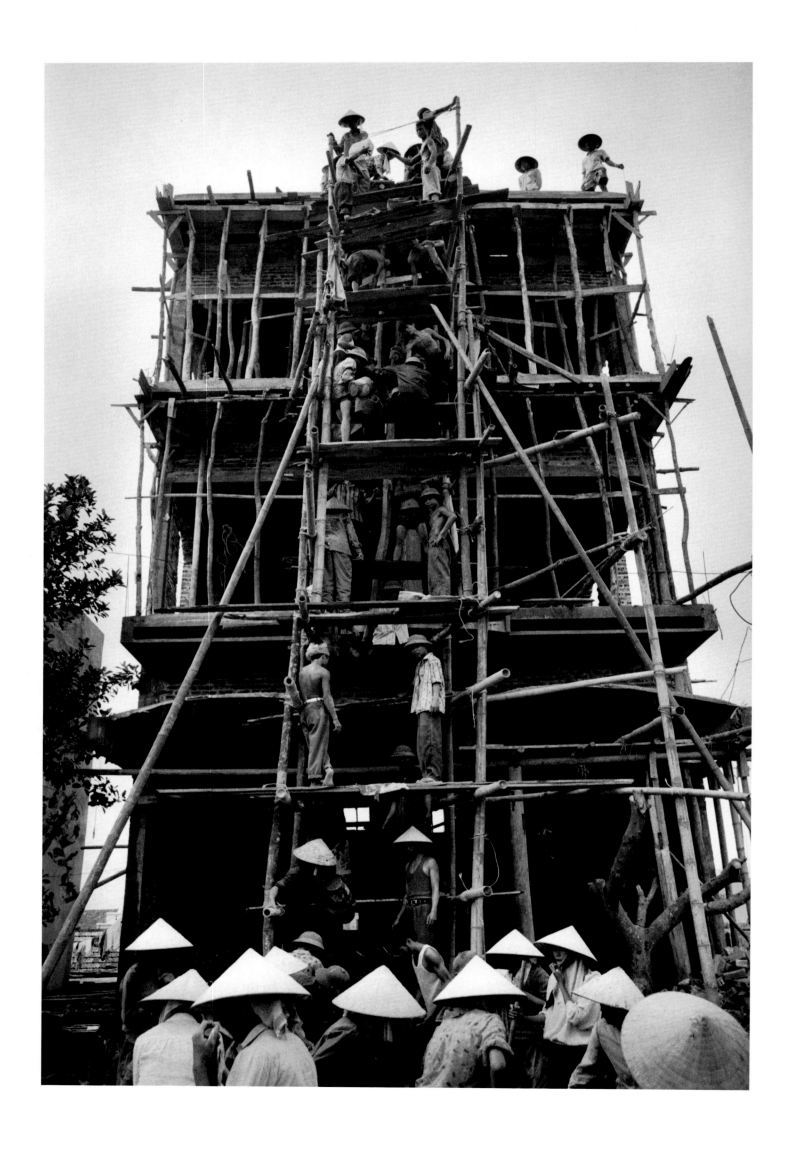

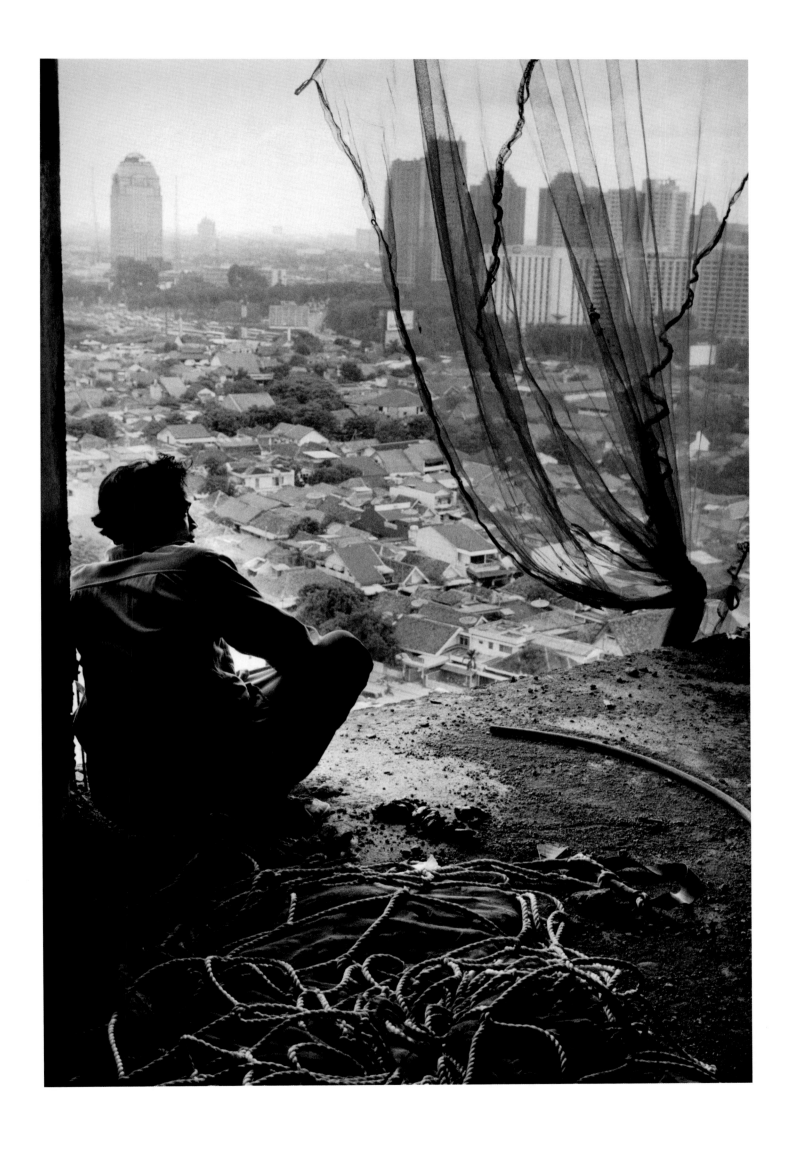

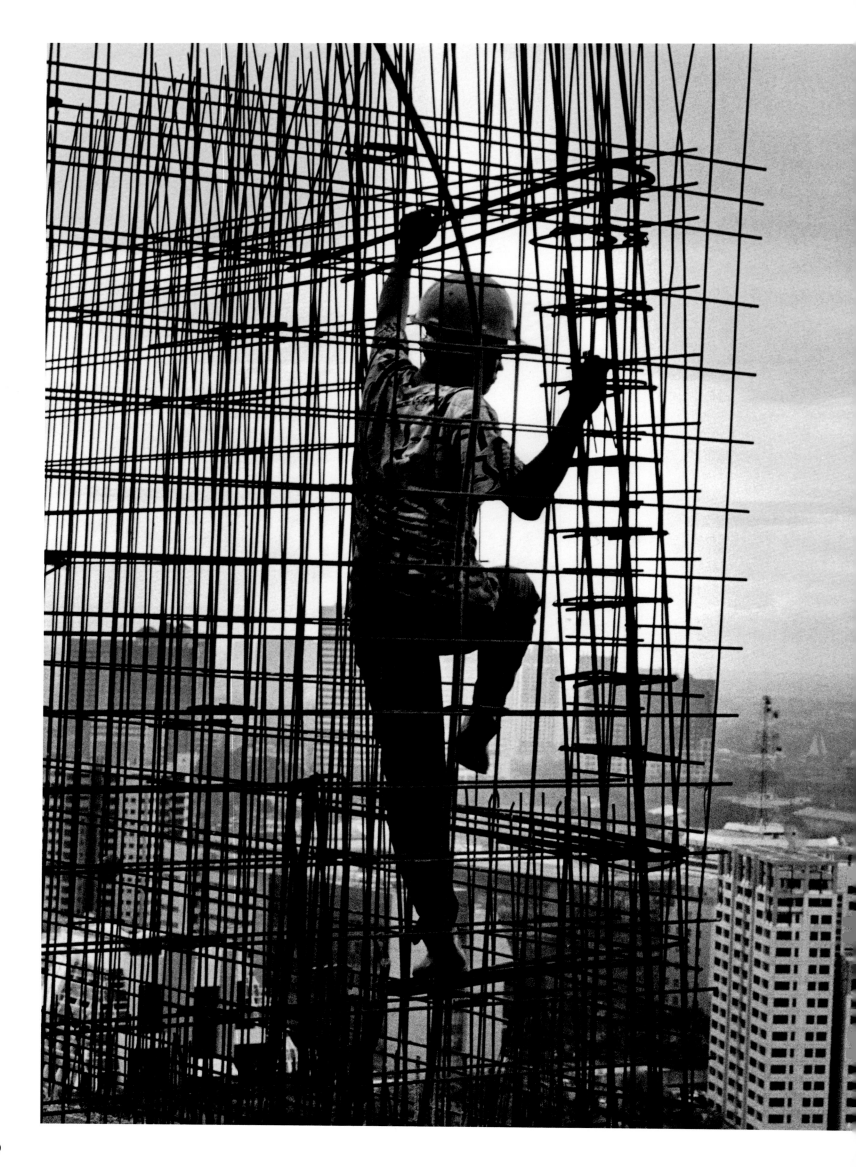

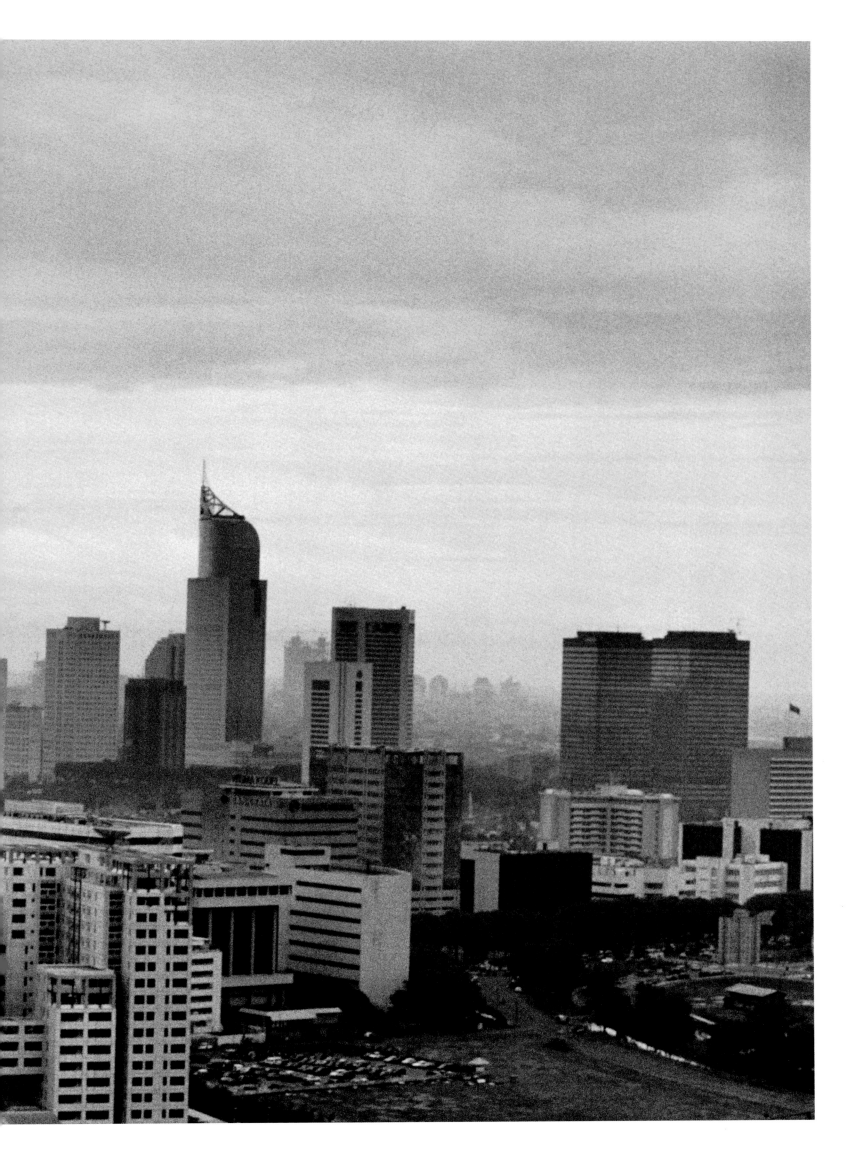

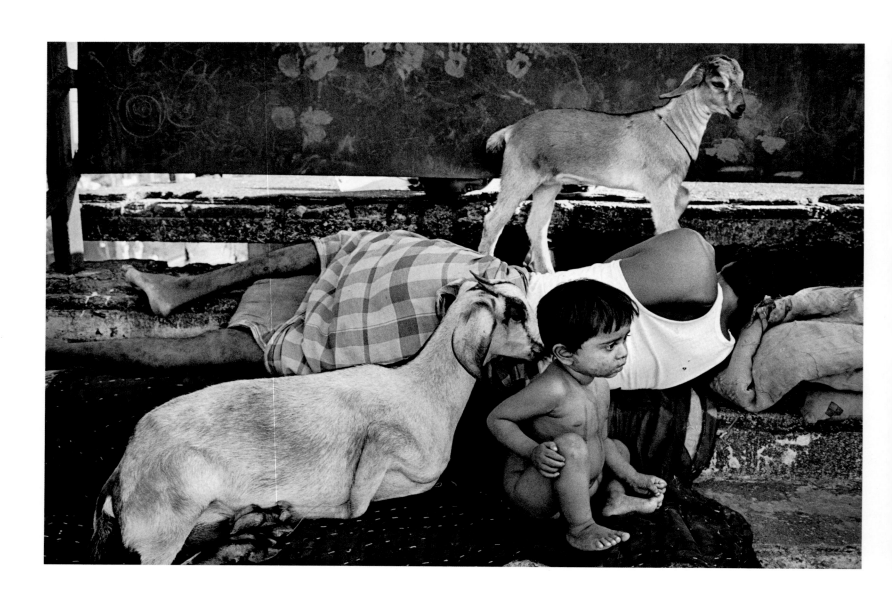

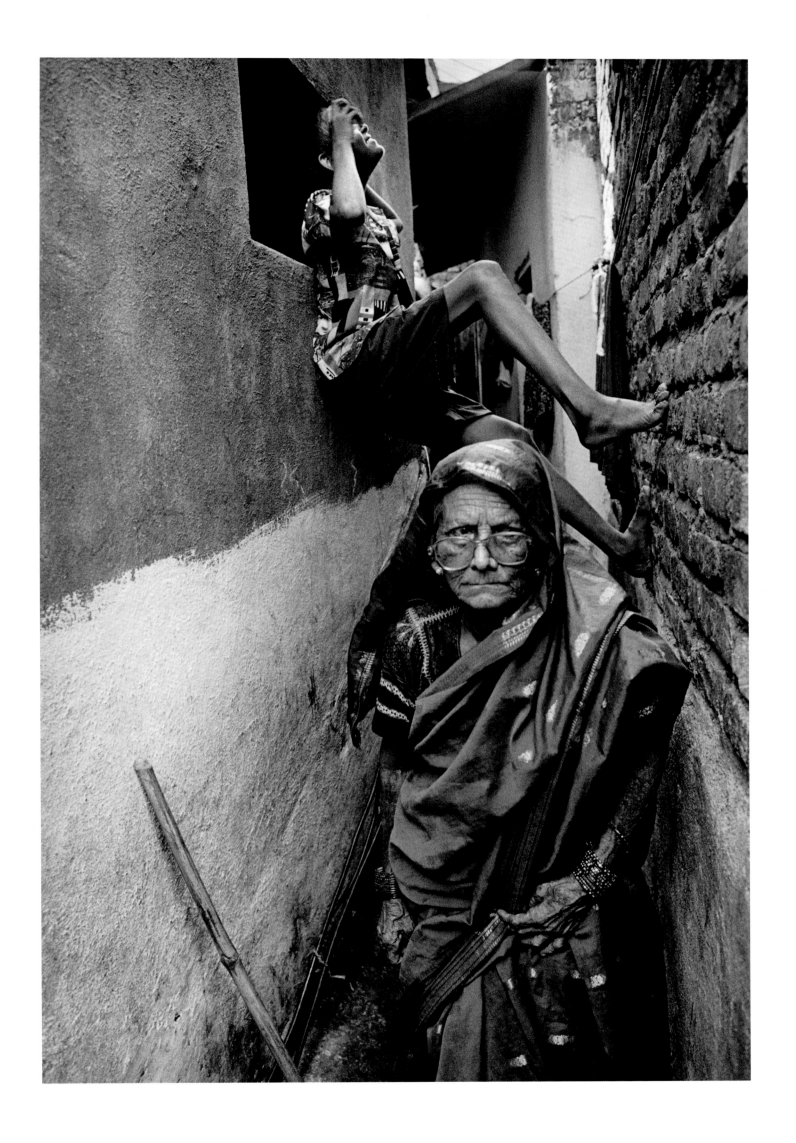

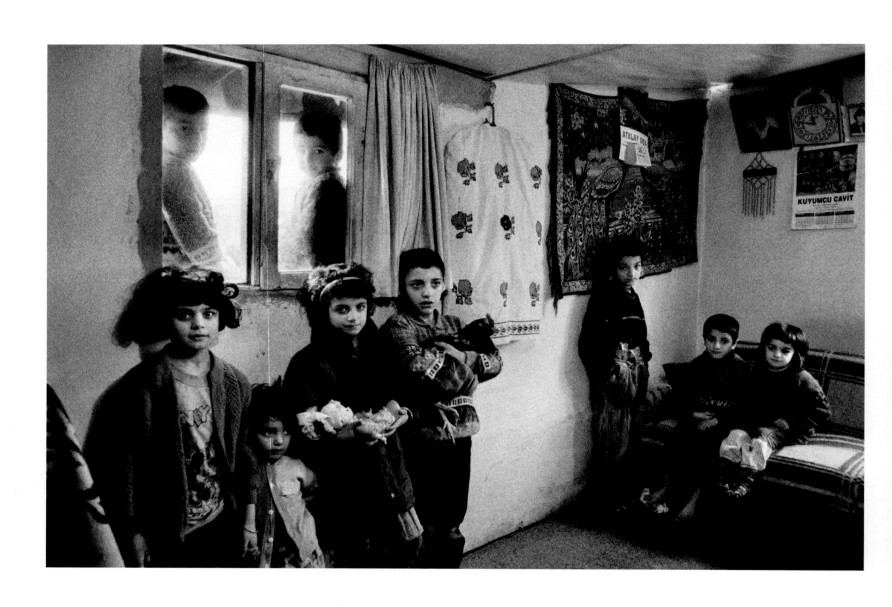

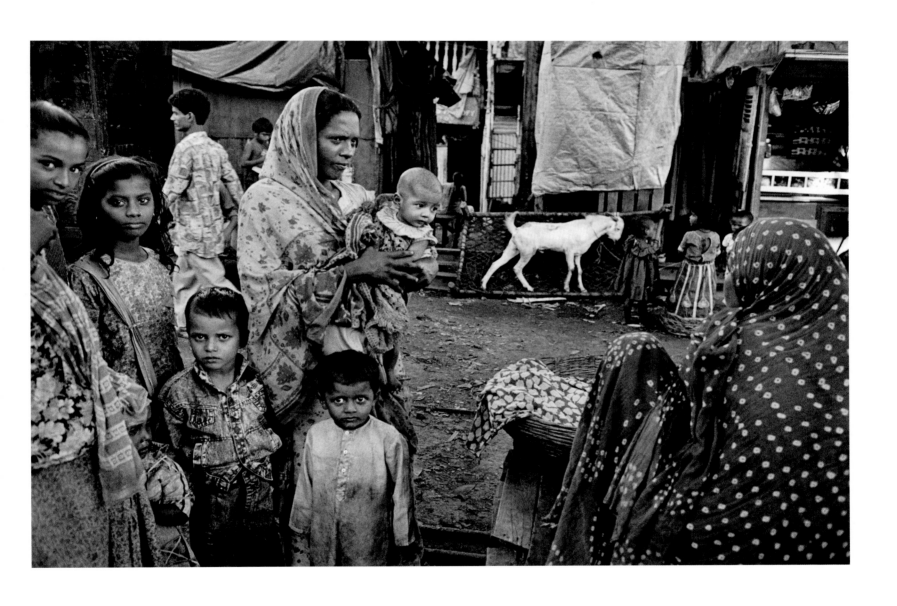

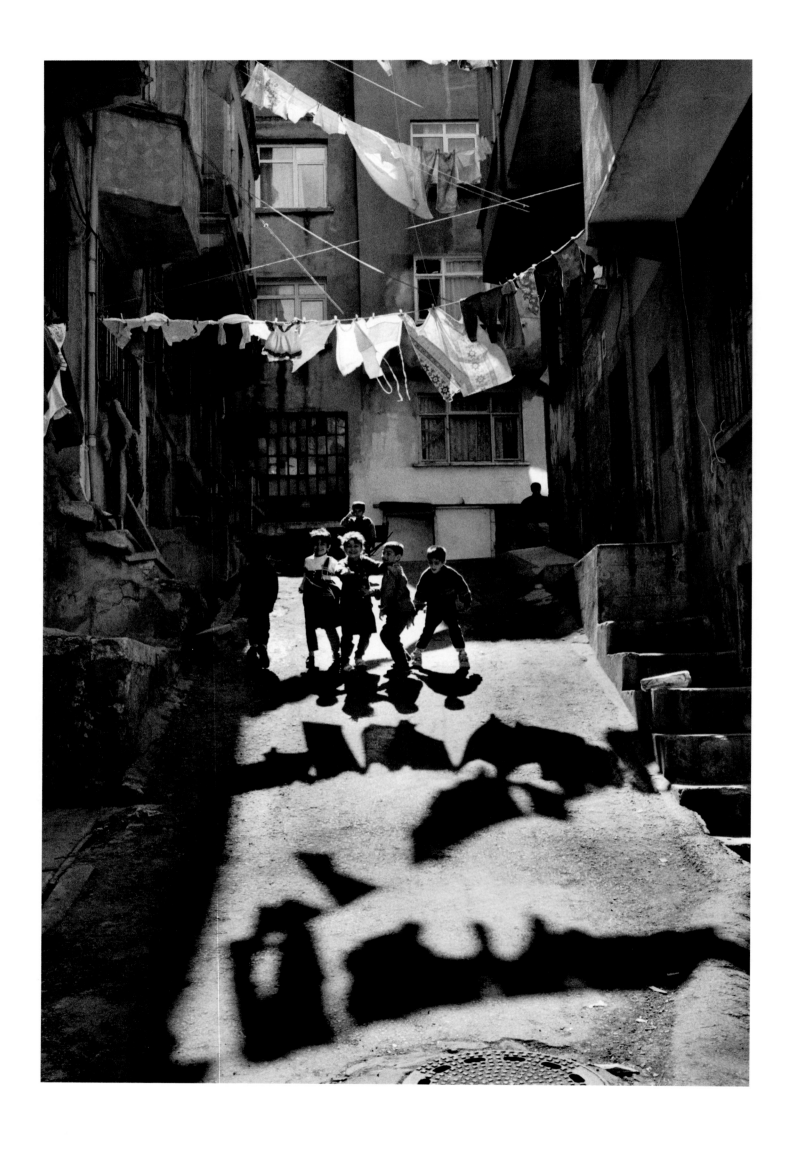

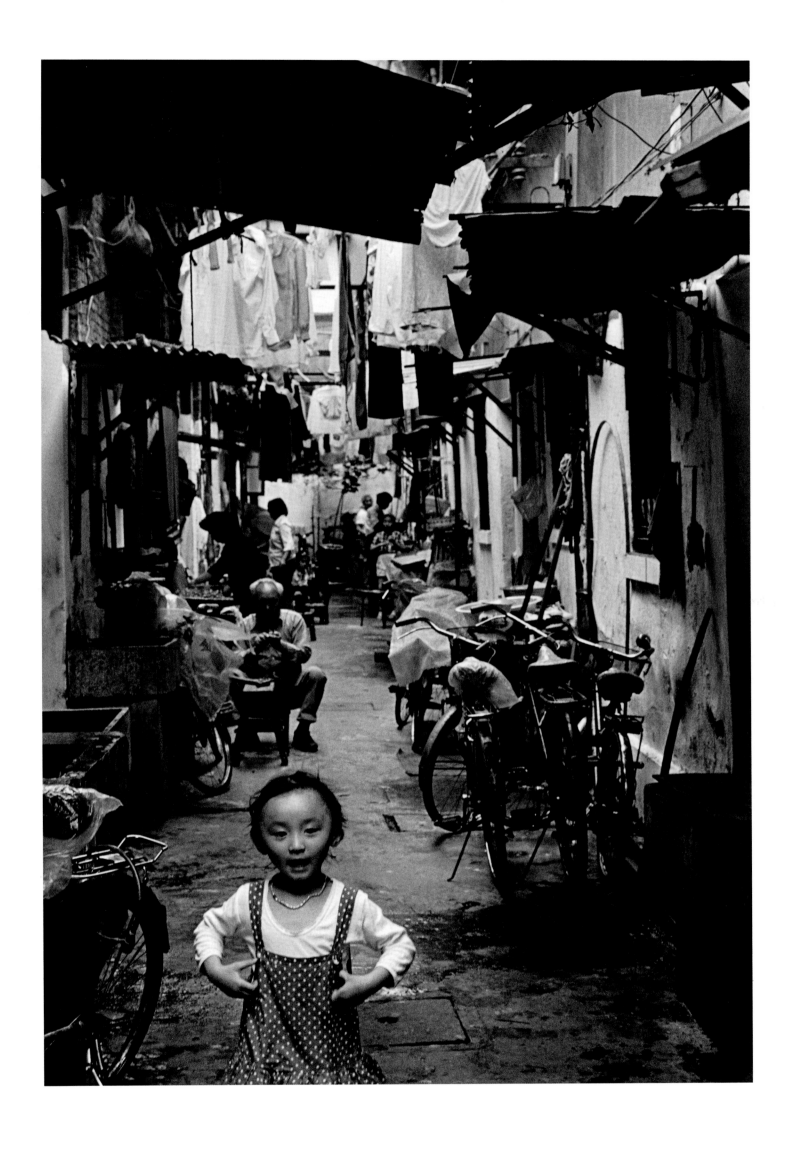

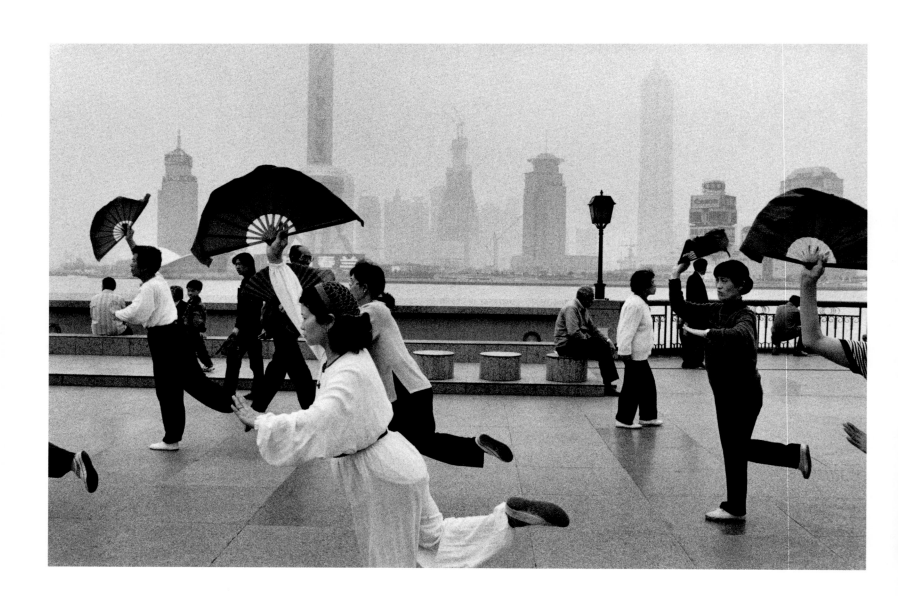

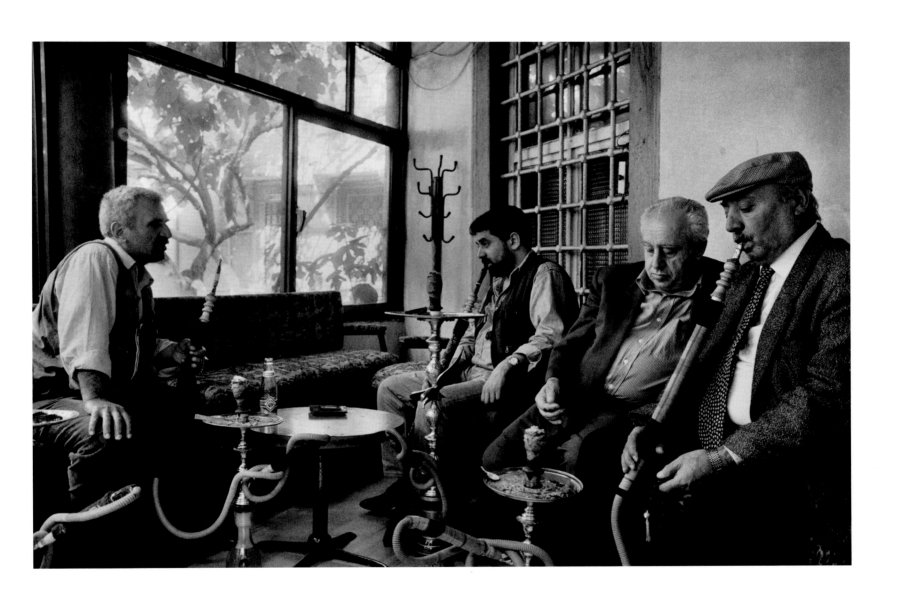

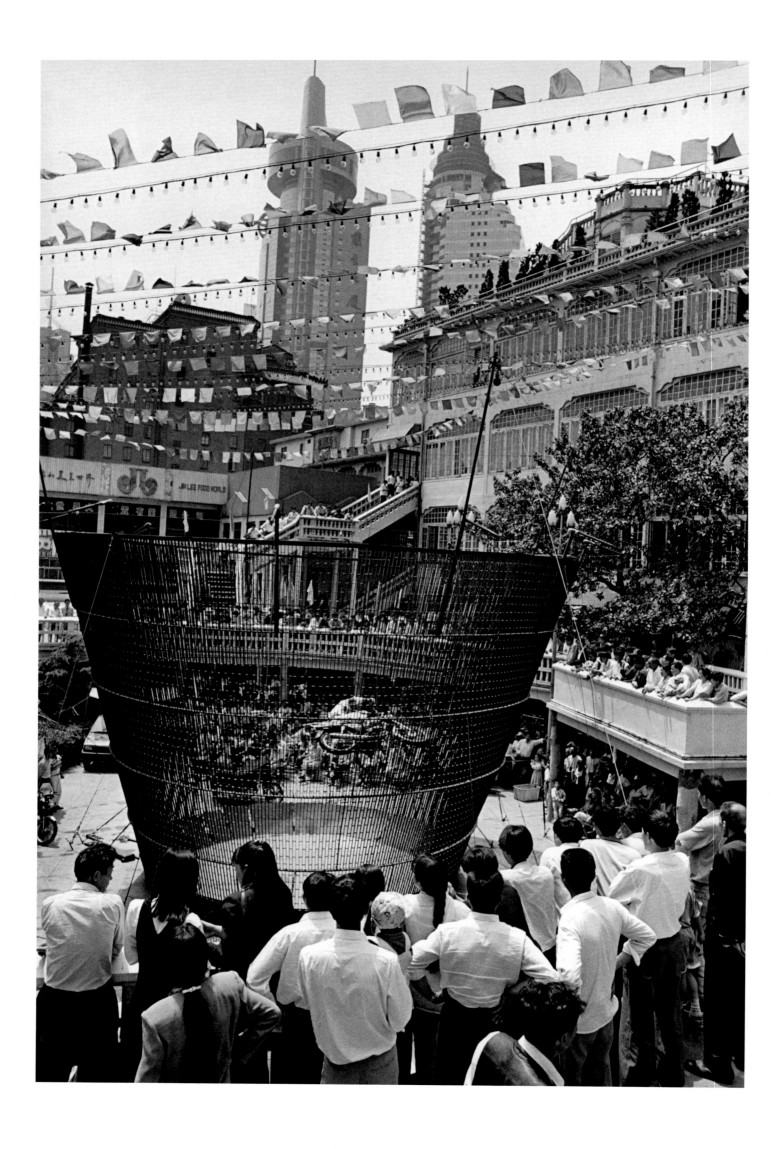

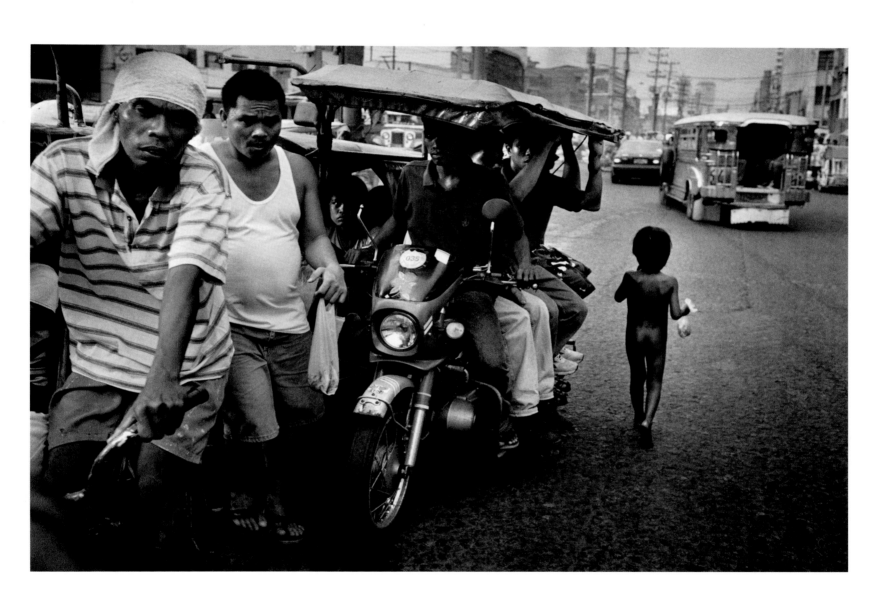

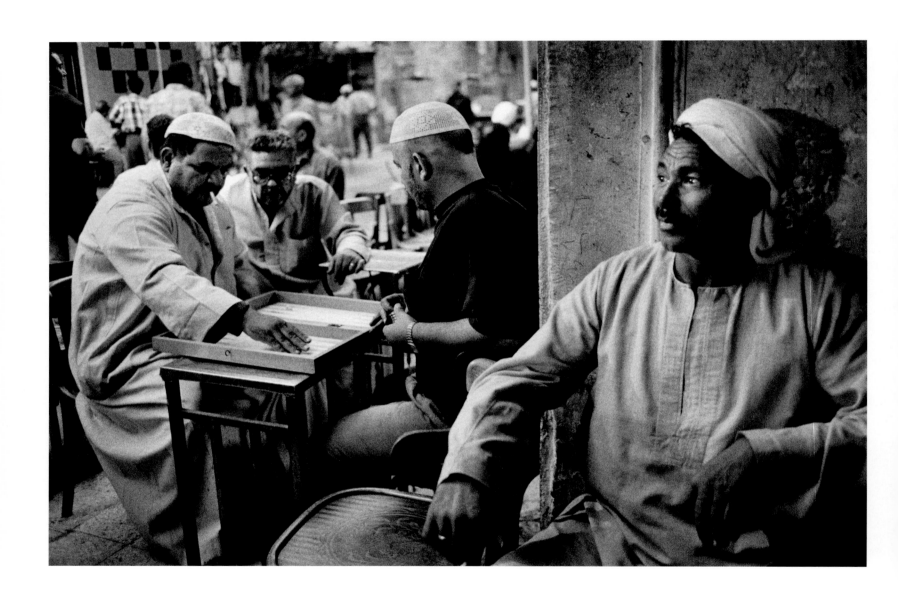

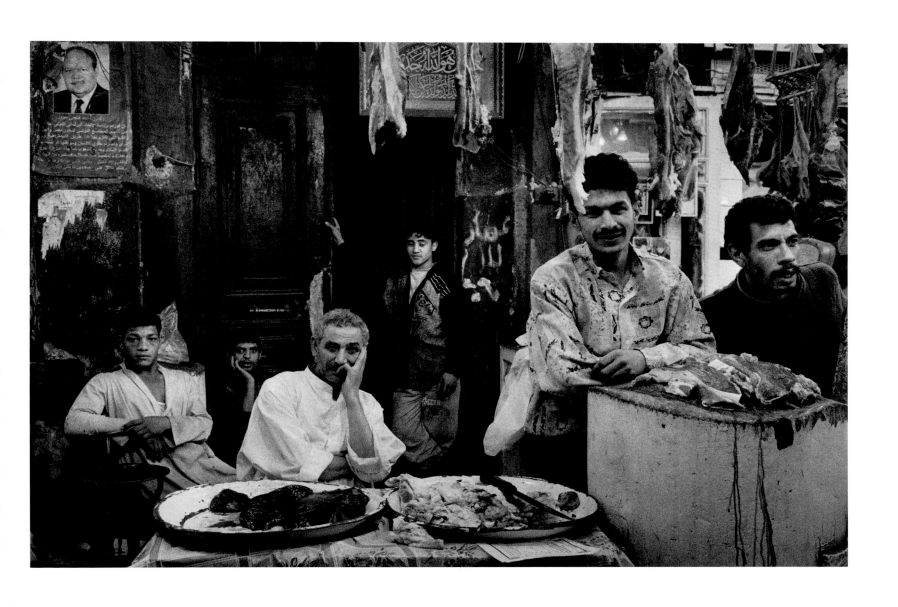

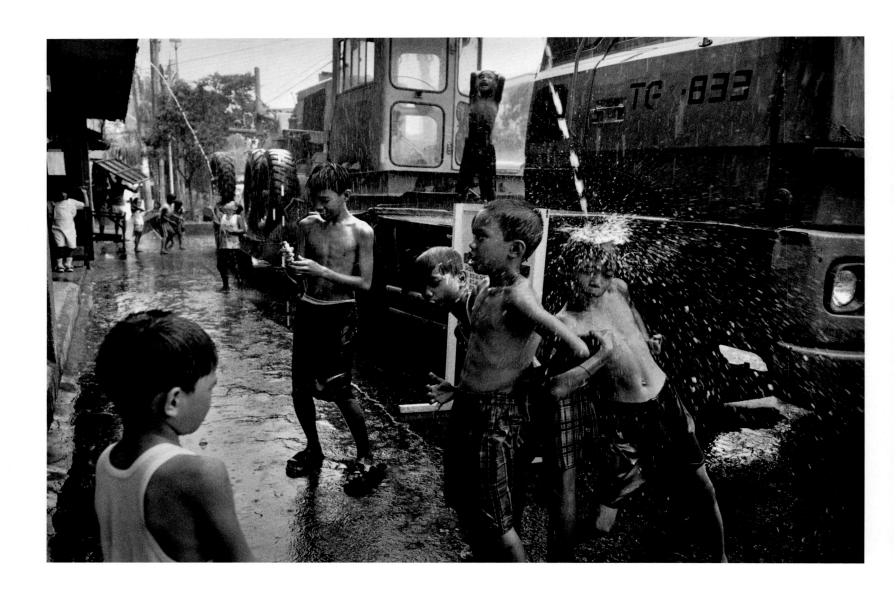

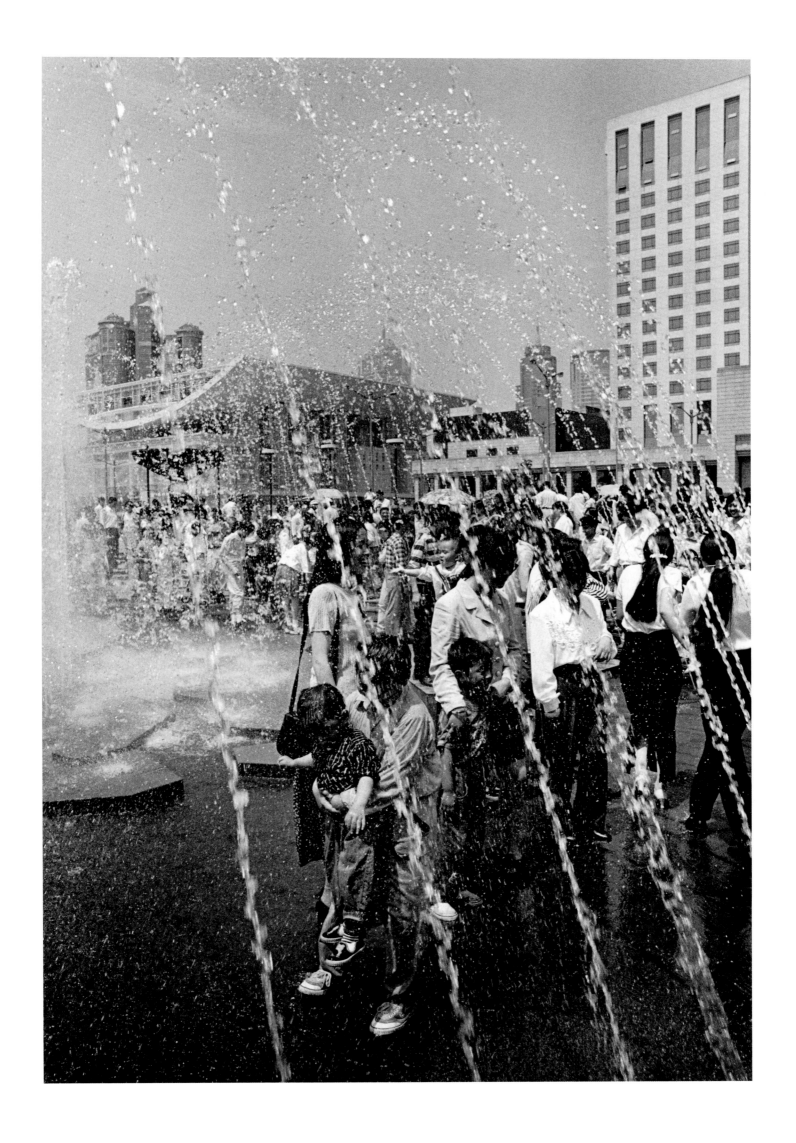

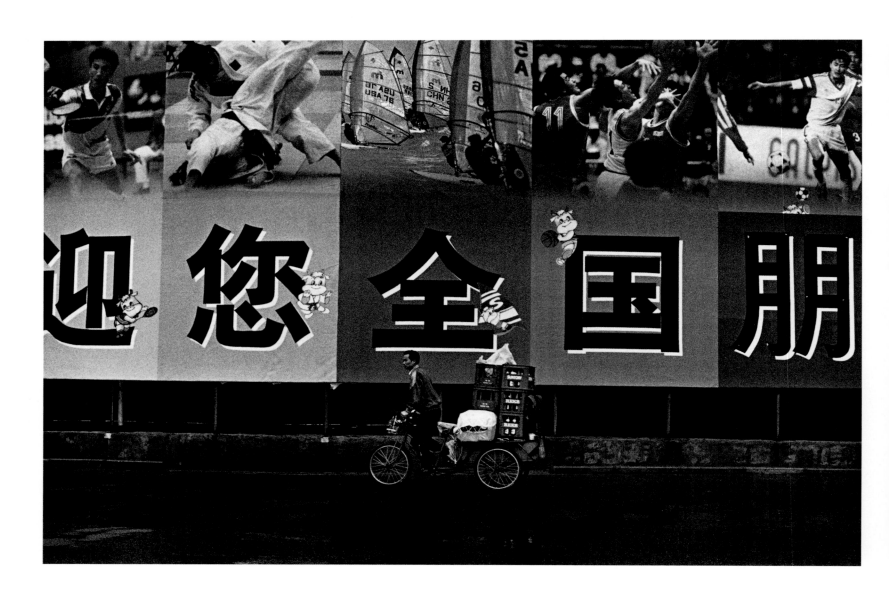

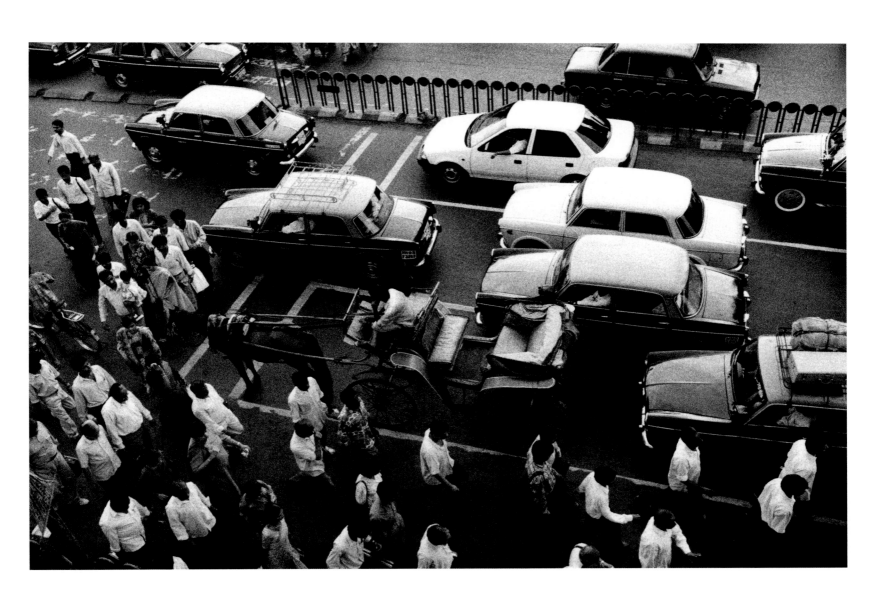

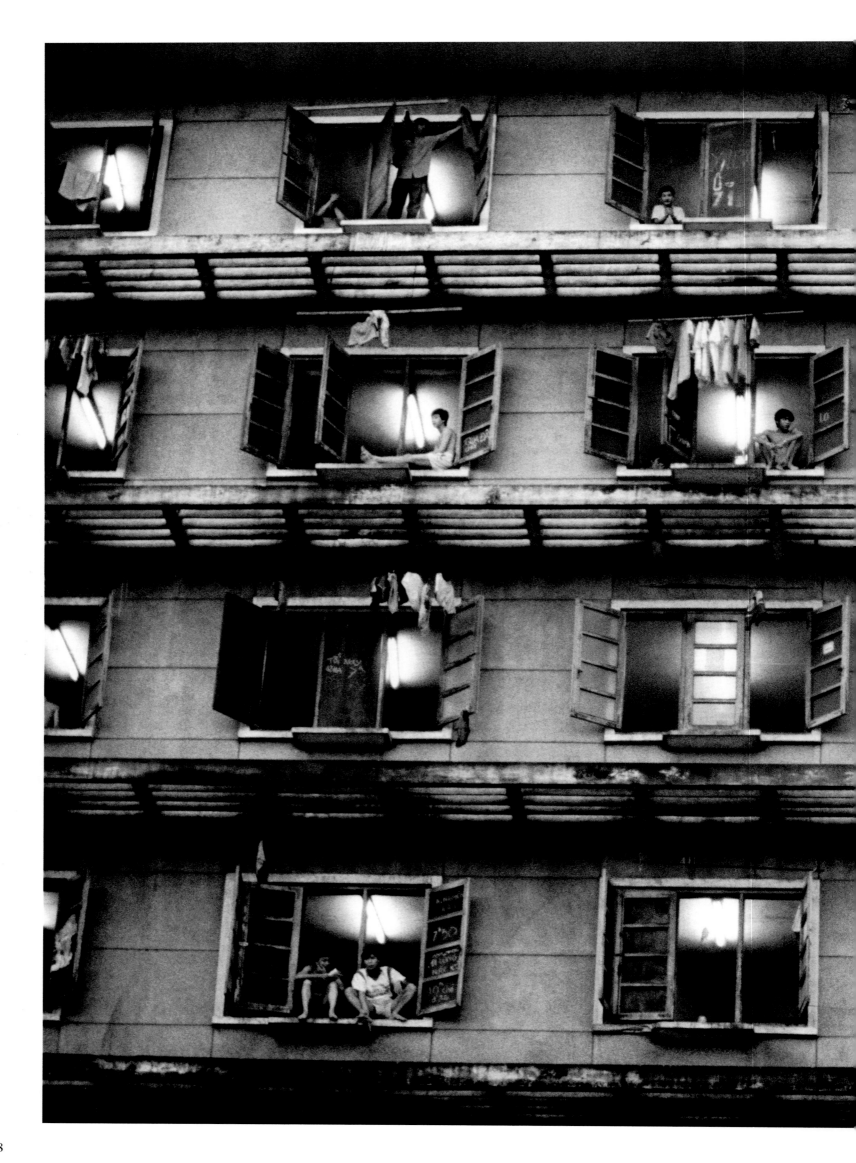

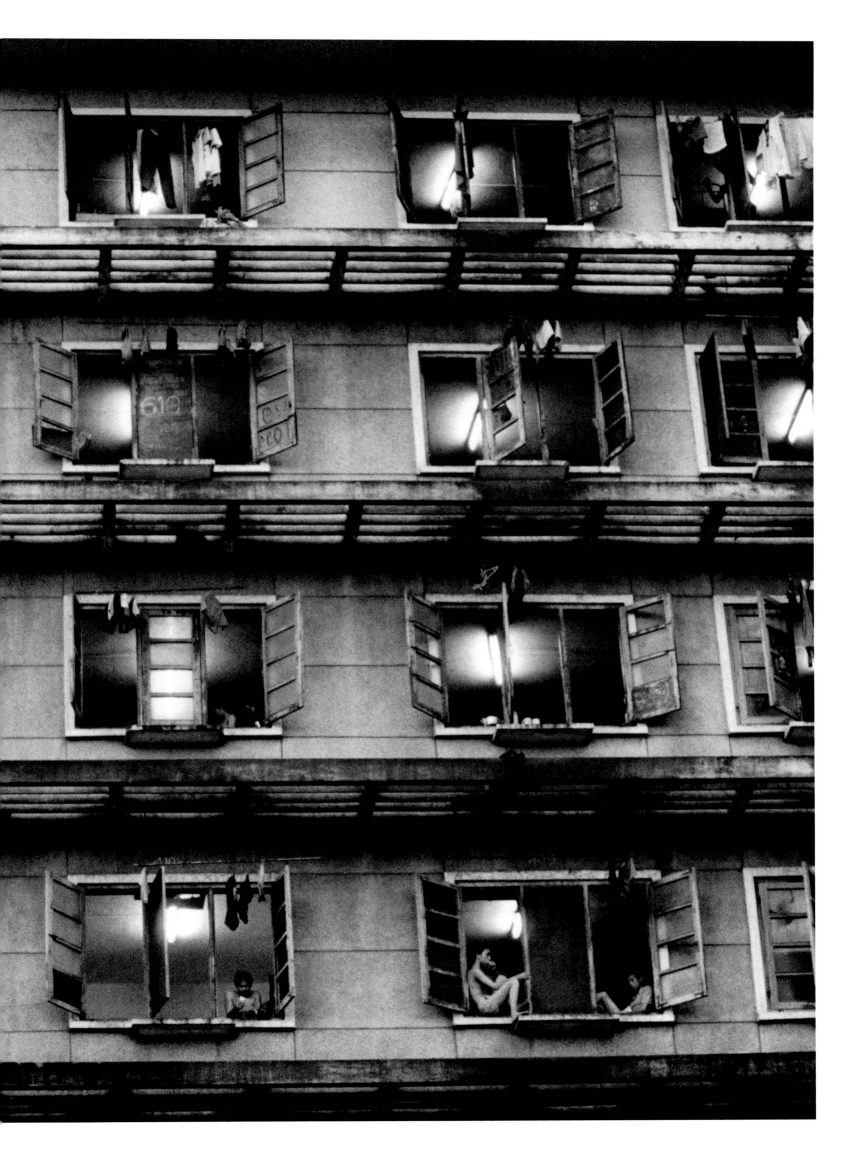

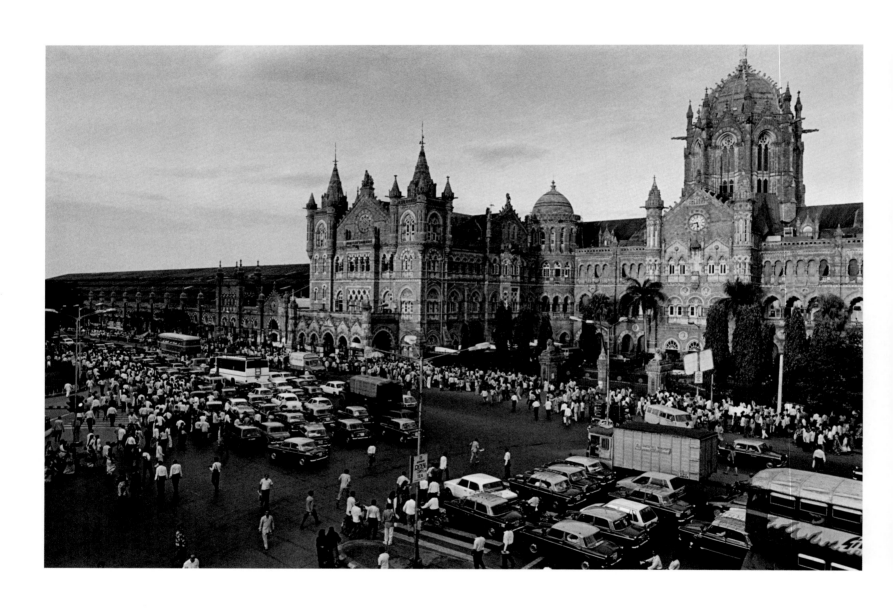

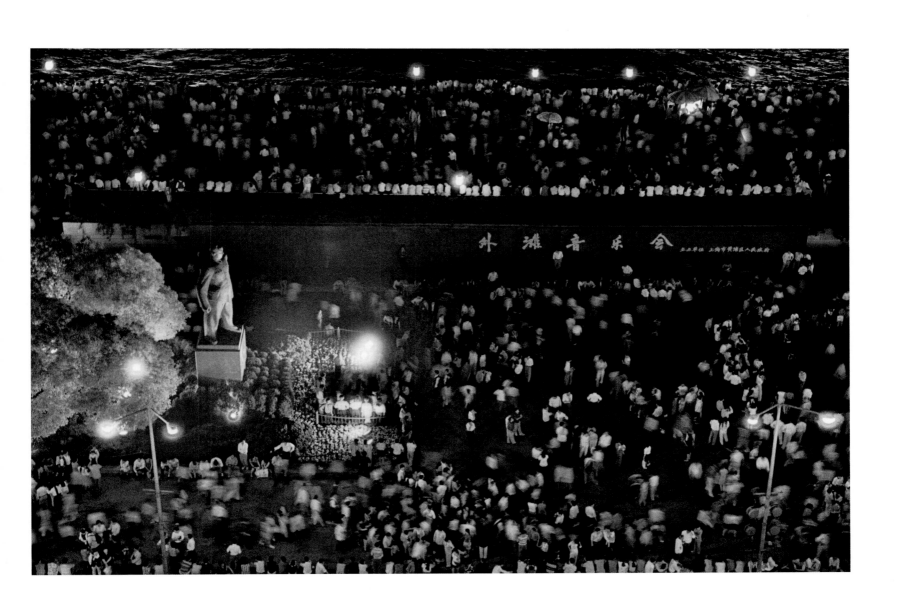

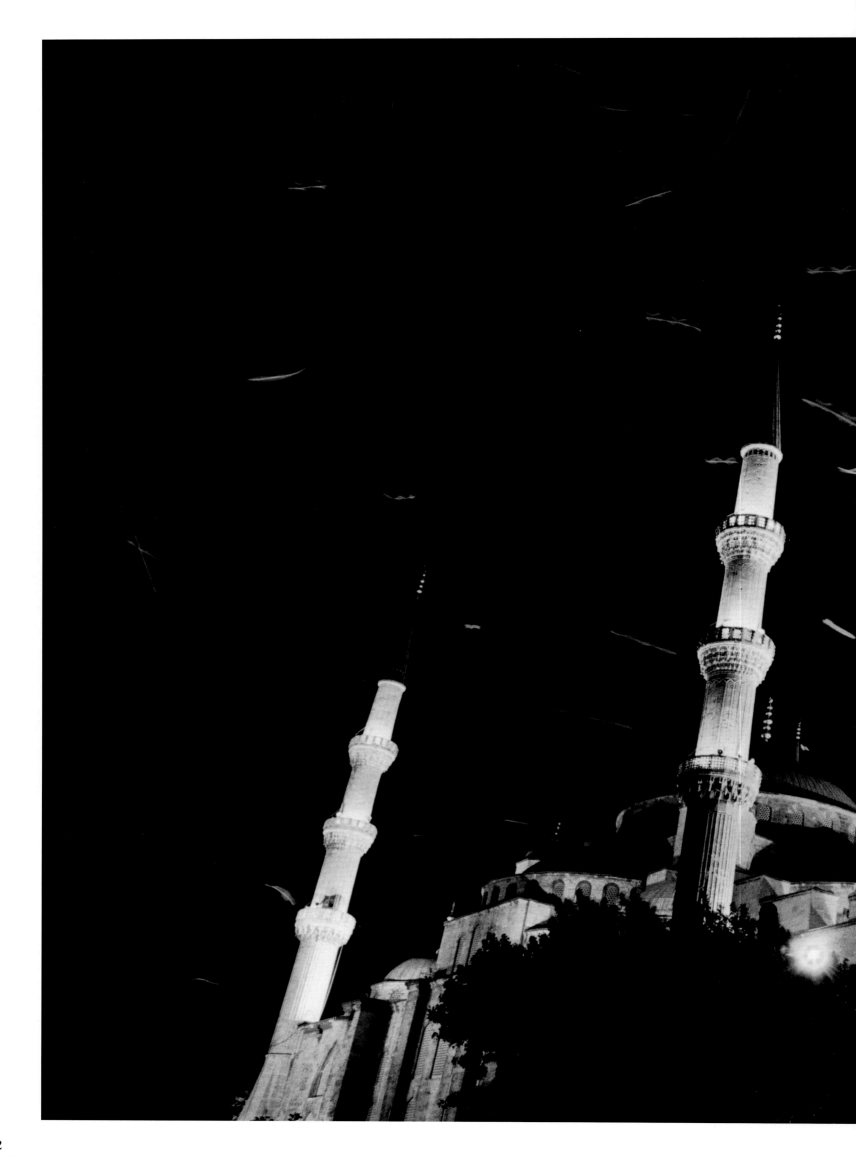

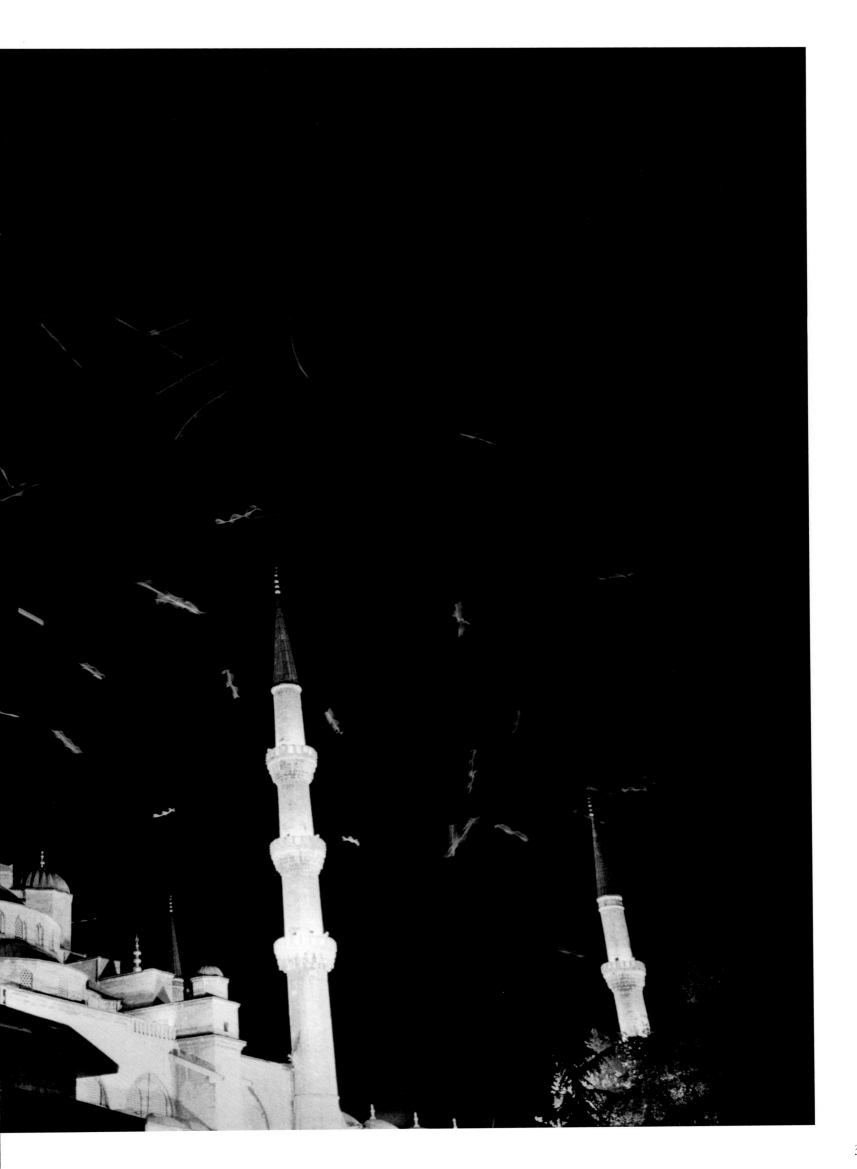

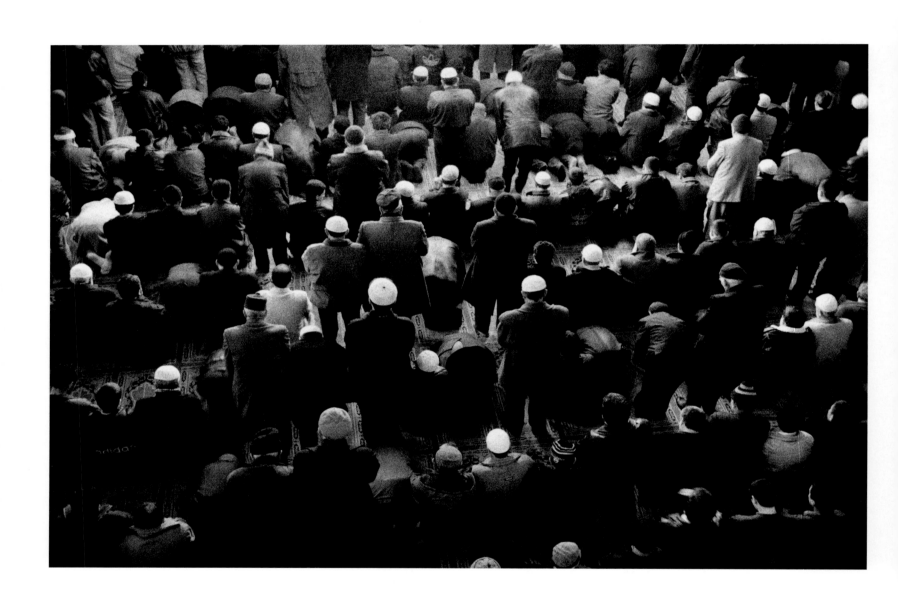

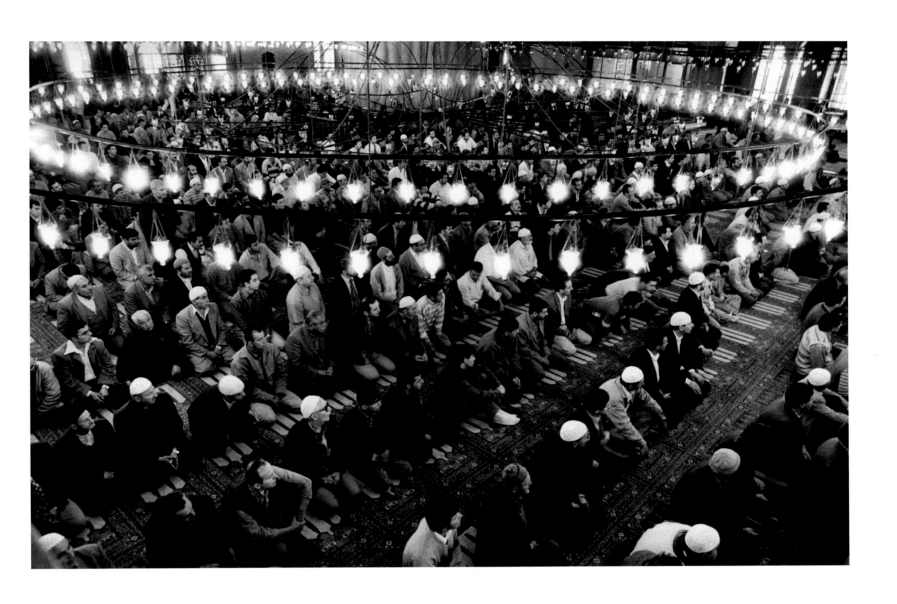

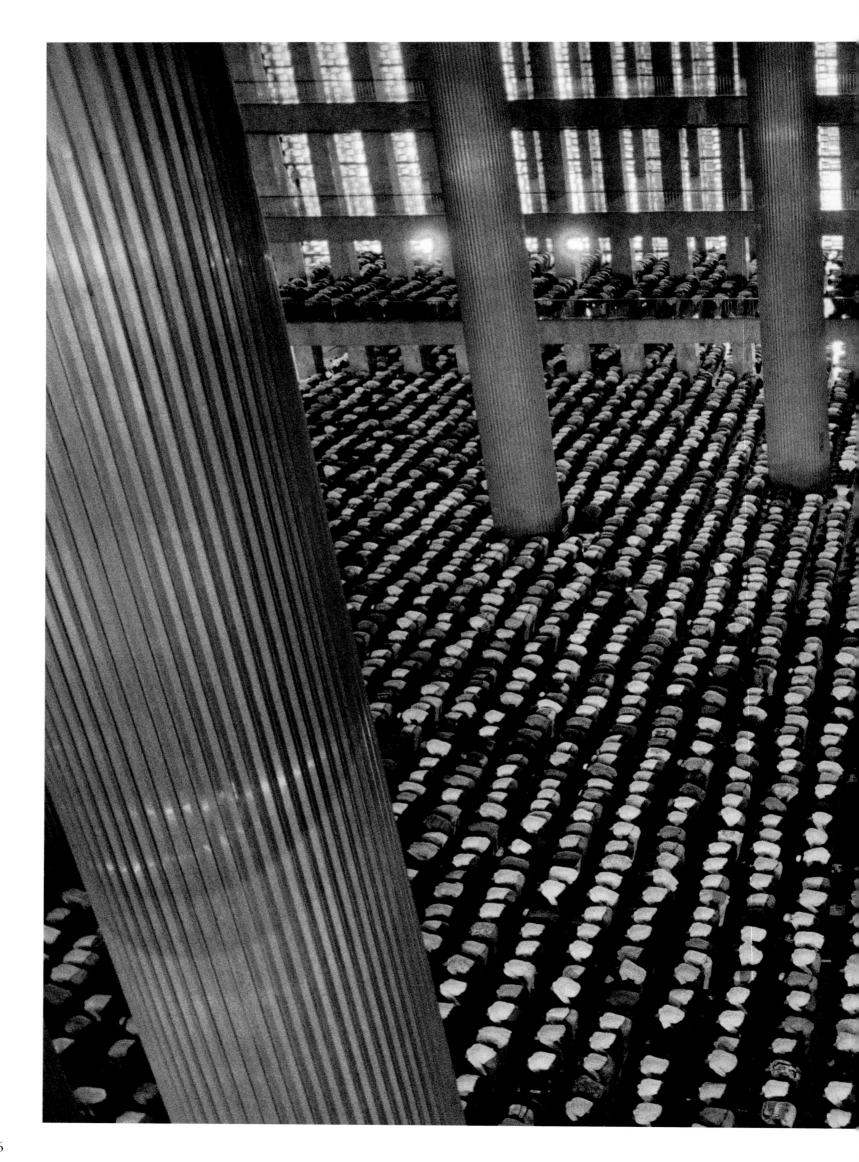

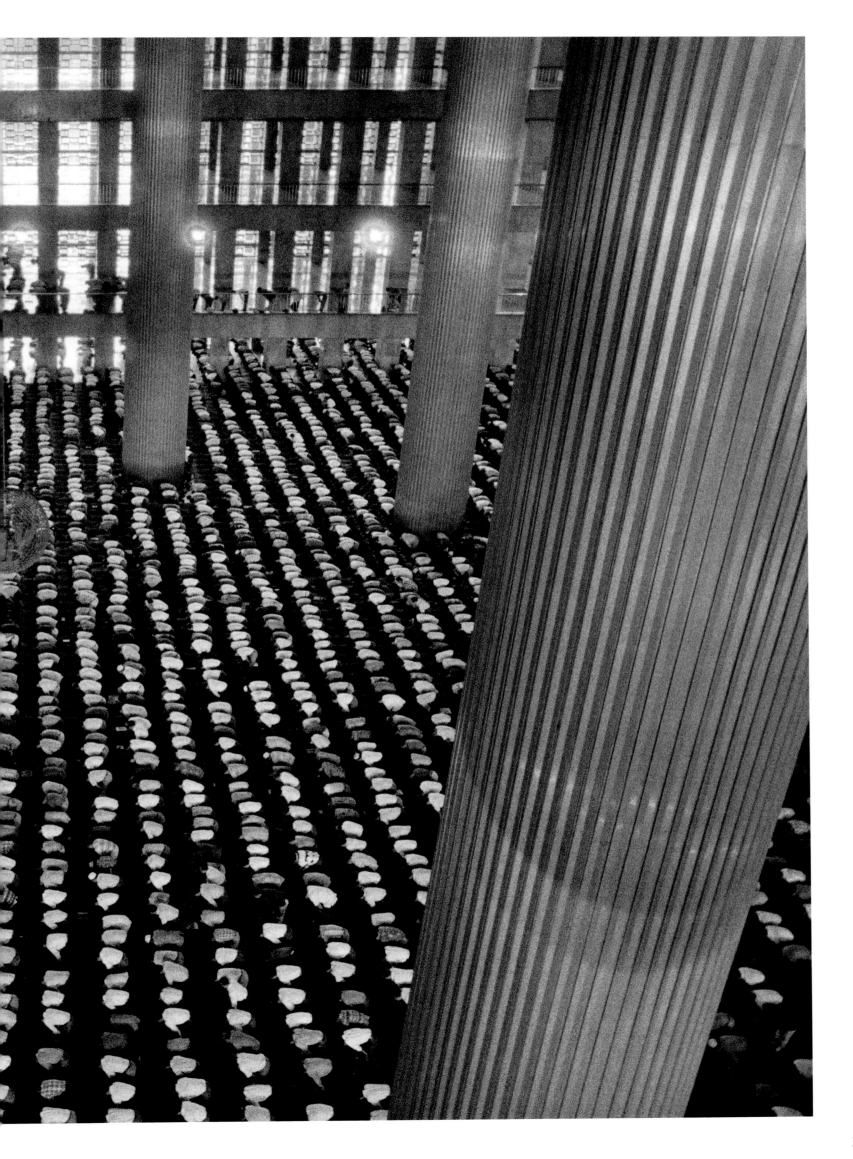

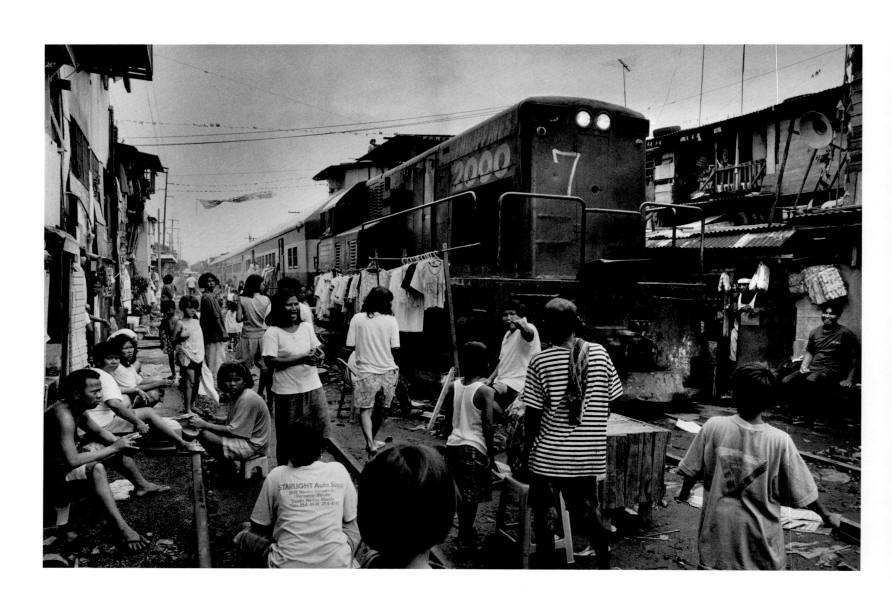

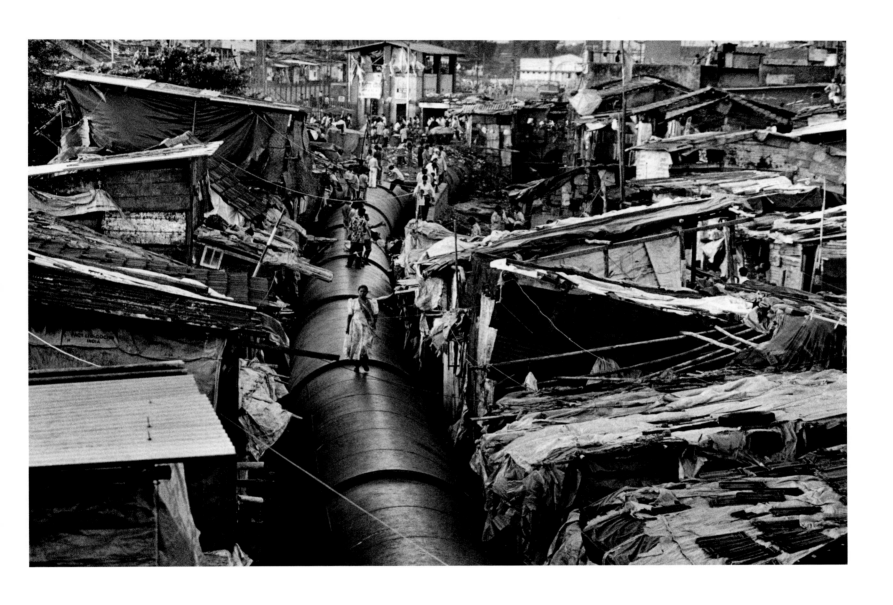

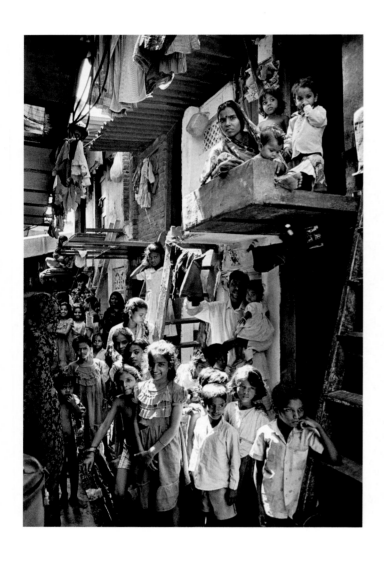

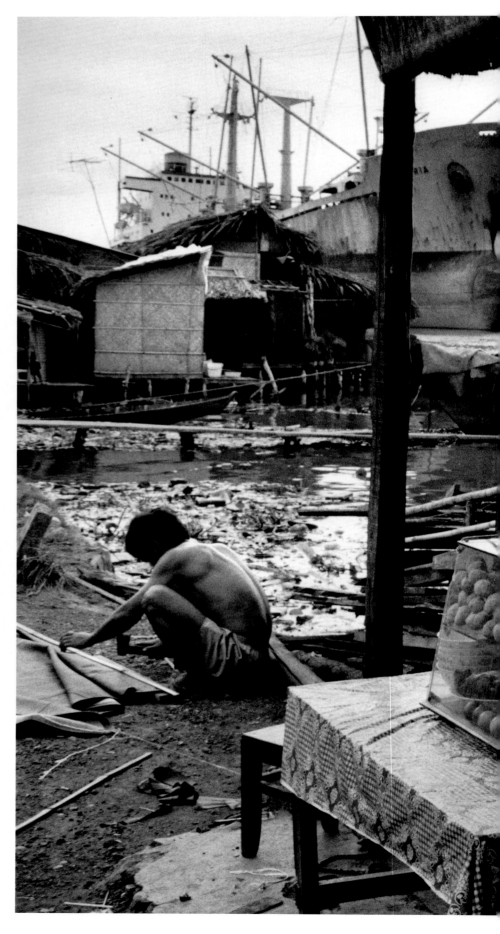

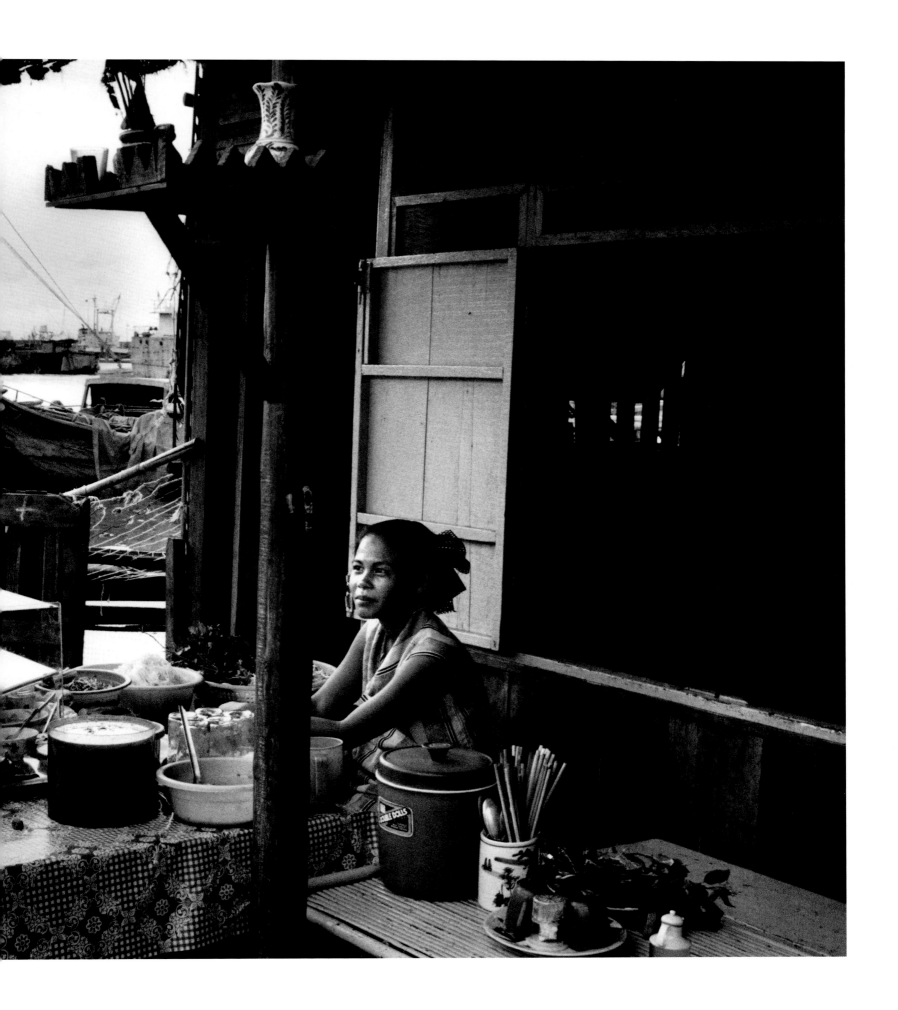

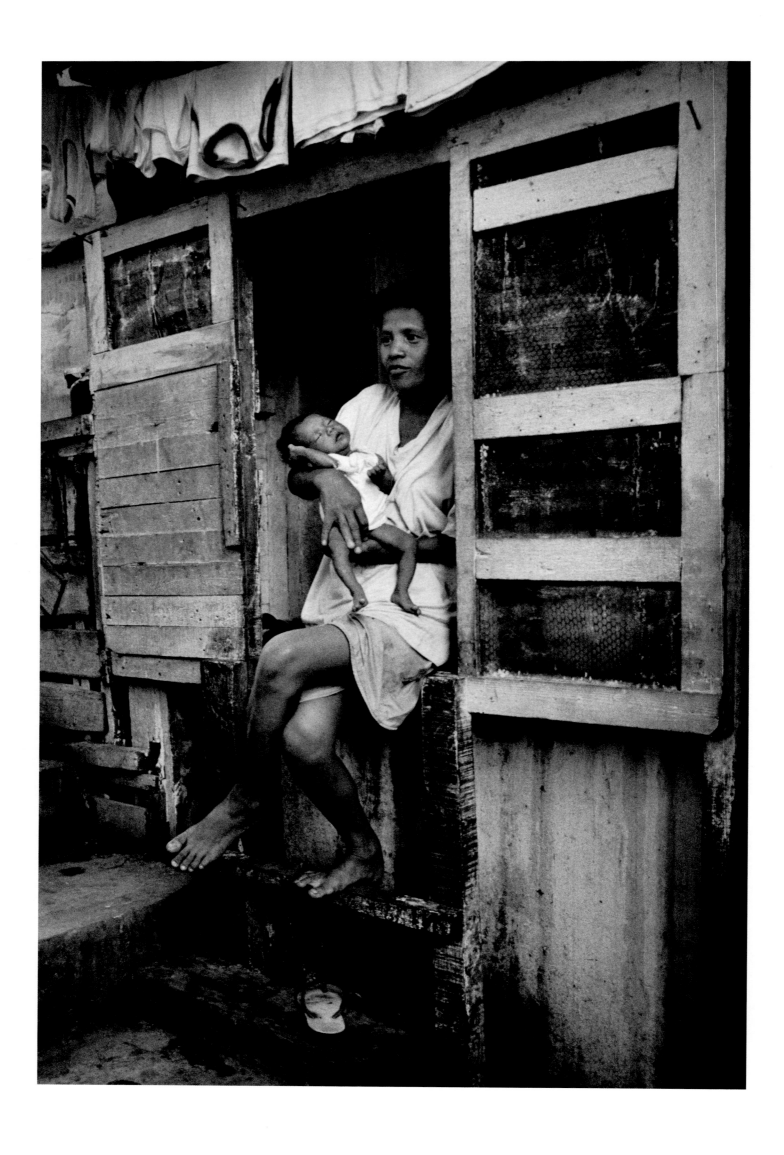

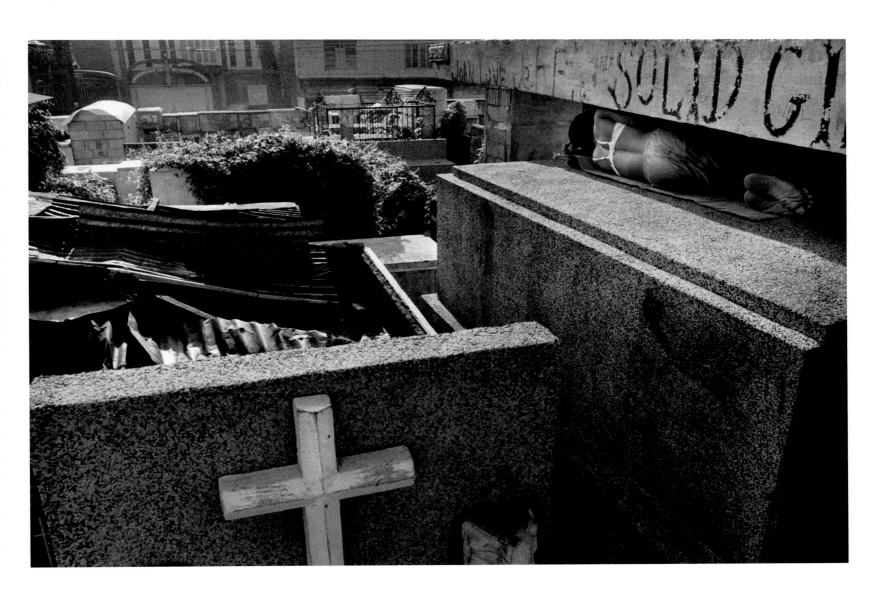

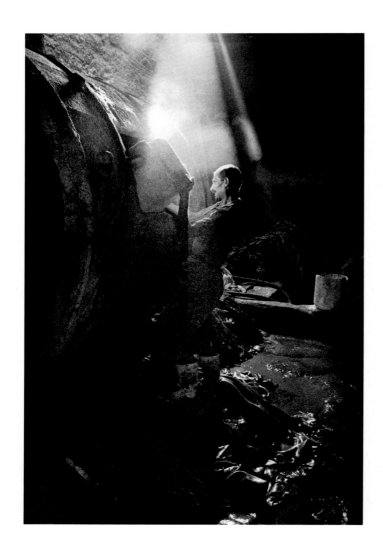

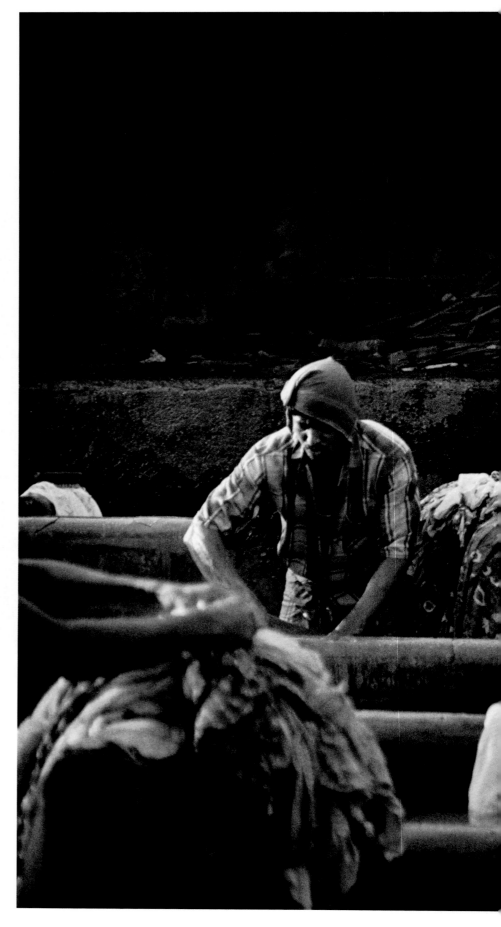

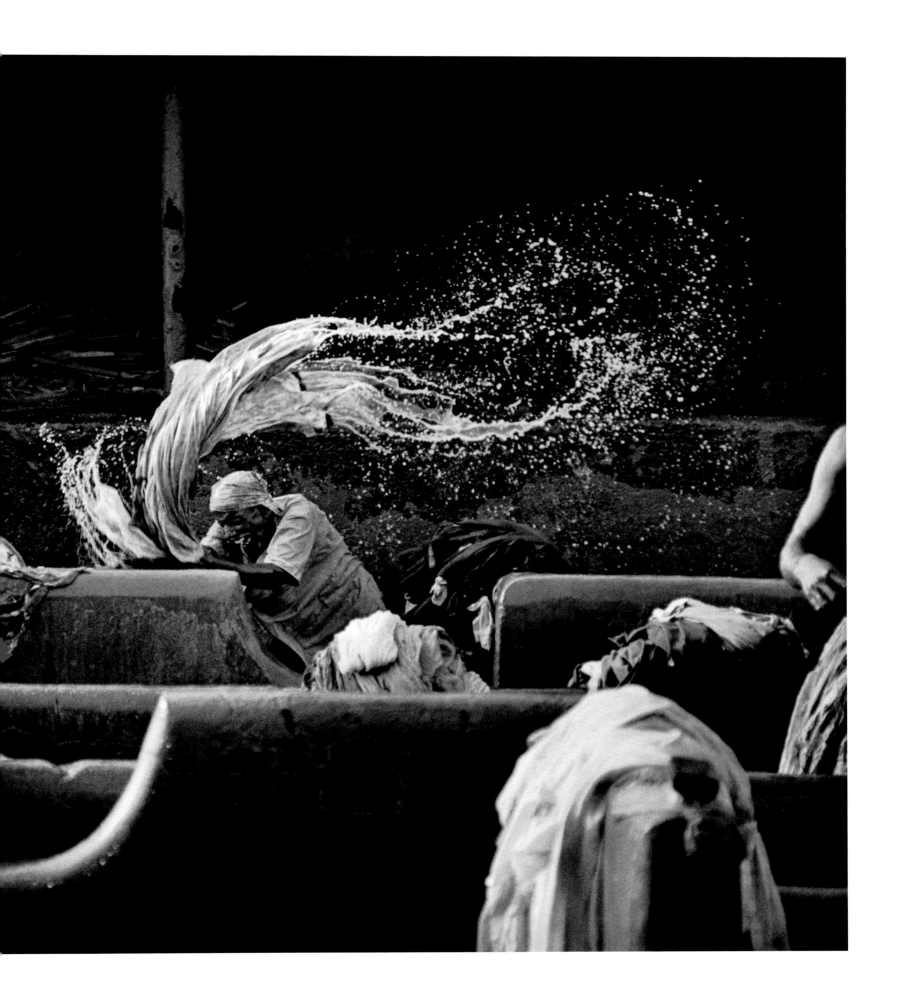

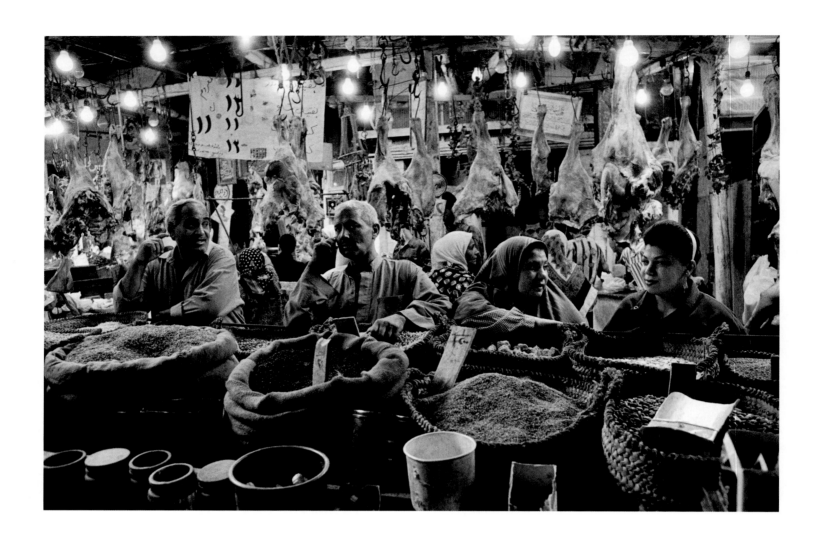

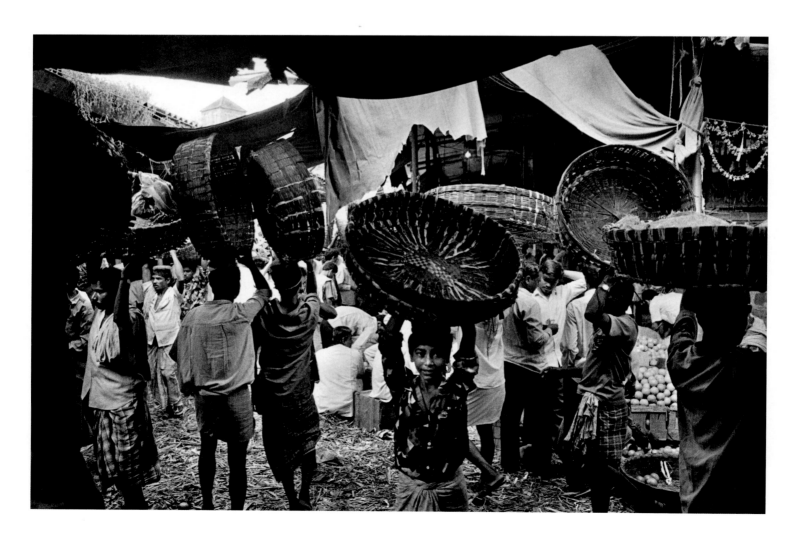

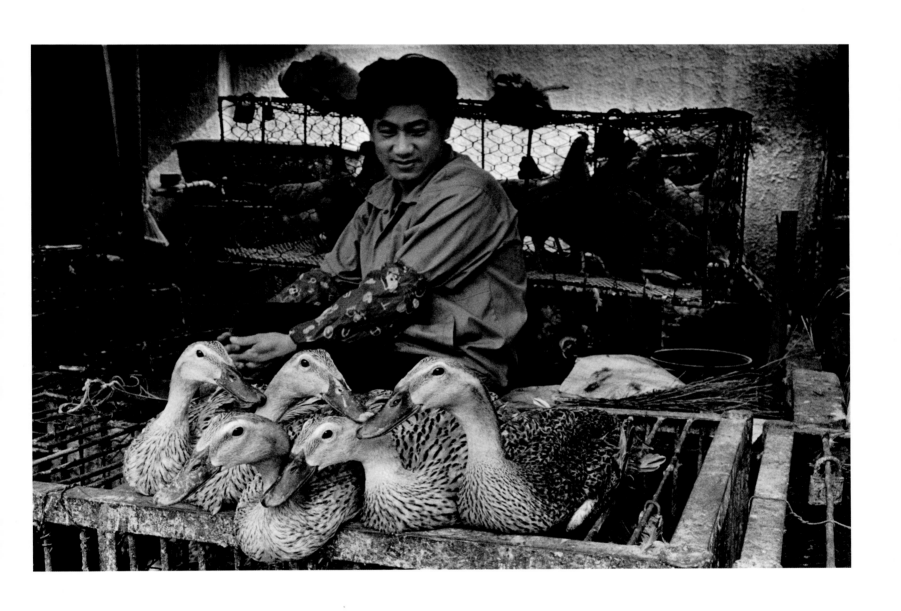

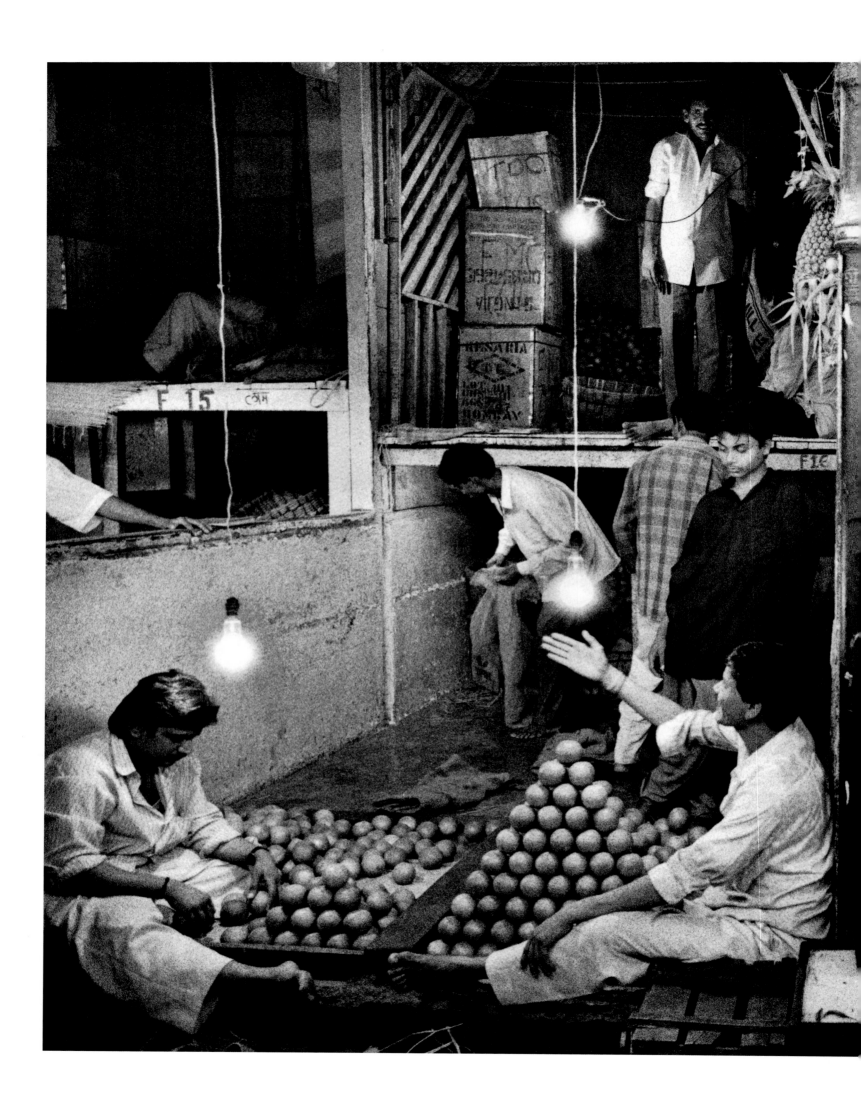

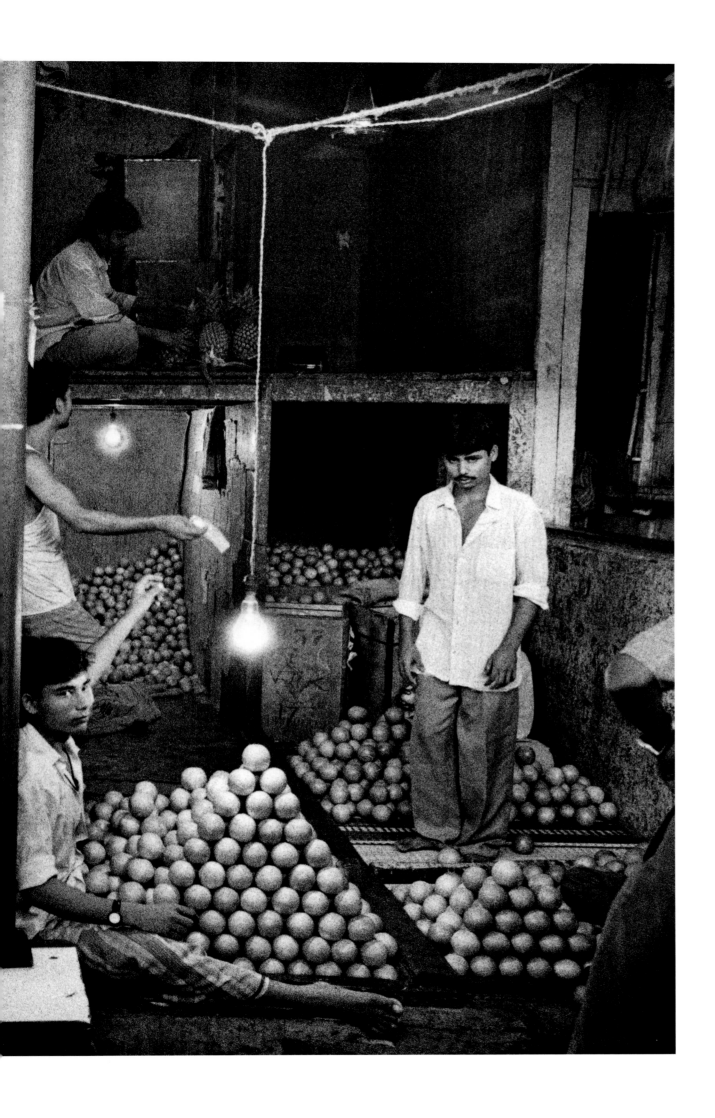

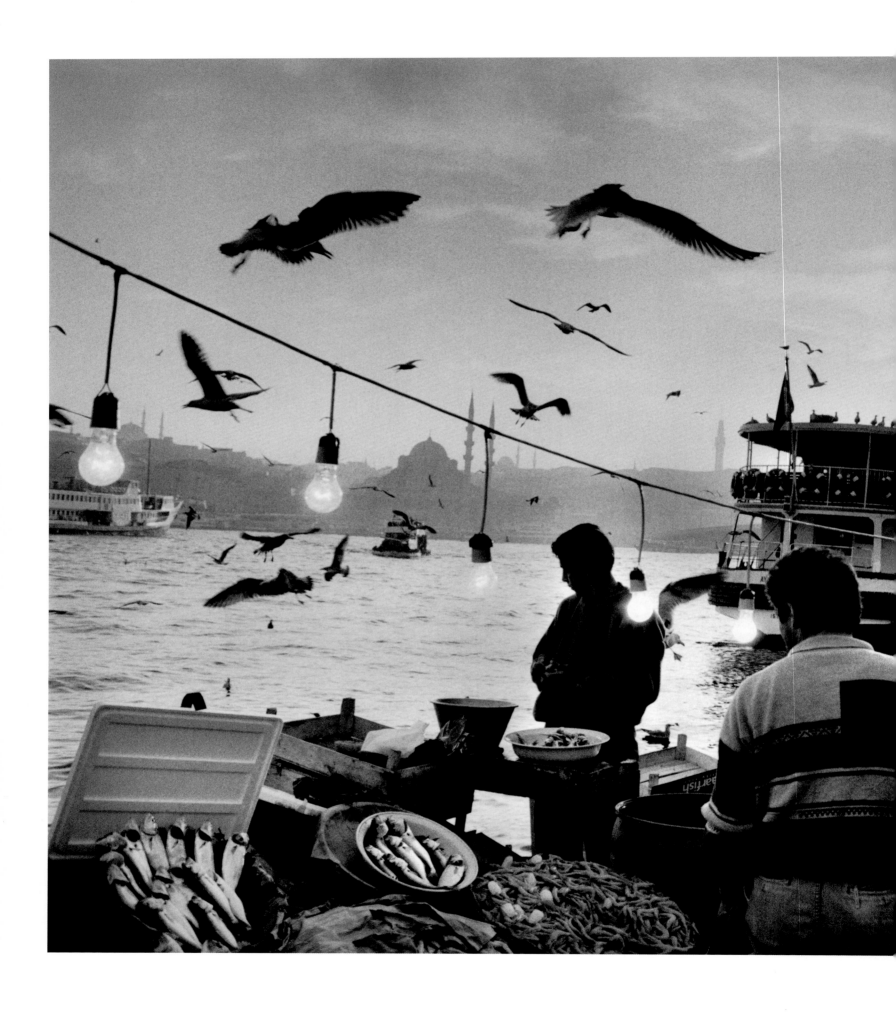

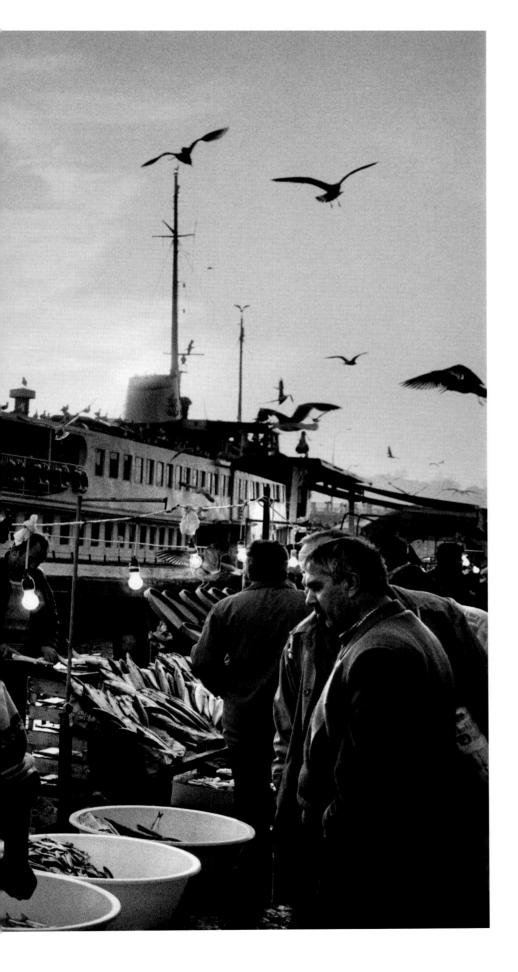

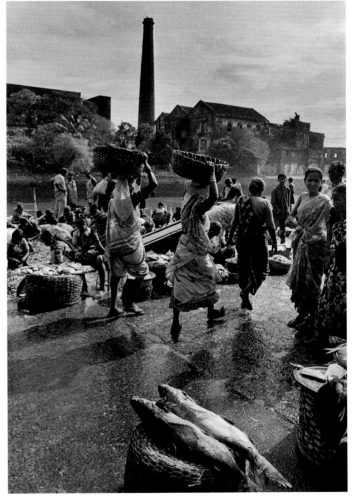

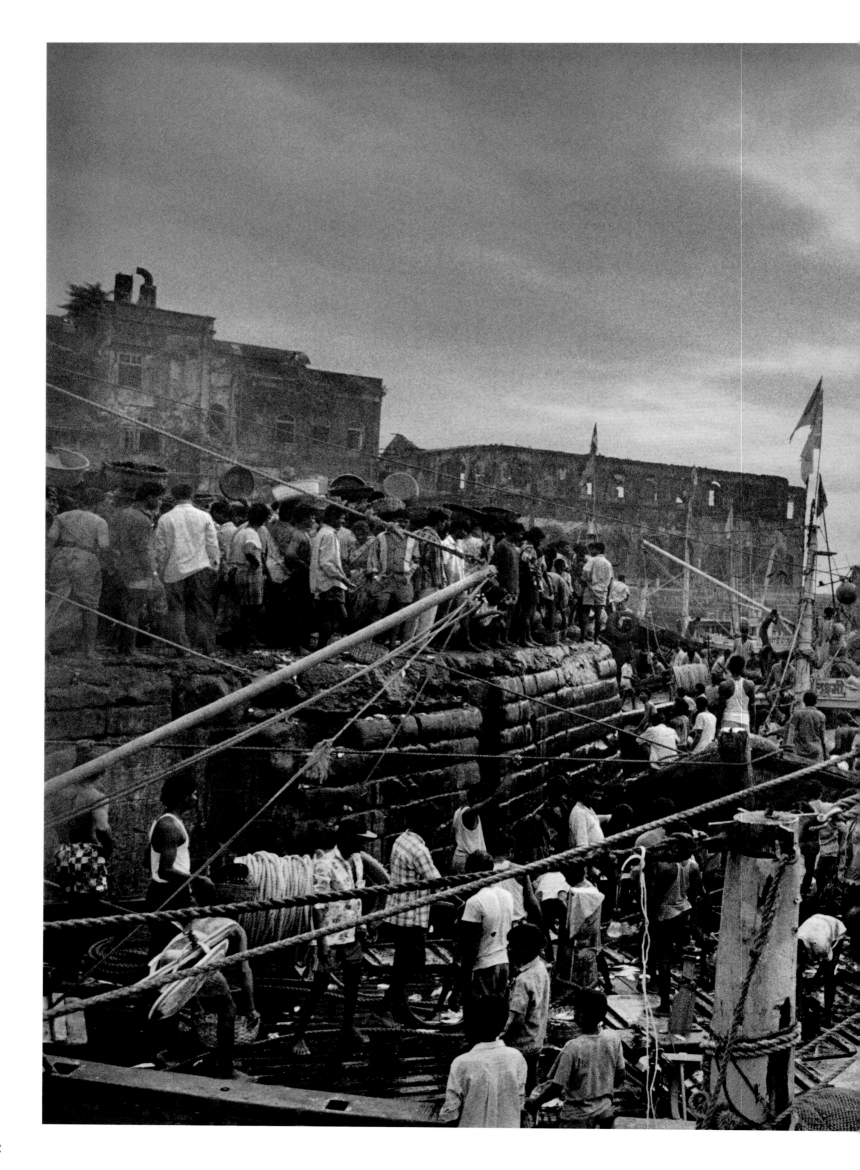

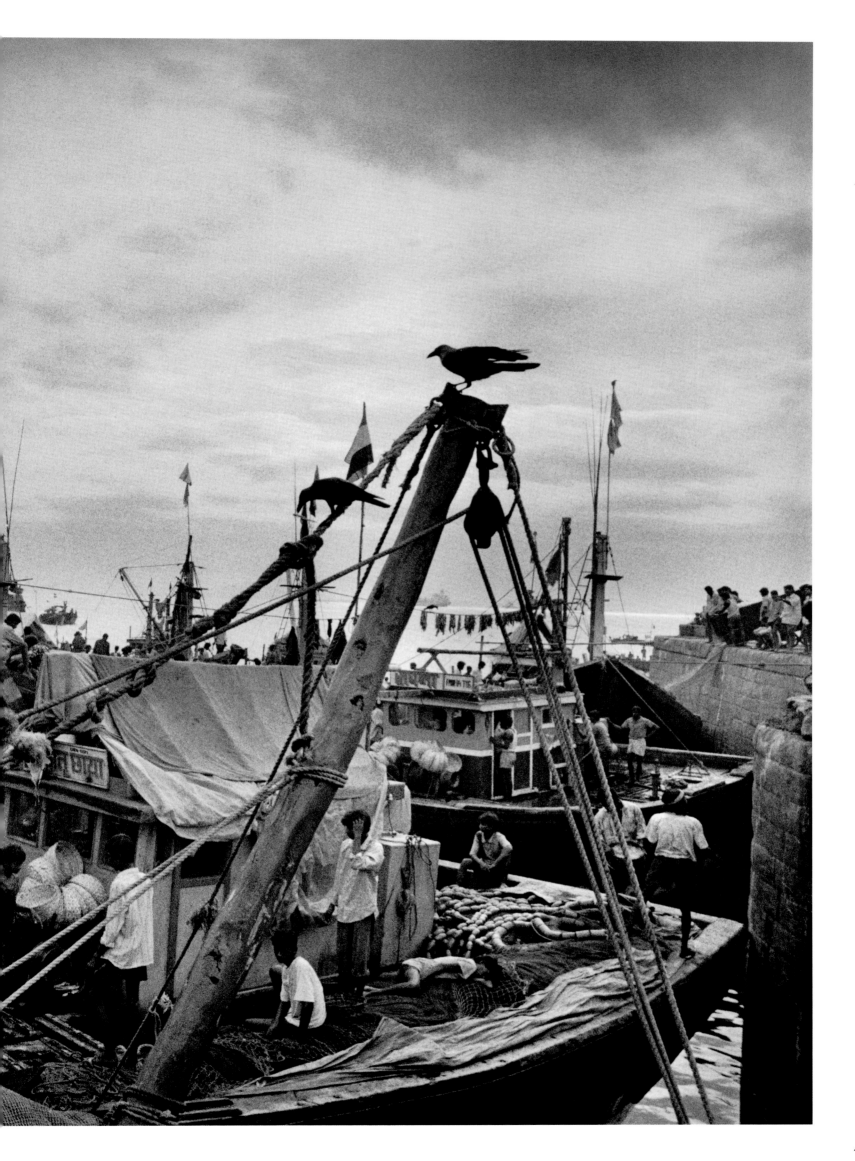

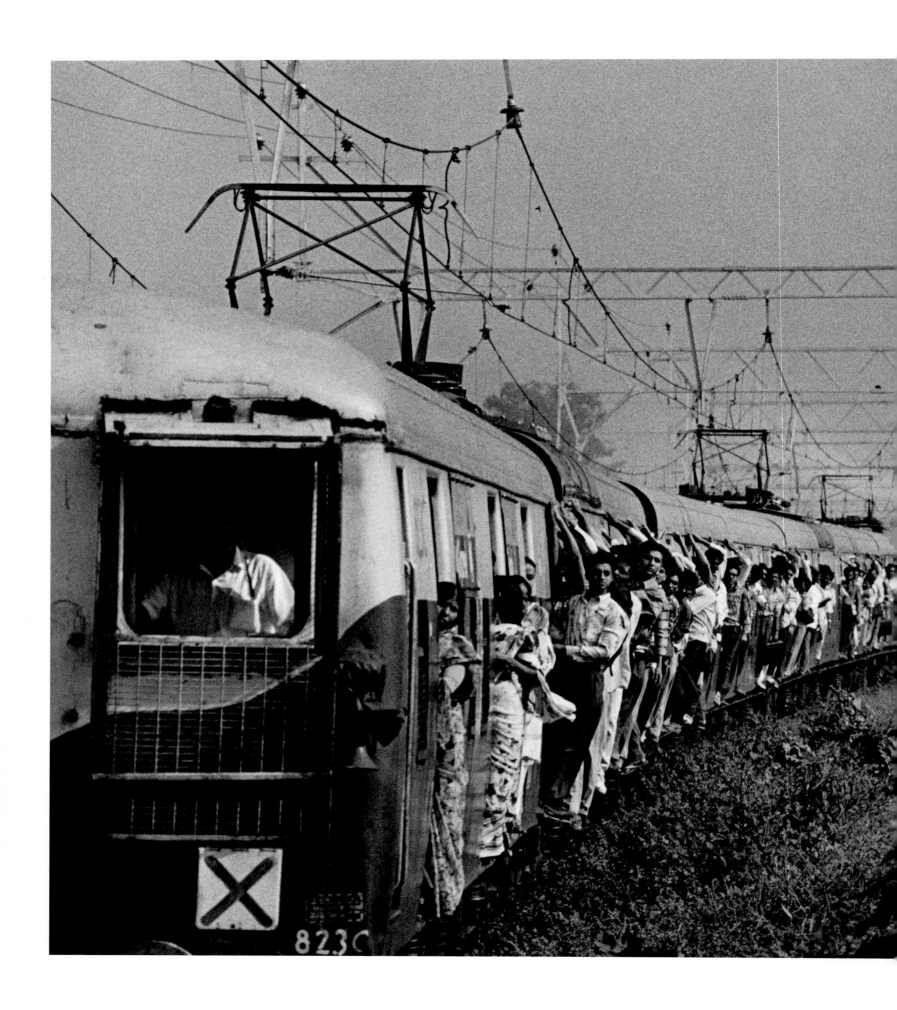

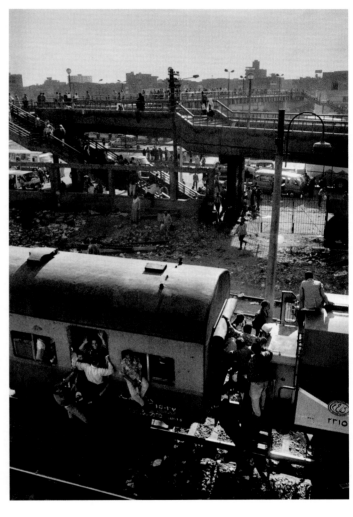

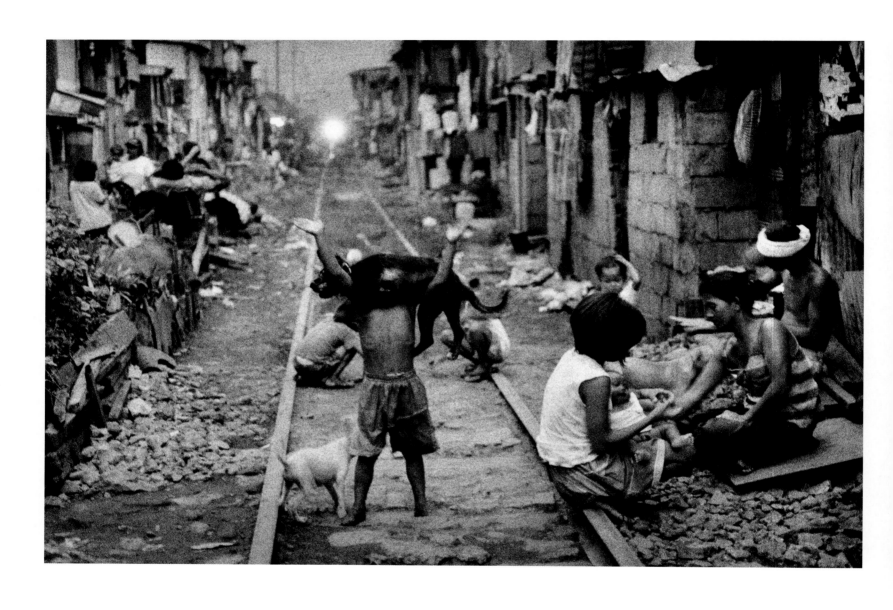

416

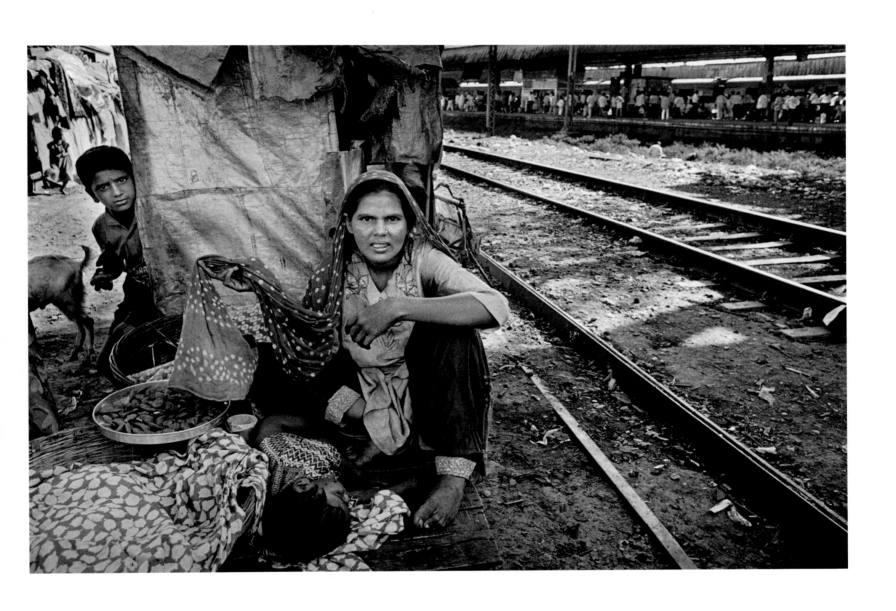

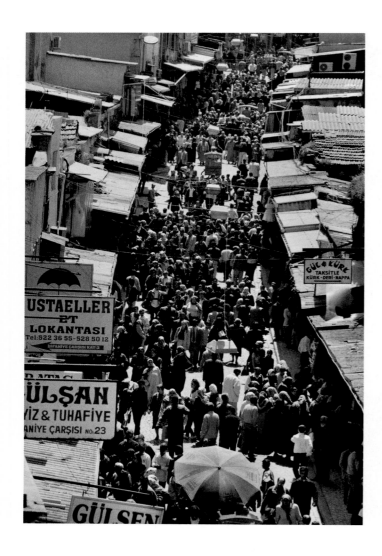

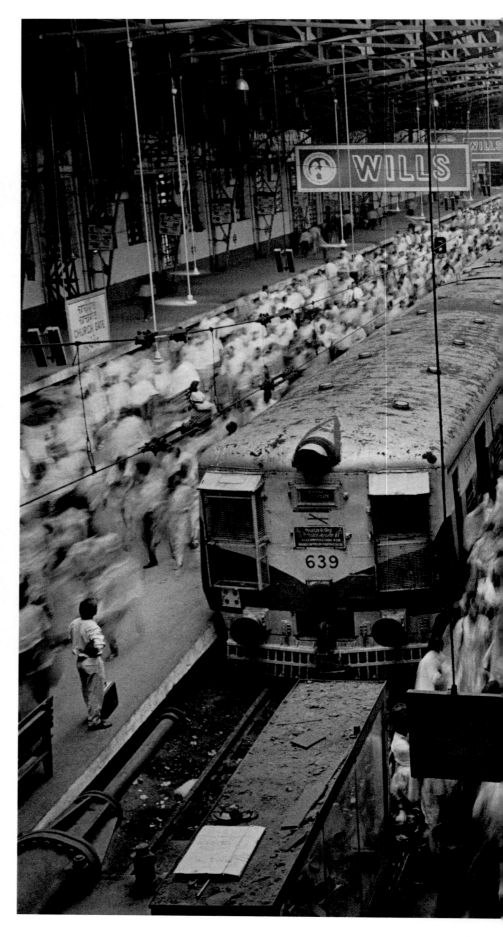

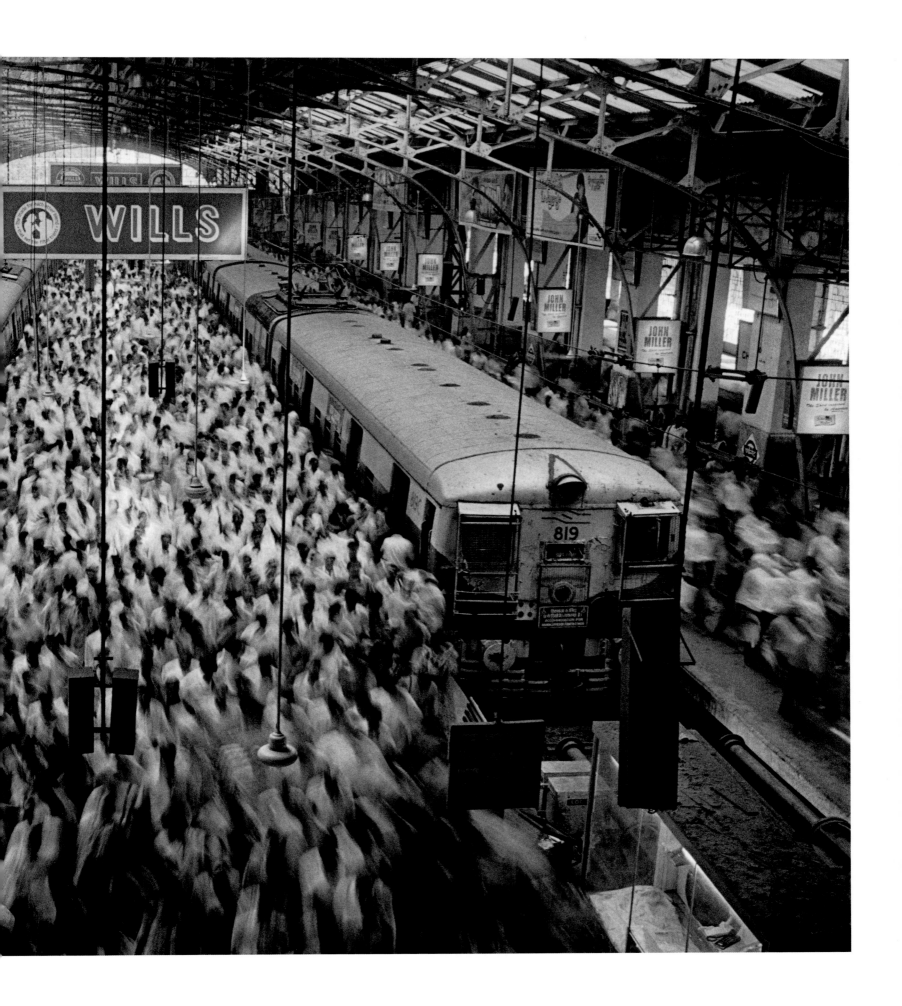

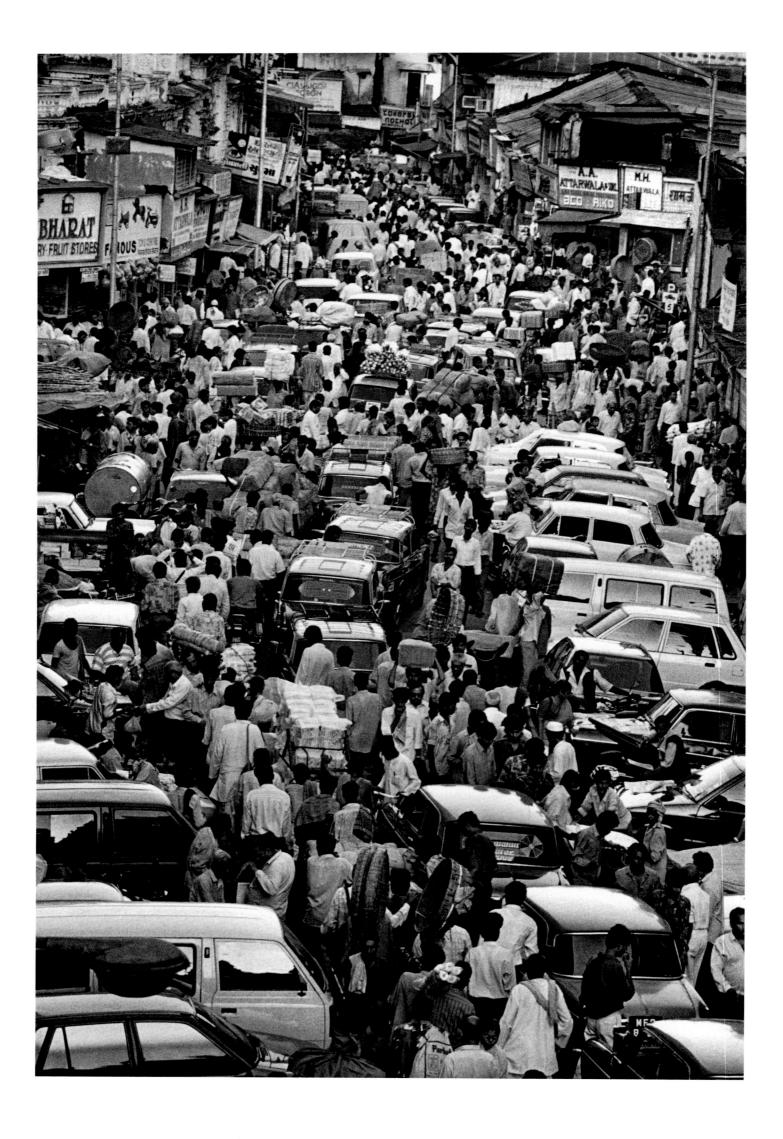

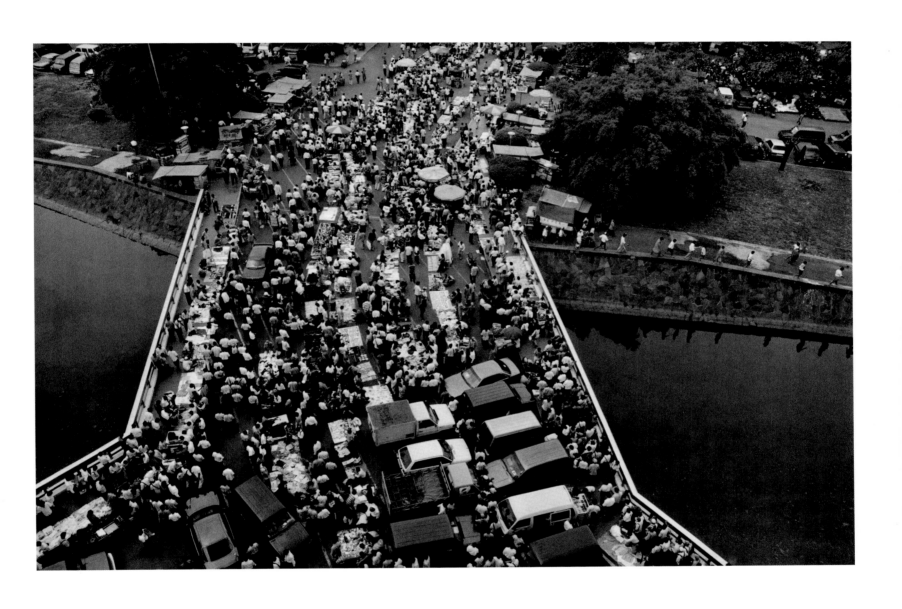

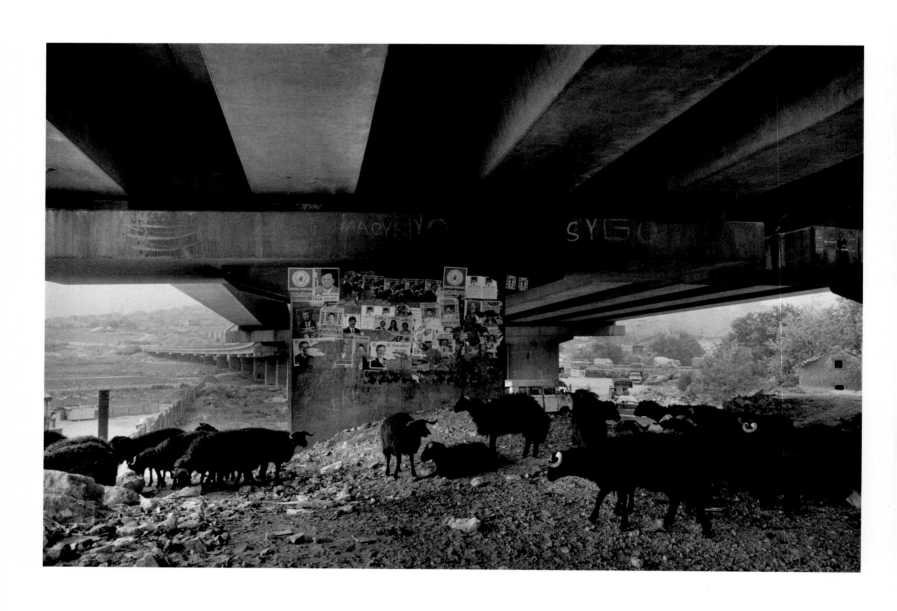

422

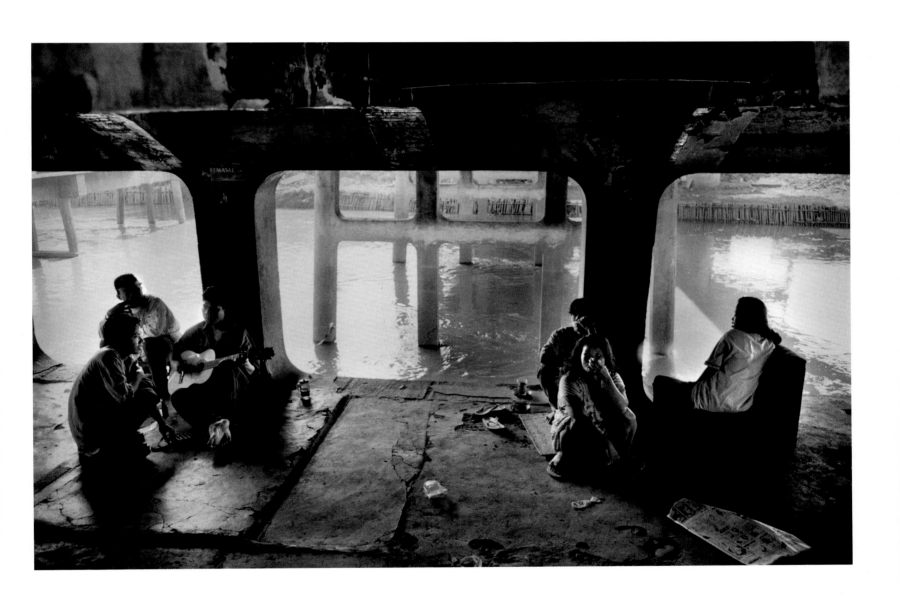

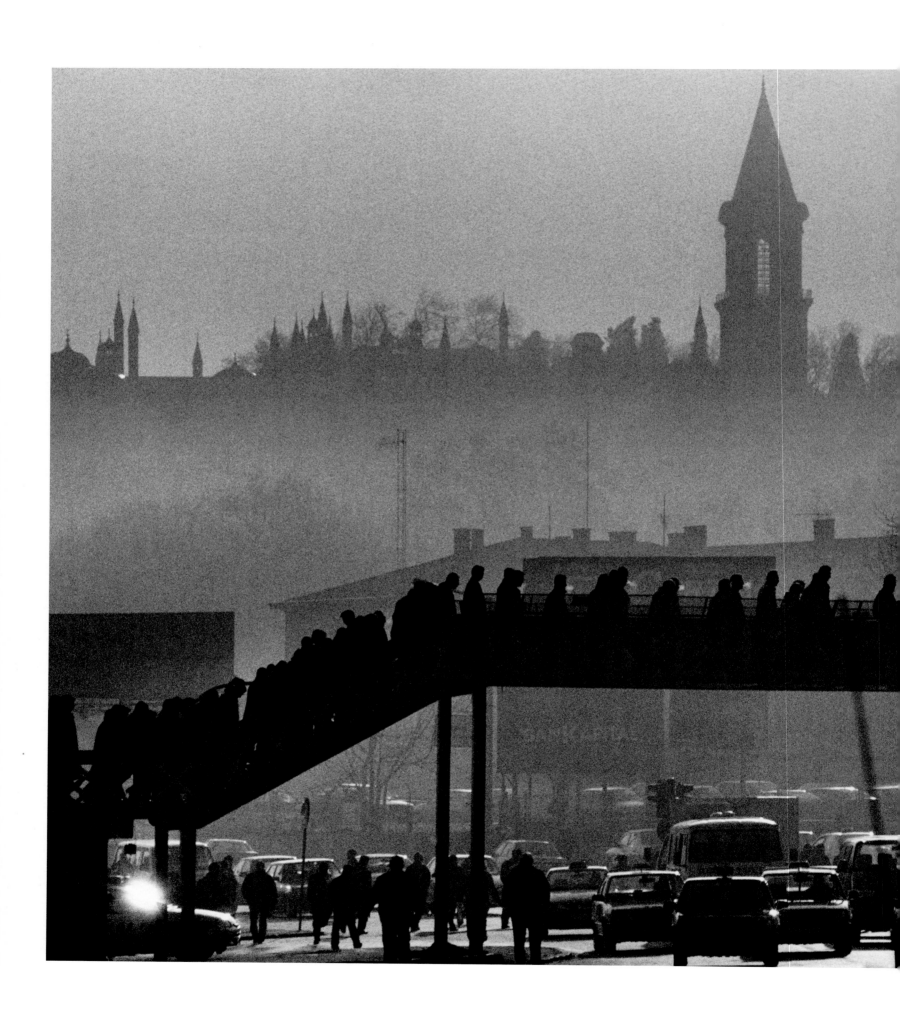

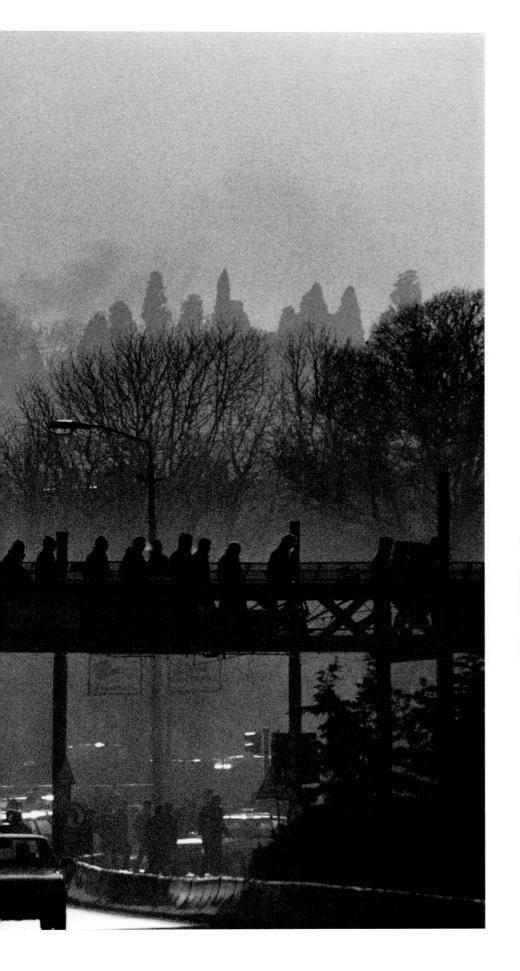

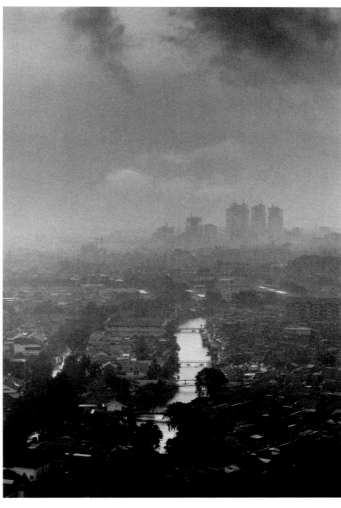

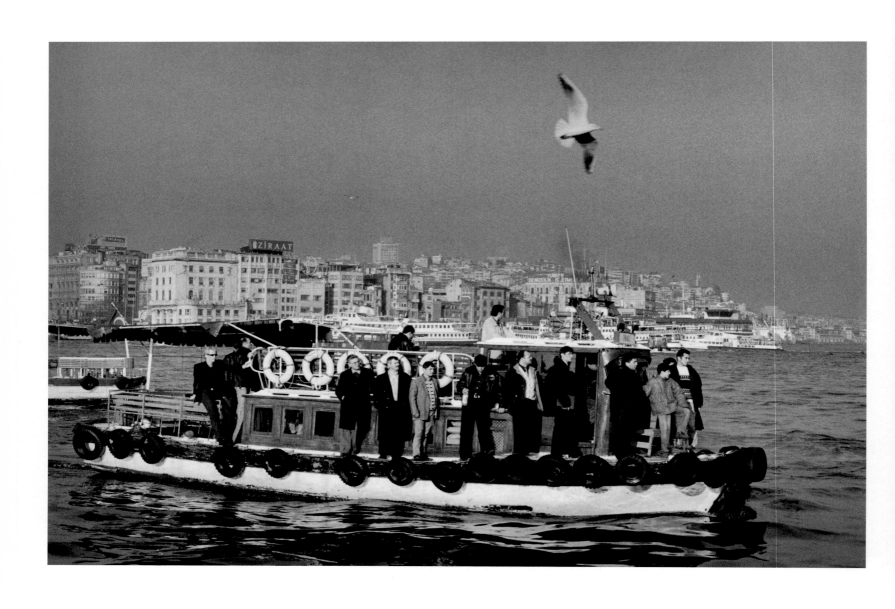

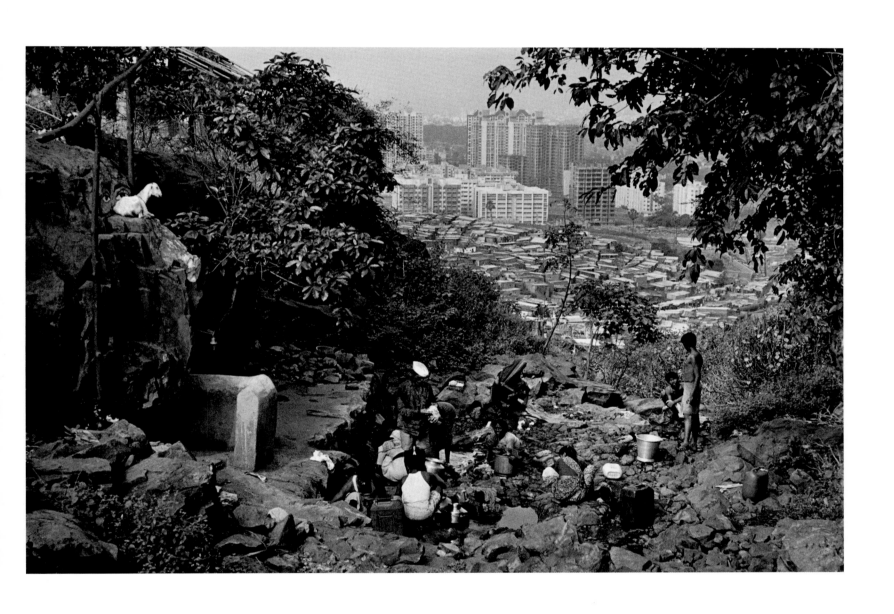

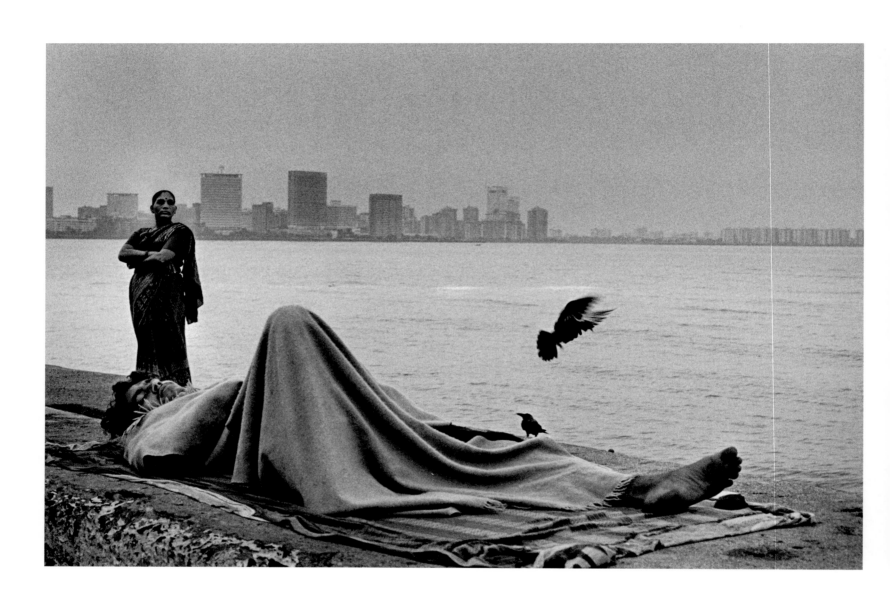

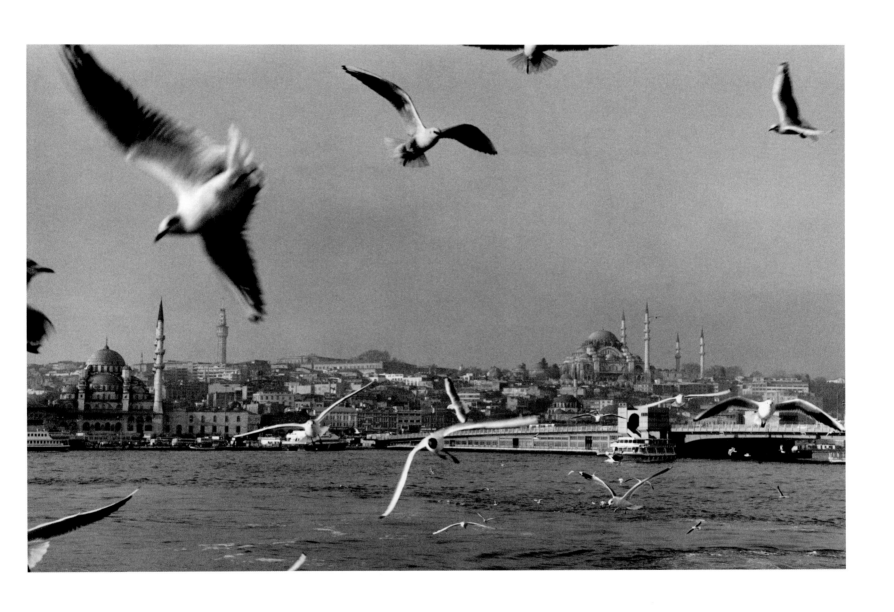

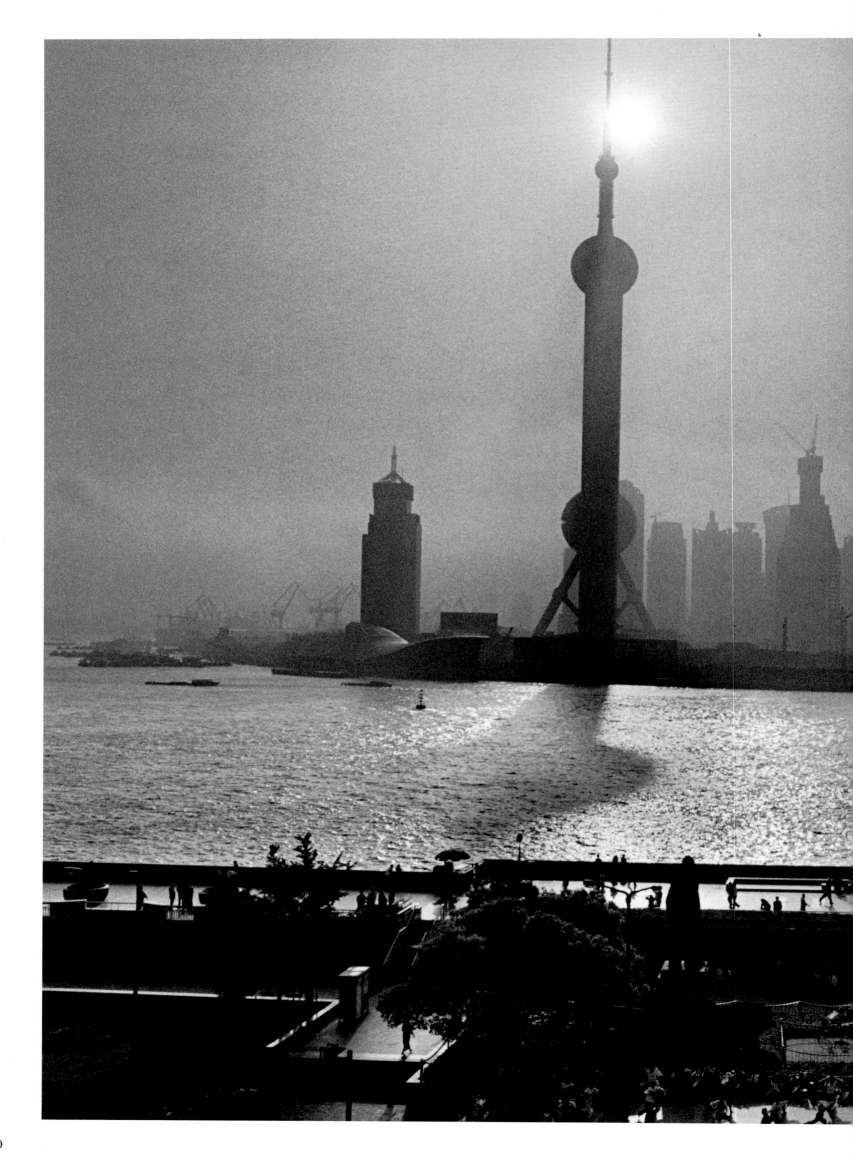

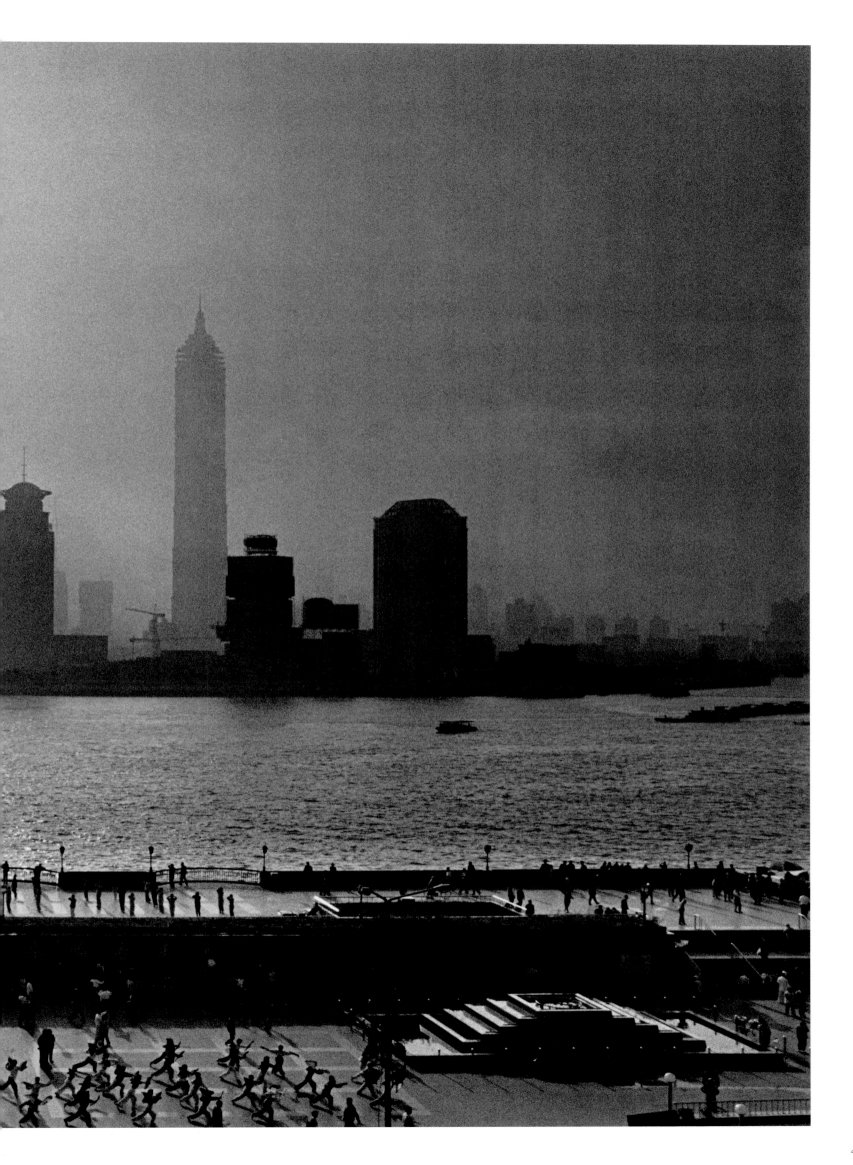

Printed in Switzerland by Entreprise d'arts graphiques Jean Genoud SA, Le Mont-sur-Lausanne